SEEING AND KNOWING

UNDERSTANDING ROCK ART
WITH AND WITHOUT ETHNOGRAPHY

LEFT COAST PRESS, INC.
1630 North Main Street, #400
Walnut Creek, CA 94596
http://www.LCoastPress.com

Library of Congress Cataloging-in-Publication Data available from the publisher.

ISBN 978-1-61132-048-0 paperback

Printed in the United States of America

The paper used in this publication meets the minimum requirements of American
National Standard for Information Sciences—Permanence of Paper for Printed Library
Materials, ANSI/NISO Z39.48–1992.

Edited by Lee Smith
Cover design by Hothouse South Africa
Layout and design by Hothouse South Africa

SEEING AND KNOWING

UNDERSTANDING ROCK ART
WITH AND WITHOUT ETHNOGRAPHY

EDITED BY

GEOFFREY BLUNDELL
CHRISTOPHER CHIPPINDALE
BENJAMIN SMITH

Left Coast Press Inc.

Walnut Creek, California

This volume is dedicated to David Lewis-Williams

Contents

Contributors

Geoffrey Blundell

Rock Art Research Institute, University of the Witwatersrand, Private Bag 3, PO WITS 2050, South Africa
geoff@origins.org.za

Christopher Chippindale

Cambridge University Museum of Archaeology & Anthropology, Downing Street, Cambridge CB2 3DZ, England; Rock Art Research Institute, University of the Witwatersrand, Private Bag 3, PO WITS 2050 Gauteng, South Africa; School of Archaeology & Anthropology, Australian National University, Canberra ACT 0200, Australia
cc43@cam.ac.uk

Jean Clottes

11 rue du Fourcat, 09000 Foix, France
j.clottes@wanadoo.fr

Margaret W. Conkey

Archaeological Research Facility and Department of Anthropology, University of California, Berkeley, CA. USA 94720-3710
Conkey@sscl.berkeley.edu

Edward B. Eastwood

Ed Eastwood passed away during the preparation of this volume. The editors pay tribute to an archaeologist who made an exceptional contribution to the field of rock art studies.

Julie E. Francis

1403 Curtis Street, Laramie WY 82070, USA
julie.francis@dot.state.wy.us

Knut Helskog

Department of Cultural Sciences, Tromsø University Museum, 9037 Tromsø, Norway
Knut.helskog@uit.no

Imogene L. Lim

Department of Anthropology, Vancouver Island University, formerly Malaspina University-College. 900 Fifth Street, Nanaimo, BC, V9R 5S5 Canada
Imogene.Lim@viu.ca

Lawrence L. Loendorf

Albuquerque, New Mexico, USA
llloendorf@yahoo.com

Johannes Loubser

Stratum Unlimited, LLC, 10011 Carrington Lane, Alpharetta, GA 30022, USA
Rock Art Research Institute, University of the Witwatersrand, South Africa
jloubser@stratumunlimited.com

David Morris

McGregor Museum, PO Box 316, Kimberley, Northern Cape 8300, South Africa
dmorris@museumsnc.co.za

Sven Ouzman

Department of Anthropology and Archaeology, University of Pretoria, Tswane 0002, South Africa
sven.ouzman@up.ac.za

Neil Price

Department of Archaeology, University of Aberdeen, St. Mary's, Elphinstone Road, Aberdeen AB24 3UF, Scotland
neil.price@abdn.ac.uk

Tore Saetersdal

Director, Nile Basin Research Programme, University of Bergen, Bergen, Norway
Tore.Satersdal@uni.no

Benjamin Smith

Rock Art Research Institute, University of the Witwatersrand, Private Bag 3, PO WITS 2050, South Africa
bws@rockart.wits.ac.za

Patricia Vinnicombe

Patricia Vinnicombe passed away during the preparation of this volume. The editors pay tribute to an archaeologist who made an exceptional contribution the field of rock art studies.

Eva Walderhaug

National Directorate for Cultural Heritage
PO Box 8196 Dep., 0034 Oslo, Norway
esw@ra.no

Nick Walker

8 Andrew Joss Street, Mossel Bay, 6506,
South Africa
nwalke@telkomsa.net

David S. Whitley

ASM Affiliates, Tehachapi CA, USA
huitli53@gmail.com

Acronyms

AMISUD	Amigos de Sudcalifornia
AMS	Accelerator Mass Spectrometry
BP	Before Present
GCI	Getty Conservation Institute
LSA	Later Stone Age
MSA	Middle Stone Age
LSCA	Limpopo-Shashe Confluence Area

FIGURE 1.1 In the field, 1996: David Lewis-Williams *(right)* with Jean Clottes *(left)* in front of the main panel, with its famous frieze of eland at Game Pass Shelter in the Drakensberg.

1.

Rock art with and without ethnography

GEOFFREY BLUNDELL, CHRISTOPHER CHIPPINDALE AND BENJAMIN SMITH
(Rock Art Research Institute, University of the Witwatersrand, South Africa)

THE LEWIS-WILLIAMS REVOLUTION:
Studying rock art in southern Africa and beyond

The overall theme and structure of this book serve to explore how best we study rock art when there exist ethnographic or ethnohistoric bases of insight, and how we study rock art when there do not appear to be ethnographic or ethnohistoric bases of insight – in short, how we understand and learn from rock art with and without ethnography. We are not aware of an exact precedent for this, although the way archaeologists work best with and without ethnography is a perpetual issue of the discipline.

The ten years between 1967 and 1977 were, we can now see, a revolutionary period in southern African rock art research. In those years the older, colonial approaches to studying San rock art were rejected and replaced with approaches based on San cognition and ethnohistory – concerns which continue to be strong in the region and are increasingly influential outside it. In particular, studies of the meanings of San rock art have received wide notice.

This is more than a local or a regional concern. For a century – ever since the unexpected discoveries of Ice Age rock art in its deep caves astonished Europe – researchers have found rock art difficult. Striking though it often is in its aesthetic force, it has been hard to date and hard to make sense of within conventional archaeological frameworks. So observant, so well done, so accomplished, it must have meant something in ancient times – but what? In South Africa, David Lewis-Williams has accurately called the well-meaning and unhappy approaches that resulted 'gaze and guess' (Lewis-Williams & Dowson 2000). Guesses have come

and gone in passing fashions over the decades as archaeologists have struggled with rock art – from totemism to sympathetic magic to aesthetic self-enjoyment to daily narrative to structuralism, back to totemism (Jones 1967) and so on – in a way that gives no confidence that the present fashion will be more than a passing phase, or even that knowledge accumulates, building and extending from stage to stage. Ideas seem just to flit about, one sometimes popular and one sometimes not, within much the same level of necessary ignorance. An influential textbook published in England at the start of that transforming South African decade, Peter Ucko and Andrée Rosenfeld's *Palaeolithic Cave Art* (1967), surveyed those various ideas about European rock art's meaning which had been or then were variously in vogue. It showed well how many and fatal were their weaknesses, but that textbook was reticent when it came to recommending where a better way forward might be found. An influential commentator today insists that the meaning of ancient art must always be unknowable: 'gaze and guess' is the best we can do, and since guesses make no useful knowledge, we do best just to gaze.

It is largely through the work of David Lewis-Williams and his colleagues at this time that San rock art has come to be understood so well, as a complex symbolic and metaphoric representation of San religious beliefs and practices. As chapters in this volume acknowledge, seminal to this enterprise was Lewis-Williams' PhD thesis, 'Believing and Seeing: An Interpretation of Symbolic Meanings in Southern San Rock Paintings'. Completed in 1977 and then published by Academic Press, London, in 1981, *Believing and Seeing* was a landmark because it employed San ethnography in order to tease out the semantic spectrum of key San symbols, first within their ritual life, then within their rock art in two areas within the Drakensberg Mountains. *Believing and Seeing* is frequently remembered now as the work which persuasively argued that Drakensberg San rock art is essentially shamanistic in nature. It actually did something rather different in identifying San rock art as referring to the multiplicity of San rituals, of which the central shamanic curing dance was only one.

In this book dedicated to David, we mention his key role but not those of others in any detail, some of whom are themselves contributors to this book. Instead, we point to the importance of the South African example as a beacon in that darkness of gloom which sees the meaning of rock art as unknowable, and therefore the whole enterprise of studying it as permanently stuck. If meaning can be known in South Africa and is known, then perhaps it can be and should be known elsewhere? Perhaps the particular approaches that seemed to work in South Africa could work in other places: what, for example, if the great many volumes of ethnography for the American West, diligently published many decades ago and now languishing on the library shelves, actually preserved ethnohistoric records pertinent to rock art, records which could offer a route to insight as the Bleek and Lloyd (1911) records do for the San? What if the knowledge of Native Americans today, and their own reactions to rock art, gave clues to ancient meanings just as the knowledge and ritual of San people today, people who do not themselves paint rock art, gave insight into the southern African images? What if the iconographic elements recognised as distinctive in South Africa had parallels in the American West? And what if, even where the specifics of the South African example seemed less easy to follow, the success of the enterprise encouraged the potential optimist to believe that by seeing the rock art in the right kinds of ways, whatever those might be in any one region, actual research progress might be made in areas of research where glum pessimism was the habit?

Rock art research is not a confined business. In parallel with developing research in South Africa, there has been much activity and important new work in other regions. Sometimes, especially in Australia with its astonishingly rich insights from ethnographic records and contemporary Aboriginal knowledge (e.g. Layton 1992; Chaloupka 1993; Doring 2000), this has paralleled advances in South Africa. And, after too long a period when rock art research in North America has been marginal, it is rapidly advancing there.

THE DUAL ETHNOGRAPHIC-NEUROPSYCHOLOGICAL APPROACH: The classic style of study in the classic area

It was in the later 1980s that South African interpretations of San art began to concentrate on shamanism. There were two reasons for this. First, as researchers studied imagery farther and farther afield, both within

the Drakensberg and beyond, it became apparent that very few images could be convincingly related to other ritual aspects of San life; yet many evidently concerned their shamanic beliefs and practices. Second, researchers became aware of the neuropsychological research pertaining to imagery experienced in altered states of consciousness. This gave them a further interpretative tool for understanding the many bizarre images in the art that, at first glance, might not appear directly explicable by ethnography.

Over the course of the last two decades, this dual ethnographic-neuropsychological approach has achieved wide acceptance as the most productive way of analysing San rock art: it has become the 'classic' approach. That the classic approach continues to yield productive results is well demonstrated by Sven Ouzman's contribution to this volume (chapter 2). He draws on ethnographic material from both 19th- and 20th-century San to explore the intriguing possibility that certain celestial events were recorded in San art. In contrast to the many discussions of 'ancient astronomy', he does not argue that the images acted as a calendar; instead, he shows how the San perceived these celestial phenomena in a more symbolic manner.

Evident in chapter 2 is how the classic approach constructs an expanding body of knowledge. Like all systems of meaning, San rock art has strong consistencies and recurrences. Once the sense of one aspect has been grasped, that insight in turn makes possible inferences about others. Thirty years since the classic approach began to reach a stable procedure, it is possible to look at a unique rock painting, at a defined group of figures not previously treated together, at a panel scrutinised more than once before, and to advance our insight into each of them as these chapters successively do.

EXTENDING BEYOND THE CLASSIC STYLE OF STUDY IN THE CLASSIC AREA

Although Ouzman's chapter clearly demonstrates the continued value of San rock art research approached in this way, two aspects of the classic approach also place limitations on what it can say. All studies that work out from a basis in historical or ethnohistoric records face issues of time and space. How far can

insight from that record be applied as one moves away in space and in time from the specific source? The accounts of what the Spanish conquistadores encountered as they stormed through the Andes give direct insight into the Inca realm at a certain place and time (and under a certain circumstance), but then: for what distance in time, in space, might those insights apply before that separation means the insights weaken or fail or – if still depended on – mislead?

The original bases for ethnographic insight into San rock art were the few direct references to painting, and the voluminous reporting of San knowledge of all kinds that was recorded over the decades, especially the Bleek and Lloyd collection compiled in the 1870s, plus the ethnographic report and anthropological analyses concerning San people in the Kalahari Desert in very recent years (for an overview, see Barnard 1992). The strong consistency found between these various sources (Lewis-Williams & Biesele 1978) was itself grounds for thinking that San knowledge was fairly stable over space and time. But there clearly must, at some distance, be a limit: this consistency cannot extend indefinitely in space or in time.

Southern African rock art, like rock art of most kinds and in most regions, is difficult to date. Developing relative chronologies is problematic because superposition sequences have been shown to be an active product of meaning construction rather than a passive record of changes through time (Lewis-Williams 1974); along with this, a small number of absolute dates means that we do not yet clearly understand change in the art even at a specific location or within a small region. This is the common story for rock art everywhere in the world. Since the rock art is not clearly placed in time, an approach is encouraged – or is even inescapable – which does not centre on change in time. One can envisage that, if a strongly structured chronology does emerge, our knowledge of San rock art will be enriched by some grasp of how (and then perhaps of why) it has changed.

The 'classic' approach was influenced more by social anthropological theory, particularly the symbolic anthropology of Victor Turner, than by the culture change that archaeologists in southern Africa and the rest of the world concentrated on in the 1970s. This sort of anthropological thinking was, indeed, criticised by historians for playing down the importance of temporal change – almost suspending a

particular people as if fixed in time. Nevertheless, the classic approach does not dodge or dismiss the idea of change in the art. The suspension of chronology in the classic efforts led to a broad-based interpretative framework. In its most fundamental formulation it follows then, given the sources available to us, that we can say with varying confidence – depending on the particular image and on the available ethnographic and neurological evidence – that at some point in time and for some San people, at least, the image is likely to have carried this and/or that meaning. The image may also have had other meanings, or those meanings may have changed through time. What those other meanings were and how they changed are matters also to be demonstrated.

Closely related to these issues of separation in time is the second limitation of the classic approach – how it will deal with distance and separation in physical space. Moving out from the original study area in the Drakensberg Mountains of south-east South Africa and Lesotho, can a similar interpretative framework be fairly applied to other rock art images in widely scattered regions in southernmost and in less southernmost Africa? If it can be, then how far in space can it go? Zimbabwe? Namibia? To the Zambezi? Beyond and up into East Africa? Is it fanciful or absurd to remember the richness of that other great zone of African rock art, in the Sahara? Using the established tools of ethnography and neuropsychology developed in the classic approach, more and more painted images could be and have been interpreted as shamanic in nature. (A case is even being made that hunter-gatherer rock art in the generality – wherever it is in place and time – will relate to shamanic experience [Pearson 2002].) Of course these efforts, in allowing researchers to see meaningful similarities in the art across space, masked variation and divergence, since regional differences were subordinated to broad-based general meanings. Today, most southern African researchers would acknowledge that the classic approach as such can only be applied to rock art south of the Zambezi River, and there only to San rock art; the other regional traditions, such as the southern African herder and farmer rock arts, require a different approach.

There was another separation to be bridged also, in the techniques of the rock art. While acknowledging that it was part of the same system of shamanic beliefs and practices, the classic approach rarely attempted to interpret southern Africa's vast body of rock engravings alongside the paintings. Only in the early 1990s – some 15 years after the initial revolution – did the first major study of rock engravings to use ethnographic and neuropsychological evidence appear (Dowson 1992; subsequently e.g. Morris & Beaumont 1994; Ouzman 1996); and the engraved tradition remains an understudied component of southern Africa's rock art heritage.

Chapters 3 to 6 push out in these research directions beyond the classic approach, extending application of the ethnographic evidence. Both David Morris and Nicholas Walker look at engravings rather than at paintings. Morris (chapter 3) takes a classic approach to interpreting rock engravings at Driekopseiland, the extraordinary and famous site to which there is specific reference in ethnohistoric accounts from the 1870s. Walker (chapter 4) extends ethnographic-based work to cupules – the little hollows pecked on to surfaces that are found in a score of African countries and, in startlingly similar forms, in archaic Australia amongst other places – with a study from the Tsodilo Hills, northern Botswana, a move also in space from the classic study area.

Chapters 5 and 6 move decidedly north in space from the classic area. Edward Eastwood, Geoff Blundell and Benjamin Smith (chapter 5) consider the art of the central Limpopo Basin, the 'Kalahari fringe', showing how it differs considerably from the paintings of the Drakensberg – the area of focus of the classic approach – and how the rock art of different peoples is found there. Imogene Lim (chapter 6) explores the use of ethnography in East Africa in studying rock art of the Sandawe, a click-speaking people in Tanzania who are apparently not otherwise related to the Khoe-San people of South Africa.

These new research interests have opened and will open a number of interesting and important questions, some of which can be answered while others remain elusive. Also to be further developed – and here the remaining 11 chapters in this volume are relevant – are studies in other rock art regions of the world where variation and constancy can be observed and explored across distances both in space and in time, alongside those few regions such as tropical north Australia, where we have a reasonably clear picture already (see e.g. Chaloupka 1993). A first-rate recent example is the definition and disentangling of

the diverse and varied art styles and traditions of the North American Great Plains in fine new studies – of the broad region by Keyser and Klassen's *Plains Indian Rock Art* (2001), and of an area within it by Francis and Loendorf's *Ancient Visions: Petroglyphs and Pictographs of the Wind River and Bighorn Country, Wyoming and Montana* (2002). This will open opportunities to look for, and perhaps to find, some repeated patterns across very separate regional traditions, and so begin to build a general model for how rock art varies in space and in time.

FROM SOUTH AFRICA TO THE WORLD, FROM INFORMED METHODS TO FORMAL METHODS

A standard and natural feature of archaeological work is its regional focus: the starting point of systematic knowledge is the material evidence in a geographically bounded unit. But alongside that is interest in common themes which unite scattered areas, and in common research approaches which – once developed or proven in one region – are ready to address matching problems elsewhere. More than most topics within archaeology, rock art has been studied too much within a regional framework. Despite the isolation of South Africa in the apartheid era,[1] and the barrier of distance that separates southern Africa from parts of the world that are seen as central, a distinctive element in David's work and in that of those who have learnt from him either follows the methodology established by the classic approach in southern Africa and applies it elsewhere or, in a less specific way, jumps the regional barrier.[2] In North America and elsewhere, rich ethnographic contexts offer new and powerful insights into the rock art – once the pertinence is acknowledged of the ethnohistoric records and of contemporary indigenous understandings.

In other places, however, sparse records or the non-existence of ethnographic records make interpretative exercises far more difficult. There we must turn more from the 'informed methods' which ethnographic insight offers towards the 'formal methods', those that deal with the material evidence to be found in the images themselves and their archaeological contexts (Taçon & Chippindale 1998). Chapters 7, 8, 9 and 10 move outside southern Africa to varied other

regions. David Whitley (chapter 7) and Lawrence Loendorf (chapter 8) draw on rich ethnographic material to offer interpretations of North American rock art which echo, in their development of informed methods, the South African experience. Jannie Loubser (chapter 9), working in Mexico, uses the stratigraphic analytical technique of Harris matrices alongside ethnographic material in his analysis of rock paintings in Baja California. Knut Helskog (chapter 10), working in northernmost Europe, an area where the relationship between the ethnographic record and the rock art is not yet well understood, investigates Scandinavian rock engravings; he shows how a combination of ethnographic material and a formal approach can produce convincing interpretations.

UNDERSTANDING ROCK ART: Informed methods, formal methods, and the uniformitarian issues

The application of matching approaches to problems so broadly separated takes us to the issues sometimes thought of as being to do with 'systematics' but in truth better and correctly called uniformitarian issues.[3] Archaeologists trying to make sense of the past do so by placing it in some relation to the present – for it is only the present to which we have any direct access and of which we can have direct knowledge. As soon as we say of some ancient thing, "This is an artefact" or "This is a rock painting", we make an observation reporting what happened in the past by the parallel of that material object with what we know of the present. So all issues of archaeological understanding have to do with what the Victorians called 'uniformitarianism' and its central paradox: we can understand and make sense of the past by its sameness, to the extent that it matches what we observe in the present, but a main reason we are interested in the past, especially the remote and other past, is that it shows or may show great or fundamental difference.

Applying methods developed in one region or for one type of material or with a certain source of social knowledge to other regions or materials or social contexts raises important questions of this uniformitarian kind – some of them about how we understand meaning in the art, about the social role of the images, and about how we look at the images themselves.

In the next chapters a series of key theoretical issues relating to uniformitarianism are investigated. Jean Clottes (chapter 11) shows how understandings and insights from southern African work changed the way in which European researchers looked at Upper Palaeolithic images, as it showed them the large significance of aspects not thought consequential. Meg Conkey (chapter 12), also working on the Upper Palaeolithic, surveys the various theoretical approaches that have been employed over the decades to interpret the imagery and put forward some 'thinking strings' that might enrich how we think about the art and how we might better understand it. More recent in time are the later prehistoric rock engravings from Scandinavia, part of the Neolithic and later regional tradition of rock art in Europe whose meaning seems even harder to infer than that of the much older Palaeolithic caves. Centring on a celebrated site in western Norway, Eva Walderhaug Sætersdal (chapter 13) links study and understanding on that cold and rainy coast to study and understanding in southern Africa, in search of ways to make better sense of that most intractable northern imagery.

Patricia Vinnicombe was one of the architects of the original rock art revolution in southern Africa. She died in March 2003 after submitting a chapter for publication in this volume. Her *People of the Eland* (1976) is the twin to David's *Believing and Seeing*. Astonishingly, they worked at much the same time in close-by regions, yet largely independently of each other. While David remained in southern Africa, Vinnicombe moved in 1977 to Australia, where Aboriginal people still paint and carve the rocks. In chapter 14 she brings her Australian experience to a consideration of how San rock art is perceived and thought about.

The final three chapters deal with change and its consequences: the changing social milieu of the rock artists, the relationship of their descendants and relations in a contemporary world to the art, and the role of the images in a changing world. Tore Sætersdal (chapter 15) looks at perceptions of rock art in Manica Province, Mozambique. His research concentrates on people who have no recognisably direct relationship by continuous cultural descent with the rock art but who nevertheless regard the art as important. Julie Francis and Lawrence Loendorf (chapter 16) explore the changing shape of North American archaeology, seeing how it has and has not used the potential of oral tradition, of ethnography, and the special character of the rock art evidence. The concluding chapter by Neil Price (chapter 17) returns to the issue of change in time and across space and considers the extent to which we can use the recent ethnographies of shamanism in our studies of ancient rock art. The questions he poses and the answers he provides lie at the core of the methodological issues addressed in this volume and speak to the global relevance of the research of David Lewis-Williams.

THIS BOOK

This book itself, of course, is subject to the transforming process which changes all human things. We have entitled it *Seeing and Knowing* in echo of David's *Believing and Seeing* of some 30 years ago – we say 'seeing' again because looking at rock art is, and will always be, central, and then what is seen when human eyes and minds look; we say 'knowing' in recognition that, by his work and by his example, we now know a little more than we knew before. Even so, as David would be the first to say, we still know only very little.

This volume is dedicated to David Lewis-Williams, and the prompt to its writing was David's retirement from his professorship at the University of the Witwatersrand ('Wits', as many of us know it). His has been a limited retirement. He has had no more teaching duties, nor obligations to open those brown envelopes from central university bureaucracy. Instead, at last, he has been able again to concentrate on research and writing, and on the more agreeable role of acting as mentor and guide to younger students in the Rock Art Research Institute. Important publications chase each other off his desk: a new volume of San tales from the Bleek and Lloyd records, *Stories that Float from Afar: Ancient /Xam San Folklore* (Lewis-Williams 2000); the best-selling analytical synthesis of the meaning of European cave art, *The Mind in the Cave: Exploring Consciousness and Prehistoric Art* (Lewis-Williams 2002b); a book of his major papers, not just compiled into a single volume but also re-thought and integrated into a new 'reader' of his ideas, *A Cosmos in Stone: Interpreting Religion and Society Through Rock Art* (Lewis-Williams 2002a); *Images of Mystery: Rock Art of the Drakensberg* (Lewis-Williams 2003), wonderfully illustrated with many photographs and his first book in years once more to

FIGURE 1.2 At the celebratory conference, Goudrivier Farm, Waterberg, Northern Province, 23 April 2000.
Standing, from left: Jannie Loubser, Marcus Peters, Jeremy Hollmann, David Pearce, Neil Price, Knut Helskog, Siyakha Mguni, Christopher Chippindale, David Lewis-Williams, Ghilraen Laue, Tore Sætersdal, Neil Lee, Peter Ammann, Gabriel Tlhapi, Sven Ouzman, Paul den Hoed, Julie Francis, Sam Challis. *Seated or kneeling, from left:* Geoff Blundell, Larry Loendorf, Ben Smith, Azizo Fonseca, Imogene Lim, Janette Deacon, Patty Bass, Justine Olofsson, Claire Dean, Joanné de Jongh, Pat Vinnicombe, Meg Conkey.

consider the rock art of the Drakensberg; sage tricks of the trade set out for students in *Building an Essay: A Practical Guide for Students* (Lewis-Williams 2004); *San Spirituality: Roots, Expressions and Social Consequences* (Lewis-Williams & Pearce 2004), which provides a synthesis of research into 70 000+ years of art-marking in southern Africa; and his most recent books, *Inside the Neolithic Mind* and *Conceiving God*, which continue the *Mind in the Cave* story, following the history of European cosmology and symbolism into early farming and then Christian times (Lewis-Williams & Pearce 2005; Lewis-Williams 2010) – to mention just the recent full-length books.

On the occasion of David's retirement, a celebratory conference was held at Goudrivier Farm in the Waterberg, on 21–24 April 2000 (Figure 1.2). It was a thrilling occasion, celebratory in its looking forward more than backward, another beginning rather than an end. Most of the chapters in this book were given in a first form at that meeting, and have been revised

and enlarged for publication. Some were added by colleagues unable to attend. In another, less-pressed, age, this volume would be a Festschrift, a book of essays which in a spirit of comradely homage would celebrate an honoured and senior colleague in diverse ways. This volume is more focused, however, with a tight theme uniting its contributions, in the hope that its chapters together will make and mark another useful step forward in that central research theme in which David has himself moved so far: how to understand and learn from the meaning of rock art when there is, and when there is not, pertinent ethnography.

As editors of this book, we thank the contributors for the good-humoured and efficient way in which they worked with us and for their patience with an overly extended editorial process.

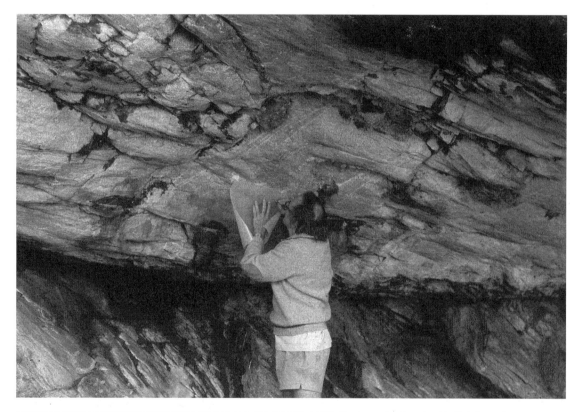

FIGURE 1.3 David Lewis-Williams tracing at Ezeljagdspoort, the site of one of his famous early ethnographically informed interpretations of San Rock Art.

Notes

1 Institutions such as David's university, Wits in Johannesburg, which honourably defended their values of racial equality against the impositions of apartheid, suffered with the rest from the isolation of South Africa and the opprobrium for all things South African in those years.

2 Starting with David and Thomas Dowson's landmark paper (1988), and subsequently, for example, Clottes and Lewis-Williams (1997 in French, 1998 in English) and Lewis-Williams (2002b).

3 As with so many other central concerns, David has written accurately and originally about this – see for example Lewis-Williams (1991).

References

Barnard, A. 1992. *Hunters and Herders of Southern Africa*. Cambridge: Cambridge University Press.

Bleek, W.H.I. & Lloyd, L.C. 1911. *Specimens of Bushman Folklore*. London: Allen.

Chaloupka, G. 1993. *Journey in Time: The World's Longest Continuing Art Tradition*. Chatswood (NSW): Reed.

Clottes, J. & Lewis-Williams, J.D. 1997. *Les Chamanes de la Préhistoire: Transe et Magie dans les Grottes Ornées*. Paris: Éditions du Seuil.

Clottes, J. & Lewis-Williams, J.D. 1998. *The Shamans of Prehistory: Trance Magic and the Painted Caves*. New York: Abrams.

Doring, J. 2000. *Gwion Gwion: Secret and Scared Pathways of the Ngarinyin Aboriginal People of Australia*. Köln: Könemann Verlagsgesellschaft.

Dowson, T.A. 1992. *Rock Engravings of Southern Africa*. Johannesburg: Witwatersrand University Press.

Francis, J.E. & Loendorf, L.L. 2002. *Ancient Visions: Petroglyphs and Pictographs of the Wind River and Bighorn Country, Wyoming and Montana*. Salt Lake City (UT): University of Utah Press.

Jones, R. 1967. From totemism to totemism in Palaeolithic art. *Mankind* 6(9): 384–392.

Keyser, J.D. & Klassen, M.A. 2001. *Plains Indian Rock Art*. Seattle (WA): University of Washington Press.

Layton, R. 1992. *Australian Rock Art: A New Synthesis*. Cambridge: Cambridge University Press.

Lewis-Williams, J.D. 1974. Superpositioning in a sample of rock paintings from the Barkly East District. *South African Archaeological Bulletin* 29: 93–103.

Lewis-Williams, J.D. 1981. *Believing and Seeing: Symbolic Meaning in Southern San Rock Paintings*. London: Academic Press.

Lewis-Williams, J.D. 1991. Wrestling with analogy: a methodological dilemma in Upper Palaeolithic rock art research. *Proceedings of the Prehistoric Society* 57: 149–162.

Lewis-Williams, J.D. 2000. *Stories that Float from Afar: Ancient /Xam San Folklore*. Cape Town: David Philip.

Lewis-Williams, J.D. 2002a. *A Cosmos in Stone: Interpreting Religion and Society Through Rock Art*. Walnut Creek (CA): AltaMira.

Lewis-Williams, J.D. 2002b. *The Mind in the Cave: Exploring Consciousness and Prehistoric Art*. London: Thames & Hudson.

Lewis-Williams, J.D. 2003. *Images of Mystery: Rock Art of the Drakensberg*. Cape Town: Double Storey.

Lewis-Williams, J.D. 2004. *Building an Essay: A Practical Guide for Students*. Cape Town: New Africa Books.

Lewis-Williams, J.D. 2010. *Conceiving God: The Cognitive Origin and Evolution of Religion*. London: Thames & Hudson.

Lewis-Williams, J.D. & Biesele, M. 1978. Eland hunting rituals among northern and southern San groups: striking similarities. *Africa* 48: 117–134.

Lewis-Williams, J.D. & Dowson, T.A. 1988. The signs of all times: entoptic phenomena in Upper Paleolithic art. *Current Anthropology* 29: 201–245.

Lewis-Williams, J.D. & Dowson, T.A. 2000. *Images of Power: Understanding Bushman Rock Art*. Johannesburg: Southern Book Publishers.

Lewis-Williams, J.D. & Pearce, D.G. 2004. *San Spirituality: Roots, Expressions and Social Consequences*. Cape Town: Double Storey.

Lewis-Williams, J.D. & Pearce, D.G. 2005. *Inside the Neolithic Mind*. London: Thames & Hudson.

Morris, D. & Beaumont, P.B. 1994. Portable engravings at Springbok Oog and the archaeological contexts of rock art of the Upper Karoo, South Africa. In: Dowson, T.A. & Lewis-Williams, J.D. (eds) *Contested Images: Diversity in Southern African Rock Art Research*: 11–28. Johannesburg: Witwatersrand University Press.

Ouzman, S. 1996. Thaba Sione: place of rhinoceroses and rain-making. *African Studies* 55: 31–59.

Pearson, J.L. 2002. *Shamanism and the Ancient Mind: A Cognitive Approach to Archaeology*. Walnut Creek (CA): AltaMira.

Taçon, P.S.C. & Chippindale, C. 1998. Introduction: an archaeology of rock art through informed methods and formal methods. In: Chippindale, C. & Taçon, P.S.C. (eds) *The Archaeology of Rock-Art*: 1–10. Cambridge: Cambridge University Press.

Ucko, P.J. & Rosenfeld, A. 1967. *Palaeolithic Cave Art*. London: Weidenfeld & Nicolson.

Vinnicombe, P. 1976. *People of the Eland: Rock Paintings of the Drakensberg Bushmen as a Reflection of Their Life and Thought*. Pietermaritzburg: University of Natal Press.

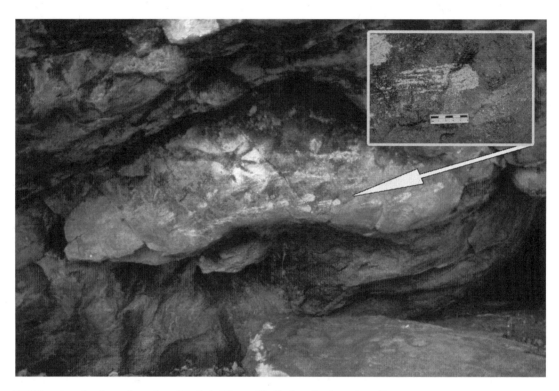

FIGURE 2.1 Arm stencil, cupules and 25 white fireball-like motifs. Northern Territory, Australia.

2.

Flashes of brilliance:
San rock paintings of heaven's things

SVEN OUZMAN

(Department of Anthropology and Archaeology, University of Pretoria, South Africa)

Because we are stars,
because we walk the sky,
we must go round forever,
sleepless, unsleeping.

Things of the heavens.
Stars. Heaven's Things.

(From 'Song of the Dawn's Heart Star'
by Stephen Watson)

HEAVENLY BODIES, HUMAN IMAGINATIONS

Life on earth began in the heavens. At least that is how many origin accounts explain our earthly genesis. There is post-Enlightenment science's 'Big Bang' and 'panspermic' postulation that begetter-like meteorites introduced the vital organic compounds that made our coil mortal (Cooper *et al.* 2001). Judaeo-Christianity Creation's extraterrestrial god and the Yoruba heavenly creator Odumare oversaw order out of chaos (Leeming & Leeming 1994). These creation stories are a recent sample of an ancient human fascination with and veneration of heavenly bodies (Kelley & Milone 2005). Evidence of this fascination is contained in art, literature, philosophy, stories and archives that cover the last three millennia. For example, in 600 BCE China's astronomical office employed a thousand workers (Vanin 1999: 15–29). For periods prior to the last 3000 years, it is archaeology that provides almost all the evidence of astral phenomena (Aveni 2008).

Demonstrable human practical engagement with heavenly bodies arcs back at least 800 000 years with a meteorite crash in southern China's Bose Basin. This heaven-sent opportunity allowed *Homo erectus* to supplement wood, bone and bamboo tools with scarce subterranean stone cobbles and tektites – glassy, melted

terrestrial rock (Yamei *et al.* 2000). More recent encounters in western and northern Australia entail Aboriginal Australians' use of tektites as tools and keep-sakes that, they believe, are imbued with potency[1] on account of their dreamtime origins (Bevan & Bindon 1996). Potent ancestral dreamtime beings such as the evil Namarrordo are shown in Aboriginal rock paint-ings trailing long streamers identified as comet or meteor tails (Chaloupka 1993: 60–61; Figure 2.1).

The dangers of assuming cross-cultural visual parity

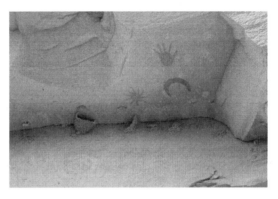

FIGURE 2.2 Rock painting said to represent 1054 CE Crab Nebula supernova. Chaco Canyon, New Mexico, USA. *(Photo by Robert Swanson)*

FIGURE 2.3 Giotto di Bondone's *c.* 1304 CE *Adoration of the Magi*, with comet-like Star of Bethlehem. Scrovegni Chapel, Padua, Italy.

FIGURE 2.4 Detail from Bayeux Tapestry showing 1066 CE Halley's Comet.

FIGURE 2.5 Aztec depiction of comet as harbinger of 1519 CE Cortés invasion.

surface in claims for 20 or more Native American rock engravings and paintings comprising a star-like motif and crescent representing the 1054 CE Crab Nebula supernova (Figure 2.2; Kelley & Milone 2005: 413). Dating one such instance of this imagery at Fern Cave produced a calibrated age range of 1440–1670 CE, seemingly eliminating that supernova, but not eliminating Kepler's 1604 CE supernova (Armitage *et al.* 2005: 128–129). More secure claims are made for geometrics engraved at European Neolithic megalithic sites (Ruggles & Hoskin 1999: 2–10). Of course, the sites themselves are argued to obey or replicate astronomical principles – as did Egyptian pyramids (Spence 2000), certain Mayan and Mississippian monuments (Kelley & Milone 2005: 403–410, 426–427), and 'geoglyphs' like the Nazca lines (Kelley & Milone 2005: 453–60). A firmer grounding of the heavens occurs at Islam's most sacred Ka'abah shrine, which has as its eastern cornerstone the Al-Hajarul Aswad or 'Black Stone of Mecca' (Kelley & Milone 2005: 137). This 50 cm diameter iron meteorite was probably venerated in pre-Islamic times and today marks the pilgrims' progress and absorbs mortal sin. Similar cometary commentary is Giotto di Bondone's *c.* 1304 CE *Adoration of the Magi* (Figure 2.3). The Magi's

visit to the Christian Christ takes place under the benediction of the Star of Bethlehem, depicted as a blazing comet probably inspired by the 1301 CE appearance of Halley's Comet (Olson 1979). Heavenly bodies being seen as harbingers owes as much to fear as to awe. The disappearance of many Middle Eastern civilisations 4000 years ago in the 'Bronze Age catastrophe' is linked to a devastating meteor impact in southern Iraq (Master 2001). The 70 m Bayeux Tapestry weaves a supernatural gloss onto the Norman invasion of Anglo-Saxon England by including Halley's Comet's 1066 CE appearance into one of its 56 scenes portending the Battle of Hastings (Figure 2.4; Gameson 1997).

Similarly, in the early 16th century, a 'pillar of fire' was part of a chain of prophetic events alerting Aztec King Moctezuma II of Hernán Cortés' 1519 CE invasion of Mexico (Figure 2.5; Colston 1985). Belief and ideology intersect in the spectacular 1976 CE meteor showers said to have marked Mao Zedong's death (Anon. 1997). Twenty-one years later, the causality was reversed when Comet Hale-Bopp's appearance triggered the suicide of 39 Heaven's Gate cultists who believed the comet would transport them to an exalted state (Bayley 1997).

HEAVEN ON EARTH IN AFRICA

These are but a few of the myriad urges that move people across time and space to great mental and physical effort in celebration of astral activity. It is therefore surprising to note the apparent paucity of African archaeoastronomy (Aveni 1993: 90–99; Doyle & Frank 1997; Kelley & Milone 2005: 204, 259–277 for overviews).

> There is no more deeply primeval experience than to gaze overhead at the Milky Way arching from horizon to horizon on a pitch-dark African night. And with good reason: our species originated in Africa; it was from there that our ancestors first looked up and pondered the mysteries of the cosmos. It should strike everyone as odd, then, that cultural astronomers have paid relatively little attention to Africa (Snedegar 1999).

With the notable exception of that being done in Egypt, much research is of dubious quality, such as Marcel Griaule's claims that Dogon astronomy describes the orbits of the invisible stars Sirius A, B and C (Griaule & Dieterlen 1950) – claims used by others to support absurd theories of alien visitation. It is rather more likely that Griaule, an amateur astronomer, abused ethnographic privilege: "many Dogon see him even now as a forceful personality, in a situation of undisputed power, with a clearly expressed preference for specific information and his own ways of getting it" (Van Beek 1992: 153). Despite misrepresentation, "… we can piece together suggestions that people had invented calendars and encoded their myths in the constellations they envisaged" (Aveni 1993: 9). Sweeping north to south, such 'suggestions' materially manifest in North African megalithic observatories like Nalota Playa dating to *c.* 6000 BP – a thousand years before Stonehenge (Malville *et al.* 1998). A *c.* 300 BP

FIGURE 2.6 Quartz-tipped Ishango bone with three columns of possible lunar calendrical markings, *c.* 22 000 BP. Lake Edward, Congo. *(Photo by Alexander Marshack [1991: 23])*

alignment of 19 magnetic stone pillars at Namoratunga near Lake Turkana is cogently argued to mark the rising position of the seven Borana calendar stars with less than 0.5 per cent probability of random alignment among 25 000 astronomical measurements (Lynch & Robbins 1978; Doyle & Frank 1997: 97).

Similarly intricate is the *c.* 22 000 BP Ishango bone from Congo (Figure 2.6). This extraordinary 20 cm long quartz-tipped bone has three rows arranged in 16 groups of between three and 19 marks that are plausibly interpreted as lunar calendrical markings (De Heinzelin 1962; Marshack 1991: 21–32; Brooks *et al.* 1995: 548). Claims for rock art representations of heavenly bodies are sporadic and superficial. Most common are suggestions that 'sunbursts', arcs, concentric circles, nested curves, rayed lines and 'swastikas' represent heavenly bodies (Figure 2.7; Leakey 1983: 49, 63; Kelley & Milone 2005: 273 for questionable Tuareg rock engravings of the seven planetary gods). Rock art is often poorly recorded, seldom capturing detail necessarily and sufficiently denotative of heavenly bodies (Tim Cooper & Boyden Astronomical Observatory pers. comm. 1999–2001, 2005). Once researchers go beyond external visual inspection and consider additional contextual evidence, most geometric rock art turns out to have known, non-astronomical functions. For example, Kenya's alleged Cushite 'astronomical' geometrics are really Turkana cattle brands (Soper 1982: 153). Similarly, Zambia's Nachitalo Hill 'comet' rock painting (Clark 1959: 187–188) transforms, on ethnographic enquiry, into a fertility and weather divination symbol (Smith 1997: 43–46).

Geometric rock art is abundant in Botswana, Namibia and South Africa. Initially recondite, research assigns visually similar geometrics to several distinct rock

art traditions. For example, the hallucinatory 'entoptics' of San[2] rock art may well encode but do not directly represent heavenly bodies (Lewis-Williams & Dowson 1988). A considerable body of rough-pecked and finger-painted geometrics forms the bulk of recently recognised Khoekhoe herder rock art that may relate to initiation and group identity (Smith & Ouzman 2004). Korana rock art incorporates geometric finger paintings in the service of a magical militantism (Ouzman 2005). Instances in which a 'gaze and guess' identification made by outsiders has had to be abandoned or altered because of relevant 'insider' information, mirrors in microcosm the history of southern African rock art research. The precocious Bleek and Lloyd /Xam ethnography lay dormant for a century until David Lewis-Williams and Patricia Vinnicombe utilised it to revolutionise our understanding of San rock art, which had hitherto seemed, by turns, primi-

tive, exotic, and quotidian (Vinnicombe 1976; Lewis-Williams 1981a). This lesson in looking beyond surface appearances makes it difficult to come up with more than the smallest handful of African rock art depictions of heavenly bodies. Most African rock arts do not seem outwardly concerned with the heavens. Perhaps this absence is a misperception and it is theory and ethnography that are like a gap-toothed comb raking over key information. But sometimes a blast from the past does illuminate our epistemic murk. Thanks to an etic research history dating discontinuously from the late 18th century (Raper & Boucher 1988: 84), southern African San rock art is the most convincing locus for heavenly body rock art. Even so, the sample is tiny. Moon, stars and sun are not obviously depicted. But at perhaps half a dozen sites (Figure 2.8), 'comets', 'meteors', 'meteorites' (called 'shooting' or 'falling stars') and 'fireballs', as defined and illustrated in Tables 2.1 and

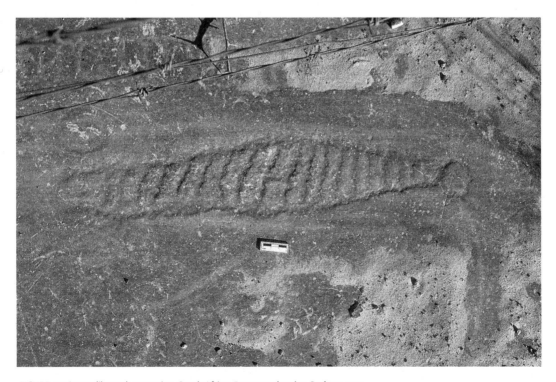

FIGURE 2.7 Comet-like rock engraving. South Africa–Botswana border. Scale 30 mm.

2.2, do seem to have been painted. Flickering at the edge of certainty are two equivocal 'comets' from South Africa's Eastern Cape (Johnson 1979: 31). More convincing is a site in northern South Africa where a rayed circle may represent the incandescent head of a comet, fireball or meteor (Figure 2.9).

The circle's 'rays' may also represent the tassels of a bag or apron, but the crucial piece where a bag or apron's ties – or a comet's tail – would be, has flaked off. Stepping back to consider the wider spatial context (cf. Skotnes 1994) shows an unusual placement on the rock shelter's ceiling – rare in San rock art. Placement that seems to include the sky in this rock painting's visual field is tantalising, but not definitive.

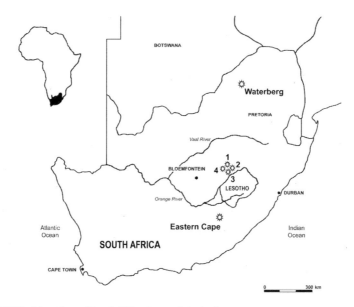

FIGURE 2.8 Locations of South African heavenly body sites.

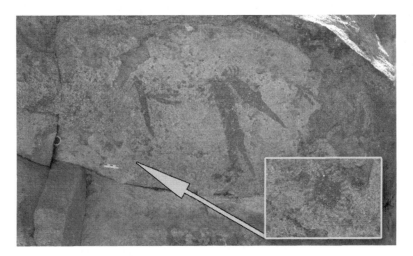

FIGURE 2.9 San rock painting of rayed circle and five human figures on shelter ceiling. Waterberg, South Africa. Scale 50 mm.

Table 2.1 Characteristics of comets, meteors, meteorites and fireballs

a) **Comets** have a small multiple solid nucleus a few metres to a few kilometres in diameter that consists of water ice, carbon monoxide, carbon dioxide, simple organic molecules and dark siliceous material. Around this nucleus is a central condensation and coma consisting of gas, ice and dust that can be 160 000 km in diameter. Comets follow parabolic or elliptical paths around the sun in periods from a few years to many thousands of years. When far from the sun (aphelion) comets are barely visible. When they approach the sun (perihelion) solar radiation causes the comet's gases to sublimate, showing a bright nucleus and gaseous tail millions of kilometres long. There is also a second 'dust' tail. 'Comet' derives from *stellae cometae* – 'hairy stars.' Only 32 comets over the last 1000 years are considered 'remarkable'.

b) **Meteor** is a general term for solid particles of rock weighing from several tons to a few grams that enter earth's atmosphere. Meteors are the dust left behind by comets during perihelion. Atmospheric friction causes ionisation of the air, heating rocks to incandescence as they gravitate towards earth. Meteors have elliptical orbits and are visible in great numbers each night – especially during meteor showers.

c) **Meteorites** are simply meteors not entirely destroyed in earth's atmosphere and which make contact with earth's surface, sometimes with massive consequences. There are four kinds: *aerolites* contain rocky material; *siderolites* are rocky with iron and nickel admixture; *siderites* are iron and nickel ; *tektites* are siliceous.

d) **Fireballs** are meteors with luminescence equivalent to that of Venus and leave a tail visible for several minutes. Exploding fireballs are bolides. Fireballs can be visible during the day.

Table 2.2 Visual guide to comets, meteors, and fireballs

Comet	Meteor	Fireball
Two tails	Single tail	Single tail
Occurs singly	Can occur in showers	Usually occurs singly
Visible for weeks or months	Visible for less than 1 second	Visible for one to several seconds
Slow-moving	Fast-moving	Fast-moving
Rare	Very common	Common

STELLAR SITES IN SOUTH AFRICA

More certain ground is provided by a constellation of four rock painting sites in the Maloti foothills (Figure 2.8: 1–4). This visually attractive landscape bears visible and subterranean marks of long-term human occupation from at least 100 000 years ago (Wadley & Vogel 1991). The region has plenty of 185-million-year-old Clarens Formation or 'cave' sandstone. Many of these 'caves' – really rock shelters – contain Khoekhoen, Korana, Bantu-speaker and European rock art traditions. But San rock paintings dominate and their quantity, detail and diversity establish the south-eastern mountains as one of the world's premier rock art regions that has attracted researchers such as George Stow, Helen Tongue, Clarens van Riet Lowe, Henri Breuil, Martha McGuffie, Joan and Vera Simpson, Georgina Rautenbach, Lucas Smits, Alex Willcox, Neil Lee and Bert Woodhouse, Harald Pager, Jannie Loubser, Pat Vinnicombe and, of course, David Lewis-Williams (Ouzman 1996). It is fitting that these names are matched by the region's stellar subject matter. At four sites distributed within a 35 km by 27 km bloc are four San rock paintings of what may be heavenly bodies (Figures 2.10–2.13).[3] These images are unique, but not new to rock art research. Bert Woodhouse, in consultation with astronomer Robin Catchpole, suggested that they represented, in no particular order, comets, fireballs or meteors (Woodhouse 1986). Since 1986 these rock paintings have received sporadic attention (Thackeray 1988; Fraser 1995) that has been imprecise for want of adequate recording of the images and site contexts. Currently,[4] the most adequate recording consists of a complementary pairing of photography and tracing. Photographs show the texture, colour and general appearance of the site, and the imagery, rock surface and surrounding physical landscape.

Tracing is a specialised technique that is subject to the ethics and legalities of rock art recording (Loubser & Den Hoed 1991). Unlike photographs that cannot always distinguish between natural and cultural marks, tracing is more agentive and capable of excavating fine iconographic detail in the form of a technical drawing (cf. Skotnes [1996] on tracing's conceptual dangers). Tracing is a cornerstone of Lewis-Williams' revolutionary reinterpretation of San rock art because it forces the researcher to spend long hours contemplating iconography, pigment, production technique, placement and association. Such contemplation and tracing enable accurate identifications of subject matter that, in turn, nurtures more comprehensive interpretations. To this end, I visited each site in spring 1998 and recorded imagery and site context. The resultant photographs and tracings contained sufficient detail to allow positive identification by Tim Cooper and Boyden Astronomical Observatory of four images as representing a bolide, two fireballs and a comet (Figures 2.10–2.13). I contextualise each representation before suggesting its implication in San notions of potency, astral travel and agency.

Site 1: Serpent and bolide

This first site is a commodious 25 m long overhang facing east over a deep perennial stream. The site was an important San aggregation locus. Numerous bone, charcoal and lithic fragments cap a soft archaeological deposit. Grinding hollows and utilitarian peckings mark the shelter's large internal boulders. Over 155 rock paintings occur in five clusters on the shelter's walls. All but two rock paintings are composed of exotic ferric oxide pigment. Imagery is varied and includes 20 red hartebeest (*Alcelaphus buselaphus*), a hive and 27 bees (*Apis mellifera*), over 30 eland (*Tragelaphus oryx*), 20 smaller antelope and three dozen human figures in a variety of postures, including a 'mother-goddess'. One human figure draws a bow at four graceful mountain rhebuck (*Redunca fulvorufula*). The largest image cluster (2.42 m by 0.96 m) has at least 43 individual motifs painted in seven superimposed layers (Figure 2.10). Pre-eminent is a linear arrangement whose main axis is a 150 cm long serpent to which a 38 cm tall human figure offers a jackal-like carcass. This otherwise detailed serpent is not species-specific beyond being adder-like (*Bitis* spp.; Rod Douglas pers. comm. 1998, 2005). The serpent is surrounded by 19 beautifully shaded polychrome eland, of which five have extra legs, three show nasal or oral haemorrhage and one on the far right has a dewlap rubbed smooth. Above the serpent, a procession of 11 human and therianthropic figures with accoutrements such as aprons, bags, bows, flywhisks, quivers and sticks are followed by a baying dog or jackal (*Canis mesomelas*). A seemingly extraneous detail is a sinuous 'thin red line' (Lewis-Williams 1981b) that travels from, or to, the serpent's head, through five of the therianthropes, six eland and then fades into the rock.

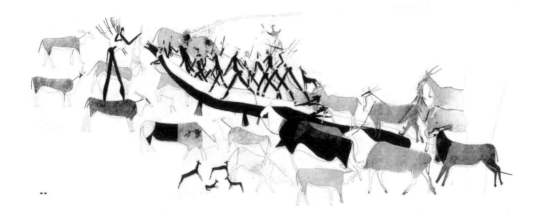

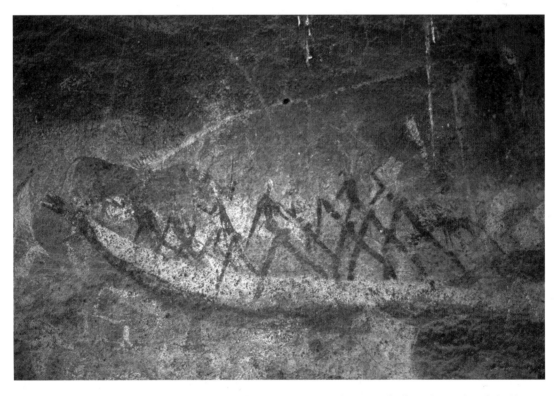

FIGURE 2.10 San rock painting with serpent and bolide. *Above*: Black = red; stipple = mustard yellow; white = white; dashed lines = water wash. Free State, South Africa. Scale 30 mm.

A radical intensification of this line occurs above the serpent as a discontinuous 78 cm long white bifurcation that ends in two red balls, each surrounded by at least 20 alternating red and white rays. Though unique in southern African rock art, this image has detail diagnostic of a bolide – an exploding fireball (Table 2.1d). A bolide begins as solid rock streaking through the earth's atmosphere, ionising the air, expanding moisture within the rock, and splitting it into two or more incandescent pieces. Just before splitting, small explosions along the bolide's discontinuous tail give a characteristic 'fizz-pop' appearance along a shallow trajectory of about 25° to the horizontal. There are thus four points of positive comparison – dual and rayed head, discontinuous tail and shallow trajectory – between bolides and the depiction in Figure 2.10.

Site 2: Medicine dance and fireball

The second site, a day's walk south-east of the first, is a 60 m long curved sandstone overhang facing north-west onto a now dammed perennial stream. Later Stone Age lithics are plentiful, and the remains of over 170 San rock paintings pulse discontinuously out of the shelter wall. The eastern overhang is more pronounced and offers better preservation for rock art. Two metres from the bulk of the paintings is a 0.78 m by 0.67 m painted cluster (Figure 2.11). Two

eland, painted with local hydrous ferric oxide, are placed on a depiction of a 'textbook' medicine dance painted with exotic ferric oxides. Seventeen human and therianthropic figures assume postures and activities invariable to the medicine or 'trance' dance. At least three human figures clap with 'stiff' fingers extended. Adjacent, two figures adopt the 'arms-back' posture diagnostic of attainment of altered states of consciousness (Lewis-Williams 1981a: 88). Up to four figures lie supine – common to people in deep trance. Below right, two partially preserved human figures jackknife at the waist – representing the stance taken when supernatural potency 'boils' in a shaman's stomach (Katz 1982: 106–107), sometimes to an intensity that requires dancing sticks to keep from falling. The three central figures – one with hooves – hold dancing sticks. These three figures have over 27 flywhisks – an artefact exclusive to the medicine dance and used to sniff out and remove illness (Marshall 1969: 358). To their left are two cattle-headed therianthropes. Above the dance two 26 cm long parallel flecked red lines angle at 15°–19° to the horizontal. These lines terminate in a red circle with lighter surrounding halation. Streaky flecked tails terminating in hallated heads are characteristic of fireballs – meteors with highly visible tails (Table 2.1d; Table 2.2). The linear nature of the tail is unlike a comet's, which is diffuse (Table 2.1a).

SITE 2

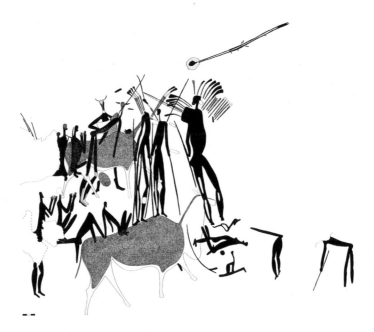

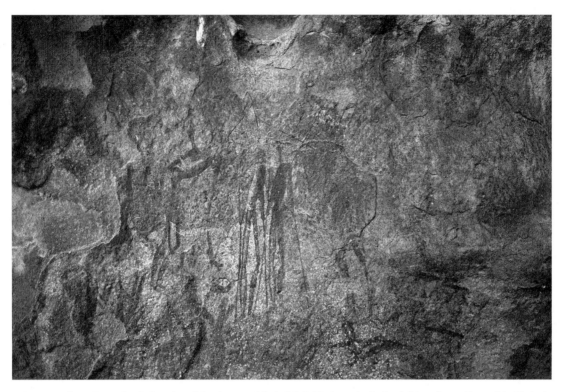

FIGURE 2.11 *Above:* San rock painting of medicine dance and fireball. *Left:* Black = red; stipple = bright yellow; white = white; dashed line = spalling. Free State, South Africa. Scale 30 mm.

Site 3: Flight and fireball

South of Site 2 – appropriately enough in the erstwhile Bethlehem Magisterial District (now Dihlabeng) – is a roomy 30 m long domed sandstone overhang with a stream at its western wall. The soft deposit has numerous artefacts under a cattle dung overburden. The walls were once densely painted, but calcite spalling spares fewer than 50 rock paintings. Among these is a particularly fat bull eland and a bizarre *en face* pawed creature. At a height of 2.8 m above the present surface level is a relatively well-preserved 0.46 m by 0.42 m image cluster, 0.85 m from the surviving paintings (Figure 2.12). Precisely painted with exotic paint, three therianthropes exhibit extreme attenuation of body and fingers. Each figure has 'hairs' or 'feathers' on and off its body, giving the impression of flight. The topmost figure has a hoofed leg tucked under its body and is formally identical to 'flying buck' that characterise San astral travel. Each figure has equipment – fly-whisks, quiver and sticks. One 'stick' is a 17 cm long 'thin red line' fringed by 27 white dots. Arcing above these therianthropes is a 21.5 cm red and white motif that consists of a discontinuous tail at a shallow 16°–18° angle terminating in a rayed and hallated head. These four features are consistent with a fireball rather than a comet (cf. Table 2.1a, 2.1d; Table 2.2).

SITE 3

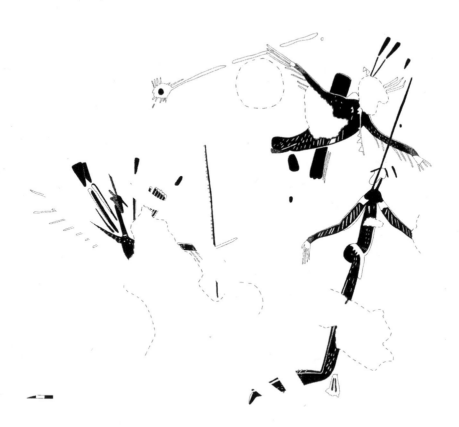

FIGURE 2.12 *Above:* San rock painting of flying therianthropes and fireball. *Left:* Black = red; stipple = mustard yellow; white = white; dashed line = spalling. Free State, South Africa. Scale 30 mm.

Site 4: Therianthrope and comet

Completing the Heaven's Things site circuit is a 24 m long krans remnant comfortably perched above a wetland fed by a waterfall and a deep pool. The site faces south-east onto Lesotho's Maloti Mountains. Within, there is stone walling, soft deposit and abundant lithic surface scatter. Over 90 San rock paintings cluster at the western end. These include two red felines chasing eight red human figures, over 20 yellow and white eland, and ten cloaked human figures. At the north-eastern end, 1.2 m from any other paintings, two facets of shelter wall encapsulate just two motifs (Figure 2.13). One motif is a red and white therianthrope with at least three flywhisks, arms held back, and one tucked up foot transformed into a hoof. Immediately adjacent, in visually identical exotic pigment, are 18 closely spaced red lines painted at a steep 60°–65° angle. At their upper extremity these lines trifurcate. At their bottom extremity a rayed red circle encapsulates a small inner circle of unpainted rock. The steep trajectory and discontinuous, diffuse lines are hallmarks of comets, not fireballs. (Compare Tables 2.1a & 2.1b, 2.1c & 2.1d.) Also, the head is small relative to the tail – as with comets – whereas Sites 2 and 3 have large heads relative to the tails – as with fireballs.

SITE 4

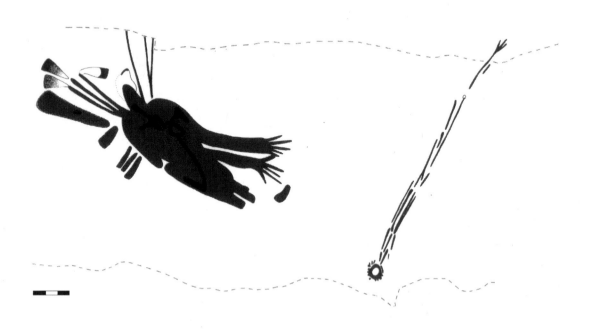

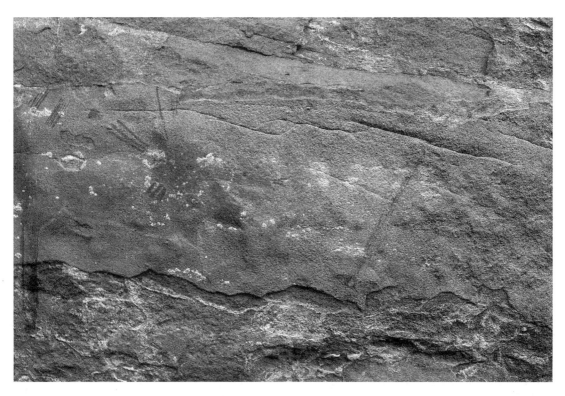

FIGURE 2.13 *Above:* San rock painting of therianthrope and comet. *Left:* Black = red; white = white; dashed line = rock facets. Free State, South Africa. Scale 30 mm.

AGE DETERMINATIONS

If these four rock paintings do depict heavenly bodies – all comets of one kind or another (Table 2.1) – rather than a hitherto unidentified theme in San rock art, there is a chance of linking them to known astral events. Bolides like that depicted at Site 1 are distinctive and uncommon. The only relevant known instance was Biela's 'comet', appearing in 1846 and again in 1852. These dates are some decades after the San of this region are thought to have fled the trauma of the 1790–1840 *Mfecane* 'shattering' that was so pronounced in the Caledon River Valley (Loubser & Laurens 1994: 98; *contra* Woodhouse 1986). Site 4's comet is adiagnostic and could represent almost any of the 1250 comets chronicled since 238 BCE (Vanin 1999: 29). That leaves the two fireball depictions at Sites 2 and 3. Though spectacular, fireballs are frequent – appearing even in daylight. A more promising age determination is provided by the paint. Heavenly body paints were made from exotic micaceous ferric oxide (Fe_3O_3), the source of which is up to 40 km distant from Sites 1–4, occurring in the higher Malotis where basalt still overlies sandstone. Regionally, about 35 000 San rock paintings at 685 sites have been studied for subject matter, sequence and relative chronology. In all but two superpositionings, exotic pigment precedes paints made from local hydrous ferrous oxides (Fe_3O_4). Local pigments were used with increasing frequency from about 400 years ago until this region's 19th-century San Apocalypse (Ouzman & Loubser 2000). This sequence is confirmed at Sites 1 and 2, where local paints overlie exotic paints – a rough *terminus post quem*. The four heavenly body rock paintings may date to when Maloti San were the sole and empowered people of this landscape, though the 'dog' in Figure 2.10 and cattle heads in Figure 2.11 hint at the presence of non-San people.

POTENCY, ASTRAL TRAVEL AND AGENCY

But why did these Maloti San choose uniquely to depict four heavenly bodies? There is a significant disjunction between the ethnographies of 19th- and 20th-century San, which are rich in astral lore (Bleek & Lloyd 1911: 44–65; Barnard 1992: 56–57, 71, 80, 82–84, 87, 114, 129, 153, 162, 252–255, 261; Guenther 1999: 68–69; Marshall 1999: 251–268; Hollmann 2004: 92, 242–248, 332, 367–369; also Skotnes 1999), and San rock art in which unequivocal imagings of heavenly bodies are restricted to this handful of sites. Do 'myth' and 'rock art' represent different expressive cultures and occupy different epistemological domains (Guenther 1994; Solomon 1997)? Or is there astral information present in San rock art that we have not yet learnt to discern? These heavenly body depictions present a rare and rich overlap between 'rock art' and 'myth', allowing careful 'tacking' between imagery, ethnography and site that helps substantiate the relationships between people, beings, objects, places and cosmological forces. All four heavenly bodies' images are embedded in unambiguous shamanic contexts – serpent, medicine dance, therianthropes, thin red lines, polymelic eland, shamanic flight, and so forth. Of San shamanism's many expressions, these implicate heavenly body imagery in three foundational shamanic contexts – potency, astral travel, and transformative agency.

Potency

The heavens declare the glory of God; and the firmament sheweth his handiwork
(*Psalms* 19: 1. The Holy Bible, King James Version).

Diverse San communities of the past few hundred years were awed by and fearful of heavenly bodies (Dornan 1925: 167; Marshall 1962: 242). As bright and demonstrably extraterrestrial entities, heavenly bodies are ideal analogues for San concepts of supernatural potency – an essence held to emanate from God and the Spirit World and manifest in a restricted range of receptacles such as honey, lightning, mega-herbivores, rain, sun (Marshall 1999: 56, 248) and, unsurprisingly, 'falling stars'. Lorna Marshall gleaned from some !Kung that 'falling stars' were one of only a dozen things into which the principal god ≠Gao n!a had deposited potency (1969: 351). Because of its unearthly origins, 'falling star' potency was more intense than the potency of earthbound things – even dangerous: "They can kill people, and at the times of the meteor showers when many are moving about and falling, the sky is very bad" (Marshall 1999: 258).

These feelings of dread and death are mirrored in folklore, where Kaoxa, the Ju/'hoansi Lord of the Animals, visits retribution on lions that harmed his sons by loosing a meteorite (Biesele 1993: 103–105; Biesele pers. comm. 1999). Such meteorites are also 'ant lions' that kill people by biting them or by shedding their 'star skin' – stepping on this skin can kill a person unless a shaman intervenes (Marshall 1999: 258–259). Nineteenth-century /Xam specifically associated heavenly bodies with the death of malevolent shamans. According to Diä!kwain's account, 'Stars and sorcerers', related on 3rd, 6th and 9th November 1875 CE:

> For our mothers used to say that when a sorceror [sic] dies, his heart falls down from the sky, it goes into a waterpit. Our mothers said, when the star is falling, approaching the waterpit into which it means to go, he takes the magic power, he shoots it back to the place where people are … That is why our mothers used to say when a star fell "A sorcerer seems to have died there. Therefore you see that his heart strings [?] have fallen, they go thundering. Now you will feel what the summer's heat will be like. For a sorcerer of illness seems to have died, it is truly a sorcerer who brings illness who has died when a star acts in this manner; when a sorcerer who brings illness has died, then a star falls down. You ought to listen whether the star falls straight down as it disappears" (Bleek 1935: 28–29; also Hollmann 2004: 245–246).

A week later, Diä!kwain spoke of "an earthquake":

> Then a star shoots [falls], for a sorceror who has gone about among things which are bodies has really died. His sorcery is shooting, because his spirits [?] have got bodies. Therefore they work magic (Bleek 1935: 26; also Hollmann 2004: 242).

Thus the death – literal or metaphoric – of a potent but punitive 'sorceror of illness' is marked by a dread-inspiring 'falling' or 'shooting' star. Janette Deacon cautions that will-o'-the-wisps[5] are common in central South Africa's erstwhile /Xam heartland and could

have been confused by the /Xam's interlocutors, Bleek, Bleek and Lloyd, for heavenly bodies. However, the word Diä!kwain uses for star – /kwatten – is one of 23 /Xam words specifically signifying 'star' or 'heavenly body' (Bleek 1956: 331) as opposed to *mumu !k?o*, the word for 'will-o'-the-wisp', 'halo' or 'ghost' (Bleek 1956: 137). Also, the manner in which the star falls – *tatten* – and shoots – /*xi* – is likened to a precipitous drop from the sky, loosing an arrow, and shooting a bullet (Bleek 1956: 26, 194, 364) – all unlike the meandering motion of will-o'-the-wisps.

These ethnographic excerpts stress negative consequences of exceptionally potent receptacles – shamans and heavenly bodies. Even though these excerpts were obtained from individuals and communities crushingly impacted by European colonialism and who lived in non-mountainous country 500 km west of the research region, they offer partial illumination. Figure 2.10 spatially unites two like potent entities – bolide and serpent. The serpent's unusual size, the two areas at which it emits 'fluid', and the offertory *mien* of the large jackal-bearing human combine to denote this as the large, menacing watersnake that so many southern Africans believe inhabits rivers, waterholes, mountains and clouds (Hoff 1997). A signature characteristic of this watersnake is the light it emits from its forehead, "described as a spot, star or mirror" by /Xam descendants (Hoff 1997: 24). At other times, the watersnake's body is iridescent. Such star-like brilliance is a visible, outward manifestation of extreme concentrations of supernatural potency. This brilliance is not reflective, but emanates from the very substance of the 'art'. Exotic ferric oxide, the primary inorganic ingredient of Figure 2.10's paint, is also called 'micaceous' ochre for its shiny mica inclusions.

Immediately relevant is one of perhaps five emic commentaries on San paints (see Lewis-Williams 1981a: 31) related to Marion Walsham How during May 1930 by the BaSotho man Mapote, who had part-San brothers. Mapote said *qhang qhang*, which "glistened and sparkled, whereas the [normal] ochre was just a dull earthly substance", was the preferred ingredient for San paint and had to be fire-heated by a woman during full moon, crushed and mixed with fat and fresh eland blood (How 1970: 37–41). Also, Maloti San may have called the trickster and First Shaman /Kaggen, '*Qhang*' – a brilliant being (Lewis-

Williams & Pearce 2004: 106). Furthermore, we have a direct shamanic referent from the /Xam linking pigment and rainsnake: shamans who owned quartz crystals thereby possessed power over hail and rain (Lewis-Williams & Pearce 2004: 144). Mapote said Maloti San believed *qhang qhang* provided protection against "hail and lightning" (How 1970: 34). Watersnake and bolide are also linked by the 'shooting star' falling into a 'waterpit', which is "the water from which sorcerers are wont to fetch waterbulls [rainanimals]" (Bleek 1935: 32) The serpent and bolide site is perhaps not coincedentally situated immediately above a perennial stream.

In somewhat less dramatic iteration, Figure 2.11 nonetheless provides an exceptionally comprehensive rendering of the architecture of the medicine dance – earthly locus of supernatural potency *par excellence* (Marshall 1969). Social bulwarking against eschatonic forces is reinforced at each site by the deployment of an unusually complete inventory of shamanic paraphernalia – bags, dancing sticks, flywhisks, offerings. Likewise, Figures 2.12 and 2.13 unambiguously focus their heavenly body contexts on shamanic transformation and flight, the next stage on the journey begun at the dance and which connects ordinary and spirit worlds through the body of the shaman.

Astral travel

The stars that Nature hung in Heav'n, and filled their lamps with everlasting oil, to give due light to the misled and lonely traveller (Milton 1972 [1637]: 17).

Death at the dance liberates the shaman from his body, from this world, and from 'ordinary' time: "When a sorceror dies, his heart comes out in the sky and becomes a star" and his "magic makes a star, in order to let his body in which he lived walk about" (Bleek 1935: 24). Some !Kung believe more instrumentally that heavenly bodies were vehicles returning shamans from the spirit world (England 1995: 199). Some G/wi believe the principal and evil God G//amama travelled on or among such heavenly bodies (Silberbauer 1981: 54). This atomistic astral travel acquires connectivity in the /Xam and !Kõ belief that heavenly bodies, stars and constellations

were related like people, travelled the sky, and left visible tracks (Bleek & Lloyd 1911: 73–98; Heinz 1975: 25). Continuing this thread, some //Gana call the Milky Way 'God's Path' (Marshall 1999: 256). Just such a path makes the incredibly diverse imagery in Figure 2.10 cohere. The bolide's trajectory is echoed by a sinuous 'thin red line' – a rare motif in this region. This line runs discontinuously along 147 cm of rock face, connecting watersnake, five human therianthropes, and at least six eland. Figure 2.12 has a short thin red line intensified by the addition of fringing white 'microdots' used to signify potency (Dowson 1989). Lewis-Williams (1981b: 12), working to the south-west where the thin red line is more common, suggested it represented a shamanic path – the "trajectory of a medicine man on out-of-body travel". Recent Kalahari San ethnography supports this suggestion by describing 'threads of light' that shamans follow to and from the spirit world (Keeney 1999: 105; Lewis-Williams *et al.* 2000).

The spirit is in the air. When you dance, it comes down to you. When it gets into you, you can see it as a string of light. The light carries you in the dance. It can take you to another person who needs healing or it can carry you to another village in the sky (Keeney 1999: 115).

Like heavenly bodies, the spirit world distributes danger and dread. It is easy to become lost there were it not for 'threads of light' to guide shamans home. Potent beings like shamans would quite plausibly leave visible, brilliant traces of their astral travels. Further proof of their maintenance of the cosmic order would be paintings of heavenly bodies and thin red lines at cynosuric locations. Perhaps there is just one thin red line – a flexible *axis mundi* – stitching together the cosmos. Though we have only two thin red lines (or two expressions of *the* thin red line), the proximity of the four heavenly body sites – each is within a day's walk of the other (Figure 2.8) – suggests a concatenation or circuit that people could follow for a gnostic purpose or to more fully explore the 'world'. The topography of each site is a mnemonic for the San cosmos (Solomon 1997; Ouzman 1998; Lewis-Williams & Pearce 2004: 51–52). The sites are large spaces bearing abundant artefactual evidence of

intense socialisation suggesting a "culture center [*sic*] of the San world" (Lewis-Williams & Pearce 2004: 52). Each site is immediately adjacent to deep water-holes or has a natural spring gushing from within – features not common in this region. Water provides an earthly anchor for heavenly bodies. Structurally, heavenly bodies have their origin in an upper spirit world. They then travel brightly and ominously through the sky before falling into a waterpit, which consitutes an earthly access to the underworld. Glistening waterpits may be like homing beacons for shamans on astral travel. Each heavenly body site provides congruence between imagery, bright pigment, ethnography and topography that is hard to dismiss as anything other than intentional. These four sites are a *genius loci* that orders, connects and perhaps contains the physical and the metaphysical.

Agency

How does he expect to be able to follow the foot-prints of a star across the sky? That is big man's work (Bosman 1962:169).

The depiction of two scarce thin red lines and four rare heavenly bodies at a specifically located and even stage-managed site constellation raises questions about the wider utility of insights derived from this type of niche study. Such insights work at two scales – large and small. The large 'pan-San' scale is concerned with the structure of the San cosmos and normative associated activities. But this broad-brushstrokes understanding is well established and does not need rote repeating. Rather, it is the second, more intimate scale that is a future horizon of San rock art research. Investigating small research regions using as much artefactual, ethno-graphic and historiographic evidence as possible helps to produce better biographies of people, objects and places. These studies broaden – and question – our understanding of a seamless past–present continuum by suggesting the normativity of contestation, contra-diction and idiosyncrasy. Significantly, the heavenly body research region is noted for its idiosyncratic rock art and localised expression of more generalised beliefs (Dowson 1988; Ouzman 1995). All four heavenly body paintings are placed in an intentionally separate and visually dominant position for the consumption

of those sharing the local idiosyncrasies: especially the journeys and transformations that heavenly body potency permits. It is perhaps because of their potency that heavenly bodies were painted but four times. Extreme potency derived directly from the principal God could be used by "only the most powerful of healers" (Katz 1982: 94) and "Only the strongest doc-tors go up the rope and learn from their ancestors and the Big God" (Keeney 2003: 44). These select, 'most powerful' shamans could have portrayed 'real' heavenly bodies in the night sky as visible evidence of their mas-tery as they journeyed, connected and maintained the cosmos: "for a sorceror [*sic*] is wont to go to many a place, when night has fallen" (Bleek 1935: 24). Obser-ving heavenly bodies at night from the socialised rock shelter gateway would constitute visible proof of a numinous and immanent cosmos. Yet even this idio-syncrasy draws on a relatively all-knowing and acquisi-tive human agency that relates to a larger societal structure (e.g. Lewis-Williams 1997: 828). The heav-enly body sites can unsettle or redistribute this agency and even question our understanding of rock 'art' by directing us beyond the 'visual' to consider a greater range of senses (Ouzman 2001). For example:

Lights like comets dangle before me, slow at first and then gaining a fury of speed and change, whirling color into color, angle into angle. They were all pure ultra unearthly colours, mental colours, not deep visual ones. There was no glow in them but only activity and revolution (Neher 1962: 157).

The distinction between 'ultra unearthly, mental colours' of hallucinations and 'deep visual ones' is that the former are kinetic – like streaking heavenly bodies. Similarly, sounds associated with heavenly bodies are not heard as much as felt. Diä!kwain spoke of "thun-dering" and "vibrations" that accompanied heavenly bodies at shamanic death (Bleek 1935: 28–29). These sensations may describe 'geophysical electrophonics':

the production of audible noises of various kinds through direct conversion by transduction of very low frequency electromagnetic energy generated by geophysical phenomena (Keay 1994: 13).

Some people are more sensitive to these radiosounds than others, and there have been instances of people "hearing" natural discharges such as Aurora Borealis and meteors entering the Earth's atmosphere (Pennick 1989: 109; also Fagg 1999).

Not all people sense electrophonics, described as hissing, thrumming or crackling. But shamans often have sensitivities or mental 'conditions' (Katz 1982: 230–249; Keeney 1999: 115) that may make them attuned to electrophonics. Recent human physiological research shows that such sounds can make a single flash of light appear multiple (Shams *et al.* 2000), disrupting the sovereignty of a five-sense model. More challenging but still plausible is disassembling and redistributing human agency (Dobres & Robb 2000). While practice theory really constructs 'individual' agents as Cartesian composites – overdetermined bundles of intentions and motivations (Johnson 1989) – heavenly body rock art expands this narrow, capitalist-influenced understanding (Thomas 2004: 26–27). Lewis-Williams' identification of a human neuropsychological base that interacts with cultural practice to produce what we narrowly understand as 'imagery' has been used primarily to establish commonality, even universality, between people and art production (Lewis-Williams 2002). Certain iconographic congruences *are* remarkable and compelling (e.g. Lewis-Williams 1997). But the workings of the human mind are poorly understood and are full of exceptions to the norm (Glynn 1999). These 'exceptions' may turn out to be both more common than is acknowledged, and more influential to human evolution.

Shamans and others prone to mental sensitivities can provide or reconfigure extraordinary knowledge that is more likely to 'punctuate' cultural equilibrium than mere repetition of cultural norms. Heavenly bodies disrupt contained conceptions of physically bounded human bodies as shamans *are* sometimes comets – what actor network theory would call a human-object co-production (Law & Hassard 1999). At the dance people sublimate their egos and form a corporation of sound, movement, sensation and imagination. The tyranny of text can make San belief and body politics appear a lot more coherent than was likely the case. Quirks, non-normative senses, chance events and an expanded human body are some of the topics that bear further scrutiny, with rock art a primary source of investigative destabilisation.

FUTURE HORIZONS

Perhaps the glitter and glamour of the heavens fuse feelings of awe, terror and hope in a nexus that only 'religion' can navigate (Rappaport 1999). Writing to his brother, Theo, in 1888, Vincent van Gogh wrote of his "terrible need of – shall I say the word – religion. Then I go out at night and paint the stars" (Van Gogh 1888, letter 543). Rock art gives us a direct if fragmented hint of how people experienced and made the world. Niche studies partly confirm orthodoxies but also temper our certitude by exposing the unexpected and heterodox. Such exposure is made possible by careful recording of rock art by photography, tracing and contextual analysis that assists more complete identifications and interpretations. 'More complete' does not, however, convey absolute certainty, and our knowledge is always contingent on new work. Further, 'heterodox' does not validate everyone's opinion. Archaeology attracts its fair share of lunatic fringe views, rock art even more so, and archaeoastronomy is riddled with 'moon puppies', prompting Chamberlain to caution:

> The question is not so much what we do as how we do it. It is really difficult to temper enthusiasm with objectivity, but doing so establishes credibility. In another decade the modern study of astronomical interpretations of rock art will be half a century old. Thus, by human standards, this interest could be considered to have reached maturity. It will be interesting to see if it takes on the wisdom that should come with old age (Chamberlain 1994: 1–2).

Recent claims for the importance and even centrality of astronomy in the rock engravings of southern Africa (Sullivan 1995), in the construction of Late Iron Age towns (Hromnik 1996), and even for absurd claims of the world's oldest observatory in the form of a natural rock formation called 'Adam's Calendar' in eastern South Africa allegedly 75 000 years old (Heine & Tellinger 2008), emphatically do not "temper enthusiasm with objectivity" but are wilful

and damaging distortions of available evidence. These claims display near-zero competence, without so much as a baseline recording or systematic examination of archaeology, ethnography and historiography. As a result, entirely inappropriate interpretations have disastrous and disempowering consequences (Doyle & Frank 1997: 98). In this respect, heavenly bodies such as comets are humbling archaeological fetishes. They are true inhabitants of the past, having had their genesis right at the beginning of the cosmos, some 15 billion years ago (Crovisier & Encrenaz 2000). These astral travellers occasionally visit us and give lustre to our endeavours. This chastening reversal of the usual archaeological temporality of present investigating past puts me in mind of David Lewis-Williams' favourite poet, T.S. Eliot (1943:449):

Time present and time past
Are both perhaps present in time future
And time future contained in time past

No spectacular heavenly bodies made their appearance in December 1999 when Lewis-Williams formally retired from his beloved Rock Art Research Unit – an event that should have been heralded by heavenly harbingers: "When beggars die there are no comets seen; The heavens themselves blaze forth the death of princes" (Shakespeare 1998 [1599]: II, ii, 30-31). That absence of astral activity gives the game away.

David Lewis-Williams' time has not passed at all, and he will journey in directions other than the revolutionary rock art research he pioneered, so that we can look forward still to his sesquipedalian flashes of brilliance.

Acknowledgements

I thank Tim Cooper (Director: Comet and Meteor Section, Astronomical Society of Southern Africa) and Boyden Astronomical Observatory for discussion on heavenly bodies. I thank Geoffrey Blundell, Chris Chippindale, Janette Deacon, Ed Eastwood, Jannie Loubser, Listie Rossouw and Gabriel Tlhapi for critical comment. I thank Ben Smith for alerting me to the Waterberg 'heavenly body' and Bert Woodhouse for directing me to Site 2. Nico Avenant, James Brink and Rod Douglas identified the painted animal species. Rentia Ouzman prepared the figures for publication. I thank the organisers of the David Lewis-Williams Colloquium and for helpful comments there offered. The financial assistance of South Africa's National Museum and National Research Foundation: Social Sciences and Humanities towards this research is acknowledged.

Notes

1 'Potency' is a numinous spirit world essence, while 'power' is the negotiation of social relations in the ordinary world, albeit sometimes with numinous validation.

2 I use 'San' as an honourable term for southern Africa's First People and reject any pejorative connotations it may have.

3 There are five other sites in the region that may have similar subject matter, but bad preservation precludes positive identification.

4 'Currently' refers to the state of recording over a decade ago, when this paper was originally submitted.

5 Will-o'-the-wisps are moving phosphorescences in low-lying areas that seem to evade the viewer, suggesting mischievous agency. Theories for their origin range from methane containing hydrogen phosphide, plant bioluminescence, piezoelectricity, and 'tectonic strain' releasing pressurised air.

References

Anon. 1997. Shower of meteors marks the end of Deng's long march. *London Sunday Times* 23–30 March: 15.

Armitage, R.A., Hyman, M., Rowe, M.W., Southon, J. & Barat, C. 2005. Fern cave rock paintings at Lava Beds National Monument, California: not the AD 1054 supernova. In: Fountain, J.W. & Sinclair, R.M. (eds) *Current Studies in Archaeoastronomy: Conversations Across Time and Space*: 121–131. Durham (NC): California Academic Press.

Aveni, A.F. 1993. *Ancient Astronomers*. Montreal: St Remy Press.

Aveni, A.F. 2008. *People and the Sky: Our Ancestors and the Cosmos*. London: Thames and Hudson.

Barnard, A. 1992. *Hunters and Herders of Southern Africa: A Comparative Ethnography of the Khoisan Peoples*. Cambridge: Cambridge University Press.

Bayley, D. 1997. Internet abuzz as UFO cult wishes upon a comet and follows its 'ET' to cyberheaven. *The Sunday Independent* 30 March: 8.

Bevan, A.W.R. & Bindon, P. 1996. Australian Aborigines and meteorites. *Records of the Western Australian Museum* 18: 93–101.

Biesele, M. 1993. *Women Like Meat: The Folklore and Foraging Ideology of the Kalahari Ju/'hoan*. Johannesburg: Witwatersrand University Press.

Bleek, D.F. 1935. Beliefs and customs of the /Xam Bushman. Part VII: Sorcerers. *Bantu Studies* 9: 1–47.

Bleek, D.F. 1956. *A Bushman Dictionary*. New Haven (CT): American Oriental Society.

Bleek, W.H.I. & Lloyd, L.C. 1911. *Specimens of Bushman Folklore*. London: George Allen.

Bosman, H.C. 1963. *Comet Cometh*. (Compiled by Lionel Abrahams). Cape Town: Human and Rosseau.

Brooks, A., Helgren, D.M., Cramer, J.S., Franklin, A., Hornyak, W., Keating, J.M., Klein, R.G., Rink, J., Schwarcz, H., Smith, J.N.L., Stewart, K., Todd, N., Verniers, J. & Yellen, J. 1995. Dating and context of three Middle Stone Age sites with bone points in the Upper Semliki Valley, Zaire. *Science* 268: 548–552.

Chaloupka, G. 1993. *Journey in Time: The World's Longest Continuing Art Tradition: The 50,000-year Story of the Australian Aboriginal Rock Art of Arnhem Land*. Chatswood (NSW): Reed.

Chamberlain, V.D. 1994. Reflections on rock art and astronomy. *Archaeoastronomy and Ethnoastronomy Newsletter* 14: 1–2.

Clark, J.D. 1959. The rock paintings of Northern Rhodesia and Nyasaland. In: Summers, R. (ed.) *Prehistoric Rock Art of the Federation of Rhodesia & Nyasaland*: 163–220. Glasgow: Glasgow University Press.

Colston, S.A. 1985. No longer will there be a Mexico: omens, prophecies, and the conquest of the Aztec empire. *The American Indian Quarterly* 9: 239–258.

Cooper, G., Kimmich, N., Belisle, W., Sarinana, J., Brabham, K. & Garrel, L. 2001. Carbonaceous meteorites as a source of sugar-related organic compounds for early Earth. *Nature* 414: 879–883.

Crovisier, J. & Encrenaz, T. 2000. *Comet Science: The Study of Remnants from the Birth of the Solar System*. Cambridge: Cambridge University Press.

De Heinzelin, J. 1962. Ishango. *Scientific American* 206(6): 105–116.

Dobres, M-A. & Robb, J.E. (eds) 2000. *Agency in Archaeology*. London: Routledge.

Dornan, S.S. 1925. *Pygmies & Bushmen of the Kalahari: An Account of the Hunting Tribes Inhabiting the Great Arid Plateau of the Kalahari Desert, Their Precarious Manner of Living, Their Habits, Customs & Beliefs, with some Reference to Bushman Art, both Early & of Recent Date, & to the Neighbouring African Tribes*. London: Seeley, Service & Co. Ltd.

Dowson, T.A. 1988. Revelations of religious reality: the individual in San rock art. *World Archaeology* 20: 116–125.

Dowson, T.A. 1989. Dots and dashes: cracking the entoptic code in Bushman rock paintings. *South African Archaeological Society Goodwin Series* 6: 84–94.

Doyle, L.R & Frank, E.E. 1997. Astronomy in Africa. In: Selin, H. (ed.) *Encyclopedia of the History of Science, Technology, and Medicine in Non-Western Cultures*. 96–99. Dordrecht: Kluwer.

Eliot, T.S. 1943. *The Four Quartets*. London: Faber and Faber.

England, N.M. 1995. *Music Among the Z'/'wã-si and Related Peoples of Namibia, Botswana and Angola*. New York: Garland.

Fagg, L.W. 1999. *Electromagnetism and the Sacred: At the Frontier of Spirit and Matter*. London: Cassell.

Fraser, B. 1995. Astronomy in the lives of the indigenous people of southern Africa. *Monthly Notes of the Astronomical Society of South Africa* 54: 126–131.

Gameson, R. (ed.) 1997. *The Study of the Bayeux Tapestry*. Suffolk: Boydell Press.

Glynn, I. 1999. *An Anatomy of Thought: The Origin and Machinery of the Mind*. London: Weidenfeld & Nicolson.

Griaule, M. & Dieterlen, G. 1950. Un Système Soudanais de Sirius. *Journal de la Société des Africanistes* 20(2): 273–294.

Guenther, M. 1994. The relationship of Bushman art to ritual and folklore. In: Dowson, T.A. & Lewis-Williams, J.D. (eds) *Contested Images: Diversity in Southern African Rock Art Research*. 257–274. Johannesburg: Witwatersrand University Press.

Guenther, M. 1999. *Tricksters & Trancers: Bushman Religion and Society*. Bloomington (IN): Indiana University Press.

Heine, J. & Tellinger, M. 2008. *Adam's Calendar: Discovering the Oldest Man-made Structure on Earth*. Johannesburg: Zulu Planet Publishers.

Heinz, H-J. 1975. Elements of !Kõ religious belief. *Anthropos* 70: 17–41.

Hoff, A. 1997. The watersnake of the Khoekhoen and /Xam. *South African Archaeological Bulletin* 52: 21–37.

Hollmann, J.C. (ed.) 2004. *Customs and Beliefs of the /Xam Bushmen*. Johannesburg: Witwatersrand University Press.

How, M.W. 1970. *The Mountain Bushmen of Basutoland*. Pretoria: J.L. Van Schaik Ltd.

Hromnik, C.A. 1996. Ancient Indian religious astronomy in the stone ruins of Komatiland, South Africa. *Monthly Notes of the Astronomical Society of Southern Africa* 55: 69–77.

Johnson, M.H. 1989. Conceptions of agency in archaeological interpretation. *Journal of Anthropological Archaeology* 8: 189–211.

Johnson, R.T. 1979. *Major Rock Paintings of Southern Africa*. Cape Town: David Philip.

Katz, R. 1982. *Boiling Energy: Community Healing Among the Kalahari Kung*. Cambridge (MA): Harvard University Press.

Keay, C.S.L. 1994. Audible fireballs and geophysical electrophonics. *Proceedings of the Astronomical Society of Australia* 11: 12–15.

Keeney, B. 1999. *Kalahari Bushmen Healers*. Rochester: Ringing Rocks Press.

Keeney, B. 2003. *Ropes to God: Experiencing the Bushman Spiritual Universe*. Rochester: Ringing Rocks Press.

Kelley, D. & Milone, E. 2005. *Exploring Ancient Skies: An Encyclopedic Survey of Archaeoastronomy*. New York: Springer.

Law, J. & Hassard, J. 1999. *Actor Network Theory and After*. Oxford: Blackwell.

Leakey, M. 1983. *Africa's Vanishing Art: The Rock Paintings of Tanzania*. New York: Doubleday.

Leeming, D. & Leeming, M. 1994. *A Dictionary of Creation Myths*. New York: Oxford University Press.

Lewis-Williams, J.D. 1981a. *Believing and Seeing: Symbolic Meanings in Southern San Rock Paintings*. London: Academic Press.

Lewis-Williams, J.D. 1981b. The thin red line: southern San notions and rock paintings of supernatural potency. *South African Archaeological Bulletin* 36: 5–13.

Lewis-Williams, J.D. 1997. Agency, art and altered consciousness: a motif in French (Quercy) Upper Palaeolithic art. *Antiquity* 71(274): 810–830.

Lewis-Williams, J.D. 2002. *The Mind in the Cave: Consciousness and the Origins of Art*. London: Thames & Hudson.

Lewis-Williams, J.D., Blundell, G., Challis, W. & Hampson, J. 2000. Threads of light: re-examining a motif in southern African San rock art research. *South African Archaeological Bulletin* 55: 123–136.

Lewis-Williams, J.D. & Dowson, T.A. 1988. The signs of all times: entoptic phenomena and Upper Palaeolithic art. *Current Anthropology* 29: 201–245.

Lewis-Williams, J.D. & Pearce, D.G. 2004. *San Spirituality: Roots, Expression and Social Consequences*. Walnut Creek (CA): Altamira.

Loubser, J.H.N. & Den Hoed, P. 1991. Recording rock paintings: some thoughts on methodology and techniques. *Pictogram* 4: 1–5.

Loubser, J.H.N. & Laurens, G. 1994. Depictions of domestic ungulates and shields: hunter-gatherer and agro-

pastoralists in the Caledon River Valley area. In: Dowson, T.A. & Lewis-Williams, J.D. (eds) *Contested Images: Diversity in Southern African Rock Art*: 83–118. Johannesburg: Witwatersrand University Press.

Lynch, B.M. & Robbins, L.H. 1978. Namoratunga: the first archaeoastronomical evidence in Sub-Saharan Africa. *Science* 200: 766–768.

Malville, J.M., Wendorf, F., Mazar, A.A. & Schild, R. 1998. Megaliths and Neolithic astronomy in southern Egypt. *Nature* 392: 488–490.

Marshack, A. 1991. *The Roots of Civilization: The Cognitive Beginnings of Man's First Art, Symbol and Notation.* New York: Moyer Bell.

Marshall, L.J. 1962. !Kung Bushman religious beliefs. *Africa* 32: 221–251.

Marshall, L.J. 1969. The medicine dance of the !Kung Bushmen. *Africa* 39: 347–381.

Marshall, L.J. 1999. *Nyae Nyae !Kung: Belief and Rites.* Cambridge (MA): Harvard University, Peabody Museum Monographs 8.

Master, S. 2001. A possible Holocene impact structure in the Al'Amarah marshes, near the Tigris-Euphrates confluence, southern Iraq. *Meteoritics and Planetary Science* 36, Supplement: A124.

Milton, J. 1972 [1637]. *Comus and Other Poems.* (Compiled by F.T. Prince.) Oxford: Oxford University Press.

Neher, A. 1962. A physiological explanation of unusual behaviour in ceremonies involving drums. *Human Biology* 34: 151–160.

Olson R.J.M. 1979. Giotto's portrait of Halley's Comet. *Scientific American* 240: 160–170.

Ouzman, S. 1995. The fish, the shaman and the peregrination: San rock paintings of mormyrid fish as religious and social metaphors. *Southern African Field Archaeology* 4: 3–17.

Ouzman, S. 1996. A brief history of rock art research in the eastern Free State, South Africa. *14th Southern African Association of Archaeologists Excursion Guide*: 28–36.

Ouzman, S. 1998. Toward a mindscape of landscape: rock-art as expression of world-understanding. In: Chippindale, C. & Taçon, P.S.C. (eds) *The Archaeology of Rock-Art*: 30–41. Cambridge: Cambridge University Press.

Ouzman, S. 2001. Seeing is deceiving: rock-art and the non-visual. *World Archaeology* 33(2): 237–256.

Ouzman, S. 2005. The magical arts of the raider nation: central South Africa's Korana rock art. *South African Archaeological Society Goodwin Series* 9: 101–113.

Ouzman, S. & Loubser, J.H.N. 2000. Art of the apocalypse: southern Africa's Bushmen left the agony of their end-time on rock walls. *Discovering Archaeology* 2: 38–45.

Pennick, N. 1989. *Games of the Gods: The Origin of Board Games in Magic and Divination.* York Beach (MN): Simon Weiser.

Raper, P. & Boucher, M. (eds) 1988. *Robert Jacob Gordon, Cape Travels, 1777–1786: Volume 1.* Johannesburg: Brentwood Press.

Rappaport, R. 1999. *Ritual and Religion in the Making of Humanity.* Cambridge: Cambridge University Press.

Ruggles, C.L.N. & Hoskin, M.A. 1999. Astronomy before history. In: Hoskin, M.A. (ed.) *The Cambridge Illustrated History of Astronomy*: 2–21. Cambridge: Cambridge University Press.

Shakespeare, W. 1998 [1599]. *Julius Caesar.* (Edited by W.A. Humphreys.) Oxford: Oxford University Press.

Shams, L., Kamitani, Y. & Shimojo, S. 2000. What you see is what you hear. *Nature* 408: 788.

Silberbauer, G.B. 1981. *Hunter and Habitat in the Central Kalahari Desert.* Cambridge: Cambridge University Press.

Skotnes, P. 1994. The visual as a site of meaning: San parietal painting and the experience of modern art. In: Dowson, T.A. & Lewis-Williams, J.D. (eds) *Contested Images: Diversity in Southern African Rock Art Research*: 315–329. Johannesburg: Witwatersrand University Press.

Skotnes, P. 1996. The thin black line: diversity in the paintings of the southern San and the Bleek and Lloyd Collection. In: Deacon, J. & Dowson, T.A. (eds) *Voices from the Past: /Xam Bushmen and the Bleek and Lloyd Collection*: 234–244. Johannesburg: Witwatersrand University Press.

Skotnes, P. 1999. *Heaven's Things: A Story of the /Xam.* Cape Town: LLARC Series in Visual History.

Smith, B.W. 1997. *Zambia's Ancient Rock Art: The Paintings of Kasama.* Livingstone: National Heritage Conservation Commission.

Smith, B.W. & Ouzman, S. 2004. Taking stock: identifying Khoekhoen herder rock art in southern Africa. *Current Anthropology* 45: 499–526.

Snedegar, K. 1999. Sub-Saharan Africa: cultural astronomy's heart of darkness. *Archaeoastronomy and Ethnoastronomy News* 32. Available at http://www.wam.umd.edu/~tlaloc/archastro/ae32.html. Accessed 6th October 2000 and 5th December 2005.

Solomon, A. 1997. The myth of ritual origins: ethnography, mythology and interpretation of San rock art. *South African Archaeological Bulletin* 52: 1–11.

Soper, R. 1982. Archaeo-astronomical Cushites: some comments. *Azania* 17: 145–162.

Spence, K. 2000. Ancient Egyptian chronology and the astronomical orientation of pyramids. *Nature* 408: 320–324.

Sullivan, B. 1995. *Spirit of the Rocks.* Cape Town: Human & Rousseau.

Thackeray, F.J. 1988. Comets, meteors and trance: were these conceptually associated in southern African pre-history? *Monthly Notes of the Astronomical Society of Southern Africa* 47: 49–52.

Thomas, J. 2004 Archaeology's place in modernity. *Modernism/Modernity* 11: 17–34.

Van Beek, W.E.A. 1992. Dogon restudied: a field evaluation of the work of Marcel Griaule. *Current Anthropology* 32: 139–167.

Van Gogh, V. 1888. Letter to Theo van Gogh. Written 28 September 1888 in Arles. Translated by Robert Harrison, number 543.

Vanin, G. 1999. *Cosmic Phenomena*. New York: Firefly.

Vinnicombe, P. 1976. *People of the Eland: Rock Paintings of the Drakensberg Bushmen as a Reflection of Their Life and Thought*. Pietermaritzburg: University of Natal Press.

Wadley, L & Vogel, J.C. 1991. New dates from Rose Cottage Cave, eastern Orange Free State. *South African Journal of Science* 87: 605–608.

Watson, S. 1991. *Return of the Moon: Versions from the /Xam*. Cape Town: The Carrefour Press.

Woodhouse, H.C. 1986. Bushman paintings of comets? *Monthly Notes of the Astronomical Society of Southern Africa* 45: 33–35.

Yamei, H., Potts, R., Baoyin, Y., Zhengtanf, G., Deino, A., Wei, W., Clark, J., Guangmo, X. & Weiwen, H. 2000. Mid-Pleistocene Acheulean-like stone technology at the Bose Basin, South China. *Science* 287: 1622–1626.

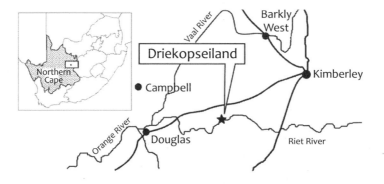

FIGURE 3.1 Driekopseiland, on the Riet River west of Kimberley.

FIGURE 3.2 A view of Driekopseiland from the south-east. (*Photo by C. van Riet Lowe*)

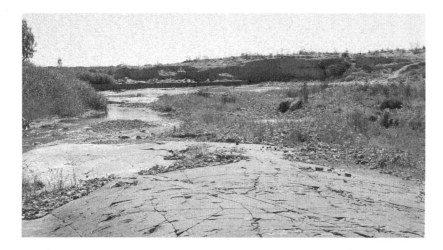

FIGURE 3.3 The western portion of the site, facing upstream. (*Photo by J. Deacon*)

3.

Snake and veil:

The rock engravings of Driekopseiland, Northern Cape, South Africa

DAVID MORRIS

(McGregor Museum, Kimberley, Northern Cape, South Africa)

DRIEKOPSEILAND

Driekopseiland, one of South Africa's most extraordinary and renowned rock engraving sites (Stow 1905; Wilman 1933; Battiss 1948; Van Riet Lowe 1952; Slack 1962; Butzer *et al.* 1979; Fock & Fock 1989; Morris 1990; Lewis-Williams & Blundell 1998), has puzzled researchers for more than a century. Situated on exposed glaciated andesite basement rock in the bed of the Riet River, and between high (10 m–15 m) banks of Quaternary gravel and silt sediment, it is indeed quite singular: some 3600 images, on expanses of rock submerged during floods, have been accounted for, more than 90 per cent of which are 'geometric' motifs (Figures 3.1–3.3). Geometric images are present, and often common, at a significant number of engraving sites in the region (Fock 1969;

Fock & Fock 1989), but nowhere in the area do they occur in such numbers and density relative to figurative engravings. Because of this difference, the question of authorship has arisen in the past in partial explanation of the site – with the most likely candidates cited in the literature being either 'San'/'Bushmen' or 'Khoekhoe'/'Korana'.[1] There is as yet no agreement on the identity/ies of those responsible for the engravings at Driekopseiland.

There has been no dearth of interpretive possibilities put forward for the site, including those entertaining ancient exotic involvement. Van Riet Lowe (1952: 770) explored the possibility that some of the engravings, evincing a "feeling for writing", were more than mere pictographs, and Willcox (1963, 1964) wondered about resemblances to child art; but most early accounts were concerned with the authorship issue.

37

Research from the 1960s was increasingly concerned with a quantitative definition of the site, and to appreciate it within the emerging cultural and environmental history of the region. The site does appear to span, in part, the last 2000 years, a period of widespread change, when new trajectories become apparent in the rock art traditions of other parts of southern Africa (Parkington 1996; Dowson 1998; Jolly 1998). In this context it is relevant to enquire in what ways existing art traditions might have been influenced by the appearance of new lifestyles and social groupings. It is even possible that an immigrant group might have produced a subset of the art – perhaps a tradition quite distinct from that generally referred to as 'San art'. But the nature of interactions between groups, and the archaeological signatures of this across the landscape, suggest that some past questions and characterisations in this respect were simplistic.

Indeed, significant cross-cultural continuity in key beliefs and rituals within Khoisan society permits the application of relevant ethnography, to build on earlier tentative speculations regarding the significance of 'place' and 'topophilia' at Driekopseiland (Morris 1988, 1990; cf. Parkington 1980; Deacon 1988). Concepts developed by David Lewis-Williams and Thomas Dowson (Lewis-Williams & Dowson 1990; Lewis-Williams 1996), on the construal of places and rock faces as meaningful supports, are drawn upon to consider possible metaphoric understandings of landscape that could also explain aspects of contemporary variability between engraving sites of the region.

WHO, AND WHY? STOW'S ACCOUNT

The first account of Driekopseiland is that of geologist G.W. Stow (1905), who knew it, in the 1870s, as 'Blaauw Bank' or 'Bloem's Homestead', on what was then still known as the 'Gumaap (!Kora for Modder or Muddy) River (now the Riet River):

> At Blaauw Bank ... rocks are found perfectly polished and striated ... proof of a remote glacial period; ... their wonderful and unwonted appearance had evidently produced a strong effect upon the Bushman mind, for, struck with their unexplained smoothness, he has covered the

space with mystic symbols ... There is very little doubt but that many of them conveyed a mystic meaning to the initiated; this seems confirmed by the frequency of certain forms, and the repetition of particular numbers (Stow 1905: 28–29).

Leaders of the last independent 'Bushmen' of this area are named by Stow, and it is in his account of their struggle (under 'Kousopp) against white settlers in the 1850s (Morris 2000) that he again mentions Driekopseiland. 'Twa-'goup, the father of 'Kousopp, ruled over the clans along the 'Gumaap and its tributaries, and 'Kousopp, after his father's death, is said to have had his headquarters at 'Kun-'kgoap, two prominent hills near the 'Gumaap and about halfway between modern Kimberley and Driekopseiland. It is in the context of this struggle that Stow mentions rock engravings as "the ancient title-deeds of their race to the wide-spread plains around them, which had been occupied not only by themselves, but by their remote ancestors" (1905: 397).[2] Stow (1905: 398) continues:

> But the grand testimonials of the great antiquity of their occupation are to be found ... recorded on the polished and striated rocks of the Blaauw Bank [Driekopseiland] ... a spot that must have been, during the time of their undisturbed sovereignty, a place memorable to their race, where thousands of square feet of ... rock surface are covered with innumerable mystic devices, intermingled with comparatively few animal figures. This must have been a palace residence of the most highly mystic of their race ... a high place, where they gathered for their festivals of dancings and mysterious rites or counsel, a place where for generations their leaders who were the most skilled in the emblematic lore, the symbols of which were engraved around, awed their less initiated brethren with frantic orgies, or vehement recitals of the traditions of the renowned and daring hunters from whom they themselves had sprung, or still more ancient myths of times yet more remote, when, as they believed, men and animals consorted on more equal terms than they themselves, and used a kindred speech understood by all![3]

Stow made 'rubbings and sketches' of some of the engravings from here, and these were among the portfolio of painting and engraving copies that Dr W.H.I. Bleek (1875: 155) received with enthusiasm, sent by Stow from the Diamond Fields in 1875 (Fock 1970).

BUSHMAN OR KORANA – AND OTHER PREOCCUPATIONS

An array of assumptions and expectations lay behind the interpretation of Driekopseiland in the first two-thirds of the 20th century. At base, though, many authors displayed a preoccupation with ethnicity and the reified art-making capacities and aesthetic sensibilities attributed to respective cultural groups – Bushmen, Korana, sundry interbred combinations, and foreigners. A yardstick implicit in much of this debate was articulated most explicitly by Cooke (1969) in what he termed the "true art of the Stone Age Bush people". Against this measure, Driekopseiland was, for him at least, no match.

Wilman[4] (1933) agreed with Stow in ascribing the Driekopseiland engravings to Bushmen, and Van Riet Lowe (1952), in his turn, did so on the basis of nearby occurrences of 'Smithfield B' and overlapping Wilton phases of the Later Stone Age. One of the originators, it seems, of a contrary view was Broom, cited by Wilman (1933: 52), who believed that Korana were responsible for these engravings; that indeed they were the makers "probably of all engraved stones". Broom even felt that "the Middle Stone Age Culture" was "due to a Korana-like native" (cf. Morris 1992: 18). Battiss (1948) meshed these opposing opinions. He recognised the engravings of animals as the oldest and linked them to Bushmen. But the later episodes of geometric symbols were, he believed, distinguishable: "meandering serpentine motifs" were "replicas of the designs found on modern Bushman bags, karosses and knapsacks"; while those featuring "dots in a crescent shape, and resembling picks and anchors" he had not seen elsewhere in Bushman contexts, and for this reason ascribed them "to other engravers, most probably the Koranas" (Battiss 1948: 59).

In the 1960s, Willcox correlated, as others had, the animal engravings with the local "abundance of Smithfield B" artefacts and with Bushmen. But he ventured that "the later Korana, moved to experiment

by what they found there, but without artistic skill, made the geometrical peckings" (Willcox 1963: 59). What puzzled Willcox were the instances, at Klerksdorp and Redan, where associations of Khoekhoe or Korana with geometric engravings were less readily made; he concluded, "no single people could it seems have made all of the sunburst type of petroglyph in the Republic unless it were a Korana-Bantu mixture" (*Ibid*).

Alternative approaches were couched in a 'developmental' framework by Van Riet Lowe (1952) and – initially as a footnote in his 1963 book – by Willcox (1963, 1964). For Van Riet Lowe (1952: 769) the geometric engravings at Driekopseiland represented a type of image to be seen throughout the African continent – and even beyond. He distinguished a "special group of figures" here that were utilitarian rather than aesthetic, which suggested "a 'feeling for writing', an anxiety to convey a message in a symbol, i.e., an ideograph rather than a pictograph" (Van Riet Lowe 1952: 770; cf. Power 1949). The Bushmen "may well have reached a stage of culture", he argued, with reference to stone tool typology, "in which their mental development enabled them to devise and use symbols to which specific meanings were attached" (Van Riet Lowe 1952: 775).

Willcox (1963: 59, 1964) introduced the work of Kellogg and pointed to a resemblance between the Driekopseiland engravings and the pre-representational drawings of children. Revising earlier conclusions, he proposed that it was "unnecessary to suppose that there is any cultural connection between the sites at which rock art of this kind occurs, or that any meaning as pictographs or ideographs need be ascribed to these glyphs" (Willcox 1963: 59). The engravings could have been "the work of people of any age and race who are still in the 'young child' stage of artistic development", he suggested (Willcox 1964: 58). Cooke (1969: 73, 100) was to concur. In this new light, Willcox believed that the Driekopseiland engravings could be the work of any of the pre-colonial populations here, and that "of the Korana and the Bushmen, the latter race is the more likely to have been the artists" (Willcox 1964: 58). Here, though, Cooke (1969: 97) would differ, for to him it implied a degeneration among Bushman artists to a more primitive stage, and it was more likely that the Korana had been the engravers of the geometric

images at Driekopseiland. Alternatively, interbreeding between Bushmen and "Hottentot or Negroid invaders" might have resulted in a form of art bearing "little or no resemblance to the true art of the Stone Age Bush people" (Cooke 1969: 100).

Departing somewhat from the 'mainstream' Bushman–Korana debate, Slack (1962) republished Van Riet Lowe's paper as an appendix to – and springboard for – her own speculations. She recorded much of the site in 1938, at van Riet Lowe's invitation, and it was hoped that the Abbé Breuil, here in 1943, might publish a monograph using her copies. But the "difficulty of his working in the area at his age" prevented this (Van Riet Lowe 1952: 769), and it was only later that Slack's work appeared, in a volume intended to popularise the engravings (Slack 1962: 11). Bent as she was on making representational sense of every engraving (Willcox 1964), she made inherently improbable connections that involved links with "an Egyptian or even Mediterranean civilization". Not unexpectedly, the site featured in Hromnik's *Indo-Africa* (1981: 100–102), and in Fell's equally bizarre pursuance of, in his case, Libyan explorers using Ogham script (Willcox 1984: 210; cf. Du Toit 1967). Breuil himself had flirted with the idea of foreigners being subjects, and even the makers, of southern African rock art (Yates *et al.* 1990: 23–26).

Major portions of the Bleek and Lloyd records were being published through this period, but little effort was made by writers on rock art to consider the art (and the cultural labels they attached) in relation to the ethnography

WHAT, AND HOW OLD?

In the 1960s–70s, G. and D. Fock undertook a regional survey (e.g. Fock 1969; Butzer *et al.* 1979; Fock 1979; Fock & Fock 1984, 1989) that included detailed recording and mapping of Driekopseiland (Fock & Fock 1989). In addition to quantification, they were concerned to date the art. With Butzer and colleagues, they researched sediment and palaeoenvironmental history to hypothesise a broad bracketing chronology for the engravings (Butzer *et al.* 1979; Helgren 1979). Their findings took the debate forward in the sense that they established more clearly the nature of this extraordinary site.

The engravings occur in two main clusters, the greater (eastern) part on an expanse of exposed glacial pavement about 60 m upstream from a second, smaller (western) part (Figures 3.2, 3.3). These areas differ in thematic and temporal definition: more than 99 per cent of the 2004 engravings in the upstream part are geometric images, while, amongst the 1543 engravings downstream, a little under 75 per cent are geometrics (Fock & Fock 1989: 142).

The 'density and intractability' of the engravings and their unequal preservation posed 'special problems' for recording and analysis. Given these constraints, spatial analysis indicated striking clustering of certain motif forms: concentrations of designs with dots in some parts of the site; and 'grid ovals', 'crossed circles', concentric circles, rectangular forms, 'fish-spines' and cellular motifs in others. Similarly, the T-shaped designs, unique to this site, are fairly locally confined.

Nor was relative sequencing of the engravings on the basis of patination or wear as straightforward as earlier writers implied. Rather, their height and distance from the modern river channel determined the patination pattern for the bulk of the engravings: "contrasts in patina can only be applied to relative dating on small surface segments, where exposure to water or sun are [sic] identical" (Fock & Fock 1989: 141). Similarly, water abrasion was "noticeably accentuated" close to the channel or on convex surfaces facing upstream; again, significant differences in abrasion could be observed in directly juxtaposed or superimposed engravings.

As to content, "only about a third of the geometric designs in the Western sector [Figure 3.4] correspond in theme, style and quality with those in the Eastern sector [Figure 3.5]; the remainder (in the Western sector) are thematically distinct, often more elaborate or better done and, on the whole, slightly to somewhat more worn" (Fock & Fock 1989: 143). Few animal motifs and one human figure were found in the eastern part, while 325 animal and 19 human depictions, "moderately to strongly abraded by stream action" (Fock & Fock 1989: 142), occurred in the western portion of the site.

This upstream–downstream variability, it was suggested, was a factor of history that could be related to the recent geology of the site. A study of the sediments flanking the engravings (Butzer *et al.* 1979) yielded evidence of alternate depositional and down-cutting

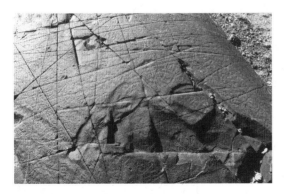

FIGURE 3.4 'Slightly to somewhat more worn' – evidently older engravings of animal and geometric images on the downstream surfaces. *(Photo by T. Smith)*

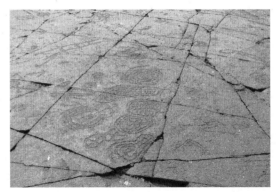

FIGURE 3.5 Geometric images festooned across part of the eastern glaciated surfaces. *(Photo by T. Smith)*

episodes. Bedrock was exposed to varying degrees at different times. A chronology was derived from a suite of palaeoenvironmental studies along the Riet and Vaal rivers and in local pan deposits (Butzer *et al.* 1979; Helgren 1979; Fock & Fock 1989).

Buried for most of the Holocene, bedrock began to be exposed in places as a result of rapid channel cutting, from a moist flood plain at +7 m after 2500 BP. Renewed aggradation of flood silts and sands took place between about 2200 and 1300 BP, stabilising as a mainly dry flood plain 2 m–3 m above the present river level, with little or no bedrock exposure. Channel cutting recommenced after 1300–1200 BP, resulting in considerable bedrock exposure, with relatively minor silt build-up and erosion since then. "As a general framework," Butzer and the Focks argued, "the Driekops Eiland engravings could only have been executed *c.* 2500–2200 BP or after 1300 BP" (Fock & Fock 1989: 141).

Reading together the environmental history and the evidence of the engravings, the animal images and the older geometric designs restricted mainly to higher, convex surfaces in the western part of the site probably date from the earlier period, *c.* 2500–2200 BP, when only portions of bedrock were

exposed. The predominantly geometric engravings in the flatter eastern part of the site, by contrast, were probably made from perhaps the end of the first millennium CE onwards, after much more of the glacial pavement was exposed (Fock & Fock 1989: 86).

The Focks' survey showed that, while the preponderance and number of non-figurative engravings here make this site unusual, several features are nevertheless consistent with other sites in the region. For example, of the animal images, the largest proportion of those that can be identified to species level are eland (10%), a central symbol in San beliefs and in the rock art of many southern African regions (Vinnicombe 1976; Lewis-Williams 1981; Lewis-Williams & Dowson 1989). At least 16 other species occur, reflecting the range commonly seen on other engraving sites.

The geometric engravings, too, are part of a regional pattern, and they predominate at 28 per cent of engraving sites north of the Orange River (Fock 1969). The major site of Klipfontein 1 (nearly 4600 engravings) has 29 per cent geometrics to 52 per cent mammals: 29 per cent of identifiable mammals are eland to 3 per cent human (Fock 1979). The average percentage presence of geometrics at lower Vaal River sites is 23 per cent and at Riet/Modder River sites, 35 per

cent. Intersite variability is often marked, however: at three sites on the plains (like Klipfontein) between the Vaal and Riet rivers, namely Wildebeestkuil (178 engravings in the Focks' sample), Vaalpan (96 engravings) and Christiansdrift (289 engravings), geometrics make up 7 per cent, 9 per cent and 3 per cent respectively (Fock & Fock 1989). This variability is not as yet well understood, but it does appear that geometric images are an integral part of the engraving genre, from at least the 'Intermediate Phase' (*Ibid*), judged to be greater than 2000 but not more than about 2500 years old, and from the 'Younger' and 'Youngest' phases, estimated as dating from within the last two millennia. If any doubt is cast on these dates, the evidence does at least indicate that some geometrics are relatively older and others younger. As regards the relative frequency of geometric engravings at sites in the area, Driekopseiland defines one end of a regional spectrum.

TOWARDS AN ARCHAEOLOGICAL CONTEXT

At the same time as the physical landscape at Driekopseiland itself was changing – in the sense that the glaciated rock surfaces were becoming exposed in the river channel – the social landscape was also far from static. The practice of a herding lifestyle was emerging in the wider region, and ceramic technology had appeared in the first millennium CE (Beaumont & Vogel 1984, 1989). A distinctive pattern of Type R stone-walled sites evolved later along the Riet River, dating from about CE 1380 to CE 1780, and distributed mainly further upstream but with isolated settlements along the lower Riet (Maggs 1971; Humphreys 1972, 1988, 1997; Brink *et al.* 1992). Frontier complexity was considerably augmented by the early 19th century, when 'Bushmen', Griqua, 'Bastards', 'Bechuana', Xhosa ('Caffers' in contemporary sources), Boers, and travellers from the Cape and between missionary centres, lived in, or passed through, the valley of the Riet (Humphreys 1997).

Pertinent evidence on the ground at Driekopseiland consists of late Holocene lithic scatters on the banks overlooking the engraving site (Battiss 1948; Van Riet Lowe 1952; Willcox 1963; Butzer *et al.* 1979), at least two burials (Battiss 1948; Mason 1954; Butzer *et al.* 1979; Humphreys 1987), and a Type R stone-walled settlement unit at the foot of the hills

some way off (Du Toit 1964; Humphreys 1972, 1987; Fock & Fock 1989). Van Riet Lowe and others characterised the lithic scatters as 'Smithfield B' and Wilton, now subsumed within the Wilton Complex (Humphreys & Thackeray 1983), though with local industries subject to closer definition. Associated with these scatters, in places, are relatively rare sherds of fine grit-tempered pottery. Substantial assemblages of comparable ceramics occur at Blinkklipkop and Doornfontein near Postmasburg from at least *c.* CE 790 to around CE 1630, after which time the pottery becomes coarser (Beaumont & Vogel 1984: 82, 92; Beaumont *et al.* 1995). By contrast, much thicker sherds from essentially undecorated pots and bowls are associated with the Type R stone-walling (Humphreys 1972, 1988). Numbers of burials from along the Riet River, having various features in common, are linked in several instances with the Type R sites, by virtue of their placement, their dating and the nature of grave goods (e.g. copper objects). Yet, one burial, conforming to the others in terms of burial pattern, yielded a date in excess of 3000 years BP, prompting Humphreys (1974: 271) to suggest that the Riet River burials represent "a relatively stable aspect of a cultural system extending from at least 3000 years ago". The human remains themselves cannot be distinguished morphologically beyond the level of 'Khoisan', but Morris's (1992: 102) analysis of the Riet River sample indicates that they do constitute a morphologically homogeneous population, with a certain amount of anatomical distinctiveness: "the Riet river population as a whole experienced a degree of genetic isolation from other South African groups," he concludes. Mortuary data for the Riet River sample are consistent with San burial practices – and none with those linked with Khoekhoe (Morris 1992: 70). The Type R settlements have been accounted for by Humphreys in terms of erstwhile hunter-gatherers having adopted pastoralism, and being engaged in trade and cultural exchange with other groups, probably Sotho-Tswana to the north (but see Brink *et al.* 1992; Humphreys 1997). An analogue for the process resulting in the stone-walled settlements is given with reference to 20th-century stock-keeping Dobe !Kung (Humphreys 1988; cf. Yellen 1984) whose settlement organisation underwent change, with similar eventual spatial layout, after the incorporation of herding into their previously hunter-gatherer social economy.

Recent PIXE analysis of pottery samples suggests that here and elsewhere in the Northern Cape, pottery assemblages and other aspects of material culture are by no means a straightforward reflection of social entities such as ethnic or even techno-economic groupings (Jacobson, Morris *et al.* 1994; Jacobson, Pineda *et al.* 1994; cf. Deacon & Deacon 1999: 184). Similarly, the idea that the animal engravings and older geometrics at Driekopseiland were made by Bushmen, linked with the 'Smithfield B' sites, and the younger geometric motifs by Korana or Korana/Bush people, may be simplistic. Rather, it seems likely that a complex 'mosaic' (Beaumont & Vogel 1984; Humphreys 1988) of economic, technological and ideological responses became manifest in the region through the last 2000 years, characterised by a variety of social and cultural interactions between differing subsistence modes (Humphreys 1988; cf. Denbow 1990; Maggs & Whitelaw 1991; Lewis-Williams & Blundell 1997: note 17). In such a scenario, the ethnic groups recorded in the colonial era might well be of uncertain time depth and perhaps even of doubtful relevance (Humphreys 1998). In the 19th century, 'Korana', for example, became something of a catch-all frontier category – at least in colonial literature, different from 'Korana' herders along the middle Orange River in the previous century (Barnard 1992; cf. Legassick 1979: 251).

TOWARDS MEANING

Quite how the changes in this period impacted on rock art traditions and beliefs locally is not clear. It has been suggested, on the one hand, that regional differences in rock art repertoires of the last two millennia may reflect different trajectories of change and forms of interaction between hunter-gatherers and other social groups in their respective areas (e.g. Prins 1991; Parkington 1996; Jolly 1998). On the other hand, Wilmsen has pointed out how the content of mythology "transcends time and tribe and ethnicity", indicating a complex history of social relations, through which elements of cosmologies "were constructed and transmitted in a less segmented social environment than presently exists" (Wilmsen 1986: 358; cf. Schmidt 1979; Dowson 1998; Jolly 1998).

Historical records of the 19th century attest to the respect in which San rainmakers were held among the farmer neighbours to whom they provided this service (Lewis-Williams 1981). This was one of the forms of interaction by which hunter-gatherers articulated with others (Wright 1971; Vinnicombe 1976; Lewis-Williams 1981; Campbell 1987; Prins 1991). Lewis-Williams has drawn attention also to the close similarity between Korana rituals and beliefs and those of the /Xam (Lewis-Williams 1981: 105–106; Prins 1991). Remarkably, aspects of the beliefs in question have been sustained to this day in the lives of some descendants of Khoisan in the Northern Cape, with a degree of regional variability (Van Vreeden 1955, 1957; Waldman 1989; Prins & Rousseau 1992; Hoff 1993, 1995, 1997, 1998; Lange 1998).

The historical contexts of the engravings, then, are probably complex and the question of authorship is, for the present, less than clear-cut (the options might, at most, be between Khoisan groupings, where the influence of emergent pastoralism and contact with Iron Age groups may have played a role). But insights with respect to significant cross-cultural continuity in the sphere of beliefs and ritual mean that the pertinent questions on diversity in the engravings here may relate more to changing emphases in the expression of widely shared beliefs (cf. Lewis-Williams 1988), including dynamic landscape temporalities (Ingold 1993) and variable contemporary uses of places, than to the relative merits of different ethnic authorships.

Bearing in mind the historical processes of the last two millennia, one may look afresh at sites such as Driekopseiland in the light of the ethnography and the ways in which it has informed recent rock art interpretation.

A useful start may well be in a consideration of the placement of rock engravings in the landscape, and in linking this to the important insight that the support on which the art was made is a "most fundamental part of the context" (Lewis-Williams & Dowson 1990: 5). Surfaces where images were placed, Lewis-Williams and Dowson suggest, constitute "in some sense a veil, a 'painted veil', suspended between this world and the world of the spirit" (Lewis-Williams & Dowson 1990: 15; cf. Lewis-Williams 1988).

At the level of individual images, there are in the engravings, as in the paintings, many examples where it is clear that the rock support is no *tabula rasa*. Rock and image often interact so that the former is integral to the latter, as a few examples will show. An engraving

of a flamingo at Klipfontein (Fock 1979), in the side of a hollow where rain water collects, has its head bent low, as if feeding, as flamingos do in shallow water (Figure 3.6). In Figure 3.7 the intent is less obvious, but the natural hole has clearly been integrated as part of the image (Fock & Fock 1989). Holes in the rock surface, it has been argued, may have been perceived as entrances into the spirit world (Lewis-Williams & Dowson 1990: 12). Lewis-Williams (1988) suggests that geometric engravings may have brought to mind the act of plunging into water – a metaphor for trance – where the plunge signified entry into non-reality. Geometric engravings in general have been interpreted as entoptics inspired by the sensations of the first stage of altered consciousness (Lewis-Williams 1988; Lewis-Williams & Dowson 1988; Dowson 1992). In a third example, engravings at Wildebeestkuil (Figures 3.8a, 3.8b), previously interpreted as 'unfinished', are arguably images of antelope and a rhino that *emerge* from the rock, the 'unfinished' portion implying that the rest of the animal in each case still resides within, or behind the 'veil' (Morris 1996; cf. Morris & Mngqolo 1995). Lewis-Williams and Dowson (1990: 15) refer to the act of art-making as in a sense the luring of images from behind the surface of the rock. An eland at the same site is headless and positioned such that it appears to *leave* the rock, from the real world, as it were, into the spiritual realm above (Morris 1996). An interaction between image and support (and in the last example, more than merely the support is implicated) is demonstrable in the engravings, and is consistent with the idea that the support itself has meaning.

That this logic in the cosmology of the engravers extended to landscape features is less easily substantiated, but important evidence has been explored by Deacon (1986, 1988, 1997; see also Ouzman 1995, 1998; Walker 1997). The 19th-century /Xam legend, "The Death of the Lizard" (Bleek & Lloyd 1911: 215–217), is linked directly to the Strandberg hills in the Upper Karoo. It tells of the *!khau* (Agama lizard), who was a man of the early race before people and animals were differentiated, and who, walking across the dry plains, was caught by the mountains, squeezed and broken. His upper body became the hill called *!guru-na*, his lower body and legs the hill */xe-!khwai*. The Agama lizard may have been a metaphor for a rainmaker, owing to its habit of mounting a rock and facing, motionless (as the hills now lie motionless),

the direction of the rain when rain is imminent (Deacon 1997). The symbolic linkages implied by the personification of Upper Karoo geographical features, in myth and legend, were evidently enhanced by those places being marked with rock art (Deacon 1988, 1997; cf. Schmidt 1979: 206). Landscape symbolism is difficult to show in the absence of oral testimony, but many place names hint at similar connections (e.g. Renosterkop near Kakamas is a direct translation of *!Nawabdanas*, meaning 'rhino head' – Morris & Beaumont 1991).

An animated landscape additionally was traversed by the destructive 'he-rain' or the more gentle 'she-rain', which left distinctive 'footprints' as they 'walked' on 'rain's legs' – the columns of rain precipitating from the clouds that were their embodiment (Bleek 1933a). Thus meanings were applied not only horizontally across the landscape, and through the 'veil' at, for example, rock art sites, but also into the realm above – as has been modelled in an analytical construct which Lewis-Williams (1996) developed to describe the biaxial structuring apparent in /Xam cosmology. Opposing ends of the horizontal axis were the camp and the hunting ground, with the waterhole midway. At the waterhole is the point of intersection, with a vertical axis associated with the supernatural. The extremities of this axis were the realm above, and the one beneath the surface of the earth. These were mediated by water, welling up in waterholes and falling from the sky (Lewis-Williams 1977: 168, 1996: 124–127).

It is argued here that Driekopseiland became a powerful place in relation to this kind of stratified and horizontally structured cosmology. I speculate that, as the striated blue-grey glaciated andesite was exposed by geological processes in the last two and a half millennia, so the rocks came to be identified, not quite as the "great whales lying in the mud", as Battiss memorably described Driekopseiland, their backs "decorated with innumerable designs" (1948: 58), but indeed as *!Khwa*, the 'Rain/Water' in the form of a giant Great Watersnake (Schmidt 1979), emerging from the depths in the channel of the 'Gumaap, and dipping down beneath the riverbed again a few hundred metres further downstream. Stow, too, had sensed that the "perfectly polished and striated" rocks, with "their wonderful and unwonted appearance" and "unexplained smoothness" (Stow 1905: 28–29) might, in terms of these qualities, have moved the Stone Age engravers. The fecund

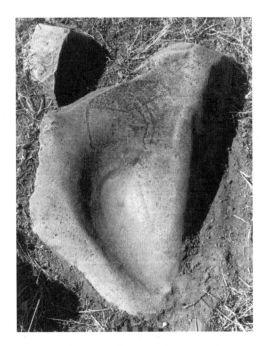

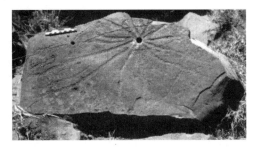

FIGURE 3.7 Entrance into non-reality (Lewis-Williams 1988): A geometric image centred on a natural hole in the rock.

FIGURE 3.6 Interaction of image and support: A flamingo 'feeding' in a natural depression in the rock (Fock 1979).

python in Ju/'hoãn tales, undulating slowly, is celebrated for her beautiful stripes, her fat, and her smoothness (Biesele 1993: 97, 121, 134, 137).

The river swells and floods in response to summer rains, and the engravings are temporarily submerged, but in the dry season the somewhat reduced flow is confined in a narrow side channel, the engravings rising up on the bulging surfaces. The combination of geological features and riverine processes – in a semi-arid region often parched by drought – makes for a potent congruity with beliefs associated with *!Khwa* and the watersnake. Imagery engraved at Driekopseiland arguably reinforced an inherent power of place, directly at the intersection, one might suggest, of the structural axes in relevant Khoisan cosmology.

To the extent that Stow's account of Driekopseiland might have been an embellishment on some form of oral testimony in the late 19th century, his use of the word 'palace' to describe the site could well be significant. When Van Vreeden collected folklore in the region in the 1950s, informants told him that it was in a 'palace' underwater that the watersnake dwelt (Schmidt 1979: 210).

Although the Bleek/Lloyd informants spoke only of *!Khwa*, the 'Rain/Water', and of *!Khwa:-ka xoro*, the 'Rain Bull', and did not mention *!Khwa*'s personification in the Great Watersnake, other sources affirm a link. Von Wieligh maintained that the Great Watersnake played a prominent role in Bushman folklore (Schmidt 1979). The attributes and power of *!Khwa* given by the /Xam, and the rituals and related symbols, correlate exactly, as Schmidt points out, with those associated with the watersnake in other accounts. Van Vreeden's (1957: 175) view, from the ethnography and his own enquiries, was that the water, the water bull and the watersnake were but

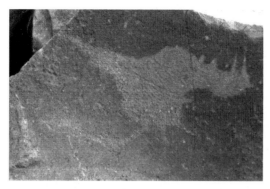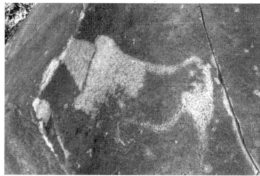

FIGURE 3.8 Wildebeest Kuil engravings: A rhino 'emerges' at the rock surface, while an eland, headless at the edge of the rock, appears to 'leave' it.

three expressions of a single spiritual concept. Similarly, Hoff (1997: 33) has found that, for people in areas of the Northern Cape where the /Xam once prevailed, "the Water Snake *is* the water" (her emphasis). As Schmidt suggests, it is these equivalences that resolve the conundrum of Diä!kwain identifying as a water bull that which Qing had said was a snake. In a seemingly older stratum of belief the position of the water bull was evidently occupied by the eland, while also being represented in rock art by other large mammals or mammal-like creatures (Schmidt 1979).

The watersnake is linked specifically with rivers in several instances. Hoff (1997) records that perennial rivers were believed to have enormous resident snakes that would travel upstream and down, and had the power to withhold water. Conversely, Van Vreeden (1957: 187–188) was told how the watersnake could make rivers rise, as well as supply the springs in the surrounding landscape, ensuring a good year. Qing, in the previous century, indicated to Orpen (1874: 5) that snakes could "fill the country with water". As one of Hoff's informants explained, "it is because of this snake that we have water to drink" (1997: 23). Appeasing *!Khwa* was thus crucial: Hewitt notes that at the conclusion of /Xam menarcheal rites, ochre was sprinkled onto the surface of the water as an act of association, lest *!Khwa* should cause the water source to dry up (Hewitt 1986: 281; Schmidt 1979: 204).

At Driekopseiland, the exposure of arguably potent, glacially smoothed rock was at its greatest when the river sank to its lowest level – defining a moment approaching maximum spiritual and material stress. Some of the geometric engravings in the western part of the site are well below the modern low-water level, suggesting that "the river was prone to drying up almost completely at the time the bulk of the geometric designs [there] were produced" (Fock & Fock 1989: 143).

In his review of the 'non-representational' engravings and finger paintings of the Northern Cape, Fock (1969: 126) suggested that some of these kinds of images might "indicate water or rain or have some connection with puberty ceremonies". This observation was based on his reading of Silberbauer's (1965) account of G/wi girls' puberty rites. As it turns out, it is argued, Fock was probably close to the mark – at least for some of the sites in question.

An almost completely dry riverbed may well have prompted determined rainmaking activity. Just as the rain bull, *!Khwa:-ka xoro*, and the rain-animal identified by Qing as a snake, were central in /Xam rainmaking practices (Orpen 1874; Bleek 1933b), so too was it possible 'to work with' the watersnake, Hoff's informants claimed (1997: 26). Rainmaking, sometimes enacted beside rivers, was clearly one possible context for the engravings at Driekopseiland (Prins 1991; Prins & Rousseau 1992).

Fock's idea of "some connection with puberty ceremonies" deserves fuller consideration. Within a shamanistic context, Lewis-Williams and Blundell (1997: 53) address the possibility that "gender- or age-differentiated responses to image making and the supernatural" are implicated in some painted images – specifically finger-dots. They allude to a direction of research pioneered and elaborated by Solomon (1992, 1994; see also Parkington 1996; Anderson 1997; Manhire 1998), who notes that female initiation is "an extremely prominent feature of San ritual and particularly prominent in narrative collections such as the Bleek/Lloyd corpus" (Solomon 1994: 345–346). Just as the place of female initiation – its symbols and meanings – is clearly to be situated at the very intersection of the axes in Lewis-Williams' (1996) /Xam cosmological model, so Solomon links it centrally in social and political relations and power, critical to the material well-being of the group, and to both female and male production and reproduction (Solomon 1994: 349; cf. Lewis-Williams 1981).

The onset of menarche in /Xam and other Khoisan societies was regarded as a dangerous condition. Its resonances in ethnographies link the female initiate with the rain, water, and blood, and with snakes. Hahn (1881: 78–79) records that the same Nama root word is shared for 'snake', 'waterhole', 'rain', 'blood', and the colour red, as well as 'to flow', and 'to milk'; while Hewitt observes that *!Khwa*'s name was used (in one recorded instance) to mean 'menstrual fluid' (1986: 284; cf. Guenther 1994). Taboos in relation to the 'new maiden' (Lewis-Williams 1981) were to be respected lest the wrath of *!Khwa* be incurred. Her menstruation placed her in the conceptual no-man's-land between culture and nature (Hewitt 1986); she occupied a place of ambiguity along the horizontal camp to hunting-ground axis. There, *!Khwa*, as water, or watersnake, operated as an impersonal force, greatly feared, that mediated and demanded to be appeased. The proper ritual observances and respect for taboos (failure in which would affect also the male domain and the hunt) would restore the balance. For violation of taboos, a girl and her family and female elders could be swept up by a whirlwind and deposited, transformed as frogs, in a pool, their material possessions reverting to the raw materials from which they were made. Lightning could strike people down; they could be turned to stone – or into stars (Hewitt 1986).

Significant at the conclusion of female puberty rites, in a cross-section of Khoisan groups, were the uses, variously, of tonsure, tattoos and scarification; and of ochre, *buchu* (two potent substances sometimes employed interchangeably) and mud, to mark, paint or daub – or to sprinkle over – the body, objects, and water (e.g. Hoernlé 1918; Engelbrecht 1936; Bleek 1937; Silberbauer 1963, 1965, 1981; Schmidt 1979; Hewitt 1986; Waldman 1989; Hoff 1995, 1997; Lange 1998). These practices ensured protection and the 'cooling' of dangerous potency in various rituals to associate the 'new maiden' with *!Khwa* or its equivalent manifestations, following her period of seclusion. As regards the engravings at Driekopseiland, on a glaciated rock support that is pregnant with symbolic possibilities, a case may well be made, alternatively (or additionally) to rain-making, for a link with the beliefs surrounding female puberty rites. Given the role of marking or image-making in these rites, the engravings could themselves have been part of the rituals, constituting, perhaps, a "residue of a ritual sequence", as Lewis-Williams and Blundell (1997) suggest in a potentially analogous instance. Might the clustering of certain image forms on different parts of the site even be linked to particular generations of ritual performance?

In the Western Cape, Manhire (1998) sees the production of handprints as primarily the work of sub-adults, possibly in the context of rites of passage. For Anderson (1997), a connection between handprints and related imagery with the practices that conclude female initiation is also compelling, but he reads these rites as being specifically Khoekhoen, whereas – as has been shown – the beliefs and practices in question were, and are, widespread among Khoisan societies (including /Xam) and beyond. The distribution of handprints in the Western Cape, moreover, indicates that authorship issues are not easily resolved in ethnic terms (Manhire 1998; cf. Yates *et al.* 1994: 58–59).

In /Xam rites, the appearance of a new moon signalled the end of a 'new maiden's' seclusion and ritual cleansing. Forms of association and protection followed, through which her potency was distributed and brought into harmony with the group and its world. With other women, the initiate shared ochre for painting cheeks and decorating karosses; while she painted ochre stripes 'like a zebra' on the young men of the band to protect them from *!Khwa*'s lightning (Hewitt 1986: 76, 281). *Buchu*, an aromatic herb that

countered the odours (sweat, blood) that potentially roused *!Khwa*'s aggression, was given to all members of the household. It also restored the girl's father's capacity in the hunt. Finally, ochre was sprinkled at the water source to appease *!Khwa* (Hewitt 1986: 281).

Twentieth-century accounts of puberty rites in the Northern Cape (Waldman 1989; Hoff 1995) are an indication of how elements in these rituals transcended time, tribe and ethnicity (Wilmsen 1986). In Griquatown in the 1980s, both the initiate's face and her handmaid's were made up using: "several large red circles surrounded by small black dots situated on their foreheads, noses, chins [and] on each cheek [with] a line of small black dots [from] cheek to ear" (Waldman 1989: 33). Strings of beads crossed their chests and backs, and tortoise shells containing *buchu* hung from their dresses. Dancing and singing, the initiate was led to the spring where *buchu* and other items were offered to the watersnake – but not before she was anointed with mud, on forehead, abdomen and knees (Waldman 1989: 38). Hoff's (1995) description, in what she characterises as a Khoekhoen context, refers to springbok and gemsbok 'patterns' as a popular form of facial decoration for an initiate's 'dancing-out' – as were linked eyebrows (believed, along with beauty spots, to mimic the watersnake), and zigzag designs painted on arms and legs. Rituals of association included the smearing of ash from the hearth, dung from the kraal, and mud from the water source. At the water, a cross was made in the middle of the forehead, between the eyes, or on the knee; a vertical line on the shin; and a horizontal smear under the nose (Hoff 1997: 30).

A key element in these Khoisan rites was appeasement of, or association with, *!Khwa* at a river or waterhole. Proper precautions had to be observed there at other times, as */Han≠kass'o* (Bleek 1933a: 300) indicated: "when a girl approaches the water and it is raining gently, she grinds *buchu*. Then as she approaches the pond, she scoops out the *buchu* and strews it on the water because the rain loves *buchu* – *buchu* is what it smells. It glides quietly along when it smells things which are unequalled in scent."

DRIEKOPSEILAND LANDSCAPE AND HISTORY

One may, as yet, merely hint at the significance and context of the engravings at Driekopseiland, but the seemingly coherent convergence of their particular focus within the landscape with beliefs in Khoisan society regarding water and its metaphoric manifestations, is suggestive of the view that the place and the rock surfaces themselves came to be construed as meaningful. With the engraved surfaces appearing to sink and rise above the water with the seasons and the vicissitudes of climate, it is argued, there is a potent congruity between culturally mediated natural processes and the biaxial understanding of the cosmos as evident in */Xam* ethnography (Lewis-Williams 1996). In that cosmos the waterhole was a powerful portal, or point of breakthrough, between spiritual realms. It was also a place where *!Khwa* was appeased and potency was brought into harmony, *inter alia* at the conclusion of female puberty rites. The site is a particularly palpable instance of what Ingold (1993: 56) refers to as the "temporality of the landscape" – "the world as it is known to those who dwell therein" – where people arguably invested the changing geology and the seasonal rhythms of the river with metaphorical and possibly ritual significance relating to some of the central concerns of their society.

Contemporary variability between engraving sites in the surrounding region may well be a reflection more of different metaphoric understandings of place, of landscape, relative to beliefs such as these, than to the discrete cultural, ethnic or techno-economic contexts that much previous writing on Driekopseiland implied. Equally, variability in engravings through time could reflect change in the expression, or emphases, in those beliefs. At Driekopseiland itself a sense of this kind of process may be discerned. As the physical nature of the site changed, so an initial limited downstream exposure of rock, with engraved animals and older geometric forms, was superseded by a later more extensive exposure of glacial pavement, bulging up – it might have seemed – like a giant watersnake between the river's high banks. This potent rock was to be festooned, in time, with almost exclusively younger geometric images. Could it be that the earlier engravings, with a certain prominence given to eland, reflect a different, perhaps earlier, emphasis linking *!Khwa:-ka xoro* with eland;[5] and possibly eland, as *animal de passage* (Lewis-Williams 1981), with the female initiate?

Increasing complexity in the political organisation of a society may correlate with the intensification of

ritual, and a corresponding decline in shamanistic practices (Prins 1991) – a process that may be found to have relevance in the valley of the Riet River during the last two millennia. But, for the present, there is no reason to doubt a shamanistic context for the engravings at Driekopseiland. If, on the one hand, the engravings do relate to female puberty rites, it is noted by Biesele that rites of passage, at least among the Ju/'hoan, have "close connections ... to the great curing dance" (1993: 81) – and hence to altered states of consciousness. On the other hand, if, as is suggested, there is a connection between the engravings here and the constellation of beliefs surrounding water and watersnakes, there are resonances in the ethnography between snakes and shamans (Lewis-Williams 1981; Lewis-Williams & Dowson 1990; Dowson 1998). Suggestive statements by Hoff's informants in the Northern Cape in the 20th century indicated the watersnake as a 'doctor' (Hoff 1997: 25), echoing Hahn's (1881) earlier record of snake 'sorcerers' in Namibia. The watersnake was itself imbued with trance metaphors (Lewis-Williams & Dowson 1990) such as subterranean travel and movement through rain, wind and even the rainbow (Schmidt 1979); it would leave the water to graze at night – a feature recorded also of the rain bull in /Xam ethnography (Bleek 1933b: 379). In the 1950s Van Vreeden recorded an appeal made to the watersnake for guidance, to "creep under the ground, where our footsteps should go" (1957: 175). Entrance to the spiritual realm was described by a !Kung shaman in analogous terms: he went in "to travel through the earth and then emerge at another place" – "I enter the earth. I go in at a place where people drink water. I travel in a long way, very far" (Biesele 1980: 56, 61). Lewis-Williams and Blundell (1997) argue that interaction with the rock surface was a way of reaching through the veil and entering – by engraving, literally 'into' – the spiritual realm. Whether or not the engravings could "sometimes be a depiction of a synesthetically transformed shaman" (Lewis-Williams & Blundell 1997: 53), it does seem that the markings on these extraordinary rock surfaces very probably became significant in themselves, "visible evidence of contact with the supernatural" (Lewis-Williams & Blundell 1997: 53), and elaborated across the smoothness over time; and so enhanced even more the power of an already potent place (Figure 3.9).

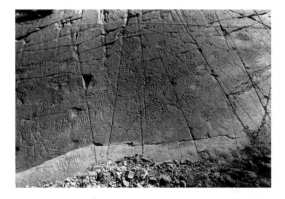

FIGURE 3.9 A convergence of landscape and belief: engravings enhance the power of an already potent place.

Much remains to be done towards achieving a fuller understanding of the rock art of this region in its historical contexts. Better dating controls would allow the testing of some of the ideas put forward in this chapter. The historical processes of the last two millennia undoubtedly influenced the making of rock art here as they did in other parts of the subcontinent. It may be possible to detect changing emphases in the engravings, perhaps even changing roles in the art, as has been intimated about some Western Cape sites (Parkington 1996; Manhire 1998). Engraving site distributions provide some hint of a change in focus, where sites with 'classical' animal representations are most commonly 'high and dry', while those with 'younger phase' geometrics are located not only on higher ground but also in river channels and flood plains (Fock & Fock 1989). That some contemporary variability resulted from different authorships cannot, on present evidence, be totally discounted, but the suggestion here is that other scenarios – where recognition and marking of meaningful places in the landscape had a significant role – may explain much of the diversity.

Notes

1 I use 'Khoisan', the term coined by Schultze and popularised by Schapera (Barnard 1992), for the cluster of socio-cultural groupings historically referred to as 'Bushman' and 'Korana' (among others). The latter terms recur in the debate over authorship of the engravings at Driekopseiland where, generally, 'Bushman' is understood as hunter-gatherer, while 'Korana' is the name of one of the Khoekhoe-speaking herder groups in South Africa. 'San', for 'Bushman', is a pejorative description in the Nama (Khoekhoe) language that gained anthropological acceptance and currency in the 20th century. Where appropriate I use '/Xam' with reference to a hunter-gatherer ('Bushman'/'San') group known historically from parts of the western interior of South Africa.

2 This episode in local history is the subject of an Afrikaans novel by Dolf van Niekerk, *Koms van die Hyreën* (1994), set in the late 20th century, in which engravings become a key factor in a bid to claim back ancestral land.

3 Stow was struck by the 'mystic' symbols from this site, commenting in correspondence with W.H.I. Bleek on their "astonishing" diversity. Anticipating a strand of future speculation, he added that "what is more surprising is the great similarity which some of them bear to the religious symbols used – by some of the most ancient, but more civilized nations" (letter to Bleek, Vaal River, 12 December 1874, cited by Fock 1970).

4 It was due to Miss Wilman's intervention in the 1940s that Driekopseiland was not flooded behind a weir that was to have been built further downstream. Proclamation of the site as a national monument followed soon after.

5 Hahn (1881:81) mentions, among the Nama, the snake called *//Huitsibis*, said "to live on the forehead of the eland-antelope".

References

Anderson, G. 1997. Fingers and finelines: paintings and gender identity in the south-western Cape. In: Wadley, L. (ed.) *Our Gendered Past: Archaeological Studies of Gender in Southern Africa*: 13–69. Johannesburg: Witwatersrand University Press.

Barnard, A. 1992. *Hunters and Herders of Southern Africa: A Comparative Ethnography of the Khoisan Peoples.* Cambridge: Cambridge University Press.

Battiss, W.W. 1948. *The Artists of the Rocks.* Pretoria: Red Fawn Press.

Beaumont, P.B., Smith, A.B. & Vogel, J.C. 1995. Before the Einiqua: the archaeology of the frontier zone. In: Smith, A.B. (ed.) *Einiqualand: Studies of the Orange River Frontier*: 236–264. Cape Town: University of Cape Town Press.

Beaumont, P.B. & Vogel, J.C. 1984. Spatial patterning of the ceramic Later Stone Age in the Northern Cape Province, South Africa. In: Hall, M., Avery, G., Avery, D.M., Wilson, M.L. & Humphreys, A.J.B. (eds) *Frontiers: Southern African Archaeology Today*: 80–95. Oxford: British Archaeological Reports International Series: 207.

Beaumont, P.B. & Vogel, J.C. 1989. Patterns in the age and context of rock art in the Northern Cape. *South African Archaeological Bulletin* 44: 73–81.

Biesele, M. 1980. 'Old K"xau'. In: Halifax, J. (ed.) *Shamanic Voices: A Survey of Visionary Narratives*: 54–62. Harmondsworth: Penguin.

Biesele, M. 1993. *Women Like Meat: The Folklore and Foraging Ideology of the Kalahari Ju/'hoan.* Johannesburg: Witwatersrand University Press.

Bleek, D.F. 1933a. Beliefs and customs of the /Xam Bushmen. Part V. The rain. *Bantu Studies* 7: 297–312.

Bleek, D.F. 1933b. Beliefs and customs of the /Xam Bushmen. Part VI. Rain-making. *Bantu Studies* 7: 375–392.

Bleek, D.F. 1937. Grammatical notes and texts in the Auni language. *Bantu Studies* 11: 253–258.

Bleek, W.H.I. 1875. Bushman researches. Part 2. *Cape Monthly Magazine* 11: 150–155.

Bleek, W.H.I. & Lloyd, L.C. 1911. *Specimens of Bushman Folklore.* London: George Allen.

Brink, J.S., Dreyer, J.J.B. & Loubser, J.H.N. 1992. Rescue excavations at Pramberg, Jacobsdal, south-western Orange Free State. *Southern African Field Archaeology* 1: 54–60.

Butzer, K.W., Fock, G.J., Scott, L. & Stuckenrath, R. 1979. Dating and context of rock engravings in southern Africa. *Science* 203: 1201–1214.

Campbell, C. 1987. Art in crisis: contact period rock art in the south-eastern mountains of southern Africa. Unpublished MSc. thesis. Johannesburg: University of the Witwatersrand.

Cooke, C.K. 1969. *Rock Art of Southern Africa.* Cape Town: Books of Africa.

Deacon, H.J. & Deacon, J. 1999. *Human Beginnings in South Africa: Uncovering the Secrets of the Stone Age.* Cape Town: David Philip.

Deacon, J. 1986. 'My place is the Bitterpits': the home territory of Bleek and Lloyd's /Xam San informants. *African Studies* 45: 135–155.

Deacon, J. 1988. The power of a place in understanding southern San rock engravings. *World Archaeology* 20: 129–140.

Deacon, J. 1997. 'My heart stands in the hill': rock engravings in the Northern Cape. *Kronos: Journal of Cape History* 24: 18–29.

Denbow, J. 1990. Congo to Kalahari: data and hypotheses about the political economy of the western stream of the Early Iron Age. *African Archaeological Review* 8: 139–176.

Dowson, T.A. 1992. *Rock Engravings of Southern Africa.* Johannesburg: Witwatersrand University Press.

Dowson, T.A. 1998. Rain in Bushman belief, politics and history: the rock art of rain-making in the south-eastern mountains, southern Africa. In: Chippindale, C. & Taçon, P.S.C. (eds) *The Archaeology of Rock-Art:* 73–89. Cambridge: Cambridge University Press.

Du Toit, M.E. 1964. Stone kraal villages found at Driekopseiland and De Krans (Riet River). *South African Journal of Science* 60: 360–362.

Du Toit, M.E. 1967. A comparative study of pictographic symbols at Driekopseiland, Riet River, and early Minoan and Aegean symbols. *South African Journal of Science* 63: 7.

Engelbrecht, J.A. 1936. *The Korana: An Account of Their Customs and Their History.* Cape Town: Maskew Miller.

Fock, D.M.L. 1970. Early copies of rock engravings from Griqualand West. *South African Journal of Science* 66: 247–250.

Fock, G.J. 1969. Non-representational rock art in the northern Cape. *Annals of the Cape Provincial Museums (Natural History)* 6: 103–136.

Fock, G.J. 1979. *Felsbilder in Südafrika Teil I: Die Gravierungen auf Klipfontein, Kapprovinz.* Köln: Böhlau Verlag.

Fock, G.J. & Fock, D.M.L. 1984. *Felsbilder in Südafrika Teil II: Kinderdam und Kalahari.* Köln: Böhlau Verlag.

Fock, G.J. & Fock, D.M.L. 1989. *Felsbilder in Südafrika Teil III: Die Felsbilder im Vaal-Oranje-Becken.* Köln: Böhlau Verlag.

Guenther, M. 1994. The relationship of Bushman art to ritual and folklore. In: Dowson, T.A. & Lewis-Williams, J.D. (eds) *Contested Images: Diversity in Southern African Rock Art Research:* 257–274. Johannesburg: Witwatersrand University Press.

Hahn, T. 1881. *Tsuni-//Goam: The Supreme Being of the Khoi-Khoi.* London: Trübner & Co.

Helgren, D.M. 1979. *River of Diamonds: An Alluvial History of the Lower Vaal Basin, South Africa.* Chicago (IL): University of Chicago Department of Geography, Research Paper 185.

Hewitt, R.L. 1986. Structure, meaning and ritual in the narratives of the southern San. *Quellen zur Khoisan-Forschung* 2: 1–305. Hamburg: Helmut Buske Verlag.

Hoernlé, W. 1918 [1985]. Certain rites of transition and the conception of !nau among the Hottentots. In: Carstens, P. (ed.) *The Social Organization of the Nama and Other Essays by Winifred Hoernlé:* 57–74. Johannesburg: Witwatersrand University Press.

Hoff, A. 1993. Die tradisionele wêreldbeskouing van die Khoekhoen. *South African Journal of Ethnology* 16: 1–9.

Hoff, A. 1995. Puberteitsrite van 'n Khoekhoemeisie. *South African Journal of Ethnology* 18: 29–41.

Hoff, A. 1997. The water snake of the Khoekhoen and /Xam. *South African Archaeological Bulletin* 52: 21–37.

Hoff, A. 1998. The water bull of the /Xam. *South African Archaeological Bulletin* 53: 109–124.

Hromnik, C.A. 1981. *Indo-Africa: Towards a New Understanding of the History of Sub-Saharan Africa.* Cape Town: Juta.

Humphreys, A.J.B. 1972. The Type R settlements in the context of the later prehistory and early history of the Riet River valley. Unpublished MA thesis. Cape Town: University of Cape Town.

Humphreys, A.J.B. 1974. Note on a date for a burial from the Riet River. *South African Journal of Science* 70: 271.

Humphreys, A.J.B. 1987. Walter Battiss and a Driekopseiland burial. *The Digging Stick* 4(2): 6.

Humphreys, A.J.B. 1988. A prehistoric frontier in the Northern Cape and western Orange Free State: archaeological evidence of interaction and ideological change. *Kronos: Journal of Cape History* 13: 3–13.

Humphreys, A.J.B. 1997. Riet River revisited: comments on recent findings at Pramberg. *Southern African Field Archaeology* 6: 78–81.

Humphreys, A.J.B. 1998. Populations, prehistory, pens and politics: some reflections from north of the Orange River. *Southern African Field Archaeology* 7: 20–25.

Humphreys, A.J.B. & Thackeray, A.I. 1983. *Ghaap and Gariep: Later Stone Age Studies in the Northern Cape.* Cape Town: South African Archaeological Society, Monograph Series 2.

Ingold, T. 1993. The temporality of the landscape. *World Archaeology* 25: 152–174.

Jacobson, L., Morris, D., Pineda, C.A., Peisach, M. & Pillay, A.E. 1994. PIXE analysis of herder and hunter-gatherer pottery from the southern Kalahari, South Africa. In: Demirci, S., Özer, A.M. & Summers, G.D. (eds) *Archaeometry 94: The proceedings of the 29th International Symposium on Archaeometry:* 233–241. Ankara: Tübitak.

Jacobson, L., Pineda, C.A., Morris, D. & Peisach, M. 1994. PIXE analysis of pottery from the Northern Cape Province of South Africa. *Nuclear Instruments and Methods in Physics Research* B85: 901–903.

Jolly, P. 1998. Modelling change in the contact art of south-eastern San, southern Africa. In Chippindale, C. & Taçon, P.S.C. (eds) *The Archaeology of Rock Art:* 247–267. Cambridge: Cambridge University Press.

Lange, M. 1998. Waterslang stories. Unpublished transcripts of interviews on water-snakes at Upington.

Legassick, M. 1979. The northern frontier to 1820: the emergence of the Griqua people. In: Elphick, R. & Giliomee, H. (eds) *The Shaping of South African Society 1652–1820:* 243–290. Cape Town: Longman.

Lewis-Williams, J.D. 1977. Ezeljagdspoort revisited: new light on an enigmatic rock painting. *South African Archaeological Bulletin* 32: 165–169.

Lewis-Williams, J.D. 1981. *Believing and Seeing: Symbolic Meanings in Southern San Rock Paintings*. London: Academic Press.

Lewis-Williams, J.D. 1988. *Reality and Non-reality in San Rock Art*. Twenty-fifth Raymond Dart Lecture, 6 October 1987. Johannesburg: Witwatersrand University Press for the Institute for the Study of Man in Africa.

Lewis-Williams, J.D. 1996. 'A visit to the Lion's House': the structures, metaphors and socio-political significance of a nineteenth century Bushman myth. In: Deacon, J. & Dowson, T.A. (eds) *Voices from the Past: /Xam Bushmen and the Bleek and Lloyd Collection*. Johannesburg: Witwatersrand University Press.

Lewis-Williams, J.D. & Blundell, G. 1997. New light on finger dots in southern African rock art: synesthesia, transformation and technique. *South African Journal of Science* 93: 51–54.

Lewis-Williams, J.D. & Blundell, G. 1998. *Fragile Heritage: A Rock Art Fieldguide*. Johannesburg: Witwatersrand University Press.

Lewis-Williams, J.D. & Dowson, T.A. 1988. The signs of all times: entoptic phenomena in Upper Palaeolithic art. *Current Anthropology* 29: 201–245.

Lewis-Williams, J.D. & Dowson, T.A. 1989. *Images of Power: Understanding Bushman Rock Art*. Johannesburg: Southern Book Publishers.

Lewis-Williams, J.D. & Dowson, T.A. 1990. Through the veil: San rock paintings and the rock face. *South African Archaeological Bulletin* 45: 5–16.

Maggs, T.M.O'C. 1971. Pastoral settlements on the Riet River. *South African Archaeological Bulletin* 26: 37–63.

Maggs, T.M.O'C. & Whitelaw, G. 1991. A review of recent archaeological research on food-producing communities in southern Africa. *Journal of African History* 32: 3–24.

Manhire, A. 1998. The role of hand prints in the rock art of the south-western Cape. *South African Archaeological Bulletin* 53: 98–108.

Mason, R.J. 1954. A burial site at Driekopseiland. *South African Archaeological Bulletin* 9: 134.

Morris, A. 1992. *The Skeletons of Contact: A Study of Protohistoric Burials from the Lower Orange River Valley, South Africa*. Johannesburg: Witwatersrand University Press.

Morris, D. 1988. Engraved in place and time: a review of variability in the rock art of the Northern Cape and Karoo. *South African Archaeological Bulletin* 43: 109–121.

Morris, D. 1990. Driekopseiland. In: Beaumont, P. & Morris, D. (eds) *Guide to Archaeological Sites in the Northern Cape*. Kimberley: McGregor Museum.

Morris, D. 1996. Wildebeest Kuil rock engraving site. Unpublished South African Museums Association conference excursion brochure, 22 April.

Morris, D. 2000. A horse and seventy sheep for your land! *Now and Then: Newsletter of the Historical Society of Kimberley and the Northern Cape* 7(2): 6–7.

Morris, D. & Beaumont, P.B. 1991. !Nawabdanas: archaeological sites at Renosterkop, Kakamas District, Northern Cape. *South African Archaeological Bulletin* 46: 115–124.

Morris, D. & Mngqolo, S. 1995. Survey of the rock engraving site of Stowlands. Unpublished report to the National Monuments Council.

Orpen, J.M. 1874. A glimpse into the mythology of the Maluti Bushmen. *Cape Monthly Magazine* 9: 1–13.

Ouzman, S. 1995. Spiritual and political uses of a rock engraving site and its imagery by San and Tswana-speakers. *South African Archaeological Bulletin* 50: 55–67.

Ouzman, S. 1998. Toward a mindscape of landscape: rock art as expression of world-understanding. In: Chippindale, C. & Taçon, P.S.C. (eds) *The Archaeology of Rock-Art*: 30–41. Cambridge: Cambridge University Press.

Parkington, J.E. 1980. Time and place: some observations of spatial and temporal patterning in the Later Stone Age sequence in southern Africa. *South African Archaeological Bulletin* 35: 73–83.

Parkington, J.E. 1996. What is an eland? N!ao and the politics of age and sex in the paintings of the Western Cape. In: Skotnes, P. (ed.) *Miscast: Negotiating the Presence of the Bushmen*: 281–289. Cape Town: University of Cape Town Press.

Power, J.H. 1949. The contribution of the Northern Cape to the study of prehistoric man. *South African Journal of Science* 46: 107–116.

Prins, F.E. 1991. The intensification of ritual and the disappearance of trace related rock art: some implications for southern Africa rock art studies. In: Pager, S-A., Swartz, B.K. Jr. & Willcox, A.R. (eds) *Rock Art: The Way Ahead*: 27–49. Johannesburg: SARARA Occasional Publications 1.

Prins, F.E. & Rousseau, L. 1992. Magico-religious interactions, dreams and ritual transformations: towards a better understanding of trance experience among the Khoi. *Southern African Field Archaeology* 1: 33–39.

Schmidt, S. 1979. The rain bull of the South Africa Bushmen. *African Studies* 38: 201–224.

Silberbauer, G.B. 1963. Marriage and the girl's puberty ceremony of the G/wi Bushmen. *Africa* 33: 12–24.

Silberbauer, G.B. 1965. *Bushman Survey Report*. Gaborone: Bechuanaland Government Press.

Silberbauer, G.B. 1981. *Hunter and Habitat in the Central Kalahari Desert*. Cambridge: Cambridge University Press.

Slack, L.M. 1962. *Rock Engravings from Driekopseiland and Other Sites South West of Johannesburg*. London: Centaur Press.

Solomon, A. 1992. Gender, representation and power in San ethnography and rock art. *Journal of Anthropological Archaeology* 11: 291–329.

Solomon, A. 1994. 'Mythic women': a study in variability in San rock art and narrative. In Dowson, T.A. & Lewis-Williams, J.D. (eds) *Contested Images: Diversity in*

Southern African Rock Art Research: 331–371. Johannesburg: Witwatersrand University Press.

Stow, G.W. 1905. *The Native Races of South Africa*. London: Swan, Sonnenschein.

Van Niekerk, D. 1994. *Koms van die Hyreën*. Cape Town: Tafelberg.

Van Riet Lowe, C. 1952. The rock engravings of Driekops Eiland. In: *Congrès Panafricain de Préhistoire: Actes de la IIe Session, Alger, 1952*: 769–776.

Van Vreeden, B.F. 1955. Die waterslang. *Tydskrif vir Volkskunde en Volkstaal* 12: 1–10.

Van Vreeden, B.F. 1957. Die wedersydse beinvloeding van die Blanke-, Bantoe-, en Kleurlingkulture in Noordkaapland. Unpublished Master's thesis. Johannesburg: University of the Witwatersrand.

Vinnicombe, P. 1976. *People of the Eland: Rock Paintings of the Drakensberg Bushmen as a Reflection of Their Life and Thought*. Pietermaritzburg: University of Natal Press.

Waldman, P.L. 1989. Watersnakes and women: a study of ritual and ethnicity in Griquatown. Unpublished Honours thesis. Johannesburg: University of the Witwatersrand.

Walker, N. 1997. In the footsteps of the ancestors: the Matsieng creation site in Botswana. *South African Archaeological Bulletin* 52: 95–104.

Willcox, A.R. 1963. *The Rock Art of South Africa*. London: Nelson.

Willcox, A.R. 1964. The non-representational petroglyphs of South Africa. *South African Journal of Science* 60: 55–58.

Willcox, A.R. 1984. *The Rock Art of Africa*. Johannesburg: Macmillan South Africa.

Wilman, M. 1933. *The Rock Engravings of Griqualand West and Bechuanaland, South Africa*. Cambridge: Deighton Bell.

Wilmsen, E.N. 1986. Of paintings and painters, in terms of Zu/'hoasi interpretations. In: Fossen, R. & Keuthmann, K. (eds) *Contemporary Studies on Khoisan 2*: 347–372. Hamburg: Helmut Buske Verlag.

Wright, J.B. 1971. *Bushman Raiders of the Drakensberg, 1840–70: A Study of Their Conflict with Stock-keeping Peoples in Natal*. Pietermaritzburg: University of Natal Press.

Yates, R., Manhire, A. & Parkington, J. 1994. Rock painting and history on the south-western Cape. In: Dowson, T.A. & Lewis-Williams, J.D. (eds) *Contested Images: Diversity in Southern African Rock Art Research*: 29–60. Johannesburg: Witwatersrand University Press.

Yates, R., Parkington, J. & Manhire, A. 1990. *Pictures from the Past: A History of the Interpretation of Rock Paintings and Engravings of Southern Africa*. Cape Town: Centaur Publications.

Yellen, J. 1984. The integration of herding into prehistoric hunting and gathering economies. In: Hall, M., Avery, G., Avery, D.M., Wilson, M.L. & Humphreys, A.J.B. (eds) *Frontiers: Southern African Archaeology Today*: 53–64. Oxford: British Archaeological Reports International Series 207.

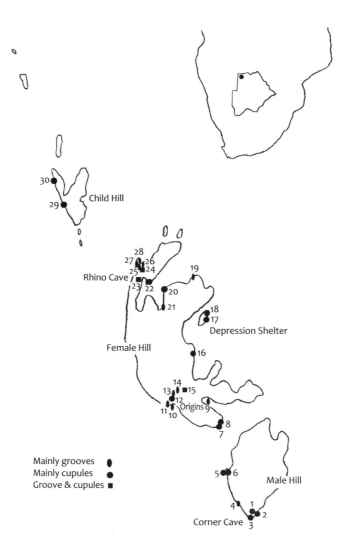

FIGURE 4.1 Map of Tsodilo Hills showing carving sites. See Table 1 for site names.
(Inset: Map of southern Africa showing location of Tsodilo in Botswana.)

4.

Cups and saucers:

A preliminary investigation of the rock carvings of Tsodilo Hills, northern Botswana[1]

NICK WALKER
(Mossel Bay, South Africa)

Throughout Africa in at least 22 countries and even further afield are rocks with clusters of enigmatic pecked or drilled hemispherical hollows and/or rocks with ground-out grooves. It is probable that these carvings are much more common than realised, but they have often been ignored because of their ambiguity, lack of iconicity or because it is often thought that they are natural or mundane manufacturing tools. For example, copies or photographs of petroglyphs of animals and other subject matter in southern Africa often include dimple-like depressions or groove-like dashes or scratches that have seldom been commented on by the researchers (e.g. Wilman 1933; Fock 1979; but see Ouzman 2001). These carvings recall the hollows that may form on hammerstones or anvilstones, on the one hand, and grooves on whetstones for sharpening tools such as arrowpoints and

axe- or adze-heads, on the other; indeed, their simple form probably has contributed to many being classified as 'utilitarian'. However, the wear, shape, lack of associated waste from manufacturing or processing, context and arrangement or placement suggest otherwise for many. It seems that several may have served as religious symbols or been the 'non-utilitarian' by-products of ritual activity, or perhaps included magical concepts in their use. Their frequency and size and the amount of effort put into their production certainly allude to their importance. Their simplicity and lack of iconicity, and the absence of any discernible meaningful patterning or syntax in their creation, suggest that they are not obviously examples of art as we understand it, especially when compared with rock paintings where the use of pigment clearly indicates an element of intentional symbolic design. Yet many

appear to have served similar symbolic functions and so they are collectively regarded here as a form of rock art for convenience.

This chapter looks at these issues in an introductory examination of the carvings at Tsodilo Hills in north-west Botswana, where they are particularly common.

TSODILO HILLS

> They rose sheer out of the flat plain and were from the base up made entirely of stone, and this alone, in a world of deep sand, gave them a sense of mystery
> (Van der Post 1958: 184).

The Tsodilo Hills are now relatively well known archaeologically, thanks in particular to recent work by Alec Campbell, James Denbow, Larry Robbins, Ed Wilmsen and others. The hills comprise four outcrops (inselbergs) of what is largely quartzite or micaceous schist belonging to the Damara Formation, dating back more than 500 million years. They spread over an area of some 30 km^2, although the actual extent of outcrop is about 15 km^2 (Figure 4.1). Respectively the hills are known by the local Zhu Bushmen, and from the south northwards, as Male (tall and steep), Female (the most extensive and well-vegetated, with several valleys and peaks), and Child (relatively small), while the smallest and northernmost is unnamed, although it is increasingly referred to as 'Baby' by the Botswana National Museum staff. (There is also a small outcrop of a few rocks still further north.) Faulting has thrust them up 400 m above the ground at the highest elevation (Male peak) and they dominate the surrounding Kalahari sandveld, being visible from the Okavango River 40 km to the east. In addition to a wide range of wild fruits, the hills offer raw materials for making stone tools, cosmetics and colouring matter, such as quartz, specularite and ochre respectively, while water seeps out of the hills in places, even late in the dry season. Thunderstorms are often spectacular here, with the lightning illuminating the impressive rock formations, and the summits of the higher peaks are often hidden in mist. A place of fierce winds, this remarkable steep and rugged outcrop rising sheer from the gently undu-

lating dunes of the surrounding Kalahari is understandably regarded as a place of immense spiritual significance by the people living in the region.

Scattered among the hills, but especially on the western sides, are numerous overhangs and shelters, and many of these show evidence of occupation or use by prehistoric people (Robbins *et al.* 1996; Robbins & Murphy 1998). Studies have shown that people have been visiting the hills for at least the past 100 000 years (Robbins *et al.* 1996, 2000), although not necessarily continuously. Excavations at two important agropastoralist settlements known as Divuyu and Nqoma have demonstrated that Tsodilo was linked with major regional trade networks from about 550 to 1090 CE (Denbow 1990), possibly with a break between about 730 and 850 CE. Large numbers of fine copper and iron jewellery imports from a variety of sources as far away as northern South Africa or north-central Zambia (Miller 1996) suggest that Tsodilo was a major centre, with specularite (see Robbins *et al.* 1997) an important export. The hills were then apparently abandoned until about the 18th century, except for seasonal visits by Ncae (Khoe-speaking) forager-herders. After this time, Hambukushu farmers and Zhu hunter-gatherers became frequent visitors. The Ncae themselves abandoned the hills in the mid-19th century. A few Hambukushu and Zhu families finally became permanent residents of Tsodilo in the mid-20th century.

Probably also towards the end of this long history, artists were practising a remarkable art tradition and over 400 rock art sites have so far been located here (Campbell, Denbow *et al.* 1994; Walker 1998). It is possible to recognise at least three broad art traditions. The best-known art comprises a series of schematic animal paintings associated with more abstract human and geometric designs in various hues of red ochre. Their age is uncertain, but Campbell, Denbow *et al.* (1994) suggest that they probably date from about 2000 years ago. They are quite likely the work of the Ncae, perhaps at times working for or with Bantu agropastoralists, on the basis of the key animal symbols. The animal figures thus include over 100 cattle in a style comparable to that of the wild animal depictions. Cattle are unlikely to have first reached the hills before 1500 years ago (Denbow 1990), although they were in the nearby Okavango region half a millennium earlier, providing a maximum age estimate for a good number of

the paintings. However, a case could be made for a slightly younger age, on the basis of cattle becoming important in the economy at Nqoma, Tsodilo, about 1100 to 900 years ago (Denbow 1990), when it could also be argued that they acquired ritual status, thereby encouraging their adoption as symbols in the art. A 10th-century date for a probable ochre factory site (Alec Campbell pers. comm. 1990) is in broad agreement with this. In fact, sheep and goats were relatively common at Tsodilo a few centuries earlier, but do not feature in the red paintings. A related group of paintings is called the white painting tradition and these are believed to be more recent and possibly farmer art, on the basis of superpositioning and subject matter (Campbell, Denbow *et al*. 1994).[2]

The third group is the carvings and they form the subject of this chapter. Although at times associated, they are never in palimpsest and show no conceptual continuity with the paintings – there are no geometric, animal or human representational petroglyphs at Tsodilo, nor are there comparable designs to the carvings among the paintings. This is especially curious given the stylistic continuity of the paintings with petroglyphs in Namibia and South Africa (Campbell, Denbow *et al*. 1994).

THE CARVINGS

Engravings were first mentioned by Balsan (1954) and Van der Post (1958), who cryptically talk about animal and human footprints (apparently referring to the Origins site, discussed below), whereas cupules are clearly described by Rudner (1965). The carvings have received scant attention ever since. They comprise two main types, namely relatively deep hemispherical cup-like hollows or cup marks, and grooves of varying length and shape. The two broad categories do occur together (13 cases) but in separate clusters and, with one exception (Rhino Cave), seldom in near-equal numbers, in which case the grooves are usually in much fewer numbers (9 of the 13 sites).

Cup marks

Concave cup marks or circular hollows seem to have been made initially by pecking, but subsequently by drilling or rather circular grinding.

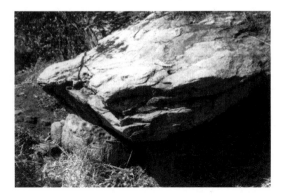

FIGURE 4.2 Cupules at Hidden Valley Shelter.

Type 1

At most sites, circular cup marks are remarkably standardised in form and tend to be 30 mm–50 mm in diameter and 2 mm–6 mm deep (Figures 4.2, 4.3a, 4.3b). They do not overlap. Similar hemispherical designs are found around the world and are usually called cupules. At Tsodilo they are usually at or near hill bases (Figure 4.1), especially below cliffs or peaks (e.g. the south-west side of Male and around the main peak in Female), and they are concentrated at the entrances to deep shelters or clefts in the rock. Some sites have over 100 cupules each and the aptly named Depression Shelter (Robbins 1990) has more than 1000 (Table 4.1), and it is likely that many have weathered away. It seems that the cupules are not always randomly arranged as it is often possible to recognise clusters, rows, arcs or bands of them, but it is not possible to make sense of these patterns. Some occur on horizontal or slightly sloping surfaces, but others are found on vertical or steep faces and so clearly are not grinding hollows for processing food or other material – such hollows are in any case much wider (over 200 mm), shallower and often oval. Experiments suggest that it took several days to make the deeper ones.

Two cupule sites, however, are deep in Female hill and probably represent a different subcategory. They

are associated with an Iron Age settlement. The one is next to a pool at an unusual groove site (see below under Origins site) and larger cups, and is more appropriately discussed with it. The other is also associated with grooves and a rock gong.

Type 2

One site deep in the hills has a few large and deep circular shafts (over 100 mm wide and deep), often more square than round, and so they represent a different category. Some are very weathered, implying a great antiquity. They occur in two clusters of three and are on horizontal surfaces. They are associated with an unusual groove site at the Origins site (Figure 4.4; and see Table 4.1 for the names of the sites) and are discussed in more detail below.

Type 3

At Rhino Cave,[3] a hidden site deep in the hills, the cupules are very variable in size and seemingly intergrade with the grooves (Figure 4.5). They are on a vertical face. The context is very different and so the site is further described below.

Grooves

Grooves were made by horizontal grinding, also with a hard, sharp or round-ended object but, unlike the cup marks, most have a high polish, suggesting intense friction or perhaps additional rubbing with an organic substance. Their deepness suggests that they may have been made over many days, perhaps years, and not in a single event. No clear evidence of any pigment or other matter is visible in them, although they have not yet been examined microscopically. The grooves are more variable in form than the cupules, with a possible five variants. They are mainly in the open or under overhangs on flat, horizontal, isolated, table-like boulders or pavements.

Type 1

Rhino Cave is a dark and hidden tunnel cave (see Robbins et al. 1996) with east and west entrances, deep in Female hill. The carvings are on a vertical panel, facing a panel with a few paintings. The carved grooves are all vertical or near-vertical and show appreciable variation in shape, generally oval but often rectangular or pear-shaped, with relatively flat bases (Figure 4.5, 4.10). These carvings also overlap and truncate each other, in contrast to the more carefully positioned cupules and ellipsoids noted elsewhere and, as noted above, there is no clear separation of grooves from cupules. These carvings are therefore here collectively termed ovoids. Intriguingly, the massive slab on which they are carved has the appearance of a giant snake. In the afternoon during winter, a thin shaft of sunshine lights up the carvings, adding to their mysterious setting and significance. To add to the esoteric nature of the site, there is a hidden recess behind the carvings with the rocks showing signs of polishing.

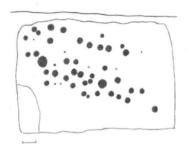

FIGURE 4.3A Redrawing of cupules, Chokxam. Scale 10 cm.

FIGURE 4.3B Profiles of two cupules, Chokxam. To scale.

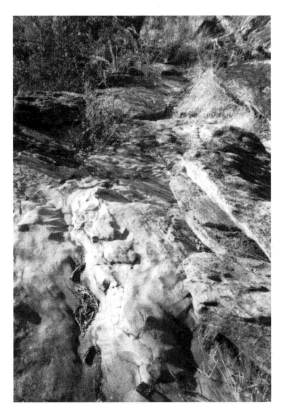

FIGURE 4.4 Origins: The Upper 'Trail', looking north. Note the highly polished, multiple ripple-like grooves.

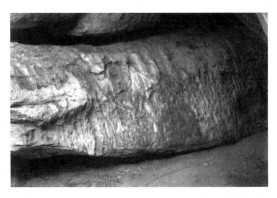

FIGURE 4.5 Rhino Cave ovoids. Note the phallic or snake-like appearance of the panel and the gap below the raised 'head' leading to the hidden 'alcove' (*bottom left*).

Type 2

One site, the Origins site, actually has a 'trail' of relatively long parallel and adjacent grooves or furrows in clusters of up to eight, but often interconnecting and overlapping, making counting difficult (Figure 4.4, 4.11). This trail extends over about 90 m (albeit with large gaps, especially in the lower portion as if parts had been deliberately removed or destroyed), making it one of the largest known examples of rock art in Africa, if indeed it is not a by-product of ritual. It slopes due north before swinging around and sloping south, ending up near an artificially dug pool. This used to be the most reliable natural water supply in Tsodilo (it is now often dry in early summer), and one regarded as sacred. The trail is believed by the nearby Hambukushu to be where God lowered their cattle to earth during creation time (Alec Campbell pers. comm. 1997; a Zhu tradition invokes the eland). This was when the rocks were still soft and so the grooves mark where the cattle (or eland) slid their way down the hill, according to tradition, before the rocks hardened. Certainly where two grooves join they often look very much like cattle/eland tracks in slippery mud. Other visitors have speculated that they are dinosaur tracks (three or four adjacent grooves do look like large lizard footprints, but of course the rock is far too old). They are most likely to have been artificially created, although a combination of natural weathering and polishing from countless feet, paws and hooves has left its imprint on the modern appearance. This is a unique type of site at Tsodilo. As noted, the large cylindrical shafts found beyond both ends of the trail are probably parts of the complex site design and may have been holes to support some structure or poles. Some, too, look like cattle or eland hoof prints. Two of the large deep hollows next to the pool below the trail are said by the Hambukushu to be where God knelt when he created the world (Van der Post 1958). Smaller cupules are present in a rock shelter immediately next to the pool (Figure 4.4) and are almost certainly linked to the site, in contrast to most other cupules. The upper part of the Origins site shares features with rock slides elsewhere and so this site may be linked with initiation (Walker in prep.).

Type 3

A further site, Upper Male Cave, high up on the east side of Male, has two cupules at the mouth and a set of three small parallel oblong grooves (about 80 mm long

Table 4.1 Sites with rock carvings at Tsodilo

Site no.	Site name	Site type	Aspect of site (degrees)	Height above ground (m)	Grooves	Cup-marks	Panel	Associations*
1	Male Cave	large cave	130	60	3		vertical	paintings
						2	slope	
2	Dead Goat	small shelter	140	1		6	slight slope	
3	Corner Cave	large shelter	165	0	4	262	vertical & sloping	LSA, MSA, spheroid
4	Watercleft	overhang	220	1		28	vertical	waterhole
					9		horizontal	
5	Ancestors	cave	deep	8		78	2, horizontal	LSA, sherds, spheroid, traditions
6	Kudu Horn	overhang	180	0		152	steep slope	LSA, sherds, spheroids
7	Female Cave	cave	195	0	3	193	sloping	traditions
8	Female East	small shelter	180	0		32		2 paintings
9	Well	open		0	3	1	horizontal	stream, valley entrance
10	Baobab	open		0	7		horizontal	stream, base of pass
11	Gobiku	shelter	180	10	7		sloping	waterhole
12	Hidden Valley	shelter, open	240	0 •	2	151	vertical, horizontal	stream, traditions
13	Origins	open		2 to 13 •	103	3	slope	traditions
14	Nqoma	open		0 •	25		horizontal	on 3 boulders, in village site
15	Nqoma East	small shelter	85	0 •	17	28	sloping	east side of village, rock gong
16	Depression	overhang	80	0	21	1039	vertical	LSA, paintings
17	Eastern			0		few		
18	Cleft	cleft		0		20		paintings
19	Northeast	large shelter	270	0	4		horizontal	geometrics, valley entrance
20	Chokxam	cave	deep	0		42	vertical	paintings nearby
21	Hands	shelter	350	0	3			paintings
22	White Cow	shelter	185	0		3		paintings
23	Rhino	cave	deep	30	126	86	vertical	LSA, MSA, paintings
24	Near Sex	overhang	200	0	1	2	horizontal	paintings, traditions
25	Ochre	open		0	30		horizontal	ochre factory nearby
26	Crab	small shelter		0	13		horizontal	paintings, near pass
27	Kudu Circles	small shelter		2	11		horizontal	
28	North	open		0	9		horizontal	near rivulet
29	Child	cave	300	5	2	32		paintings
30	Child 1	open	45	0	2	33		sherds, paintings

* LSA and MSA refer to Later and Middle Stone Age material respectively; traditions refer to myths and beliefs concerning site or nearby features.

• Note that sites 12 to 14 refer to height above a valley that is itself some 80 m above the hill base, while site 15 is on the plateau about 100 m above the surrounding plains.

by 10 mm wide and a few millimetres deep) at the back of the cave. It is not possible to suggest their purpose.

In the remaining sites, the grooves are more standardised in form. They often occur in rows, arcs or circles and thus, as with the cupules, sometimes seem to be arranged in patterns; again, there is no superpositioning among them.

Type 4

The most common can be called ellipsoids. They are usually about 100 mm–150 mm long, and about 50 mm–70 mm at the widest and 5 mm–20 mm deep, but some are 30 mm deep (Figures 4.6, 4.8). They are on near-horizontal surfaces and are semi-circular in cross-section and basin-like or canoe shaped in longitudinal section. They are unlikely to be sharpening grooves, which have a more V-shaped cross-section and indeed are usually made on more brittle stone. Again it could be expected that protruding surfaces or edges would be favoured for sharpening, which is not the case. Ellipsoids occur mainly near Nqoma village at Slag and a probable ochre factory site on the western side of Female hill (it seems that the local iron-rich rock was piled up here with firewood and set alight, which facilitated crushing (Alec Campbell pers. comm. 1997). One adjacent to a natural waterhole on Male is ochre-stained, although this might be from the rubbing of the bodies of people collecting water. At Nqoma, a test excavation by the author showed that the adjacent soil is rich in fine specularite dust and it is thought that the grooves were used in grinding the ore down into a powder here. Significantly, about 95 per cent of ellipsoids lie in a broad north-south orientation (between 312° and 62°; Figure 4.7). This hints at some ritual observances during the grinding up of pigment or specularite and it is hoped to test for this in due course.

Type 5

A variant, here referred to as lenticulates, occurs on smaller boulders Crab, Baobab and Well. These are relatively wide at the mid-point (suggesting an intermediate form with cupules), but typical ellipsoids are occasionally present. These show no strict orientation (although 53% do have broad ENE or ESE aspects; Figure 4.7), but they tend to be placed radially (Figures 4.9a, 4.9b). They are more suited to sharpening blades than the ellipsoids. A test excavation at one found carbonised fruit remains and pieces of probable haematite.

FIGURE 4.6 Ellipsoids, Nqoma. One of two boulders. Scale 10 cm.

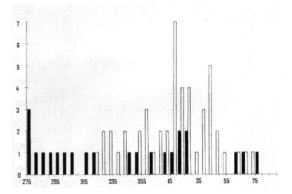

FIGURE 4.7 Orientation of grooves. Site legend: White columns = Crab, Baobab and Well. Black columns = Slag and Nqoma. Measurements were taken by compass and so are magnetic readings. True north is 12° 30′ east of magnetic north.

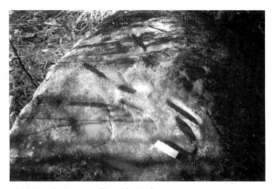

FIGURE 4.8 Nqoma, ellipsoids. Scale 10cm.

At least three sites are near natural or artificial wells or small streams flowing out of the hills (in addition to the one ellipsoid site already mentioned on Male); they may thus be linked to activities requiring, or beliefs about, water. On the other hand, three of these (and a couple of sites with a few true ellipsoids) are also at passes through or valley entrances into Female. They might well then be appropriate ritual frontiers beyond which only the sanctified can progress. It is thus difficult to approach the Origins site without going past at least one set of ellipsoids or lenticulates.

Type 6

A final variant is a series of near-vertical and relatively deep and narrow channels, often over 50 cm in length, found only at Rhino Cave, associated with ovoids (Figure 4.10), and here called stringers. They are not particularly straight.

LOCAL BELIEFS

None of the local communities can offer a satisfactory explanation as to who made the cups or grooves, or their purpose. Xuntae Xhao (pers. comm. 1994) of the nearby Zhu village suggested that they were "made so that future generations could see what the older people had done", as some sort of land title deed. Interestingly, the Zhu call the ellipsoids pestles and the cupules mortars. The Zhu also noted that they used to mark trees to identify ownership of property – i.e. fruit, honey (Xuntae Xhao pers. comm.). Marshall (1965) notes how Zhu girls mark *mongongo* (*Schinziophyton rautanenii*) trees with their apron and scarification designs, but unfortunately does not discuss this, but there may well be some fertility link, seeing that the *mongongo* fruit is a staple food (see below). It is also worth noting that some of these carvings occur near similar but natural hollows in the rock, some of the latter having even been rubbed, and perhaps their inspiration owes something to copying the 'works' of the 'early people', God, spirits, etc. Dindo, a Ncae elder whose ancestors formerly lived at Tsodilo (pers. comm. 2002), described them variously as fingerprints left by the ancestors when the rocks were still soft, places where meat was pounded, or game stones.

That these carvings were of great significance can be gauged by the large amount of effort that went into their making. The variation in depth and frequency suggests that some locations were more significant than others or that the efforts were better rewarded there. We can also note their uneven distribution among the

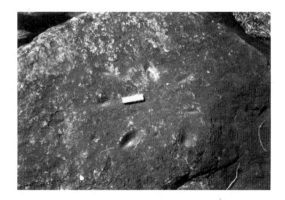

FIGURE 4.9A Baobab site, lenticulates. Scale 10 cm.

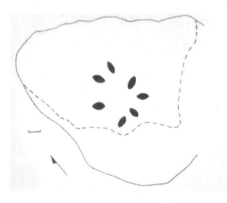

FIGURE 4.9B Redrawing of lenticulates, Baobab site. Scale 10 cm.

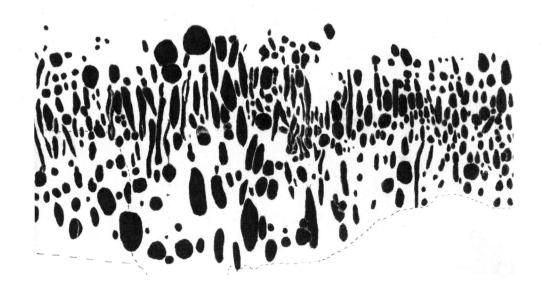

FIGURE 4.10 A redrawing of the central part of the Rhino Cave panel of carvings. The hatch lines define the weathered edge.

hills. Most cupules are at hill bases (south-west Male, south and north-east Female, west Child) and this gives them a linear arrangement, as if they may have defined some trail (the two exceptions within the hills are next to Nqoma village and are probably linked to farmer rituals, as noted above). Cliff bases were particularly favoured. Conversely, the various grooves, with the one exception on Male, cluster in two areas of less than 1.5 km across on Female. Usually the grooves are quite accessible, in strong contrast to Rhino Cave, where they are in a seemingly secretive location and thus different.

ANTIQUITY

The age of the carvings is largely uncertain, although current research is trying to resolve this, but in at least two instances, slabs have fallen away or boulders have moved, making it impossible to reach some of the carvings and suggesting a great antiquity for them. Some

cupules are relatively fresh-looking, but most are as patinated as the rest of the rock surface, implying a relatively long tradition surviving up until recently. Conversely, the Origins grooves are relatively fresh-looking.

Robbins (1990) recovered a fragment of rock with two small dimple hollows pecked on it in an archaeological context dating back almost 2000 years when he excavated Depression Shelter. These hollows are small, perhaps incipient, but this particular slab might have been a nutting anvil – *mongongo* nuts are plentiful in the area and formed an important part of the diet at this time (Robbins 1990). This shelter seems to have been regularly visited during the Later and Middle Stone Age since late upper Pleistocene times, but the main uses of the site date to some time prior to about 20 000 BP, and again to about 2000 years ago. Quartz hammerstones that could have been used in cupule manufacture were noted down to a 10 900-year-old level (Robbins unpub. field notes). Careful checking of the rock below the soil surface found no deeper carvings

(Alec Campbell pers. comm. 1999) and, as the deposit goes down some 5 m below the present floor, this implies no more than a Holocene age, unless scaffolding was used. On the other hand, no excavation was done below the cupules themselves, and they cannot be directly associated with the manufacturing debris.

Similar hammerstones were found in abundance in an undated excavated deposit at a further cupule site, Kudu Horn Shelter, on Male hill (Alec Campbell pers. comm.). These quartz spheres and another broken

example found near Corner Shelter fitted some of the nearby cupules exactly (*Ibid*).

Excavations at another cupule shelter, here called Ancestors Cave, also suggested a Holocene age (Campbell, Robbins *et al.* 1994), although the site was not excavated to bedrock. Of interest is the fact that the assemblage was dominated by quartz debris, and it is likely that this was used to make the cupules (or that the quartz was shaped in the cupules). More recent work by the author at another shelter, Corner

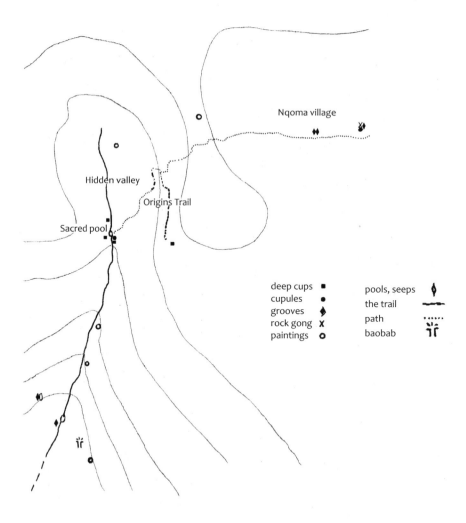

FIGURE 4.11 Map of Origins and nearby sites

Cave, suggests that some of the cupules date from the Middle Stone Age (Walker in press). Similar cupules elsewhere are believed to be the oldest creative designs in the world, for example in India and Australia (Bahn 1997; Ouzman *et al.* 1997; Taçon *et al.* 1997).

The Chifubwa Stream site in Zambia (Clark 1958) provides some clues as to the possible age of some carvings elsewhere. Here a series of inverted U and line motifs together with a few cupules are associated with an early Nachikufan (i.e. terminal Pleistocene) assemblage covered by sand. The grooves are not unlike the so-called 'vulva' signs in Palaeolithic European art (cf Bahn 1997). A date of about 6300 BP from just above the Late Stone Age industry is not too helpful as it came from a scattered charcoal sample and may have been of natural origin, blown or washed in with the sand. It comes from below the lowest shelter wall engravings, but it seemingly also post-dates four ellipsoids on a boulder covered by the deposit. Although not satisfactory, our understanding of the age of the early Nachikufan does suggest a hunter-gatherer context and antiquity of more than 12 000 years for these particular carvings.

Further evidence on the possible age of some carvings comes from Rhino Cave where the excavators uncovered the top part of a deposit probably over 3 m deep (Robbins *et al.* 1996, 2000). Here a concentration of nine round quartz hammerstones or spheroids at a depth of 110 cm–130 cm in a Middle Stone Age assemblage may be indirect evidence for the age of these carvings (ovoids). The hammerstones come from below a date of about 5300 BP, a date which seems to be associated with a sparse Later Stone Age use of the site. The authors cautiously ascribe the underlying layer, between about 70 cm–110 cm, to the Later Stone Age, despite the presence of triangular points and other tools that are not microlithic and that typologically appear to be Middle Stone Age. More recent excavations below the carving by the author (Walker in press)[4] have, in fact, unearthed fragments of rock with grooves derived from the carved panel, plus the grindstones used in some of their manufacture, in the Middle Stone Age levels. These levels incidentally show evidence of intense fires.

No carvings have been found in the schist mines reported by Robbins *et al.* (1997), which were seemingly abandoned some 1000 years ago. This suggests that the carvings are unlikely to be younger as it might be argued that they could then have also been carved there, although this does not preclude them from having been made by the same people.

Ellipsoids occur near both the Divuyu and Nqoma Iron Age villages and again near a 10th-century CE ochre factory location on the western side of Female (Alec Campbell pers. comm.), but these correlations may be fortuitous as ellipsoids are also sometimes near rock paintings or Later Stone Age material. No Later Stone Age material was noted with the Nqoma grooves, however. No likely grinding stones that could have been used in their making have been located near the grooves, unlike with the cupules, but this may reflect the limited excavation at such sites.

Other grooves elsewhere also occur near Stone Age scatters. On the other hand, some grooves in Zambia and southern Sudan may be early farmer (Iron Age and Neolithic) sites as they or fragments of portable slabs with similar grooves apparently occur at or near village sites (Mills & Filmer 1972; Phillipson 1972, 1981) and so the correlations are equivocal.

Sets of ellipsoids comparable to the Tsodilo ones have been found near seasonal pans, often in areas unreached by prehistoric farmers, including 115 at Van Zyl's cutting (a natural but cleaned-out waterhole in solid rock) 300 km south of Tsodilo; at a site overlooking the fossil Okwa River, about 400 km south of Tsodilo (Aldiss 1987; Campbell 1989), and at another site 150 km to the west of it (Mike Main pers. comm. 1998); at Kang Pan 200 km further south (Alec Campbell pers. comm. 1997); at Lake Dau (Jerry Collins-Hooper pers. comm. 1995); at Madu waterhole south-west of Serowe (associated with spoor petroglyphs and the Later Stone Age); and again at Matsieng near Gaborone (Walker 1997). Several more sets of long thin grooves on near-vertical surfaces in rock shelters occur far to the east near the Thune and Limpopo rivers in eastern Botswana, where there is also at least one set of cupules, some fairly fresh but most well weathered. In these instances farmer sites are often found nearby. Intriguingly, some of the paintings in this area are comparable stylistically to the schematic Tsodilo pictures (Walker in prep.). There are at least a further 30 sites along the Limpopo immediately to the east in southern Zimbabwe and the Limpopo province of South Africa (Eastwood & Blundell 1999; Sven Ouzman pers. comm. 2001) with cupules, grooves and ellipsoids, and so there is a broad 'belt' of these

carvings at a similar latitude just north of the Tropic of Capricorn in southern Africa.

Other authors have described further occurrences of cupules and grooves throughout the continent – e.g. Wayland 1938; Fosbrooke & Marealle 1952; Dixey 1953; Fosbrooke 1954; Lanning 1956; Viereck & Rudner 1957; Clark 1958, 1959; Robinson 1958; Fagg 1959; Beater 1960; Schoonraad 1960; Chaplin 1961, 1962, 1964; Cooke 1961, 1964; Juta 1961; Singer 1961; Sydow 1961; Guy 1965; Phillipson 1966, 1972, 1981; Davies 1967; Rudner & Rudner 1968; Scherz 1970, 1975; Mills & Filmer 1972; Hillman & Hillman 1984; Derricourt 1986; Soleilhavoup 1990; Odak 1991; Boonzaier et al. 1996 – although north of the Zambezi the grooves are often long meandering lines, inverted U-shapes or rings. They are particularly common in northern Zambia.

MEANING

There are numerous hemispherical cups about 150 mm–200 mm in diameter in hard rock in gold-bearing areas on the Zimbabwean plateau that were used in crushing auriferous ore (e.g. Swan 1994; Van Waarden 1999). These 'dolly holes' are extremely smooth and always on flat surfaces, often near water. The Tsodilo cupules are much smaller and often on steep faces, and so are unlikely to have been used for crushing anything. Nor is there any correlation between their placement and the Tsodilo mines, which are specularite mines. The Tsodilo cupules are also much rougher. They still need to be tested for trace elements. Again, the carvings can be distinguished easily from riffle plates or metal bead and ingot mould stones.

Fosbrooke's (1954) related practical suggestion that iron was broken into small pieces in cupules for trading seems unlikely as it is wasteful, let alone difficult, and there is no ethnographic support for such a practice, although the correlation may be significant. Of course, this might be because the site provided an easy reference place for where to meet and not because of a direct relationship with trade. Nor can we rule out coincidence. Certainly there is no clear correlation with trade at carving sites, including Tsodilo. On the other hand, crushing ochre should have been common at Tsodilo, judging by the num-

ber of paintings, but no ochre grindstones have yet been recognised, although the lenticular and ellipsoid grooves look like good candidates for this activity.

We can also note game-board carvings (*isafuba*, *tsoro* or *macale*) throughout the continent, which consist usually of parallel (mainly four) rows of (usually eight) hollows for gaming dice (e.g. Townsend 1979), but clearly these are different, not having the regular arrangement or often being on vertical faces. On the other hand, some *isafuba* designs in Botswana and Zimbabwe are too small to have been used as games, or they are on vertical rocks, indicating that they too often had symbolic value.

Malan (1955) and Maggs (1995) have suggested that some circle and dot engravings in South Africa may well be plans or maps of Iron Age homesteads and fields (cf. Summers [1959] for similar designs in Zimbabwe). Although a few are convincing as plans others are less so, and any purpose is not plausibly demonstrated; indeed, many associated designs are not easily accommodated in this interpretation. Some of the concentric circle designs are not obviously homestead plans and other meanings are possible, but these careful designs are not cupules or ellipsoids. These complex 'petroglyph' designs in any case are shallow relative to the carvings.

A related suggestion is that cupules perhaps were astronomical maps (Wayland 1938; Odak 1991), but no support evidence (such as recognisable constellations) is presented and it seems unlikely that those in deep caves could possibly have had any such purpose. This does not preclude a link with the celestial bodies and seasons, considering the sunlight filtering through the rocks that seasonally lights up the otherwise dark Rhino and Ancestors caves (see also below). The north–south orientation of the ellipsoids also implies some sort of concern with the solar system, seasons (e.g. noon, sunset, moonrise, etc.) or beliefs, etc. (considering that humans often place the dead facing their place of origin).

At a couple of farmer sites in eastern Botswana, there are a few very deep cylindrical shafts about 150 mm–200 mm wide in sandstone (over 500 mm deep in one instance). Some of these are thought to have supported poles, and at Thataganyane near Serowe, where there is a cluster of rock slides not unlike those at Origins, they are about 300 mm deep and in rows, like the foundation holes of a palisade.

This seems the most plausible explanation for the large cup marks at Tsodilo – namely that they were holes for posts or structures, probably used as signals or in the rites carried out there. Other hollows at Thataganyane and other rock slides (e.g. Fagg 1956; Robinson 1958) are more cup-like and comparable to the standardised Tsodilo cup marks (Walker in prep.). A group of shallow hollows occurs in calcrete at the Kalkfontein Pan west of Ghanzi, but these are wider than the Tsodilo cupules. They are about 150 mm wide and are linked by wide channels. Local folklore describes them as elephant footprints but they are also probably ritualistic and the proximity of the associated waterhole is likely to be significant (Walker in prep.).

Also scattered throughout the continent, for example in Zimbabwe, are granite boulders that resonate when struck with stones (Robinson 1958; Cooke 1964). These rock gongs often have similar or slightly more irregular hollows than the Tsodilo shafts and grooves. Some may be natural, certainly many are well weathered, but most seem to be the product of repeated striking. It is clear that horizontal parts had also been struck in the past. Granite often produces a metallic ring when hit, but the key requirement is for the rock to be loose so that it can vibrate (Kurt Huwiler pers. comm. 1973; Kirby 1972). Some of the Zimbabwe examples and one at Parwe near Mahalapye in central Botswana do not resonate, but it is possible in these instances that the rocks have shifted and are no longer free to vibrate. It is believed that these gongs were used in rituals, such as sacrifice or praying for success before undertaking a journey (Robinson 1958: 159, 162), and a few are associated with places where there is evidence of initiation, rainmaking or gatherings, as at the Precipice Ruin at Khami (Robinson 1959; John Thokozane pers. comm. 1972; see also Lanning 1958). The Tsodilo examples are usually in solid rock and none vibrate, although the cupules on the east side of Nqoma village are associated with a gong and grooves, and this probably formed part of an Iron Age ceremonial site.

A tradition recorded by Campbell, Robbins et al. (1994) at Tsodilo may provide some light on some carvings. The Hambukushu go to a shrine in a cave (called Ancestors) on Male hill when the men wish to pray to their ancestors for help in hunting or to give offerings as thanks for success in the hunt. They then beat the rock to summon the ancestors. This cave has a natural monolith in the centre and an altar-like bench behind it; at certain times of the year when the sun is at a particular angle, the cave lights up eerily. This particular site does have cupules at the entrance, although the Hambukushu stated that they beat a different spot. It is possible that a similar explanation of praying to the spirits lies behind many of the cupules.

We must also here note the occurrence of cupules elsewhere placed on or next to or incorporated into petroglyph designs throughout the continent (e.g. Soleilhavoup 1990). This correlation clearly reflected coded values being added to or gained from the existing motifs.

There are equally few traditions pertaining to the ellipsoids and lenticulates. The various explanations by local people, such as the work of God or the footprints of the ancestors or animals, all suggest a great antiquity (although we cannot exclude metaphoric ambiguity) and, in the case of Tsodilo, that the designs were there prior to the arrival of the ancestors of the present residents within the last two centuries. They recall the grinding hollows created by sharpening stone or metal tools but, as Derricourt (1986) notes, following Chaplin (1961), the cross-sections and longitudinal sections are too round. Derricourt makes a case for ellipsoids in Zambia having been used to crush stone for temper in pottery, but the Tsodilo examples appear to be too narrow and typologically distinct for such a function to be likely (in fact, the temper in the local pottery was usually of charcoal). Rock is easier to crush by vertical hammering although a paste might be mixed in grooves. These points also preclude Chaplin's suggestion that ellipsoids were used in grinding food, they being much narrower than the well-attested and ubiquitous cereal quern stones found on Iron Age settlements (e.g. Sassoon 1962). Derricourt's ideas were influenced by his observation that many of the Zambian grooves are striated. Such ridges, it could be presumed, are unlikely to form with a smooth upper grindstone and soft cereal, but this could indicate fairly rough stones being used. If they had been used to crush ochre, as suggested by Boonzaier et al. (1996: 21), one might expect traces of the pigment in cracks in the rock carvings – any traces are sure to have survived as some carvings are in protected locations, but there is no obvious pigment in them. Still, context does suggest that they were used for grinding

specularite and ochre. On the other hand, the vertical placement of the Rhino Cave grooves would make such a use impractical in that instance.

Fosbrooke and Marealle (1952) describe some rocks near Kilimanjaro with designs of meandering grooves and occasional cupules that were used during boys' initiation rites. These pecked lines are quite thin and superficial, apparently less than 10 mm deep and 10 mm wide, judging from the photographs. According to Marealle, the youths spit into a hole specially drilled at each ceremony as they swear to keep secret the knowledge learnt, while the instructor adds a line, the length of which is claimed to relate to the number of initiates. The meandering lines, however, are unlikely to be simple tallies as they interlink in a complex manner and perhaps other meaning was imputed to the design, now forgotten or not disclosed. Similar meandering lines occur in South Africa and Namibia (e.g. Scherz 1975) and ritual offers a plausible if less decipherable explanation for these designs.

In several north African countries the grooves are linked with fertility, including some on phallic stelae in Ethiopia, while in eastern Chad they are even called 'the beautiful ladies' (Alec Campbell pers. comm. 2002). In Ethiopia and at Karnac, Egypt, women rub a finger down the grooves to collect a little stone dust which they lick, as this is believed to aid conception (Alec Campbell pers. comm. 2002). Of course, modern people can reinvent ancient rituals and exploit a perceived potency from seemingly supernatural phenomena, but we cannot preclude the long survival of particular powerful beliefs, especially where sites (and related traditions) are so widespread.

Grooves in particular and cupules often are near springs, wells or streams at Tsodilo and this seems to be a recurrent feature with many sites elsewhere (e.g. Wayland 1938; Lanning 1956; Guy 1965; Hillman & Hillman 1984; Aldiss 1987). Derricourt (1986) may be wrong in attributing this association to the essential requirement of water in the production of temper in his particular interpretation, and a symbolic correlation with water (e.g. rainmaking) is probably more plausible. Alternatively, it is impossible to approach the Origins (and Nqoma) site without passing such locations and they might be prayer or offering points. We have already noted the cupule 'trails' and it is possible thus to move from the east end of Male to near Rhino Cave by following an easy route

that bypasses the peaks but goes past most of the cupules (sites 2 to 9, 16 to 18, 20, 22 in Figure 4.1) and past very few grooves, as if on a pilgrimage. The hill base can itself be regarded as a boundary and thus an appropriate place to contact the spirits of the hills when approaching from the plains.

Grooves and cupules are possibly related conceptually by opposition. Grooves are formed by horizontal rubbing while cupules are made mainly by vertical drilling. Ellipsoids occur more often in the open while cupules tend to occur at the entrance to caves. Taçon et al. (1997) also noted several recurring or favoured locations for cupules in the sites that they studied in northern Australia. This suggests some relationship between the two categories. We can also recall the Zhu's naming of cupules and ellipsoids as mortars and pestles, and their female and male allegories, respectively. Caves are often regarded as entrances to the spirit world (e.g. Huffman 1981) and, furthermore, are often identified as supernatural wombs; they thus lend themselves to sexual, female and fertility metaphors.

One interesting clue then may be the naming of the hills. Virtually all the grooves occur on Female while Male and Child mainly have cupules (suggesting that the latter is a male child). The fact that several ellipsoids occur near the place where the Zhu believe that God demonstrated how to perform sex by carving out three vulvae (they are natural rock formations; Campbell, Robbins et al. 1994) is also suggestive. Grooves and cupules may thus have had sexual connotations (cf. Huffman [1996], who notes that groove designs may have had female symbolism in Zimbabwe buildings).

CONCLUSIONS

It seems clear that certain carvings were powerful symbols for diverse peoples over long periods throughout the continent. Different forms and locations suggest changes or several meanings. There is, however, a suggestion that some are extremely old, although we cannot preclude many ages and indeed purposes for them. The Tsodilo examples remain enigmatic and we clearly need to date them if we hope to understand them, as some could equally have been made by forager or farmer, perhaps even in a collaborative venture.

For the present, the variably shaped ovoids and stringers at the unique Rhino Cave may well be over

60 000 years old. The smaller standardised cupules, generally around the hill bases, probably had a long history dating over 40 000 years in some cases, some perhaps over 10 000 years, but others possibly only a few thousand years or less. Some of the ellipsoids are perhaps contemporary with them, but others later and linked in with ochre production and specularite mining, and the large cupules and meandering grooves at Origins possibly the by-products of a 1000-year-old initiation site. The associated standardised cupules, along with those adjacent the rock gong on the eastern outskirts of Nqoma village, are probably of a similar antiquity. Early carvings might have been appropriated and reinterpreted by later peoples, as for example the cupules at the Ancestors site and the carvings at Rhino Cave.

Origins' proximity to Nqoma (and Divuyu) deserves some comment, for it is strange that such isolated farmer settlements were so wealthy. Tsodilo is not particularly suited to ranching (the poisonous *mogau* [*Dichapetalum cymosum*] plant is common here) or agriculture and there are better-watered parts in the region. Indeed, it is surprising to find an Early Iron Age settlement so deep in the hills and so far from the nearest arable fields. Some of Nqoma's wealth could have been built up through exchanging specularite, but the lack of cattle kraals is curious, although this could mean that they were kept some distance from the hills (Denbow 1990). An alternative hypothesis is that these sites owe their wealth to ritual. It is thus hypothesised that Nqoma and Divuyu were located deliberately within the hills for ritual purposes. Hills were normally avoided because of their proximity to potentially dangerous spirits, before the Leopard's Kopje/Mapungubwe/Toutswe and successor states appropriated such locations precisely to establish divine leadership. Divuyu and Nqoma may thus have been settlements of the successive keepers of the nearby Origins ritual site, with cattle, jewellery and other wealth being tribute, sacrifices or offerings from people coming from afar to enjoy the spiritual sanctification of Tsodilo. Our current interpretation of the paintings suggests that many were contemporary with Nqoma and so it is possible that these were made for people coming to pray for rain and so on. Certainly the presence of Later Stone Age lithics at Nqoma (Denbow 1990) suggests close cooperation between Bantu agropastoralist and Khoe forager-

artist, if the ethnic distinction was indeed so clear-cut.

Turning back to those carvings with possible symbolic content, Alec Campbell (pers. comm. 2001) notes that it is uncertain whether it was the act of creating them, the grinder shaped in them, the dust produced by carving them, the resultant carvings themselves, or several or all of these which were important. Wadley (1988) has noted the ritualistic value of quartz and perhaps the Tsodilo spheroids or the resultant dust were appropriate media for controlling or exploiting the supernatural. Spheroids may even have been a ritual item for export (Walker 2008). Whatever the explanation, there is sufficient evidence in the carvings to suggest their links with religion and initiation, and tentative correlations with magic, possibly even fertility and/or rainmaking.

Their symbolic nature may support the incorporation of carvings into the broad label of rock art even if they defy most modern definitions of art. It is also important to stress their difference from the painted art at Tsodilo, about which we still know so little – apart, seemingly, from expressions of potency. Again it is important to note the apparent non-applicability of the southern African rock painting shamanic model (in which the art is seemingly in part a visual mnemonic of cognitive experience) to this expression, and it would seem that the human mind used alternative means to explore and negotiate the supernatural world in different parts of southern Africa in the forgotten past. The difference is that elsewhere the shaman recaptured his visions in paint. The Tsodilo paintings lack the clear shamanistic component (therianthropes and trance-related attributes) and seem to be pure symbols of potency. This, of course, does not preclude shamanism in the rituals – the possible shamanistic properties of the quartz balls (cf. Wadley 1988) might well have been significant, but certainly the esoteric nature of some of the sites and indeed the noise of chipping, grinding or drilling would have added to the charged atmosphere. The recess behind the carved panel at Rhino Cave lends itself to an oracle-like use, as suggested by the polished rocks. Certainly combined with the east/west entrances, the snake-like panel that is lit up by the sun, fires and other features, reminds us of sites chosen for ritual purposes by contemporary societies (Walker in press). Ouzman (2001) in fact stresses that we should remember that art need not be created in a

silent context. Music and rhythm are important attributes of the trance dance. Physical exertion and the shock waves of striking or rubbing stone on stone, especially in a confined area, would have added to the emotional stress when approaching the trance state.

To the above we can add the intriguing phenomenon of tribo-luminescence (Whitley *et al.* 1999). When pieces of quartz are rubbed or struck together or against quartzite or sandstone, they produce a glow and this could easily have been perceived in supernatural terms, for example as a release of supernatural potency from the rock (Whitley *et al.* 1999). The fact that the spheroids found at Tsodilo are all of quartz is suggestive and the glowing effect in dark or semi-dark caves or at night-time must have been dramatic. The carvings were produced by grinding and drilling (i.e. intense and continuous friction) after chipping and it seems improbable that the makers were not aware of this phenomenon. Pieces of quartz will also produce a spark when struck together and the Zhu

and Hambukushu preferred this method of making fire at Tsodilo to firesticks as it was much easier (Alec Campbell pers. comm. 2002). This seemingly magical or supernatural attribute might then explain why quartz crystals were adopted by Bushmen as shamanistic objects (cf. Wadley 1988), as well as the origins of the carvings.

In conclusion we can note the remarkable character of Tsodilo, a place of ritually valuable minerals and of contrasts and contradictions – a high mountain of solid rock surrounded by a sea of loose sand, deep caves and distant views, dryness and pools, where earth meets sky. A place where people would have come for spiritual communication, and in which rock carving frequently played a major role. It is hoped to test these ideas further. What is particularly important, however, is that we have very early evidence of symbolic behaviour and ritual in a Middle Stone Age context at Tsodilo, suggesting some of the oldest evidence for religion in the world (Walker in press).

Acknowledgements

Alec Campbell kindly commented on an earlier draft, providing valuable unpublished information. I am also grateful to Kurt Huwiler, Mike Main, John Thoko-zane Dindo and Xuntae Xhao for the information referred to in the text. Jerry Collins-Hooper and 'KG' Nkage helped with the portage of surveying equipment and ideas. My thanks also to the input from Sven Ouzman, Chris Chippindale, Geoff Blundell and Dave Whitley. This research was conducted under permit from the Office of the President of Botswana. It was partly financed by the Office of Research & Development, University of Botswana, and partly supported by the UBTromso programme. The fieldwork for this project was conducted between 1997 and 1999 whilst I was a member of the National Museum, Monuments & Art Gallery of Botswana. Since writing the original of this paper, I conducted excavations at Corner Cave and Rhino Cave, the preliminary findings of which were published in the 2005 PAAC in Gaborone (see Walker in press). Sheila Coulson and Sigrid Staurset have continued the project since then.

Notes

1 It is proposed to use the generic term 'rock carvings' for them as they are often deep, and also to differentiate them from the more recognisable iconic and geometric engraved or pecked art forms (petroglyphs). A variety of terms appear in the literature and it is proposed to retain the term 'cupules' for the circular hollows, but to adopt terms like shafts for the deeper versions and ellipsoids, lenticulates and stringers for the various grooves.

2 Campbell (pers. comm. 2002), however, now believes that they are also more probably the work of Ncae (Khoe) Bushmen. Certainly they are stylistically and symbolically close to the red paintings.

3 The site is named after a weathered painting, but the 'horn' is more probably the upraised trunk of an elephant. The other paintings are of a giraffe and a few geometrics.

4 Sheila Coulson and Sigrid Staurset are currently working on the lithics from Corner Cave and Rhino Cave respectively

References

Aldiss, D. 1987. A record of stone axes near Tswaane borehole, Ghanzi district. *Botswana Notes & Records* 19: 41–43.

Bahn, P. 1997. *Journey Through the Ice Age*. London: Weidenfeld & Nicolson.

Balsan, F. 1954. *Capricorn Road*. London: Arco.

Beater, B. 1960. An engraved design found on cave sandstone in the Drakensberg, Natal. *South African Archaeological Bulletin* 15: 14.

Boonzaier, E., Berens, P., Malherbe, C. & Smith, A. 1996. *The Cape Herders: A History of the Khoikhoi of Southern Africa*. Cape Town: David Philip.

Campbell, A. 1989. Unpublished archaeological impact assessment, Sekoma-Ghanzi-Mamuno road. Gaborone: Roads Department.

Campbell, A., Denbow, J. & Wilmsen, E. 1994. Paintings like engravings. In: Dowson, T.A. & Lewis-Williams, J.D. (eds) *Contested Images: Diversity in Southern African Rock Art Research*: 131–158. Johannesburg: Witwatersrand University Press.

Campbell, A., Robbins, L. & Murphy, M. 1994. Oral traditions and archaeology of the Tsodilo Hills. *Botswana Notes & Records* 26: 37–54.

Chaplin, J. 1961. A note on rock grooves in Northern Rhodesia. *South African Archaeological Bulletin* 16: 149.

Chaplin, J. 1962. Further unpublished examples of rock art in Northern Rhodesia. *South African Archaeological Bulletin* 7: 5–13.

Chaplin, J. 1964. Rock engravings at Nyambwezu, Northern Rhodesia. *South African Archaeological Bulletin* 19: 13–14.

Clark, J.D. 1958. The Chifubwa Stream rock shelter, Solwezi, Northern Rhodesia. *South African Archaeological Bulletin* 13: 21–24.

Clark, J.D. 1959. *The Prehistory of Southern Africa*. Harmondsworth: Penguin.

Cooke, C. 1961. Incised boulders. *South African Archaeological Bulletin* 16: 116.

Cooke, C. 1964. Rock gongs and grindstones: Plumtree area, Southern Rhodesia. *South African Archaeological Bulletin* 19: 70.

Davies, O. 1967. *West Africa Before the Europeans*. London: Methuen.

Denbow, J. 1990. Congo to Kalahari. *African Archaeological Revue* 8: 139–176.

Derricourt, R. 1986. Striated grinding grooves in central Africa. *South African Archaeological Bulletin* 41: 27–31.

Dixey, F. 1953. Stone Age tool grinding sites in Lake Banguela. *Northern Rhodesia Journal* 2: 72–74.

Eastwood, E. & Blundell, G. 1999. Re-discovering the rock art of the Limpopo-Shashi Confluence Area, southern Africa. *South African Field Archaeology* 8: 17–27.

Fagg, B. 1956. The discovery of multiple rock gongs in Nigeria. *Man* 56: 17–18.

Fagg, W. 1959. Grooved rocks at Apoje near Ijebu-Igbo, western Nigeria. *Man* 59: 205.

Fock, G. 1979. *Felsbilder in Sud Afrika. Teil 1: Die Gravierungen auf Klipfontein, Kapprovinz*. Koln: Bohlau Verlag.

Fosbrooke, H. 1954. Further light on rock engravings in northern Tanganyika. *Man* 54: 101–102.

Fosbrooke, H. & Marealle, P. 1952. The engraved rocks of Kilimanjaro. *Man* 52: 179–181.

Guy, G. 1965. Grooves and stone mortars, Selukwe, Rhodesia. *Arnoldia* 8(2): 1–3.

Hillman, J. & Hillman, S. 1984. Archaeological observations in Bangangai Game Reserve, south-western Sudan. *Azania* 19: 115–120.

Huffman, T. 1981. Snakes and birds. *African Studies* 40: 131–150.

Huffman, T. 1996. *Snakes and Crocodiles.* Johannesburg: Witwatersrand University Press.

Juta, C. 1961. Incised boulders on the Springbok flats, Transvaal. *South African Archaeological Bulletin* 16: 116.

Kirby, P. 1972. Musical character of some South African rock gongs. *South African Journal of Science* 9: 247.

Lanning, E. 1956. Rock markings, Uganda. *South African Archaeological Bulletin* 11: 102–103.

Lanning, E. 1958. A ringing rock associated with rain-making, Uganda. *South African Archaeological Bulletin* 13: 83.

Maggs, T.M. 1995. Neglected rock art: the rock engravings of agriculturist communities in South Africa. *South African Archaeological Bulletin* 50: 132–142.

Malan, B. 1955. Zulu rock engravings in Natal. *South African Archaeological Bulletin* 10: 67–72.

Marshall, L. 1965. The !Kung Bushmen of the Kalahari Desert. In: Gibbs, J.L. (ed.) *Peoples of Africa*: 241–278. New York: Holt, Rinehart & Windus.

Miller, D. 1996. *The Tsodilo Jewellery: Metal Work from Northern Botswana.* Cape Town: Cape Town University Press.

Mills, E. & Filmer, N. 1972. Chondwe Iron Age site, Ndola, Zambia. *Azania* 7: 120–146.

Odak, O. 1991. Distribution of cupmarks at Keborati hill sites of south Nyanza district of Kenya. In: Pager, S-A., Swartz, B.K. Jr. & Willcox, A.R. (eds) *Rock Art: The Way Ahead*: 166–174. Johannesburg: SARARA Occasional Publications 1.

Ouzman, S. 2001. Seeing is deceiving: rock art and the non-visual. *World Archaeology* 33(2): 237–256.

Ouzman, S., Taçon, P.S.C., Fullager, R. & Mulvaney, K. 1997. The world's oldest rock art? *Digging Stick* 14(3): 47.

Phillipson, D. 1966. The Late Stone Age and Zambia's first artists. In: Fagan, B. (ed.) *A Short History of Zambia*: 56–80. Nairobi: Oxford University Press.

Phillipson, D. 1972. Early Iron Age sites on the Zambian Copperbelt. *Azania* 7: 93–128.

Phillipson, D. 1981. A preliminary archaeological reconnaissance of the southern Sudan. *Azania* 16: 1–6.

Robbins, L. 1990. The Depression site. *National Geographical Research* 6: 329–338.

Robbins, L. & Murphy, M. 1998. The Early and Middle Stone Age. In: Lane, P., Reid, A. & Segobye, A. (eds) *Ditswa Mmung: The Archaeology of Botswana*: 50–64. Gaborone: Pula Press.

Robbins, L., Murphy, M., Brook, G., Ivester, A., Campbell, A., Klein, R., Milo, R., Stewart, K., Downey, B. & Stevens, N. 2000. Archaeology, palaeoenvironment and chronology of the Tsodilo hills White Painting Rock Shelter, Northwest Kalahari Desert, Botswana. *Journal of Archaeological Science* 27: 1085–1113.

Robbins, L., Murphy, M., Campbell, A. & Brook, G. 1996. Excavations at the Tsodilo hills Rhino Cave. *Botswana Notes & Records* 28: 23–45.

Robbins, L., Murphy, M., Campbell, A. & Brook, G. 1997. Intensive mining of specular hematite in the Kalahari. *Current Anthropology* 39: 144–150.

Robinson, K. 1958. Venerated rock gongs and the presence of rock slides in Southern Rhodesia. *South African Archaeological Bulletin* 13: 75–77.

Robinson, K. 1959. *Khami Ruins.* Cambridge: Cambridge University Press.

Rudner, I. 1965. Archaeological report on the Tsodilo Hills, Bechuanaland. *South African Archaeological Bulletin* 20: 51–70.

Rudner, J. & Rudner, I. 1968. Rock art in the thirstland areas. *South African Archaeological Bulletin* 23: 75–89.

Sassoon, H. 1962. Grinding grooves and pits in northern Nigeria. *Man* 62: 145.

Scherz, E. 1970. *Felsbilder in Sudwest Afrika: Teil 1.* Cologne: Bohlau Verlag.

Scherz, E. 1975. *Felsbilder in Sudwest Afrika: Teil 2.* Cologne: Bohlau Verlag.

Schoonraad, M. 1960. Preliminary survey of the rock art of the Limpopo Valley. *South African Archaeological Bulletin* 15: 10–13.

Singer, R. 1961. Incised boulders. *South African Archaeological Bulletin* 16: 27.

Soleilhavoup, F. 1990. A problem in ethnoarchaeological interpretation. *Digging Stick* 7(1): 5–7.

Summers, R. (ed.) 1959. *Prehistoric Rock Art of the Federation of Rhodesia and Nyasaland.* Salisbury: National Publications Trust.

Swan, L. 1994. *Early Gold Mining on the Zimbabwean Plateau.* Uppsala: Societas Archaeologica Upsaliensis, Studies in African Archaeology 9.

Sydow, W. 1961. Archaeological notes from South West Africa. *South African Archaeological Bulletin* 16: 111–113.

Taçon, P.S.C., Fullager, R., Ouzman, S. & Mulvaney, K. 1997. Cupule engravings from Jinmium-Granilpi (northern Australia) and beyond: exploration of a widespread and enigmatic class of rock markings. *Antiquity* 71: 942–965.

Townsend, P. 1979. Makale in eastern and southern Africa. *Azania* 14: 109–138.

Van der Post, L. 1958. *The Lost World of the Kalahari.* London: Hogarth Press.

Van Waarden, C. 1999. *Exploring Tati*. Francistown: Marope Research.

Viereck, A. & Rudner, J. 1957. Twyfelfontein – a centre of prehistoric rock art in South West Africa. *South African Archaeological Bulletin* 12: 15–26.

Wadley, L. 1988. *Later Stone Age Hunters and Gatherers of the Southern Transvaal*. Oxford: British Archaeological Reports International Series 380.

Walker, N. 1997. In the footsteps of the ancestors: the Matsieng creation site. *South African Archaeological Bulletin* 52: 95–104.

Walker, N. 1998. Botswana's prehistoric rock art. In: Lane, P., Reid, A. & Segobye, A. (eds) *Ditswa Mmung: The Archaeology of Botswana*: 206–232. Gaborone: Pula Press.

Walker, N. 2008. Through the crystal ball. Making sense of spheroids in the Middle Stone Age. *South African Archaeological Bulletin* 63: 12–17.

Walker, N. In press. Cups and balls: early symbolism at Tsodilo? In: Tsheboeng, A., Segobye, A. & Walker, N. (eds) *Proceedings of the 12th Congress of the PanAfrican Association for Prehistory and Related Studies*. Gaborone: Botswana Society.

Walker, N. In preparation. Prehistoric female initiation sites.

Wayland, J. 1938. Note on a prehistoric 'inscription' in Ankole, Uganda. *Uganda Journal* 5(3): 102–103.

Whitley, D., Dorn, R., Summs, T., Rechtman, R. & Whitley, T. 1999. Sally's rock shelter and the archaeology of the vision quest. *Canadian Archaeological Journal* 9(2): 221–247.

Wilman, M. 1933. *The Rock Engravings of Griqualand West and Bechuanaland, South Africa*. Cambridge: D. Bell.

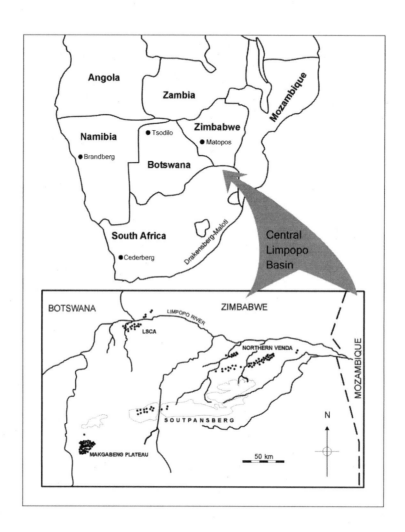

FIGURE 5.1 Map of southern Africa showing the study area and other rock art regions mentioned in Chapter 5.

5.

Art and authorship in southern African rock art:

Examining the Limpopo-Shashe Confluence Area

EDWARD B. EASTWOOD,[1] **GEOFFREY BLUNDELL AND BENJAMIN SMITH**
(Rock Art Research Institute, University of the Witwatersrand,
Johannesburg, South Africa)

ROCK ART AND REGIONALITY

In 1925, Samuel Shaw Dornan, an Irish Presbyterian missionary, remarked on Bushman forager rock art: "The paintings are of the same general type all over South Africa. I have seen examples in the Cape Province, Orange Free State, Basutoland, Bechuanaland and Rhodesia, and they all looked the same; one cannot tell from reproductions of these paintings unless one is told where they come from" (1925: 182). It was not until the late 1920s that differences in various parts of the subcontinent were formally recognised; regional bodies of rock art were classified according to differences in stylistic characteristics and other features (e.g. Burkitt 1928; Van Riet Lowe 1952; Willcox 1963a; Malan 1965; Rudner & Rudner 1970; Lewis-Williams 1983; cf. Laue 1999). Today, researchers would not offer general statements such as Dornan's.

With the recognition of regional diversity comes the dual challenge of its explication and explanation. One obvious suggestion is that diversity is an indication of cognitive and cultural differences among the artists (e.g. Lewis-Williams & Dowson 1994: 207; Skotnes 1996: 238). Diversity is, of course, well noted in other aspects of forager culture; ethnographic studies point to the diversity of Khoisan languages and the fluidity of forager religious thought (e.g. Barnard 1992; Guenther 1994, 1999), despite broad similarities. Yet, one needs to guard against any simplistic correlation between material culture and cultural identity (Hodder 1985; Johnson 1999: 98–101; Hammond-Tooke 2000). Differences in material culture do not necessarily translate into a different cognitive system, and any particular example is likely to be more complex than some archaeological models portray. In southern Africa, a poor chronological

understanding of the rock art makes such correlations even more difficult.

Nevertheless, determining more precisely which linguistic group of foragers made what particular cluster of art could allow for the use of more specific ethnography and also for a more nuanced understanding of the diversity of southern African forager rock art than at present. A tightly localised ethnographic approach was employed by Janette Deacon (1988, 1994, 1998), who used the Bleek and Lloyd ethnographic collection to explain the /Xam rock engravings of the Northern Cape. Unfortunately, such close correspondence between local ethnography and rock art imagery is rarely possible in southern Africa or anywhere else in the world; most researchers must rely on building up a number of correspondences between particular images and wide-ranging ethnography for the elucidation of the meanings of specific images (Lewis-Williams 1991). This approach is most persuasive in areas of forager thought and ritual for which broad cross-regional parallels can be demonstrated (Lewis-Williams & Biesele 1978; Lewis-Williams 1981; Hollmann 2004).

The rock art that is the subject of this chapter, that of the Limpopo-Shashe Confluence Area (LSCA), has so far been explained only in terms of wide-ranging features in Khoisan ethnography. Although more specific, !Kung ethnography (e.g. Marshall 1957, 1962, 1969, 1976; Lee 1984; Biesele 1993) has been used to interpret some of the rock art of the LSCA (Eastwood 1999), but this ethnography has been used without an adequate understanding of its relevance to the LSCA forager artists (but see Eastwood 2003: 23–24, 2005). To rectify this situation, we draw on rock art, archaeological, linguistic and historical studies to determine the cultural affinities of the past painters of the LSCA rock art. Using the iconography, we identify a specific Khoisan language group as the authors of this body of art. We then discuss the implications of our findings for rock art studies in general.

THE STUDY AREA, ITS ENVIRONS, AND ROCK ART TRADITIONS

The LSCA lies at the centre of the Limpopo Basin, a water catchment area that extends from the Witwatersrand (South Africa) in the south to Bulawayo (Zimbabwe) in the north, and from the edges of the Kalahari Sandveld (Botswana) in the west to a narrower 'corridor' where the Limpopo flows into the Indian Ocean in the east in Mozambique. For the purposes of rock art study, we divide the Limpopo Basin into three sections: southern, central and northern. Here we focus on the art of the central Limpopo Basin. This comprises the rock art areas of the LSCA, the Soutpansberg, northern Venda and the Makgabeng plateau. The northern Limpopo Basin incorporates the rock art areas of the Matabeleland South Province of Zimbabwe. The southern Limpopo Basin includes the Waterberg rock art area (Figure 5.1).

The bulk of the central Limpopo Basin, including the LSCA (Figure 5.2), is dominated by Mopane Bushveld (Low & Rebelo 1996: 20) and outcrops of Karoo Sandstone of the Clarens Formation. One hundred and sixty-one rock art sites have been recorded in the LSCA. The three other main rock art areas in the central Limpopo Basin, the Soutpansberg range, northern Venda and the Makgabeng plateau (Figure 5.2) have a total of 852 rock art sites. Data from these sites are drawn upon in this chapter where they are able to supplement the information available from the final results of the survey in the LSCA.

In the LSCA there are three, broadly distinct rock art techniques that frequently co-occur in the same shelters (see Figure 5.3). These techniques are engravings (Schoonraad 1960; Willcox 1963b), 'geometric' finger paintings (Smith & Ouzman 2004; Eastwood & Smith 2005) and fine-line paintings (Schoonraad 1960; Pager 1975). The engravings consist of cupules, grooves, geometric designs, animal representations and animal tracks. The engravings were made by abrasion, incision and pecking. We do not consider the authorship of the engravings here.

The geometric finger paintings consist largely of rows and clusters of finger-dots and strokes, and circular, oval and rectangular motifs (see Figure 5.4). These paintings were frequently made with red pigment and/or white pigments. In the Western Cape, Bill van Rijssen (1984, 1985, 1994) associated similar paintings with Khoekhoe herders. Ben Smith and Sven Ouzman have demonstrated the application of this finding to the LSCA by showing that this is an art tradition that extends through the Free State, Limpopo Province and into neighbouring Zimbabwe and Botswana. They correlate this distribution pattern with the proposed routes of Khoekhoe herder migra-

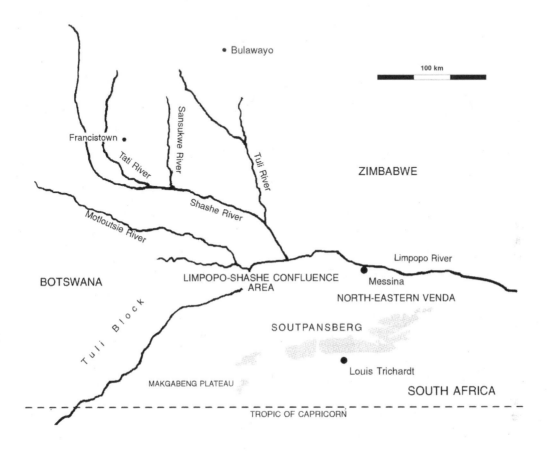

FIGURE 5.2 Map of the central Limpopo Basin showing the study area and adjacent rock art areas.

tions (proposed on the basis of archaeological and linguistic data [Smith & Ouzman 2004]). Our findings at 195 sites in the central Limpopo Basin (including 21 in the LSCA) lend further support to their argument and produce exactly the patterns they predicted, such as that extensive sequences of fine-line technique paintings will be found under, and also over, herder art (Eastwood & Smith 2005).

For the fine-line images of the LSCA it has been universally assumed that the authors were foragers (see Schoonraad 1960; Pager 1975; Eastwood & Fish 1996; Eastwood 1999; Eastwood & Blundell 1999). Recently, a forager authorship has been explicitly assigned by Hall and Smith (2000: 40). Our observations of the LSCA sequences provide no evidence to challenge this association, but they have led us to grow increasingly uncomfortable with the rather vague category of 'forager art'. At first glance, the

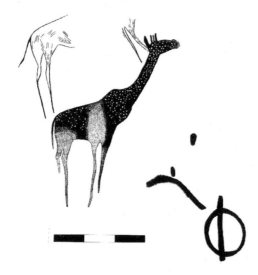

FIGURE 5.3 An example of the co-occurrence of engravings, fine-line paintings and geometric finger paintings. The animal at the top is a lightly incised engraving; the giraffe is black with red body markings and nose; the geometric finger paintings are red. Northern Venda. Scale 300 mm.

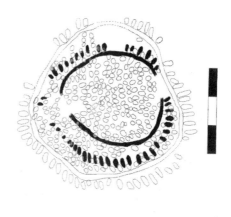

FIGURE 5.4 Typical circle-and-dot geometric motifs. Black represents red, white represents white. Northern Venda. Scale 300 mm.

categoy seems useful because there are striking broad similarities in manner of depiction and subject matter between the fine-line paintings of the LSCA and those found in other places south of the Zambezi River, such as the Matopos, Drakensberg, Cederberg and Brandberg. The reasons for these similarities have now been well explained, not just in that all the art was made by Khoisan-speaking foragers, but because certain shared symbols and experiences fundamental to the pan-Khoisan forager shamanistic world view are depicted in all areas (Huffman 1983; Maggs & Sealy 1983; Yates *et al.* 1985; Garlake 1987, 1995; Kinahan 1991; Lewis-Williams 1998; Eastwood 1999). Detailed study of these regions, however, reveals equally important differences and it is these that concern us in this chapter. These differences can only be explained if we shift from a pan-Khoisan-speaker focus to a more nuanced locally informed study. Before considering the detailed similarities and differences between areas and before seeking to determine precisely to which forager cultural and linguistic group the authors of the LSCA art belonged, we must define what we mean by fine-line forager paintings.

Fine-line forager paintings comprise predominantly human beings and animals. Human beings are depicted in a continuum from very detailed to very sketchy 'crude' representations. There are a great many variations in the treatment of body proportion, size and detail such as limb shape, clothing decoration, head shape and so forth. In most areas the majority of the human images cluster at the fine end of the continuum, with just occasional crude images. Examples include the art of the Drakensberg, Cederberg, Brandberg and Matopos (Figure 5.5). A number of authors have argued that the few crude images are later and that they represent a shift in technique

of recent date (Vinnicombe 1976; Loubser & Laurens 1994; Ouzman & Loubser 2000). In a few places, such as the Tsodilo Hills (Walker 1998: figure 9.10) and the Waterberg (Laue 2000), one finds another pattern whereby most human images are at the crude end of the continuum and just a few (if any) are fine. This pattern is unexplained.

Animal depictions show a similar pattern of variation between crude and finely detailed, and from indeterminate to species-specific. As with human depictions, in certain areas the animals are noticeably cruder. The pattern corresponds to that found in the human figures; areas such as Tsodilo and the Waterberg also have crude animals. The detailed manner of animal representation differs from region to region, but there are broad commonalities throughout. For example, a pan-southern African feature of forager paintings is that certain animals were represented using combinations of diagnostic features (Smith 1998; Eastwood *et al.* 1999), making identification of particular species possible. Such a widespread convention suggested that the painter intended the viewer to know exactly which animal was being portrayed. Painting the animal in lateral view meant that most of its diagnostic features, such as shape, markings, horn shape and so forth, were presented to optimum effect (Smith 1998: 215).

In addition to animals and human beings, a range of equipment is depicted, including bows, arrows, spears, digging sticks, quivers and bags (e.g. Figures 5.5B, 5.5D). Sometimes the equipment is carried, sometimes it is not. There are also items of clothing such as karosses, cloaks and aprons. Often, humans are given exquisite body decoration (e.g. Figure 5.5B). Given the size of the human figure, the most intricate brushwork was required to capture these items. The areas with art at the fine end of the continuum thus have many of these items whereas the areas at the cruder end of the continuum have few, if any. At least part of this variation was forced by the difference in painting technique.

The finest techniques were achieved through the use of brushes made from bristles, quills, feathers or twigs. Within fine figures solid areas, blocked with paint, may have been applied by finger. The cruder technique was also made using brushes, but of a far thicker type. At least some of the cruder art was applied partially by finger. Both types of paintings were either blocked, that is, painted in solid silhouette, or were first outlined

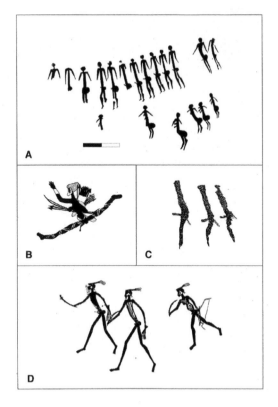

FIGURE 5.5 Variation in depiction of human beings in southern African rock art.

A. Limpopo-Shashe Confluence Area. All paintings are red. Scale 100 mm.
B. Drakensberg (redrawing from RARI archive).
C. Tsodilo Hills, Botswana (after Walker 1998: figure 9.11).
D. Brandberg, Namibia (after Pager 1993: 87, plate 2).

using ochre crayon or liquid paint applied by brush or finger, and then either left as an outline figure or filled in with paint. Along this continuum from fine to crude technique, the fine-line tradition of the LSCA and northern Venda lies towards the crude end. Perhaps unsurprisingly, it has its closest parallels with the nearby Waterberg (Laue 2000). While not as crude as Tsodilo, it is far closer to that art in terms of technique than it is to the arts of the Matopos, Drakensberg, Brandberg and Cederberg.

A comparison of details of the subject matter among the forager arts of the various areas reveals certain quantitative similarities. In all regions antelope are numerically predominant among the animal depictions. Quantitative studies usually show that indeterminate and species-specific antelope are the largest category of animal images (e.g. Maggs 1967; Pager 1971; Lewis-Williams 1972, 1974; Tucker & Baird 1983; Hollmann 1993; Lenssen-Erz 1994; Walker 1996; Eastwood & Blundell 1999; Eastwood & Cnoops 1999a; Laue 1999). This is true also of the LSCA and all the other rock art areas of the central Limpopo Basin, with the exception of northern Venda, where the giraffe is the most often painted animal.

In most parts of southern Africa the total number of human beings is greater than the total number of animals. This holds true for the Western Cape (Maggs 1967; Halkett 1987; Hollmann 1993), the Drakensberg (Pager 1971; Lewis-Williams 1972, 1974), the Matopos (Walker 1996) and the Trelawney and Darwendale districts of Zimbabwe (Tucker & Baird 1983). The one exception to this is the paintings of Tsodilo Hills (Campbell *et al.* 1994). The Soutpansberg, Makgabeng and LSCA also have more humans than animals, but if one includes the statistics from 60 forager sites found in northern Venda the overall figures become 14 per cent people and 71 per cent animals. This area then becomes only the second to have been found to have more paintings of animals than humans, again tying it more closely to Tsodilo than to any other painting area.

Another widespread feature of southern African forager rock art is local emphasis upon a particular animal. The chosen animal may be numerically predominant, but more striking than frequency is the special attention lavished upon it. It is often depicted in finer detail, given more varied use of colour, shown larger and found in more complex associative contexts. In the Drakensberg of South Africa, for example, this dominant animal is the eland (e.g. Vinnicombe 1976; Lewis Williams 1981); in the Matopos of Zimbabwe it is the giraffe (Walker 1996); in the Brandberg of Namibia it is the springbok (Lenssen-Erz 1994; Lenssen-Erz & Erz 2000); in Mashonaland of Zimbabwe it is the elephant (Garlake 1989); in the Waterberg it is the hartebeest (Laue 2000); in northern Venda it is the giraffe; while in the Soutpansberg, Makgabeng and LSCA it is the kudu

(Eastwood & Cnoops 1999a, 1999b; Eastwood *et al.* 2000). Although the choice of animal differs, it was always one of the larger animals.

Three important features of LSCA rock art underscore its distinctiveness from the finer forager rock art regions. These are the frequency of depictions of women; the diversity and choice of animal species; and the presence, in significant numbers, of loincloths and aprons. We discuss each in turn.

One of the major differences between the rock art of the LSCA and almost every other documented rock art region in southern Africa is the number of depictions of women and the conventions used in their portrayal. In the LSCA, images of women, identifiable by breasts, make up 28.2 per cent of the total number of depicted human beings, while men, identifiable by a penis, make up only 23.5 per cent. The percentage for women is exceptionally high compared to figures elsewhere (Eastwood 2005). In the Drakensberg, percentages range from as little as 0.3 per cent in the Barkly East area (Lewis-Williams 1981) to 2 per cent for a larger sample area in the southern Drakensberg (Vinnicombe 1976), and as high as 14.8 per cent for the small area of the Ndedema Gorge (Pager 1971). Elsewhere, percentages of depictions of women are also small: 9.6 per cent and 6.4 per cent for the Putslaagte and Koebee areas of the Western Cape respectively (Halkett 1987; Hollmann 1993), and 8.5 per cent for the Trelawney and Darwendale districts of Zimbabwe (Tucker & Baird 1983). The way in which the images of women in the LSCA are depicted is also distinctive. Typically, they are characterised by exceptionally large buttocks, forward-curved spine, and reverse articulation of the knee joints (see Figure 5.5A). Both the exaggerated backward bending of the knees and the slenderness of the legs suggest the hind legs of an animal, rather than those of a human.

The second distinctive feature of the LSCA forager fine-line rock paintings is the diversity of painted animal species. Like paintings in rock art regions in other parts of southern Africa, those in the LSCA depict a variety of animal species. The average number of animal species per site in the LSCA is 2.7, suggesting at first glance that only a small range of species was painted. This figure is, however, misleading: 39 species of mammals, fish, birds and insects are depicted in the LSCA (Eastwood & Cnoops 1999a). This is far higher

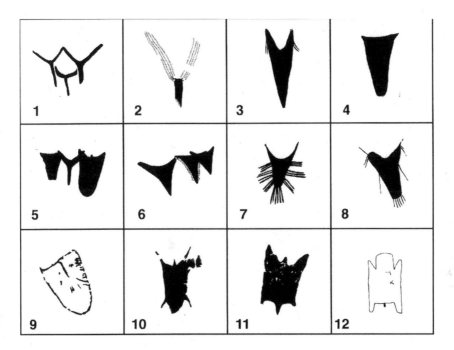

FIGURE 5.6 Examples of formal variation in the loincloth and apron motif in the central Limpopo Basin.

1–3. Limpopo-Shashe Confluence Area.	**4.** Soutpansberg.
5. Limpopo-Shashe Confluence Area.	**6–7.** Soutpansberg.
8–12. Limpopo-Shashe Confluence Area.	

All paintings are red monochrome, with the exception of number 2, which is white and black, and number 7, which is yellow.

than in the Drakensberg, where David Lewis-Williams (1972) recorded only 11 species, and in the Cederberg Wilderness Area of the Western Cape, where only eight species were recorded (Deacon 1993: 32). It is interesting to consider that in the Trelawney and Darwendale districts of Zimbabwe 26 species of animals were noted (Tucker & Baird 1983: 44–45), and in the Matopos over 40 species are depicted (Walker 1996: 79–80); these figures suggest that depicted species' diversity may increase farther north in southern Africa. This diversity in the rock art, however, may be a reflection of differential species diversity in different ecological biomes.

The third and most distinctive attribute of the LSCA forager fine-line paintings is depictions of loincloths and aprons (the 'loincloth/apron motif' [Blundell & Eastwood 2001; Eastwood 2003]). Although images of humans wearing loincloths or aprons are an infrequent but widespread feature in Khoisan-speaker rock art (e.g. Vinnicombe 1976; Garlake 1987, 1995), the category 'loincloth/apron motif' is used here to refer to a range of loincloths and aprons that may be depicted as large as the human and animal images and that are not worn. The variation in form of the motif is shown in Figure 5.6. In a sample of 142 sites containing forager fine-line paintings in the LSCA, 36.6 per cent (n=52)

contain images of loincloths and aprons. The loin-cloth/apron motif constitutes 8.8 per cent of the total number of paintings (n=2441). The loincloth/apron motif is not confined only to the LSCA, however: it is a significant feature of the fine-line paintings of the Soutpansberg, northern Venda and Makgabeng plateau (with 3.2, 3.8 and 1.7 per cent of the total number of paintings respectively). In no other area of southern Africa are images of loincloths and aprons found painted (we consider engravings later) in such profusion and diversity as in the central Limpopo Basin. We argue later in this chapter that Tsodilo is an exception to this trend. Again the LSCA will be drawn most closely into association with Tsodilo. At this point we simply note that the loincloth/apron motif is a significant symbolic component of LSCA iconography.

These three features of LSCA fine-line forager rock paintings (the diversity of painted animal species, the conventions used in the portrayal of women, and the depiction of the loincloths and aprons) make the art instantly recognisable and distinguish it from that of most other regions. Even though the paintings of the LSCA are fine-line in technique, the unusual nature of the subject matter and the peculiar manner of depiction suggest that the authors of the LSCA paintings were, to some degree, cognitively and culturally different from those who made paintings using the finer techniques seen in other parts of southern Africa. The emphasis on items of clothing and the high frequency of women in the LSCA are seemingly more fully explicable as a manifestation of a localised belief system, which is, perhaps, attributable to a specific historical context.

TOWARDS UNDERSTANDING THE HISTORICAL CONTEXT

Although a pan-forager ethnographic model could be employed successfully to explain some elements in the LSCA rock paintings, other elements would be better understood if it could be demonstrated which particular group of Khoisan speakers made the images. In other words, a more focused ethnographic model would hold the potential to explain diversity in southern African forager rock art. In particular, the depiction of loincloths and aprons in the LSCA rock art suggests a belief system partially different from that

of the fine-technique rock painters of other parts of southern Africa. To understand this cosmology better, we need to determine the authorship of these images more precisely. In order to do so, we turn to archaeological and linguistic evidence.

EVIDENCE FROM EXCAVATION

In the LSCA there is archaeological evidence for a complex and varied history of interaction between foragers, herders and agropastoralists (farmers). We are primarily concerned here with the forager part of this sequence, but will examine herder and farmer remains where there is evidence that these groups interacted with and affected forager groups. Excavations in the LSCA have been heavily focused upon the sequence of farmer settlements (e.g. Huffman 1989), but recent work by Simon Hall (Hall & Smith 2000) has shed new light upon the forager and herder presence in the region. Hall's preliminary findings can be worked into a more thorough reconstruction of forager–herder–farmer contact when placed in the context of complementary findings from neighbouring Zimbabwe (Walker 1995) and Botswana (Reid et al. 1998; Walker 1998).

Excavations in the Matopos of Zimbabwe show a long forager occupation sequence extending back at least 12 000 years and ending about 1500 years ago (Walker 1995). Nick Walker argues that the forager sequences ended because the people were pushed out of the area (or left of their own choice) because of the intrusion of herder and farmer groups. In stark contrast to the Matopos, the Zimbabwean section of the Limpopo lowveld immediately to the south has produced no evidence of forager activity older than 2000 BP (Walker 1995: 238). Walker explains the increase in forager activity after 2000 BP in the lowveld by associating it with the exodus from the Matopos. He argues that the foragers who moved out of the Matopos moved south towards the Limpopo River (Walker 1995). This finding is supported by work in the adjacent Tuli Block of eastern Botswana. Here, excavations show a similar increase in forager deposits around 2000 BP (Campbell et al. 1994; Walker 1994, 1995, 1998).

In northern South Africa it has long been noted that there is an absence of Late Stone Age forager deposits before 2000 BP (Mason 1962). Despite extensive recent excavation in rock shelters in the

Waterberg, Maria van der Ryst reports a long hiatus in forager occupation prior to 1600 BP (Van der Ryst 1998: 129). In the LSCA, the limited excavation evidence fits this well-established pattern; a number of good shelter deposits have been trenched and none have yielded remains older than 2000 BP (Hall & Smith 2000: 34). Hall believes that older deposits will be found (Simon Hall pers. comm. 2001), but the evidence from the Limpopo Valley as a whole is now sufficient to demonstrate that if foragers were in the LSCA before 2000 BP, they were there in very low numbers. Unlike in most other areas, therefore, the forager occupation of the LSCA was not well established prior to herder and farmer intrusions. Rather, it seems that foragers moved into this area in significant numbers for the first time because of the herder and farmer intrusions. The implication is that the forager population may have been quite diverse, potentially coming from a number of disparate areas. Also implied is that most forager rock art was made in the context of interaction with herder and farmer societies.

Identifying a specific herder presence in the archaeological deposits of LSCA is difficult because, in the absence of sheep bones, a herder signature is far less clearly defined than the familiar lithic signature of foragers and the ceramic/iron signatures of farmers. The best-excavated evidence for a herder presence comes from Botswana, where sheep bones are found in repeated association with distinctive forms of thin-walled, comb-stamped pottery. These first domesticates and this first pottery tradition appear in archaeological layers dated between 2000 BP and 1600 BP (Walker 1983; Reid et al. 1998: 87). Both introductions came from the north. Reid and colleagues challenge the assumption that the appearance of this cultural package came via migration; instead, they follow the current European trend of reading 'diffusion' instead of migration (Reid et al. 1998: 94–95). Yet, when one adds radical changes in rock art to the sheep-plus-pottery package (see Hall & Smith 2000: 40; Smith & Ouzman 2004), the evidence points to major cultural and cognitive change and therefore away from the diffusionist trend, back to the older, well-honed migration models (e.g. Elphick 1977). These older models fitted far better with a variety of linguistic reconstructions (e.g. Westphal 1963; Ehret 1982) and we believe, as past archaeologists and linguists used to concur, that this is because

people actually moved. Finally, in deciding upon this issue, one must turn one's mind to the social context of the time. The period 2000 BP–1500 BP was a time of movement in this area: foragers moved in from the north (Walker 1995: 255; Hall & Smith 2000: 34), accompanied by successive waves of farmers (Prinsloo 1974; Hanisch 1979, 1981; Huffman 1989; Meyer 1997); this was a time of unprecedented human migration, not a time of diffusion.

The earliest evidence of farmers migrating into the LSCA dates to between 1600 BP and 1350 BP and is tied to the arrival of Happy Rest pottery; this distinctive pottery appears at sites that follow formal farmer settlement patterns (Prinsloo 1974; Hanisch 1979). These early farmer settlements appear to concentrate along the southern slopes of the Soutpansberg (Prinsloo 1974; Hanisch 1981; Hall & Smith 2000: 34). To date, Happy Rest sites have been found at the base of Mapungubwe (Meyer 1998: 201), and on the tops of hills and in rainmaking contexts (Thomas Huffman pers. comm. 2002).

Soon after 2000 BP we thus see the LSCA as inhabited by three distinctive yet interacting groups – foragers, herders and farmers. Let us be clear what we mean by these terms. We use 'forager', 'herder' and 'farmer' to characterise the traditional lifeway of culturally and cognitively (and linguistically) distinct groups. We take it as a given that farmers and herders both foraged and that foragers will have taken on domesticates on occasion. We do not believe that the divisions between these groups were insurmountable barriers. We accept that individuals must have crossed from one group to another through intermarriage and so on. However, we argue that in joining another group that individual would have taken on not just a new lifeway, but a fundamentally different cultural and cognitive identity.

The first of these identities to disappear in the LSCA area (though not in neighbouring Botswana – see Reid et al. 1998) is that of herders. It is clear that the herder identity comprised a diverse collection of broadly related groups. Some of this diversity is observable in the archaeological record. In Botswana, herders have been divided into three major archaeological groups (Reid et al. 1998). Using Elphick's model, the model that we prefer, the bulk of LSCA herder groups must have moved away to the south, some eventually reaching the western Cape (Elphick 1977). Certainly

by 1400 BP a distinct herder presence is no longer visible in the archaeological record of the central Limpopo Basin (Hall & Smith 2000: 32). It is assumed that those herders who remained became fully integrated within a forager or farmer identity (but see Eastwood and Eastwood [2006] for other areas of the central Limpopo Basin). It seems more likely that the main integration was with forager groups as it is with these groups that there is most evidence of herder interaction. Both herders and foragers used and painted in the same shelters, at times visibly competing for the same spaces (Hall & Smith 2000: 39–40). The interaction is perhaps at its most visible in the depictions of sheep and their 'herders' that make up an important part of the forager art assemblage (Eastwood & Fish 1996; Eastwood & Eastwood 2006: Chapter 7).

At around 1050 BP a new, more intensive wave of farmer settlement occurred throughout the LSCA. These farmers are identified by a particular type of pottery known as Zhizo. It may have been this more intensive farmer presence that caused the bulk of the herders to move out of the LSCA. Zhizo settlements are dated to between about 1050 BP and 950 BP (Hanisch 1980; but see Calabrese [2000] for later dates of a Zhizo derived settlement). Hall and Smith (2000: 34–37) provide extensive evidence of farmer–forager interaction and exchange throughout this period. The next period, known by archaeologists as the K2 period, saw a major shift from kin- to class-based political and social systems. The years 950 BP–650 BP were dominated by the great capitals of K2 and Mapungubwe (Huffman 2000). During this time foragers became increasingly excluded from all forms of exchange networks with farmer societies (Hall & Smith 2000: 36–37). By the time the Mapungubwe kingdom was at its zenith, the foragers were completely marginalised and dispersed into more rocky terrain unsuitable for farmer occupation. The forager presence disappears as an identifiable trace from the archaeological record after the collapse of Mapungubwe in about 650 BP. The farmer presence has endured.

EVIDENCE FROM ARCHAEO-LINGUISTIC STUDIES AND HISTORICAL SOURCES

We now turn to the linguistic models and examine how these mesh with, and lend support to, a particular reconstruction of the past. At a broad level one can divide the languages spoken in this region into two major language families: Bantu languages and Khoisan languages. At this level a link with the archaeological remains is easy – farmer groups speak Bantu languages while those groups who traditionally have practised herder and forager lifestyles speak Khoisan languages. The distinctive feature of the Khoisan languages is their use of click sounds. Within both Bantu and Khoisan language families there is significant linguistic variation and linguists differ in their opinions of how to cluster languages within each family. This is especially true of the Khoisan language family, which, because it is the one relevant to the LSCA fine-line painters, is the one that interests us here. One of the reasons it is so difficult to associate Khoisan languages is the remarkable divergence between them; most are mutually unintelligible. Tony Traill (pers. comm. 2002) suggests that the explanation for this level of divergence is that, almost uniquely in world linguistics, each of these languages grew up over tens of thousands of years without displacement or intrusion.

In grouping Khoisan languages there is a single point of agreement between almost all linguists: that Khoe languages can be separated from non-Khoe languages (Bleek 1928, 1956; Greenberg 1950; Westphal 1963; Ehret 1982; Barnard 1992). There remains a debate as to whether the two have a common origin (Westphal 1963; Honken 1977). The Khoe languages are presently widely scattered across the Khoisan-speaking area but are concentrated in the central and eastern Kalahari (Barnard 1992; see Figure 5.7). The Khoe languages spoken outside of this area are those spoken by highly mobile groups who were still practising a herder lifeway at the time of European–Khoekhoe contact. In this chapter we differentiate herders from the main Khoisan language category by calling these groups Khoekhoen (after Barnard 1992). Of crucial importance to our study are reconstructions of how the present distribution of Khoe and non-Khoe languages came about (particularly those of Westphal [1963] and Ehret [1982]).

There is broad agreement that the Khoisan languages in Botswana, Namibia, Zimbabwe and South Africa were predominantly non-Khoe until a point some 2500–2000 years ago. This date is proposed on the basis of glottochronological estimates

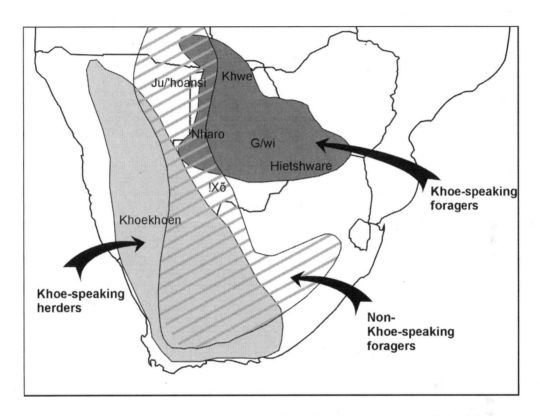

FIGURE 5.7 Map of southern Africa showing approximate distribution of main Khoisan language families, and of specific forager and herder groups mentioned in the text.

(Köhler 1966: 147; Ehret 1982: 169). At this time Khoe languages (or proto-Khoe languages if one follows Westphal [1963: 257–259]) started to spread southwards from a point whose exact location is contested, but which all place no further south than northern Botswana and the Zambezi Valley (Westphal 1963; Ehret 1982). The link between this date and place and the archaeological knowledge of the origins of herding has led both linguists and archaeologists to link the southward expansion of the Khoe languages to the migration of herder groups (e.g. see Westphal 1963; Elphick 1977; Ehret 1982; Barnard 1992). This link finds support in the fact that recent herder populations such as the Nama and Korana all spoke dialects of Khoe (never non-Khoe) into recent times. Again, a few archaeologists have questioned whether linguists should not talk of diffusion rather than migration (e.g. Parkington 1984; Reid *et al.* 1998)

but the linguists build a strong case upon their evidence for a pattern of both migration and diffusion (Westphal 1963; Ehret 1982).

Both Westphal (1963) and Ehret (1982) agree that as herders moved southwards through eastern Botswana and western Zimbabwe to northern South Africa, they had a profound linguistic impact upon the non-Khoe-speaking foragers among whom they settled. They argue that many centuries of interaction with herders turned the foragers of this region into Khoe speakers. For the LSCA, the implication is that the older non-Khoe-speaking forager inhabitants lost (or at least radically changed) their languages during interaction with Khoe-speaking herders. The former non-Khoe languages of the LSCA cannot now be known; even the names are lost. On a broad level they will have related to modern non-Khoe languages such as !Xu and Ju/'hoansi. The completeness of the loss of the non-Khoe languages of the LSCA is no doubt partly explained by the archaeological evidence that the non-Khoe population of the region was very small at the time of contact. This need not mean that all foragers automatically became herders; this seems unlikely. Rather, it shows a more profound level of influence by herder groups than is evident from the archaeological remains. Linguistics shows that behind the LSCA rock paintings of sheep there were more complex changes being brought about by interaction and influence than the images themselves betray.

On the details of the herder groups living in the LSCA the linguists support the existence of distinct groups comparable to the kind of divisions recognised by Reid *et al.* (1998) in the archaeological remains. Westphal (1963: 259) places one group in north-eastern Venda and another in Mpumalanga. Ehret (1982: 167) also postulated the presence of two herder groups whom he terms "Limpopo Khoi". Based on loan words that moved into the languages ancestral to modern xiTsonga and tshiVenda, he places one group in the north-eastern parts of South Africa and adjacent southern Mozambique. Based on loan words in proto-Shona, he places the second group in Limpopo Province, South Africa (Ehret 1982: 163). As well as these herder groups he suggests the presence of at least two Khoe-speaking forager groups in the greater Kalahari area, namely Nharo and Hietshware. He suggests that these languages were in existence by 2500 BP. Although we have reservations

about the manner in which it was derived, the date is compatible with archaeological evidence and therefore seems to us plausible though a little on the high side. We prefer to place the most significant phase of LSCA forager–herder interaction between 2000 BP and 1500 BP.

The Nharo and Hietshware are classed respectively as western and eastern Khoe-speaking foragers (Barnard 1992). Of the two, the Hietshware (eastern Khoe speakers) were geographically the closest to the LSCA. In the 1920s Dornan (1925: 66–68) reported that the Hietshware occupied the Tati River area of what is now Botswana and the Tuli River area of what is now Zimbabwe (see Figure 5.2). He also noted them as living along the Shashe and Motloutsi rivers of the LSCA. Nick Walker (1991: 187) reported that the Hietshware still live along the Shashe River in Botswana, but that they have lost many of their customs and much of their distinctive identity. In the adjacent Zimbabwean part of the LSCA some individuals of Khoisan-speaker descent, presumably therefore of Hietshware descent, were still living as recently as the 1950s. A Northern Sotho and two Venda locals, Johannes T., Maime N. and Nyamu-kamadhi K., told one of us (Eastwood) that in the 1950s they had observed Vhasarwa (tshiVenda for Khoisan-speaking foragers) camps of grass huts in the mopane veld away from the sandstone koppies of the Limpopo River valley. They emphasised that the men carried bows and poisoned arrows. Another local (Shona), Faru M., claimed to have known a Khoisan-speaking medicine man by the name of Toma. Toma was said to have been very skilled in the use of divining dice for the diagnosis of illness and in the use of veld medicines. What gives credibility to the claim that Toma was of Khoisan-speaking descent is that he is said to have worn an animal skin loincloth, to have always had a bow and quiver of arrows by his side, and to have been an exceptionally skilled hunter and healer.

The linguistic evidence when combined with this oral testimony therefore leads us to the firm conclusion that the LSCA fine-line forager painters were eastern Khoe speakers,[2] very likely ancestors of the Hietshware and, if not Hietshware, then at least people very much like the Hietshware. There is a single piece of evidence that seems to confirm that, in the past, the Hietshware were rock painters.

Dornan writes as follows:

> The artist, a half-bred Bushman, first took a pebble and rubbed the surface of the granite boulder on which he was going to paint as smooth as he could, and wiped away all the dust carefully. Then he took a burnt stick and drew the outline of the figure, in this case a zebra. Next he took his lump of dry paint, his crayon in fact, and rubbed it over the figure, roughly filling in the outline. Then he brushed away all the dust, and then he took a small feather brush, some liquid paint which he heated in a small hollow pebble, and laid this carefully on the figure, and the painting was complete. He painted a zebra, a tortoise, a porcupine and some guinea-fowl, and it took him the best part of three hours to complete the set of pictures, for which he was paid five shillings. The figures were quite small, only about three inches high, and he did not work hard, as he stopped to smoke more than once (Dornan 1925: 188–189).

The exact location of this event is unknown and we have not been able to relocate the site where the painting was made. Dornan's description seems to imply one of the granite outcrops between the Tuli–Shashe confluence in the south and Bulawayo–Francistown in the north. Walker (1991: 187) suggests a location north of the Shashe in the vicinity of the Sansukwe River, a tributary of the Shashe River (Figure 5.2). More than the exact location, of crucial importance for us is that Dornan records that this painter, and three other painters whom he names (1917: 49, 1925: 182), were all of the "Sansokwe peoples" whom he clearly identifies as Hietshware (Dornan 1917: 37–38, 1925: 67). Significantly, Dornan (1917: 38) also noted the presence of Hietshware on the Motloutse River, an area which falls within the LSCA (Figure 5.2).

The subjects painted by Dornan's artist are not typical of the animals depicted in the LSCA art, with the exception of the zebra. However, the technique of outlining the painting with crayon and then providing a painted infill is a technique we have identified as characteristic of the LSCA and its environs (e.g. Eastwood & Tlouamma 2002: 58). There is a number of examples of LSCA painting where crayon or painted outlines are discernible in painted images, where the paint has not been accurately applied to cover the outline. Infrequently, unpainted outline images in crayon are also found. The importance of Dornan's observation of this unusual painting technique will become clearer as, in the light of our knowledge of the cognitive and cultural affiliations of the painters of the LSCA, we now return to consider the particular similarities between the LSCA and Tsodilo (and the differences with Matopos, Brandberg, Drakensberg and Cederberg).

EVIDENCE FROM THE ROCK ART

Some 1000 km north-west of the LSCA lie the famous Tsodilo Hills in north-western Botswana. The rock art of the Tsodilo Hills can be divided into a number of traditions, discernible by technique, pigment preference, subject matter and manner of depiction. Walker (1998: 217–218) categorises these paintings into two groups: red/yellow ochre paintings and, later, white finger paintings.

In the first category he includes outline animals such as zebra, eland, cattle and kudu, together with silhouette (blocked) animals such as elephant, giraffe, gemsbok, hyena and rhinoceros, crude anthropomorphic figures, and a variety of geometric designs including grids, double parallelograms, and circular motifs. The second category includes oval grids, 'circle cluster' motifs, animals – including domestic animals – and anthropomorphic figures. These are executed in a manner of depiction that is diagnostic of Bantu speakers (Smith 1997; Smith & van Schalkwyk 2002). For the White Painting shelter, Campbell *et al.* (1994: 152) provide evidence that the paintings must have been made by Bantu speakers.

In this chapter we are specifically concerned with Walker's first, red/yellow ochre category. Smith and Ouzman's (2004) recent study of the distribution of geometric herder art allows us to break this category into two parts:

- blocked and outline animals, and blocked 'animal skins', shield shapes and triangular motifs, which we label the 'Tsodilo Forager Monochromes';
- red 'geometric' herder finger paintings of circular motifs, ladders, 'skins', herringbones, and finger marks and handprints.

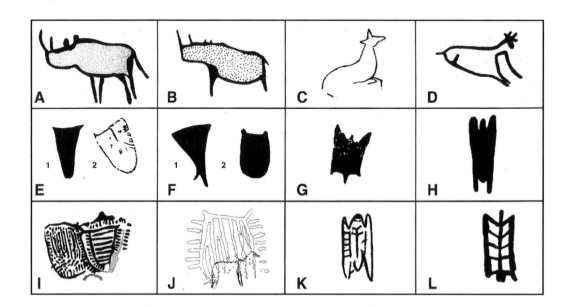

FIGURE 5.8 Comparisons of painting technique and subject matter in the central Limpopo Basin and the Tsodilo Hills.

A. Rhinoceros painting in outline and infill in red pigment. Northern Venda.
B. Rhinoceros painting in outline and infill in red pigment. Tsodilo Hills (after Campbell *et al.* 1994: figure 15).
C. Outline antelope in red pigment. Limpopo-Shashe Confluence Area.
D. Outline antelope in red pigment. Tsodilo Hills (traced from a photograph).
E1. Semi-triangular loincloth in red pigment. Soutpansberg.
E2. Outline, shield-shaped apron in red pigment. Limpopo-Shashe Confluence Area.
F1. Triangular loincloth in red pigment. Tsodilo Hills (traced from a photograph).
F2. Shield-shaped apron. Tsodilo Hills. Red pigment (traced from a photograph).
G. Animal skin apron in red pigment. Limpopo-Shashe Confluence Area.
H. Animal skin apron in red pigment. Tsodilo Hills (traced from a photograph).
I. Red finger-painted geometric aprons. Limpopo-Shashe Confluence Area.
J. White finger-painted geometric apron with fine-line animal painted under it. Limpopo-Shashe Confluence Area.
K. Red geometric finger-painted apron. Tsodilo Hills (after Campbell *et al.* 1994: figure 7.7e).
L. Red geometric finger-painted apron. Tsodilo Hills (after Walker 1998: figure 9.12).

Here we are concerned only with the Tsodilo Forager Monochromes and their relationship with the fine-line forager art of the LSCA. We note that both areas have extensive assemblages of geometric herder art.

The Tsodilo Forager Monochromes fall within the crude type of fine-line forager art that we have recognised. The art is significantly more scant in the use of fine detail than the forager art of the Matopos and Brandberg, for example (both about 900 km away). The most similar art in terms of technique is the fine-line forager art of the LSCA and northern Venda. While there are a few differences (for example there are many more paintings of women in the LSCA and many more cattle painted at Tsodilo), the similarities are far more striking. As well as a certain crudeness in the technique of painting, three additional points of similarity emerge. First, in both areas the forager paintings were executed using the particular outline technique that was observed by Dornan (see above). This technique is peculiar to the LSCA and Tsodilo. Outlined figures (sometimes applied by finger) may be left either as outlines or given a lighter infill (see Figures 5.8A–D for comparison). The second strong similarity is the remarkably high species diversity in the paintings of both areas: 30 species-specific animals are depicted at Tsodilo (Campbell *et al.* 1994: 139) and 39 in the LSCA.

While these similarities are highly significant, a third correspondence is even more crucial: the fact that loincloths and aprons are present in significant numbers in both areas. Campbell *et al.* (1994: 142) identify 2.5 per cent of the total number of painted images in the Tsodilo Hills as representing 'animal skins', images that we identify as aprons. We contend that the number of aprons depicted at Tsodilo is far higher than this. Many of the images that Campbell *et al.* label ladders (0.7%), shields (3.2%) and squares (4.2%) in fact fall within the category of image-form that we have identified as aprons and loincloths (Eastwood 2003). In Figure 5.8, for example, one can see that the red monochrome triangular and 'animal skin' motifs at Tsodilo Hills correspond to male loincloths and female aprons in the fine-line forager paintings of the LSCA respectively (Figures 5.8E–H). Moreover, plain shield-shape aprons are numerous at Tsodilo Hills (n=35; Campbell *et al.* 1994: table 5), and are similar to the shield-shaped aprons of the LSCA. Even allowing that there is some diversity in

Campbell *et al.*'s categories and that we suspect that some of the individual paintings in them need to be placed within the separate herder art tradition (Smith & Ouzman 2004), we are confident that the number of depictions of loincloths and aprons in the Tsodilo Hills is at least 10.6 per cent of the total number of images. The percentage in the LSCA is 8.8 per cent of the total; these figures are far too similar to be coincidental, especially given that in all other painted areas of southern Africa these motifs are either not present or make up less than one per cent.

Moreover, Tsodilo Forager Monochrome apron motifs are closely juxtaposed with (in order of frequency) gemsbok, kudu, and giraffe (Campbell *et al.* 1994: table 7). In the LSCA the three most frequently juxtaposed animals are kudu, giraffe and impala (in that order). Significantly, zebra, rhinoceros, gemsbok, eland and ostrich are also frequently juxtaposed with the loincloth/apron motif in both areas.

We contend that the extent and breadth of similarities between the art of Tsodilo and the LSCA and, in particular, the numerous depictions of loincloths and aprons in both areas, can only be explained by the existence of a cognitive and cultural link between the two areas. To determine whether this is indeed the case, we need to examine the question of the authorship of the forager art at Tsodilo Hills.

Fortunately, there is pertinent oral evidence. Three groups are known to have lived at Tsodilo Hills (Johnson *et al.* 1979: 14; Wilmsen 1989: 207; Campbell *et al.* 1994: 135, 155; Taylor 1998: 359; Walker 1998: 22). The first were the ancestors of the modern N/hae, a group that remained foragers until recent times (referred to as 'Gokwe' by Passarge [1907], they are reported to have been living at Tsodilo in 1893). Oral traditions state that they were displaced by the Ju/'hoansi groups (non-Khoe speakers) who still live at Tsodilo today. The third inhabitants of the area are the Bantu-speaking Hambukushu. The first known inhabitants, the N/hae or Gokwe, along with the //Anikhwe, Bumakhwe and Bugakhwe, are subgroups of the Khwe (Kxoe) language group of foragers (W. le Roux and K. Mmaba pers. comm. 2004; see also Westphal 1963: 250) and show close linguistic relationships to the Nharo – they are Khoe speakers (Barnard 1992: chapter 7). While it is not clear if the Ju/'hoansi make a distinction between the various traditions of rock art in the

Tsodilo Hills, it is clear that they do not claim that they themselves made any of the images, bar one panel of white paintings consisting of horses and people (Campbell & Coulson 1988: 15). We do not challenge this; it is well known that the Ju/'hoansi have no history of rock painting (Lewis-Williams 1981; Biesele 1993). As the Ju/'hoansi are the only non-Khoe Khoisan speakers in this area, both at present and in what is known of the past, it seems certain that, if the ancestors of N/hae were not themselves the painters, then the painters would have been a related group of Khoe-speaking foragers such as the neighbouring Bugakhwe (see also Chumbo & Mmaba 2002: 8).

Like the painters of the LSCA, the painters of Tsodilo were therefore Khoe speakers. We suggest that this explains the similarities between the forager art of the two areas; and the differences between the art of these two areas and the art of the Matopos, Drakensberg, Brandberg and Cederberg. Khoe speakers were cognitively and culturally distinct because of the level of influence upon them derived from Khoekhoe herders. Just as linguists note extensive borrowing between these two groups, so do ethnographers (e.g. Schapera 1930: 395–399; Barnard 1992: 16–36; Biesele 1993: 34–37; Guenther 1999: 87–88). Evidence of cross-influence in the rock art should therefore be anticipated.

One direct piece of evidence of borrowing between forager and herder arts in the LSCA and Tsodilo is in the loincloth/apron motif. While the apron and loincloth motifs that we have discussed all form part of the fine-line forager paintings, there is at least one class of image in the geometric herder art assemblage that can be clearly identified as aprons. These are shield shapes – usually depicted as an elongated half-circle (Eastwood 2003). We have identified 18 herder tradition aprons at eight sites in the LSCA and northern Venda. In six of these sites they are associated with fine-line forager images of aprons. The technique of painting these aprons in the LSCA (Figures 5.8I, 5.8J) corresponds to the unblocked red finger-painted animal skins, ladders, shields and double parallelograms in Tsodilo, suggesting that these paintings are also Khoekhoe aprons (Figures 5.8K, 5.8L) and form a part of the Tsodilo herder art assemblage. The apron image is therefore one that spans the divide between fine-line forager and herder rock arts (Eastwood 2003). It provides definite evidence that borrowing occurred between these traditions, a form of artistic influence that we suggest explains the unusual appearance of the forager arts of Tsodilo and the LSCA.

One of the keys, we contend, to recognising Khoe-speaking forager rock art is in the distribution of loincloth and apron motifs in southern Africa. Whereas the rock art of the Khoe-speaking painters of the LSCA and the Tsodilo Hills has high numbers of images of loincloths and aprons, this motif is all but absent in areas where forager art was made by non-Khoe speakers. There appear to be none in the extensive published recordings by Harald Pager from the Brandberg (Pager 1989, 1993, 1995, 1998) or in those by Nick Walker from the Matopos (Walker 1996). In the thousands of large and well-known rock art sites of the Drakensberg complex there are only a handful of such images (e.g. Vinnicombe 1976: figure 75b; Woodhouse 1995: plate 52). In Mpumalanga only one painting of an apron has been discovered (Hampson *et al.* 2002: 234); in the Western Cape, too, they are either absent or make up a negligible part of the total number of images (Jeremy Hollmann pers. comm. 2002). They seem more common in the rock engravings of the interior plateau (Fock & Fock 1989; Sven Ouzman pers. comm. 2002), particularly in places where there is known to have been a strong Khoekhoe influence. We believe the seemingly incongruent occurrence of aprons and loincloths in this area is explained by this influence. When plotted on a map, the distribution pattern could hardly be more convincing: in the areas where Khoe speakers are/were found, aprons and loincloths are prevalent in the rock art, but in the areas where non-Khoe speakers lived loincloths and aprons are all but absent (see Figure 5.7).

IMPLICATIONS

Although arguments have been put forward that demonstrate the Khoekhoe and Bantu-speaker authorship of some rock art in southern Africa, this is, to the best of our knowledge, the first time a body of rock art outside of the Tsodilo Hills has been shown to have been made by Khoe-speaking foragers. There are at least three important implications of this

conclusion for southern African rock art. We discuss each in turn.

First, the recognition that Khoe-speaking foragers made the fine-line images in the LSCA raises questions about the use of appropriate ethnography. Some images, such as those of humans dancing and depictions of eland, are well explained in terms of pan-forager beliefs and rituals (e.g. Lewis-Williams & Biesele 1978). While not wishing to abandon this explanatory potential, we believe that other images in the rock art of the LSCA may best be interpreted by recourse to the more specific ethnography of Khoe-speakers – and, in particular, eastern Khoe-speakers. Unfortunately, ethnographic accounts of Hietshware and, indeed, eastern Khoe-speakers' beliefs and rituals are limited (Barnard 1992: chapter 7) and therefore some of the information required to elucidate the symbolism of the LSCA may not be documented. In the absence of eastern Khoe-speakers' ethnography we have to rely on ethnography from other Khoe-speaking foragers. Importantly, groups such as the Nharo, G/wi and Khwe (classified as western, central and northern Khoe-speakers respectively) share cultural traits with the Hietshware (Guenther 1989: 60; Barnard 1992: 117, 123; cf. Valiente-Noailles 1993: 8–10), so such ethnography would be next in line in terms of direct relevance. We contend that this kind of focused scrutiny of the ethnography will prove crucial to unravelling the more idiosyncratic features of LSCA rock art, such as the images of loincloths and aprons. Our demonstration that these images are found in significant numbers only in areas where Khoe speakers occurred historically implies that their symbolic associations will only be understood by recourse to the values imbued upon these items by Khoe-speaking communities.

Secondly, our findings suggest strongly that the unusual appearance and content of LSCA fine-line rock art are products of the particular influence of Khoekhoe peoples on the autochthonous foragers of this area. This suggestion finds significant support in the linguistic evidence whereby the intruding Khoe languages came to dominate over the older autochthonous languages and in the fact that a number of the unusual features in the rock art appear to derive from (or at least are shared by) Khoekhoe rock art. For example, the crudeness of both animal and human depictions in the LSCA is more reminiscent of the finger-painted manner introduced by the Khoekhoe than the fine brushwork typical of forager paintings in other parts of southern African. Also, recent discoveries in northern Venda and the Makgabeng Plateau have brought to light a significant number of cases where loincloths and aprons are found applied using the Khoekhoe finger-painted technique and associated with Khoekhoe geometric paintings. Aprons and loincloths thus provide at least one subject that bridges forager and Khoekhoe art in this area. Just as the evidence of interaction between Khoekhoe herders and the autochthones is inherent in the content of the art, so it is also apparent in the overlay sequences at larger shelters. Finger-painted Khoekhoe images are found both over and under the fine-line brush technique images of the LSCA and Makgabeng Plateau, showing that the two communities shared and painted in the same shelters (Hall & Smith 2000: 42–44; Eastwood & Eastwood 2006: chapter 7).

The recognition of a Khoe-speaking forager art poses questions about the broader diversity of forager rock arts in southern Africa. For example, it is known that Khoe speakers in general place a greater emphasis on girls' puberty rites, and that these rituals are more elaborate than those of non-Khoe speakers (Barnard 1980: 117, 1992: 112), at least in the Kalahari, so can such differences in ritual emphasis between Khoe- and non-Khoe speakers be discerned in their respective rock arts? Because distinctive features such as the apron motif seem to be absent from the Matopos and the Brandberg, where painting activity mainly pre-dated Khoekhoe herder incursions (Pager 1989: 33, 1993: 30; Walker 1996: 14), does this suggest distinctive Khoe-speaking and non-Khoe-speaking forager painting traditions throughout southern Africa? This and other questions may be partially resolved by further study of the distinctive features found in central Limpopo Basin and Tsodilo rock art, by a careful unpacking of the archaeological record of both areas, and by more detailed inter-regional rock art studies.

Thirdly, the existence of significant numbers of images of aprons and loincloths in the engravings of parts of southern Africa raises questions about the authorship of these engravings. Indeed, these engravings are found in areas where Khoekhoe herders, but not always Khoe-speaking foragers, were found

historically. While this again suggests that images of loincloths and aprons were a particular interest of Khoekhoe peoples, it also suggests that the authors of many of the engravings in the interior of southern Africa were Khoekhoe herders. This goes some way to understanding some of the important differences among southern African paintings and engravings.

These three implications form the topics of ongoing research that will advance our appreciation of the complexity and diversity of southern African rock art. The recognition that a diversity of peoples produced rock art opens up exciting prospects for the study of their interactions; and of the flow and reshaping of particular cosmologies.

Acknowledgements

Palaeo-Art Field Services received support from the De Beers Fund, the Anglo American Chairman's Fund, the Swan Fund, the South African Heritage Resources Agency and the Trans-Vaal Branch of the South African Archaeological Society. The Rock Art Research Institute is funded by the National Research Foundation and the University of the Witwatersrand. We thank the traditional leaders, farm owners, managers and custodians of rock art in the central Limpopo Basin for allowing us access to rock art sites. We are grateful to T. Johannes, M. Faru and K. Nyamukamadhi for talking to us about the Limpopo San, and Colin Bristow for his interpreting skills. Cathelijne Eastwood, Simon Hall, Tom Huffman, David Lewis-Williams and Sven Ouzman commented on various drafts of this chapter. Bruce Murray and Laura van Zyl provided the maps and composite line drawings.

Notes

1 Ed Eastwood passed away during the preparation of this volume. The editors pay tribute to an archaeologist who made an exceptional contribution to the field of rock art studies.

2 In this chapter we use the terms Khoekhoe herders or Khoe-speaking foragers respectively so as to avoid confusion. It should be noted, however, that the term 'Khoe-speaking foragers' may be misleading because the eastern Khoe peoples have had a long history of interaction with herders and farmers and a hybrid culture of some antiquity (Barnard 1992: 117). Nevertheless, 'forager' distinguishes the herders, or historical Khoekhoen, from Khoe-speaking 'Bushmen'.

References

Barnard, A. 1980. Sex roles among the Nharo Bushmen of Botswana. *Africa* 50: 115–124.

Barnard, A. 1992. *Hunters and Herders of Southern Africa: A Comparative Ethnography of the Khoisan Peoples.* Cambridge: Cambridge University Press.

Biesele, M. 1993. *Women Like Meat: The Folklore and Foraging Ideology of the Kalahari Ju/'hoan.* Johannesburg: Witwatersrand University Press.

Bleek, D.F. 1928. *The Naron, a Bushman Tribe of the Central Kalahari.* Cambridge: Cambridge University Press.

Bleek, D.F. 1956. *A Bushman Dictionary.* New Haven (CT): American Oriental Society, American Oriental Series 41.

Blundell, G. & Eastwood, E.B. 2001. Identifying Y-shapes in the San rock art of the Limpopo-Shashe Confluence Area: new ethnographic and painted evidence. *South African Journal of Science* 97: 301–308.

Burkitt, M.C. 1928. *South Africa's Past in Stone and Paint.* Cambridge: Cambridge University Press.

Calabrese, J. 2000. Interregional interaction in southern Africa: Zhizo and Leopard's Kopje relations in northern South Africa, southwestern Zimbabwe and eastern Botswana, AD 1000 to 1200. *African Archaeological Review* 17: 183–210.

Campbell, A. & Coulson, D. 1988. Cultural confrontation at Tsodilo. *Optima* 36: 12–19.

Campbell, A., Denbow, J. & Wilmsen, E.N. 1994. Paintings like engravings: rock art at Tsodilo Hills. In: Dowson, T.A. & Lewis-Williams, J.D. (eds) *Contested Images: Diversity in Southern African Rock Art Research*: 131–158. Johannesburg: Witwatersrand University Press.

Chumbo, S. & Mmaba, K. 2002. *The Khwe of the Okavango Panhandle: The Past Life.* Shakawe: The Teemacane Trust.

Deacon, J. 1988. The power of a place in understanding Southern San rock engravings. *World Archaeology* 20: 129–140.

Deacon, J. 1993. Management guidelines for rock art sites in two wilderness areas in the Western Cape. Unpublished report for Department of Environmental Affairs and Tourism.

Deacon, J. 1994. Rock engravings and the folklore of Bleek and Lloyd's /Xam informants. In: Dowson, T.A. & Lewis-Williams, J.D. (eds) *Contested Images: Diversity in Southern African Rock Art Research*: 237–256. Johannesburg: Witwatersrand University Press.

Deacon, J. 1998. 'My heart stands in the hill': rock engravings in the Northern Cape. In: Banks, A., Heese, H. & Loff, C. (eds) *The Proceedings of the Khoisan Identities and Cultural Heritage Conference*: 135–141. Cape Town: University of the Western Cape.

Dornan, S.S. 1917. The Tati Bushmen (Masarwas) and their language. *Journal of the Royal Anthropological Institute* 47: 37–112.

Dornan, S.S. 1925. *Pygmies & Bushmen of the Kalahari: An Account of the Hunting Tribes Inhabiting the Great Arid Plateau of the Kalahari Desert, Their Precarious Manner of Living, Their Habits, Customs & Beliefs, with some Reference to Bushman Art, both Early & of Recent Date, & to the Neighbouring African Tribes.* London: Seeley, Service & Co. Ltd.

Eastwood, E.B. 1999. Red lines and arrows: attributes of supernatural potency in San rock art of the Northern Province, South Africa and south-western Zimbabwe. *South African Archaeological Bulletin* 54: 16–27.

Eastwood, E.B. 2003. A cross-cultural motif in San, Khoekhoe and Northern Sotho rock paintings of the Central Limpopo Basin, southern Africa. *South African Archaeological Bulletin* 58: 14–26.

Eastwood, E.B. 2005. From girls to women: female imagery in the San rock paintings of the Central Limpopo Basin, southern Africa. *Before Farming: The Archaeology and Anthropology of Hunter-gatherers* [online version] 2005/3 article 2.

Eastwood, E.B. & Blundell, G. 1999. Rediscovering the rock art of the Limpopo-Shashi Confluence Area, southern Africa. *Southern African Field Archaeology* 8: 17–27.

Eastwood, E.B., Bristow, C. & van Schalkwyk, J.A. 1999. Animal behaviour and interpretation in San rock art: a preliminary study in south-western Zimbabwe and the Northern Province of South Africa. *Southern African Field Archaeology* 8: 60–75.

Eastwood, E.B. & Cnoops, C.J.H. 1999a. Results of the Limpopo-Shashi Confluence Area rock art survey: a quantitative and interpretive study. Unpublished report for the De Beers Fund.

Eastwood, E.B. & Cnoops, C.J.H. 1999b. Capturing the spoor: towards explaining kudu in San rock art of the Limpopo-Shashi Confluence Area. *South African Archaeological Bulletin* 54: 107–119.

Eastwood, E.B., Cnoops, C.J.H. & Straughan, P. 2000. Results of the Soutpansberg rock art survey. Unpublished report for the De Beers Fund.

Eastwood, E.B. & Eastwood, C.J.H. 2006. *Capturing the Spoor: An Exploration of Southern African Rock Art.* Cape Town: David Philip.

Eastwood, E.B. & Fish, W.S. 1996. Sheep in the rock paintings of the Soutpansberg and Limpopo River Valley. *Southern African Field Archaeology* 5: 59–69.

Eastwood, E.B & Smith, B.W. 2005. Fingerprints of the Khoekhoen: geometric and handprinted tradition rock paintings of the Central Limpopo Basin, southern Africa. *South African Archaeological Society Goodwin Series* 9: 63–76.

Eastwood, E.B & Tlouamma, J.N. 2002. The rock art of the Makgabeng Plateau. Volume 2: Nieuwe Jerusalem. Unpublished report for the Swan Fund.

Ehret, C. 1982. The first spread of food production to southern Africa. In: Ehret, C. & Posnansky, M. (eds) *The Archaeological and Linguistic Reconstruction of African History*: 151–181. Berkeley (CA): University of California Press.

Elphick, R. 1977. *Kraal and Castle: Khoikhoi and the Founding of White South Africa*. New Haven (CT): Yale University Press.

Fock, G.J. & Fock, D.M.L. 1989. *Felsbilder in Südafrika Teil III: Die Felsbilder im Vaal-Oranje-Becken*. Köln: Böhlau Verlag.

Garlake, P.S. 1987. *The Painted Caves*. Harare: Modus.

Garlake, P.S. 1989. The power of the elephant: scenes of hunting and death in the rock paintings of Zimbabwe. *Heritage of Zimbabwe* 8: 9–33.

Garlake, P.S. 1995. *The Hunter's Vision*. Harare: Zimbabwe Publishing House.

Greenberg, J.H. 1950. Studies in African linguistic classification: IV. The click languages. *Southwestern Journal of Anthropology* 6: 223–237.

Guenther, M.G. 1989. *Bushman Folktales: Oral Traditions of the Nharo of Botswana and the /Xam of the Cape*. Stuttgart: Franz Steiner Verlag Wiesbaden, Studien zur Kulturkunde 93.

Guenther, M.G. 1994. The relationship of Bushman art to ritual and folklore. In: Dowson, T.A. & Lewis-Williams, J.D. (eds) *Contested Images: Diversity in Southern African Rock Art Research*: 257–274. Johannesburg: Witwatersrand University Press.

Guenther, M.G. 1999. *Tricksters and Trancers: Bushman Religion and Society*. Bloomington (IN): Indiana University Press.

Halkett, D. 1987. Archaeology of the Putslaagte. In Parkington, J. & Hall, M. (eds) *Papers in the Prehistory of the Western Cape, South Africa*: 377–392. Oxford: British Archaeological Reports International Series 332(ii).

Hall, S.L. & Smith, B.W. 2000. Empowering places: rock shelters and ritual control in farmer-forager interactions in the Northern Province. *South African Archaeological Society Goodwin Series* 8: 30–46.

Hammond-Tooke, W.D. 2000. 'Ethnicity'and 'ethnic group' in Iron Age southern Africa. *South African Journal of Science* 96: 421–422.

Hampson, J., Challis, W., Blundell, G. & De Rosner, C. 2002. The rock art of Bongani Mountain Lodge and its environs, Mpumalanga Province, South Africa: an introduction to problems of southern African rock art regions. *South African Archaeological Bulletin* 57: 15–30.

Hanisch, E.O.H. 1979. Excavations at Icon, northern Transvaal. *South African Archaeological Society Goodwin Series* 3: 72–79.

Hanisch, E.O.H. 1980. An archaeological interpretation of certain Iron Age sites in the Limpopo/Shashi valley. Unpublished MA thesis. Pretoria: University of Pretoria.

Hanisch, E.O.H. 1981. The northern Transvaal: environment and archaeology. In: Voigt, E.A. (ed.) *Guide to Archaeological Sites in the Northern Transvaal and Eastern Transvaal*: 1–6. Pretoria: Transvaal Museum.

Hodder, I. 1985. Postprocessual archaeology. In: Schiffer, M. (ed.) *Advances in Archaeological Method and Theory* 8: 1–26. New York (NY): Academic Press.

Hollmann, J. 1993. Preliminary report on the Koebee rock paintings, Western Cape Province, South Africa. *South African Archaeological Bulletin* 48: 16–25.

Hollmann, J. (ed.) 2004. *Customs and Beliefs of the /Xam Bushmen*. Johannesburg: Witwatersrand University Press.

Honken, H. 1977. Submerged features and proto-Khoisan. In: Traill, A. (ed.) *Khoisan Linguistic Studies* 3: 145–169. Johannesburg: African Studies Institute.

Huffman, T.N. 1983. The trance hypothesis and the rock art of Zimbabwe. *South African Archaeological Society Goodwin Series* 4: 49–53.

Huffman, T.N. 1989. *Iron Age Migrations: The Ceramic Sequence in Southern Zambia*. Johannesburg: Witwatersrand University Press.

Huffman, T.N. 2000. Mapungubwe and the origins of the Zimbabwe culture. *South African Archaeological Society Goodwin Series* 8: 14–29.

Johnson, M. 1999. *Archaeological Theory: An Introduction*. Oxford: Blackwell.

Johnson, P., Bannister, A. & Wannenburgh, A. 1979. *The Bushmen*. London: Country Life Books.

Kinahan, J. 1991. *Pastoral Nomads of the Central Namib Desert*. Windhoek: New Namibia.

Köhler, O. 1966. Die Wortbeziehungen zwischen der Sprake Kxoe-Buschmanner und dem Hottentotischen als geschichtliches problem. In: Lukas, J. (ed.) *Neue Afrikanistische Studien*: 144–165. Hamburg: Deutsches Institut für Afrika-Forschung.

Laue, G. 1999. Rock art of the Uniondale district: the significance of regionality in southern African rock art. Unpublished BA Honours thesis. Johannesburg: University of the Witwatersrand.

Laue, G. 2000. Taking a stance: posture and meaning in the rock art of the Waterberg, Northern Province, South Africa. Unpublished MSc thesis. Johannesburg: University of the Witwatersrand.

Lee, R.B. 1984. *The Dobe !Kung*. New York: Rinehart and Winston.

Lenssen-Erz, T. 1994. Jumping about: springbok in the Brandberg rock paintings and in the Bleek and Lloyd Collection: an attempt at a correlation. In: Dowson, T.A. & Lewis-Williams, J.D. (eds) *Contested Images: Diversity in Southern African Rock Art Research*: 275–292. Johannesburg: Witwatersrand University Press.

Lenssen-Erz, T. & Erz, M-T. 2000. *Brandberg: Der Bilderberg Namibias*. Stuttgart: Thorbecke.

Lewis-Williams, J.D. 1972. The syntax and function of the Giant's Castle rock paintings. *South African Archaeological Bulletin* 27: 49–65.

Lewis-Williams, J.D. 1974. Superpositioning in a sample of rock paintings in the Barkly East district. *South African Archaeological Bulletin* 29: 93–103.

Lewis-Williams, J.D. 1981. *Believing and Seeing: Symbolic Meanings in Southern San Rock Paintings*. London: Academic Press.

Lewis-Williams, J.D. 1983. *The Rock Art of Southern Africa*.

Cambridge: Cambridge University Press.

Lewis-Williams, J.D. 1991. Wrestling with analogy: a methodological dilemma in Upper Palaeolithic rock art research. *Proceedings of the Prehistoric Society* 57: 149–162.

Lewis-Williams, J.D. 1998. *Quanto?* The issue of 'many meanings' in southern African rock art research. *South African Archaeological Bulletin* 53: 86–97.

Lewis-Williams, J.D. & Biesele, M. 1978. Eland hunting rituals among Northern and Southern San groups: striking similarities. *Africa* 48: 117–134.

Lewis-Williams, J.D. & Dowson, T.A. 1994. Aspects of rock art research: a critical perspective. In: Dowson, T.A. & Lewis-Williams, J.D. (eds) *Contested Images: Diversity in Southern African Rock Art Research*: 201–221. Johannesburg: Witwatersrand University Press.

Loubser, J.H.N. & Laurens, G. 1994. Depictions of ungulates and shields: hunter-gatherers and agropastoralists in the Caledon River Valley area. In: Dowson, T.A. & Lewis-Williams, J.D. (eds) *Contested Images: Diversity in Southern African Rock Art Research*: 83–118. Johannesburg: Witwatersrand University Press.

Low, A.B. & Rebelo, A.G. 1996. *Vegetation of South Africa, Lesotho & Swaziland: A Companion to the Vegetation Map of South Africa, Lesotho and Swaziland*. Pretoria: Department of Environmental Affairs and Tourism.

Maggs, T.M.O'C. 1967. A quantitative analysis of the rock art from a sample area in the western Cape. *South African Journal of Science* 63: 100–104.

Maggs, T.M.O'C. & Sealy, J. 1983. Elephants in boxes. *South African Archaeological Society Goodwin Series* 4: 44–48.

Malan, B.D. 1965. The classification and distribution of rock art in South Africa. *South African Journal of Science* 61: 427–430.

Marshall, L. 1957. N!ow. *Africa* 27: 232–240.

Marshall, L. 1962. !Kung Bushmen religious beliefs. *Africa* 32: 221–251.

Marshall, L. 1969. The medicine dance of the !Kung Bushmen. *Africa* 39: 347–381.

Marshall, L. 1976. *The !Kung of Nyae Nyae*. Cambridge (MA): Harvard University Press.

Mason, R. 1962. *Prehistory of the Transvaal*. Johannesburg: Witwatersrand University Press.

Meyer, A. 1997. Settlement sequence in the central Limpopo Valley: the Iron Age sites of Greefswald. *Research by the National Cultural History Museum* 6: 9–42.

Meyer, A. 1998. *The Archaeological Sites of Greefswald: Stratigraphy and Chronology of the Sites and a History of Investigations*. Pretoria: University of Pretoria.

Ouzman, S. & Loubser, J.H.N. 2000. Art of the Apocalypse: southern African Bushmen left the agony of their end time on rock walls. *Discovering Archaeology* 2(5): 38–45.

Pager, H. 1971. *Ndedema: A Documentation of the Rock Paintings of the Ndedema Gorge*. Graz: Ackademische Druck.

Pager, H. 1975. Rock paintings depicting fish traps in the Limpopo valley. *South African Journal of Science* 71: 119–121.

Pager, H. 1989. *The Rock Paintings of the Upper Brandberg, Part I: Amis Gorge.* Cologne: Heinrich-Barth-Institut.

Pager, H. 1993. *The Rock Paintings of the Upper Brandberg, Part II: Hungorob Gorge.* Cologne: Heinrich-Barth-Institut.

Pager, H. 1995. *The Rock Paintings of the Upper Brandberg, Part III: Southern Gorges.* Cologne: Heinrich-Barth-Institut.

Pager, H. 1998. *The Rock Paintings of the Upper Brandberg, Part IV: Umuab and Karaob Gorges.* Cologne: Heinrich-Barth-Institut.

Parkington, J.E. 1984. Changing views of the Late Stone Age of South Africa. In: Wendorf, F. & Close, A.E. (eds) *Advances in World Archaeology* 3: 89–142.

Passarge, S. 1907. *Die Buschmänner der Kalahari.* Berlin: Dieter Reimer.

Prinsloo, H.P. 1974. Early Iron Age site at Klein Afrika, Wylliespoort, Zoutpansberg Mountains, South Africa. *South African Journal of Science* 70: 271–272.

Reid, A., Sadr, K. & Hanson-James, N. 1998. Herding traditions. In: Lane, P., Reid, A. & Segobye, A. (eds) *Ditswa Mmung: The Archaeology of Botswana*: 81–100. Gaborone: The Botswana Society and Pula Press.

Rudner, J. & Rudner I. 1970. *The Hunter and His Art.* Cape Town: Struik Publishers.

Schapera, I. 1930. *The Khoisan Peoples of South Africa.* London: George Routledge & Sons.

Schoonraad, M. 1960. Preliminary survey of the rock art of the Limpopo Valley. *South African Archaeological Bulletin* 15: 10–13.

Skotnes, P. 1996. The thin black line: diversity in the paintings of the southern San and the Bleek and Lloyd Collection. In: Dowson, T.A. & Lewis-Williams, J.D. (eds) *Contested Images: Diversity in Southern African Rock Art Research*: 234–244. Johannesburg: Wits University Press.

Smith, B.W. 1997. *Zambia's Ancient Rock Art: The Paintings of Kasama.* Livingstone: National Heritage Conservation Commission.

Smith, B.W. 1998. The tale of the chameleon and the platypus: limited and likely choices in making pictures. In: Chippindale, C. & Taçon, P.S.C. (eds) *The Archaeology of Rock Art*: 212–228. Cambridge: Cambridge University Press.

Smith, B.W. & Ouzman. S. 2004. Taking stock: identifying Khoekhoen herder rock art in southern Africa. *Current Anthropology* 45: 499–526.

Smith, B.W. & van Schalkwyk, J.A. 2002. The white camel of the Makgabeng. *Journal of African History* 43: 235–254.

Taylor, M. 1998. These are our hills: processes of history, ethnicity and identity among Ju/'hoansi at Tsodilo. In: Banks, A., Heese, H. & Loff, C. (eds) *The Proceedings of the Khoisan Identities and Cultural Heritage Conference*: 351–363. Cape Town: University of the Western Cape.

Tucker, M. & Baird, R.C. 1983. The Trelawney/Darwendale rock art survey. *Zimbabwean Prehistory* 19: 26–58.

Valiente-Noailles, C. 1993. *The Kua: Life and Soul of the Central Kalahari Bushmen.* Rotterdam: Balkema.

Van der Ryst, M.M. 1998. *The Waterberg Plateau in the Northern Province, Republic of South Africa, in the Later Stone Age.* Oxford: British Archaeological Reports International Series 715.

Van Riet Lowe, C. 1952. *The Distribution of Prehistoric Rock Engravings and Paintings in South Africa.* Pretoria: Archaeological Survey, Archaeological Series 7.

Van Rijssen, W.J.J. 1984. South-western Cape rock art – who painted what? *South African Archaeological Bulletin* 39: 125–129.

Van Rijssen, W.J.J. 1985. The origin of certain images in the rock art of southern Africa. *Rock Art Research* 2: 146–157.

Van Rijssen, W.J.J. 1994. The question of authorship. In: Dowson, T.A. & Lewis-Williams, J.D. (eds) *Contested Images: Diversity in Southern African Rock Art Research*: 159–176. Johannesburg: Witwatersrand University Press.

Vinnicombe, P. 1976. *People of the Eland: San Rock Paintings of the Drakensberg as a Reflection of Their Life and Thought.* Pietermaritzburg: Natal University Press.

Walker, N.J. 1983. The significance of an early date for pottery and sheep in Zimbabwe. *South African Archaeological Bulletin* 38: 88–92.

Walker, N.J. 1991. Rock paintings of sheep in Botswana. In: Pager, S-A., Swartz, B. Jr. & Willcox, A. (eds) *Rock Art: The Way Ahead*: 54–60. Johannesburg: Southern African Rock Art Research Association.

Walker, N.J. 1994. The Late Stone Age of Botswana: some recent excavations. *Botswana Notes and Records* 26: 1–36.

Walker, N.J. 1995. *Late Pleistocene and Holocene Hunter-gatherers of the Matopos.* Uppsala: Societas Archaeologica Upsaliensis, Studies in African Archaeology 10.

Walker, N.J. 1996. *The Painted Hills: Rock Art of the Matopos.* Gweru: Mambo Press.

Walker, N.J. 1998. The Late Stone Age. In: Lane, P., Reid, A. & Segobye, A. (eds) *Ditswa Mmung: The Archaeology of Botswana*: 65–80. Gaborone: The Botswana Society and Pula Press.

Westphal, E.O.J. 1963. The linguistic prehistory of southern Africa: Bush, Kwadi, Hottentot and Bantu linguistic relationships. *Africa* 33: 237–265.

Willcox, A.R. 1963a. *The Rock Art of South Africa.* Johannesburg: Thomas Nelson & Sons.

Willcox, A.R. 1963b. Painted petroglyphs at Balerno in the Limpopo Valley, Transvaal. *South African Journal of Science* 59: 108–110.

Wilmsen, E.N. 1989. *Land Filled with Flies: A Political Economy of the Kalahari*. Chicago (IL): Chicago University Press.

Woodhouse, H.C. 1995. *The Rock Art of the Golden Gate and Clarens Districts: An Enthusiast's Guide*. Rivonia: William Waterman.

Yates, R., Golson, J. & Hall, M. 1985. Trance performance: the rock art of Boontjieskloof and Sevilla. *South African Archaeological Bulletin* 40: 70–80.

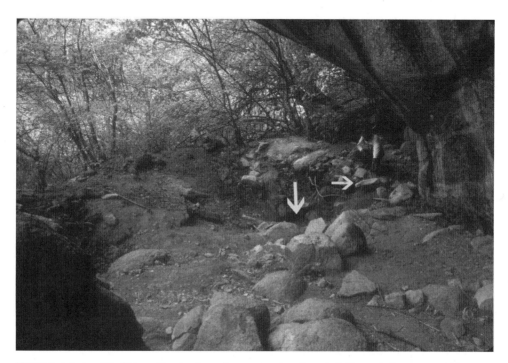

FIGURE 6.1 Interior of Bonk'olo 1 with extensive surface scatter of artefacts, including a grinding stone. Worth noting is the area 'excavated' by treasure hunters.

6.

Archaeology, ethnography, and rock art:
A modern-day study from Tanzania

IMOGENE L. LIM
(Vancouver Island University, Nanaimo BC, Canada)

TANZANIA: Rock art and ethnography

Wherever hunter-gatherers lived and there is rock, rock art exists. Rock art research in Tanzania has not been carried out as extensively or as systematically as in South Africa. Some early works were by colonial administrators and officials (e.g. Bagshawe 1923; Culwick 1929, 1931; Aitken 1948; Fosbrooke *et al.* 1950; Fozzard 1959). Later, the documentation of rock art was an outcome of research in other fields, such as in the doctoral studies of Fidelis Masao (1979) on the Later Stone Age of central Tanzania and that of Eric Ten Raa (1967) on Sandawe oral literature. My own study is one of the few that was conceived and directed at specifically exploring the rock art found among the Sandawe people (Lim 1992). This gives a limited body of data from which to work – both in terms of ethno -

graphy and archaeology (rock art studies). This chapter suggests the need to re-evaluate methodologies and theories in the Tanzanian context, given its embryonic stage of study. South African rock art practices are valuable as a guide, but interpretations should not be limited only to those noted there; research requires being open to alternative possibilities.

The work of David Lewis-Williams and the University of the Witwatersrand's Rock Art Research Institute has dramatically changed how rock art research is undertaken – in emphasising the use of ethnography, and in its understanding of images as metaphors and symbols. As Lewis-Williams and others developed methodologies and theories over the past three decades (Lewis-Williams 1983; Dowson & Lewis-Williams 1994), extensive areas of southern Africa were investigated, with many paintings discov-

ered and documented. A constantly expanding body of data allowed for the continued testing and refining of interpretations. Since the 1960s, rock art studies have matured and become an established sub-discipline of archaeology – a study accepted and popularised worldwide. South Africa is one of the few countries that is as rich in rock art sites as it is in the number of researchers actively engaged in rock art studies.

As in South Africa, in Tanzania ethnography is critical to understanding the process and meaning of rock painting among the Sandawe, a click-language-speaking people who were traditionally hunter-gatherers. Oral tradition supports a historical continuity between the painters of rock art and the modern Sandawe, and confirms Sandawe antiquity in the region (Ten Raa 1969). According to the Sandawe, they have inhabited the hilly areas they call Usandawe (in Kondoa District, Dodoma Region) since 'time immemorial'. One important difference between using Sandawe ethnography and that of the San used by South African researchers is that the Sandawe continue to maintain a painting tradition – even though it is not a rock painting one. Ten Raa (1971: 44) was perhaps the last, in 1960, to document a hunter painting a giraffe on a rock before setting off towards the Songa Hills and beyond. The practice of rock painting no longer seems to persist; nevertheless, the Sandawe continue to paint in a ritual activity known as *iyari*: the dance of twin births.

In attempting to understand *iyari*, I came to realise that it offered an explanation for some of the rock art. It also appeared to support the geographic distribution of rock art sites. Rock art analysis through formal and informal methods (etic and emic) ultimately provided valuable insights (Lim 1996).

LOCATION, LOCATION, LOCATION

People involved in real estate and business invoke the importance of 'location, location, location'. There is a truth to this. Why do people live, work, and play where they do? Location. Of course, with increasing globalisation and industrialisation, there are factors influencing decisions regarding location beyond simply the physical environment. Yet, for hunters and gatherers who are dependent on the natural environment, location is significant (Lim 1992: 52ff.).

Whether they survive or not is dependent on their intimate knowledge of, and relationship with, nature.

During my field investigations, a 4 km² area was surveyed to determine types of sites and their locations. Though my focus was on rock art, I had a broader desire to know how the landscape was used. Why did one shelter have paintings while another did not? The use of rock shelters was not limited to painting alone. Many sites showed evidence of being occupied over an extensive period, given the number of lithic and ceramic remains littering the shelter's surface (Figure 6.1). The obvious question follows: were these materials associated with the painters or with other people? Chronometric dating and excavation will have to wait. Sites outside the defined survey area were documented as well, with physical and cultural attributes noted. Of the 105 sites located, 33 had rock art.

If location was a consideration, then what were the characteristics of each site? Usandawe is notable for its *inselberg*-studded hills. Unlike the bergs of South Africa, the sites often appear to have had some Goliath strew the ground with giant boulders (Figure 6.2). After tramping up and down hills and criss-crossing the landscape, I can confirm that the choice of rock art sites is selective. The hilly nature of the terrain provides for low as well as high hills, yet the preference is for lower elevations (Figure 6.3). The majority of sites, whether with rock art or not, lie within a range of 0 m–75 m from the base of the hill. More revealing than elevation is the positioning of these sites in the landscape, such as an imposing granitic mass resting atop a low-lying solitary-standing (knoll-like) hill. All five such sites in this study had rock art (see Lim [1992: 123–127, 149ff.] for details regarding site attributes and analysis).

Among the data collected, there appear to be no distinguishing differences between sites chosen for rock art and other utilised rock shelters. In all cases the preferred location was relatively close to the base of the hill, close to water resources (95 per cent of the sites are within 2 km of water), and with multiple points of entry or sun exposure (a westerly direction was the next 'favourite'). These characteristics suggest that selection was involved, but that the specific functions of the rock art did not affect the choice. How then can these site preferences be explained?

In seeking an answer, cultural attributes were also considered in the formal analysis. Rock paintings were

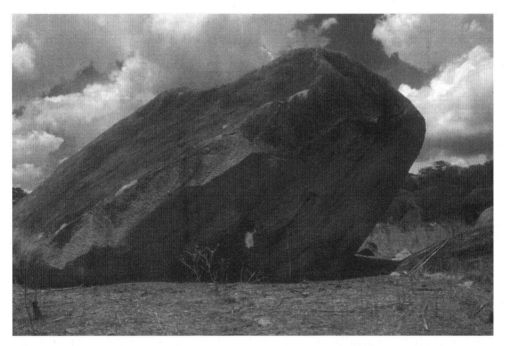

FIGURE 6.2 The rock shelter Kitolongo 6 has been occupied within living memory at least twice as a place of habitation (grinding stones are evident) and work. It has rock art and/or graffiti (lines, and what appear to be dates).

FIGURE 6.3 The rock shelter Bonk'olo 1 is shown to the left behind a *tembe* residence in the mid-ground area. It is the most massive of the *inselbergs* illustrated in this photograph.

FIGURE 6.4 Tl'atl'akwaa 1, an example of a 'non-mural' rock art site.

noted along with all other cultural associations. With regards to the paintings, the sites were categorised into 'mural' and 'non-mural' sites. The 'non-mural' had singular images, while the 'murals' had a palimpsest of multiple images (compare Figure 6.4 ['non-mural'] with Figure 6.5 ['mural']; also see Lim 1996: figures 3 & 4). The cultural associations recorded included whether the site was used today for rain or clan sacrifice, medicinal sacrifice, *haba* (a half-animal, half-human spirit), N/íni (the reputed ancestors of contemporary Sandawe), and *ninga* (a drum made of a hollow log said to have special properties) (Lim 1992: 127–130). I wanted to find out the significance of these associations, if any. As noted by Janette Deacon, given all the possible suitable sites for rock painting, the choice of certain ones "was pur-poseful and therefore held some meaning" (1988: 131). For purpose, one must look to the ethnography and how the Sandawe culturally construct their landscape. In this case, a detailed understanding of *iyari* provided a key (Lim 1992: 163ff.).

SANDAWE PRAXIS: *Iyari*

When this research was first initiated, the possibility that rock art was related to 'hunting magic' was still in vogue. As mentioned, Ten Raa had seen for himself what appeared to be an example of this. I asked hunters about hunting, painting, and rock shelters. But as any good ethnographer advises, I did not neglect other events: they were witnessed and documented during a

FIGURE 6.5 Tambase 3, an example of a 'mural' rock art site.

full seasonal cycle. The time spent in the field, two periods including a continuous stay of over a year, revealed the intimate relationship between the Sandawe and their landscape in a way that would not have been adequately understood through short or intermittent visits. Through participation in, not just observation of, Sandawe life, the meaning behind the active use of colour in Sandawe thought became apparent.

The Sandawe have an oral tradition of their presence as one hunter-gatherer group among many and, in addition, as painters of the rocks (Ten Raa 1969, 1971). Much change has occurred throughout Tanzania, yet some traditions continue. Among the Sandawe, *iyari* or *doà*, the dance of twin births, is still celebrated; it is one of the few activities in which painting occurs today (Figures 6.6, 6.7).

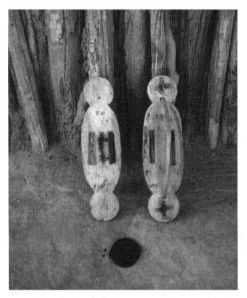

FIGURE 6.6 A pair of twin boards from identical male twins. Front and back of boards are shown.

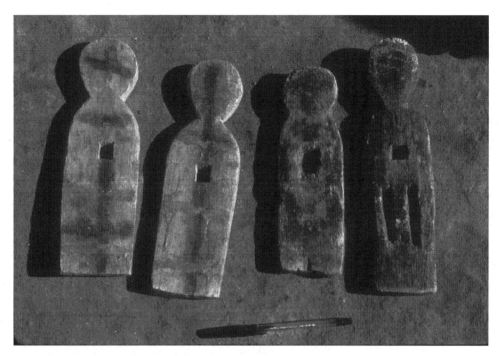

FIGURE 6.7 Two sets of twin boards from one family. To the left are boards for identical female twins, born in 1987, and to the right are those for fraternal twins, born in 1979.

A twin birth among the Sandawe is an event to rejoice in and celebrate. It is considered a rare occurrence (the data I present here reflect the essence of three *iyari* ceremonies[1]). When asked, "What is *iyari*?" people provide a number of responses: "A dance for a woman who has borne twins", "A dance in which people decorate themselves", "A dance to protect twins and parents against lightning", "Rain calling". All of these explanations are *iyari*, but it is the latter, 'rain-calling', that is significant in understanding the relationship between Sandawe and the natural objects within their landscape.

Having twins is not normal and the mother is often believed to be endangered physiologically and socially by the birth. In a number of African societies (Nyakyusa, Nuer, Nyoro and Sukuma), ritual danger is associated with twin births (Evans-Pritchard 1936;

Cory 1944; Wilson 1954; Beattie 1962). This is equally true among the Sandawe. *Iyari* is commonly viewed as a prophylactic to protect twins and their parents against lightning. The Sandawe are adamant about the danger brought upon parents and twins by their birth. One informant said that Sandawe twins born outside the area must be returned to Usandawe at least once to participate in *iyari*. In another example, a family that had abandoned many Sandawe traditions after converting to Catholicism nevertheless performed *iyari* immediately after a twin birth. The mother continues the practice of protecting herself against lightning, while the sons do not.

In explaining how and why lightning is a danger to twins, we need to understand that the danger comes from the nature of lightning and the nature of twins. Twins, at least identical ones, appear to have

been split exactly into two, and lightning has the ability to split. Twins therefore attract lightning. If a person is struck by lightning, or 'split', death is the most likely outcome. There is then an inherent danger accompanying the birth of twins. This ability to attract danger meant that I could only record and photograph one out of three *iyari* celebrations. The recording equipment was perceived as electrical, and among the Sandawe electricity and lightning are associated. Therefore, the use of this equipment was thought likely to increase the intensity of lightning.[2]

Iyari recreates the process of procreation and the reproductive cycle based on the metaphors employed. *Iyari* is not dance alone. As with any ritual, even in western society, this is a public event witnessed and acknowledged by the community. In *iyari*, both parents and immediate relatives (grandparents and siblings) participate, but the main focus of the ceremony is on the mother and other females. *Iyari* begins in the home of the twins; this house is 'a womb' where life issues forth and recalls one of the Sandawe origin myths (Ten Raa 1967: 293–294, text 20: *The Origin of All the Tribes*). Inside the house during one *iyari* event, walking sticks and other types of large sticks were thrust several times through the doorway. As noted by an informant, these sticks represented "a man entering a woman". The metaphor of an opening to the womb is used again when thorny branches are placed in the doorway to block the celebrants' exit from the house (Figure 6.8). To open the doorway, the twins' mother pushes her way out using her buttocks. The same informant stated, "The purpose of doing like that is because they represent how the children were born."

In the house, or 'the womb', there is impregnation, growth of the foetuses, then birth. The foetuses are represented in the form of boards, typically carved by men from a tree known locally as *maapin* (*Albizia tanganyicensis*). The boards are decorated with ground ochre and charcoal mixed with fat. The decoration is done by women only, (although a photograph in Ten Raa's [1981] article shows a board being painted outside the house by a man). In the house ('the womb') the boards become the twins and are decorated in the same manner as the infants when they were born. On their 'birth' these boards, or 'the twins', are taken to a *leba* tree (*Ostryoderris stuhlmanni*) specifically chosen for this event. It is the same tree under which their placenta was buried, and will continue to be the place of

FIGURE 6.8 The *iyari* ceremony is held in the twins' home. Note the painted boards held by female elders and the thorny brush placed at the doorway.

iyari for that particular set of twins. Each twin has its own *leba* tree.

On leaving the house the celebrants make their way to this tree, where the surrounding ground has been prepared as a dance area. The people dance around the *leba* tree, thrusting their pelvises in a rather provocative manner that seems to flaunt their sexuality. This impression was confirmed at the next *iyari* attended, when I was no longer an observer but participated as a dancer. A stick (*c.* 15 cm) was found or given by an older female to all the dancers (only women this time). This was placed under one's cloth (women are typically attired in a *kanga* or *kitenge* cloth that is wrapped around the waist or chest) and held to resemble an erect penis while dancing. Again, there was much pelvic thrusting and gyrating in a circle around the *leba* tree. Although I had been told that dancing was for women only, I had seen men in the circle at the previous *iyari*.

FIGURE 6.9 Bambara nuts are placed around the *leba* tree.

One informant said that men could participate, but that they were to stand behind the women.

Throughout the ceremony, both inside the house and at the *leba* tree, songs are sung to the accompaniment of hand clapping and the playing of an overturned wooden trough (*la'sé*). This is typically played by women rubbing a cooking spoon (*mekentó*) on the surface and produces a rumbling or roaring sound. According to Ten Raa (1981: 188), the song used in the child-bed rituals immediately following a twin birth is one of the bawdiest songs in the Sandawe language. This is the only *iyari* song described by Ten Raa, but it was not among those I captured during the one opportunity I had to make a recording. Of the seven songs taped, one was said to be meaningless: "only words". Later, two close informants provided the general meaning of each song. Included in these were two songs recorded independently of any *iyari* ceremony which mentioned rain falling gently and the rubbing of millet in a small container (*la'sé*). A singer said that one song was mostly concerned with the *iyari* ceremony as witnessed and that there were no other songs. The words in this song are most likely figurative, or 'sexual'; as Ten Raa (1981) has noted, there is a double meaning in the language, particularly when juxtaposed with ritual. The other song is commonly sung during rain-calling. This aspect was confirmed by other informants, but of the seven songs recorded, five were said to be specifically associated with *iyari* (though one was recognised as sung during female initiation rites involving clitoridectomy).

After some dancing, Bambara nuts (*Voandzeia subterranea*) are placed on the ground around the *leba* tree (Figure 6.9). The women grab these nuts with their mouths; they cannot use their hands. They do so because, as one informant said, "Women are the ones who are concerned with birth and not men." Also during the procession to and at the *leba* tree, millet is thrown at the participants. This was described as "the seeds of man".

A black sheep is then led into the circle of people surrounding the *leba* tree. Adult females bounce on the sheep's stomach while it is being held by two other women. This is referred to as "to kill with buttocks". As one Sandawe woman said, "Animals killed in this manner [with buttocks] represent the birth of these twins," presumably because childbirth is painful and laboured, just as is the death of this animal. Since some

of the members of the community are Islamic, a Muslim elder kills the animal before it ultimately dies of shock (so that they may share in the meat). The chyme is smeared on the *leba* tree (Figure 6.10) by participants before the animal is butchered, roasted and then eaten by the women. Another animal is slaughtered for the men.

METAPHORS FOR FERTILITY:
Objects and colour

In examining the metaphors employed by the Sandawe, *iyari* appears to be a celebration of procreation and fertility, that is, a ritual to increase the 'wealth' (number of people) of the clan. *Iyari* acts as a prophylactic against the dangers of lightning because the twins embody the duality of good and bad in nature. They are good, a sign of over-abundance, yet bad because of the inherent danger of attracting lightning. Lightning is bad not only for twins, but also for the fertility of the land. The Sandawe believe that rain and lightning are mutually exclusive acts of nature. Therefore, if there is lightning, then there is no rain. Without rain, there is no growth for the land. So, to prevent lightning is, in fact, a means of increasing the opportunity for rain, as well as the fertility of the land and, ultimately, the fertility of the people. Following this reasoning, *iyari* is rain-calling.

A further examination of the objects used in *iyari* illustrates the dual purpose of the ceremony in preventing lightning and helping rain-calling. These objects are also juxtaposed with others that evoke fertility. The Sandawe believe in a type of sympathetic magic that rationalises their actions. When twins are first born, soot from a cooking pot is used immediately to mark each child and the mother. Soot is black and, in this instance, black represents rain clouds. Many objects used in *iyari* are black in colour, for example blackened cooking pots, black sheep/goats, black cloths worn by male and female participants, black lines and marks applied to the participants and boards. In *iyari*, the colour black serves two purposes: firstly, it attracts rain clouds and therefore prevents lightning and potential harm and/or death since the two (rain and lightning) do not occur concurrently. Secondly, it hides or disguises the person: "Lightning, being white and bright, cannot see blackness, just like people who are used to seeing objects in

FIGURE 6.10 A sheep is sacrificed and its chyme is smeared on the *leba* tree.

the brightness of day find it difficult to discern them in the darkness of the inner rooms of their houses" (Ten Raa 1981: 189). Black is used to "hide or disguise" in other instances. On one occasion a man marked his forehead with a line and darkened the area around his eyes with charcoal (black) as a way to disguise himself from a spirit (*simbò*) that sought to possess him.

The other colours used in *iyari* are red and white. All three colours – red, black and white – are found on twin boards, although the use of red and black only was witnessed on participants. Red, in this case, is the mark of fertility (the mother's blood or menses). The use of red and black together seems to emphasise the twin characteristics of *iyari* that celebrate the reproductive cycle of the Sandawe and of nature itself. But there is a dual quality to the colour red. Red also attracts lightning and is said even to attract a rainbow. In both cases, the desired rain is prevented. One woman, a

twin herself, commented that in the past they always used red and black in *iyari*, but these days, because of the poor availability of ochre, they use only black. She also said that many clans intermarry with people who do not like using red. In her case, she said that during her next *iyari* she intended to clean her board and only use black, because she now believed that to use red increased the severity of lightning. Because the colour red has this double meaning (see Turner [1967: 68] for discussion on the 'ambivalent' nature of the colour red), its use may seem contradictory. But, consider where this colour is employed: inside the house ('the womb'). It is in a natural place, rich in blood and rich in nutrients for life. It is purposefully not used outside where it is out of place, where blood is a sign of infertility (menstruation = not pregnant) or even death.

The colour white is said to be an indication of rain clouds, but it is as likely to represent milk and/or semen, given the colour of the seeds ingested by the women in *iyari*. In the ceremony of 'returning the bride', white beads represent the bride's breasts. Since the Sandawe make use of similitude, the meaning of white in *iyari* can be extrapolated to refer to breast milk, or the fertility in women who bear children and produce milk. Earlier, the millet being thrown in *iyari* was referred to as "the seeds of man". Millet is also light-coloured ('white'), so the white Bambara nuts likely share the same meaning in this ceremony. Turner notes, as well, the dual representation of white as both semen and milk (suggesting pan-cultural symbols): "White symbols may then stand for both the masculine and feminine objects, according to the context or situation and are not reserved for feminine objects" (1967: 65). In the Sandawe case of *iyari*, both meanings of milk and semen operate to emphasise their celebration of fertility. For Sandawe, twins are the clan's blessing. One woman implied that the Bambara nuts were eaten to better the chances of the twins' mother giving birth to another set of twins! (In one village, two unrelated families had two sets of twins each.) A person, through the magic of similarity, can influence vegetation either through the good or the bad character of his acts or states – so, in the Sandawe situation, not only is over-abundance welcomed and desired by the clan, it is also of value to the land. As Frazer (1978: 41) notes, "A fruitful woman makes plants fruitful."

This interpretation of 'the seeds of man' is supported by text 14, *The Cripple who Became a Handsome Youth,* in the stories collected by Ten Raa (1967: 229–246). In this 'miraculous' story a child is born without legs or hands. As a youth, he goes out during a famine, finds, and takes some white sorghum. A young woman later takes the sorghum and eats it while the youth quenches his thirst from a well. When the youth discovers that his sorghum has disappeared, he enquires and is told that the young woman took it. He follows her home, singing:

> The fruits which have been given are of your husband, of your husband. The ear of sorghum is mine, of your husband, of your husband. The fruits which have been given are of your husband, of your husband (Ten Raa 1967: 236).

The narrative continues with the young woman being forced to accept him as a husband, as he will not leave. Soon thereafter, the 'cripple' is transformed into a handsome and able-bodied youth (Ten Raa 1967: 242). In this tale, the sorghum seeds connote fertility for land and the human species. It is important to note that these were white sorghum seeds, because there is also a red sorghum variety. In this tale, then, white seeds again emphasise the fertility or fruitfulness that springs forth from women. The youth finds the sorghum during a famine; when it is taken and eaten by the young woman, she has irrevocably accepted the 'fruits' of her husband.

In *iyari*, the sacrificial animal is meant to 'cool' or decrease the power of lightning. According to the Sandawe, sheep are considered 'cool' animals, whereas goats are 'hot', and therefore sheep are more suitable to the 'coolness' of women versus the 'hotness' of men (Ten Raa 1981: 189). Consequently, sheep are only eaten by women and old men (who no longer fight, that is, those who have lost their 'hotness'). The chyme is said to have a cooling property; being wet, it is literally cool as well. One informant commented that traditionally to kill the animal with a knife was taboo because knives cut or split as lightning does. But, as noted, the animal is now killed according to Islamic custom to accommodate Muslims participating in *iyari*. This latter point indicates the flexibility of 'tradition' in changing and adapting. It also suggests that there were earlier modifications or borrowings: sheep and goat, millet and sorghum are domesticates not typically associated

with hunter-gatherer subsistence. Variations in this ritual may reflect differences between clans and from village to village. Ten Raa's (1981) data are drawn primarily from among the Téhla (acculturated) Sandawe, north of the Bubu River, while this study is from among the Bisa (traditional) Sandawe.

The one other common characteristic of the *iyari* ceremony is the *leba* tree, which is nature's counterpart to human twins. The *leba* tree is an evergreen – green even during the dry months. For the Sandawe, the *leba* tree is the perfect metaphor for twins. As Ten Raa notes (1981: 190):

> Its trunk normally divides close to the ground. The *leba* is therefore a true 'twin' tree but the Sandawe develop their twin analogies even further along the logic of similarity. When an ordinary tree is hit by lightning it is split and often killed, yet the *leba* is divided in two and lives. Therefore it represents a victory of life over death: it is itself a twin, and its foliage makes it even more convincing as a symbol of life.

Van de Kimmenade (1936: 411) noted the same thing: that the *leba* tree is a symbol of fertility. The red resin of the *leba* tree and its common reference as 'blood' are additional evidence for its use as a metaphor for life and, in *iyari*, for twins.

The *leba* tree and twins are equally anomalous in their respective worlds of nature and Sandawe society; they are victors of life over death. The *leba* tree is a symbol for twins, yet twins are themselves a symbol. Both have dual natures representing fertility (life) and the potential for danger (lightning, death). In *iyari*, the dance of twin births, the Sandawe people's intimate relationship with, and dependence on, nature is reaffirmed.

RAIN-CALLING

This is especially true when *iyari* is performed for the purposes of rain-calling. If twins are born in the dry season, only the essentials of *iyari* are completed: burying the placenta, and marking mother and twins with pot soot. Not until the rainy season approaches are the final elements performed, for only then is

there a real danger of lightning occurring. While some informants insist that *iyari* should be danced every year, others maintain that it is only necessary when rain is a problem. This area has a history of drought; even when there is rain, it may be very localised.

One begins to hear of the need for rain rituals, including *iyari*, only when rain is insufficient (Lim 1992: 193ff.). In every sacrifice there are elements that have to be carried out in a particular fashion; in addition, there is always the possibility that a person may tamper with the rain. If it rains, then the sacrifice is a success; if not, a person may be to blame, or there may be some other cause, such as a problem in a technicality of the procedure. Thus, when rain is not forthcoming after a sacrifice, further consultation occurs. It was at this point in my fieldwork that women from several neighbouring villages began to discuss the possibility of holding an *iyari* ceremony specifically as a rain ritual. *Iyari*'s rain-calling nature became obvious in this context when divorced from its stated protective function of twins. A woman renowned for her abilities as a traditional female healer described rain-calling:

> … we go to a baobab tree [the one by Kukumba] where we do this activity of throwing chyme; we take potsherd pieces and then we put water inside the pieces of pot [water represents rain] and then we put pot ashes [black soot] on our foreheads while we make much noise and throw the chyme at all the leba trees used in iyari. Also, we go around the hill and all places where they meet for rain.

> It is just specifically for rain; it includes a very large area, maybe even from Donsee they would come here [Farkwa] for that ceremony. Even by now, it is near to dance such a ceremony, so you might see it.

The use of *iyari* in rain-calling is strictly the women's prerogative. It resembles other rain sacrifices in the choice of animal colour. The chyme comes from a black-coloured animal "because the black colour attracts black clouds, so it makes a hope for rain. But white colour is bad because it can make the clouds run away and then there will be no rain."

The women also sing the "rain falling gently" song while they dance. For these Sandawe women, rain-calling is a means by which they exert control over the environment in a way that men cannot. They wait until there are no other options except for them to perform rain-calling.

A rain sacrifice generally begins at a baobab tree associated with a particular rock or rock shelter (Figure 6.11). These two objects are significant as metaphors; they recall the creation myth of Matunda from which all living things originate (Ten Raa 1967: 290–291, translation of Dempwolff's text 43):

> At first Matunda emerged from the inside of a baobab tree; God opened the gate, and then he stood on the earth. When he had stood up completely he stood at the opening. While he stood [there], then the hyena ran out first. And he let him go, and [the hyena] ran away. And then sheep came out [of the tree] and he stopped them and held them fast. And immediately after, a woman with children came out. And now he held them fast and he inquired: 'Where is your husband?' – 'He is inside the house'. And he too came out; then the cattle came out and he held them fast. And then all the creatures together came out in turn; then the snake came out, and he let it go and it ran away; and then the lion came out, and he let it go; and then the leopard came out, and this one he let go; and the rhinoceros came out and he let it go; and the elephant came out and he let it go; and the gazelle came out and he let it go; all the birds came out and he let them go [but] the chicken he held fast; and the giraffe came out and he let it go; the eland came out and he let it go; and the zebra came out and he let it go; and all the animals came out and he let them go.

In this text, all life originates from the baobab; "[t]he hole in the baobab is referred to by the Sandawe as an aboriginal 'womb' (*guba*)" (Ten Raa 1967: 290). In addition, the baobab serves as a good starting point to call rain as it is a source of water. Water can be extracted from its stripped bark in an emergency. Once more in Sandawe beliefs we see how 'like attracts like' – in this case, water and life.

FIGURE 6.11 This baobab tree is associated with the clan rain hill, Malagwe.

An 'aboriginal womb' is not limited only to the baobab. In Dempwolff's text 44, the creator Matunda's rock shelter serves the same purpose in peopling the area (Ten Raa 1967: 293–294, translation of Dempwolff's text 44):

> This Matunda lived at one rock; and he built a house [there] and he killed a black cow and sacrificed it. Now the other people [also] sacrifice, because God made the opening. And now he reared many people, and there were many ... And then the earth had sufficient people. But these, [some] others have remained, and our [people] too [remained] here, our forebears were left [here]; they reared us, and now then our forefathers reared us. It was enough, and then we were many.

The locations of both the baobab and the rock shelter for rain sacrifice are circumambulated in rain-calling; in this way, the fertile nature of women lends fecundity to the land through the powers of sympathetic magic. The women bring together and activate all the metaphors of fertility and life in themselves and in the land ('aboriginal womb'). For the land, fertility means rain. This was probably so even when the Sandawe were primarily hunter-gatherers; given the intimate relationship between Sandawe and the land, they likely recognised an association between the coming of rain and large game animals long before researchers quantified this correlation. The wet season is the optimal time for African herbivores to gain weight and accumulate the stores of both fat and muscle that are then depleted gradually during the dry season (McNaughton & Georgiadis 1986: 54). Migratory populations are able to track rainfall distribution to exploit the high protein content of new grasses. Obviously, when the Sandawe were strictly hunter-gatherers the coming of rain (and their concern about it) carried the meaning of the continuation of their life-giving sources (water and food).

ARCHAEOLOGY AND ETHNOGRAPHY IN ROCK ART STUDIES:
Lessons from the Sandawe

In Sandawe creation myths, all living beings (animal and human) come forth from the baobab tree or the creator Matunda's rock shelter. Therefore, a rock shelter and/or a baobab carries more meaning as a place for rain sacrifice given the Sandawe's strong belief in the powers of sympathetic magic. Not only did their ancestors live in rock shelters, but they also owe their creation or origin to the 'fertility' of these 'aboriginal wombs'. By sacrificing at a baobab and its associated rock shelter, the Sandawe were/are able to increase the fecundity of the land. Although the Sandawe do not paint in the rock shelters today, chyme is taken from the sacrificed animal and brought to the shelter to be thrown. In one documented case (Malagwe 1), chyme is smeared on rocks in the interior of the shelter. Given Sandawe logic (the magic of similarity), this seems to suggest that, by painting their images, the Sandawe attempted to increase the fertility of animals and people.[3]

Rain was directly responsible for bringing animals in search of new grass and renewing other food sources to continue Sandawe life. The rain sacrifice sites of both Beseto 1 (Figure 6.12) and Bonk'olo 1 (Figure 6.13) have numerous groupings of painted human figures and multiple images of large animals (giraffes and elephants). None are solitary figures ('non-mural' sites). Repeated use of these locales for rain sacrifice offers an explanation for the multiple images found at 'mural' sites. Informants have stated that a rain sacrifice is performed only when necessary; it is not an annual event. For some sites, an interval of four or five years may pass before a sacrifice occurs so that a site may be visited only half a dozen times in a generation. In this way, the rock face of a shelter becomes a palimpsest. Since the Sandawe are known for their rather nomadic ways, there are multiple rain sacrifice sites within an area associated with the branches of a homeland clan, what Ten Raa (1967: 21) defines as the larger structural unit of a clan hill or locality. As implied by one informant, rain sacrifice sites were established wherever they lived. For example, his grandfather had sacrificed in the area of Onkotl'era and, when he moved to Kitolongo, he began sacrificing at this new locale. As people moved about, 'new' sites were found and 'old' ones were lost if not maintained. This same informant remarked that the knowledge of rain sacrifice at Onkotl'era remained, but not the location. In another case, the Tl'iawo (Sandawe clan) had sacrificed at Sekonse but when the last Tl'iawo left the area, the care of this site was passed on to the Tl'umta (Sandawe clan) who moved into the region.

Based on extrapolations from *iyari*, the use of certain colours must have been purposeful in rain sacrifice sites. All the sites had paintings in red pigment; if white was used, it generally covered images in red. Without knowing the source of colour pigments, if the colour black was indeed derived solely from ground charcoal, one would assume a greater frequency of black figures. Why then the prominence of the colour red?

In *iyari*, the house is a metaphor for the womb, just like the baobab and the rock shelter in the creation myths. The use of colour in *iyari* suggests a similar meaning for the choice of colour in rock art. The rock shelter is the metaphor for the womb where blood (the colour red) is appropriately found. Ten Raa (1986) used the Sandawe word *butl'* (red of any kind) in reference to special colour patterns of domestic

animals, but *butl'* is not restricted to the description of cattle alone. When I pointed at coloured cloth and other objects and asked the name of the colour, the response was always *butl'* for a 'red' colour that westerners might describe as 'magenta', 'blood red', or 'orange-red'. For the Sandawe, the range of variability in the colour red is great.[4]

The meaning and potency of the place is reproduced through ritual: the meaning is in the doing (process), not specifically in the object (the painted image). This conclusion is based on combining formal and informal analyses grounded in archaeology and ethnography respectively. With the aid of ethnography, the metaphors of Sandawe life can be extrapolated. Sandawe ethnography provides insights that allow us to understand the behaviour that produced the rock art and the use of these sites in the same manner that San ethnography was/is used in South African rock art studies. Archaeological analysis supports these findings. The location of the rock art sites implies this. To say simply that "painted rock shelters are rain sacrifice sites" belies the complex nature of Sandawe beliefs. Only by carefully examining the Sandawe belief system does *iyari* reveal the complexity of meaning to be found in the use of colour, object and action.

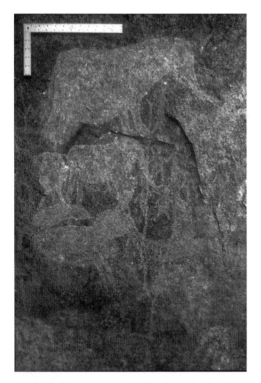

FIGURE 6.12 Beseto 1, a rain sacrifice site with primarily red-coloured figures.

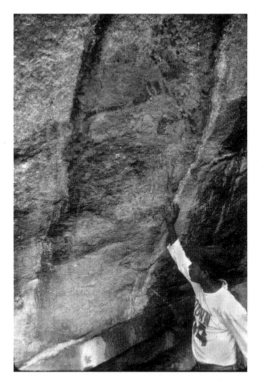

FIGURE 6.13 Bonk'olo 1, a rain sacrifice site with red- and white-coloured figures.

FIGURE 6.14 A *simbò* dancer with charcoal around his eyes. The charcoal protects the dancer from spirit possession. *(Photo by B.W. Smith)*

Acknowledgements

Major funding came from the Social Sciences and Humanities Research Council of Canada, while logistical support came from Suzuki Motor Company Limited and Caltex (Tanzania) Ltd. Research in Tanzania was facilitated by the offices of UTAFITI (Tanzania Commission for Science and Technology), Antiquities, the National Museums of Tanzania, and the Archaeology Unit, UDSM. Thanks are also extended to the University of the Witwatersrand's Rock Art Research Institute for hosting the colloquium at which this chapter was originally presented. Chris Chippindale's skill at editing is gratefully appreciated. The opinions expressed and/or any inadequacies in this chapter are my responsibility alone.

Notes

1 Two were in Farkwa, one in Mombose. The latter was a celebration-cum-remembrance of past and present twin births. Only at the first was documentation possible, that is, tape recording and photography. Ten Raa's (1981) article on twin births focuses on the activities immediately during and surrounding birth. As no births were witnessed, the information and interpretation here are directed at the celebration after mother and twins are allowed to leave the house (when the tied umbilical cord falls off). The data re-emphasise the sexual nature of the celebration, as noted by Ten Raa, and illustrate the multiple levels of meaning and use of the dance.

2 Permission was granted to photograph and tape during the first instance, most likely because of the author's relationship with the participants. The twins' mother was the niece of the mother of the household in which the author resided. The niece knew that copies of the photographs would be given to her.

3 There has been no quantification of figures in East African rock art studies, unlike in South Africa (e.g. Maggs 1967; Lewis-Williams 1972). Masao (1976), in his work in Kondoa and Singida districts, notes the paintings' subject matter, but to tabulate these is a very subjective process since they are frequently incomplete and generally in poor condition. The images showed to informants elicited responses that proved inconclusive.

4 This variability in the colour red is worth noting as it was used to establish typologies (style) and chronologies in the past (compare Aitken [1948] to Leakey [1950]).

References

Aitken, W.G. 1948. Report on certain sites of archaeological interest in the Kondoa Irangi District. Unpublished manuscript. Kondoa District Book, 12 pp. Microfilm, National Archives, Dar-es-Salaam, Tanzania.

Bagshawe, F.J. 1923. Rock paintings of the Kangeju Bushmen, Tanganyika Territory. *Man* 23: 146–147.

Beattie, J.H.M. 1962. Twin ceremonies in Bunyoro. *Journal of the Royal Anthropological Institute of Great Britain and Ireland* 92: 1–12.

Cory, H. 1944. Sukuma twin ceremonies: Mabasa. *Tanganyika Notes and Records* 17: 34–43.

Culwick, A.T. 1929. Paintings and rock shelters in Singida District, Tanganyika Territory. Unpublished manuscript. Kondoa District Book, 21 pp. Microfilm, National Archives, Dar-es-Salaam, Tanzania.

Culwick, A.T. 1931. Ritual use of rock paintings at Bahi, Tanganyika Territory. *Man* 31: 33–36.

Deacon, J. 1988. The power of a place in understanding southern San rock engravings. *World Archaeology* 20(1): 129–140.

Dowson, T.A. & Lewis-Williams, J.D. (eds) 1994. *Contested Images: Diversity in Southern African Rock Art Research.* Johannesburg: Witwatersrand University Press.

Evans-Pritchard, E.E. 1936. Customs and beliefs relating to twins among the Nilotic Nuer. *Uganda Journal* 1: 230–238.

Fosbrooke, H.A., Ginner, P., Leakey, L.S.B. & Fosbrooke, J. 1950. Tanganyika rock paintings: a guide and record. *Tanganyika Notes and Records* 29: 1–61.

Fozzard, P.M.H. 1959. Some rock paintings in south and south-west Kondoa-Irangi District, Central Province. *Tanganyika Notes and Records* 52: 94–110.

Frazer, J.G. 1978. *The Illustrated Golden Bough.* Abridged by Sabine MacCormack. Garden City (NY): Doubleday.

Leakey, L.S.B. 1950. The archaeological aspect of the Tanganyika paintings. *Tanganyika Notes and Records* 29: 15–19.

Lewis-Williams, J.D. 1972. The syntax and function of the Giant's Castle rock paintings. *South African Archaeological Bulletin* 27: 49–65.

Lewis-Williams, J.D. (ed.) 1983. *New Approaches to Southern African Rock Art.* Cape Town: South African Archaeological Society Goodwin Series 4.

Lim, I.L. 1992. A site-oriented approach to rock art: a study from Usandawe, central Tanzania. Unpublished PhD thesis. Providence (RI): Department of Anthropology, Brown University.

Lim, I.L. 1996. A site-oriented approach to rock art: a case study from Usandawe, Kondoa District. *Kaupia* 6: 79–85.

Maggs, T.M.O'C. 1967. A quantitative analysis of the rock art from a sample area in the Western Cape. *South African Journal of Science* 63: 100–104.

Masao, F.T. 1976. Some common aspects of the rock paintings of Kondoa and Singida. *Tanzania Notes and Records* 77/78: 51–64.

Masao, F.T. 1979. *The Later Stone Age and the Rock Paintings of Central Tanzania*. Wiesbaden: Steiner, Studien zur Kulturkunde 48.

McNaughton, S.J. & Georgiadis, N.J. 1986. Ecology of African grazing and browsing mammals. *Annual Review of Ecological Systems* 17: 39–65.

Ten Raa, W.F.E.R. 1967. Sandawe oral literature. Unpublished DPhil thesis. Oxford: Department of Anthropology, Oxford University.

Ten Raa, W.F.E.R. 1969. Sandawe prehistory and the vernacular tradition. *Azania* 4: 91–103.

Ten Raa, W.F.E.R. 1971. Dead art and living society: a study of rock paintings in a social context. *Mankind* 8: 42–58.

Ten Raa, W.F.E.R. 1981. Ritual change: Sandawe twin-birth festivals before and after Tanzania's villagization. *Paideuma* 27: 181–195.

Ten Raa, W.F.E.R. 1986. The acquisition of cattle by hunter-gatherers: a traumatic experience in cultural change. *Sprache und Geschichte in Afrika* 7(2): 361–374.

Turner, V. 1967. *The Forest of Symbols: Aspects of Ndemu Ritual*. Ithaca (NY): Cornell University Press.

Van de Kimmenade, M. 1936. Les Sandawe. *Anthropos* 31(3/4): 395–416.

Wilson, M. 1954. Nyakyusa ritual and symbolism. *American Anthropologist* 56: 228–241.

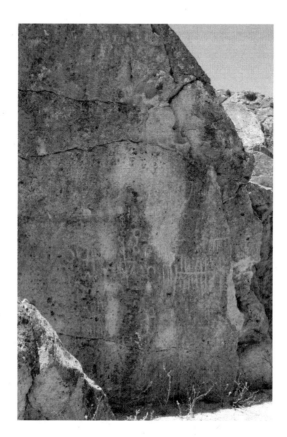

FIGURE 7.1 Continuity in Native American beliefs about rock art sites, extending from the first recorded accounts into contemporary times, is evident in many regions. For example, the connection between Numic shamans and Great Basin rock art sites was first documented by westerners in 1874. In 1999 Numic consultants continued to refer to this engraving panel at the Red Canyon site in eastern California as a 'doctor's rock', meaning a panel created by a shaman. *(Photo by D.S. Whitley)*

7.

Art and belief:
The ever-changing and the never-changing in the Far West

DAVID S. WHITLEY
(ASM Affiliates, Tehachapi CA, USA)

The history of North American rock art research is unusual relative to this type of research in much of the rest of the world. For better or for worse, researchers here largely have walked their own path for the last 300 years, allowing us to avoid the intellectual dominance of Upper Palaeolithic studies and the influence these have had on much of the rest of Anglophone archaeology (the Abbé Henri Breuil and the 'White Lady of the Brandburg', as one example, comes to mind). Central to our American research discourse, extending back to Henry R. Schoolcraft in 1851 and Garrick Mallery in 1893, has been the debate over the place of Native American commentary and exegesis in the understanding of this art, including the importance of shamanism to it. It might be said, and not entirely tongue in cheek, that it was not until the 1980s that the rest of the world caught up with Americanist research in this regard.

The obvious link between the American rock art record and Native Americans is one reason why American academic structure stands slightly apart from that in many parts of the rest of the world, especially Europe. But more important is the fact that our slightly divergent intellectual history has problematised our local research agendas in specific ways. No place is this more evident than in the tension presented by an *ethnographic* interpretation of the *prehistoric* past. Does this work and, if so, how possibly can it?

This is no small problem because it entails the full weight of, first, processualism, which in countering the direct historical approach has denied that there is value in directly interpreting the past from the present; and second, postcolonial and postmodernist studies. Here the issue is essentialism and the view that ethnographic interpretations are ahistorical, monolithic and

especially restrictive in the sense that they seem to deny individual agency, change and free will. Processualist and post-processualist archaeologists would of course probably be surprised that they agree on anything, especially on something as fundamental as the dismissal of ethnographic interpretations of the archaeological record. In this circumstance, such seems to be the case.

My concern in this chapter is the viability of ethnographic interpretation in understanding the prehistoric past. As with all academic problems, there are empirical and theoretical sides to this issue; sides which I tend to view as thoroughly inter-paginated. In what follows I hope to emphasise the theoretical matters, particularly as they concern the nature of traditional thought and symbolic systems and how these tend to change over time (or to resist change). But I begin with some historical and substantive observations that set the stage for the more general discussion to follow, before concluding with an empirical example from the Coso Range, California.

ETHNOGRAPHY AND NORTH AMERICAN ROCK ART

Two conclusions emerge from the last century and a half of American rock art research. The first is that considerable ethnographic information exists on rock art, its making and its meaning.[1] The second and related point is that most of this rock art, particularly that made by hunter-gatherers, is shamanistic in origin.

For example, Henry Schoolcraft (1851–1854) included then-existing Native American ethnography in his mid-19th-century synthesis of North American rock art, particularly for the Ojibwa, their bark scrolls and the relations these might have to rock art. Schoolcraft concluded that some of this art was undeniably associated with shamans, although he referred to them in the vernacular of his time as "priests" or "prophets" versed in "magic medicine". More recently, Schoolcraft's conclusions have been accepted by and substantiated in subsequent studies by Vastokas and Vastokas (1973), Conway and Conway (1990) and Rajnovich (1994), working in the same general part of the continent.

Slightly later, Garrick Mallery (1893) continued to recognise the religious nature of much if not most American rock art, including the fact that some of it was associated with shamans. In his concluding remarks, for example, Mallery (1893: 770) states that:

a large proportion of the petroglyphs in America are legitimately connected with the myths and the religious practices of the [Native American] authors. The information obtained during late years regarding tribes such as the Zuñi, Moki [Hopi], Navajo and Ojibwa, which have kept up on the one hand their old religious practices and on the other that of picture writing, is conclusive on this point. The rites and ceremonies of these tribes are to some extent shown pictorially on the rocks, some of the characters of which have until lately been wholly meaningless, but are now identified as drawings of the paraphernalia used in or diagrams of the drama of their rituals. Unless those rituals with the creeds and cosmologies connected with them had been learned, the petroglyphs would never have been interpreted.

This intellectual tradition of ethnographic interpretation continued in the first 'modern' synthesis of western North American rock art, published by Julian Steward (1929). Steward, too, concluded that much rock art was religious in origin and was connected to the general system of Native American shamanistic beliefs and practices, including the depiction of visionary imagery during puberty initiations. He states that:

Among the Quinault of the Puget Sound ... pictographs were made by boys at their puberty ceremonies and the figures represented mythical water monsters seen by the boys in their visions. Among the Nez Percé, Spinden ... reports a number of pictographs made by girls during their puberty ceremonies and representing objects seen by them in dreams or connected with the ceremonies. And among the Cupeño and Luiseño of southern California[,] pictographs were also made by girls during their adolescence ceremonies ... These facts do not of course prove that all petrographs were made during puberty ceremonies. But it does strongly suggest that most if not all

were undoubtedly more than the results of idle moments, even of efforts to produce works of art (Steward 1929: 225).

The connection between this art and shamanism has subsequently been accepted by almost all contemporary scholars in the Far West, demonstrating that near-unanimous consensus on this point has been achieved.[2] Yet even though there is widespread agreement among serious Euro-American researchers, there remains a more subtle issue warranting discussion. This is the important question of whether there is evidence of long-term continuity and consistency in the existing ethnographic record, an issue that is somewhat different from the current intellectual concurrence of rock art researchers.

A historical review of the ethnographic record in the Far West clarifies this question immediately. Table 7.1 presents a summary of the references, discussions and data so far identified on rock art, shamanism and vision questing in the Columbia Plateau. This record extends back to 1878 and continues to June 1999, when Jim Keyser and I had an opportunity to collect additional primary ethnographic information on rock art and vision questing while conducting fieldwork at Miller Island. As is immediately apparent, Columbia Plateau rock art was made during vision quests conducted by shamans, male and female puberty initiates, and adults during life crises. For each, the goal was to obtain a spirit helper during a visionary trance (commonly transliterated as 'dream' in the Far West). And as is also clear from these data, it is precisely these dreams that were depicted by the visionary supplicants on the rocks. Given this long and consistent history, it is then not surprising that the one book on North American rock art senior-authored by an elderly and traditional Native American consultant, Annie York, is titled *They Write Their Dreams on Rocks Forever* (York *et al.* 1993).

The Plateau ethnographic record is not at all unique in this respect. Table 7.2 presents the evidence for the southern Sierra Nevada, California. Here the ethnographic record dates to 1851, a generation prior to Euro-American occupation of this mountainous region. This early comment demonstrates an association between sites, shamans and shamanic curing by use of the term 'medicine', which was widely used in 19th-century North America for shamans[3] or 'doc-

tors' (as they were glossed also in the southern Sierra). This connection is reiterated, substantiated and amplified subsequently, especially in the studies of Anna Gayton (1930, 1948). Her lengthy discussions of "shaman's caches" (variously termed *pachki*, *taiwan* and *choshishiu* in different Yokuts dialects) are descriptions of the ritual uses of and beliefs about rock art sites. These are arguably the most detailed accounts of rock art use in Native America. Other statements from this same period demonstrate that the art portrays the shaman's visionary imagery.

And as on the Plateau, the southern Sierra ethnographic record extends into the modern era. In the 1990s, I and other archaeologists worked with a Wukchumni Yokuts traditional religious practitioner. Not only has he confirmed the earlier ethnographic details about rock art sites, in some cases to the most specific detail, both he has also corrected some minor errors in the ethnography which had been repeated since the 1930s by a number of anthropologists.[4]

These two cases, one involving a major culture area and the other a small region within another large culture area, demonstrate the kind of detail and breadth but also the long-term consistency and continuity in the western American ethnographic record. These cases are neither unique nor exceptional, inasmuch as similar circumstances can be found in other parts of the Far West. To cite just one additional case, for example, the connection between shamans and rock art in the Numic-speaking Great Basin was first documented before 1874 in the word lists obtained by John Wesley Powell. He glossed *poagunt* (or *poh-agunt*, from *poa/poha*, 'supernatural power') in its common form as 'medicine man', but also as 'a man who writes' (Fowler & Fowler 1971: 144–145). This was apparently a reference to the then-common term for rock art as 'picture writing' (hence Mallery's [1893] *Picture Writing of the American Indians*).

Powell's translation and what can be inferred from it is substantiated and amplified by the following subsequently collected kinds of information:

- the use of rock art sites by shamans for vision quests, documented by Lowie (1924), Park (1938), Shimkin (1953, 1992), Hultkrantz (1961, 1981, 1986, 1987), Malouf (1974), Brooks *et al.* (1979), Riddell (1978), Voget (1984), Trenholm & Carley (1964), Fowler (1992), Zedeño *et al.* (1999), and Stoffle *et al.* (2000);

- the creation of rock art by shamans recorded by Driver (1937), Riddell (1978), Brooks *et al.* (1979) and Cole (1990);
- the depiction of visionary imagery in the art noted by Lowie (1909), Phillips (1986), Hultkrantz (1987), Shimkin (1992), Zedeño *et al.* (1999) and Stoffle *et al.* (2000);
- the use of the term *pohaghani*, 'house of supernatural power', as the Numic term for 'rock art site', according to Malouf (1974: 81) and Shimkin (1992);
- more generally, the terms 'medicine rock', 'doctor's rock', or 'shaman's rock' used as generic names for rock art sites by people consulted by

Steward (1943), Heizer & Baumhoff (1962), Wheat (1967), Grosscup (1974), Liljeblad (1986), Hultkrantz (1987) and Park (in Fowler 1992).

Continuity in these beliefs to the present among Numic-speaking peoples is demonstrated in a number of sources, including a series of Cultural Resource Management-related projects concerning traditional cultural properties (e.g. Brooks *et al.* 1979; Fowler *et al.* 1995; Zedeño *et al.* 1999; Stoffle *et al.* 2000). Indeed, in 1999 the Northern Paiute continued to refer to rock art sites as 'doctor's rocks' (Figure 7.1; Kirk Halford pers. comm. 1999). The continuity and consistency in this ethnographic record are then obvious.

Table 7.1 Ethnographic data on rock art, shamans and vision quests on the Columbia Plateau

1878	A Klamath informant said that pictographs were made by Indian doctors and inspire fear of the doctor's supernatural power (Denison 1878).
1896	Thompson River Indians: boys and girls reaching maturity go to the hills for a long ceremony of purification and make offerings to secure good luck. At the end of this period they record their offerings and ceremonies on a boulder (Teit 1896: 227–230).
1906	Among the Lillooet, "Paintings were made on rocks and trees by adolescent boys and girls as a record of their [puberty] observances, but also by men as a record of their dreams" (Teit 1906: 282).
1909	For the Shuswap, "All pubescent lads and some girls made pictures with paint on rocks during … their training period. Most … [paintings] were representations of objects seen in their dreams, and the painting of them was … to hasten the attainment of a person's manitou [power]" (Teit 1909: 590).
1912	For the Yakama it was claimed that medicine men made and used rock art, and that they were the ones who could interpret it (Hines 1992: 104–107, 331–332).
1916	For Lower Columbia River tribes (Wasco, Warm Springs, Yakama), "in his early teens [each] Indian youth had to visit [a petroglyph boulder] at night by himself, cut his sign upon it and remain there all night alone … with the job finished … his was a charmed life" (Anon. 1916).
1917	Among the Yakama an Indian doctor whose spirits painted the pictures on the rock, painted one of the rock art designs on the face of a woman he was curing (Hines 1993: 103).
1918	For interior Salish tribes and Kutenai, "[rock] paintings are found in places … where Indians were in the habit of holding vigil and undergoing training during the period of their puberty ceremonials when they generally acquired their manitous [power] … At the expiration of the training (or sometime during it …) the novice painted pictures on cliffs or boulders near by … The paintings were records of the most important of the novice's experiences … things seen in striking visions, things obtained as guardians" (Teit 1918: 1–2).
1926	One night a Wishram medicine man used an unseen power to paint a pictograph during the night. He was found in a trance at the foot of the pictograph the next morning (Ranck 1926).

Table 7.1 (continued)

1926	Kutenai people go to pictographs for visions. There they talk to the spirits about the future. The spirits told them how they would live and what they would do. Red paint was a medicine; it had supernatural power. They painted pictures to make things happen (Barbeau 1960: 207–211).
1930	The Klamath refer to rock art as shamans' paraphernalia and indicate that sites are maintained by shamans and repainted by shamans' assistants (Spier 1930: 142).
1930	For the Coeur d'Alene, "Rock paintings were ... records of dreams, objects seen in dreams, guardian spirits ... they were supposed to transmit power from the object depicted to the person making the pictures ... young men during their puberty ceremonials made rock paintings ... older men also painted dreams on cliffs" (Teit 1930: 194).
1930	For the Okanagan, "In connection with the training period, adolescents of both sexes made records of remarkable dreams, pictures of what they desired or what they had seen." Rock paintings were also made by adults as records of notable dreams (Teit 1930: 283).
1938	Among the Okanagan, shamans advertise their power with pictographs, which served to help the painter employ his power to cure illness. "Only people with strong power painted pictures on rock" (Cline 1938: 143–144).
1938	Among the Okanagan, to announce his power, a man would "paint symbols of [his guardian spirits] on a large rock in the hills." A man might "send his child to rock paintings he had made many years before [to obtain a guardian spirit] ... for each [spirit] he scored a short red line on the rock surface beside the paintings" (Cline 1938: 136–138).
1953	A Kutenai informant said "[the spirits] held a big meeting at Painted Rocks ... and one said 'I'm going to give this power to them [human vision questors]. If they seek me for it I will give it to them.' Finally all the [guardian spirits] put their names [signs] on the rock" (Malouf & White 1953: 30–31).
1954	Among the Okanagan, "[a child] who painted these [pictographs] could be depended on to [become a] doctor" (Lerman 1954: 191).
1954	Okanagan informants reported: "When a person has a power he paints a picture [pictograph] of it." Pictographs were done by kids on their spirit quest, a painting represents a kid's power (Lerman 1954: 99, 142, 191).
1975	Elderly Spokan informants knew of paintings painted by one's grandfather, and they identified a pictograph site as a place for a vision quest where one got power (Coburn 1975: 39).
1993	Among the Thompson Indians, "People that learn to be a medicine man ... they paint [pictographs]" (York *et al.* 1993: 6).
1993	Among the Thompson Indians, "Old people train the young in the mountains ... They teach them about the red paint and how to put it on the rocks. From the writings on the rocks they teach young people how to live. You use [your] drawing in later life ... that's your strength ... any ... animal you dream that's going to be your power" (York *et al.* 1993: 6).
1999	A Yakama vision quest supplicant would sit at a petroglyph, facing the setting sun, and sing for as long as seven days. When a vision came to him he would put it on the rock (Keyser & Whitley 2000).

Source: Keyser & Whitley (2000); see also Hann et al. (in press)

Table 7.2 Ethnographic data on Southern Sierra rock art

1851	Rock art site called 'Great Medicine Rock'; site held "in great reverence"; cures conducted at site; offerings of small stones left in front of site (Eccleston, in Crampton 1957: 65).
1914	Rock art site called *pusun tinliw*, literally 'spirit helper cave'. Painting depicts shaman in ritual dress (Harrington n.d.).
1920s	"The [shaman's] cache would be in a cliff or rock pile; cracks indicated the door, which opened at the shaman's command. The rocks were usually painted; in fact, any rock with pictographs was thought to be a cache" (Gayton 1948: 113).
1920s	Shamans' caches were: "some knoll which was shamans' customary meeting place; shamans met there with their *taiwan* [literally 'ritual trays', but see below where also used for 'cache']; plotted deaths of other shamans; played eagle-bone whistles and danced around fires; got magical airshot from sun, and shoot it; ordinary people were afraid of caches" (Gayton 1930: 391).
1920s	Shaman Wasic's description of his cache: "I have lots of money and baskets up at Tawatsanahahi in a big rock like a house; there is a lot of poison there, too" (Gayton 1930: 393).
1920s	"As in foothills, doctors were believed to have private caches where the wealth they accumulated was hidden: such a cache is called *taiwan*. One is located in a little ridge about 800 yards north of the Lemoore Rancheria" (Gayton 1948: 33).
1920s	"A *taiwan* [cache] is always guarded by some kind of creature. This one [near Lemoore Rancheria] is inhabited by personified fire" (Gayton 1948: 33).
1920s	"This taiwan [cache] is an old one; nobody knows what doctor owned it. Poso'o [Tachi shaman Bob Bautista] told J.A. about it and warned her to keep away from it. He said a big sickness (*tau'mai*) like consumption or pneumonia would 'come out' if anyone attempted to disturb the place" (Gayton 1948: 34).
1920s	Shamans' caches called *pachki* (literally 'red'; here meaning 'rock art site'), where wealth and talismans were kept. One cache is in Drum Valley; another at Hoganu (both are rock art sites). Large cache near Gutsnumi (Terminus Beach) called Choishishiu, marked with pictographs (Gayton 1948: 113; site is Bell Bluff, CA-TUL-2, name confirmed by Latta 1977: 185; see also Whitley 1992).
1920s	"S.G. said there were several inner chambers [in Bell Bluff] 'each as big as a house' and that they were filled with native treasures … S.G. expressed apprehension lest the hill might some day be dynamited, for if so, 'all kinds of bad diseases would fly out over the country' " (Gayton 1948: 113).
1920s	"M.P. had a frightening experience there [at Bell Bluff] … The rocks of the bluff are painted with pictographs, she said, but she could not accompany me there" (Gayton 1948: 113).
1920s	(At Bell Bluff) the uncle of M.P. saw a "beautiful weird dog there which came out of the rocks to attack investigators … the dog which guarded the cache had a snake's body and human hands for feet" (Gayton 1948: 113).
1920s	M.P. went there (Bell Bluff) and saw a ghost that "looked like fire" (Gayton 1948: 113).
1920s	Common term for shaman's cache is *chosishiu*, 'dog place' (i.e. 'spirit helper place'); but 'correct' name is *pachki* (Gayton 1948: 113; confirmed by Latta 1977: 600).
1920s	Shamanism ran in families, and son would usually inherit father's wealth and *pachki* (cache). If no son, *pachki* lost forever. *Pachki* always located on hill, with rock for door. No mark of ownership. After shaman's son had gotten supernatural power, could enter at will. Son danced outside and called name of father/grandfather, and it opened. Within were baskets, money, feathered ornaments, skins – "all valuable things". Son could take what he wanted from left side. Things on right belonged to most ancient ancestors and were too powerful. These served as guardians of place, who killed anyone who touched them (Gayton 1948: 168–169).

Table 7.2 (continued)

1920s	Shaman's acquisition of power: man awoke after dream and went into hills, "to dream some more". When man had dreamed sufficiently he went to a cache (rock art site) where his spirit helpers opened the door and stayed inside four days. No one knew where he was while in his pachki. 'Animals' (i.e. spirits) told him what to do, gave him songs, danced with him, gave him talismans. Remained in hills two more days (total=six). Then did debut dance, where he talked about his supernatural experience (Gayton 1948: 168–169).
1920s	According to one informant, only rain shamans had shamans' caches. Outfit was kept within rock, which the shaman could open but otherwise couldn't be seen. "Each doctor had his own place" (Gayton 1948: 207).
1930s	Site CA-TUL-19 depicts painting of *soksouh*, supernatural spirit (Latta 1977: 199).
1930s	Rock art sites at permanent villages and locations of ceremonies. 'Tribal equipment' (jimsonweed mortars and ceremonial costumes) concealed nearby; sites are *tripne*; i.e. supernaturally potent (Latta 1977: 600).
1930s	Informants identified shaman's ritual tray and 'mythological characters' in rock art (Latta 1977: 601).
1932	Rock art site in Hooker Cove made by shaman known as Sigurup (Gifford 1932: 51).
1932	Pictograph four miles east of Fuller's Meadow depicted man's dream (Gifford 1932: 52).
1937	Eight informants – pictographs made by recent humans; six informants – pictographs made by shamans (Driver 1937: 86).
1937	Description of making of pictographs: "Specifically [made by] doctors, *po'hage*. They painted their 'spirits' (*anit*) on rocks 'to show themselves, to let people see what they had done. The spirit must come first in a dream.' The informant said he was certain that the Yokuts from Tule river north and the other W Mono had the same belief and practice" (Driver 1937: 126).
1943	Pictographs made by shamans (Aginsky 1943: 426).
1990s	Information from modern Wukchumni consultant: pictographs are "doctors' marks"; one rock art panel described as "shaman's dream"; some motifs portray blue heron (shaman) dancers; some sites still used for non-shamanic curing rituals (Franco 1992; Woodbury 1992; Whitley 1994a, 1996).

Source: Keyser & Whitley (2000)

BEYOND THE TYRANNY OF THE ETHNOGRAPHIC RECORD

Each of the above three examples demonstrates over 100 years of continuity and consistency in ethnographic information about the making and meaning of western North American rock art. Each also illustrates that traditional knowledge about rock art is still maintained in certain Native American communities. And in each case the evidence also ties the art to shamanistic beliefs and practices, including specifically the depiction of visionary imagery. Given this wealth of information and detail, it is hard to know how an intellectually honest argument could be constructed to support an alternative interpretation.

Yet left unsaid are the problems that this creates for archaeologists and archaeological interpretation: how can this pervasive ethnographic religious system and interpretive model be reconciled with an otherwise apparently changing prehistoric past? If this ethnographic interpretation is valid for the prehistoric past, then what job can archaeologists actually have in studying prehistory? Here we confront processualist concerns with projecting the recent onto the deeper

past, with the potential irrelevancy this implies for the archaeologist, as well as postmodernist concerns with creating an essentialist archetype of prehistoric peoples.

These problems are made all the more real by an empirical argument that my colleagues and I made recently (see Whitley, Dorn *et al.* 1999; Whitley, Simon *et al.* 1999). In summary, we argue for over 10 000 years of continuity in ritual and belief in the Mojave Desert, California. This is based on four major lines of empirical evidence:

- the time-depth of the rock art itself;
- the continuous use of the same rock art sites over this lengthy period;
- the continuous use of a specialised lithic tool, quartz hammerstones, for making rock engravings;
- continuity in both the general nature of the motif assemblage and a series of four specific iconographic conventions in one important class of motifs: bighorn sheep.

How can we reconcile this empirical argument with the theoretical concerns noted above? In the following, I argue, first, that cultural conservatism is the norm for traditional societies, that there are well-known conditions that cause it and, thus, that it should be expected by the archaeologist. Second, I contend that, because of the way that symbols function and symbolic acts are conducted, this need not necessarily result in essentialist models of the past. Symbolic systems are dynamic and inherently include conservative and radical elements, even if their overall tendency is towards stasis. The key to analysis then includes the need to distinguish those 'sites' in a culture that promote the status quo and those that support change. Third, I illustrate these points using an example from the Coso Range, California.

THE CONSERVATISM OF CULTURE

Ethnographers as diverse as Julian Steward (1955) and Maurice Bloch (1974) have pointed to the fundamental conservatism of traditional cultures, especially with respect to concerns such as religion, belief and symbolism. They have argued that these aspects of culture are the most resistant to change, if in fact they change at all. In part this is because, as Sahlins (1985) noted, different traits or characteristics of a given culture change at very different rates or, in his terms, certain 'sites' of

culture are more prone to historical action than others. Alterations in such things as stone tool assemblages thus may occur frequently and rapidly, but in fact probably tell us very little – if anything at all – about change in many other aspects of a given prehistoric culture.

There are ample empirical examples in the ethnographic record of this kind of cultural conservatism, but one case demonstrates this point in a personal way. As we all know, Euro-American societies have experienced in the last few hundred years rates and degrees of demographic, political, subsistence and technological change that are unprecedented in human prehistory and history. Yet, while these changes have been ongoing, one basic component of our cultural foundation – our religious beliefs, rituals and iconography – is all but unchanged.[5] This is well illustrated by the fact that, as a child, I attended ritual services performed in an archaic language, Latin, which had not been spoken as a secular language literally in centuries. My circumstance was not unique: Roman Catholicism was, and remains, the single most widely practised religion in the United States. All of us know practising members of other religions whose rituals have been continually practised for an even longer period of time. Truly traditional cultures, by which I mean pre-industrial revolution, small-scale, and non-western, are or were even more strongly tied to deep and ancient cultural traditions.

That traditional cultures are conservative is one thing; why they are so is another matter entirely. Three anthropologists have made observations which help explain this phenomenon.

The first is Claude Lévi-Strauss, who has considered the distinction between traditional and modern thought systems in some detail (especially in *Tristes Tropiques*). One of his pertinent comments concerns the place of history and how it is perceived in traditional thought systems. Lévi-Strauss notes that:

> [Traditional societies] view themselves as primitive, for their ideal would be to remain in the state in which the gods or ancestors created them at the origin of time. Of course this is an illusion, and they can no more escape history than other societies ... (Lévi-Strauss & Eribon 1991: 125).

As a general tendency, then, traditional societies prefer to shun change and progress whenever possible,

because their model of society – codified in myth and ritual – is based on an ancient and unchanging paradigm. Yet as Lévi-Strauss also concedes, this does not preclude change and historical influences, which in some cases are inevitable. Instead, it indicates that traditional cultures tend to create cognitive structures intended to minimise just such a possibility.

Robin Horton (1967, 1982) has addressed more directly the distinction between traditional and modern thought systems and the differing cognitive structures that these imply. He has shown that traditional systems of thought are 'open', meaning that they are designed to accommodate and incorporate changes in order to avoid unresolvable conflicts with their underlying primary theories or world views. One result is the common appearance of syncretic religions in contact situations between traditional and modern western societies. In such cases continuity and compromise, not replacement, are the operative processes. Modern cognitive systems, which historical analysis indicates first appeared in Europe at *c.* CE 1200, are, in contrast, 'closed'. By this Horton means that modern westerners tend to insist on choosing between rival theoretical frameworks (be they religious, scientific or political) rather than attempting to find an accommodation for them all. For us, change is an all or nothing proposition.

Again, while these observations are useful for apprehending the *why* of this matter, they fail to fully explain the *how* of this circumstance. Marshall Sahlins provides some clarification in this regard in his distinction between prescriptive and performative aspects of cultural acts: "the performative orders tend to assimilate themselves to contingent circumstances; whereas, the prescriptive rather assimilate the circumstances to themselves" (1985: xii). Meanings in this sense are performative in that they are socially constituted yet, in action, always at risk. They have the potential to threaten social order and instigate change, or to be ignored. This is because meanings are also prescriptive in that they are historically structured and (frequently) conservatively interpreted. Often, they are understood, and misunderstood, to suit the desires and needs of the community at large.

The pervasive tension embodied in cultural acts between creativity and change versus the conservative status quo ultimately devolves to what might be called culture's lowest common denominator. For surely any cultural act, regardless of how innovative, is always contextualised and interpreted within the framework of a pre-existing social and cultural order, and longstanding historical precedent. Cultural innovators then are, by definition, individuals who operate outside of the norm; otherwise they *would be* the norm. Yet, regardless of their individual intentions, their cultural acts are processed, packaged and to some degree 'spun' by a pre-existing cultural context. Cultural acts in this sense are always at risk because their very expression requires submission by the actor to a process of interpretation, review and acceptance or rejection by an audience with unequal skills or interests in full apprehension. Indeed, as Turner (1969) has argued, even the seemingly most antithetical cultural acts can devolve to nothing more than antistructure, which instead of changing a culture serves, to the contrary, to stabilise the system as a whole.

Change does occur, certainly. But cultures seem to exist partly in order to prevent it.

Academic research is one cultural process involving conservatism, innovation and change that illustrates this point. As all publishing academics will acknowledge, almost any new intellectual argument is accompanied by a significant dose of critique and, often, ridicule and disparagement. Indeed, linguist Deborah Tannen (1998) has characterised academia as an 'argument culture'. She notes that:

> Valuing attack as a sign of respect is part of the argument culture of academia – our conception of intellectual interchange as a metaphorical battle … Younger or less prominent scholars can achieve a level of attention otherwise denied or eluding them by stepping into the ring of someone who has already attracted the spotlight (Tannen 1998: 367–370).

One result of this pervasive academic world view – the "*need* to make others wrong" (Tannen 1998: 278; her emphasis) – is the valorisation of critique over substance. What occurs then is a kind of academic journalism rather than intellectual exchange in which every contention is vocally countered by an opposing opinion that, regardless of how ill-informed, is often awarded equal consideration. The irony is that this process of critique putatively occurs to achieve intellectual balance.

Sometimes it does. But as often as not it results in just the opposite as the hard work of the lengthy and well-thought-out research project is subjected to the quick read and immediate reaction and opinion of the vocal critic who, too frequently, is only vaguely familiar with the subject at hand, or to the careerist whose goal is instant recognition in the limelight. And because scientists are trained to be sceptical, and because these hit-and-run critiques play to this innate scepticism, they are usually what is given credence rather than the much more substantial research they aim to discredit. We forget that real balance, and the real scepticism that it requires, should always go both ways.

Although Tannen focuses primarily on academia, what she has revealed is an expression of a larger and more widespread cultural phenomenon. This is probably best labelled a "culture of scandal". Here critique becomes fact, conspiracy is pervasive, intellectual correctness is conflated with moral (self-)righteousness, and disbelief is the order of the day: the 'truth is out there' syndrome writ large.

Despite the fact that many truly innovative and creative acts do manage to emerge from academia, there is nonetheless a strong conservative tension inherent in even our modern intellectual system, one that we might think is as far removed from conservative elements as possible. Some might argue that this circumstance is fully acceptable because science needs necessarily to be conservative. Perhaps this is so.

Which is precisely my point.

THE ESSENTIALIST CHALLENGE

There is, on the one hand, compelling evidence that cultures are conservative. Indeed, one key concept at issue here – culture change – is by its very nature a relational one that can only be apprehended by virtue of its opposite: conservatism and stasis. The problem for the prehistoric archaeologist is then how we avoid essentialist models that rob traditional cultures of agency, self-will and, ultimately, individual action in light of this countervailing conservatism.

This problem obviously touches my concern with the use of ethnographic interpretation by archaeologists. As Peter Nabokov (1996, 2002) has noted concerning Native American histories, the tendency exists to assume that, because traditional cultures lack writ-ten histories, they constituted timeless essences lying outside of history and the historical processes of differentiation and change. Yet our common intellectual fix to this problem – the essentialist critique – is little better in its outcome in this particular instance. It usually devolves to an argument that runs more or less as follows: since these cultures *had* histories and *were* capable of change, and thus did from time to time *differ*, they *must have* changed, and any generalisation about their essential characteristics is therefore *necessarily* wrong and restrictive.[6]

Though unintended, the outcome of this position is politically problematic, in my mind, because it supports arguments for a complete disjunction between contemporary Native Americans, ethnographic accounts, and the archaeological record. In the guise of giving traditional peoples back their histories and individualities, the essentialist critique moves even further backwards from this goal, substituting feel-good sloganeering for actual product, and in fact helping to strip Native Americans of their historical heritage. For the contemporary Native American the essentialist critique yields not some potentially restrictive and monolithic cultural identity founded on the ethnographic present, but instead no historical identity whatsoever.

Our dilemma then is that traditional cultures are dynamic, fluid, changing and charged with individual action. These are all conditions we need to explore and understand. But these cultures are also static, conservative, restrictive and characterised by a lowest common denominator type of status quo. Life, it seems, is much more complicated than archaeologists might like. Where, then, do we find the past?

SITUATING CULTURAL STABILITY AND CHANGE

My suggestion for a way out of this conundrum starts with Sahlins' (1985) observation that different 'sites' of culture are differentially prone to historical action and thus to processes of stasis or change. The distinction between stone tools and religion is an obvious case in point. Yet there is much more to Sahlins' observation than this facile comparison alone suggests. For in addition to distinctions of this kind, we can also identify similar distinctions within symbolic systems of meaning themselves – precisely the arena

in which cultural acts are promoted and in which processes of stasis or change are instigated or stymied.

My concern here is with kinds of symbols and the ways in which they are used. For a number of years I have argued that rock art interpretations necessarily need to consider the different kinds of symbols used at sites (Whitley 1988, 1992, 1998a). By this I have not meant the different types of motifs at a site. Instead, my frame of reference has been Victor Turner's (1967) well-known distinction between *dominant* and *instrumental* symbols. The dominant symbols consist of the primary motifs at rock art sites, while the rock art site itself serves in this case as the instrumental symbol: the symbolic context which imparts specific meaning to the dominant symbols painted or engraved thereon.

This distinction can be taken one important step further by reference to Sherry Ortner's (1973) discussion of *key* symbols (her elaboration on Turner's concept of the dominant symbol). Ortner distinguishes two kinds of key/dominant symbols: *summarising* versus *elaborating*. Summarising symbols are sacred symbols in the broadest sense; they stand for the system in general and thus consolidate attitudes and beliefs in terms of a thick and dense emotional whole. Elaborating symbols, in contrast, are analytical and help order experience; they serve to formulate relationships between diverse cultural elements. Elaborating symbols, moreover, can be further divided into *root metaphors*, which are categories for organising conceptual experience, and *key scenarios*, which are strategies for organising action.

Two things are obvious from these distinctions. The first is that we should expect that different kinds of symbols will be used in different ways. The second, and more relevant to our archaeological problem, is that we can then distinguish within systems of symbols the probable sites for stability versus those for change. Summarising symbols, in particular, are sites of conservatism for, as Ortner (1973: 1343) notes, these are logically and affectively prior to the other meanings of the system. And when change occurs, it will presumably emerge out of the elaborating symbols, or at least be played out and negotiated in this arena.

Ortner's observations, put another way, result in the recognition that any given symbolic system embodies both conservative and potentially creative or disruptive elements. The task for the archaeological analyst concerned with the relationship of the ethno-graphic and archaeological records is then not to assume that this is an either–or situation: either there is a connection and it is complete, or there is none and there is total disjunction. It is instead to identify these different components within a given system of meaning, and to find the 'sites' and mechanisms for both stability and change, and how the two interact.

MAKING SUPERNATURAL POWER PERSONAL: The emergence of Numic bands and headmen

The rock engravings of the Coso Range, California, have been used in our argument for 10 000 or more years of ritual continuity in the Mojave Desert, specifically involving shamanistic vision questing (Whitley, Dorn *et al.* 1999; Whitley, Simon *et al.* 1999). Yet an analysis of this art following the above distinction shows that, despite this continuity, change and individual action can also be identified: action that seems to reflect the changing nature of prehistoric society. This becomes apparent when the three major components of this corpus of roughly 100 000 motifs are considered: (i) bighorn sheep (about 51% of the corpus total); (ii) geometric designs (29%); and (iii) anthropomorphic figures (13%; see Whitley 1994a, 1996, 1998a, 1998b). We can see in the prehistory of uses of these different classes of motifs the distinctions between summarising symbols, whose uses and meanings appear to have been relatively stable, and an elaborating symbol, which was a locus for action and change.

LONG-TERM USES OF SUMMARISING SYMBOLS

Two of these motif classes appear to have served as summarising symbols: the bighorns and the entoptics. Following far western North American patterns, all evidence suggests that the bighorn sheep (Figure 7.2) depict shamans' spirit helpers. Numic ethnographic evidence indicates that, during the historical period at least, these were the specialised helpers for rain shamans. Hence, the large concentration of these motifs in this region demonstrates its importance as a nexus for rain-making rituals and power, a conclusion supported by a variety of kinds of independent evidence.

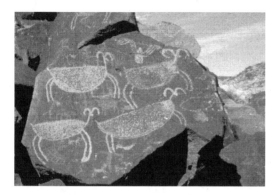

FIGURE 7.2 The hallmark representational motif in the Great Basin is the bighorn sheep. These are particularly common in the Coso Range of eastern California, which contains roughly 51 000 bighorn engravings, representing shamans' spirit helpers. These examples are from Big Petroglyph Canyon. (*Photo by D.S. Whitley*)

Geometric designs (Figure 7.3), in contrast, appear to have resulted from the entoptic light images perceived by shamans during trance. In addition to their creation as rock art images, they were also painted on shamans' ritual robes and shields. They probably had many specific meanings, but in general terms can be taken as signs of power. Note, however, that many of these entoptics are essentially idiosyncratic and while they surely had quite specific meanings, these would have been as effectively hidden from Numic peoples as they are from us. Both the bighorn/spirit helpers, repeated almost endlessly in the region, and entoptic designs are markers for supernatural power, but they are entirely depersonalised markers. Although an individual shaman could use them, and even use them exclusively (the idiosyncratic entoptic patterns), little or no effort was made to draw a connection in the art with a specific shaman.

The evidence for overall long-term continuity in the rituals and beliefs underlying this art was mentioned above. To elaborate on a key point briefly, this included iconographic continuity in a series of different forms involving these two summarising symbols.

The first involves the motif assemblage as a whole; specifically, the admixture of bighorn sheep and entoptic designs, which is evident throughout the sequence. The second consists of a separate series of repeated attributes or conventions specific to bighorn imagery (Figure 7.4). These include:

- near-complete emphasis on adult male bighorn sheep, as indicated by the portrayal of large incurving horns, which both females of all ages and juvenile and adolescent males lack;
- an anatomically impossible head and horn convention involving a profile view of the snout and body matched against parallel curved horns;
- a greatly exaggerated and upraised tail posture.

The significance of the anatomically impossible body and horn posture stems from the possibility that this graphical convention results from the construal of a common entoptic form, nested curves, as the horns of the mountain sheep. This possibility is enhanced when the first kind of iconographic continuity is recalled: the repetition of combinations of bighorns and entoptic patterns, which is an expectation of trance-based arts (Lewis-Williams & Dowson 1988). The sum is multiple lines of support for the connection between the art and trance imagery.

The importance of the large and upraised tail, which is so unnatural to real bighorns that it was first noted and commented upon by Julian Steward (1929), augments this circumstance even further. The upraised tail appears to denote the fact that these are dead sheep; in bighorns, an upraised tail is a product of death and *rigor mortis*. (Unlike the mule deer, the bighorn does not 'turn tail and run'.) The significance of this conclusion emerges from the fact that death was a common metaphor for a shaman's trance; a shaman and his spirit helper were semantically and epistemologically indistinguishable, and the 'killing of a bighorn' was a graphic and verbal metaphor for making rain (Whitley 1994a, 1994b, 1998a, 1998b, 1998c, 2000a, 2001a).

The long-term stability in these summarising symbols can be partly explained by their embodied nature. As Sahlins (1985: xiii) once noted: "The symbolic system is highly empirical." Such appears to be the case here, where the source for these symbols lies in natural models created by the somatosensory and mental hallucinations of trance (Whitley 1994b, 1998c, 2001a; Whitley, Dorn *et al.* 1999) combined with observations on animal physiology and ethology.

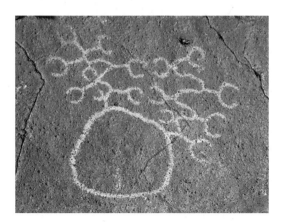

FIGURE 7.3 Geometric engravings are also very common in Great Basin rock art where, in most regions, they are the most common class of motif. In the Coso Range they are the second most common motif class, after bighorns. This example is from Little Petroglyph Canyon in the Cosos and, like many of the geometrics, is a variation on an entoptic pattern, in this case a meander. *(Photo by D.S. Whitley)*

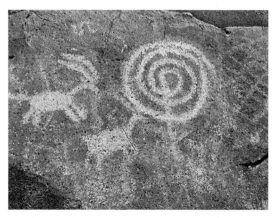

FIGURE 7.4 The combination of bighorns and geometric motifs is present throughout the 10 000 years+ engraving tradition in eastern California. This continuity in the nature of the motif assemblage is paralleled by a series of specific continuities in the iconographic attributes of the majority of the bighorns. These include large side-facing horns, indicating the depiction of adult male rams; an anatomically impossible twisted head and horn combination; navicular bodies; and exaggerated tails in an upraised posture (associated with death and *rigor mortis*). Example from Little Petroglyph Canyon in the Cosos. *(Photo by D.S. Whitley)*

Entoptics, as many researchers have shown, for example, are common characteristics of trance imagery, as is the construal of entoptics as culturally and personally meaningful iconic forms (Lewis-Williams & Dowson 1988). The complex metaphor, 'killing a bighorn sheep', on the other hand, itself lacks an empirically grounded basis in the general sense. But like most complex metaphors, it reflects a logical association of a series of 'atomic' primary metaphors that themselves were grounded in everyday bodily experience (see Lakoff & Johnson 1999). 'Killing a bighorn sheep', in other words, likewise is partly based on personal empirical experience in trance combined with observations about animal ethology, following a metaphor- and symbol-generating process that is common to all humans. In both cases, the origins of this symbolism and the processes by which it is generated are essentially timeless and universal. It is no mystery, at least at the neurochemical and symbol-generating levels, why there was constancy in this motif use over time.

It is certainly possible to debate the time-length which we have posited for this ritual continuity, especially inasmuch as the temporal range is partly based on a series of experimental dating techniques. But it is nonetheless clear that continuity in the symbolic system, not the replacement of one iconography by another, is characteristic of this prehistoric record, regardless of its overall age.

ELABORATING SYMBOLS: Where power becomes personal

Yet even while this is so, substantial change over time has also been noted in Coso rock art (Whitley 1994a, 1998b; Whitley, Dorn *et al.* 1999; Whitley, Simon *et al.* 1999). This can be seen in two kinds of evidence.

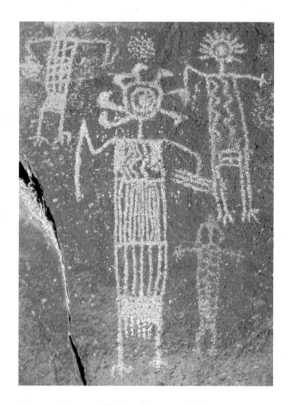

FIGURE 7.5 'Patterned-body anthropomorphs' become a common component of the rock art assemblage during the last 2000 years. The internal body patterns represent the designs that shamans painted on their ritual shirts and appear to reflect the integration of iconic and entoptic imagery. Note that there is effectively no duplication in the internal designs, with each pattern serving as a unique 'signature' piece. This suggests the development of a concern with the expression of personal identities, and the emergence of band headmen-shamans. The central figure on this panel, from Little Petroglyph Canyon in the Cosos, wears a quail topknot feather headdress. This was the special headgear of the rain shaman. The bighorn sheep was said to be the special spirit helper for the rain shaman; and the Cosos region, where bighorn motifs are heavily concentrated, was renowned for its rain shamans. *(Photo by D.S. Whitley)*

The first involves the rate of motif creation. There appears to have been a significant acceleration in the rate at which the petroglyphs were made during roughly the last 2000 years, an increase that is not plausibly attributable to some kind of taphonomic process inasmuch as we are dealing with relatively deep engravings carved into very stable basalt surfaces. More petroglyphs were made, and they were made more frequently.[7] What this suggests is that shamanic rituals, specifically shamanic vision questing directed towards the acquisition of rainmaking power, intensified significantly in the last few thousand years.

The second change is specific to the anthropomorphic figures. The elaborate ('patterned-body') humans (Figure 7.5), the majority of the human representations, are apparently the shaman himself transformed into his spiritual essence. Our best chronological evidence for human motifs stems from their associations with depictions of weaponry: *atlatls*, which were used until about 1500 years ago; and bows and arrows, which good archaeological evidence first places in the region immediately thereafter (Yohe 1992). According to Grant's (1968) tabulation of over 12 000 motifs, fully 96 per cent of the human figures with weapons have bows. The vast majority of the human figures, in other words, date to the same period that experienced an increase in petroglyph manufacture: the last 1500 years.

Moreover, there is a second important aspect of the human figure imagery. A significant number of these motifs are elaborate 'patterned-body anthropomorphs'. Each is shown wearing a hide shirt or dress covered with geometric designs, apparently reflecting the fact that shamans wore such painted ritual dresses during their ceremonial activities. Yet each of these ritual shirts is unique: none shows repetition in design or layout, across the entirety of the Mojave Desert (W&S Consultants 1997). They are, in essence, signature pieces for each shaman. And they are signature pieces that could not have resulted exclusively from the integration of entoptic designs with iconic images, as might be suggested by the second stage of trance in Lewis-Williams and Dowson's (1988) neuropsychological model. For if such were the case, we would expect some repetition from shaman to shaman in the internal designs, just as we do see occasional repetition in the entoptic designs engraved in isolation. As seems certain, shamans apparently went to some effort to

create their own internal body marking, including visiting all of the rock art sites in the region in order to examine other such patterned-body engravings in order to ensure that theirs were unique. Here we see a circumstance in which trance imagery was mediated by cultural factors, in this case the desire on the part of each shaman to obtain a unique body design.

The patterned-body anthropomorphs suggest then the emergence of a concern with identifiable personal supernatural power in contrast to the almost faceless shamanic imagery of earlier times, with this emergence occurring during a time of ritual intensification. These changes are matched by others in the archaeological record, including:

- a shift in subsistence practices away from mobile foraging and hunting towards increasing emphasis on intensive but more reliable seed gathering (Bettinger & Baumhoff 1982);
- a change in settlement patterns involving the appearance of numerous upland camps (Whitley *et al.* 1988).

The relevance of these synchronous changes becomes apparent when aspects of ethnographic Numic socio-political organisation are considered. The Numic were organised into loose bands led by headmen. These headmen were, in fact, also shamans, and this headmanship–shamanism ran in family lines (Whitley 1994a, 1996). One outcome of this circumstance is the apparent fact that shamanism, including shamanic curing, involved much more than healing in the medical sense. Carobeth Laird noted that:

> The culmination of the shaman's work was the public revelation of the evil intent or malevolent thought which was at the root of the illness, and the exposure of the person responsible ... the shaman's song would reveal the hidden evil; and not infrequently this would bring about the confession of the guilty party and so complete the cure. The public telling was an integral part of the healing ritual (1976: 36; see also Steward 1938a: 194).

Conflict resolution in the broad sense, in other words, was part and parcel of the headman–shaman's tasks.

In fact, substantial debate has occurred in the anthropological literature concerning these Numic bands. Julian Steward (1938b, 1955, 1977), for exam-

ple, maintained that Numic bands only existed in areas of unusual resource potential and that they reflected historical developments engendered by Euro-American contact. This was contested by Omer C. Stewart (1939, 1966, 1978), who argued that bands were common throughout Numic territory, and that they represented the truly aboriginal rather than simply historical pattern of socio-political organisation.

The evidence sketched above, including the argument for the use of specific rock art motifs as elaborating symbols, tends to support Omer Stewart's contentions. For in the personalisation of supernatural power we can assume that a personalisation of power in all its aspects, including political and social, also occurred. Shaman–headmen appeared as they began to proclaim themselves Men of Power in the canyons of the Coso Range, and around the band campfire.

Band organisation and headmanship apparently then did appear during the prehistoric past, sometime during the last 2000 to 1000 years, and this important change was partly negotiated and expressed in the rock art of the Coso Range. But more to my general points, we can only really understand the dynamics of this changing prehistoric past by combining ethnographic interpretations with archaeological evidence. In this case the sum is much greater than either of the two halves.

CONSERVATISM VERSUS CHANGE

Conservatism as a personal or political ideology is probably anathema to many academics. Yet the very research that we practise is, by the nature of our intellectual discourse, intrinsically conservative and not terribly prone to change. So, too, is the case for traditional cultures. These are inherently conservative, unchanging and set in their ways, and to interpret them intelligently we must acknowledge these conditions.

Yet, that traditional cultures tend towards the unchanging should not be confused with the conclusion that they never change, for surely they do, as the archaeological record occasionally reveals. And while traditional cultures, like academia, are structured to ensure that change only occurs in special cases, they nonetheless always contain within themselves the possibility for radical alteration. Both stasis and change, in this sense, result from ongoing tensions between

the conservatism of the system and the potentially radical behaviours of cultural actors.

What this means for American rock art interpretation specifically and American archaeology more generally is that, first, ethnographic data are crucial for interpreting the prehistoric past (at least with respect to the last few thousand years). Yet, second, it is also true that the ethnographic and prehistoric pasts were dynamic places where individual agency, variability and change played their parts. Despite the strength of our own theoretical prejudices, the past was a thoroughly sloppy and complex place. We will only sort it out when we acknowledge this fact and use every means at our disposal in its interpretation. Ethnography combined with archaeology, perhaps including neuropsychology as well as a more detailed consideration of the nature of symbolism, are all approaches that can help get us to that end.

Acknowledgements

I am greatly indebted to Peter Nabokov for a long-running series of discussions and conversations that have greatly helped my conceptualisation of the issues discussed in this chapter, and whose recipe for barbecued salmon is unmatched anywhere in the world. I also thank Chris DeCorse for repeatedly insisting that I read *Islands of History* and who, in frustration over the snail-pace of the Fillmore Library, eventually sent me a copy so that we could discuss it. I, however, retain all culpability for any errors or omissions as well as the opinions expressed in this chapter.

Notes

1 This fact is only notable because of its denial by Robert Heizer, an influential mid-century rock art researcher. The subtext of and cause for Heizer's denial and its implications are discussed in detail elsewhere (Whitley 2001b). Suffice it to note here that even while Heizer denied that there was directly relevant ethnography on rock art, he still inferred that the cause for its creation lay in shamanism, in this case shamanistic hunting magic (e.g. Heizer & Baumhoff 1962). The reason for rock art's connection to shamanism to Heizer was obvious and straightforward, even if the inferred nature of the shamanism involved was incorrect: by all plausible evidence the rock art was religious in origin, and shamanism was undeniably the religious system practised by all pertinent North American hunter-gatherer cultures. To argue that this rock art was not somehow shamanistic was then to contend either that it was not religious in origin or that it derived from a religion that has no analogue in the ethnographic record. Heizer knew that, on the evidence, both of these implications were manifestly implausible, and they remain so as additional research and data collection have occurred over the last 40 years.

 Hence, intellectual debate over far western North America for over 100 years has revolved primarily around two issues: (i) the kind of shamanism responsible for its creation; and (ii) between about 1960 and 1980, whether there were direct ties between contemporary Native Americans and the creators of the art.

2 For example, see Hedges (1976, 1982, 1983, 1992), Blackburn (1977), Garvin (1978), Wellmann (1978), Wilbert (1981), Hudson & Lee (1984), York *et al.* (1993), Parkman (1994), Ritter (1994), Keyser *et al.* (1998), Stoffle *et al.* (2000), Hann *et al.* (in press), as well as many of my own publications (e.g. Whitley 1992, 1994a, 1994b, 1994c, 1998a, 1998b, 2000a, 2000b).

 But as is discussed subsequently, the fact that completely unanimous consensus has not been achieved on this point (e.g. Woody & Quinlan 1999; Quinlan 2000) is quite significant, and is to be expected in the 'argument culture' of modern academia.

3 Hence 'medicine man' for shaman; 'Medicine Butte', a major vision questing location; and 'medicine hat', a shaman's headdress. Note that, with respect to Numic and Native California shamanism, I have intentionally not employed gender-neutral terminology in my subsequent discussion of shamanism. This is because, in these specific regions, shamanism was almost exclusively a male practice.

4 This consultant does not claim to be a shaman and apparently does not make rock art. It is apparent, however, that he is engaged in the very lengthy process of preparing to become a traditional doctor. His corrections of the ethnographic record concern the correct identification of the Huhuna shaman/dancer. Anthropologists had identified this ritual officer as a loon dancer; the consultant independently claimed it was a blue heron dancer (he gives no evidence of having read the ethnographies). As it turns out, loons do not occur in California, yet blue herons are commonly mistaken for them.

5 While some might cite Erwin Panofsky (1983) to contest this conclusion, I argue instead that his arguments demonstrate my point in the sense that the changes that he identifies are trivial with respect to a larger perspective on the continuity of Judaeo-Christian beliefs and iconography.

6 Ironically, this same kind of logic also underlies New Archaeology's rejection of the direct historical approach – if time has passed, change must have occurred – although, clearly, the essentialist critique and new archaeology differ on almost every other point. What is more important is that, in the heated context of NAGPRA (the Native American Graves Protection and Repatriation Act of 1990), the essentialist argument bolsters conservative archaeological claims that Native Americans have no right to a say concerning the management of the archaeological record, or the disposition of burial remains. Rather than helping Native Americans reclaim some sense of their history, essentialism has instead helped to strip them of any vestige of it.

7 A somewhat subjective but still systematic tabulation of relative degrees of revarnishing as a very gross measure of age suggests that about two-thirds of the Coso petroglyphs were made in very roughly the last 2000 years (Whitley 1994a). The late intensification in petroglyph manufacture is supported chronometrically for the Mojave Desert as a whole (W&S Consultants 1997). The gross estimate of 100 000 motifs in the region would then indicate that over 66 000 petroglyphs were made during this span, or about 33 per year. In contrast, only about four per year would have been created for the previous 8000+ years.

References

Aginsky, B.W. 1943. Culture element distributions: XXIV, Central Sierra. *University of California Anthropological Records* 8(4): 393–468.

Anon. 1916. Indian tells story of City Hall rock. *The Oregonian* 24 (January): 3.

Barbeau, M. 1960. *Indian Days on the Western Prairies.* Ottowa: National Museum of Canada Bulletin 163, Anthropological Series No. 46.

Bettinger, R. & Baumhoff, M. 1982. The Numic spread: Great Basin cultures in competition. *American Antiquity* 47: 485–503.

Blackburn, T.C. 1977. Biopsychological aspects of Chumash rock art. *Journal of California Anthropology* 4: 88–94.

Bloch, M. 1974. Symbols, song, dance and features of articulation: is religion an extreme form of traditional authority? *Archives, European Journal of Sociology* 15: 55–81.

Brooks, C.R., Clements, W.M., Kantner, J.A. & Poirier, G.Y. 1979. *A Land Use History of Coso Hot Springs, Inyo County, California.* China Lake Naval Air Weapons Station, Ridgecrest, NWC Administrative Publication 200.

Cline, W. 1938. Religion and world view. In: Spier, L. (ed.) *The Sinkaietk or Southern Okanagon of Washington*: 33–82. Menasha (WI): George Banta, General Series in Anthropology 6.

Coburn, L.W. 1975. A theoretical framework for investigating the relationship of pictographs to mythology in the Northern Plateau. Unpublished MA thesis. Pullman (WA): Washington State University.

Cole, S.J. 1990. *Legacy on Stone: Rock Art of the Colorado Plateau and Four Corners Region.* Boulder (CO): Johnson Books.

Conway, T. & Conway, J. 1990. *Spirits on Stone: The Agawa Pictographs.* San Luis Obispo: Heritage Discoveries Publication 1.

Crampton, C.G. (ed.) 1957. *The Mariposa Indian War, 1850–1851: Diaries of Robert Eccleston: The California Gold Rush, Yosemite, and the High Sierra.* Salt Lake City (UT): University of Utah.

Denison, J.S. 1878. *Letter to Samuel Gatschet.* Bureau of American Ethnology document number 315.

Driver, H.E. 1937. Cultural element distributions: VI, Southern Sierra Nevada. *University of California Anthropological Records* 1(2): 53–154.

Fowler, C.S. 1992. *In the Shadow of Fox Peak: An Ethnography of the Cattail-Eater Northern Paiute People of Stillwater Marsh.* Nevada: Nevada Humanities Committee, Stillwater National Wildlife Refuge Cultural Resource Series 5.

Fowler, C.S. & Fowler, D.D. (eds) 1971. *Anthropology of the Numa: John Wesley Powell's Manuscript on the Numic Peoples of Western North America.* Washington (DC): Smithsonian Contributions to Anthropology 14.

Fowler, K., Dufort, M. & Rusco, M.K. 1995. Timbisha Shoshone tribe's land acquisition program: anthropological data on twelve study areas. Unpublished report submitted to the Timbisha Shoshone – Death Valley Land Restoration Project.

Franco, H. 1992. Comments on Rocky Hill. *Native American Heritage Newsletter* 3: 2.

Garvin, G. 1978. Shamans and rock art symbols. In: Clewlow, C.W. Jr. (ed.) *Four Rock Art Studies*: 65–88. Socorro (NM): Ballena Press.

Gayton, A.H. 1930. Yokuts-Mono chiefs and shamans. *University of California Publications in American Archaeology and Ethnology* 24: 361–420.

Gayton, A.H. 1948. Yokuts and Western Mono ethnography. *University of California Anthropological Records* 10: 1–290.

Gifford, E.W. 1932. The Northfork Mono. *University of California Publications in American Archaeology and Ethnology* 31(2): 15–65.

Grant, C. 1968. *Rock Drawings of the Coso Range, Inyo County, California.* China Lake (CA): Maturango Museum.

Grosscup, G. 1974. Northern Paiute archaeology. In: (no editor) *Paiute Indians IV*: 9–52. New York: Garland Publications.

Hann, D., Keyser, J.D. & Cash Cash, P.E. In press. Columbia Plateau rock art: a window to the spirit world. In: Taylor, M. (ed.) *Oregon Archaeological Society Publication 18*.

Harrington, J.P. (n.d.) *Papers.* Washington (DC): National Anthropological Archives, Smithsonian Institution, Northern and Central California – Yokuts.

Hedges, K.E. 1976. Southern California rock art as shamanic art. *American Indian Rock Art* 2: 126–138.

Hedges, K.E. 1982. Phosphenes in the context of Native American rock art. *American Indian Rock Art* 7–8: 1–10.

Hedges, K.E. 1983. The shamanic origins of rock art. In: Von Tilberg, J. (ed.) *Ancient Images on Stone*: 46–61. Los Angeles (CA): UCLA Institute of Archaeology, Rock Art Archive.

Hedges, K.E. 1992. Shamanistic aspects of California rock art. In: Bean, L.J. (ed.) *California Indian Shamanism*: 67–88. Menlo Park (CA): Ballena Press.

Heizer, R.F. & Baumhoff, M. 1962. *Prehistoric Rock Art of Nevada and Eastern California.* Berkeley (CA): University of California Press.

Hines, D.M. 1992. *Ghost Voices: Yakima Indian Myths, Legends, Humor, and Hunting Stories.* Yakima (WA): Great Eagle Publishing.

Hines, D.M. 1993. *Magic in the Mountains. The Yakima Shaman: Power and Practice.* Yakima (WA): Great Eagle Publishing.

Horton, R. 1967. African traditional thought and western science: parts 1 and 2. *Africa* 37: 50–71, 155–187.

Horton, R. 1982. Tradition and modernity revisited. In: Hollis, M. & Lukes, S. (eds) *Rationality and Relativism*: 201–260. Cambridge (MA): MIT Press.

Hudson, D. & Lee, G. 1984. Function and symbolism in Chumash rock art. *Journal of New World Archaeology* 4(3): 26–47.

Hultkrantz, Å. 1961. The Master of the Animals among the Wind River Shoshone. *Ethnos* 26(4): 198–218.

Hultkrantz, Å. 1981. *Belief and Worship in Native North America*. Syracuse (NY): Syracuse University Press.

Hultkrantz, Å. 1986. Mythology and religious concepts. In: D'Azevedo, W.L. (ed.) *Handbook of North American Indians, Volume 11, Great Basin*: 630–640. Washington (DC): Smithsonian Institution.

Hultkrantz, Å. 1987. *Native Religions of North America: The Power of Visions and Fertility*. San Francisco (CA): Harper and Row.

Keyser, J.D., Poetschat, G., Cash Cash, P. & Hann, D. 1998. *The Butte Creek Sites: Steiwer Ranch and Rattlesnake Shelter*. Portland: Oregon Archaeological Society Publication 11.

Keyser, J.D. & Whitley, D.S. 2000. A new ethnographic reference for Columbia Plateau rock art: documenting a century of vision quest practices. *INORA (International Newsletter on Rock Art)* 25: 14–20.

Laird, C. 1976. *The Chemehuevis*. Banning (CA): Malki Museum.

Lakoff, G. & Johnson, M. 1999. *Philosophy in the Flesh: The Embodied Mind and Its Challenge to Western Thought*. New York: Basic Books.

Latta, F. 1977. *Handbook of the Yokuts Indians (2nd edition)*. Santa Cruz (CA): Bear State Books.

Lerman, N.H. 1954. Okanogan (Salish) ethnology. Unpublished field notes and manuscript. Seattle (WA): Melville Jacobs Collection, University of Washington Library Archives.

Lévi-Strauss, C. & Eribon, D. 1991. *Conversations with Claude Lévi-Strauss* (translated by P. Wissing). Chicago (IL): University of Chicago Press.

Lewis-Williams, J.D. & Dowson, T.A. 1988. The signs of all times: entoptic phenomena and Upper Palaeolithic art. *Current Anthropology* 29: 201–245.

Liljeblad, S. 1986. Oral tradition: content and style of verbal arts. In: D'Azevedo, W.L. (ed.) *Handbook of North American Indians, Volume 11, Great Basin*: 641–659. Washington (DC): Smithsonian Institution.

Lowie, R.H. 1909. The Northern Shoshone. *Anthropological Papers, American Museum of Natural History* 2(2): 165–306.

Lowie, R.H. 1924. Notes on Shoshonean ethnography. *Anthropological Papers, American Museum of Natural History* 20: 185–314.

Mallery, G. 1893. *Picture Writing of the American Indians*. Washington (DC): Bureau of American Ethnology, 10th Annual Report.

Malouf, C. 1974. The Gosiute Indians. In: (no editor) *The Shoshone Indians, American Indian Ethnohistory: California and Basin-Plateau Indians*: 25–172. New York: Garland Press.

Malouf, C.I. & White, T. 1953. The origin of pictographs. *Montana State University Anthropology and Sociology Papers* 15: 30–31.

Nabokov, P. 1996. Native views of history. In: Trigger, B.G. & Washburn, W.E. (eds) *The Cambridge History of the Native Peoples of the Americas, Volume 1, North America, Part 1*: 1–59. Cambridge: Cambridge University Press.

Nabokov, P. 2002. *A Forest of Time: American Indian Ways of History*. Cambridge: Cambridge University Press.

Ortner, S. 1973. On key symbols. *American Anthropologist* 75: 1338–1346.

Panofsky, E. 1983. *Meaning in the Visual Arts*. Chicago (IL): University of Chicago Press.

Park, W.Z. 1938. *Shamanism in Western North America: A Study in Cultural Relationships*. Evanston (IL): Northwestern University Studies in the Social Sciences 2.

Parkman, B. 1994. Community and wilderness in Pomo ideology. *Journal of California and Great Basin Anthropology* 16: 13–40.

Phillips, H.B. 1986. Symbolic and cognitive content of Ute rock art. Unpublished paper presented at the Twentieth Great Basin Anthropological Conference, Las Vegas.

Quinlan, A. 2000. The ventriloquist's dummy: a critical review of shamanism and the rock art in Far Western North America. *Journal of California and Great Basin Anthropology* 22: 92–107.

Rajnovich, G. 1994. *Reading Rock Art: Interpreting the Indian Rock Paintings of the Canadian Shield*. Toronto: Natural Heritage/Natural History Inc.

Ranck, G. 1926. Tribal lore of Wishram Indians rich in traditions of Columbia. *The Sunday Oregonian* 7 February: 9.

Riddell, F.A. 1978. *Honey Lake Paiute Ethnography*. Carson City (NV): Nevada State Museum Occasional Paper 3(1).

Ritter, E.W. 1994. Scratched art complexes in the Desert West: symbols for socio-religious communication. In: Whitley, D.S. & Loendorf, L.L. (eds) *New Light on Old Art: Recent Advances in Hunter-gatherer Rock Art Research*: 51–66. Los Angeles (CA): Institute of Archaeology, University of California, Monograph 36.

Sahlins, M. 1985. *Islands of History*. Chicago: Chicago University Press.

Schoolcraft, H.R. 1851–1854. *Historical and Statistical Information Respecting the History, Condition, and Prospects of the Indian Tribes of the United States*. Philadelphia (PN): Lippincott, Grambo.

Shimkin, D. 1953. The Wind River Shoshone Sun Dance. *Bureau of American Ethnology, Bulletin* 151: 397–484. Washington (DC): Smithsonian Institution.

Shimkin, D. 1992. Unpublished letter to D.S. Whitley enclosing sections on Shoshone religion.

Spier, L. 1930. Klamath ethnography. *University of California Publications in American Archaeology and Ethnology* 30(1): 1–388.

Steward, J.H. 1929. Petroglyphs of California and adjoining states. *University of California Publications in American Archaeology and Ethnology* 24(2): 47–238.

Steward, J.H. 1938a. Basin-Plateau Aboriginal sociopolitical groups. *Bureau of American Ethnology, Bulletin* 120: 1–346.

Steward, J.H. 1938b. Pantatübiji', an Owens Valley Paiute. *Bureau of American Ethnology, Bulletin* 119: 183–195.

Steward, J.H. 1943. Culture element distributions: XXIII, Northern and Gosiute Shoshoni. *University of California Anthropological Records* 8(3): 263–392.

Steward, J.H. 1955. *Theory of Culture Change: The Methodology of Multilinear Evolution.* Chicago: University of Chicago Press.

Steward, J.H. 1977. *Evolution and Ecology: Essays on Social Transformation.* Urbana (IL): University of Illinois Press.

Stewart, O.C. 1939. Northern Paiute bands. *Anthropological Records* 2(3): 127–149.

Stewart, O.C. 1966. Tribal distributions and boundaries in the Great Basin. In: D'Azevedo, W.L., Davis, W., Fowler, D. & Suttles, W. (eds) *The Current Status of Anthropological Research in the Great Basin: 1964*: 167–238. Reno (NV): Desert Research Institute, Social Sciences and Humanities Publication 1.

Stewart, O.C. 1978. The Western Shoshone of Nevada and the U.S. Government, 1863–1900. In: Tuohy, D.R. (ed.) *Selected Papers from the 14th Great Basin Anthropological Conference:* 77–114. Ramona (CA): Ballen Press, Publications in American Archaeology, Ethnology and History 4.

Stoffle, R.W., Loendorf, L., Austin, D.E., Halmo, D.B. & Bulletts, A. 2000. Ghost dancing the Grand Canyon: southern Paiute rock art, ceremony and cultural landscapes. *Current Anthropology* 41: 11–38.

Tannen, D. 1998. *The Argument Culture: Moving from Debate to Dialogue.* New York: Random House.

Teit, J.A. 1896. A rock painting of the Thompson River Indians, British Columbia. *Bulletin of the American Museum of Natural History* 8(12): 227–230.

Teit, J.A. 1906. The Lillooet Indians. *Memoirs of the American Museum of Natural History* 4(4): 193–300.

Teit, J.A. 1909. The Shuswap. *Memoirs of the American Museum of Natural History* 4(7): 447–758.

Teit, J.A. 1918. Notes on rock painting in general, by J.A. Teit, Spences Bridge, 1918. Unpublished manuscript. Ottawa: National Archives of Canada.

Teit, J.A. 1930. The Salishan tribes of the Western Plateau. *Bureau of American Ethnology Annual Report* 45: 23–396.

Trenholm, V.C. & Carley, M. 1964. *The Shoshonis: Sentinels of the Rockies.* Norman (OK): University of Oklahoma Press.

Turner, V. 1967. *The Forest of Symbols: Aspects of Ndembu Ritual.* Ithaca (NY): Cornell University Press.

Turner, V. 1969. *The Ritual Process: Structure and Anti-Structure.* Ithaca (NY): Cornell University Press.

Vastokas, J.M. & Vastokas, R.K. 1973. *Sacred Art of the Algonkians: A Study of the Peterborough Petroglyphs.* Peterborough: Mansard Press.

Voget, F.W. 1984. *The Shoshoni-Crow Sun Dance.* Norman (OK): University of Oklahoma Press.

W&S Consultants. 1997. Rock Art Studies at CA-SBR-2347, the Paradise Bird Site, Fort Irwin N.T.C., San Bernardino County, California. Unpublished manuscript on file, Fort Irwin N.T.C., Department of Public Works.

Wellmann, K.F. 1978. North American Indian rock art and hallucinogenic drugs. *Journal of the American Medical Association* 239: 1524–1527.

Wheat, M.W. 1967. *Survival Arts of the Primitive Paiutes.* Reno (NV): University of Nevada Press.

Whitley, D.S. 1988. Bears and baskets: shamanism in Californian rock art. In: Dowson, T.A. (ed.) *The State of the Art: Advances in World Rock Art Research:* 34–42. Johannesburg: Department of Archaeology, University of the Witwatersrand.

Whitley, D.S. 1992. Shamanism and rock art in Far Western North America. *Cambridge Archaeological Journal* 2: 89–113.

Whitley, D.S. 1994a. By the hunter, for the gatherer: art, social relations and subsistence change in the prehistoric Great Basin. *World Archaeology* 25: 356–373.

Whitley, D.S. 1994b. Shamanism, natural modeling and the rock art of Far Western North America. In: Turpin, S. (ed.) *Shamanism and Rock Art in North America:* 1–43. San Antonio (TX): Rock Art Foundation, Special Publication 1.

Whitley, D.S. 1994c. Ethnography and rock art in the Far West: some archaeological implications. In: Whitley, D.S. & Loendorf, L.L. (eds) *New Light on Old Art: Recent Advances in Hunter-gatherer Rock Art Research:* 81–93. Los Angeles: UCLA Institute of Archaeology, Monograph 36.

Whitley, D.S. 1996. Numic bands and headmen revisited: social factors in the origin of political differentiation. Unpublished paper presented at the biannual Great Basin Anthropological Conference, Lake Tahoe.

Whitley, D.S. 1998a. Finding rain in the desert: landscape, gender, and Far Western North American rock art. In: Chippindale, C. & Taçon, P.S.C. (eds) *The Archaeology of Rock-Art:* 11–29. Cambridge: Cambridge University Press.

Whitley, D.S. 1998b. Meaning and metaphor in the Coso petroglyphs: understanding Great Basin rock art. In: Younkin, E. (ed.) *New Perspectives on the Coso Petroglyphs:* 109–174. Ridgecrest (CA): Maturango Museum.

Whitley, D.S. 1998c. Cognitive neuroscience, shamanism and the rock art of Native California. *Anthropology of Consciousness* 9: 22–37.

Whitley, D.S. 2000a. *The Art of the Shaman: Rock Art of California.* Salt Lake City (UT): University of Utah Press.

Whitley, D.S. 2000b. Use and abuse of the ethnohistorical record. *American Indian Rock Art* 26: 1–12.

Whitley, D.S. 2001a. Science and the sacred: interpretive theory in US rock art research. In: Helskog, K. (ed.) *Theoretical Perspectives in Rock Art Research*: 130–157. Oslo: Novus Press.

Whitley, D.S. 2001b. Rock art and rock art research in a worldwide perspective: an introduction. In: Whitley, D.S. (ed.) *Handbook of Rock Art Research*: 1–43. Walnut Creek (CA): Altamira Press.

Whitley, D.S., Dorn, R.I., Simon, J.M., Rechtman, R. & Whitley, T.K. 1999. Sally's rockshelter and the archaeology of the vision quest. *Cambridge Archaeological Journal* 9: 221–247.

Whitley, D.S., Gumerman, G. IV, Simon, J.M. & Rose, E. 1988. The Late Prehistoric period in the Coso Range and environs. *Pacific Coast Archaeological Society Quarterly* 24(1): 2–10.

Whitley, D.S., Simon, J.M. & Dorn, R.I. 1999. The vision quest in the Coso Range. *American Indian Rock Art* 25: 1–31.

Wilbert, W. 1981. Two rock art sites in Calaveras County. In: Meighan, C.W. (ed.) *Messages From the Past: Studies in California Rock Art*: 107–122. Los Angeles: Institute of Archaeology, University of California, Monograph 20.

Woodbury, N.F.S. 1992. Pictures from the past: the study of rock art. *Anthropology Newsletter* 33(8): 5, 20.

Woody, A. & Quinlan, A. 1999. Marks of distinction: rock art and ethnic identification in the Great Basin. Unpublished paper presented at the biennial Great Basin Anthropological Conference, Bend, Oregon.

Yohe, R.M. 1992. A reevaluation of western Great Basin cultural chronology and evidence for the timing of the introduction of the bow and arrow to eastern California based on new excavations at the Rose Spring Site (CA-INY-372). Unpublished PhD thesis. Riverside (CA): University of California.

York, A., Daly, R. & Arnett, C. 1993. *They Write Their Dreams on Rocks Forever: Rock Writings of the Stein River Valley of British Columbia.* Vancouver (BC): Talonbooks.

Zedeño, M.N., Stoffle, R.W. & Dewey, G. 1999. Rock art and the architecture of place. Unpublished paper presented at the 64th annual meeting of the Society for American Archaeology, Chicago.

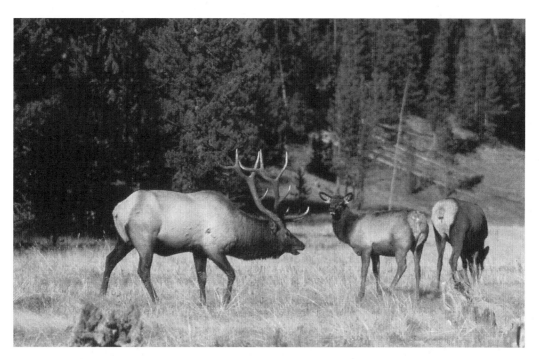

FIGURE 8.1 A bull elk with two cows. Bulls have massive antlers whereas cows have none. Yellowstone National Park digital slide file. *(Photo by John Good 1966)*

8.

Crow Indian elk love-medicine and rock art in Montana and Wyoming

LAWRENCE L. LOENDORF

(Albuquerque NM, USA)

The Crow Indians of Montana recognise the power possessed by a variety of animals, among them grizzly bears, eagles, and bison, but the power of the American elk to control human love and passion exceeds that of any other species. Through recent research, I have learnt that rock art sites associated with elk love-magic may be a relatively common component of the rock art record in Montana and Wyoming.

LOVE-MAGIC AND THE AMERICAN ELK

The American elk (*Cervus elaphus*), known in northern Europe as the red deer, is a large *Artiodactyla* that was originally distributed across most of North America. An average mature bull elk weighs 700 lb (315 kg), stands 5 ft (1.5 m) at the shoulder, and measures more than 8 ft (2.4 m) from nose to rump; cows are about three-quarters the size of bulls (Figure 8.1). Each spring, as the testosterone levels in their blood rise in response to increasing amounts of daylight, bull elk begin to grow antlers from the pedicles on their skulls. By September, the antlers are hard and fully developed, weighing as much as 40 lb (18 kg) per pair. Rising testosterone levels in bull elk throughout September also stimulate mating behaviours. Bulls emit a loud whistling bugle sound to attract cows and then must fight other males seeking access to their harem. Charging at one another and locking their massive antlers, bull elk repeatedly engage in duels of strength. The reproductive pay-off for a successful mature bull elk is that he might control as many as 40 or 50 cows throughout the rutting season.

American Indians across North America identified the elk as an important power animal. This association

was especially prevalent among Plains Indians, in whose mythology, songs, and art the elk occupied a significant position. Among the Lakota, for example, the elk has been described as:

> the emblem of beauty, gallantry, and protection. The elk lives in the forest and is in harmony with all his beautiful surroundings. He goes easily through the thickets, not-withstanding his broad branching horns. In observing the carcass of an elk it is found that two teeth remain after everything else has crumbled to dust. These teeth will last longer than the life of a man, and for that reason the elk tooth has become an emblem for long life (Densmore 1918: 176).

Ivory elk teeth, the evolutionary remnants of tusks, were highly valued by Plains Indians, who made them into necklaces and used them as decoration on clothing. Because elk teeth symbolised the power of seduction, a man would want his wife to wear them not only as evidence of his prowess as a hunter but also because they identify him as a lover.

For a man to have a vision in which he is instructed by an elk conferred upon him the power to captivate and control members of the opposite sex. Among the Lakota, this power – which some women also acquired by dreaming of elk – was formalised by the creation of an Elk Dreamers' Society, whose members acted out their dreams and tested their power in dance performances. To represent the elk, Lakota Elk Dreamers wore triangular rawhide masks with small branches indicating antlers and painted their bodies yellow and their arms and legs black from elbow to hand and from knee to ankle. Elk Dreamers met for feasts and dances during which they sang and made medicine to attract women. They carried mirrors or hoops through which they shot their power at rivals or toward the individuals they were trying to bring under their influence.

Elk power was also used extensively by the Crow Indians of Montana. The power was personally owned and often obtained in a vision that occurred during a period of grief associated with an unrequited love. The medicine, kept in a bundle and used by individuals for their own purposes, was not the focus of a specific society such as the Lakota Elk Dreamers, but was still con-

sidered to be significant. Between 1918 and 1927, William Wildschut, a Billings, Montana businessman, collected more than 260 elk love-medicine bundles from the Crow and donated them to various museums across North America. Wildschut learnt that both Crow "men and women possessed these medicines and with them sought to attract a person of his or her choice, tried to regain the affection of an unfaithful wife or husband, or to revive a lost love" (Wildschut 1975: 123). Associated with each elk medicine bundle was a personal saga describing how it was acquired and used, and there was considerable variation in these love-medicine stories. The points of resemblance between stories can be enumerated by relating a tale collected by Wildschut from a Crow man named Travels.

Travels was middle-aged when he fell in love with a younger woman (Wildschut 1975: 123–125). When she refused his advances and told him to leave her alone, Travels went to the mountains to seek a vision. After four nights, he returned to camp without having had a vision and tried again to win the heart of his beloved. When she refused a second time, Travels chose the highest peak in the Crazy Mountains (*Awaxaawippiia*) as the site of his continued attempt to seek a vision and, five days and nights later, he was rewarded.

In his vision, Travels saw an elk standing in a river. After some time had passed, it began to walk toward him, changing into a human being. The elk-man wore an elk-skin robe and carried a bone whistle. Stopping a short distance from Travels, the elk-man told Travels to watch him. Then, facing in each of the cardinal directions in succession, he blew the whistle and sang songs. In response, dozens of female animals of all species came running. When he had finished, the elk-man told Travels that if he returned home, made a robe and a whistle, and sang songs, no woman would refuse his offers of love. Then the elk-man sang one more song, 'When I Talk it Rains', which caused a large storm with lightning and rain to approach. The elk-man told Travels that he would also have the power to make rain.

After his vision, Travels killed a large bull elk and returned to camp. He made an elk-skin robe and painted it with the same scene that had appeared on the elk-man's robe. He made a whistle, practised the magic, and sang the songs, after which the young woman came to him and they were married. They had a long and prosperous marriage and, around 1900,

Travels died at the age of 100 (Wildschut 1975: 124).

Wildschut relates several more stories about how elk love-medicine was obtained through visions. In many of them, a bull elk is first seen standing in water. As it approaches, it turns into a human being who is wearing an elk-skin robe. The transformation of an elk into a human is a significant part of the vision and occurs in many of the descriptions of Crow elk medicine. The elk-turned-human tells the visionary about medicinal herbs such as mountain holly or lichen, about how to use a whistle, to sing certain songs, and to make a painted robe on which the vision is depicted. Apparently, visionaries also made replicas of their dreams on rock surfaces. Less frequently, the elk confers additional powers on the supplicant, but the primary power is that of control over the opposite sex.

Although it was less common for Crow women to possess and use love-medicine acquired through dreams, its availability is demonstrated by Wildschut's description of a Crow wife whose husband left her for another woman. Ignoring the warnings of her relatives, the woman followed her husband and remained near him and his new love. The husband scolded her, called her names and told her to leave, but she refused to go. One night the spurned wife fell asleep and had a dream in which a bull elk gave her the pitch of a certain pine tree and yellow moss for medicine and incense (Wildschut 1975: 131). The elk showed her how to play a flute and make the medicine work. The woman was overjoyed and she went back to her own camp and made the medicine. Within a few days, her husband returned and afterwards remained faithful to her. Although in this story the woman is not instructed to make any images of her vision, there may be other instances in which depiction followed a vision.

ELK IMAGES AT ROCK ART SITES IN MONTANA AND WYOMING

Pictographs and petroglyphs of elk are relatively common throughout the former territory of the Crow Indians in Montana and Wyoming, and some are quite clearly associated with elk love-medicine. A petroglyph at the Castle Gardens site in central Wyoming includes a bull elk that measures about 64 cm from nose to tail. The elk appears to be stumbling or falling, as though it is dying, and erect hairs – which are signs of power

– project from its nose and beneath its throat.

The image of a woman wearing a large dress decorated with elk teeth is enclosed in a circle and situated in front of the elk (Figure 8.2). The woman's arms are raised upward and her hair is flowing above her head. The width of the dress and the position of the hair suggest the woman is lying on a blanket. The hem of the dress is raised, exposing a large and well-defined vulva. Other depictions of vulvas are found throughout the rock art panel, including one on the rump of the elk. A bear-claw design and a smaller v-shouldered human, between the elk and the woman, complete the petroglyph. Although not well defined, the central figure appears to have antlers and may represent the elk-man who intercedes in the vision. Describing this petroglyph, Ted Sowers, a Wyoming rock art researcher, suggested that the woman was pregnant and that, without doubt, the panel represented "a prayer for multiplication of both men and game" (Sowers 1941: 4). It seems more likely that the scene is a replica of a vision in which an elk gave a man the power of love.

At the Castle Butte petroglyph site in south-central Montana, a bull elk measuring about half a metre from head to tail is depicted leading a cow elk (Figure 8.3). The bull elk, which has a disproportionately long body, is shown with its head turned back toward the cow. The more correctly proportioned body of the cow suggests that the elongation of the bull's body was intentional. The bull's front feet are connected to several lines, suggesting that the animal is being restrained by a snare or similar device. There are few other details except for the elongated tail of the bull, which is shown erect, and a line protruding from the back of the animal in an unusual position.

Beneath these figures is a woman whose long, unbound hair spreads out and down along the right side of her body. An enlarged vulva is shown beneath her dress. The woman appears to hold something, which may be a flute, in her upraised hand. The female cow is positioned above the woman; its head is turned and it appears to be calling the bull, whose head is turned toward her. This scene may be recording dynamics at two levels: on the human level it may depict the elk power obtained by a woman, who then uses a flute to reclaim a lost love; on the level of animal interaction, the images may indicate that the female elk has an analogous power to draw the bull elk to herself.

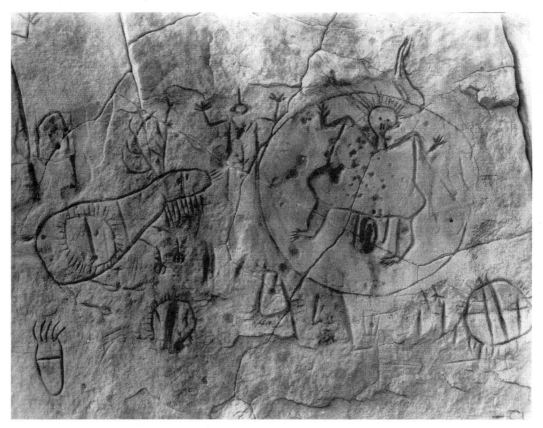

FIGURE 8.2 Castle Gardens, Wyoming. Petroglyphs depict an elk love-magic scene. The female figure, whose dress is lifted to expose her vulva, appears to be lying on her back. Note that elk teeth decorate her dress. A male figure at the far left, only partly visible in this photograph, has an erect phallus. An elk appears to be stumbling or falling as though in death. Vulva forms are present throughout the scene. *(Photo by J. David Love c. 1930)*

As part of my research I questioned Tim McCleary, an anthropologist who lives on the Crow Reservation and teaches at Little Bighorn College, about his knowledge of Crow elk medicine. He reported that the effigies, whistles, and rawhide cut-outs and blankets decorated with elk are only superficially involved in elk medicine. The core of the power lies in the combined use of a light-green lichen, a tuft of hair from the centre of an elk's forehead, and deep yellow ochre paint. McCleary also said that he had visited the Castle Butte site, which is several hundred miles north of the Crow Indian Reservation, with a middle-aged male Crow friend who took him to the panel containing the images of the two elk and the woman. There the Crow man performed a small ceremony in which he patted the images and then patted his torso, instructing McCleary to do the same (McCleary pers. comm. 2 February 2000).

The use of the Castle Butte site by contemporary Crow Indians for love-magic is strong evidence for a direct association between the rock art and elk love-medicine. McCleary's Crow friend also told him that he had complied with an uncle's instruction to put away his love-medicine bundle once he was married. McCleary suspects, although he cannot prove it, that a member of this Crow family received the original

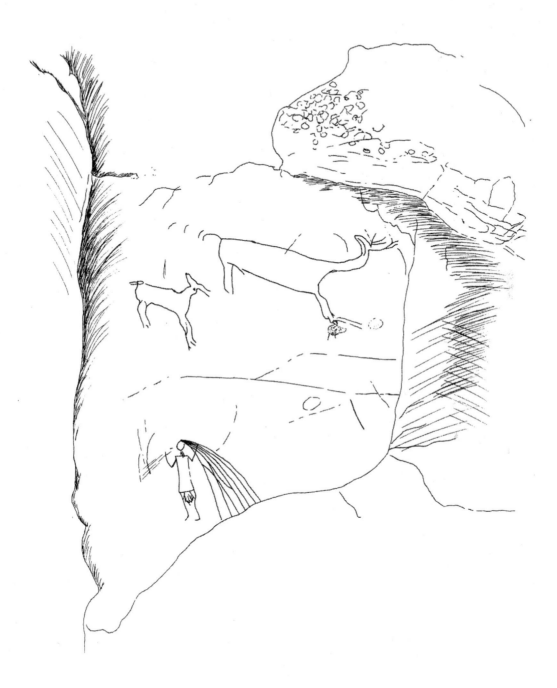

FIGURE 8.3 The Castle Butte bull and cow elk. The female figure in the scene, recognisable by her long hair, appears to be playing a flute. This scene may represent elk love-power as used by women to control errant husbands. *(Drawing by Linda Olson)*

love power in a vision at Castle Butte and that it has since been passed on to other family members.

The recognition that Crow love visions have been depicted in rock art provides new interpretive possibilities and means that many sites with images of elk need to be re-examined for evidence that they might be related to love-medicine. For instance, it is not unusual to find elk figures with vulva forms placed either on or near them. An elk petroglyph at the Davidson Microcave site in southern Montana measures 45 cm from the top of its antlers to the bottom of its front feet and has several vulvas immediately behind it (Figure 8.4). A human hand reaches toward one vulva, perhaps suggesting an association between the visionary and the vulvas. Although the figure of the elk is not shown stumbling, an arrow stuck in its back seems likely to be a symbol of death. The elk has an erect tail, and short lines radiate along its throat

and between its antlers – attributes suggesting that the animal is in a power state.

This petroglyph's physical placement inside a small, egg-shaped cavity in a large sandstone boulder is interesting as well. Small portals such as these leading to the interior of a rock are often thought of as places where power might be obtained. This location would also have been ideal for the storage of medicine bundles or the practice of the magic associated with elk.

Elsewhere, some large elk petroglyphs appear to be considerably older than the simple vulva forms found with them in the same panel, suggesting that an earlier rock art tradition was incorporated into more recent activities with a new purpose. In some of these panels, the elk on the rock may have been perceived by a visionary as the personification of an elk appearing in his or her dream, after which the vulva was added to the scene. Other examples may represent the work

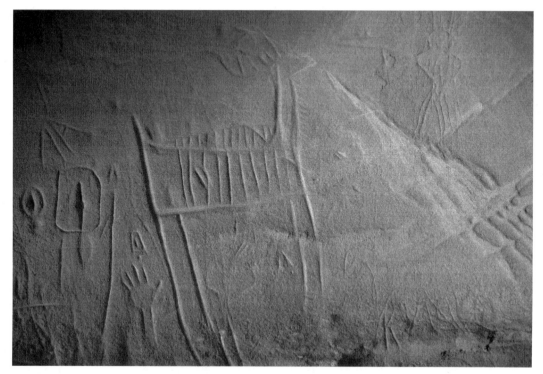

FIGURE 8.4 The Davidson Microcave elk and associated vulva forms. A faint arrow in the back of the elk symbolises its death. Vulva forms are present throughout the scene. *(Photo by Lawrence Loendorf)*

FIGURE 8.5 An elk in the process of changing into a human. The human figure is emerging from the elk's antlers. *(Drawing by Linda Olson)*

of individuals trying to practise elk magic by using an older rock art elk figure as a potential source of power.

The conflation of elk and human is an essential part of Crow elk love-magic. In a compelling image at a south-central Montana site that is associated with the Crow, a figure assumes human form as it emerges from the antlers of a large bull elk (Figure 8.5). Power lines trail from the nose, foreleg, and penis of the elk. Even though this figure is not directly associated with any other images, such as vulvas, in an adjacent petroglyph a woman is shown lifting her dress to expose her vulva.

SUMMARY

The depictions of elk and humans in the rock art of Montana and Wyoming may best be interpreted by referral to the theoretical framework developed by David Lewis-Williams during his research in South Africa. Indeed, the elk figures at Crow Indian rock art sites share some of the characteristics of animal species depicted in Bushman rock paintings. For example, the elk at the Castle Gardens site is shown with bent forelegs in a stumbling or death posture, much like the eland at Game Pass Shelter in South Africa. Based on his study of San ethnographic resources, David Lewis-Williams recognised the transformational character of the painting in which the eland assumes a death posture so that the human might experience a powerful, life-giving trance. The same dynamic underlies the scene at Castle Gardens, where the elk is transformed into a human to assist the Crow visionary. Similarly, the transformation of an elk into a human is unambiguously displayed in the south-central Montana site, where a partially formed human is emerging from the elk's antlers.

Crow folklore describes incidents in which an elk is killed to make a robe on which a visionary's dreams could be painted. Not only does the elk die physically prior to its coat being made into a robe on which the power associated with love-magic is depicted, but it also dies as it is transformed into a human. Both

events require the visionary to represent the elk in a dying posture. At the Davidson Microcave site, the elk figure has an arrow in its back, which is symbolic of death. In this example, the adjacent vulvas and human hand indicate that the scene is intended to depict love-magic. The clarity of this association of an arrow and symbols of elk love-magic underscores the necessity of re-examining other rock art images of elk previously believed to be related to hunting to determine whether they may actually represent elk dying in the context of love-magic.

Other features of rock art images at sites such as Castle Gardens and the Davidson Microcave may also become more meaningful when they are analysed in terms of the dynamics of power and death. Short rayed lines around the heads of the Castle Gardens and Davidson Microcave elk petroglyphs might be interpreted as hair except that each is erect and clearly depicted and they are shown in the nose or between the antlers, where they seem out of place. These rayed lines suggest that the elk is experiencing a power state like that of the South African eland, from which power lines also radiate. These short lines may, however, be referring to the elk hair found in Crow medicine bundles. The "tuft of hair from the centre of an elk's forehead" that Crow sources say is used in love-magic would not normally be significant to an elk hunter and the inclusion of this detail in a rock art panel depicting a hunting scene is unlikely. The presence of such a detail in elk petroglyphs is therefore a strong indication that the scene represents the practice of elk love-magic. Similarly, the tail positions of elk in the Montana and Wyoming petroglyphs have their counterpart in South African rock painting. In both locations, elk and eland tails are erect and are either pointed above the animal's back or straight out at an unnatural angle. In South Africa, these details signify the trance state of the animal, and they may be conveying the same information in elk petroglyphs in Montana and Wyoming.

Crow ethnography recounts that humans suffering from unrequited love or who have been deserted by an errant lover may retreat to the mountains to cry or to fast as a remedy for their sorrows. In some stories, the visionary specifically seeks the power of the elk to resolve the problem, while other persons simply experience a vision while they are sleeping. In all examples, however, an elk becomes the animal associated with the medicine needed for love-magic. Elk

depicted in death poses, with radiating hairs or tails at unnatural angles – even if they are not associated with vulvas or other depictions of a sexual nature – may also be associated with love-medicine. Researchers need to be alert to the presence of these characteristics in petroglyphs and pictographs of elk.

It is also likely that some of the rock art scenes featuring elk are associated with women and their use of love-magic. Crow ethnography describes the vision of a woman who successfully reclaimed her lost husband, while other sources record instances in which independent women searched for lovers who were lost on hunting trips or tell of husbands who had run off with other women. The scene at Castle Butte is unique in that it includes both a bull and a cow elk, and the representation of the female elk may be indicating that the petroglyph expresses the use of female love-magic. The fact that the petroglyphs were known and used by a Crow male suggests, however, that they also hold power for men. Another possibility is that the image of the cow elk was added at a later date in a separate, female-focused episode of elk love-magic.

More than 15 other sites with petroglyphs or pictographs of elk (or large deer) have been recorded in Wyoming and Montana. These sites need to be carefully re-examined to determine whether the images contain attributes now known to be associated with elk love-magic as practised by women, men, or by both genders. Research should also continue to focus on the ethnography associated with love-magic and with the iconography of materials in elk love-medicine bundles of the Crow and other Plains tribes, since these resources have been shown to contain much relevant information bearing on an understanding of the rock art.

The research described here makes it very clear that we all owe an enormous debt to David Lewis-Williams for his pioneering investigation into the practice of shamanism and its interpretive relevance to trance-related rock art images. The petroglyphs I have described were previously thought to be associated solely with hunting magic or – in the case of sexual scenes – to represent projections of species fecundity and hoped-for increases in the size of animal herds. In fact, however, through an informed use of ethnographic sources, petroglyphs with specific characteristics associated with animals in a trance state (and still visited by contemporary Crow people) appear related to the very important practice of elk love-medicine.

Acknowledgements

This chapter is much as it was when delivered at the David Lewis-Williams symposium in South Africa in April 2000. In the subsequent years Linea Sundstrom (2004) has found and reported on elk medicine rock art with good examples that represent the Lakota elk-medicine societies. I want to thank all the participants in the David Lewis-Williams symposium for their remarks regarding this paper. I am especially grateful to Benjamin Smith and Geoffrey Blundell for bringing this manuscript to publication. Nancy Medaris Stone edited this version of the chapter and Linda Olson supplied illustrations at the last minute. I appreciate their help.

References

Densmore, F. 1918. Teton Sioux music. *Bureau of American Ethnology, Bulletin* 61. Washington (DC): Smithsonian Institution.

Sowers, T.E.D. 1941. Petroglyphs at Castle Gardens, Wyoming. Unpublished Archaeological Project Report, Works Progress Administration, Casper, Wyoming. Original on file at the Coe Library, University of Wyoming, Laramie.

Sundstrom, L. 2004. *Storied Stone: Indian Rock Art of the Black Hills Country*. Norman (OK): University of Oklahoma Press.

Wildschut, W. 1975. *Crow Indian Medicine Bundles* (Second edition, edited by Ewers, J.C.). New York: Museum of the American Indian, Heye Foundation.

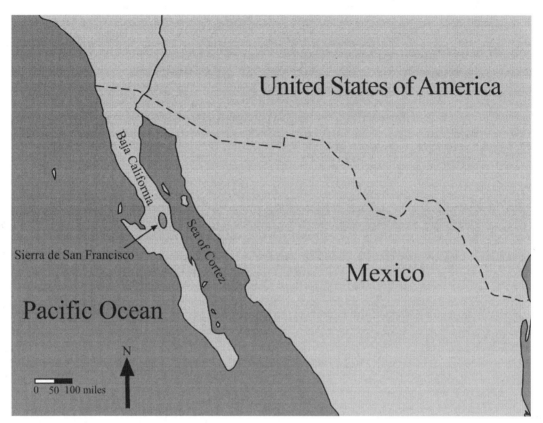

FIGURE 9.1 Map of Baja California showing the location of the Sierra de San Francisco.

9.

Layer by layer:

Precision and accuracy in rock art recording and dating

JOHANNES LOUBSER

(Stratum Unlimited, Alpharetta GA, USA.
Rock Art Research Institute, University of the Witwatersrand, South Africa)

BACKGROUND: Informed and formal approaches in conjunction

This chapter deals with the ethnographically informed interpretation and formal stratigraphic recording of the 'Great Murals' (Crosby 1984) within Cueva de El Ratón, central Baja California, north-western Mexico (Figure 9.1). The premise of this chapter is that neither informed use of ethnography nor formal archaeological recording can, done in isolation, give an adequate picture of prehistoric rock art (Chippindale & Taçon 1998a), such as evidenced at El Ratón. Albeit essential in any empirical investigation, the mere adoption of rigorous methodologies in both informed ethnographic and formal archaeological studies is not sufficient to guarantee an

accurate picture of the past. It is only when treated in conjunction that informed and formal approaches reach their full potential. Although local ethnographic records are the most logically valid starting points for analogies, the archaeological record is not a one-to-one reflection of the ethnography. Demonstrable patterns observed in the rock art record, for example, sometimes contain information not directly mentioned in the ethnography. Instead of despairing that we cannot interpret the rock art due to a lack of a perfect 'fit' with the ethnographic record, such an ostensible disjunction should be viewed more positively. Indeed, if all rock art neatly reflected the ethnography, then the best we could claim is to have learnt something about the rock art. However, if the rock art reveals convincing bits of information not

mentioned in the ethnographic record, then we can rightly claim to have learnt something from the rock art (Inskeep 1971). Herein lies the strength of rock art studies as proposed by David Lewis-Williams (1981) in his seminal *Believing and Seeing*, in which careful observations of San rock art revealed aspects not always immediately obvious in San ethnography. Ever since his early days of rock art research, Lewis-Williams (1974, 1992) advocated meticulous observation and exploration of patterns, such as superpositioning sequences. Nevertheless, as Lewis-Williams has repeatedly stated, meticulous observation alone is not adequate in the absence of a correct understanding of how ethnography and rock art are linked. It is in tribute not only to Lewis-Williams' insights concerning the subtle and often evasive relationship between ethnography and rock art, but also to his ongoing insistence on close observation and meticulous recording, that I have approached the El Ratón study.

EL RATÓN AND ITS ROCK PAINTINGS

El Ratón is a long and narrow rock shelter (66 m long, 13 m wide and 6 m high) that lies near the central and high-lying portion of the Sierra de San Francisco (*c.* 1230 m above mean sea level). The Sierra is a mountain massif of volcanic origin near the middle of the Baja peninsula (Figure 9.1). A series of deep canyons radiating from a central plateau of the Sierra characterises the topography of the area. Cueva de El Ratón, located between the uppermost reaches of the Santa Teresa canyon and the edge of the central plateau, is the highest-known painted shelter within the Sierra. Most of the Great Mural paintings occur in rock shelters located in the abundant precipitous canyon walls below El Ratón. The rock paintings, characteristically greater than life-size, on the upper back walls and ceilings of the rock shelters in the Sierra, are mostly of humans, animals, and spear-like lines; they also include smaller grid-like imagery on the lower walls. Harry Crosby (1984) notes that whereas the animals – typically deer and mountain sheep – are painted in profile and appear animated, the human figures – mostly male – face the viewer and appear static. While most animals are depicted as running with legs outstretched, virtually all humans are depicted in erect postures with their arms upraised. A

few figures are clearly female, depicted with breasts below the arms. Red and black are the principal colours in both human and animal paintings, with human figures often exhibiting a sharp vertical separation between the colours. Yellow accentuates most of the comparatively small grid-like patterns in the Sierra de San Francisco. Another characteristic of the Sierra paintings is that most shelters have multiple layers of overlapping imagery. In spite of such general similarities between sites in the Sierra, each shelter is characterised by idiosyncratic elements. Within the Santa Teresa canyon, for example, Flechas rock shelter is known for its meticulous and abnormally frequent depictions of arrows and spears associated with both human and animal motifs, while El Ratón rock shelter is known for its unique depiction of a cat-like creature. Local ranchers have identified this feline creature as a big rodent (hence its name El Ratón, or 'the rat').

The large numbers and the scale of the paintings have impressed generations of visitors to the sites. Even within the elevated Sierra, the climate is semi-arid, with rainfall perhaps minimally higher than in the surrounding plains of the central peninsula (less than 100 mm of rainfall a year). Natural springs occur in the canyons and surrounding plains, creating small oases with palm trees. Vegetation in the Sierra, of the Sonoran desert type, includes cactus, agave, mesquite, and yucca. Animals typical of the area include pronghorn antelope, mule deer, mountain sheep, mountain lion/panther, and various smaller species, such as rabbit – and these are depicted in the paintings. Cueva Pintada, a large rock shelter with more images than any other site in the Sierra, contains rare depictions of birds, fish, and stingray. The marine species occur in the Pacific Ocean to the west and the Gulf of California to the east. Paintings of plants are almost completely absent. The fact that some of the massive painted images are up to nine metres above the ground has resulted in suggestions that they were done with the aid of scaffolding (local palm trees make excellent scaffolds) and/or long paintbrush handles (Crosby 1984). Whatever the technique of painting, the existence of such large images high above the ground surface and the mere effort to acquire big quantities of pigment for their completion, strongly suggest collaborative efforts and long-distance contacts among the gatherers and hunters who once inhabited the peninsula.

PEOPLE OF THE SIERRA DE SAN FRANCISCO

Gathering and hunting people have been living in the region for at least ten millennia, as attested, among other evidence, by the recovery of a Clovis-type point at an open-air site in the area (María de la Luz Gutiérrez pers. comm. 1994). Conventional and Accelerator Mass Spectrometry (AMS) radiocarbon dates from charcoal and painting implements found within Great Mural rock shelters suggest that occupation flourished between 2000 and 500 years ago (Hyland 1997). Three direct AMS measurements of the murals within El Ratón, ranging between 5000 and 1300 years ago (Fullola *et al.* 1994), are suspect for reasons discussed below (see also Loubser 1997). The archaeological record shows that the most recent gatherer-hunter occupation of the area occurred merely 500 years ago, contemporary with the initial Spanish occupation of the peninsula in the 16th century. This temporal overlap between the archaeological record and historical accounts has facilitated the use of the regional ethnography to interpret its archaeology and rock art (e.g. Grant 1974; Hyland 1997; Hyland n.d.).

Jesuit missionaries who entered central Baja California in the 18th century were the first to write extensively about the local Cochimí Indians they encountered in the region. The same missionaries also commented on the numerous rock paintings. According to one documented account (Stanley Price 1996), the Cochimí ascribed the paintings to giants who had entered the peninsula from the north. An overly literal interpretation of such a statement could be that the Cochimí did not paint the Great Murals. Yet the Cochimí statement can be interpreted in various ways; it cannot be taken as positive proof that others painted the Great Murals. Inferred denial of authorship can result from a variety of reasons, not least of which might be the desire to hide sensitive spiritual information from inquisitive missionaries. On the other hand, instead of being an outright concealment of information, the statement could actually be the informant's metaphorical allusion to the painters' status within Cochimí society. Only a more critical reading of the original Spanish document and the most likely context in which it was written may help resolve uncertainties pertaining to the statement concerning giant painters. As the Cochimí settled increasingly on the Spanish missions, their existence as independent gatherers and hunters came to an end; by the middle of the 19th century, the Cochimí had become virtually extinct (Gutiérrez *et al.* 1996).

Although no known ethnographic sources refer to the production of the rock art by the aboriginal inhabitants of Baja California, Justin Hyland (n.d.) has shown that the Great Mural paintings of the central peninsula were most probably a manifestation of a very old peninsula-wide religious complex. This ceremonial complex was principally associated with communication with the dead through the use of shamanic objects. A recurrent set of material culture objects required for performance of the religious complex has been thoroughly documented in the ethnographic record. Hyland justifiably proposes that if a similar set of material cultural remains is identified in the archaeological record, then we have empirical evidence that the complex existed in prehistoric times. Linguistic evidence indicates that Cochimí speakers once occupied the entire central portion of the Baja peninsula (Aschmann 1959). The greatest dialectical differentiation within the Cochimí language is between the extreme northern and southern edges of its occurrence. This, and other linguistic evidence not adumbrated here, suggests fairly permanent occupation of the Baja peninsula over a long period of time. Moreover, well-preserved artefacts from the dry deposits within the excavated rock shelters with Great Mural paintings suggest continuity between the prehistoric occupants and proto-historic Cochimí peoples (Meighan 1966).

Documented ethnographic observations of Baja Indian material culture dating back to the 18th century and earlier indicate that human-hair capes, wooden tablets, wooden effigy figures, smoking and sucking pipes, and feathered wands were part of the distinctive peninsular ceremonial complex related to lineage-based ancestor veneration (Hyland n.d.). Thanks to good preservation in the dry rock shelters of the Baja peninsula, similar objects have been recovered from archaeological contexts. In the ethnographic record such paraphernalia were used in a mourning ceremony intended to appease the dead founding fathers of particular lineages. During the mourning ritual, boys left the ritual items within a special structure. The bodies of participating boys were painted red and black (Meigs 1939, as quoted

by Hyland n.d.), "representing each of the deceased, as is believed are painted the spirits" (Ochoa Zazueta 1978: 253–254, as quoted by Hyland n.d.). In the presence of the painted boys, the presiding shaman would 'die'. Death in this sense explicitly referred to the shaman leaving his body while in a trance to find dead ancestors. Normally one of the dead would take possession of the shaman's body and speak in an unintelligible voice. In some instances the shamans demonstrated their communication with the spirits of the dead to the rest of the community by little wooden boards cut from the heart of the mesquite tree, "on which they have painted absurd figures, that they said copied authentically the tabla, which the visitant Spirit left them when they went to the sky" (Venegas 1943: 95). As Hyland convincingly shows, ancestor impersonation was crucial to this and other closely related ceremonies. Moreover, the deceased ancestral lineage heads were presented as shamans in various myths, so the distinction between these dead spirits and the performing shamans acting as the deceased ancestors was blurred. Taken together, then, ethnographic evidence shows that shamans and painted participants temporarily became mythical founding fathers during mourning rituals (see Turner [1995] on the concept of *communitas*, which accounts for the merging of separate time periods and individuals on ritual occasions).

Various researchers (e.g. Grant 1974) have remarked on the similarity between ethnographic descriptions of ritualised body painting and the colour divisions on the Great Mural figures. On a more specific level of interpretation, the association of idiosyncratic figures with particular rock shelters could refer to ancestors of particular lineages. Bearing in mind that 'death' was a well-documented Cochimí metaphor for entering the world of the spirits, Hyland (n.d.) suggests that the Great Mural paintings of impaled human figures with outstretched arms depict shamans and/or lineage ancestors. Furthermore, the peculiar 'headdresses' depicted in some rock paintings likely represent the hair capes used in the ancestor impersonation ceremonies. The painting of imagery on the sacred wooden boards by shamans who were inspired by dead ancestors shows that the act of painting had ritual connotations. And the crowding and multiple superpositioning of painted figures and animals in most shelters suggest that the production of

imagery, rather than the creation of narrative scenes, was important (Gutiérrez *et al.* 1996).

Ethnographic descriptions show that sharing experiences in the spirit world with the rest of the community was important to the shamans, even if it required painting representations of the spirits on wooden tablets, or tabla. Evidence from the spirit world was often met with fright. For example, surprise appearances of painted boys representing the ancestors or possessed shamans talking in strange voices are reported to have scared bystanders (e.g. Ochoa Zazueta 1978, as quoted by Hyland n.d.). Similarly, it could well be that the imposing painted figures on the high walls and ceilings of the rock shelters of the Sierra were intended to intimidate the viewer. Bearing in mind the ethnographic evidence then, the characterisation of the Great Murals as 'ghostly' is probably not far off the mark.

The Great Murals are best seen when viewed from a distance, generally when approaching a rock shelter from outside. Observed from closer quarters, normally within the drip-line of a shelter, juxtaposed images become hard to separate and the viewer has difficulty recognising overall composition. Viewed at even closer quarters, a few metres from the rock face, the outlines of some bigger figures and animals become confusing. Multiple overlaps of painted figures and animals add to the confusion when viewed from too close. In the sense that they are most recognisable from a distance, Great Mural paintings resemble billboards. Particularly big figures and animals in Pintada and Palma rock shelters are clearly recognisable from the bottom of the Santa Theresa canyon, many metres below. Prehistoric gatherers and hunters travelling through the canyon must have clearly recognised from a long distance away the imposing paintings. Ethnographic evidence and idiosyncratic modes of depiction suggest that at least some of the figures represented particular lineage ancestors. It is conceivable that such lineage ancestors were painted in the shelters of their descendants.

Ethnographic observations of the gatherers and hunters of the Baja peninsula indicate that people aggregated during the summer and fall. Whereas such gatherings of dispersed bands were facilitated by the seasonal availability of a particular cactus fruit, mourning ceremonies were the primary incentive for aggregation (Aschmann 1959). Mourning ceremonies were

known to have required surplus food to feed the dead, the participants, and their families. Archaeological evidence from excavated rock shelters certainly does not contradict this scenario, as it yielded the full range of items normally associated with aggregation sites (Hyland 1997). As the monumental scale of the Great Mural paintings surely required the collaborative efforts of well-organised groups, it is tempting to speculate that the size of groups participating in mourning ceremonies and the monumental scale of the representational imagery were in fact public displays of lineage influence and prestige.

Although the vast majority of Great Mural rock art is monumental and representational, there are some smaller and inconspicuous grid-like paintings within the same rock shelters (Crosby 1984). These grids typically occur lower down the shelter walls, and tend to be the closest paintings to the shelter floor. To view these 'abstract' images properly, it is best to stand close to the rock surface or even to bend down; within Soledad rock shelter, well-preserved grids occur underneath a very low ceiling. Possibly due to the generally good condition of the grid patterns, Crosby (1984) has postulated that this "aberrant subject matter" post-dated the Great Murals. On the other hand, Hyland proposes that the grids and Great Murals are probably contemporary. While Crosby refers to comparatively small grids accentuated with a rare yellow pigment, Hyland refers to a particularly big white grid on the ceiling of El Músico shelter. When these two types of grids are compared, then the execution, size, placement, and overall appearance of Crosby's grids differ from those of Hyland's. As will be shown later in this chapter, close-up observation of the rock surface and pigment within El Ratón shelter conclusively shows that the yellow grid-like motifs actually pre-date the Giant Murals.

RECORDING METHODS AND TECHNIQUES

The rock paintings within El Ratón rock shelter were recorded during three field campaigns undertaken by the Getty Conservation Institute (GCI) in collaboration with the Instituto Nacional de Antropología e Historia, the Governorate of Baja California Sur, and Amigos de Sudcalifornia (AMISUD). The main aim of the three campaigns – conducted in the spring of 1994, 1995 and 1996 – was to record the site in its entirety and so obtain a baseline record for subsequent conservation and management actions. In order to achieve these objectives, the GCI, in consultation with its Mexican partners, decided to survey the site in its vertical and horizontal dimensions and to produce a baseline documentation of the paintings. Since the campaigns were also intended as a means to train a team of five archaeologists and conservators in rock art recording, a variety of recording techniques were employed (see Bell *et al.* [1996] for technical details).

Cueva de El Ratón posed unique recording challenges, owing to the big size, height, and extent of its Great Mural paintings, and to the highly irregular substrate of volcanic conglomerate. Conventional tracing and/or grid recording of the higher, bigger, and more uneven motifs were simply not possible. Moreover, the narrow level area within the shelter (13 m maximum) and rapid fall-off outwards precluded overall photography and total station measurements from within. After much deliberation and discussion prior to fieldwork, a camera and a total station (the latter is a computerised theodolite/transit) were placed on two rock outcrops in the valley, directly opposite the shelter, to record the overall site dimensions. Supplementary techniques of conventional recording within the shelter captured details not obvious from a distance or hidden behind boulders. Mapping of the back wall, boulders, and historic period walls was accomplished mainly through plane-table surveying during the first field campaign. More intricate details, such as the outlines and fill of the paintings, were examined from closer quarters during the second and third field campaigns. Access to the higher paintings, some up to six metres above ground level, was accomplished with the aid of scaffolds.

To facilitate recording, it was decided to divide the long El Ratón shelter into areas. Each area basically comprised a spatially distinct cluster of paintings, separated from the next cluster by an unpainted stretch of rock and/or irregularity in the rock surface, such as corners. Facing the shelter, from left to right, El Ratón shelter was divided into six main areas (A to F). Larger (Area B) and/or more irregular areas (particularly D and E) were subdivided according to the angles of the painted surfaces. During the first field campaign, each area of paintings was photographed, using colour and black-and-white film. Partly because

of surface accretions covering some paintings within the rock shelter, better illumination for colour photography was necessary. This was achieved by the use of a cross-polarising filter on the flash, placed at right angles to a similar horizontal filter on the camera lens (Bell *et al*. 1996). At this time a 1:100 site plan and a site-elevation mosaic using panoramic photographs were also completed. The site plan, photo mosaic, and close-up photographs of each area were useful reference tools during subsequent fieldwork.

Albeit precise, the use of advanced technology does not automatically ensure accuracy. This is so because precision merely implies being exact, whereas accuracy necessitates conformity with a verifiable standard. Precision concerns uncertainty in measurement, whereas accuracy concerns uncertainty in what is being measured. Since what is measured can be wrongly perceived, precise recordings are not necessarily accurate. It is also possible to be accurate without precision, as applies to some tracings. That it is indeed possible to be precise and yet inaccurate, or even 'precisely inaccurate', in rock art recording is illustrated by an example during the plotting stage of the stereophotographs in Canada after the first field campaign. A highly qualified plotter, unfamiliar with Baja rock art, was not able to plot the paintings with confidence. Cracks and discolourations on the rock surface, even when viewed in three dimensions through the stereoplotting instrument, may appear as pigment. Without rock art experience, it is possible to confuse surface anomalies with paintings. The outline of a protrusion, for example, is exact but wrong when identified as a painted motif. To ensure accuracy, one of the participants familiar with both the El Ratón paintings and the plotting instrument, Valerie Magar, spent some time in Canada meticulously plotting the painted imagery within Area B3 and parts of Area D1. Area B3 is the central and most dramatic panel within El Ratón rock shelter. Apart from areas B3 and D1, no additional stereophotographs were plotted, bearing in mind the prohibitive costs in time and labour associated with stereoplotting.

In spite of their good quality and high precision, the stereophotographs still did not match the accuracy obtained through close-up field observations. Accordingly, even after the plotting of Area B3, it was necessary to check the plots in the field during the second and third campaigns. Also, the delineation of motifs on the colour photographs needed detailed and close-up comparison with the actual rock surface. By covering each photograph with a transparent plastic sheet, it was possible to make annotated outlines and infills with colour pens. The best light conditions for recording were in the mornings, between 8 and 11 am, when the reflected sunlight from the shelter floor hit the shelter wall at a 90° angle. During other times of the day, the use of artificial halogen lights allowed recorders properly to view pigmented areas. With the aid of scaffolds, general observations made from ground level during the first field season could be checked during the second and third campaigns. All colour readings were done with a Munsell Soil Colour Chart and a Minolta Chromameter.

Comparatively small and faint red motifs, which include a rendition of a horse and rider, were located on big boulders resting on the shelter floor (Area C). The subject matter indicates that the paintings are the most recent in the shelter; they could have been painted either by the last Cochimí gatherers and hunters or by the Arce family of mixed Cochimí and European descent who once inhabited Cueva de El Ratón. The small red paintings were recorded by careful tracing with fine-tipped felt pens on transparent plastic sheets. By slightly pulling away the plastic sheets from the rock surface and applying minimal pressure with the pens, the recorders minimised contact with the pigment. Close inspection prior to tracing showed that pigment and rock surfaces were sufficiently stable to allow tracing without causing damage. Direct tracing has the advantage over photo-overlays of forcing the recorder to scan the actual three-dimensional surface in great detail. Moreover, checking tracings against the actual motifs is almost instantaneous. This makes it a far more efficient and cost-effective recording technique than working with photo-overlays. It could be argued that tracing lacks in precision, bearing in mind slight movements of the sheet, for example. Given the experience and thoroughness of a tracer in recording every single detail in true outline, however, tracings are accurate and one-to-one scaled copies that are easily verifiable by other workers in the field. Accurate tracings by recorders in El Ratón shelter showed that this technique is effective when recording fairly small paintings on stable surfaces. This point is amply illustrated by the work of Harald Pager (1971), Patricia Vinnicombe (1976) and David Lewis-Williams

(1985) in South Africa, and by James Keyser's (1977) recordings in North America.

Area B1, on the left-hand side of El Ratón shelter, comprised faint remnants of Great Mural paintings on a heavily weathered surface. The paintings were too faint for adequate recording by photography, even under cross-polarised light that captures imagery below surface crusts. It was accordingly decided to record Area B1 by means of a simple grid constructed of strings. These were carefully suspended from natural crevices and protrusions in the rock. An elegant scaled drawing by Freddy Taboada of the rock face and painted motifs showed that the technique is a viable alternative to tracing on more friable surfaces. With grid recording, however, precision is compromised by parallax. This error occurs when the same point appears in different positions depending on the angle from which it is viewed. The greater the distance between string and rock, the greater the parallax. Another disadvantage of grid recording is detailing the often complicated and uneven edges of painted areas. Basically, the smaller the unit of measurement, the more complicated the edges would appear. The fractal nature of painted edges is why bigger grids capture less detail than smaller ones.

Obviously, not everything can be recorded by any one technique. If this were indeed possible, we might be left with a very confusing picture. All recording is selective and involves decisions about what is important to know. In this sense, recording is a compromise: it involves selecting certain details at the expense of others in order to make sense of a complicated 'reality'. Basically, then, recording is goal-specific and ultimately driven by hypotheses, tacit or explicit, about the rock and the imagery. Conservators typically ask questions about deterioration rates, for example. To them, high-tech recording serves as a precise baseline to monitor deterioration. Edges of rock, drip-lines, bedding plains, joints, and pigment are considered as important baseline controls. In this paradigm, precision is a constant concern. On the other hand, archaeologists trying to understand time differences and the possible meanings of rock paintings tend to be more concerned with accuracy than precision *per se*. Intricate details concerning painted motifs and their associations with other motifs and the rock surface are usually of more importance to them than precise measurements. While it could be argued that

state-of-the-art stereophotography and colour-recognition instruments yielded precise baseline documentation of El Ratón's preservation condition in 1994, these techniques did not yield reliable information concerning paint sequence.

With the exception of areas B1 and C, all the areas within Cueva de El Ratón contained superimposed painted motifs. This meant that for the purposes of properly recording the motifs, superpositioning could not be ignored. The only reliable way accurately to record superpositioning was to examine the pigment from very close, often with the aid of binocular magnifiers (20x). The use of scaffolds during the second and third field seasons enabled recorders to check tentative inferences concerning relative stratigraphy from ground level during the first field campaign. Close-up inspection showed that the brightest and best-preserved paintings were not necessarily the most recent ones. Black pigment painted over red or yellow often flaked off, creating the false impression that the red and yellow were on top, for example. In these instances, small remnant islands of black pigment, resting on a sea of red or yellow, conclusively showed that black was in fact on top. To ensure accuracy of observation, recorders double-checked the results of their colleagues. In rare cases of uncertainty, Alan Watchman gently inserted a small dental pick into the pigment to extract a cross-section of pigment layers. Viewed from the side under magnification, this 'lasagne' of pigment normally conclusively answered questions pertaining to sequence. In only one instance could layers not be separated, where black occurred on black.

Pigments within El Ratón were applied as layers in a liquid medium with a brush. As shown above, these layers were distinguished by viewing their edges and 'thickness' from the side. As an alternative to actually being at the rock face, this depth perception can be assessed by stereophotographs with very good resolution (the set-up of the cameras across the valley from the shelter precluded high-quality close-up views for photogrammetric purposes). The recording at El Ratón highlighted the importance of close-up observations in the field with the naked eye. In the final analysis, recognition of pigment and the order of its placement had to be made in front of the rock surface. In spite of technological advances, there is as yet no substitute for verification in the field.

A too-close-up focus on the rock and the pigment does not, of course, reveal interesting relationships that could exist between different motifs and natural anomalies in the rock surface. To detect aspects about motif placement and composition, it is necessary to step back and take a macro view of a site, very much as the original inhabitants most probably did. As 20th-century observers, we find it difficult, but not impossible, to imagine what was important to the gatherers and hunters of the time. By considering the ethnography of the Cochimí authors and of similar gatherers and hunters elsewhere, it becomes possible at least to look closer and consider aspects that could have been important to them. A strictly scientistic approach, emphasising precision and cutting-edge technology to the exclusion of almost everything else, tends to ignore other, ostensibly 'less precise', avenues of investigation.

Comparative ethnography and rock art studies in other parts of the world have shown beyond reasonable doubt that less obvious details, such as cracks, holes, and the placement of rock art in relation to these natural features, were important to the makers of the rock art. Even though overall photogrammetric plots at El Ratón enabled at least the rock surface to be captured on photographs that can be later viewed as three-dimensional images, staring at photographs through a stereoplotter is unfortunately no substitute for being in the rock shelter. When viewed on foot from a distance, normally at the drip-line or farther downslope, the placement of the painted panels in relation to natural features within most rock shelters of the Sierra de San Francisco becomes meaningful. Even though this macro perspective yields tantalising clues about Baja rock art in general, ignoring a micro-scale analysis of paint stratigraphy runs the risk of missing significant chronological and possible ethnographic shifts in the archaeological record. It is to this micro, or forensic, approach that the discussion now turns.

RELATIVE STRATIGRAPHY AND DATING AT EL RATÓN

Rock art archaeology has some distinctive advantages over conventional 'dirt' archaeology. One is that the researcher does not have to destroy the stratigraphy to record it. The results of a rock art stratigraphic study are accordingly open to scrutiny and replication, whereas those of archaeological excavation cannot be repeated. Another advantage of rock art studies is the ability accurately to assess relative chronology from stratigraphy. This is not necessarily the case at 'dirt' sites. Due to natural re-deposition and/or cultural reuse of archaeological soils, the topmost layer is not always the most recent one. Within archaeological sites, artefacts and charcoal notoriously move around and can enter stationary features such as pits after their use and so give a false impression of their antiquity. Over and above these problems, the more recent soil layers within rock shelters sometimes wash away, leaving wrong clues concerning chronology, such as too old a date for a site's abandonment. Inverted stratigraphy and mixing are not problems faced by the rock art archaeologist trying to reconstruct a relative chronology from painted layers, for it is simply not possible for a painted motif magically to swap its position within a sequence of superimposed motifs. If pigments contain binding mediums with carbohydrates, then it is possible that such pigments might dissolve and 'bleed' into more newly applied pigments with carbohydrates. In spite of such practical problems needing to be considered and overcome, however, rock art has the inherent potential to be a more accurate way of dating events and sequences than conventional 'dirt' archaeology (see Chippindale & Taçon 1998b).

In practice, dating methods such as direct AMS dating of pigment and/or associated crusts have not been without their problems, unfortunately. Even though advanced sample preparation and careful AMS procedures and instrumentation typically ensure high precision (Chaffee et al. 1993), error tends to be introduced when small samples are collected in the field or through contamination. As in the case of recording, precise measurements do not guarantee accurate results (Bowman 1990). This is illustrated in the carbon-dating attempt of pigment from El Ratón rock shelter. Prior to the GCI recording campaign, a team of Spanish archaeologists sampled at least three of the Great Murals for AMS dating (Fullola et al. 1994). All three pigment samples came from Area B3, the central and most imposing panel within the shelter. A red human figure with zigzags on its body near the left-hand side of the panel yielded the earliest date (5290+80 BP). The next oldest date (4810+60 BP) came from the unique black mountain lion (called El Ratón by local people) near the bottom centre of the

panel. Standard counting errors included, this estimate is 300 years older than the date from the red human figure. The youngest date (295+115 BP) came from a deer-like animal. Clearly, this date is significantly younger (i.e. by at least 4000 years) than those for the other two paintings.

As it stands, the radiocarbon chronology suggests a major chronological gap: the relatively early red human figure and mountain lion on the one hand, and the substantially later 'deer' on the other. Can there be an independent check on the ages of these motifs from El Ratón rock shelter? One control is relative chronology by means of overall paint stratification. However, no single cross-section, or profile, drawing through a complicated rock art panel with its varying stratigraphy can be taken as representative. The challenge is to find the best way of recording and representing a complicated three-dimensional sequence on paper. The historical archaeologist, Edward Harris, solved this problem while working on intricate urban sites by developing the Harris Diagram (Harris 1989). Whereas South African researchers such as Lewis-Williams (1974, 1992) and Vinnicombe (1976) had systematically considered paint stratigraphy in their studies, Christopher Chippindale and Paul Taçon (1993) were the first archaeologists known to have applied the Harris method to complicated rock art stratigraphy in Australia; they were soon followed by Jannie Loubser (1993) in South Africa. More detailed discussions on compiling Harris diagrams and appropriate 'reduction rules' appear in Edward Harris and colleagues (1993) and Clive Orton (1980).

Harris notes that the directly observed stratigraphic relationship between any two motifs can have only the following four permutations:

- motif A is underneath motif B: A is earlier than B;
- motif A is on top of motif B: A is later than B;
- motifs A and B are in the same layer: A and B are contemporary;
- no relationship exists between motifs A and B: unknown time differences between A and B.

Once the direct relations between any pairs of rock art motif have been recorded, it is possible to compile a master diagram of the overall sequence. The master sequence can be simplified by using certain 'reduction rules'. For example, the 'transitive rule' states that if A is on top of B and B is on top of C, then A can be said to be later than C. The 'anti-symmetric' rule states that if A is on top of B in one instance, but B is on top of A in another, then A and B are contemporary. Use of the Harris method in this fashion enabled the reconstruction of both the internal stratigraphy of individual polychrome paintings and the stratigraphic relationship between different paintings, both mono- and polychrome, within El Ratón. Natural layers were also included in a Harris Diagram where their position in the overall sequence could be determined. The general painting sequence is now described (Figures 9.2–9.4), starting with the earliest.

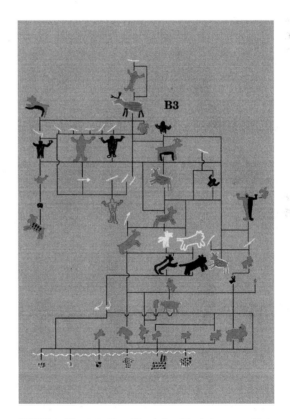

FIGURE 9.2 Direct stratigraphic relationships between motifs in Area B3. Internal stratigraphy of individual motifs not shown unless separated by other motifs. Calcium oxalate layer shown by wavy line. Not to scale.

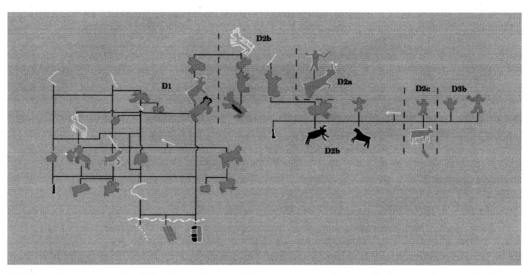

FIGURE 9.3 Direct stratigraphic relationships between motifs in areas D1, D2a, D2b, D2c and D3b. Internal stratigraphy of individual motifs not shown unless separated by other motifs. Calcium oxalate layer shown by wavy line. Not to scale.

The six checkerboard patterns identified in the shelter, five from Area B1 and one from Area D1, are the earliest in the sequence (Figures 9.2, 9.3). Most checkerboards consist of black and red blocks, yellow grids and white dots. The black paint was applied first, with a yellow grid carefully painted over the black with a fine brush (Figure 9.5). Red squares were then added, sometimes directly on top of the black. Finally, white dots were applied in an apparently haphazard fashion, most likely with the tip of a finger. A relatively thick encrustation of a pale grey translucent material covers the checkerboards in both areas B1 and D1. This opaque layer could be a 'horizon marker' that separates the checkerboards from the rest of the paintings. Arie Wallert, analytical chemist on the third field campaign, determined through spot tests that the opaque layer in Area B3 contained calcium oxalate salts. This implies that it is possible to date the layer by AMS and so to obtain a minimum date for the checkerboards and yellow grids (Watchman & Campbell 1996). The pertinent point, however, is that calcium oxalate was deposited on top of the checkerboard/yellow grid

motifs at some period within El Ratón rock shelter. This opaque layer effectively sealed and separated the yellow grids from subsequent paintings. Protection against weathering afforded by the natural layer could explain why the yellow grids are in good condition when compared with subsequent representational images.

This natural layer dividing paintings in El Ratón, and very likely at other sites in the Sierra de San Francisco (pers. obs.), strongly suggests that a chronological gap exists between the abstract grids and the more representational imagery associated with the Great Murals; combining the yellow grids with the Great Murals is flawed, and may have repercussions for interpretation. It is very likely that the early abstract grids represent a somewhat different painting tradition than the representational Great Murals. Stratigraphic observations at other shelters in the Sierra may confirm or refute this hypothesis. At present, it is safe to say that the grid form does continue into the Great Mural tradition, since the bodies of animals and humans are often depicted as grids, for example. Also, the big white grid in El Músico shelter could be part of this

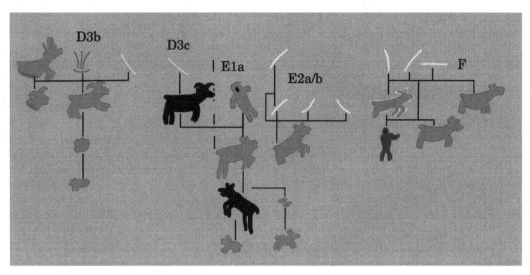

FIGURE 9.4 Direct stratigraphic relationship between motifs in areas D3b, D3c, E1a, E2a/b and F. Internal stratigraphy of individual motifs not shown. Not to scale.

FIGURE 9.5 Typical internal stratigraphy of a checker-board-like motif in Area B3. Not to scale.

continued use. Nevertheless, within El Ratón, yellow grids and checkerboards are consistently at the bottom of the sequence, not far from the shelter floor.

Painted on top of the checkerboard and the translucent layer in El Ratón is a series of small red rabbit-like and deer-like animals (Figures 9.2, 9.3). Only some of these small animals have traces of a white outline (Figure 9.6). Among the small animals are a few bigger ungulates that are painted in red and outlined in white. Due to extensive superimpositioning by later figures, the identity of these animals is not always clear. However, at least some resemble mountain sheep and deer, animals typical of the Great Mural tradition. In Area B3, two small rabbit-like animals are painted on top of bigger ungulate-like animals (Figure 9.2); so by the 'anti-symmetric rule', small animals are contemporary with the bigger ones. The small red animals and bigger red ungulates are generally painted in the same location as the earlier yellow grids, not high above the shelter floor. Within Area B3, these red animal paintings tend to be placed higher up against the back wall of the shelter than the yellow grids.

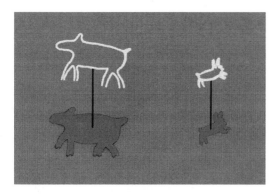 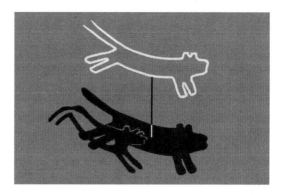

FIGURE 9.6 Typical internal stratigraphy of rabbit-like and deer-like animals. Not to scale.

FIGURE 9.7 Stratigraphic relationship between the 'mountain lion' and 'deer' in Area B3. Not to scale.

Painted on top of the small red rabbit-like and deer-like animals are the bodies of the black mountain lion and an overlapping deer-like animal (Figure 9.2). It is virtually impossible to distinguish between the black pigment of the mountain lion and that of the 'deer' (Figure 9.7). The white outline of the mountain lion is on top of both the mountain lion and a 'deer', suggesting that the mountain lion is the later of the two animals. Other examples in the shelter illustrate that outlines are actually separated stratigraphically from the 'solid' figure they outline by other motifs, so they cannot be assumed to be roughly contemporary. Whatever the case, both lion and 'deer' are sandwiched by the same motifs and should be roughly contemporary. In the light of their relative stratigraphic contemporaneity, the time difference of four millennia in radiocarbon years between the two motifs is curious.

Seven layers of painted motifs occur on top of the lion outline and the 'deer' (Figure 9.2). These later layers also possibly include the red human figure that pre-dates the 'deer' in terms of radiocarbon years! Unfortunately, no painted motifs separate the lion and 'deer' motifs from the red human, so the possibility that the human is older than the lion and 'deer' cannot be ruled out with any degree of confidence. It is

difficult to determine the cause of the discrepancy between the radiocarbon dates and the relative sequence. One reason could be that samples included multiple pigment layers and surface crusts with organic content that skewed the date. Spot tests conducted by Wallert indicated that calcium oxalate did indeed occur in accretions at the site. The relatively recent date for the 'deer', for example, could have been derived from younger carbon-bearing crusts. There is unfortunately no way positively to identify the specific problems, as we have no information on the collection techniques and locations chosen by the Spanish team. If multiple layers were indeed sampled, then the dates are merely a mean estimate of the radiocarbon content. At least we know that the assessment of painted layers is accurate; it is possible for relative chronologies to be right and absolute dates to be wrong.

The Harris Diagram shows that paintings of human beings tend to occur relatively later in the sequence than those of mountain lion. In other painted areas of the shelter, humans also appear later in the relative sequence. In general, humans are normally painted on top of animals, rather than the other way around. However, in Area B3 at least two human figures occur under animals (Figure 9.2), and in Area E2a/b, a

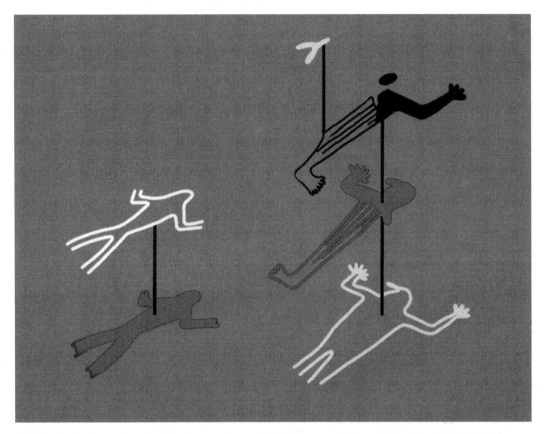

FIGURE 9.8 Typical internal stratigraphy of human paintings (left) and human paintings with black faces (right). Not to scale.

human is under a mountain sheep (Figure 9.4). These 'anti-symmetric' relations between humans and animals show that they are contemporary.

As in the case of animal paintings, the bodies of the majority of humans are painted first and are then outlined (Figure 9.8). The two exceptions to this rule are human figures, both with black faces; these were done in outline first before their bodies were filled with paint (Figure 9.8). They occur towards the later part of their respective sequences. The bigger and more elaborate figures and animals tend to be placed higher against the back walls and ceiling of El Ratón. The only clear depiction of a female figure is also one

of the latest and highest motifs in the shelters. In terms of placement, size, detail, and ethnographic accounts above, it is very likely that at least some females were prominent in ancestor veneration ceremonies. A massive deer is painted immediately under and below the female figure.

The painting of two polychrome mountain sheep in the upper left-hand side of Area B3 shows signs of repainting or, more specifically, re-outlining (Figure 9.9). A checkerboard pattern has been painted on the solid red body of the first mountain sheep. Painted on top of the checkerboard is a series of black lines resembling the hair cape found on human paintings. On top

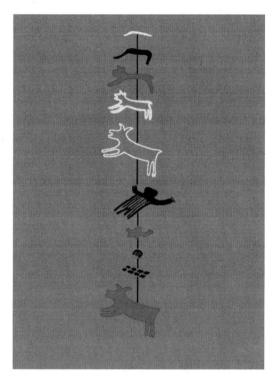

FIGURE 9.9 Internal stratigraphy of two mountain sheep in Area B3. Note that two human figures are sandwiched within the lower sheep. Not to scale.

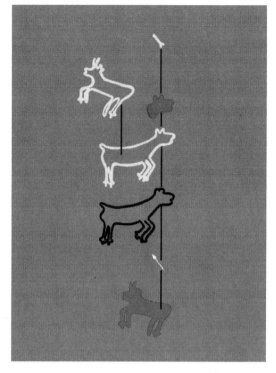

FIGURE 9.10 Internal stratigraphy of two deer-like animals in Area D1. Note that the one animal is sandwiched within the other. Not to scale.

of this hair cape is the upper torso of a human figure in red. A fairly complete human in black is painted on top of this red figure. It is only after the completion of this black figure that the red mountain sheep was finally outlined in white. The white outline of the second mountain sheep occurs on top of the white outline of the first, indicating that it was painted later. Within the white outline of the second mountain sheep was first painted a red head and back and then a belly in black. A streak of white paint on the line that horizontally divides its body occurs on top of all the other colours. Evidence for repainting then indicates that the painter(s) came back to accentuate both mountain sheep.

Similar accentuation of two deer-like animals is apparent in Area D1 (Figure 9.10). Here a white

'arrow' covers the buttocks of the first red deer-like animal. The black outline of the second deer-like animal's face and neck covers the spear. A white line accentuates the black outline of the second 'deer'. Red pigment has been added to the face of this 'deer'. Only after the re-outlining of the second 'deer' in white did the painter(s) outline the first 'deer' with white. A white line, resembling the rear end of an arrow, is painted on top of the red head of the first 'deer'. This shows that three layers of painting separate the apparent repainting of the 'arrow'.

The final example of re-outlining comes from Area D2b (Figure 9.11). Here, the body of a big red and black deer is covered by two red animal paintings, while its white outline covers the same two red animals.

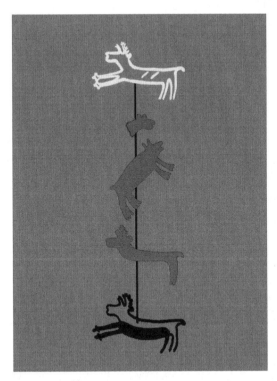

FIGURE 9.11 Internal stratigraphy of a deer-like animal incorporating two other animal paintings in Area D2b. Not to scale.

the presence of carbohydrates, a fact that may account for its solubility when in contact with newly applied carbohydrates, even long after initial application. Unfortunately, the 'bleeding' of pigments is not conclusive evidence for a short time lapse between the applications of different motifs. Apart from the checkerboards with yellow grids, there is no evidence for stylistic or stratigraphic distinctions in the Cueva de El Ratón to suggest temporal differences. Virtually identical motifs often occur in different layers within the relative sequence. For example, two layers of paintings separate a pair of mountain sheep in Area B3 (Figure 9.2). Stratigraphic separation of such identical motifs suggests fairly rapid intervals between the applications of the different layers.

PROVISIONAL SEQUENCE AT EL RATÓN AND SOME IMPLICATIONS FOR INTERPRETATION

Overall, then, pigment layers in El Ratón show that early checkerboards with yellow grids are separated by a thin opaque calcium oxalate layer from the Great Mural paintings. This is not to deny that less visible mineral layers are sandwiched between other paintings within the shelter. Less obvious layers can probably only be detected with electron microscope analysis of thin cross-sections taken from selected areas. What appears in this summary is only the broad sequence apparent at 20x magnification (Figure 9.12). It is indeed likely that a more precise physical examination of the micro stratigraphy may reveal additional details that could be informative about the paintings and their sequence of application.

Following the grids in the relative chronology of El Ratón shelter are red paintings of comparatively small animals. These mostly resemble rabbit-like or juvenile deer-like animals, although a few bigger depictions could represent adult ungulates. Although the bigger paintings tend to be on top of the smaller ones, the presence of a few 'rabbits' on top of ungulates shows them to be contemporary by the 'anti-symmetric' rule (Figure 9.12). The 'rabbits' and small ungulates have a similar appearance; both are done in solid red. Some of the well-preserved ones are outlined in white.

Painted on top of these smaller animals are bigger and more elaborate ones, sometimes done as polychromes. Associated with the bigger animals are

White lines resembling spears normally cover animals and humans. However, animals and humans also cover spears in a few instances. By the 'anti-symmetric' rule, then, animals, humans, and spears are contemporary. Spears are painted mostly in white, but a few are red. With only a few exceptions, spears tend to be painted last in the sequence of all the areas with superpositioning. Like the more prominent animals and humans, spears also tend to be located high on the back walls and ceiling of El Ratón shelter. No spears are covered by the smaller red animal motifs near the bottom of the sequence and closer to the shelter floor.

The white pigment of spears is often coloured pink or orange where they cross the red of other figures. Spot tests of white pigments done by Wallert show

human figures and spears. Although human figures tend to be later than the animals, and spears tend to be later than human figures, the 'anti-symmetric' relationship between these three motifs shows that they are contemporary. Figure 9.12 is a convenient summary of the paintings at Cueva de El Ratón. This summary should considerably simplify comparison with sequences from nearby painted shelters in the Sierra de San Francisco. In this step-by-step fashion a regional chronology can be constructed, very much like a lithic and/or ceramic sequence in conventional 'dirt' archaeology. Since El Ratón is still the only shelter with a relative sequence in Baja, it is not possible at this stage to make any claims as to the regional validity and possible chronological division between the smaller bichrome animals and the bigger polychrome animals and humans.

The early grids and the earlier representational paintings occur comparatively low on the back wall of the El Ratón shelter, particularly in Area B3. The Great Murals seem to exhibit a trend towards bigger and more elaborate animals and humans later in the relative sequence. These progressively later motifs also tend to occur higher against the ceiling of the shelter.

At this stage of research we can confidently state that within El Ratón there are at least two painting episodes: an early geometric one followed by representational paintings. By comparative ethnography and research on neuropsychology, Hyland (n.d.) justifiably identifies the grids as entoptics. In terms of the Lewis-Williams and Dowson (1988) model, this implies that the earlier 'grid episode' was a portrayal of only 'early-stage' visions, whereas subsequent iconic imagery portrayed later stages of trance visions. If the grids and the iconic imagery were indeed contemporary, this could have been construed as a neat graphic representation of the stages of trance-generated imagery. However, in the light of evidence for chronological separation, a shift in the kind of shamanic activity and trance vision through the course of Cochimí prehistory is probably a more fruitful avenue of investigation.

One way of determining the time lapse between the grids and the representational paintings is to sample and date at least the following three micro layers: pigment from the grid, calcium oxalate from the opaque layer, and pigment from the small red animals. Based on results from the Victoria River District in northern Australia, Alan Watchman (pers. comm. 1999) estimates that the distinct oxalate layer within El Ratón may have taken between 1000 and 3000 years to form. If this estimate is valid, then the time gap between grids and representational imagery is sufficiently significant to take into consideration possible shifts in ritual activity. Of course, chronological differences alone do not signify change in cultural practices. However, if time differences can be shown to coincide with visible changes in material remains, then cultural changes cannot be denied.

PLACEMENT AND DEPICTION OF MOTIFS IN EL RATÓN

It is easy to get enmeshed in the intricacies of painting details during recording and so to miss the greater picture. Standing back within El Ratón rock shelter towards the end of the third and last recording cam-

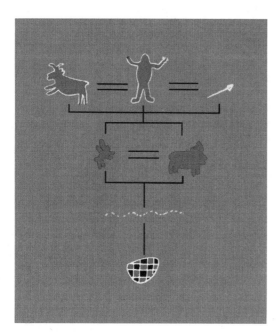

FIGURE 9.12 Summary of painting sequence within Cueva de El Ratón. Not to scale.

paign in Baja California, I made an observation that should have been obvious earlier on. For the first time I realised the possible significance of the central and most imposing panel, Area B3, being located directly above a small alcove at the bottom of the back wall. The early yellow grids and subsequent small red animals were clustered directly above this alcove. Farther up the back wall and ceiling of the shelter were progressively later and more widely spaced humans and animals. These images were clearly arranged in an open U-shape. From an admittedly European perspective, it was as if the images came bursting out of the alcove. Great was my surprise when I realised that the painted areas to the right of this alcove exhibited a related pattern. Areas D1 to F are located progressively farther away from the alcove, Area D2b marking the corner that turns away from the alcove. In each of these panels, images that are spatially closer to the alcove also tend to be earlier in the sequence. Clearly, then, the painters first focused on the area around the alcove and then progressively moved away from it. This recalls the emergence theme identified in the rock art of gatherers and hunters on an international scale (e.g. Whitley 1998).

An additional hint at 'emergence' comes from the partial painting of many animal and human motifs. Only the heads of some mountain sheep are painted, and the hind legs of many other animals are left out. These incomplete portions of the animals are not due to weathering, as can be attested by close-up examination of the rock surface. Instead, the bodies or lower extremities of these animals were simply not painted. The lower bodies and legs of some human figures were similarly left out. Moreover, Area D3b contains a depiction of a deer with its hind legs partly inside a natural hole in the rock. Viewed from a distance, these partially painted images appear to emerge from the rock. Lower down the Santa Teresa canyon, huge figures with outstretched arms in the main panel at Cueva Pintada also appear to emerge from behind boulders at the bottom of the shelter wall. In the light of ethnography from the Baja peninsula, this could have been an apt way to illustrate trance apparitions of ancestors during mourning ceremonies. In the absence of ethnographically informed theory, these aspects of the paintings would have been overlooked.

Acknowledgements

Nicholas Stanley Price, the GCI's project leader, kept an eye on proceedings and provided opportunities for the various specialists to use their own initiative. The field coordinator, Alan Watchman, was always there to help with every aspect of the project, ranging from the erection of the scaffolding to assisting in the tracings of paintings. Enrique Hambleton from AMISUD volunteered his help in various ways. My colleague, Antoinette Padgett, provided advice and support. Arie Wallert, analytical chemist, did some interesting spot tests with his field chemistry set, while Jesús Prieto, geologist from the Universidad Autónoma de Baja California Sur, increased our understanding of the regional geology. The five participants, Luz de Lourdes Herbert Pesquera, María Isabel Hernández Llosas, Bernardita Ladrón de Guevara, Valerie Meurs Magar, and Freddy Téllez Taboada, were good researchers, students, and teachers. I also benefited from discussions with Giora Solar and Alberto Tagle from the GCI and with María de la Luz Gutiérrez of the Mexican Instituto Nacional de Antropología e Historia. John Bell, Jean-Pierre Jérôme, and Allan Maher from the Canadian Heritage Recording team did the photogrammetry and photography. Glen Neumann and his excellent crew of four Mexican cooks of Baja Expeditions, Inc. made sure that all of us were well fed and looked after. As always, the local inhabitants from San Francisco de la Sierra were very friendly and helpful. I thank Justin Hyland for giving me permission to reference his innovative forthcoming paper on Cochimí ethnography.

References

Aschmann, H. 1959. *The Central Desert of Baja California: Demography and Ecology.* Berkeley (CA): University of California Press, Ibero-Americana 42.

Bell, J., Jérôme, J-P., Sawyer, P., Magar V. & Stanley Price, N. 1996. Stereophotogrammetric recording of rock art at the Cueva de El Ratón, Baja California, Mexico. *ICOM Committee for Conservation* 1: 454–457.

Bowman, S. 1990. *Radiocarbon Dating.* Berkeley (CA): University of California Press.

Chaffee, S.D., Hyman, M. & Rowe, M.W. 1993. Direct dating of pictographs. *American Indian Rock Art* 19: 23–30.

Chippindale, C. & Taçon, P.S.C. 1993. Two old painted panels from Kakadu: variation and sequence in Arnhem Land rock art. In: Steinbring, J., Watchman, A., Faulstich, P. & Taçon, P.S.C. (eds) *Time and Space: Dating and Spatial Considerations in Rock Art Research: Papers of Symposia F and E, AURA Congress Cairns 1992*: 32–56. Melbourne: Australian Rock Art Research Association, Occasional AURA Publication 8.

Chippindale, C. & Taçon, P.S.C. (eds) 1998a. *The Archaeology of Rock-Art.* Cambridge: Cambridge University Press.

Chippindale, C. & Taçon, P.S.C. 1998b. The many ways of dating Arnhem Land rock art, north Australia. In: Chippindale, C. & Taçon, P.S.C. (eds) *The Archaeology of Rock-Art*: 90–111. Cambridge: Cambridge University Press.

Crosby, H. 1984. *The Cave Paintings of Baja California: The Great Murals of an Unknown People.* Revised edition. La Jolla (CA): Copley Books.

Fullola, J.M., Castillo, V., Petit, M.A. & Rubio, A. 1994. The first rock art datings in Lower California (Mexico). *International Newsletter on Rock Art* 9: 1–4.

Grant, C. 1974. *Rock Art of Baja California.* Los Angeles (CA): Dawson's Book Shop.

Gutiérrez, M.L., Hambleton, E., Hyland, J. & Stanley Price, N. 1996. The management of World Heritage sites in remote areas: the Sierra de San Francisco, Baja California, Mexico. *Conservation and Management of Archaeological Sites* 1: 209–225.

Harris, E.C. 1989. *Principles of Archaeological Stratigraphy.* London: Academic Press.

Harris, E.C., Marley R.B. III & Brown, G.J. (eds) 1993. *Practices of Archaeological Stratigraphy.* London: Academic Press.

Hyland, J.R. 1997. Image, land, and lineage: hunter-gatherer archaeology in central Baja California, Mexico. Unpublished PhD thesis. Berkeley (CA): University of California, Department of Anthropology.

Hyland, J.R. n.d. Talking with the dead: context, continuity, and the Great Mural tradition of Baja California.

Inskeep, R.R. 1971. The future of rock art studies in southern Africa. In: Schoonraad, M. (ed.) *Rock Paintings of Southern Africa.* Johannesburg: South African Journal of Science Special Issue 2: 101–104.

Keyser, J.D. 1977. Writing-on-stone: rock art on the Northwestern Plains. *Canadian Journal of Archaeology* 1: 15–80.

Lewis-Williams, J.D. 1974. Superpositioning in a sample of rock paintings in the Barkly East District. *South African Archaeological Bulletin* 29: 93–103.

Lewis-Williams, J.D. 1981. *Believing and Seeing: Symbolic Meanings in Southern San Rock Paintings.* London: Academic Press.

Lewis-Williams, J.D. 1985. Rock art recording and interpretation in the Harrismith District. Unpublished report submitted to the HSRC. Johannesburg: University of the Witwatersrand.

Lewis-Williams, J.D. 1992. *Vision, Power and Dance: The Genesis of a Southern African Rock Art Panel*. Amsterdam: Stichting Nederlands Museum Voor Anthropologie en Praehistorie, Veertiende Kroon-Voordracht.

Lewis-Williams, J.D. & Dowson, T.A. 1988. The signs of all times: entoptic phenomena in Upper Palaeolithic art. *Current Anthropology* 29: 201–245.

Loubser, J.H.N. 1993. A guide to the rock paintings of Tandjesberg. *Navorsinge van die Nasionale Museum, Bloemfontein* 9(11): 345–384.

Loubser, J.H.N. 1997. The use of Harris diagrams in recording, conserving, and interpreting rock paintings. *International Newsletter On Rock Art* 18: 14–21.

Meighan, C.W. 1966. Prehistoric rock paintings in Baja California. *American Antiquity* 31: 372–392.

Meigs, P. 1939. *The Kiliwa Indians of Lower California*. Berkeley (CA): University of California Press, Ibero-Americana 15.

Ochoa Zazueta, J.A. 1978. *Los Kiliwa y el Mundo Se Hizo Así*. Mexico City: Instituto Nacional Indigenista.

Orton, C. 1980. *Mathematics in Archaeology*. London: Collins.

Pager, H.L. 1971. *Ndedema*. Graz: Akademische Druck.

Stanley Price, N. 1996. The Great Murals: conserving the rock art of Baja California. *Conservation: The Getty Conservation Institute Newsletter* 11(2): 4–9.

Turner, V.W. 1995. *The Ritual Process: Structure and Anti-structure*. New York (NY): Aldine de Gruyter.

Venegas, M. 1943. *Noticia de la California y de su Conquista Temporal y Spiritual, 1739*. Mexico City: Editorial Layac.

Vinnicombe, P. 1976. *People of the Eland: Rock Paintings of the Drakensberg Bushmen as a Reflection of Their Life and Thought*. Pietermaritzburg: University of Natal Press.

Watchman, A. & Campbell, J. 1996. Micro-stratigraphic analyses of laminated oxalate crusts in northern Australia. In: Realini, M. & Toniolo, L. (eds) *Proceedings of the 2nd International Symposium on the Oxalate Films in the Conservation of Works of Art*: 409–535. Milan: CNR Gino Bozza, Politecnico di Milano.

Whitley, D.S. 1998. Finding rain in the desert: landscape, gender and far western North American rock art. In: Chippindale, C. & Taçon, P.S.C. (eds) *The Archaeology of Rock-Art*: 11–29. Cambridge: Cambridge University Press.

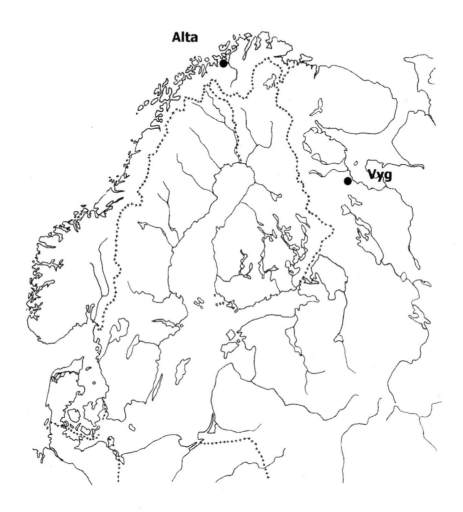

FIGURE 10.1 Map of northernmost Europe showing the location of Alta and Zalavruga (at the river Vyg).

10.

From the tyranny of the figures to the interrelationship between myths, rock art and their surfaces

KNUT HELSKOG

(Department of Cultural Sciences, Tromsø University Museum, Tromsø, Norway)

Rock art was often deliberately made where communication with the spirits was believed to be good. It was therefore made in caves and shelters, on steep cliffs, high in the mountains and on the shore – a range of localities all considered transitional spaces between cosmic worlds (Lewis-Williams & Dowson 1990; Tilley 1991; Whitley 1998; Helskog 1999). This emphasises that rock art is often just one part of a broader ritual landscape. This chapter focuses on the physical rock art panel, the surface with art, and how this art engages with the rock art figures. On some surfaces, specific topographic features enhanced the form of the figures. Figures directly associated with cracks and fissures appear to be climbing out from inside/under the surface, or a serpent depicted in a basin is interpreted as a serpent within water, or the tracks of the bear entering a basin are interpreted

as the bear going underwater, passing through to the underworld (Helskog 1999). To secure a prosperous field season at Besov Nos on the east coast of Lake Onega in Karelia, some Russian archaeologists always start fieldwork by sacrificing a shot or two of vodka into the mouth – a fissure – of the large rock engraving called 'the demon'. Fieldwork is always good.

Topographic features might be one reason for selecting a particular surface; orientation to the sun, dark hidden places, colours and the presence of water are others. It is to be expected that around the world the reasons will be numerous, the locations different – each particular to a specific culture and to that people's rituals and understandings of their life in the known universe. However, in many areas it is clear that surfaces were selected with great care, for specific reasons, all connected with the symbolism of the rock

art. These points are demonstrated for a series of rock art panels made by prehistoric hunter-fisher-gatherers in Alta, Arctic Norway (Figure 10.1).

THE TYRANNY

During the last few years, my understanding of rock art has changed. The process began when I saw compositions in which bears were the central 'actors' (Figure 10.2). These seemed to be illustrations in which the animals moved through space and time. This was a story in which I could recognise some key elements without needing to know the full meaning (Helskog 1999). I realised that the rock surface itself played a much larger part in the composition than I had previously thought. I then understood that my recorded rock art information was incomplete; I lacked detailed knowledge of the surfaces. The thousand photographs taken as part of my documentation

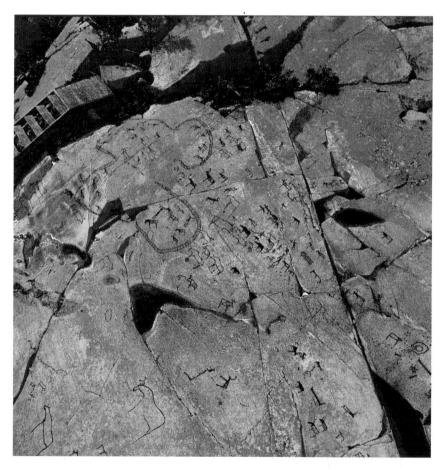

FIGURE 10.2 Bergbukten I. Photograph of part of the panel, taken from a high ladder; a perspective that was probably never seen in prehistoric times. Water has collected in small pools after a rainstorm. Tracks lead up to but do not descend into the largest of these pools (bottom right corner). Clearly, this pool of water formed a part of the story of the panel. The figures are now painted red so as to be more visible to visitors.

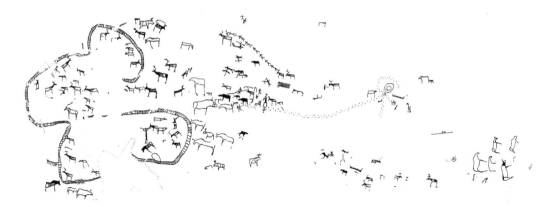

FIGURE 10.3 The main part of Bergbukten I. This redrawing shows a common type of rock art documentation in which only the engraved figures are represented. It is devoid of 'disturbing' topographic features and has flattened out an otherwise undulating surface. Not much can be gained from it concerning any meanings that may be derived from the relationships between the figures and the rock surface.

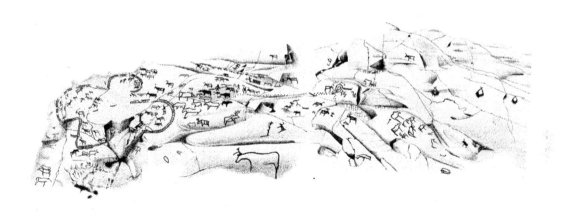

FIGURE 10.4 Bergbukten I. A perspective drawing which emphasises the relationships between the figures and the rock surface. The view is from the direction of the shoreline. This is a more 'correct' representation than the redrawing in Figure 10.3. (Drawing by Ernst Høgtun, Tromsø Museum)

have not relieved my uneasiness or made me feel more comfortable. In 1997 I asked an artist to draw one of the large panels (Figures 10.2, 10.3). The artist found that the changes in perspective that occurred in different parts of the panel made it impossible to make a satisfactory single rendering of the panel, and no (three-dimensional) drawing was made.

In 1999 I challenged another artist, illustrator and technical drawer to work on the same panel. Part of the result is seen in Figure 10.4. At around the same time I bought a book, *Drawing on the Right Side of the Brain* (Edwards 1979), with the Norwegian title *To Draw is to See* (*Å Tegne er å Se*), because nobody seemed able to give me what I wanted. Reading and

practising drawing made me realise how bound I was to the long-established traditions of seeing and recording, and why I had gone wrong in my redrawing of the rock art. I had focused on the figures themselves as so many before me had done (such as Gjessing 1936; Simonsen 1958; Hallström 1960; Malmer 1981). In good Scandinavian tradition, I had traced all of the figures onto plastic sheets, joined them together and then reproduced all within a single redrawing, but without really seeing the surrounding rock or the surfaces between the images. I knew that aspects of the surfaces had to be recorded, but I really did not know which features to record. Traditionally, some fissures and cracks are drawn, especially if they run through engravings, but they are not included in the discussion of meaning. Recently Coles (2000), in his re-analysis of the so-called *Dansaren* ('the dancer') rock engraving panel in southern Sweden, recognised that fissures and cracks subdivide larger panels into smaller units. The point applies to Norway as well. In 2004, my own cooperation with the artist bore fruit – another copy, and with better technical drawing control (Helskog & Høgtun 2004). Also, from 2002 I became involved with a large Scandinavian project – Rock Art of Northern Europe – and I introduced high-level technology and video scanning to my recording practices. These methods give an accurate three-dimensional recording of the surface topography, emphasising the spatial interrelationship between the engravings and the surface on which they are located (Helskog 2003). The method is still expensive, but will no doubt become a standard method of documentation in the future.

In retrospect, one of the rewarding aspects of working with rock art is the fact that the research is rarely destructive, unlike the practice of excavation: what goes unrecorded can be recorded later. For that I am grateful, and have been many times.

The recognition of 'panels' on rock art surfaces is as old as the discovery of rock art. At times the physical layout of the compositions is clearly distinguished within panels (Hallström 1960), or panels can be regarded as metaphoric pages a few metres apart or separated by cracks (Tilley 1991). In some cases the panels are 'natural', such as the slabs found in the Kivik grave, or those found under the Bronze Age grave mound of Høgholmen (Goldhahn 1999), or among the ledges at New Zalavruga (Savvatejev 1970). Panels have always

been recognised, yet much focus has been on individual figures (e.g. Malmer 1981) – which figures are located adjacent to which others and, although less so, on the relationship between the figures and the rock surface. The focus on the figure might partly be explained by the constraints placed by the strong preoccupation with chronology, and therefore with the need to 'prove' which figures are contemporaneous and which are not.

To record all cracks and fissures in a panel involves subjective choices and afterwards there is the problem of distinguishing cracks and fissures from the rock art images in the photographs and the repro copies of the plastic sheets. And what about the different colours, the elevations, the depressions, the seeping water, the changing gradients – all of which can complicate and make tracings unintelligible. The inability to draw is part of the reason why documentation by drawing/tracing has been primarily two-dimensional, supplemented by a vast array of photographs. Photographs, snapped at a hundredth of a second, copy an image onto a flat surface and do not necessarily enhance one's observation of a surface the way drawing does. In addition, how does one record the surrounding/adjacent surfaces, sounds, smells, and the ambience of a place? Archaeologists are selective when recording data; capturing all is not possible. In the case of rock engravings, the easiest, least cumbersome choice is to focus on the figures. Today I find that good documentation is demanding and time consuming.

Even in those cases where figures and surface features are recorded by rubbing, interpretations do not include comment on the structure of the surface any more frequently than where the figures are traced and when fissures and cracks are recorded (e.g. Poikalainen & Ernits 1998). If the rock surfaces – the landscapes in which the rock art story is told (Helskog 2004) – are meaning-rich, then we also have to make sure that when curators 'mend' rock surfaces to preserve rock art they do not inadvertently destroy part of that landscape.

Our traditional strong focus on the figures constrains what we see, record and interpret: this is what I mean by the tyranny of the figures in the chapter title.

CHOOSING THE SURFACE

Myths and folklore are an important source of information on any culture: some offer an explanation as

to why things are as they are – events and natural phenomena, sickness, good or bad hunts – and they serve to reinforce social order, the organisation of society and relationship with the supernatural. The origin of stories can only be speculated upon. Some 'travel' between populations and others appear to be indigenous; some were perhaps first narrated by a shaman following an experience in an altered state of consciousness (Lewis-Williams & Dowson 1988). Judging from the diversity of shapes and the content of global rock art, the cultural dimension in the choice of what is depicted was a dominating factor. In Scandinavia, it can be demonstrated how form and content changed through time, from prehistoric hunter-gatherer societies to agricultural societies (Hagen 1973) or, as in Alta, within hunting-fishing-gathering societies (Helskog 1988, 1989). The explanations for visualising stories and choosing form and content are bound to be multiple, and the stories, storytellers and experiences will be culturally bound. Furthermore, connecting the rock art to the vast range of stories/narratives known from ethnographic sources, or to the many recorded beliefs and rituals, is difficult. But the repetition of figures depicted in rock art indicates that the stories in Alta focused on a relatively small number of figures and outdoor activities: there is a focus on the 'few' rather than on the massive range of activities that might have been depicted. Even given a possible 'freedom' of choice, the artist chose within tight parameters. So why the selectivity? It is this choice we find on the rock surfaces.

Compositions imply that the artist had a story to tell, which again means that the surface chosen had to 'fit' the story, or that the story needed to be appropriate to the surface. Any artist, past or present, was/is bound by this simple relationship. A story may or may not have been created because of the form of the surface, but we can see that some rock engravings (and therefore their stories) were positioned because of the features on or in the surfaces. Rock surfaces must have been, at least at times, instrumental in the choices made. At a particular ritual area some surfaces might have been more conducive to conveying particular narratives and messages than others. Alternatively, as Pat Vinnicombe noted while we were walking through the Drakensberg before the symposium for David Lewis-Williams, "in a living nature the story might have been in the surface already, and the figures only needed to

be added" (Patricia Vinnicombe pers. comm. 2000).

When a surface was engraved, the panel – the surface and figures – might become bound to a particular story and ritual. Yet, we know that, at some surfaces, figures are added at later points in time. Panels can expand. The panels discussed in this chapter are all dated to approximately the late 7th and early 6th millennia BP. If engravings added to these panels were intentionally related to those made earlier, then there was an accumulative effect in which the story was continued in some form. If not, then the new composition represents only a later chronological instant in the life of the panel and the story at that point was probably different from earlier stories told on the same panel. Indeed, stories might have changed with changing contexts. If place was a meaning-giving element, environmental changes might have caused changes in the ritual associations between the panel and its landscape. In Arctic Scandinavia in particular, where new land emerged from the sea with shore displacement and climatic changes throughout the Holocene, old associations might have been broken.

Where a landscape remained unchanged, rock art panels would have been more prone to have been engraved in variable manners over a long period of time. For panels where the landscape changed, the rock art would more likely have been made over a shorter period of time and will therefore appear fairly uniform and homogeneous. Examples of both alternatives can be found among the panels at Lake Onega, eastern Karelia, Russia. It is well documented that the panels are all located adjacent to water. There are several cases along rivers and lakes where engravings still are, or until recently were, overflowed by water (Savvatejev 1970, 1984; Ramqvist et al. 1985; Shumkin 1990; Tilley 1991: 56). Panels appear to have touched water (Bertilsson 1987; Hesjedal et al. 1996; Helskog 1999). In Alta, there is a chronological difference between panels at different heights above sea level: those lower down are younger than those higher up. New panels continued to hug the shoreline as the land rose. This does not necessarily mean that those panels at a higher altitude were discarded, but new engravings seldom appear to have been added to the older surfaces. This is particularly evident in the boat figures (Helskog 1985, 1988). Many of the panels at Alta thus do not appear to be extensively chronologically mixed, although there is no method that can guarantee a 'chronological homogeneity'.

The figures at the panel of Storsteinen were made on the top surface (20.4 m above sea level) of a four-metre high, flat-topped boulder on the steep slope of a glacial frontal deposit. They contain a mixture of manners of depiction, covering a longer time span than at any other panel. The reason for this is that in front of this boulder there are no lower rock surfaces where new figures could be made as the waterline receded – this boulder is unique in this respect in Alta. Storsteinen appears to have been used and engraved for 1500–2000 years, as long as the boulder was connected to the shoreline. A radiocarbon date from deposits covering figures 20 m above sea level on the rock surface indicates that a part of the panel was covered by peat when surfaces at 8.5 m–11 m above sea level were engraved. The obvious point here is that a panel which represents a relatively short period of time will provide clearer rock art units and will be easier to tie to other aspects of the prehistoric record than one with figures covering a long period of time. The bigger question is: are changes in rock art content and manner of depiction over time indicative of changing meanings?

In contrast to the rock engravings, the environment associated with the rock paintings changed less. The painted figures are found on vertical surfaces in dark caves and shelters. Inside the caves, all along the Norwegian coast, the changes were minimal, while the outside environment changed with the shore displacement and climatic changes. In caves and shelters, paintings of human figures dominate numerically (Bjerck 1995); in many caves only images of humans are painted. To the east, in Finland, no engravings have yet been found and the paintings, all on open cliffs above water (Kivikäs 1995), are more diverse than those in the caves and shelters of Norway.

Part of the explanation for the differences between paintings and engravings is to be found in the rituals associated with the location of the panels, and possibly with the surfaces themselves. The painted figures in caves (inside) and shelters (inside–outside) are all on vertical surfaces, while the engraved figures are always on the outside, on a variety of surfaces but seldom on a totally vertical surface. The engravings, with the absolute largest number of classes and types of figures, are embedded into the rock in the open, and were, judging from variety, sheer numbers and diversity of surfaces, associated with a larger diversity of rituals and stories than the paintings.

The surfaces on which modern painters normally work are flat with a vertical or horizontal dimension, while the makers of rock engravings worked on surfaces of which no two are identical. These surfaces vary in size, topography, gradient and orientation. Added to this, the light would have been constantly changing. A large surface has room for more figures than small surfaces. Uneven and undulating surfaces with cracks or fissures can be utilised differently to flat, even and unbroken surfaces. Steep surfaces can be used to convey different messages to horizontal surfaces, and so on. But, we have also to keep in mind that different surfaces could be used in a similar way and could carry similar meanings.

Modern painters have learnt to convey a sense of depth of field by using shading, foreshortening, perspective, and so on. The rock artists at Alta and Zalavruga, and those from all parts of northern Europe, do not use these techniques in their images and compositions. Yet the engravings themselves are three-dimensional. Also, the integration of features in the rock surfaces provides a similar sense of depth and of three-dimensionality as when one is looking at places in a landscape. The integration of surface features might indeed make the total representation a three-dimensional one. Further dimensions were also represented, for example the worlds under the rock and in the sky, as I will argue below. So, in the minds of the original viewers, the meanings associated with the figures and the compositions probably included multiple dimensions.

Evidence to show that there are structural similarities in the organisation of figures and compositions can be found in the larger, older panels in Alta, particularly those located on slanting surfaces (Helskog 1999, 2004). These compositions, with the bear as the central motif, used different parts of the rock surface to show the bear moving though a cosmological landscape divided into an upper, middle and lower world (Helskog 1999). Four compositions have been found with variations on a process in which the bear moves through time and space on the rock surfaces: the compositions capture an entire seasonal cycle. One interesting aspect is the fact that, on three of these four surfaces, the height is as much as 250 cm from the top to the bottom of the composition. The contact with the upper world, the world of the major spirits, is at the top of the panel; the entrance to the

lower world, the world of the dead, is at the bottom; and in between one finds the middle world, the world of the living. The focus of the scenes, if judged in terms of size and numbers of figures, is on the middle world where humans, animals, insects and plants live. Not only does the bear seem to wander between these three cosmic worlds, but, in its wanderings, it moves through the entire annual cycle. It is as if the place of the bear in the cosmos represented the changes between the seasons – a belief that we know was held among the Nenets (Ovsyannikov & Terebikhin 1994) and the Sámi in recent historic time (Nordlander-Unsgaard 1987).

There may have been some variation in where the other worlds were believed to be located, or at least in where the entrances between them were found. The ethnographic records in the European north and Siberia indicate that the other worlds were seen as being located in cardinal directions. To the east, where the sun rises, or to the south where it is warm, is the entrance to the upper world; the entrance to the lower world is in the west, where the sun sets, or to the north, where it is cold and dark. There is some variation in beliefs between different groups, something not unexpected because the locations are connected with moving natural features and phenomena. For example, the sun constantly changes its altitude above the horizon and it is totally present then absent for a period of two months in summer and winter respectively. Simultaneously, there are significant changes in the environment. The associated rituals and the location of the entrance to the different worlds may have changed in a living environment.

Inverted figures in the rock art of Alta may be indicative of the idea that the lower world (world of the dead) was inverted in relation to the (middle) world of the humans (Holmberg 1927: 72–73), but that life in the other worlds was otherwise somewhat similar to that in the world where people lived (Anisimov 1963a; Holmberg 1927: 484, 1987: 23; Ovsyannikov & Terebikhin 1994: 54).

The question to be addressed in the remainder of this chapter is whether the position of figures other than the bear can also yield information about prehistoric concepts of the universe. In order to answer this question, I shall focus on the most frequently depicted animal associated with human figures: the European elk (American moose). Elk are strongly represented in

the engravings: their heads are placed on the prow of boats and sometimes there is a tail in the stern as if elk and boats were interchangeable, or elk were boats and boats were elk. In other compositions the heads of elk are placed on top of poles, while elk are sometimes depicted in compositions that appear to represent rituals involving human figures. In recent arctic ethnography, mythological stories about the position and role of the elk are well known in Siberia, but are almost absent in northern Scandinavia. There are a few myths about the cosmic elk (Sarvas) and cosmic elk hunts among the Sámi (Lundmark 1982: 93–104), but when compared with the frequent stories of the bear, elk stories have a much smaller role. Judging by the rock art of northern Scandinavia, it seems that the elk once had an equally strong if not stronger position than the bear, but in contrast to the bear did not maintain its position into the recent past.

Part of the reason why elk gained a special meaning within the system of belief and practice may be related to the nature of the elk itself, its size and behaviour, and the habitat in which it lives. The elk is the largest land animal in the north. Elk live in woodland and associated open country, including mountains. In particular, they favour marshlands, river valleys and lakes in summer and drier ground in winter. In north-east Europe they can migrate up to 150 km between feeding grounds in summer, although some are known to be non-migratory (MacDonald & Barrett 1993). In the summer their diet comprises mainly large herbs and leaves, including aquatic plants for which they wade, swim and even dive. Of the terrestrial animals in the north, the elk is the one most oriented towards a watery habitat.

THE PANELS

With the exception of one panel from Zalavruga, northern Karelia, Russia, all the examples I discuss are from Alta. In Alta no two panels are identical. The angles of the rock surfaces vary from approximately 45° to horizontal, and the panels vary in size from 70 m² to less than 1 m², from polished to eroded, and from red to grey. Other variations include large panels with a large number and variety of figures, to small panels with few figures and little variation. The group of panels that I examine here are all from the earliest phase.

The first panel, Bergheim I (Figures 10.5 & 10.6), Alta (6200 BP–5600 BP), was first recorded in 1975. The lowest part was well preserved under peat while the upper two-thirds was strongly eroded. We worked all hours of the day and night to exploit the shifting light of the sun, but did not succeed in recording many engravings on the upper part. In the summer of 1999 I re-examined the upper section – looking

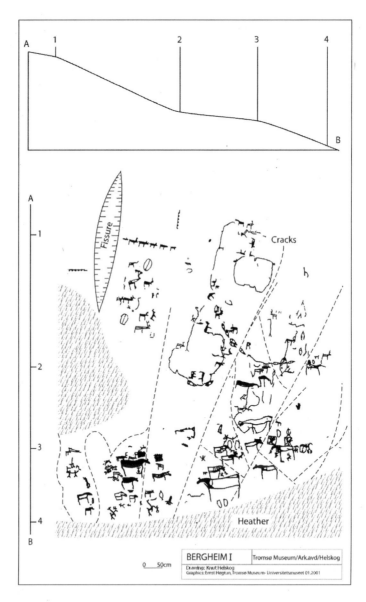

FIGURE 10.5 Bergheim I. This redrawing emphasises a number of figures and cracks that have been added to a standard redrawing such as that seen in Figure 10.3. As a result, the perspective is faulty. Note the concentration of elk in the lower section.

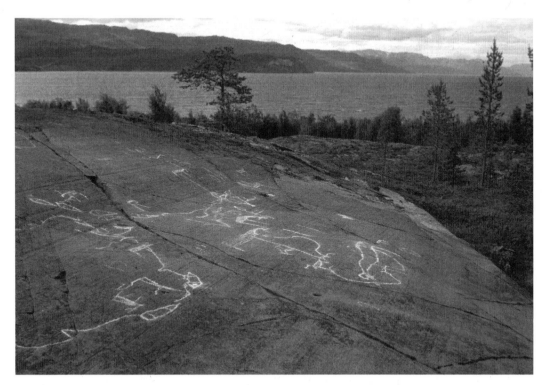

FIGURE 10.6 Bergheim I. Photograph showing the northern section of the surface, looking north-north-west.

with different eyes, and using a large black plastic sheet to manipulate light and shadows – eager to discover what figures were actually there. The result was astonishing, and the distribution of the figures reinforced the impression that entire panels can represent a landscape with stories. The eroded rock surface is, however, undoubtedly still hiding engraved lines to be discovered, but we have recorded most of what there is without stripping additional peat.

The surface of the panel is even, with striation marks from the last glaciation at 90° to the direction of the slope. The top section of the panel is relatively horizontal before sloping (20°–30°) downwards to another relatively horizontal surface which steepens into a 45° slope. The rounded 'horizontal' top, the slope and the relatively horizontal surface are all

strongly eroded and the engravings are difficult to see, while on the lowest slope the engravings are well preserved, having once been protected by a cover of peat that the upper surfaces lacked.

The animal figures in the top section are strongly eroded. The group of five animals to the right are either elk or reindeer. The animals to the left all appear to be reindeer. In the slope immediately below, all are reindeer, with one exception. To the left there are two vertically split 'ovals'. There is what appears to be some form of enclosure marked by long, wide lines similar to those on two other contemporaneous panels. Snow shoes, or prints thereof, are depicted in a semicircle moving from the right to the left, in a way similar to the foot soles interpreted as those of a god on south Scandinavian engravings (Almgren 1927: 212–218;

Almgren 1962). On the lower right there is a human figure standing on similar snow shoes. The lowest set of snow shoes extends down onto the relatively horizontal middle section of the panel. To the left of the large halibut hooked on a line there are four distinct female elk and a line which continues down to what appears to be an elk or a reindeer on top of the lowest section of the panel. Beneath the naked foot and two human figures holding elk-headed poles, the surface changes into a slope of approximately 45°. With the exception of two reindeer on the upper left, the terrestrial animals are mainly female elk. In the central right there are two elk, which appear to be defending their offspring from attacking dogs or wolves. Furthermore, there are two more scenes with human figures holding elk-headed poles, a copulation scene, three fish, two boats and a few geometric patterns and, lowest of all, a pair of bear paws under the stomach of a large elk. Both the similarities and the differences between the figures are large and signal meanings yet to be discovered and explored. The point to be noted here is that the elk are positioned on the lowest part of the panel, while reindeer are not found lower than the upper part of the lowest slope.

This general positioning is repeated at other slanting panels from the same time period. At Ole Pedersen I there is a line of oblong-bodied figures (the uppermost, horizontal figure looks like a humpback whale owing to the two downward-extending flipper-like lines [Helskog 1999: figure 7]) and I suggest that they do depict whales. High on the surface there are a bear and an elk, while all the reindeer are located on the central part of the panel and the elk are mostly on the lower part, together with bears and a whale, and the hips to feet of a large human figure. On the adjacent panel to the north there are bears at the top, reindeer in the centre, and elk at the bottom. Also, the lowest figure is an upside-down elk-headed boat (Helskog 1988: 50).

At Bergbukten IV B (Figures 10.7, 10.8), on a 45° slope, only reindeer are depicted in the upper section. In the central section reindeer also dominate and there are human figures, standing in boats as well as on land, who are aiming at the animals with bows and arrows. Towards the bottom of the panel the number of reindeer is reduced and the number of elk increase. The boats with elk heads in the prow are in the middle, together with bear and halibut. All the elk are to the right in the panel and the majority are in the lowest

part. One of the elk appears to be hunted by a human figure with an axe-like weapon; another appears to be caught in a foot trap. At the bottom of the panel there is a male elk facing human figures holding elk-headed poles, spears and a short curved implement, as if in the performance of a ritual, either real or in a narrative. To the right of the panel there is a break in the slope of the surface – a change in direction and another composition of an elk ritual (with a male elk). To the right there is a herd of female elk with two reindeer in the middle. The point here is that the elk are again positioned in the lower part of the panel.

At the panel at Kåfjord (Helskog 1999: figure 3), connected with a composition of bears, one of the two figures at the top is an inverted elk. In the centre there are mainly reindeer and possibly two to three elk inside a reindeer corral. At the lower section, beneath the horizontal tracks of the bear, to the right of the basin into which the downwards extending footprints lead, there is a concentration of elk although elk are not dominant among the animals depicted in the lower section of the panel.

The panel at Ole Pedersen IX has a small, almost horizontal top surface, from which it slopes down in four different directions (Helskog 1988: 54–55). The altitudinal difference between top and bottom is approximately 20 cm. Most figures are oriented along the slopes. There are mainly elk, three bears, a reindeer, a fox, two hares, and human figures with bows and arrows and spears (one with a drum, some in a procession, two with elk-headed poles, four holding on to an oval and each other), a face, and a long line ending in a circle with a central point. It is a compact panel, and the story narrated and the landscape involved appear different from those in the two previously described panels. The elk dominate. The elk-headed poles are a central focus at the highest section, in contrast to their location at the lower part of the other panels. The vertical structures that point towards the vertical division of the universe are absent; instead, the figures are interwoven in an entirely different way, and boats and fish are not included. There is also no lack of surrounding rock surfaces where engravings could have been made, but were not.

I note also that, at the large, horizontal, undulating to sloping panel Bergbukten I, with a reindeer corral, the lower animals closest to the shoreline are all elk (Figure 10.2).

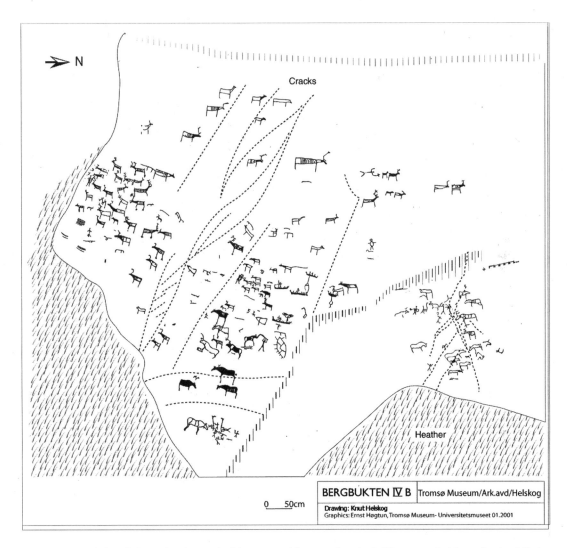

FIGURE 10.7 Bergbukten IV B. A redrawing emphasising engraved figures and cracks. In this case most of the surface is relatively flat, with a gradient of approximately 45°. The northern and southern sections are oriented in slightly different directions. Note the concentration of elk in the lower section.

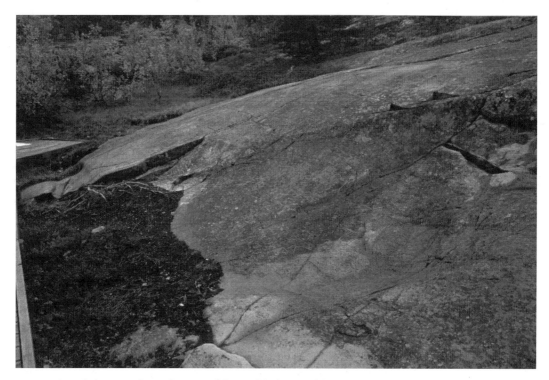

FIGURE 10.8 Bergbukten IV B. The northern part of the panel, looking south.

In contrast to Alta, the engravings at Zalavruga in northern Karelia, Russia, are all on relatively flat horizontal surfaces on an old river bank. The distinction between panels on horizontal and sloping surfaces is not as pronounced as at Alta. Some of the panels are separated by pools of rainwater and small ledges. Inside the pools no engravings are found. But, clearly, the surfaces are chosen because they fit the story or the story can be fitted to the surface. At Staraja (Old) Zalavruga (Zalavruga I [Savvatejev 1970: figure 14]) the surface is smooth and few other surfaces could have fitted a composition of this size and form, especially if the form of the surface was significant. The location was on a small north promontory on the shore landscape, unlike that of any other section (Savvatejev 1970: figure 16). Three large elk and some boats are depicted towards the top of the west slope,

and a 'wedge' of reindeer cuts off the outermost part of the promontory (Figure 10.9). The water would have bounded the western, northern and eastern surfaces. There are no engravings immediately to the south, while to the north-northeast, downslope, there are smaller-sized figures such as human figures on skis, elk, boats and a few beluga (white whales). The large figures, considered by some researchers to be the oldest (Stoljar 1977), include large elk, elk-headed prow boats, all female. These large figures occur behind, almost within, the wedge formation of reindeer. They all move from the left (north) to the right – along the shoreline. Fifty metres further to the south-southeast, at the site New Zalavruga, is the well-known hunting scene in which three skiers hunt three elk (Savvatejev 1984) and in which the ski tracks and the tracks from the elk move downhill in accordance with the topo-

graphy of the rock surface. As stated earlier, the positioning of the elk requires a thorough examination in all panels before any specific conclusions can be drawn for these Karelian sites, but, as at Alta, it is evident that the ancient Karelian population also used elk and the surface as a part of the story being told.

UNDERSTANDING THE ELK

On a sloping rock surface, when illustrating a story in which the sky, earth, water and below (underworld) played a part, one would expect the sky to be positioned uppermost, below to be lowermost, and the world in which people live to be depicted in the middle. In the Alta panels, this seems to be the case. Yet, some of the figures – birds, reindeer, boats and fish – also signal different environments, but this may also be related to the different worlds. The spatial relationships between the figures not only reflect the spatial relationships in the physical world but also their interwoven associations to the different worlds as the people understood them: to a universe alive with souls, spirits and other non-human beings that moved about doing what supernatural beings do. In essence, we should not expect that figures will be located according to our understanding of nature but, rather, according to a nature that was understood as the place where worlds met and where people, animals and supernatural beings acted and interacted.

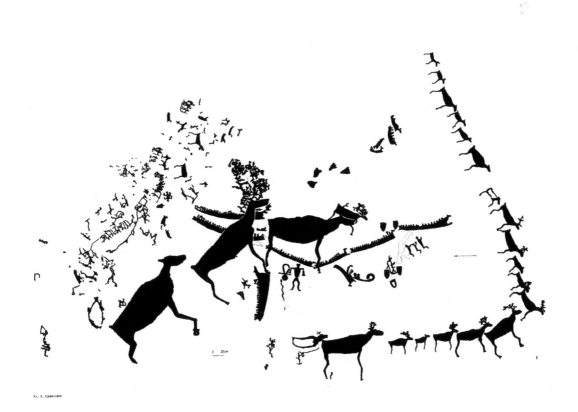

FIGURE 10.9 Old Zalavruga, at the river Vyg, Karelia, Russia (Savvatejev 1970: figure 14). The 'plow-shaped' concentration of elk and reindeer acts as a 'boundary' between the panel and the rock surface to the south. In other directions, the panel is bounded by a river.

It is perhaps such an understanding that the positioning of the engravings reflects. A pattern emerges where the majority of elk on the oldest panels at Alta appear to be located towards the lower section of slanting panels, reindeer in the central and upper sections, and the bear in all sections. I do not claim that any class of animal is excluded from any section but instead that there appears to be a pattern of emphasis. It must be noted that, on the more horizontal surfaces, similar patterns have not yet emerged. This is a distribution that needs to be examined more closely at other panels and at other sites. The positioning of the animals at Zalavruga, where the majority of the surfaces are relatively horizontal, does not show a similar spatial relationship. On the other hand, there is no doubt that all the surfaces were used to create compositions, and it is therefore obvious that a focus on the panel can give different and more information than a focus on individual figures.

Prehistoric sculptures shaped like the head of elk and bear are found all over northernmost Europe (Carpelan 1977). The largest elk head found, in northern Finland, is made of pine (Era-Esko 1958) and dates to the late 8th millennium BP. Yet in the many middens in northern Norway dating to the Stone Age, elk bones are missing, as are those of bear. This suggests that both animals were given some sort of preferential burial, as witnessed by the bear graves from the early Middle Ages, or thrown into a river/water, as among the Voguls (Kannisto et al. 1958). Alternatively, these animals may never have been hunted or eaten, but this is contrary to the hunting scenes in the rock art. In the forested areas of northern Sweden, elk bones become dominant in the archaeological record, while their continued prominent position in the rock art of that area indicates their continued ritual significance. It appears that there were regional cultural differences in ritual behaviour associated with elk.

Okladnikov and Martynov (1972, cited in Jacobson 1993: 92–93), claimed that the sun cult and solar rituals were important in Neolithic Siberia and that the boats frequently overlaying or underlying the elk refer to the passage after death from one world to another. The predominance of female elk points to the animal as a source of life. However, the relationship of the elk with the major rivers suggests that, if the rivers were considered by Neolithic cultures to be the paths that souls took to the netherworld, the

world of the dead, then elk were as closely associated with death as with life (Jacobson 1993: 92–97). Assuming that the elk-boat relationship refers to the passage after death, the elk must also have been invoked in funerary rituals.

The elk is an animal which thrives in water, in river valleys and marshes, during the summer, and in forests during the winter. More than any other terrestrial animal, it connects with water and this behavioural characteristic might have become a metaphor for a spirit animal that mediated land and water – therefore boats with elk-headed prows. The elk heads on boat prows do not have antlers and therefore may be female. Some have asserted that elk without antlers in herds represent a winter phenomenon (Ramqvist et al. 1985), while others (Hagen 1976; Mikkelsen 1986; Tilley 1991) have focused more on them as an indicator of femininity, a point of view which is also common among Russian scholars (Jacobson 1993). The elk has been associated ethnographically with totemism, death and resurrection (Tilley 1991); it was polysemic, as has been shown for rock art symbols elsewhere (Lewis-Williams 1998).

Our knowledge of the elk in prehistory is based on artefacts, osteological remains and engravings on artefacts and rock surfaces, while our understanding of the meanings of the elk is based solely on the ethnographic record. The problems in applying analogies need hardly be repeated (e.g. Wylie 1985; Lewis-Williams 1991, 1995). Ethnographic examples associated with the elk in a north European and Siberian context may, however, provide a part of the framework for interpreting the rock art when complex patterns in the ethnography fit closely with complex patterns in the rock art. In the cosmology of the Siberian populations, the elk represents one of the most important spirits, while in Sámi folklore information about the elk is minimal; there seems to be no continuity within northern Scandinavia. The elk, however, especially the female animal, was once an important animal in the world of beliefs of the populations of northern Scandinavia, as has been claimed for northern Russia, and across the taiga and tundra of Siberia (Jacobson 1993: 2). According to Anisimov (1963a: 110), the elk was also an ancient totem among the Evenk.

According to Jacobson (1993: 242), the role of the elk among the Evenk and the Ket of western Siberia has Bronze Age roots, and these peoples'

myths are thus especially relevant as an analogy. In the ethnographic record there is a heavenly elk, a mother elk, a cosmic elk, a gigantic female elk, associated with hunting and regeneration (Anisimov 1963b: 161–162; Jacobson 1993: 242). The elk seems to be connected to all cosmic worlds. It was a creator linked with the creation of the mountain and rivers in the middle world (Anisimov 1963b: 166). Among the Evenk, the bear and the elk were the most powerful animals, and the bear was the master of all animals:

> In the upper world of the universe the bear mangi pursues the elk *kheglen*, giving rise to the succession of day and night in the land of people. In the nether world the mythical elk cow *khargi* lies under the roots of the cosmic world tree, giving birth to animals and people for the middle world, while the spirit master (a bear) of the nether world takes the souls of the dead back to himself, to the nether world. In the middle world of the universe, the place of the living people, the spirit *lukuchen* (an elk) fights with other spirits of the tribal pantheon (Anisimov 1963b: 198).

The linking of the cosmological image of the elk (deer) with the image of the mammoth, functionally analogous, and in turn, that of the mammoth with the views on the nether world, is characteristic of the mythology of most of the nationalities of northern Asia, and truly, it may be considered a common Siberian phenomenon (Anisimov 1963b: 167).

Also, among the spirit rulers of the netherworld the image of the elk-deer was used as the guard for the river of the mythical shaman clan. This elk-deer had the antlers of an elk and the tail of a fish and connects with both water and land.

The Voguls (Kannisto *et al.* 1958: 89), west of the northern Ural Mountains, saw the star constellation known today as the Big Bear as a male elk. The Evenk saw the same elk as female. In general, the elk is associated with the passage of seasons (Anisimov 1963b: 163), and especially with the regeneration of nature. For example, among the Soswa Voguls, (Kannisto *et al.* 1958: 93, 391–392), when the ice breaks and starts to move in a village, the men cook and consume an elk head while the women also cook and eat elk meat. Small girls take part, as on other occasions, in the consumption of the elk head. The meal is consumed at the river bank. When the ice starts to move, the dish with sacrificial meat is placed on the shore and the men shoot their guns, bow their heads and utter an incantation to secure future yields of food from the river. After the incantation the meat is thrown onto the river ice. There was also the tradition in different areas that elk bones had to be thrown into water. If they were thrown onto the ground, the elk would not let hunters come close.

Among the Unter Kunda Voguls, who sacrificed small gifts, the weak elk bones were given to the dogs while the hard, strong bones were boiled, split to extract the marrow, and then sunk into water (Kannisto *et al.* 1958: 93, 391–392). The Pelymka were not required to throw elk bones into water, as was their custom with the bones of the bear, but the people were careful not to spill elk blood or meat on the floor of the house, while the blood and meat of the bear do not appear to have been as important. Elk meat could not be eaten out of an unclean dish from which red fish had been eaten. If, however, the dish was properly cleaned, it was possible to eat meat from such a dish and it was even possible to cook elk meat and dried fish together (Kannisto *et al.* 1958: 392).

Among the many examples of the cosmic and ritual significance of the elk I have found no mention of an association between boats and elk. The sole reference to boats in rituals comes from Holmberg (1927: 32–33), who mentions that the Ugrians and the Karelian Finns had a custom of burying their dead in a boat or a punt, and it is argued that this is connected both with an old belief regarding the journey across water to the world of the dead, and with the need for a boat in the world of the dead. Also, the Vikings buried their dead in boats to ensure that they would journey to the realm of death. In essence, there is a plausible connection between death and transportation of the dead in boats. While one might not want to draw the conclusion that all boats in the rock art are similarly connected, some might be.

It is possible that the elk beliefs in the ethnographic records represent the last vestiges of a belief system that had its roots far back in prehistory. I therefore conclude by considering how the rock engravings relate to the ethnographic traditions. These give the elk several major roles. The elk is associated with all dimensions of the universe but, of all terrestrial ani-

mals, they are the ones most clearly associated with the underworld and water. There is a notable correspondence when comparing this ethnographic trend with the positioning of the elk as the dominant animal on the lower section of some of the slanting rock art panels. Both the ethnography and the art position the elk in relation to the underworld. It can therefore be argued that there is at least some correspondence between the archaeological and ethnographic records.

This discussion of the 'interplay' between archaeological evidence, interpretation and ethnography certainly proves the long antiquity of elk as an important symbol in beliefs and rituals. Of this there can be no doubt. Nor should there be doubt about continuity within these northern regions. On the other hand, pointing out the existence of prehistoric representations and ethnographic lore within the same or adjacent geographic regions is not the same as saying that prehistoric beliefs were identical to those recorded ethnographically. The research of Russian scholars (Anisimov 1963a, 1963b; Okladnikov & Martynov 1972) and of others (Jacobson 1993) points to changes both in meaning and in associated social structures. Yet, I argue, we may still use some ethnographic material in our interpretive model.

CONCLUSION

From the above discussion I extract a few general points which, obviously, stem from my experience from northernmost Europe. I give these to contribute to the experiences of others, in other places, in the many-sided world of rock art studies.

First, to enhance an understanding of rock art, I feel there is a need to break away from the tradition of focusing on the figures themselves, and to include not only a detailed examination of the relationship to rock surfaces, but also the positioning of the figures on these surfaces. Such an understanding would benefit from more people drawing the panels in addition to photographing them, because drawing provides an interactive way to see structures that bind or separate figures – to see what is between the figures and not reiterate what one thinks one sees, what the brain 'orders' one to see. I encourage us to break away from this tyranny.

Second, the reasons why prehistoric artists chose a particular surface at a particular place are undoubtedly many, as are the reasons for choosing what to (or what not to) depict. Any of these choices involves space, although not necessarily as a decisive factor. At the level of the rock surface, the compositions at Alta and other places indicate that there was a spatial relationship – a need to fit – between individual engravings, compositions and the surface. There had to be room enough for making the figures needed; and, judging from the engravings from the earliest period in Alta, size was reasonably standardised and choices were non-random. There was not much flexibility in manipulating figure size when the artists assessed fit and positioning.

Third, the position of the figures on the surfaces might be as important as the spatial relationship between the figures and their orientation. This does not mean that individual figures were not important, but does incorporate placement and position as potential meaning-giving factors. In addition, surface gradient and orientation may have played a role, while in Alta as at other places specific features such as colours, cracks and basins were part of the meanings and stories intended within the art. Such features might be one of the reasons why a particular engraving or composition was made on a specific surface. This is a point often made.

Finally, and specific to northernmost Europe, the position of elk on some rock surfaces, as with that of bears, leads me to suggest that it reflects, among other things, a prehistoric division of the universe. The dominant location of elk, on the lower sections of slanting panels, places them physically closer to the water's edge than any of the other figures. Furthermore, the combination of boat–elk reinforces the connection to water, as does the behaviour of the elk. The stories and the position of the elk in the ethnographic record also associate the elk with water, among other links, and in this way reinforce the observation from the engravings and the behaviour of the animal. The ethnographic record is a vestige of beliefs whose antiquity is unknown, while the engravings are remnants of a world of beliefs vastly pre-dating the ethnographic record. We do not know if there is a connection, but the similarities in what is described ethnographically and observed archaeologically are so striking that it is highly likely that there are some similarities in meanings, even if there is no direct historical continuity. A belief that connects the elk with water and the underworld among prehistoric populations is supported by the evidence in the rock

art from Alta, as, I would like to add, is a belief in the transport of the souls of the dead in boats with elk heads and the regeneration of life. In these cases it appears that the elk is the boat, with the head in the bow, while the body is the hull and the tail extends from the stern. But from the ethnographic record, as well as from the positioning of the elk at the top of the composition in Kåfjord in Alta, the elk also appears to have been a spirit in the upper world. The elk was in all worlds, as was the bear, representing different spirits with different functions and powers. The positioning of the elk in the rock art therefore places it in all worlds, as with the bear, but the elk appears to be more dominant in its connection to the lower world. In this way, what is seen in the rock art appears to be a variant of the beliefs in the ethnographic record.

Acknowledgements

This chapter was first prepared during my sabbatical year, 1999–2000, at the Department of Archaeology at the University of Cambridge, United Kingdom. It has since been amended and revised. I thank the department for giving me access to its facilities and library. It was a good year. I also thank the artist Ernst Høgtun for his drawing (Figure 10.4) and computer graphics, and his willingness to experiment with drawings of rock art panels.

References

Almgren, B. 1962. Den osynliga gudomen. In: Hamberg, P.G. (ed.) *Proxima Thule: Sverige och Europa Under Forntid och Medeltid*: 3–71. Stockholm: Norstedt, Svenska Arkeologiska Samfundet.

Almgren, O. 1927. *Hällristningar och Kultbruk: Bidrag till Belysning av de Nordiska Bronsalder-sristningarnas Innebörd*. Stockholm: Kungl, Vitterhets Historie och Antikvitets Akademiens Handlingar 35.

Anisimov, A.F. 1963a. The shaman's tent of the Evenks and the origin of the shamanic rite. In: Michael, H. (ed.) *Studies in Siberian Shamanism*: 84–123. Toronto: University of Toronto Press.

Anisimov, A.F. 1963b. Cosmological concept of the people in the north. In: Michael, H. (ed.) *Studies in Siberian Shamanism*: 157–229. Toronto: University of Toronto Press.

Bertilsson, U. 1987. *The Rock Carvings of Northern Bohuslän*. Stockholm: Stockholm University, Department of Archaeology.

Bjerck, H. 1995. Malte Menneskebilder i 'Helvete'. Betraktninger om en Nyoppdaget Hulemaling på Trenyken, Røst, Nordland. *Universitets Oldsaksamling Årbok* 1993/1994: 121–150.

Carpelan, C. 1977. Älg och björnhuvudforemål från Europas nordliga deler. *Finskt Museum* 1975: 5–67.

Coles, J.M. 2000. The dancer on the rock: record and analysis at Järrestad, Sweden. *Proceedings of the Prehistoric Society* 65: 167–187.

Edwards, B. 1979. *Å Tegne er å Se*. Oslo: Grøndahl og Dreyers Forlag.

Era-Esko, A. 1958. Die Elchskopsculptur von Lehtojarvi in Rovaniemi. *Suomen Museo* 68: 8–18.

Gjessing, G. 1936. *Nordenfjeldske Ristninger og Malninger av den Arktiske Gruppe*. Oslo: Instituttet for Sammenlignende Kulturforskning Series B Skrifter 30.

Goldhahn, J. 1999. Rock art as social representation. In: Goldhahn, J. (ed.) *Rock Art as Social Representation*: 1–25. Oxford: British Archaeological Reports International Series 794.

Hagen, A. 1973. De to slags helleristninger. In: Stamsø Munch, G. & Simonsen, P. (eds) *Bondemann-Veidemann. Bofast ikke Bofast i Nord-Norges Forhistorie*: 129–143. Tromsø: Tromsø Museum Skrifter.

Hagen, A. 1976. *Bergkunst*. Oslo: Cappelens Forlag.

Hallström, G. 1960. *Monumental Carvings of Northern Sweden from the Stone Age*. Stockholm: Almqvist och Wiksell.

Helskog, K. 1985. Boats and meaning: a study of change and continuity in the Alta fjord, arctic Norway, from 4200 to 500 years BC. *Journal of Anthropological Archaeology* 4: 177–205.

Helskog, K. 1988. *Helleristningene i Alta: Spor Etter Ritualer i Finnmarks Forhistorie*. Alta: Knut Helskog.

Helskog, K. 1989. *Naturalisme og Skjematisme i de Nordnorske Helleristningene*. Tromsø: Tromsø Museum Skrifter 22.

Helskog, K. 1999. The shore connection: cognitive landscapes and communication with rock carvings in northernmost Europe. *Norwegian Archaeological Review* 32(2): 73–94.

Helskog, K. 2003. The World Heritage Site in Kåfjord, Alta, North Norway. *INORA* 37: 12–17.

Helskog, K. 2004. Landscapes in rock-art: rock-carving and ritual in the old European North. In: Chippindale, C. & Nash, G. (eds) *The Figured Landscapes of Rock Art: Looking at Pictures in Place*: 263–288. Cambridge: Cambridge University Press.

Helskog, K. & Høgtun, E. 2004. Recording landscapes in the rock carvings and the art of drawing. In: Milstreu, G. & Prøhl, H. (eds) *Prehistoric Pictures as Archaeological Source*: 23–31. Gothenburg: Gothenburg University, Gotharc, Series C 50.

Hesjedal, A., Damm, C., Olsen, B. & Storli, I. 1996. *Arkeologi på Slettnes. Dokumentasjon av 11.000 års Bosetning*. Tromsø: Tromsø Museums Skrifter 26.

Holmberg, U. 1927. *The Mythology of All Races 4: Finno-Ugric, Siberian*. London: George G. Harrap.

Holmberg, U. 1987. *Lapparnes Religion*. Uppsala: Uppsala University, Uppsala Multiethnic Papers 10 (Translated from Finnish).

Jacobson, E. 1993. *The Deer Goddess of Ancient Siberia: A Study in the Ecology of Belief*. Leiden: Brill Academic.

Kannisto, A., Virtanen, E.A. & Liimola, M. 1958. *Materialen zur Mythologien der Wogulen*. Helsinki: Mémoires de la Société Finno-ougrienne 113.

Kivikäs, P. 1995. *Kalliomaalaukset – Muinainen Kuva-Arkisto*. Jyväskylä: Atena.

Lewis-Williams, J.D. 1990. Review article: documentation, analysis and interpretation: dilemmas in rock art research. *South African Archaeological Bulletin* 45: 126–136.

Lewis-Williams, J.D. 1991. Wrestling with analogy: a methodological dilemma in Upper Palaeolithic rock art research. *Proceedings of the Prehistoric Society* 57: 149–162.

Lewis-Williams, J.D. 1995. Seeing and constructing: the making and 'meaning' of a southern African rock art motif. *Cambridge Archaeological Journal* 5(1): 3–23.

Lewis-Williams, J.D. 1998. *Quanto?* The issue of 'many meanings' in southern African San rock art research. *South African Archaeological Bulletin* 53: 86–97.

Lewis-Williams, J.D. & Dowson, T.H. 1988. The signs of all times: entoptic phenomena and Upper Palaeolithic art. *Current Anthropology* 29: 201–245.

Lewis-Williams, J.D. & Dowson, T.H. 1990. Through the veil: San rock paintings and the rock surface. *South African Archaeological Bulletin* 45: 5–16.

Lundmark, B. 1982. *Baei'vi Mánno Nástit. Sol- och Mänkult Samt Astrala och Celesta Föreställningar Bland Samerna.* Umeå: Västerbottens Museum, Acta Bothniensia Occidentalis.

MacDonald, D. & Barrett, P. 1993. *Mammals of Britain and Europe.* London: HarperCollins.

Malmer, M. 1981. *A Chorological Study of North European rock art.* Stockholm: Almqvist & Wiksell.

Mikkelsen, E. 1986. Religion and ecology: motifs and locations of hunters' rock carvings in eastern Norway. In: Stensland, G. (ed.) *Words and Objects: Towards a Dialogue between Archaeology and History of Religion*: 127–141. Oslo: University Press.

Nordlander-Unsgaard, S. 1987. On time-reckoning in old Saami culture. In: Ahlbäck, T. (ed.) *Saami Religion*: 81–93. Åbo: Almqvist & Wiksell International, the Donner Institute for Research in Religious and Cultural History.

Okladnikov, A.P. & Martynov, A.I. 1972. *Sokrovishcha Tomskikh Pisanits.* Moscow: Iskusstvo.

Ovsyannikov, O.V. & Terebikhin, N.M. 1994. Sacred space in the culture of the Arctic regions. In: Carmichael, D.L., Hubert, J., Reeves, B. & Schanche, A. (eds) *Sacred Sites, Sacred Places*. 44–81. London: Routledge.

Poikalainen, V. & Ernits, E. 1998. *Rock Carvings of Lake Onega: The Vodla Region.* Tartu: Estonian Society of Prehistoric Art.

Ramqvist, P.H., Forsberg, L. & Backe, M. 1985. ...and here was an elk too ... A preliminary report on new petroglyphs at Stornorrfors, Ume River. *Archaeology and Environment* 4: 313–337.

Savvatejev, J.A. 1970. *Zalavruga: Arkheologicheskiye Pamyatniki Nizovya Reki Vyg 1: Petroglifi. Otvetstvennyie Redaktor A.M. Linevsky.* Leningrad: Akademia Nauka.

Savvatejev, J.A. 1984. *Karelische Felsbilder.* Leipzig: E.A. Seeman Verlag.

Shumkin, V. 1990. The rock carving of Russian Lapland. *Fennoscandia Archaeologica* 7: 53–68.

Simonsen, P. 1958. *Arktiske Helleristninger i Nord-Norge II.* Oslo: Aschehaug, Instituttet for sammenlignende kulturforskning, Serie B, 49.

Stoljar, A.D. 1977. Opyt analiza kompozicionnyh struktur petroglifor Belomor'ja (Karelja). *Sovetskaja Arkeologica* 3: 24–41.

Tilley, C. 1991. *Material Culture and Text: The Art of Ambiguity.* London: Routledge.

Whitley, D.S. 1998. Finding rain in the desert: landscape, gender and Far Western North American rock art. In: Chippindale, C. & Taçon, P.S.C. (eds) *The Archaeology of Rock-Art*: 11–29. Cambridge: Cambridge University Press.

Wylie, A. 1985. The reaction against analogy. *Advances in Archaeological Method and Theory* 8: 63–111.

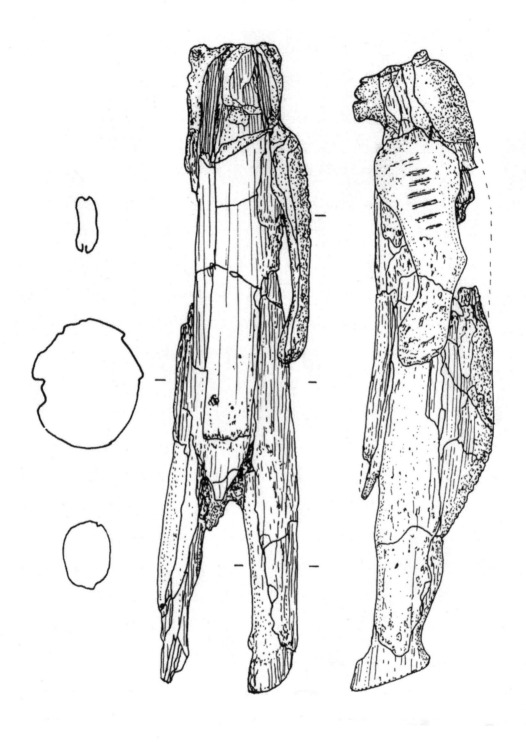

FIGURE 11.1 The figure with the head of a lion and the body of a human, in ivory, from Hohlenstein-Stadel (Germany). Height 28 cm. *(Drawing by J. Hahn 1986)*

11.

Composite creatures in European Palaeolithic art

JEAN CLOTTES
(Rue du Fourcat, Foix, France)

IDENTIFYING COMPOSITE CREATURES

In Palaeolithic art, whether parietal or portable, composite creatures (anthropozoomorphs or therianthropes) are defined as "representations with morphological characteristics indisputably attributable on the one hand to Man and on the other hand to Beast" (Clottes 1993: 198). When they were re-evaluated within the framework of the systematic general survey of the *Groupe de Réflexion sur l'Art Pariétal Paléolithique* (GRAPP 1993) on the theme of 'methodology', we took the narrowest definition. In effect, we accepted neither 'phantoms', where Leroi-Gourhan (1965: 96–97) saw a deliberate ambiguity between humans and birds or other animals, nor humans with prognathous heads, even though Leroi-Gourhan (1965: 96) admitted that in this case a

"certain pursuit of animal likeness" cannot be excluded. We omitted both the bird-headed humans in the shaft at Lascaux and at Altamira, and the frog-headed ones at Los Casares. Our objection at that time was that "too many human heads are wilfully deformed and [that] one finds so many intermediaries between the most realistic human heads and those with characteristics of an animal that it is difficult to draw an unequivocal line when dealing with representations that are relatively lacking in detail" (Clottes 1993: 198). As a result, the GRAPP list of parietal composite creatures was very short, with only seven individuals in three caves: three at Gabillou, three at Trois-Frères and one at Hornos de la Peña. In the portable art were mentioned those observed at Espélugues, at Enlène, at Tuc-d'Audoubert, and at Hohlenstein-Stadel in Germany. We could have quoted others such as the 'lit-

tle devils' of l'Abri Mège at Teyjat (Dordogne) (Capitan *et al.* 1909: 72, figure 11).

Strict restraint justified our position within the framework of a work explicitly dedicated to methods where rigorous steps must be taken to determine such and such a figure and to classify it within a precise category only if the identification is certain. It is too easy to move from 'probable' or even 'possible' to 'certain' the moment statistics are compiled (Clottes 1989). Furthermore, it was clearly indicated that the elimination of heads which had been distorted, voluntarily resulted from difficulties in determining an obvious boundary between categories. It is a case of having a systematic regard for a method peculiar to ourselves, a regard which still stands – but which was not necessarily the same as that of the Magdalenians or of their pre - decessors. We can therefore legitimately ask ourselves whether, in drawing the definition so tightly and reducing the numbers so greatly, we have too hastily abandoned an important aspect of Palaeolithic thought.

Discoveries of recent years reinforce the idea that the number of what we refer to as composite creatures is much greater than we thought at the time of the GRAPP study. In certain instances, animals carry one or more anatomical characteristics that are unquestionably human. On the other hand, some humans are endowed with one or two animal characteristics. Each of these kinds of representation, by the same fact of their studied ambiguity, may be debatable. Yet the regularity of their appearance allows one to put forward the idea that this is not a question of chance, accident or error, but instead arises through a graphic transcription of beliefs prevalent in Europe throughout the Palaeolithic period.

MAN-BEAST

The man with a lion's head from Hohlenstein-Stadel (Figure 11.1), brought to light in an Aurignacian level at this shelter situated in the Swabian Jura, is well known. In his case, only the head betrays the extrahuman character, the rest of his body seeming faultlessly anthropomorphic. He is generally classified, without hesitation or soul searching, with composite creatures (Bosinski 1990: 74). The same is true for two of the individuals at Gabillou: their bodies and arms are human but each is endowed with a bovine

head (Gaussen 1964: pl. 7, figure 1; pl. 18, figure 4).

On the other hand, the individual falling backwards in the 'Scene in the Shaft' at Lascaux has never been qualified as anything but human, even though he has the head of a bird; this theme is reinforced by the bird that can be seen perched on a stick just under him. It is the same for the 'wounded men' of Cougnac and Pech-Merle, whose heads are strongly reminiscent of that of the Lascaux bird-man. The one at Cougnac is even endowed with a tail-like appendage (Clottes & Courtin 1994: 157–158). The representations at Los Casares, with heads evocative of frogs, have been termed 'semi-human' and classified amongst the 'humanoids' in the article in the GRAPP notice specifically dedicated to 'human figures' (Gaussen 1993: 91); likewise the individuals of Lascaux and of Hornos de la Peña. Yet, elsewhere in the same GRAPP work they are described separately as purely anthropomorphic (Clottes 1993: 198). Several others are acknowledged by Gaussen (1993): an entirely prognathic head with menacing teeth at Massat, the bestial silhouette at Combarelles, the bird-headed humans at Altamira (cf. also Pales & Tassin de Saint-Péreuse 1976: pl. 178, no.1–7).

The slaughtered man at Cosquer (Clottes & Courtin 1994) is endowed with whiskers identical to those of the nine seals carved in the same cave; also, as has already been duly noted, he is represented not as a dead human but as an animal – on its back, with its four limbs in the air (Figure 11.2). Moreover, its tapering lower limb brings it closer to the seal images of the cave, these too symbolically killed by spears. It therefore falls, as with the others, into the category of discreet composite creatures.

Among the portable art, several human images, generally not included amongst therianthropes, are sporting tails (at Enlène, Tuc d'Audoubert, Espélugues). Many more are given animal-like heads, such as that of the celebrated woman carved on bone who is following another woman at Isturitz (in a scene formerly called the 'amorous pursuit') (Figure 11.3). She was not, however, classified by Pales and Tassin de Saint-Péreuse among the 'humanoids', any more than was the head at Massat, but is listed among 'realistic' humans (1976: pl. 177, no. 43–44, 174).

Since the beginning of the last century (Breuil 1914; Déonna 1914), these bestialised heads have often been termed 'masks', whether they be viewed

FIGURE 11.2 The 'killed man' in the Grotte Cosquer (Marseilles, France). Length 28 cm. (*Drawing by J. Clottes*)

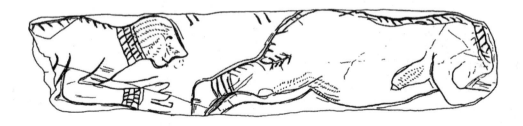

FIGURE 11.3 Female human with feline head. Isturitz (Pyrénées-Atlantiques, France). Height 12 cm. (*Drawing by L. Pales*)

as ceremonial masks or hunting camouflage, seen as spiritual or imaginary beings (Breuil 1914: 301), or again as dependent upon a 'primitive indefiniteness' (Déonna 1914). The extreme prognathism of the human images has been so integrated into the thinking of researchers that it is considered commonplace, and it is hardly mentioned whenever one discusses anthropomorphic representations. However, a good many human heads – such as those from La Marche – are sufficiently naturalistic to permit one to be certain that the brutalisation established in other cases was a matter of choice. So it was not a question of artistic licence or of an inability to draw the human form, but rather the depiction of a different reality.

BEAST–MAN

Following the article quoted by Déonna (1914), Breuil wrote a paper with the explicit aim of refuting the idea that there existed in Palaeolithic art a bison or any other species of animal with a human head (Breuil 1914). It is true that certain bison heads are frequently interpreted by amateurs as human heads, for example that of a young animal (no. 129) opposite the 'arrowed' female bison (no. 130) on Panel 6 of the Salon Noir at Niaux (Clottes 1995: 123, figure 150). These superficial resemblances, more subjective, effectively remain insufficient to establish a firm belief that they were deliberately made.

On the other hand, representations were ranked either among humans or among composite creatures that are essentially animal from the head; in truth, all of the upper part of the body at Gabillou is animal, and the 'Sorcier à l'arc musical' of Les Trois-Frères even has front paws and a tail. One of the 'petits sorciers' of Les Trois-Frères is particularly interesting in this respect: it has the head, body and front paws of a bison, with relatively discreet human characteristics – sexually a man with a leg (albeit with what seems to be a hoof) and bowed posture (Figure 11.4). The indisputable dominance of animal characteristics and the discrete human attributes set this one aside and led to its being put in the same category as bison

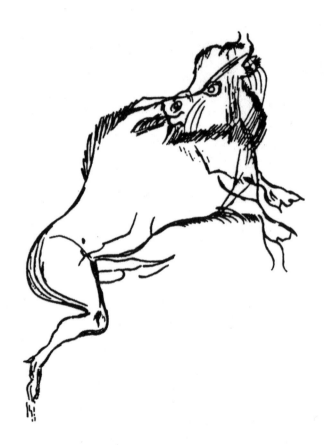

FIGURE 11.4 The little hybrid being ('*petit être mixte*') from Les Trois-Frères (Ariège, France). Length 30 cm. (*Drawing by H. Breuil*)

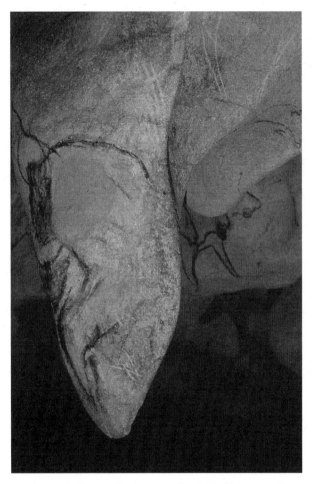

FIGURE 11.5 The 'Sorcerer' in the Grotte Chauvet (Ardèche, France). Length about 100 cm. Notice the arm ending with tapering fingers on the thigh of the female figure to the left. *(Discovery and photograph by Y. Le Guillou)*

(Baffier 1984: 144); yet it had originally been assigned to the category of composites (cf. Bégouën & Breuil 1958: 51, figure 55, '*être mixte*', a 'hybrid being'), an attribution since accepted (Clottes 1993: 198, figure 148.3). It ought to be set among discreet composite creatures.

A recent discovery is that of the '*Sorcier*' at the Grotte Chauvet (Figure 11.5), first reported in 1995. This figure is visible from the entrance to the Salle du Fond. It occupies the whole surface of the lower part of a hanging rock and it faces the left wall, which is

adorned with splendid figures. It represents the frontal of a bison with its hump. The head, detailed with a white eye with a central point, is thrown into relief with shading. The forefoot appears as a converging double line which is prolonged, with a hand resting on the thigh of a second figure, that of a woman. For this one only, the lower body is shown with her two lines and her pubic triangle (Le Guillou 2001). An internal smoothing in an identical way has been carried out on the hump and on the thigh. One cannot ascertain a similar smoothing on the rest of the

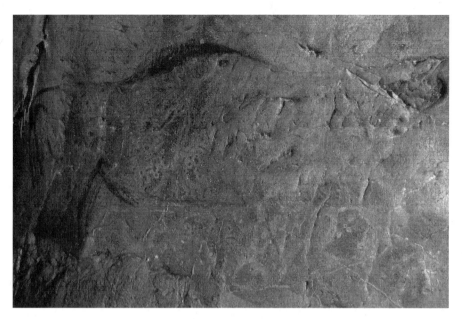

FIGURE 11.6 Bison 52 in Niaux (Ariège, France), with sheath in the groin. Length about 108 cm. *(Photograph by J. Clottes)*

panel. The intention, therefore, was to establish a link between the top and the bottom of the bison–human figure and the thigh of the woman, which prevents one from dissociating one from the other.

The 'man–bison' at Castillo, as described by Ripoll Perelló (1971–1972), is reminiscent of that at Chauvet, with its upright posture. In this connection, one can observe that it is bison that are privileged among animal–men, whereas the man–animals appear more eclectic.

This remark is reinforced by four cases, observed in three different caves, and belonging to different cultures. In Niaux (Figure 11.6), in Cosquer (Figures 11.7, 11.8) and in Ebbou (Figure 11.9), bison have been endowed with a sheath not placed right in the centre of the belly as is normal with bulls, but in the groin as a man's (or a horse's) penis is. This has been attributed to "an anatomical error" (Clottes 1995: 136), attributable to the desire to characterise animals by their size and their sexual dimorphism, in other words, the secondary characteristics (Baffier 1984) that enable us to identify them from a distance. In

that case it would seem to be some sort of negligence on the part of the artists.

This hypothesis remains a possibility, albeit not a satisfactory one, since Palaeolithic people were far too good at observing animals, which they at all times reproduced with too great a profusion of detail and precision to have made such errors. There are of course incorrect drawings, such as horses on a 'flying gallop', or the inverted curvature of bison horns. These generally result from optical illusions or problems with perspective, but the position of the penis, often appearing in a naturalistic way on other bovines, was too well known for them to have been mistaken; and this error is repeated over many millennia and in caves as far apart as Niaux (in the Pyrenees) and Cosquer (on the central French Mediterranean coast). It is much more plausible to envisage a deliberate desire on the part of the artists to represent a composite creature.

The same phenomenon is found in composite animals. Some – determined at first sight as bears, lions, or reindeer – hold some bodily attributes belonging to other species. Thus it is with, among many other

examples, the bear with a wolf's head at Trois-Frères (Bégouën 1993: 203, figure 151), and, in the same cave, the female cervid with a bison's head (Bégouën 1993: 202, figure 150). In the Chauvet Cave, a vertical lion, its head down, has paws with ungulate hooves (Chauvet *et al.* 1995: 75, figure 63).

HUMANS AND ANIMALS

The aim of this chapter is to draw attention to the extent, much greater than was believed to date, of a phenomenon formerly known about, of course (Tymula 1995), but whose breadth and manifestation have been underestimated: the modification of anatomy in Palaeolithic art, especially in relation to the proximity of humans and animals.

Confronted by this phenomenon, researchers have taken up very diverse positions, often even contradictory ones, which bear witness to a certain unease. Why is the ivory character from Hohlenstein-Stadel accepted as a composite creature and not the woman at Isturitz, when they both have heads that are indisputably animal? Why does the 'bison' with some human characteristics (Les Trois-Frères, above) give rise to reservations one does not have with the *'Sorcier'* at Gabillou, or with the other two therianthropes in the same cave? Why are the individuals at Cougnac and Pech-Merle accepted as humans, while that at Cosquer is termed (without the least discussion) an "extremely doubtful humanoid figure" (Bahn & Vertut 1998: 173)? One can see how the expectations of researchers for the ordering of the Palaeolithic world have closely – too closely! – reflected the categories of the modern western world in which there are animals divided into biological categories, and there are humans – in every way distinct from the animals. Accordingly, a Palaeolithic depiction that does not clearly fall into one or the other class is scrutinised and only accepted into an intermediate or composite class if it cannot be seen as simply animal or simply human.

Three consequences are inferred by the repetition of this phenomenon in parietal and portable art from the Aurignacian to the Magdalenian. First, it once more emphasises the conceptual unity of Palaeolithic art. Then, it guarantees that the transcription of a different reality from that normally observed was deliberate and not an error arising through inability or artistic licence. Finally, it throws light on the concep-

FIGURE 11.7 Bison Bi1 at Cosquer, radiocarbon-dated to 18 530±180 BP (Gif A 92.492). Length about 120 cm. *(Photograph by A. Chêné)*

tion of a world where humans were not so distinct from animals, where transformations operated at different levels – sometimes obviously but on many occasions relatively discreetly. As was so well said by Bosinski (1990: 74) about the figure from Hohlenstein-Stadel, "such half-man, half-animal creatures cross the mythology of hunting cultures in the Upper Palaeolithic. They bear witness to the possibility of a fusion between animals and man as well as to their interchangeability and enable us to catch a glimpse of the imaginary world of Shamanism."

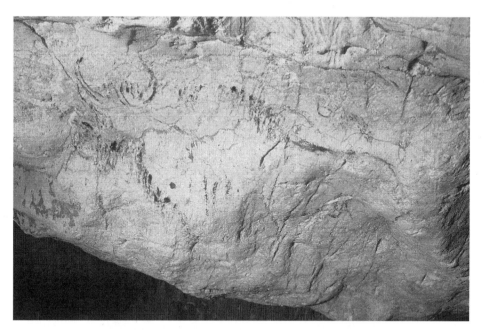

FIGURE 11.8 Bison Bi2 at Cosquer, which has two radiocarbon dates: 26 250±350 BP (Gif A 96.069) and 27 350±430 BP (Gif A 95.195). *(Photograph by A. Chêné)*

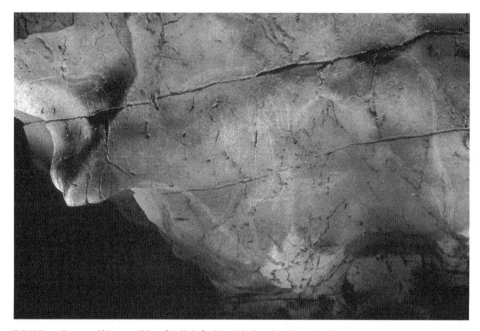

FIGURE 11.9 Engraved bison at Ebbou (Ardèche), also with sheath in the groin. *(Photograph by B. Gély)*

References

Baffier, D. 1984. Les caractères sexuels secondaires des mammifères dans l'art pariétal paléolithique franco-cantabrique. In: Bandi, H-G., Huber, W., Sauter, M-R. & Sitter, B. (eds) *La Contribution de la Zoologie et de l'Éthologie à l'Interprétation de l'Art des Peuples Chasseurs Préhistoriques*. 143–154. Fribourg: Editions Universitaires.

Bahn, P.G. & Vertut, J. 1998. *Journey Through the Ice Age*. Second edition. London: Weidenfeld & Nicolson.

Bégouën, H. & Breuil, H. 1958. *Les Cavernes du Volp: Trois-Frères – Tuc d'Audoubert, à Montesquieu-Avantès (Ariège)*. Paris: Arts et Métiers Graphiques.

Bégouën, R. 1993. Les animaux composites. In: *GRAPP, L'Art Pariétal Paléolithique: Techniques et Méthodes d'Étude*: 201–205. Paris: Éditions du Comité des Travaux Historiques et Scientifiques.

Bosinski, G. 1990. *Homo Sapiens: l'Histoire des Chasseurs du Paléolithique Supérieur en Europe (40 000–10 000 avant JC)*. Paris: Éditions Errance.

Breuil, H. 1914. Observations sur les masques paléolithiques. *Revue Archéologique* 2: 300–301.

Capitan, L., Breuil, H., Bourrinet, P. & Peyrony, D. 1909. Observations sur un bâton de commandement orné de figures animales et de personnages semi-humains. *Revue de l'École d'Anthropologie de Paris, XIXème année* 2: 62–76.

Chauvet, J-M., Brunel Deschamps, E. & Hillaire, C. 1995. *La Grotte Chauvet à Vallon-Pont-d'Arc*. Paris: Seuil.

Clottes, J. 1989. The identification of human and animal figures in European Palaeolithic art. In: Morphy, H. (ed.) *Animals into Art:* 21–56. London: Unwin Hyman.

Clottes, J. 1993. Les créatures composites anthropomorphes. In: *GRAPP, L'Art Pariétal Paléolithique: Techniques et Méthodes d'Étude*: 87–96. Paris: Éditions du Comité des Travaux Historiques et Scientifiques.

Clottes, J. 1995. *Les Cavernes de Niaux: Art Préhistorique en Ariège*. Paris: Le Seuil.

Clottes, J. & Courtin, J. 1994. *La Grotte Cosquer: Peintures et Gravures de la Caverne Engloutie*. Paris: Le Seuil.

Déonna, W. 1914. Les masques quaternaires. *L'Anthropologie* 25: 107–113.

Gaussen, J. 1964. *La Grotte Ornée de Gabillou (près Mussidan, Dordogne)*. Bordeaux: Imprimerie Delmas. Publications de l'Institut de Préhistoire de l'Université de Bordeaux, Mémoire 3.

Gaussen, J. 1993. Les figurations humaines. In: *GRAPP, L'Art Pariétal Paléolithique: Techniques et Méthodes d'Étude*: 197–199. Paris: Éditions du Comité des Travaux Historiques et Scientifiques.

GRAPP. 1993. *GRAPP, L'Art Pariétal Paléolithique: Techniques et Méthodes d'Étude*. Paris: Éditions du Comité des Travaux Historiques et Scientifiques.

Hahn, J. 1986. *Kraft und Aggression*. Tübingen: Verlag Archaeologica Venatoria.

Le Guillou, Y. 2001. The Pont d'Arc Venus. *INORA* 29: 1–5.

Leroi-Gourhan, A. 1965. *Préhistoire de l'Art Occidental*. Paris: Mazenod.

Pales, L. & Tassin de Saint-Péreuse, M. 1976. *Les Gravures de La Marche II: Les Humains*. Gap: Éditions. Ophrys.

Ripoll Perelló, E. 1971–1972. Una figura de 'hombre-bisonte' de la Cueva del Castillo. *Ampurias* 33/34: 93–110.

Tymula, S. 1995. Figures composites de l'art paléolithique européen. *Paléa* 7: 211–248.

FIGURE 12.1 Entrance to Niaux Cave

12.

Thinking strings:
On theory, shifts and conceptual issues in the study of Palaeolithic art

MARGARET W. CONKEY
(Archaeological Research Facility and Department of Anthropology, University of California, Berkeley, CA, USA)

AFTER A FOUNDING TEXT

In a 1985 article entitled 'Present and Future Directions in the Study of Rock Art', art historian Whitney Davis noted, among other things, that Lewis-Williams' 1981 classic, *Believing and Seeing*, was likely to become regarded as a 'founding text' in what Davis (1985: 5) predicted would be a rock art research that "will advance, after many decades of relative neglect, to the forefront of anthropological and art historical theory." Although Lewis-Williams (1995a) has distanced himself from this founding text, each of us has many observations on his role in and contributions to the achievement of what Davis predicted more than 20 years ago. There are two not unrelated aspects of Lewis-Williams' enormous corpus that are of particular interest and inspiration to me,

as someone who has long focused on the 'art' of the Palaeolithic European world.

On the one hand, there has been his attention to and always eloquent articulation of the issues of theory and epistemology that have provided the veritable bedrock on which 'advance to the forefront' could take place; on the other hand, his engagement – albeit varying – with 'the social' has been a pervasive theme (e.g. Lewis-Williams 1982, 1995a, 1995b, 2000). Furthermore, he sets a model for a self-reflexive commentary on one's own historical intellectual trajectory, which includes (e.g. Lewis-Williams 1995a) recognition of his experimentation over the years with a variety of approaches, from very early structuralist, through somewhat marxist (with a lower-case 'm') – perhaps more accurately, historical materialist (Lewis-Williams 1982) – to more recent recognition and use

(Lewis-Williams 1995a, 1997) of social theory that draws on aspects of agency and praxis.

My original intent in this chapter was to assess the state of social archaeology today, especially in relation to my usual topic of the Palaeolithic of Europe, combining two strands of Lewis-Williams' influence: the explicit engagement with theory and an explicit concern for 'the social'. In some ways, these concerns do not neatly fit the two thematic emphases of this volume, which elaborates on the two approaches to rock art set out by Taçon and Chippindale (1998; see also Chippindale 2001): informed contexts (e.g. the use of and relation to ethnography) and formal methods (for situations lacking direct or relevant ethnographic contexts). However, I would suggest that no formal methods could ever be taken up outside of some informing context, and anyone investigating imagery from an informing context approach must also use some methods or means to link the informing context to the images. Certainly, to take on the cultural production of imagery in a specific historical context (i.e. as in the Palaeolithic of Europe), the so-called formal methods approach must be embedded in some wider interpretive frameworks; frameworks that might structure or inform the very selection of formal methods. This is precisely what Clottes and Lewis-Williams (1996, 2001) would argue they have been doing with their application of a shamanism model to the study and interpretation of some of the Palaeolithic cave art, although their model is, of course, very much dependent upon the informed context of ethnography, an ethnography of hunter-gatherer shamanism.[1] Furthermore, while there is indeed much to be gained from engaging with ethnography, especially the ethnography of visual culture or art, the very anthropology of art has shifted theoretical (and, concomitantly, analytical) gears (see below), which now makes the 'uses' of the ethnographic (informed contexts) something to revisit rather than assume.

My intent in this chapter is not to engage with the theory, methods, or interpretive results of the so-called shamanism (or any other) interpretation of Palaeolithic art, but rather, to cast an interpretive net in a less specified, less ethnographic direction, a net comprised of 'thinking strings', so to speak. The specifics of shamanism, or any other such specified cultural practices, may well fit within this net, but my interests lie in going down three complementary paths:

- to continue an explicit concern with the place of theory in rock art research;
- to review some recent shifts in scholarship associated with the interpretation of the European Palaeolithic imagery, in particular;
- to put forward some 'thinking strings' that may enrich the ways in which we think about both the phenomena of the art and how we might come to better understand it.

For more than 100 years, we have known about the cave painting and material culture elaboration of late Ice Age hunter-gatherers who lived across what is today Europe and onto the Russian Plain. We have long called this phenomenon 'Palaeolithic art'. Over the years, this corpus of painting, engraving, sculpting and carving has been taken as the 'origins of art', associated with what were thought to be some of the earliest established populations of ourselves, anatomically modern humans, *Homo sapiens*. This notion of an original, if not also an inaugural, art has held particular salience in western thought in that it is also a European art. Despite the abundance of prehistoric arts, especially rock art, in many other parts of the world (e.g. Australia, Africa, North America, China) – some of which has been shown to be of considerable antiquity – the Euro-Russian images and visual culture have continued to command an awe and reverence or, as Gell (1998) might say, an enchantment, among the lay public, poets, artists, tourists and scholars.

The images and the very production of such have variously been explained in terms of sympathetic hunting magic; as a 'mythogram' in which the animals and signs being created were the manifestations of a structured world view; as part of the ways in which social alliances and/or social space were maintained; as ways in which a time-factored existence was being marked out; and, most recently, as imagery associated with the visions of shamans. Each of these different interpretations can best be understood in the intellectual climates of opinion that have prevailed (and changed) since the 1879 discovery of the first major cave art site – Altamira (Santander, Spain). But, as I will discuss below, there have been a number of shifts in a variety of fields, over the last decade in particular, as well as shifts in what we might call pattern and evidence, that have simultaneously destabilised the imagery from its positioning as 'the origins of art' and repositioned it as a rich variety of archaeological materials that must

be taken on their own varying historical and contextual terms. While any one of the shifts in scholarship, evidence, and current thought may not be particularly revolutionary, it is a particular convergence of such shifts that forms a new crucible within which we might come to understand this 'Palaeolithic art' and our relationships to it.

ON THEORY AND THEORISING

If left to my own devices, I would straightforwardly advocate and pursue a theoretically explicit social archaeology of prehistoric image-making. In fact, I have been told that what follows here sounds very programmatic and, if so, well, perhaps it is.[2] My intent is not so much to 'show the way', or even show a way. Rather, given the fact that the interpretive field for Palaeolithic art is hardly one of consensus, I believe there is some space, if not some need, for alternative and perhaps complementary frameworks. A theoretically explicit social archaeology of prehistoric image-making entails, first, an assessment of the current state of 'social archaeology' in relation to the Upper Palaeolithic period in Europe, and, second, an elucidation of the frameworks at hand within which the images and objects can be understood for what they were: namely, social and cultural 'facts'; manifestations of meanings, motivations, social roles, social codes and social practices; and media that are drawn upon and deployed in social action (Thomas 1996: 60). Few would disagree that these images and forms and the practices that brought them into being must have had referential contexts; what Hodder (1982) long ago referred to as "the referential context of social action", or what Lewis-Williams (1990) has called "an informing context".

I will not here delve into the history of social archaeology except to note several things. As an explicit concept this has one set of roots in what is called the Anglo-American New (or processual) Archaeology (cf. Trigger 1989; Johnson 1999). The latter was an intellectual movement that developed in the 1960s and that advocated explicit theory and the idea that we could make inferences about past social phenomena based on variability in material culture (for other versions of the history, see Meskell and Preucel [2004]). By the end of the 20th century, the social approach had become quite different and more expansive, given the greater elaboration of social theory, including various forms of practice theory and the more widespread interest in aspects of human agency, which were hardly up for discussion in early social archaeology (see Meskell *et al.* 2001). When it comes to explicitly social interpretations of European Palaeolithic imagery – in caves or mobiliary – almost all of it has been done by Anglo-Americans. Most of these approaches, to varying degrees, have been within a so-called paradigm of adaptationist approaches that stress the way in which the appearance and existence of the imagery were part of cultural adaptations, such as the solving of socio-spatial needs and negotiating information storage and retrieval (e.g. Gamble 1982; Jochim 1983; Mithen 1988; Barton *et al.* 1994).

These Anglo-American social approaches only rarely (but see, for example, Soffer 1997) make linkages to specific images. They primarily appeal to macro social processes (e.g. information storage; social stresses of ecological circumscription), and most often in a functionalist way. In retrospect, while the study of Palaeolithic art from these social perspectives opened up a wider set of interpretive possibilities (beyond being art that was 'magic for the hunt', as religion, etc.), this line of thinking has told us very little that we did not already know anthropologically; namely, that "images have functions or are a well adapted 'solution' to some social 'problem' " (Davis 1985: 8). We are hopefully beyond the initial inspirations of the social archaeology of the 1960s and 1970s, in which images "have only been used as the archaeological evidence for the existence of social phenomena" (Davis 1985: 8) – social phenomena that, while they might have been in doubt many decades ago, are now widely accepted, if not assumed.

Before making some conceptual moves beyond the more adaptationist social archaeology framework (see also Lewis-Williams 1997; Dobres 2001), I want to make two detours: first, a few words about theory; second, a few words about the current state of Palaeolithic art research. Why does there appear to be an avoidance – or attempted avoidance – of theory? This is a much longer discussion than can be pursued here, but, minimally, it is more complicated than the French archaeologist, Anick Coudart, for example, makes it out to be. In her critique of why there is no processualism or post-processualism (what have become two major rubrics or schools in [Anglo-American] archaeological

theory; cf. Johnson 1999) in French archaeology, she terms all theory an "ideological cul-de-sac" (Coudart 1999). Perhaps some French archaeologists share with certain historians a suspicion of theory (or anything that might be called that). There has been some debate (at least in the United States) over "whether it is possible to do history and theory at the same time" (Briggs 2000: 20).

Theory's two main failings have been construed to be, firstly, that "it neglects 'real people' and the 'real experience' in favor of the abstract" and, secondly, "that it draws us away from careful empiricist [i.e. for history] archival work" (Briggs 2000: 20). This is not the place to deal with the issues raised by the first concern (but see again Briggs [2000]), although it is worth noting that one of the strong points of some post-processual archaeology, especially feminist archaeology, is its explicit concern to 'people the past'.

Insofar as the second concern goes, it is not all automatically or necessarily the case that learning, talking or producing theory makes us careless about evidence, and few scholars are too busy doing theory to not find time for careful empirical work. However, figuring out how to write accessible theory is no mean feat, especially if it is also firmly connected to the empirical, the materials, the evidence. To write accessible theory is not only an admirable goal in and of itself; it is "politically essential" (Briggs 2000: 21).

Of course, I cannot here engage with all that could be said about theory in archaeology. We require explicit theory in an archaeology that is increasingly recognised – appropriately – as full of ambiguity, with the hopefully now commonplace notion that all data are theory-laden, given the very underdetermined nature of what we work with, especially if we have anthropological goals. Culler proposes that theory today is a way to challenge and reorient thinking because it can offer novel and persuasive accounts that "make strange the familiar and perhaps persuade readers to conceive of their own thinking and the institutions to which it relates in new ways" (Culler 1994: 13, citing Culler 1992: 203). To 'borrow' theory, he says, is part of its definition; the nature of theory, in Culler's account, is to "undo, through a contesting of postulates and premises, what you thought you knew" (Culler 1994: 15). Furthermore, theory is best considered in terms of its effects, its practical effects: such as what changes people's views, makes them conceive differently of their objects of study/objects of knowledge and their activity of studying. And this will be "different for people differentially situated" (Culler 1994: 16). Thus, theory is inevitably practice and the value of theory "cannot be separated from participation in that activity itself" (Culler 1994: 16).

From this, and following Longino (1994; Wylie 1995), the points of theory would be to inhibit compartmentalisation of knowledge-making, to democratise it, and to encourage it as a pluralistic enterprise, serving divergent goals, engaging dissent seriously, and fostering views from all sorts of vantage points, from 'many wheres'. All of these attributes are components of what Longino (1994) has argued for under the rubric of 'diffusion of power', one of her principles of doing epistemology as a feminist (Wylie 1995). Two other and relevant 'theoretical virtues' that Longino advocates would be, first, the preference for ontological heterogeneity, and second, the complexity of relationship, both of which are directives to "*avoid* themes or research programs which assume that simplicity is a pre-eminent virtue" (Wylie 1995: 352, original emphasis): so much for Occam's razor!

How does all this bear on the interpretation of Palaeolithic art? It has long been the tendency in all of European Palaeolithic archaeology, including the study of Palaeolithic art, to 'freeze' the period (even its chronocultural subdivisions, such as *the* Magdalenian *c.* 15 000–11 000 years ago, the apogee of Palaeolithic art) into static descriptions or characterisations/representations. Although many are quick to say we freeze the past only in order to interpret it (Thomas 1996: 63), nonetheless the effect is that we regularly 'disappear' the complexity and heterogeneity of data, of form, causality, and representation. To detail this for both Palaeolithic archaeology and the study of Palaeolithic art is another and long inquiry, but that it happens cannot be dismissed. Our very maps of 'the' Magdalenian, for example, depict a large geographic expanse across Europe that inhibits any engagement with variations, complexities, or heterogeneities.

In a recent presentation of a pan-European model for how some Palaeolithic peoples obtained their raw materials for stone tools, an otherwise reflexive archaeologist disappointed me terribly. I suggested to him after the talk that he had not said anything at all about the differential distributions of their raw materials (naturally occurring flint), which might have grounded

this macro-scale model. His reply was: "Oh, why ruin such a nice grand pattern with local variations?"

The great irony in the study of Palaeolithic imagery is that, despite its privileged position for so long – as the birth of art – and the central role that it has had in influencing how we (used to) think about the prehistoric arts, it is a field of inquiry that is among the least theorised. There are many who would say that this is because of the antiquity of Palaeolithic imagery; because most of it cannot be dated securely, if at all; because it lacks an ethnographic connection; and/or because we can only know (cf. even Trigger 1991) about the functional, ecological, and external constraints in Palaeolithic life. But these, I would say, are all excuses.

SHIFTS IN AND FOR THE STUDY OF PALAEOLITHIC ART

There is no doubt that the last few decades have been witness to a veritable explosion of fascinating and important empirical work on the imagery and archaeology of Palaeolithic art: [14] Carbon AMS (Accelerator Mass Spectrometry) dating has allowed us not only to obtain the first so-called absolute (preferably called 'chronometric') dates for any Palaeolithic European cave art[3] (see Clottes 1997b; Davidson 1997: 149; Rowe 2001), but also to specify something we had long suspected in many cases, namely that some painted images were accumulated, touched up, and reused (e.g. as is suggested by the span of dates for the Altamira images, from 18 000 to 13 500 years; see Moure 1999). In other instances, the dates challenge or confirm some of the chronological attributions originally made on stylistic grounds. In other cases (e.g. from a painted bull at Lascaux) we have learnt about the touching up of painted images from forensic analyses of pigments and the micromorphology of cave walls and pigment layers. Pigment studies (e.g. Couraud & Leroi-Gourhan 1979; Clottes 1993, 1997a, among many) have clarified procurement loci, and postulated the existence of differing so-called recipes (for mixing binders and extenders), allowing links to be made among different sites where the same 'recipes' were used, even if we don't yet agree on what might account for these 'links'.

Experimental archaeology or replicative studies (e.g. Lorblanchet 1980, 1991) have been suggestive

about how pigments were applied, as well as about how not all cave sites are full of accumulating, reused/touched-up imagery. Some images (e.g. the 'black frieze' in Pech-Merle) appear to have been quickly made and then never revisited. Also, there has been an intensification of what is called the 'archaeology of decorated caves', culminating in the careful attention to human activities in the caves, such as characterises the current research at the Grotte Chauvet (Ardèche, France) (see Clottes 2001): footprints; the deliberate placement of bone fragments into cave crevices or on the cave floor; and the *chaîne opératoire* of how certain images were brought into existence, stroke by stroke.

But the point is that theory-building has not proceeded apace, with the exception of developing the applicability – both theoretically and empirically – of, as mentioned above, a shamanistic model. But it is precisely with all the new empirical work at hand that more theory, especially theory that attends to social contexts and the social embeddedness of image production, is called for. Rather than assuming that such early imagery cannot be explained because it is not possible empirically to substantiate symbol and meaning, it is now possible to use a great deal of excellent empirical work with the images, forms, and contexts, to reconceptualise the imagery as material practices and performances with linkages to social facts and cultural logics, even if, at this point, such facts and logics might still entail a variety of alternatives, of which shamanism may be just one (Layton 2000).

INTELLECTUAL SHIFTS AND NEW PERSPECTIVES

As pointed out above, there are a number of intellectual shifts or developments that, when taken together, form a new crucible within which we might come to better understand this Palaeolithic art and our relationship to it. A simplistic list of such shifts would include the following:

1 It has now been advanced that there is 'early art' in locales other than the heartland of Euro-Russia (e.g. in Australia). It is therefore no longer a radical move to question the privileged status of the Euro-Russian imagery and materials as *the* origins of art (and this is despite the early dates on such cave

imagery as at Chauvet, at 32 000 years ago or more). What is implicated, in part, is to problematise that which has been a necessity in both archaeology and art history, namely an absolutely inaugural artwork standing at the beginning of art history and at the beginning of the successes of modern humans (Whitney Davis pers. comm. 1998).

2 But these anatomically modern humans (*Homo sapiens*) are now very late in appearing in southwest Europe instead of originating there. New evidence shows that modern humans have been in Africa for more than 100 000 years and in Europe only 35 000–40 000+, and perhaps in Australia even before they were in France. And some of these earlier, presumably modern, humans were 'doing things' with material culture, such as incising ochre. This suggests different ways of being in the world, socially and materially, than we had previously thought at such times and in non-European places (e.g. Henshilwood *et al.* 2002).

These first two shifts of evidence and pattern mandate a much more historical and contextual understanding – drawing directly on an archaeology of 'art' – of why and how visual culture(s), over some 20 000 years or more, was (were) developed and differentially elaborated in Euro-Russia, at these particular times, in the particular locales, forms and associated practices. I would like to think that the long-lingering 'vitalistic' notion that we 'get' art with modern humans has got to slink away and be overcome by a barrage of questions about contexts and histories.

3 The very notion of 'art' is now understood differently by anthropologists (e.g. Errington 1998; Gell 1998; Phillips & Steiner 1999). There has been a revitalisation of interest in the material world studied by anthropologists and the so-called anthropology of art is now simultaneously more complicated and exciting. While archaeology's use of 'art' – through its styles and form – has tended towards viewing (art) objects as absolutes of human experience (e.g. as magic, as fertility), the new directions provide theoretical and empirical inspiration for a view of artworks and artefacts as evolving and multivalent phenomena without essential properties (e.g. Pinney & Thomas 2001; Weiner 2001).

The so-called anthropological approach to art has moved away from the prevailing combination

of viewing it "in an aesthetic awe [that borders on the religious]" (Murray 1991), and ethnocentrically, both in identification and judgement. How and why people value 'things' and the anthropology of cultural representations or material culture have been central to turn-of-the-millennium anthropology. Studies have proliferated that show how cultural representations are themselves crucial to the articulation of debates on gender, power relations, colonialism, exchange, possession, consumption, tourism, perceptual knowledge, landscape and more (after Townsend-Gault 1998).

4 Over this same period of the past 15 or more years, both art history and archaeology have undergone transformations that have repositioned each in more mutually influential ways: art history has taken seriously the idea that artworks and images are socially made and distributed things; some archaeologists have come to approach artefacts as 'texts' or as meaningful representations more so than as mere measures or reflections of past essences. Both fields have come to take the prehistoric arts more seriously, and any consideration of the conceptual frameworks for understanding the Palaeolithic arts must now engage with these new directions.

5 Archaeology itself has, in part, allowed itself to be influenced by recent developments in literary theory and interpretive perspectives, while maintaining a keen appreciation for its strengths as a forensic inquiry. As noted, we have generated a wealth of insights into the 'making' of imagery, a 'making' that itself can be understood as one facet of 'meaning'.

To a certain extent, if one takes the above mandate – to treat the imagery as material practices and performances with linkages to social facts and cultural logics – to its logical extensions, this actually calls for a new Palaeolithic archaeology, since there is not an extant body of findings that addresses such notions as the 'social facts' and/or 'cultural logics' of the Upper Palaeolithic. Thus, a call for a new Palaeolithic archaeology – which is now dominated by inquiries based on specific archaeological sites, which now emphasises technology, food-getting, and functional approaches (even to the art) – is a major task. This is a field that prides itself on its empiricism, and even on not being able to say very much. Palaeolithic archaeology is a field that is marked by a complicity that often allows the limits of evidence to define the limits of past

experience, and it is a field that, even in the minds of some of archaeology's smarter thinkers (e.g. Trigger 1991, 1995), is frustrated by this being 'deep time' and a 'deep past' that is cut off from the ethnohistoric or ethnographic handholds so crucial to the archaeology of other periods and places. Trigger says quite explicitly that "without a substantial direct historical approach or immediately relevant non-archaeological forms of data, we can scarcely hope to learn more about the meaning of Palaeolithic Western European cave paintings than can be learned about hunter-gatherer art in general" (1995: 445).

Is it really the case that what we are trying to find out in our inquiries is *the* meaning – in this case, of Palaeolithic cave paintings? Is the meaning – especially of thousands of images and forms that appear to have been produced over a 25 000-year period (or about 1250 generations) – the next question after grasping something from the study of external constraints (such as resources, climate, demographics)? On the one hand, given the recognition of the unstable and mutable nature of 'meaning', especially in the world of symbolic and visual culture, it is unlikely that there will be some sort of even semi-definitive meaning, even with available non-archaeological data, and informing contexts.

But, on the other hand, and more importantly, part of what the so-called post-processualist critique (in contemporary archaeology) calls for is more engagement with the ways in which humans produce and reproduce a meaningful world, with attention to the ways in which the material world only partially known to archaeologists is part of the historical practices whereby this takes place. Thus, while we may never know *the* meaning of the cave paintings, we nonetheless should not be constrained from pursuing an inquiry into the ways in which the archaeological remains of a rich and diverse material and visual culture may have been meaningful to the peoples of the Upper Palaeolithic. In this, we are not limited to the eco-techno-economic universalising generalisations of the middle-range research option, which may be necessary but insufficient/incomplete components.

Furthermore, what do we want to do with the kinds of research we undertake? Do we really want to – in some definitive, perhaps positivist sort of way – somehow close off the case at hand, nail down the meaning of Palaeolithic cave art? To me, the value of

an archaeology of the 'deep past' is more to open up than to be both limited and limiting. I take seriously the suggestion of Lock (1994) – in his critique of the use of semiotic approaches to cave/rock art, which often engage with trying to universalise – that we need to at least be open "to the position that there is no such thing as 'humanity' or 'human experience', and that these are merely imperialist constructs" (1994: 406).

THINKING STRINGS: Some different conceptual directions

In which directions, then, could our thinking usefully move?

Imagery and the elaboration of 'public time'

Despite what may appear to be a pessimism over the (limited) state of Palaeolithic archaeology, there are some hopeful signs. Firstly, there are a number of socially oriented studies of individual materials (e.g. Dobres [1995] on bone technologies, and even on some of the art [Dobres 2001]; or Soffer *et al.* [2000] on nets and net-making, which includes a closer and deserved scrutiny of the so-called Venus [female] figurines, emphasising the variations rather than the figurines-as-essences). Secondly, there is Gamble's (1999) (award-winning) book that brings together such concepts as the *chaîne opératoire* (or operational chain of artefact manufacture); Ingold's (1993: 162) notion of a 'taskscape'; and Gosden's (1994: 182) notion of 'landscapes of habit', in order to take the same overwhelming amount of Palaeolithic archaeological data and show how social inferences about networks, for example, can be made. Unfortunately, Gamble's book only goes up to 21 000 years ago, leaving the later Upper Palaeolithic to a subsequent book. Overall, there is not much attention to the specificities of cave 'art' (and most of the mobiliary art is after 21 000 years ago) and how they are linked to and enacted by the social models proposed. Nonetheless, this is a landmark contribution and a valiant attempt at 'making social' our accounts of the Palaeolithic. In this section, I will lay out two complementary directions, primarily in order to generate discussion, evaluation, commentary and critique: first, an approach, as advocated by Gosden (e.g. 1994: 182–186); and second,

one inspired by a second look at the field of semiotics, or the so-called science of signs.

Gosden (1994) has a much more ambitious project than to account for or understand the emergence and contexts of Palaeolithic art, but his theme (and book), *Social Being and Time,* has some general and some specific relevance to our concerns. To Gosden, the appearance of new tool types, an expanded range in the use of materials, cave and portable art – archaeological attributes of the Upper Palaeolithic in Europe – are not (merely) "evidence of new forms of social relations but a dual emergence of new forms of habit together with a more developed sense of public time" (1994: 183). His term 'public time' is derived from this concept as developed by Ricœur and Heidegger; from such notions that our understanding derives from our practice. Put simplistically, public time is the "conscious use and manipulation of materials, spaces, and times" (Gosden 1994: 125). As an example, Gosden (1994: 87–100) argues that the orchestrated spaces created by (megalithic) monuments were an attempt to give manageable dimensions to the expansive world of the Neolithic and the early Bronze Age. He makes the case that public time "derives from and draws its power out of the structure of habitual times" (1994: 125).

Gosden urges us to contextualise the cave and portable art in the mundane world of techniques, habits, and practices (see Conkey 1993; Dobres 2001) – that is, to situate the image-making in worlds of "increased structures of anticipation involved in daily action, creating new forms of time" (Gosden 1994: 184). He suggests a fundamental shift in human affairs after 40 000 years ago in this particular geographic locale, a shift that arose through the juxtaposition of habit and public time. What needs to be worked out here is how 'public time' arises from the newly elongated chains of habitual action, and Gamble (1999) addresses some of this explicitly in both his modelling and in his analyses of archaeological evidence.

Gosden does not, however, situate this 'shift in human affairs' in any relation (causal, associative, or none at all) to the probable co-residence of anatomically modern humans (*Homo sapiens*) and Neanderthals in this same region at about 40 000–30 000 years ago, an issue well worth pursuing (e.g. Lewis-Williams 2002); nor does he really account for how or why the shift might have taken place. Gamble, on the other hand, is quite explicit as to the idea that

the so-called shift in human affairs was "about the emergence of individuals as creative agents beyond the limitations set by the rules of co-presence" (1999: 269) and that it is this development – the social, technical and cultural "separation of the gesture from the body" – that was transpiring in the shift that we call the Middle-to-Upper Palaeolithic transition. Could this shift or transition have been the crucible within which emerged the performance and production of the imagery and forms that we call Palaeolithic art?

It is worth quoting at length from Gosden to convey his approach, as well as to expose it to some critique or questions:

> the new complexity of group forms also set up a series of clashes in time and space, which needed resolving through the most remarked upon elements of Upper Palaeolithic life: cave art and mobiliary art ... These form the first real archaeological evidence of public time; that is, attempts to deliberately manipulate people and the world. These new coping mechanisms entered into the habitual forms of life and their enduring nature [enduring even into the present!] became part of the ways in which wider-ranging and longer-lasting forms of group life were created. But public time also created a new set of forms of power manipulation, and the conscious manipulation of human and material relations created a new dynamic ... The dual dynamics of habit and public time ... blend and clash ... (Gosden 1994: 184)

Let me add quickly that despite Gosden's (and most everyone else's) pointing to the cave and mobiliary imagery as being the "most remarked upon" aspect of the Upper Palaeolithic in Europe, this should not be taken (as is usually the case) to draw particular attention to the images as *a priori* more important and interesting because they are 'artistic' (and somehow, as Davis [1985: 6] notes, "more developed, subtle, or intrinsically complex than tools or other social, public behaviors"). To do so, to insist on:

> the unique qualities of an art-object or the mysterious 'creativity' of certain activities has become a means of reinforcing certain ideologies of human

nature (Stoliar 1977; Preziosi 1982; Conkey 1983) and especially of bringing alien cultural practices into line with our own sensibilities, preferences and psychology of art (Davis 1985: 6–7).

This is all the more reason, I would argue, why an understanding of the images we call 'Palaeolithic art' is simultaneously a study of the entire material repertoire – from hearths and spatial structures, through local and regional distributions of archaeological materials across landscapes, to the in-depth analyses of (all sorts of) raw material procurement, engraving techniques on bone/antler and the like. By taking up a conceptual framework that seeks to investigate the specifics of not just the emergence – or at least the expansion – of 'public time', but also of its juxtaposition with, if not embeddedness within, the 'dynamics of habit', we have a different starting point, and we see that an understanding of the visual culture of Upper Palaeolithic Europe is not an 'art' question, but an archaeological one – in both the traditional sense (as a disciplinary practice that works with empirical evidences) and in the sense suggested by Foucault (1972), which is a genealogical sense: how did this come to be?[4]

It is a particularly propitious moment at which to promote such a conceptual framework: the studies that can be drawn upon to specify the 'dynamics of habit' are multiple and increasing, but not yet brought together under a more unified conceptual approach that is more explicitly social (and practice/agency focused) than the *techniques et culture/chaîne opératoire* approaches that underlie many of the studies. Even the much contested interpretation of the imagery as shamanistic can be evaluated within this approach. While the proponents of this latter interpretation have made a good case that shamanism is a plausible way to comprehend some of the images, and their placements and attributes, I, for one, need to understand the particular historical crucibles within which such social and ritual practices that go under the (wide) rubric of shamanism could have emerged. But this is another and much longer story. I am not fully satisfied with an appeal to the 'universality' of shamanism in hunter-gatherer societies, nor to the 'universality' of the images said to be seen if in an altered state of consciousness. As the proponents themselves recognise (e.g. Lewis-Williams 1997), image-making is a social activity, and the images/objects take on meanings through the social uses made of them. With Palaeolithic art, we have specific forms and images that can be seen as a special kind of discourse about aesthetic and symbolic practice that emerged only in certain social contexts, not as something that would emerge naturally or eventually in the course of human evolution, and not something that is merely part of how and why there was a successful 'population replacement' (of Neanderthals by the moderns). How can we probe and thus expand upon our understandings of those social contexts? This is one major set of research questions to pursue.

Imagery and the semiotic advantage

Semiotics, or the science of signs, has been implicated in interpretations of Palaeolithic art ever since the so-called structuralist break-out of the 1960s, when Leroi-Gourhan implicitly drew upon the assumptions of structuralist thought (Conkey 1989, 2001a). This, in turn, generated his proposal for an underlying 'mythogram'. As he explicated in some of his later publications (Leroi-Gourhan 1986), he viewed the cave as-container, as-text. Leroi-Gourhan was explicitly engaging with issues of signification and the structures of cultural elements, although he never once indicated that he thought we could know the specific meanings or significations of the imagery. While cave art may not be thought of as a system of signs, semiotic assumptions meant that one could now treat it as such. Thus, attempts at reading the signification (of the imagery in/on the rock) were possible.[5]

This is not the place to expand upon the domain of thinking known as semiotics (see for example Hawkes [1977] for one summary), which has long been considered one of the most fruitful concepts deriving from structuralist approaches. While there has never been a universally accepted theory of semiotics, there are many important, varied, and useful approaches under this rubric (e.g. Barthes 1972; Eco 1976) in addition to those considered foundational (the work of De Saussure, R. Jakobsen, and/or Charles S. Peirce). Kristeva (1973: 1249) says:

> What semiotics has discovered … is that the … major constraint affecting any social practice lies in the fact that it signifies (i.e. that it is articulated like a language).

I have elsewhere (Conkey 2001b) suggested that there are some useful aspects of some semiotic perspectives for how to think about what the cultural effects might have been of the production of images by Upper Palaeolithic peoples. In taking a view that cultural practices – such as painting (what appears to us to be) a horse – are recursive and 'feed back' into, or even constitute, the social and cultural contexts from which they derive, it is as important to consider the effects of the image-making as the motivations. True, most adaptationist accounts for the art have looked at effects, but at a more macro scale and long-term effects, and in usually quite functionalist, post-hoc accommodative ways: the cave art served to establish socio-spatial boundaries; the art communicated important information for initiation rites; the art signalled group identity and fostered (ecologically needed) alliances; and so forth.

However, what I find provocative in semiotics is a particular concept elaborated by Peirce, called 'unlimited semiosis'. Given that there is, in Palaeolithic art, some aesthetic (in the broadest sense of the concept) use of imagery, forms, shapes and marks, signifiers manifest a high degree of plurality, that is, of ambiguity. As Eco (1976: 262) points out: "semiotically speaking, ambiguity must be defined as a mode of violating the rules of the code." The images, which we call 'art', we now know (even from the most rudimentary kinds of structural analyses) are not haphazard. The 'art' is a way of connecting messages together, in order to produce texts in which the rule-breaking roles of ambiguity and self-reference are fostered and organised. The effect (whether viewed by a few or by many) is to create or generate, semiotically speaking, a kind of special language, specific to the so-called work of art, and this induces something that has been called 'cosmicity' (Hawkes 1977: 141) – that is, endlessly moving beyond each established level of meaning the moment it is established; a sense of continuously transforming its denotations into new connotations (cf. Barthes's [1972: 109–159] account of myths). One need not accept the language-like terminology here (messages, texts, language) to appreciate this process.

From Eco's elaboration of the Peircean notion of unlimited semiosis, we get the notion that the (aesthetic) message integral to image-making works:

as a continuing 'multi-order' system of signification which moves from level to level, its denotations becoming connotations in a kind of infinite progression. As a result, we never arrive at a 'final' decoding or 'reading' because each ambiguity generates further cognate 'rule-breaking' at other levels, and invites us to continuously dismantle and reassemble what the imagery seems at any point to be 'saying' (Hawkes 1977: 142).

Although I now stray somewhat from my primary line of discussion, it is relevant to point out that Eco has clarified that "the notion of unlimited semiosis does not lead to the conclusion that interpretation has no criteria. To say that interpretation (as the basic feature of semiosis) is potentially unlimited does not mean that interpretation has no object and that it 'riverruns' for the mere sake of itself" (Eco 1990: 6; see also Eco *et al.* 1992). In other words, not all interpretations are authorised; there are, in fact, limits to interpretation. Those readings that are not authorised can be called over-interpretations and Eco proposes that it is possible to prove that some meanings are over-interpretations even if one does not know which is the 'right' interpretation. This entire topic of 'the limits of interpretation' is well worth a much longer discussion, as Layton and Díaz-Andreu (1999) have suggested specifically for rock art research.

What most people want to know when it comes to Palaeolithic art is, what does it mean, is this the 'first art', and why did people start making 'art'? The questions are about the cultural and evolutionary significances of early art. What these semiotic perspectives lead to is the idea that the signs-symbols-icons that we call 'Palaeolithic art' not only elicit(s) feelings but also produce(s) further knowledge (Eco 1976: 274); they do not merely reflect but also galvanise meaning (Bryson 1983). The so-called reader of the visual imagery (to borrow again from Barthes [1972]) not only begins to 'see the world' differently but learns how to create a new world. This semiotic perspective reinforces the recognition (and all of its implications for social, cognitive, evolutionary and semantic interpretation) that the image-making that we call 'Palaeolithic art' is not the "mere 'embroidery' of reality, but a way of knowing it, of coping with it, and of (potentially) changing it" (Hawkes 1977:

143). Or, as Davis (e.g. 1984: 7) has pointed out, "graphic representation is a mode of knowledge", and representation is the "material site of one's thought about one's knowledge of the world".

I am not saying that the material and – fortunately for us – preserved imagery of Upper Palaeolithic Europe is the first/'earliest' evidence for this kind of semantic displacement and multi-order signification. I *am* saying that what we can be sure of – if not the specific meanings of a cave art scene or image – is that this imagery is *not* a mere recording of a static reality (whatever that is). It is a semiotic process that is producing (new) knowledge, a re-inscription of a multiplicity of meanings and their further semantic transformation that can potentially expand/ramify into new understandings and elaborated knowledge. This is not the same as saying – as has been said in functionalist terms – that the Upper Palaeolithic is a time when human (i.e. anatomically modern human) success is, in large part, due to success at storing and transferring more information (in some encyclopaedic sense) (cf. Pfeiffer 1979; Gamble 1982; Mithen 1988, 1996; Barton *et al.* 1994) using 'new' media – such things as painted cave walls, perforated objects or ornamentation and the like. As Gamble suggests (1999: 363–364), furthermore, it cannot be just a matter of more information; it has to be more a matter of 'chunking' it. What we see is, semiotically speaking, a breaking of the rules of signification – a painted horse is not/no longer (just) a horse – and in ways that produce ambiguous, multiple significations that do not 'fix' meaning, but galvanise it; that do not record knowledge but produce further knowledge. It is the embodiment of this knowledge at the level of both the individual and the social group that, one might say, mobilised a semiotic advantage for these human groups; mobilising 'public time'.

Maybe this is not saying anything new, but saying it somewhat differently. If we take the idea that the making of 'art' produces new/further knowledge, this can inform our understanding of the significance of the phenomenon of Palaeolithic art in the big picture of human evolution. The argument is no longer so simple. We are prone, from our privileged vantage point, to point to this time and place, and pronounce them 'fully modern humans', 'a slice of the ethnographic record', 'the way we were' – because they produced (achieved?) what we call 'art', images that

conveniently cohere with our own aesthetic sensibilities, and in media (especially painting which, at least in late 19th-century Europe, was considered a pinnacle of what it meant to be 'artistic') that we also value. The 'unlimited semiosis' approach would shift this assessment and understanding: what this visual culture attests is how, in one particular historical context, some people of the past sustained their own 'humanity' by engaging in a socially practised context of generating new and further knowledge. And this would be a more substantive way of enacting what Gosden calls "public time" and what Gamble (1998) calls "the release from proximity", the "stretching of social relations across time and space". And this provides one of the core accounts as to why a framework for trying to think about Palaeolithic art is necessarily one of social action.

ARE THERE 'CONCLUSIONS'?

To take up a consideration of the interpretations and the ontological, epistemological and historical aspects of the phenomenon of Palaeolithic art would be an enormous task. The images have played such a varied and yet crucial role in the constructions of prehistory, a prehistory that has as much to do with our preconditioned imaginations (after Stoczkowski 1994; see also Moser 1998) as with the specific evidence at hand, even after several centuries of research. There is much more to be said (e.g. Moro 2006) about the intellectual histories that have, nonetheless, generated a legacy of ideas, concepts and understandings that are hard to see through, hard to set aside. We have not really done all, or much, of the critical archaeology of that knowledge.

However, I have tried here to do a few things: first, to engage somewhat with the concept of theory and its weak 'signature' in the study of Palaeolithic art and its problematic assumptions in Palaeolithic archaeology more widely; second, to review some recent shifts in scholarship associated with the contexts and therefore the interpretations of European Palaeolithic imagery, even if this chapter is not the place to develop or expand upon such shifts; and third, to put forward some 'thinking strings' to enrich or perhaps expand the conceptual 'nets' within which we grapple with Palaeolithic arts. How do we develop that 'perspectival suppleness' so that we can best 'think

ourselves into another world', which Daston (M.T. 1993) has advocated? First, there is still an enormous amount of 'archaeological' work to be done with concepts – such as art, image, public time, shamanism, informing context, and the like – and with the intellectual history of how we have constructed certain narratives and how we have constructed 'the evidence' and all too often settled for equating the limits of evidence with the limits of (past) experience.

At a specific research design level, what I am arguing for is more work on a social approach, which would involve something different than the adaptationist macro social models, models that focus on institutions and structures more than on individuals and social agency. From a wider theoretical context that draws on aspects of contemporary social theory, one way we might move at this point is to 'break and enter', so to speak, the rather bloc-like characterisations that have prevailed for Palaeolithic art: two categories of images (wall/portable); two foci of subject matter (animals/signs); specification of so-called regional traditions, such as 'the prehistoric art of the Pyrénées'. Furthermore, the theoretical framework calls for a simultaneous engagement with and attention to both the 'dynamics of habit' and all that might go under the rubric of 'public time'; it calls for a more integrated and interrelated theoretical matrix for a full archaeology of image-making. It means, in fact, a revised version of Palaeolithic archaeology, what Gamble refers to as "pulling aside the Palaeolithic curtain" (1999: 31).

Metaphorically, for an archaeology of the 'deep past', when we are tempted to lean heavily on 'universals' that may be as much a hindrance as a help, we should confront the notion that we are dealing more with palimpsests than with individual slices of time or snapshots of evidence and pattern. Whitney Davis (1997) suggests that in trying to 'read' the prehistoric images that are often quite literally superimposed, we cannot turn the pages one by one to read each page, but "must try to read all the pages all at once". Because the past can be thought of as a palimpsest, metaphorically, "the narrative [of the past] comes toward us in the place where we stand, rather than allowing us (or forcing us) to scan different places and different times as if created in an array". Perhaps, Davis suggests, we can extricate detached segments if we take different vantage points, or perhaps we can use different approaches, different metaphorical effects to illuminate the different patches of the palimpsest at different times, much in the way we suppose that the stone lamps held by makers and viewers at places such as Lascaux lit up just a part of the image array at a time. As such, the palimpsest metaphor, says Davis, is "equally a metaphor for coherent integration of an organic sort" – with traces of the past embedded in subsequent transformations – and "[a metaphor] for disjunction, contradiction and frustration", aspects of our work which we do not discuss enough.

Readers may find it frustrating indeed that this chapter does not end with much insight into the meaning(s) of Palaeolithic art, but I hope I have expanded upon the ways in which the imagery might have been meaningful, and stimulated further discussion of how we might assemble a veritable social archaeology of Palaeolithic art.

Notes

1 As is well known, this ethnography (and, therefore, the 'applicability' of the model) has been hotly contested (e.g. DeMoule 1997; Hamayon 1997; Clottes & Lewis-Williams 2001), although the debates have also been taken up in a productive (e.g. Layton 2000) review of how to think about ethnography and the interpretation of rock art.

2 I am grateful to the participants in two conferences for comments on much of this chapter. Although the attendees at the festschrift conference for David Lewis-Williams, from which the other chapters in this volume derive, were more lukewarm about my ideas – ideas that stray from both the ethnographic focus and perhaps even the shamanism focus of most other participants – they nonetheless drew my attention to some important issues that I have tried to address in this revised version. And I am extremely grateful for the opportunity to attend this celebratory conference. The participants at 'Origins', The Summer Academy of the Max Planck Institut für Wissenschaftsgeschicte (Berlin 2001), mostly historians of science, were much more supportive, but also heard and read (a considerably different version of) the chapter as a programmatic one. It is with their encouragement and insights, for which I am grateful, that I have not retreated as much as I might have from my original position on some of these ideas.

3 Because one needs only very minute samples when organics are present in the pigments.

4 Increasingly, these may also be attributes of much earlier and elsewhere (e.g. southern Africa) archaeological contexts, especially the 'expanded range of use of materials' (cf. Henshilwood *et al.* 2002). To me, this does not invalidate thinking about 'public time' among Euro-Russian Upper Palaeolithic peoples, but rather, suggests that it may be a concept of use in trying to understand the so-called behavioural shifts (usually glossed as 'modern behaviours') that were 'at work' elsewhere and perhaps much earlier.

5 It has become more widely recognised that Leroi-Gourhan was influenced quite directly by Annette Laming-Emperaire (1962) and by Max Raphael (e.g. 1945), the latter of whom one scholar of his works calls "a 'pioneer' of the semiotic approach to paleolithic art" (Chesney 1994).

References

Barthes, R. 1972. *Mythologies*. London: Cape.

Barton, C.M., Clark, G.A. & Cohen, A. 1994. Art as information: explaining Upper Palaeolithic art in Western Europe. *World Archaeology* 26(2): 185–207.

Briggs, L. 2000. In contested territory: review of E. Perez, The decolonial imaginary: Writing Chicanas into history. *Women's Review of Books* 17(6): 20–21.

Bryson, N. 1983. *Vision and Painting: The Logic of the Gaze.* New Haven (CT): Yale University Press.

Chesney, S. 1994. Max Raphael (1889–1952): a pioneer of the semiotic approach to Palaeolithic art. *Semiotica* 100(2/4): 109–124.

Chippindale, C. 2001. Theory and meaning of prehistoric European rock art: 'informed methods', 'formal methods' and questions of uniformitarianism. In: Helskog, K. (ed.) *Theoretical Perspectives in Rock Art Research: Alta II Conference Proceedings*: 73–104. Oslo: Novus.

Clottes, J. 1993. Paint analyses from several Magdalenian caves in the Ariège region of France. *Journal of Archaeological Science* 20: 223–235.

Clottes, J. 1997a. New laboratory techniques and their impact on Paleolithic cave art. In: Conkey, M.W., Soffer, O., Stratmann, D. & Jablonski, N. (eds) *Beyond Art: Pleistocene Image and Symbol*: 37–52. San Francisco (CA): California Academy of Sciences, Memoir 23.

Clottes, J. 1997b. Art of the light and art of the depths. In: Conkey, M.W., Soffer, O., Stratmann, D. & Jablonski, N. (eds) *Beyond Art: Pleistocene Image and Symbol*: 203–216. San Francisco (CA): California Academy of Sciences, Memoir 23.

Clottes, J. 2001. *La Grotte Chauvet: l'Art des Origines*. Paris: Le Seuil.

Clottes, J. & Lewis-Williams, J.D. 1996. *Les Chamanes de la Préhistoire: Transe et Magie dans les Grottes Ornées*. Paris: Le Seuil.

Clottes, J. & Lewis-Williams, J.D. 2001. *Les Chamanes de la Préhistoire: Texte Intègral, Polémique et Réponses*. Paris: La Maison des Roches.

Conkey, M.W. 1983. On the origins of Paleolithic art: a review and some critical thoughts. In: Trinkaus, E. (ed.) *The Mousterian Legacy: Human Biocultural Change in the Upper Pleistocene*: 201–227. Oxford: British Archaeological Reports International Series 164.

Conkey, M.W. 1989. The structural analysis of Paleolithic art. In: Lamberg-Karlovsky, C.C. (ed.) *Archaeological Thought in America*: 135–154. Cambridge: Cambridge University Press.

Conkey, M.W. 1993. Humans as materialists and symbolists: image making in the Upper Paleolithic. In: Rasmussen, D.T. (ed.) *The Origin of Humans and Humanness*: 95–118. Boston (MA): Jones and Bartlett.

Conkey, M.W. 2001a. Structural and semiotic approaches. In: Whitley, D. (ed.) *Handbook of Rock Art Research*: 273–310. Walnut Creek (CA): AltaMira.

Conkey, M.W. 2001b. Semiotics and the study of rock art. Unpublished paper presented at the Annual Meetings of the Society for American Archaeology, April, New Orleans (LA).

Coudart, A. 1999. Is post-processualism bound to happen everywhere? The French case. *Antiquity* 73: 161–167.

Couraud, C. & Leroi-Gourhan, A. 1979. Les Colorants. In: Leroi-Gourhan, A. & Allain, J. (eds.) *Lascaux Inconnu*: 153–170. Paris: CNRS, Gallia Préhistoire, XIIe Supplément.

Culler, J. 1992. Literary theory. In: Garibaldi, J. (ed.) *Introduction to Scholarship in Modern Languages and Literatures*: 201–235. New York (NY): Modern Language Association.

Culler, J. 1994. Introduction: what's the point? In: Bal, M. & Boer, I. (eds) *The Point of Theory: Practices of Cultural Analysis*: 13–17. Amsterdam: Amsterdam University Press.

Davidson, I. 1997. The power of pictures. In: Conkey, M.W., Soffer, O., Stratmann, D. & Jablonski, N. (eds) *Beyond Art: Pleistocene Image and Symbol*: 125–160. San Francisco (CA): California Academy of Sciences, Memoir 23.

Davis, W. 1984. Representation and knowledge in the prehistoric rock art of Africa. *African Archaeological Review* 2: 7–35.

Davis, W. 1985. Present and future directions in the study of rock art. *South African Archaeological Bulletin* 40: 5–10.

Davis, W. 1997. Prehistoric palimpsests. Unpublished lecture presented at the National Gallery of Art, May, Washington (DC).

DeMoule, J-P. 1997. Images préhistoriques, rêves de préhistoriens. *Critiques* 606: 853–870.

Dobres, M-A. 1995. Gender and prehistoric technology: on the social agency of technical strategies. *World Archaeology* 27(1): 25–49.

Dobres, M-A. 2001. Meaning in the making: agency and the social embodiment of technology and art. In: Schiffer, M.B. (ed.) *Explorations in the Anthropology of Technology*: 47–7. Albuquerque (NM): University of New Mexico Press.

Eco, U. 1976. *A Theory of Semiotics*. Bloomington (IN): Indiana University Press.

Eco, U. 1990. *The Limits of Interpretation*. Bloomington (IN): Indiana University Press.

Eco, U., Rorty, R., Culler, J. & Brooke-Rose, C. 1992. *Interpretation and Overinterpretation* (edited by Stefan Collini). Cambridge: Cambridge University Press.

Errington, S. 1998. *The Death of Authentic Primitive Art and Other Tales of Progress*. Berkeley (CA): University of California Press.

Foucault, M. 1972. *The Archaeology of Knowledge*. New York (NY): Pantheon.

Gamble, C. 1982. Interaction and alliance in Palaeolithic society. *Man* (NS) 17(1): 92–107.`

Gamble, C. 1998. Palaeolithic society and the release from proximity: a network approach to intimate relations. *World Archaeology* 29: 426–449.

Gamble, C. 1999. *The Palaeolithic Societies of Europe*. Cam - bridge: Cambridge University Press.

Gell, A. 1998. *Art and Agency: An Anthropological Theory*. New York (NY): Oxford University Press.

Gosden, C. 1994. *Social Being and Time*. Oxford: Blackwell.

Hamayon, R. 1997. La transe d'un préhistorien: au propos du livre de J. Clottes et D. Lewis-Williams. *Les Nouvelles d'Archéologie* 67: 65–67.

Hawkes, T. 1977 *Structuralism and Semiotics*. Berkeley (CA): University of California Press.

Henshilwood, C.S., d'Errico, F., Yates, R., Jacobs, Z., Tribolo, C., Duller, G.A.T., Mercier, N., Sealy, J.C., Valladas, H., Watts, I. & Wintle, A.G. 2002. Emergence of modern human behavior: Middle Stone Age engravings from South Africa. *Science* 295: 1278–1280.

Hodder, I. 1982. Theoretical archaeology: a reactionary view. In: Hodder, I. (ed.) *Structural and Symbolic Archaeology*. 1–16. Cambridge: Cambridge University Press.

Ingold, T. 1993. The temporality of the landscape. *World Archaeology* 25: 152–173.

Jochim, M. 1983. Palaeolithic cave art in ecological perspective. In: Bailey, G. (ed.) *Hunter-gatherer Economy in Prehistory: A European Perspective*: 212–219. Cambridge: Cambridge University Press.

Johnson, M. 1999. *Archaeological Theory: An Introduction*. Oxford: Blackwell.

Kristeva, J. 1973. The system and the speaking subject. *Times Literary Supplement* (12 October): 1249.

Laming-Emperaire, A. 1962. *La Signification de l'Art Rupestre*. Paris: Picard.

Layton, R. 2000. Shamanism, totemism, and rock art: 'Les Chamanes de la préhistoire' in the context of rock art research. *Cambridge Archaeological Journal* 10(1): 169–186.

Layton, R. & Díaz-Andreu, M. 1999. Echos from Eco: authorising readings of art in the past. Unpublished symposium organised for World Archaeological Congress 4, University of Cape Town, South Africa.

Leroi-Gourhan, A. & Michelson, A. 1986. The religion of the caves: magic or metaphysics *October* 37: 5–17.

Lewis-Williams, J.D. 1981. *Believing and Seeing: Symbolic Meaning in Southern San Rock Paintings*. London: Academic Press.

Lewis-Williams, J.D. 1982. The economic and social context of southern San rock art. *Current Anthropology* 23(4): 429–449.

Lewis-Williams, J.D. 1990. Documentation, analysis, and interpretation: dilemmas in rock art research: a review of 'The rock paintings of the Upper Brandberg. Part I: Amis Gorge', by H. Pager (1989). *South African Archaeological Bulletin* 45: 126–136.

Lewis-Williams, J.D. 1995a. Perspectives and traditions in southern African rock art research. In: Helskog, K. & Olsen, B. (eds) *Perceiving Rock Art: Social and Political Perspectives*: 65–86. Oslo: Instituttet for Sammenlignende Kulturforskning.

Lewis-Williams, J.D. 1995b. Some aspects of rock art research in the politics of present-day South Africa. In: Helskog, K.

& Olsen, B. (eds) *Perceiving Rock Art: Social and Political Perspectives*. 317–337. Oslo: Instituttet for Sammenlignende Kulturforskning.

Lewis-Williams, J.D. 1997. Agency, art and altered consciousness: a motif in French parietal art. *Antiquity* 71(274): 810–829.

Lewis-Williams, J.D. 2000. Activity areas and social relations in the Upper Palaeolithic Volp Caves (Ariège, France): a methodological study. Unpublished paper presented at the symposium, PaleoArt 2000, Society for American Archaeology, Annual Meetings, Philadelphia (PA).

Lewis-Williams, J.D. 2002. *The Mind in the Cave: Consciousness and the Origins of Art*. London: Thames & Hudson.

Lock, C. 1994. Petroglyphs in and out of perspective. *Semiotica* 100(2/4): 405–420.

Longino, H. 1994. In search of feminist epistemology. *The Monist* 77: 472–485.

Lorblanchet, M. 1980. Peindre sur les parois de grottes. *Dossiers de l'Archéologie* 46: 33–39.

Lorblanchet, M. 1991. Spitting images: replicating the spotted horses of Pech Merle. *Archaeology* 44: 24–31.

Meskell, L. & Preucel, R.W. (eds) 2004. *A Companion to Social Archaeology*. Malden (MA): Blackwell.

Meskell, L., Gosden, C., Hodder, I., Joyce, R. & Preucel, R. 2001. Editorial statement. *Journal of Social Archaeology* 1(1): 5–12.

Mithen, S. 1988. Looking and learning: Upper Palaeolithic art and information gathering. *World Archaeology* 19(3): 297–327.

Mithen, S. 1996. *The Prehistory of the Mind: A Search for the Origins of Art, Religion and Science*. London: Thames and Hudson.

Moro, A.O. 2006. Art, craft, and Paleolithic art. *Journal of Social Archaeology* 6(1): 119–141.

Moser, S. 1998. *Ancestral Images: The Iconography of Human Origins*. Ithaca (NY): Cornell University Press.

Moure, A. 1999. *Arqueología del Arte Prehistórico en la Península Ibérica*. Madrid: Editorial Síntesis.

M.T. 1993. Challenging assumptions (a commentary on the research of Lorraine Daston) in "Investigations". *University of Chicago Magazine* (April): 34–35.

Murray, S. 1991. *The Anthropology of Art*. Field statement on file at the Department of Anthropology, University of California, Berkeley (CA).

Olive, M., Pigeot, N., Taborin, Y. & Thiébault, S. 1991. *Il y a 13 000 ans à Etiolles*. Paris: Imprimerie d'Indre.

Pfeiffer, J. 1979. *The Creative Explosion*. Ithaca (NY): Cornell University Press.

Phillips, R.B. & Steiner, C.B. (eds) 1999. *Unpacking Culture: Art and Commodity in Colonial and Postcolonial Worlds*. Berkeley (CA): University of California Press.

Pinney, C. & Thomas, N. 2001. *Beyond Aesthetics: Art and the Technologies of Enchantment*. Oxford: Berg Publishers.

Preziosi, D. 1982. Constru(ct)ing the origins of art. *Art Journal* 24: 320–325.

Raphael, M. 1945. *Prehistoric Cave Paintings*. New York (NY): Pantheon.

Rowe, M.W. 2001. Dating of rock paintings. *INORA* 29: 5–13.

Soffer, O. 1997. The mutability of Upper Paleolithic art in central and eastern Europe: patterning and significance. In: Conkey, M.W., Soffer, O., Stratmann, D. & Jablonski, N. (eds) *Beyond Art: Pleistocene Image and Symbol*: 239–264. San Francisco (CA): California Academy of Sciences, Memoir 23.

Soffer, O., Adovasio, J. & Hyland, D.C. 2000. The "Venus" figurines: textiles, basketry, gender, and status in the Upper Paleolithic. *Current Anthropology* 41(4): 511–538.

Stoczkowski, W. 1994. *Anthropologie Naïve, Anthropologie Savante: de l'Origine de l'Homme, de l'Imagination et des Idées Reçues*. Paris: Editions CNRS.

Stoliar, A.D. 1977. On the genesis of depictive activity and its role in the formation of consciousness. *Soviet Anthropology and Archaeology* 16: 3–41.

Taçon, P.S.C. & Chippindale, C. 1998. Introduction: an archaeology of rock art through informed methods and formal methods. In: Chippindale, C. & Taçon, P.S.C. (eds) *The Archaeology of Rock-Art*: 1–10. Cambridge: Cambridge University Press.

Thomas, J. 1996. *Time, Culture, and Identity: An Interpretive Archaeology*. London: Routledge.

Townsend-Gault, C. 1998. At the margin or the center? The anthropological study of art. *Reviews in Anthropology* 27: 425–439.

Trigger, B.G. 1989. *A History of Archaeological Thought*. Cambridge: Cambridge University Press.

Trigger, B.G. 1991. Distinguished lecture in archeology: constraint and freedom, a new synthesis for archeological explanation. *American Anthropologist* 93: 551–569.

Trigger, B.G. 1995. Expanding middle-range theory. *Antiquity* 69: 449–458.

Weiner, J.F. 2001. *Tree Leaf Talking: A Heideggerian Anthropology*. Oxford: Berg.

Wylie, A. 1995. Doing philosophy as a feminist: Longino on the search for a feminist epistemology. *Philosophical Topics* 23(2): 345–358.

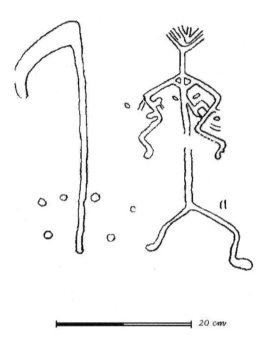

FIGURE 13.1 Human and one of many puzzling hook-like engravings from Vingen, western Norway. Extent of image is 40 cm by 40 cm. *(Tracing by E. Bakka)*

13.

Rock art without ethnography?

A history of attitude to rock art and landscape at Frøysjøen, western Norway

EVA WALDERHAUG
(National Directorate for Cultural Heritage, Oslo, Norway)

ROCK ART AND ETHNOGRAPHY

> ... the text-like quality of rock art may allow it to outlive the artist's culture and eventually become incorporated into a new, perhaps radically different, culture that succeeds the first, so that there is no necessary connection between the meanings now attributed to it, and its significance to the original artists (Layton 1985: 441).

A central aspect in rock art research is the discussion and application of ethnography in interpretation. In areas of the world such as Africa, Australia and North America, ethnographic knowledge exists which may be linked, at least in some form, to rock art (e.g. Deacon & Dowson 1996; Katz *et al.* 1997; Whitley *et al.* 1999; Chippindale *et al.* 2000; Stoffle *et al.* 2000). Study of rock art from the later European prehistoric periods prevents the use of 'informed' sources[1] linked, directly or indirectly, to the makers or users of rock art; in this sense we deal with 'rock art without ethnography'. I have elsewhere considered this problem in regard to rock art in western Norway, noting that it is "entirely prehistoric, leaving us no direct clues as to its meaning, and without the means to study it through any informed method" (Walderhaug 1998: 285). Working with this art I have consequently applied a combination of formal and analogical approaches. In this chapter I will not concern myself with formal methods, but rather consider methods of rock art study that depend on use of ethnography in some form – through informed sources or the use of analogy.

Much rock art of the former colonial world was produced well into the 'historic' period, but representatives of imperial powers seldom recorded information pertaining to its use and meaning. The meanings of prehistoric images are often enigmatic: the hook-like images found in western Norwegian Stone Age rock art (Figure 13.1) or the Copper and Bronze Age halberds depicted in the engravings of Alpine Mont Bego are clearly laden with meaning lost to us through lack of informed sources. Rock art found in historic contexts can still be puzzling; alongside prehistoric halberds on Alpine sites are both Christian motifs, which we think we know the meanings of, and other shapes in medieval rock art that remain puzzling to us. The study of medieval and post-medieval rock art of the Christian era is underdeveloped in European research; yet as Ouzman (1999: 5) notes when discussing white settler rock art of the South African Anglo-Boer War, "the urge to mark rocks, in whatever fashion and to whatever end, is a deeply-held and universal human impulse". In Scandinavia the common dating of prehistoric rock art is to the Stone, Bronze and Early Iron ages. Yet permanent marking of various media – rocks, stone or wooden churches, wooden secular buildings and a variety of objects – is known from the late Iron Age until the present. Meanings can appear to echo between one period and another when chosen themes and motifs are quite similar through time. Wild game, domestic animals and ships are frequently found in the prehistoric rock art of Scandinavia. Sámi late Iron Age/medieval engravings of boats are also found at Padjelanta, northern Sweden (Bayliss-Smith & Mulk 1999). Ships and animals, such as horses, are frequently carved into the wood of Norway's ancient stave churches, post-medieval farm buildings and hunting cabins; hunting engravings and medieval runic inscriptions are found together at Storhedderen rock shelter in the mountains of Setesdal, southern Norway (Hagen & Liestøl 1947; Blindheim 1980; Christensen 1980). There is also 'rock art' in our present-day culture. We might include urban graffiti or even the carvings of names and initials at prominent or important places, found for example at many rock art sites.

Attempts towards clear-cut compartmentalisation into 'formal' and 'informed' approaches reveal a more complex reality; every time will have its rock art and for every rock art there will be some form of ethnography. Yet, using ethnography to explain prehistoric rock art is often a case of "wrestling with analogy"

(Lewis-Williams 1991). Chippindale and Taçon (1998: 8) present analogy as a third methodological option, not duplicating but related to formal methods – a kind of middle-range theory. 'Analogy' is generally applied in archaeology for three different purposes: as a source of ideas broadening the horizons of possibilities about how the past *might* be interpreted; to buttress arguments concerning past events in a particular case; or to test ideas about the past (Hodder 1999: 46). An analogical approach to rock art often means searching for a comparative body of material fulfilling a certain degree of similarity points, thus focusing on *sameness* rather than on the intriguing *otherness* also experienced in prehistoric rock art. Ethnography can serve equally well to remind us of the distance existing between the material we study and ourselves, urging us to reflect on the elements missing as much as on those present in our own material. Studying rock art in a situation significantly *different* from that in which our prehistoric material is found, can inspire a more cautious and careful approach. This can be contrasted to using a source of analogy to draw conclusions on the grounds of similarity in areas other than symbolic expression, and presuming this will also entail similarity in the latter.

ROCK ART OF WESTERN NORWAY AND WESTERN MOZAMBIQUE

Frøysjøen is a wide expanse of water, running northeast from the outer coast of the Bremanger municipality in the province of Sogn og Fjordane, between the large island of Bremangerlandet and the mainland (Figure 13.2). North of Bremangerlandet, the Nordfjord flows east into the interior. These two main waterways connect through Skatestraumen strait at the foot of the distinctive mountain Hornelen. The landscape surrounding Frøysjøen is generally mountainous, the human occupation concentrated on narrow landrims between mountains and fjord, below numerous screes and waterfalls. In this rocky landscape, in the innermost eastern part of Frøysjøen, more than 2000 engravings are found at several locations less than four kilometres apart. The main rock art area is found at Vingen, on the southern shore of small Vingepollen Bay, surrounded by mountains steeply rising to nearly 1000 m. North, on Vingenes headland, which protrudes into Frøysjøen at the inlet to the bay, rock art is

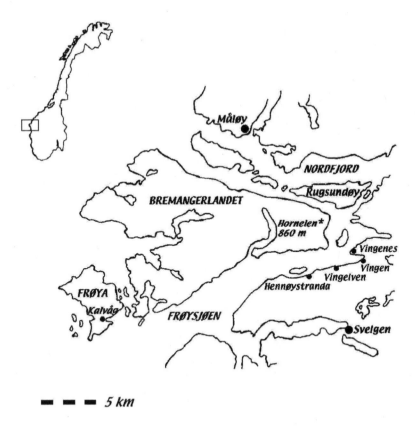

FIGURE 13.2 Frøysjøen area showing places mentioned in the text.

found on gently sloping rock panels below Tussurfjell Mountain. About three kilometres west of Vingen there is more rock art at Vingelven farm, and a further kilometre westwards at the abandoned Fura homestead (Figure 13.3).[2] As is frequently the case with Scandinavian rock art, it is difficult to place securely the sequence of production and use of this rock art in time. Motifs include red deer, hook-like images, geometrics and some humans. The motifs and their relationship to prehistoric shoreline levels and to other archaeological evidence have led most researchers to conclude that they were made by Stone Age hunter-gatherers (e.g. Bakka 1973a, 1979; Walderhaug 1998; Lødøen 2001, 2003; Bergsvik 2003: 276; Mandt & Lødøen 2005). I will not engage in lengthy discussion on the specifics or merits of chronology or rock art tra-

ditions (e.g. 'hunter-gatherer' or 'farmer') and their distinction here, but prefer to attempt to show how a certain type of rock art believed to be of hunter-gatherer origin has been dealt with in history.

Before discussing the Frøysjøen rock art more closely in light of ethnography, I find it useful to consider some experiences from work with rock art in a different context, namely the Manica District of Manica Province, west-central Mozambique. Here several shelters have been recorded containing paintings of humans, animals and other motifs executed in the fine-brush technique associated throughout southern Africa with San hunter-gatherer societies (Sætersdal 2004). I draw attention to this rock art here, because so much research has been focused on understanding the meaning and significance of San rock art in southern Africa –

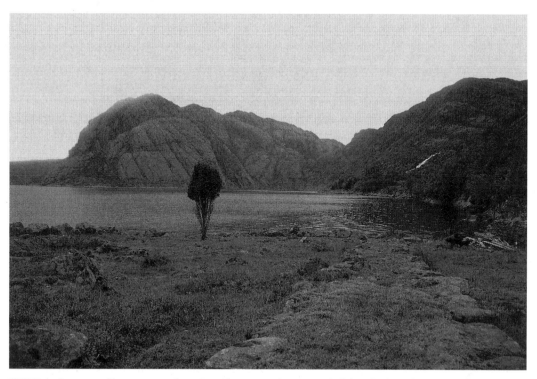

FIGURE 13.3 Remnants of human occupation at Fura. Vingenes can be seen on the left at the foot of Tussurfjell Mountain. The enclosed Vingepollen Bay with the Vingen rock art site and farmstead is at the far centre. Vingelven, with the present-day farm, lies to the right, between Fura and Vingen. (*Photograph by E. Walderhaug*)

the use of various sources of San ethnography being at the centre of the debate (e.g. Vinnicombe 1976; Lewis-Williams 1981, 2002; Dowson & Lewis-Williams 1994; Jolly 1998). This ethnography, while in fact not collected directly from San groups producing rock art, has provided a basis for developing sophisticated interpretive frameworks that have also supplied analogies for interpretations of Scandinavian and other European rock art (e.g. Clottes & Lewis-Williams 1996; Walder-haug 1996; Bradley 1997; Lewis-Williams 1997; Grønnesby 1998; Lahelma 2005). Despite inherent difficulties, analogical approaches of this kind are relatively common in rock art research and, though they may be criticised, are accepted as part of regular archaeological practice. Gutorm Gjessing, whose work I shall discuss

more closely below, was already using San ethnography to explain Norwegian rock art 80 years ago!

A more than 500-year-long ethnohistory of agriculturalist Shona-speaking people exists in the Manica District, but there is no recorded historical knowledge of the local San hunter-gatherer culture that they displaced (Beach 1980; Bhila 1982). But notably, sites with San and later paintings figure in ancestor beliefs and rainmaking rituals of the present-day Shona-speaking population (Figure 13.4 and see Chapter 15 of this volume). Therefore a valuable contemporary ethnography also exists with regard to the Manica sites, as a result of their re-adaptation and renegotiation into another cultural situation. This ethnography is now being recognised and recorded in its own right

FIGURE 13.4 Mbeya Gondo, spirit medium and traditional custodian of the San rock paintings at Chinhamapere rock shelter in Manica District, Mozambique. The site is used in annual rainmaking ceremonies and proper ancestor rituals must be observed whenever visiting it. *(Photograph by E. Walderhaug)*

(Sætersdal 2004). The situation in Manica is not unique in an African context. But, in reference to European rock art, it alerts us to the long-term and often changing role played by rock art in both past and present-day societies, the latter so seldom focused upon in our research. Unlike San or other hunter-gatherer ethnography, it is unlikely that the present use of Manica rock art would be accepted as a 'proper' analogy in questions regarding Norwegian rock art. Yet it may aid us in a shift in attitude towards this northern art, which can help us study it in a different way.

Rock art is also presently of emotional and political concern in northern Scandinavia, as seen in reference to the minority Sámi population in northern Norway. Hætta dismisses current archaeological viewpoints on the Alta rock art in Finnmark, stating: "my intuition tells me that Norwegians cannot have carved the figures in the rock" (Hætta 1995: 355ff.). Sámi ethnography is applied in archaeological interpretation of the art (e.g. Helskog 1987, 1999). This rock art remains potent in contemporary discourse. Even beyond the ethnic or political melting pot, rock art without ethnography does not exist if we accept that historic and present use and meanings are of value in understanding its role in the long term. Where prehistory is hidden from us, history may still be open to us. This history, which influences and is influenced by our research, also deserves consideration in its own right.

Returning to Frøysjøen, there is no recorded folklore, history of use or understanding directly linked to the rock art there, but there is a history, a known history of human use of the space shared with the rock art. The special place of this rock art in research history, and shifting attitudes towards it, are of particular interest to the present theme. In what follows I therefore consider more closely the ethnohistory, and the history of attitudes, connected to this rock art.

'PRE-CONTACT' NATURAL HISTORY AND ETHNOHISTORY AT FRØYSJØEN

The most common rock art motif found at Frøysjøen is that of red deer. We know from the 18th-century writings of Hans Arentz (1731–1793) (Bull 1999: 87) and J.A. Krogh (1740–1783) that, like today, red deer were probably plentiful in the area at that time, though numbers fluctuated owing to wolves. "During summer they mostly stay in the innermost country in the most remote valleys, from where as winter approaches they begin wandering in flocks over the mountains towards the coast where there is the least snowfall"[3] (Krogh 1813: 124). Reindeer were also quite numerous in the innermost fjord areas and mountains at that time, but elk were not observed west of the central interior mountains (Krogh 1813). Shepherds guarded livestock against brown bears and wolves; bears reportedly caused much yearly damage in the 1700s and 1800s, often breaking into the animals' sheds at night (Krogh 1813: 118; Rimstad 1936: 60; Bull 1999: 75). A bear was reportedly shot by a 12-year-old boy in a hunting party in the Svelgen valley near Frøysjøen in 1893 (Sande 1981). Krogh also notes various whales and porpoises. They sometimes followed the herring into the inner fjord areas; porpoises today occasionally come in a school right into the Vingepollen Bay. They were not generally hunted, though Krogh describes the spontaneous killing of a stranded whale at Skatestraumen, just north-west of Vingen (Krogh 1813: 170).

The narrow, less than a kilometre long habitable and cultivable land-rim at Vingen is sandwiched between the sea and numerous screes below steep mountainsides. Rock outcrops, huge boulders and stones are scattered throughout – this is where the rock art is found – and what soil there is provides only a thin covering for the rocky underground. A more detailed human history at Vingen starts in the 1640s, when a man named Jokum cleared land for a small farm there, on which he kept three cows, six sheep and eight goats. In the late 1600s the farm was abandoned, and in the first half of the 18th century roots from abundant pine trees were burned for tar-making, keeping 12 to 16 men occupied yearly. In 1746 the farm was rebuilt. Traces can still be seen of almost 20 small, simple stone and wooden farm buildings and boathouses huddled together against the winds and the sea at innermost Vingepollen (Figure 13.5). Population counts between 1825 and 1900 note between 19 and 23 people sharing this very limited space: the inhabitants of two independent farmsteads and at most three cotters' farms,[4] and their employed labourers. Patches of green grass dotted among the multitude of grey rock and boulders along the shore are reminders of the small fields once cultivated here. This farming activity was kept up until the last resident

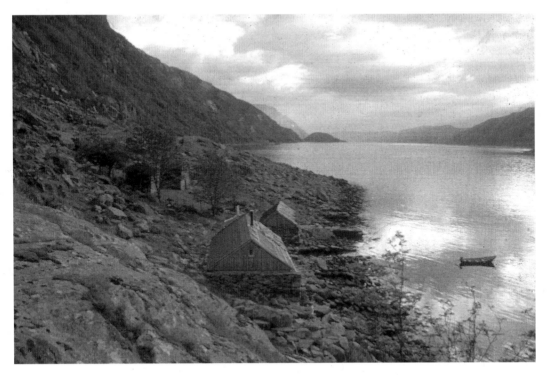

FIGURE 13.5 Innermost Vingepollen and the site of the old Vingen farms. Ruined walls bear witness to the many buildings once found here; later boathouses and a cottage used as a holiday home have been built on the foundations of the older buildings. Rock art is found here on boulders and outcrops. (*Photograph by E. Walderhaug*)

farmer left in 1933. Vingen then became, and remains, the hayfield and grazing land of the neighbouring Vingelven farm. Vingelven, cleared to make a farm in the 1750s, is still an operating sheep and goat farm (Aaland 1939; Vanberg 1988).

The physically confined, rocky landscape and thin soils at Vingen provided meagre means for farming. The present landscape bears witness to the enormous effort put into clearing every accessible space and the collecting and shifting about of limited soils, yet the results have remained poor. Of greater importance was animal husbandry, though feeding of the animals was difficult. Collecting fodder was hard work, especially for the women. Hay, leaves, heather and seaweed were often assembled on expeditions far into the mountains or along the edges of the fjords; even fish heads and household rubbish were used (Vanberg 1988: 16; Helle 1990: 27ff.). Semi-starvation of the animals during winter was a common occurrence (Ohnstad 1980: 236; Bull 1999: 73ff.), but in spring and summer fresh mountain pastures provided welcome release. Collecting fuel and manure for fields and pastures demanded similar hard labour and resourcefulness. The cotters had no land at all, but fed a few cows and sheep on what could be assembled from the shores and ledges along the fjords. Here they also collected earth to grow potatoes and swedes on large boulders at Vingen (Vanberg 1988: 19ff.). Remnants of low stone walls assembled to keep the earth in place can still be seen. The largest of these boulders is the flat,

sloping and aptly named Kålrabisteinen – 'the swede stone'. Its earth covering now gone, it displays engravings of humans and animals.

It was not the land alone that supported the relatively large number of people living in this limited space, but the fisher-farmer economy typical of coastal Norway. As Arentz noted in 1785, when fishing was good a farmer could earn more in a week at sea than in a whole year on the farm. But, when fishing fails for those who rely more on it than on the land, "death is in the pot" (Bull 1999: 51). Herring and cod fishing were important seasonal occupations on the outer coast for centuries. In good years fishermen from the whole of western Norway would congregate at fishing villages such as Kalvåg in outer Frøysjøen – more than 20 000 men were reportedly involved in fishing and processing there at one time in 1867 (Nordbotten 1966: 82). Winter herring was hung and dried, and the summer herring salted and eaten fresh. The stockfish was often the 'bread' of the coastal people (Lefdal 1936: 8).

The spring herring and winter cod in some years came deeper into the fjords and could even be caught at Vingepollen itself (Aaland 1939: 6; Vanberg 1988: 13). Thorvald Vingelven remembers the winter cod fishing around the end of World War I, when, as a child at Vingelven farm, he "tried to count the boats from here towards Vingen. We found there were 70 boats with masts, how many without we could not even say … everyone caught fish wherever they cast their nets" (Vingelven n.d. a). Herring fishing could be extremely lucrative. The innermost part of Vingepollen – Vingehola – was a perfect catching place. Thorvald Vingelven tells of the tradition of the shore seine: "Vingehola was an exceptionally good herring fishing place … fortune had it that the mountains rose almost vertically from the sea on both sides, and 20–30 metres above the water surface a man sat guard, and when he saw the herring coming into Hola, those in the boat had to be ready to cross with the seine" (Vingelven n.d. b). Vingepollen was and remains rich in other kinds of fish as well. But historic records also show the fluctuating fortunes of those participating in both herring and cod fishing over the last three centuries. The 'black seas' of the 1870s, when the winter and summer herring as well as the cod disappeared, were the beginning of the end at Vingen. Debts grew and people were forced off the land; some emigrated. The landless cotters might have been reduced to begging when the

FIGURE 13.6 Vingen's last resident farmer, Thue Vingen, with his wife, photographed at their home around 1920. Father of 15 children by two marriages, Thue lived here from 1890 to 1933 and died in 1934.

fishing failed, and this final disaster was the ultimate blow – by the late 1870s they were all gone. Both self-owned farmsteads at Vingen changed owners in the 1890s, but in the end only one farmer prevailed – Thue Gullaksen who, upon buying the farm and marrying a local woman, became known as Thue Vingen (Aaland 1939; Vanberg 1988) (Figure 13.6).

THE 'POST-CONTACT' PERIOD: A grand discovery, and its aftermath

It was in Thue Vingen's time that the rock art at Vingen was officially 'discovered' (though it was known to the local people at the time, and it is hard to imagine that it went entirely unnoticed by earlier generations) by mountaineer and solicitor Kristian Bing, on an excursion from Bergen at Easter 1910.[5] He published the first article on the subject in 1912, by which time 100 engravings had been found (Bing

1912). There followed almost a century of contact and interaction with the outside world, and national politics, academic rivalry and economic exploitation entered the scene. Life would never again be the same.

Bing had interests other than archaeology. Industrial progress of the early 20th century led to a rush to secure suitable watercourses for hydropower development (Michelet 1980). Water rights became investment objects. Thue sold his land to Bing in the year of their first meeting, though he stayed on at Vingen until 1933. In 1916, Bing, having acquired both farmsteads at Vingen, resold them and the water rights with handsome profit. The waterfall and associated rights at Vingelven were also sold in 1909 (Aaland 1939: 253ff.). Luckily, no industrial development ever took place at either site, though Vingelven farm for decades produced electric power from its own water turbine.

Swedish archaeologist Gustaf Hallström and his Norwegian colleague, Johannes Bøe, dominate the research history of the Frøysjøen rock art in the first half of the last century. Hallström spent a limited time here in 1913 and 1917, tracing and recording (Hallström 1938: 415). Fieldwork, in his terms, demanded "meticulous attention to detail" in its documentation: "not one detail must escape detection" (Baudou 1998: 90). Bøe of Bergen Museum spent a great deal more time there in 1925, 1927 and 1931 (Bøe 1932). His focus was much the same as Hallström's, and in total they recorded almost 1000 engravings at Vingen and Vingenes, with a "considerable after-crop" expected (Hallström 1938: 444). Both men planned publication of Norwegian rock art on a grand scale. By 1906, Hallström had begun his documentation and subsequent publication of Swedish and Norwegian hunter-gatherer rock art sites (Hallström 1907a, 1907b, 1908, 1909). When he started work at Vingen and Vingenes, less than a decade had passed since Norway's independence from Sweden in 1905. Archaeology had become a field of political importance. The vigorous A.W. Brøgger, professor and director of the University Museum of Antiquities in Oslo from 1915 onwards and much involved in writing and politics, was instrumental in the publication and exhibition of the Oseberg Viking ship and grave find – adopted as a potent symbol in the identity building of a young nation (Klindt-Jensen 1975; Marstrander 1986). Alarmed by the thought of a Swede publishing the Vingen rock art, he wrote to his counterpart, Professor Shetelig at Bergen Museum, of the urgent need to "arrest the conquest hungry of the brother nation" (Brøgger 1917a). In a letter to Hallström he argues that the publication of original material whenever possible should be reserved for "the country's own sons" (Brøgger 1917b). In 1927, Brøgger initiated a national archaeological meeting to discuss the "advancement of Norwegian archaeology", where plans were drawn for comprehensive field studies and collective publication of Norwegian rock art (Engelstad 1932: 36). A series of monographs of hunter-gatherer (termed 'Arctic') type rock art were published within a decade, including – to Brøgger's likely satisfaction – Bøe's Vingen and Vingenes studies in the German language (Bøe 1932; Gjessing 1932, 1936; Engelstad 1934). Hallström's large work on the Norwegian 'monumental art' first appeared in 1938; his volume on the Swedish localities was even more delayed (Hallström 1938, 1960).

Recording of Hallström's 'after-crop' continued, expanding geographically with Fett's publication of 33 engravings from Vingelven and a solitary deer figure from Fura (Fett 1941). Following new discoveries by the local people, Egil Bakka extensively documented rock art at Vingen from 1962 to 76 (Bakka 1973b; Mandt 1999), almost doubling the number of recorded engravings. Sadly, little of this material had been published upon his death in 1985, and then only briefly in articles dealing with subjects such as stylistic variation and chronology (Bakka 1966, 1973a, 1979; see also 1975a, 1975b). The combined rock art materials collected between 1910 and 1976 total almost 1800 engravings, of which roughly 38 per cent depict animals – almost all deer and presumably mostly red deer; 'hooks' account for 27 per cent; and humans for 3 per cent. The remainder are mainly either unclassifiable ('dots', 'dashes', damaged, etc.) or other 'abstract'-type motifs ('geometric' forms and patterns, cup marks, etc.).[6] Ninety-five per cent of the engravings were found at Vingen, though these statistics are slightly biased because more intensive surveying took place here. Documentation of rock art in the Frøysjøen area[7] has continued in the decades following Bakka's death, with this unpublished material reportedly bringing the total number of images to more than 2100 in all (Viste 2003; Mandt & Lødøen 2005: 138ff.).

Recent statistics include a more generous reclassification of other researchers' work, as well as a number of damaged or otherwise unclassifiable figures that

most likely were intentionally overlooked by early researchers in the field. Numbers are generally seen as important when dealing with "the largest collection of hunter-gatherer engravings in northern Europe" (Bakka 1973a: 156) or the "largest engraving site in southern Norway" (Mandt & Lødøen 2005: 137). But we have still to prove a relationship between numbers and their relative importance. Nordbladh notes how the task of comprehensively documenting Scandinavian rock art is both enormous and impossible, and "in combination with different views of what is a site, a figure, an area, etc., offers no firm base for calculations. Interpretations and search for meanings must be done along other paths" (Nordbladh 1995: 28). The ever-growing body of images and panels has not significantly altered the range or relative frequencies of motifs found at Frøysjøen or the numerical dominance of the Vingen site. Throughout a century of academic activity, Hallström's views on the importance of documentation and detail have been upheld as new generations have continued to add to and re-document their predecessors' work. Is this descriptive tendency in Scandinavian rock art studies perhaps a way of avoiding the interpretive problems of a rock art without ethnography?

FRØYSJØEN 'ETHNOGRAPHY' AND THE MAKING OF THE HUNTING-MAGIC EXPLANATION

The Frøysjøen rock art is intimately linked to the development of Scandinavian rock art research and interpretation, to which questions regarding ethnography are of importance.[8] Until the turn of the last century, research concentrated on rock art of a south Scandinavian type, believed to be connected to Bronze Age farming societies. In the latter part of the 19th century, rock art was discovered that seemed to belong to another type of culture, for it was dominated by motifs of non-domestic fauna. Initially termed 'Arctic rock art' (Hansen 1904; Brøgger 1906), it became linked to contemporary views on the 'Arctic culture' of the northern hunter-gatherers (Helskog 1991: 72). This was the context in which such 'hunter-gatherer art' was first interpreted, as a tradition separate from the south Scandinavian 'farmer art', with its Bronze Age social context.[9]

Inspired by contemporary studies of Palaeolithic rock art, hunting magic was quickly seized upon by some of the most influential archaeologists of the time in order to explain the art. Shetelig believed the art expressed the "primitive magic of a stone-age people where hunting held first place" (Shetelig 1922: 145, see also 1921, 1925, 1930). The Vingen rock art soon became important evidence for this viewpoint, based on a piece of 'local ethnography' – an account of deer hunting from Stadlandet, some 30 km north of Vingen, where in the 18th century hunters would drive the animals off steep cliffs. Brøgger (1925: 78) wrote: "No story could better explain the Vingen rock art. Should we attempt to express its meaning it must be stated in very simple words like an incantation, a prayer to the forces: 'Give us rich autumn flocks of deer that will run towards the sea in the west, so we can overthrow them and have food and clothing for our long winters'."[10] (See Figure. 13.7). Brøgger in fact does not clearly state the source of this hunting tale, nor does he claim that the events described took place at Vingen itself. Yet this tale of 'local ethnography' gained momentum over time. Soon Shetelig was stating that the Vingen rock art is found "in a pass where great flocks of deer until recent times would trek west to the sea in autumn. Still in the 18th century the farmers here would hunt deer by driving them in flocks off the cliffs" (Shetelig 1930: 48). The rock art here exerted such a 'magic force' that the animals "simply had to come and throw themselves off" the cliffs (Fett 1938: 316). In fact, "No other rock art so explicitly expresses the Stone Age hunting magic as this" (Bjørn 1933: 59). And so the story grows, finding its way into the work of Herbert Kühn, who in an inaccurate and fanciful description marvels at the engravings being found 'just at the place' described in the local ethnography:

> Clearly these hundreds of figures chiselled upon the cliffs must exercise powerful magic upon the beasts and lure them down to their destruction. As a matter of fact all the Vingen animal-figures are represented with their heads drooping downwards to the waters below. The engravings depict the deer as they appeared when they were huddled in their herds upon the cliffs' edge and just about to slither down to death. We could hardly ask for more decisive proof of sympathetic magic and of the wizardry of the chase (Kühn 1956: 92).

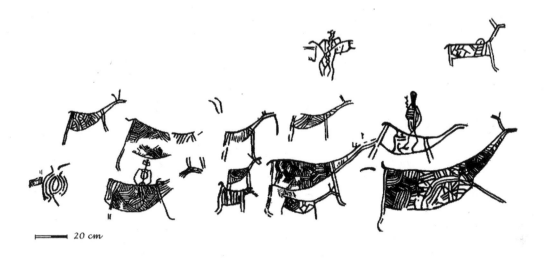

20 cm

FIGURE 13.7 Red deer and other motifs from Vingen. The animals are depicted running westwards towards the sea, a fact emphasised by proponents of the hunting magic viewpoint. *(Tracing by E. Bakka)*

Bøe (1932: 44) also saw Vingen as a natural hunting trap and Hallström (1938: 445) had no quarrel with this, though his only interest seems to be the consequences for chronology. Later, referring to Vingen also, Hallström (1943, 1960) expresses similar views regarding elk hunting at Swedish rock art sites, and at Nämforsen, northern Sweden, in particular.

Gjessing's views on Scandinavian hunter-gatherer rock art were first presented within this research climate, and remained extremely influential throughout the next half-century.[11] He noted the uniform agreement on hunting magic, but did not accept that site location gave a general explanation for this (Gjessing 1936: 138, 1945: 315). With his work on Arctic rock art a shift takes place from discussion of local ethnography to ethnographic analogy. Gjessing (1951) was a strong and early proponent of the need for archaeology to find support in anthropology. In order to produce more sophisticated explanations for the rock art, he searched for analogies from ethnographic sources

of the late 19th and early 20th centuries. Through the work of Stow and Frobenius, he studied African rock arts and ethnography. Dismissing Kühn's "program manifesto" regarding the "irreligious" Bushmen, Gjessing argued that San art could not be interpreted "without the aid of primitive magic or religion" (Gjessing 1936: 139). But, it was Hoffman's and Mallery's studies of the Native Americans that particularly intrigued him; a certain aspect found in Scandinavian hunter-gatherer rock art – the 'lifeline' (a line drawn between the animal's heart and mouth) motif – he linked to Hoffman's description of the 'Grand medicine society' of the Ojibwa Indians and "the preparation of the 'hunter's medicine' and the pictographic drawings employed in connection therewith" (Hoffman 1891: 221; Figure 13.8). Tracing the motif also to Asia and art of the circumpolar region in general, Gjessing found "a continuous culture belt" in the Arctic and sub-Arctic regions (Gjessing 1941, 1944, 1945, 1978).

Gjessing's large influence stems also from his construction of the shamanistic society that produced the rock art, in which it was made by the specially initiated and understood only by those informed of the mysteries of hunting magic (Gjessing 1945: 312). The concept of style is linked to society and the development of shamanism into more dogmatic forms, shifting from impressionism to the expressionism through which ecstasy is portrayed, and which Gjessing regarded as typical of contemporary indigenous societies. The hunter-gatherer rock art develops from an "a-social individual magic" towards a professional, organised social phenomenon; from the art of the hunter to the "non-distinctive and characterless art" of the professional shaman who "perhaps seldom or never had hunted" (Gjessing 1945: 312, 313ff.). There was some weak opposition, such as the 'l'art pour l'art' approach

to rock art as being the "primitive artist's soul's need to express itself" (D. Gjessing 1937: 303). But Gjessing's theories and the fundamental notions of links between rock art and hunting magic, hunting methods and hunting sites continued to inspire research for more than half a century (e.g. Simonsen 1958, 1986; Hagen 1970, 1976, 1990; Mikkelsen 1977, 1981, 1986). The importance of subsistence and economic adaptation to interpretation was also underlined by a certain influence from Anglo-American processual archaeology. However, many of those following in Gjessing's footsteps increasingly acknowledged that hunting magic must be part of a larger, more complex picture. In this spirit and 40 years after Bøe, Bakka (1973a) also placed the Frøysjøen rock art within the context of hunting magic and the 'psychological situation' linked to collective deer hunting. The entire layout of landscape and rock

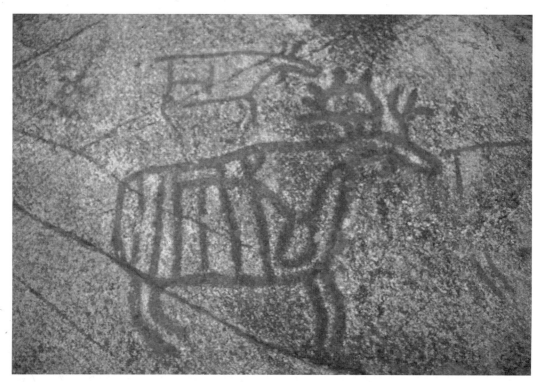

FIGURE 13.8 Engravings from Møllerstufossen rapids in eastern Norway, showing the alleged lifeline motif. *(Photo by E. Walderhaug)*

art made Vingen "a natural hunting-trap of immense proportion" (Bakka 1973b). The topography could be used to trap the animals between the rocks and the sea, and in fact "most of the carvings at Vingen are placed at the exact spots where the hunt itself must have taken place" (Bakka 1973b).

AFTER HUNTING MAGIC: The past in the present

A strong past inheritance is expressed in current Scandinavian research, albeit in new or refined versions and theoretical frameworks. For more than a decade researchers have been keen to abandon hunting magic entirely or at least to point out that it does not present an overall explanation for hunter-gatherer rock art (e.g. Hultkrantz 1989; Hagen 1990; Helskog 1991; Hesjedal 1994; Sognnes 1994). The link between rock art sites and communal hunting has been questioned in regard to rock art in general, and at Frøysjøen in particular (Hagen 1989), but not dismissed (e.g. Bang-Andersen 1992; Blehr 1993). Some authors link their readings of rock art to subsistence economy in a surprisingly direct way (e.g. Lindqvist 1994); others focus more on relationships between rock art, subsistence strategies and seasonal cycles of movement and aggregation (e.g. Ramqvist et al. 1985; Baudou 1993; Forsberg 1993). Exploration of ethnographic analogies in the circumpolar region has continued (Hultkrantz 1986, 1989; Helskog 1987, 1995, 1999; Odner 2000). Few papers discussing hunter-gatherer rock art avoid recurrent themes such as totemism and shamanism, even when placed within new theoretical frameworks (e.g. Tilley 1991; Hesjedal 1994). Interest in the location and topography of rock art has continued, developing further into spatial analysis, sensory and phenomenological approaches to rock art and landscape, and interest in the micro topography of rock art sites (e.g. Hood 1988; Sognnes 1994, 2004; Helskog 1999; Forsberg 2000; Walderhaug 2000; Goldhahn 2002), a trend reflected in rock art research globally (e.g. collected papers in Nash & Chippindale 2002; Chippindale & Nash 2004).

In the last decades the Frøysjøen rock art has also been discussed in light of various influences of the post-hunting magic era. The importance of a more social approach to the art has been recognised, including it in

rather than setting it apart from current archaeological debates (e.g. Walderhaug 1994, 1998; Prescott & Walderhaug 1995; Bergsvik 2003; Lødøen 2003). Post-processual influences have inspired structuralist and phenomenological interpretations (Mézec 1989; Mandt 1998, 2001). Eighty years after Gjessing, aspects of San ethnography and shamanism are being revisited (Mandt 2001; Viste 2003). In a feminist rereading of rock art and landscape at Frøysjøen, Mandt attacks the androcentric bias she sees as prevalent within studies of hunter-gatherer rock art. Her survey of motifs – animal, human and abstract-geometric – indicates that they are "expressions of female and fertility symbolism accentuating aspects of life-death-rebirth" (Mandt 1998: 215). This also strikes a familiar note as Gjessing believed concepts regarding fertility and fertility rites to be of vital importance to hunting magic and might explain why so many hunter-gatherer sites were found close to water (e.g. Gjessing 1936, 1945). Similar views were maintained by his followers. Despite the early and somewhat forced separation of rock art into hunter-gatherer and farmer traditions, there was a two-way influence in how the traditions were interpreted. Through the early 19th-century works of Almgren, Ekholm, Althin and others, relationships between the living and the dead, and fertility cult, magic and religion became lasting key concepts in interpreting farmer art (Mandt 1991; Hauptman Wahlgren 2000).

Gjessing's analogies reflect a very select proportion of the African and Native American ethnography concerned, where aspects of 'magic' appear as small and integrated parts of a much larger picture. It is notable how an interpretation based on ethnography collected in a faraway time and context, and by methods then prevalent (Sognnes 1996b: 26), remained fundamental to the interpretation of rock art in a totally different context long after the circumstances of its derivation had been forgotten and the understanding of the ethnography on which it was built had long changed. The same fundamental problem is evident in the contemporary feminist approach to the Frøysjøen rock art (Mandt 1996, 1998, 2001). By borrowing uncritically from the female and goddess symbolism advocated by Gimbutas, it attempts to replace the hunting magic of old with another kind of all-encompassing explanation of much-debated origin (e.g. Anthony 1995; Haaland & Haaland 1995; Meskell 1995; Conkey & Tringham 1996, 1998; Shee Twohig 1998; Insoll 2004: 57ff.).

It is important to acknowledge the valuable influences from past research; we need not always dismiss 'un-modern' viewpoints and should certainly avoid replacing old dogmas with new ones. We must rather free ourselves from explanations that claim to define a singular constituting context for, or an exhaustive explanation behind, the production and meaning of rock art, be it hunting magic or otherwise. It is wise to remember David Lewis-Williams' (1995: 410) words of warning that "contexts are in fact not 'discovered'; rather, they are constructed by researchers in terms of features that they, on a priori theoretical and methodological grounds, consider to have influenced the production of rock art in some way".

ROMANCING A MOUNTAIN: Folklore and myth at Frøysjøen

While views on hunting and hunting magic at Vingen were inspired through 'local' ethnography of a kind, this 'ethnography' reflects little of the farmer-fisher existence as it was and is actually known from the Frøysjøen area in historic times. In later years there have been attempts to link rock art and folklore. The acknowledgement that the meanings of ancient monuments outlive the period of their creation, and are constantly redefined and reinvented (see Walderhaug Sætersdal 2000), has led to renewed interest in the relationship between archaeology and folklore (e.g. Gazin-Schwartz & Holtorf 1999). Mandt attempts to bridge the gap formed by lack of informed insight by drawing on the European tradition of folklore, legend and song regarding horned animals – particularly the hind – in order to interpret the Frøysjøen deer motifs within the frame of fertility symbolism (Mandt 1998: 210, also 1996, 2001). The tradition of the sung 'Hind game' (Hindeleik) is historically known from the Nordfjord District, a song and dance game linked to 'young love' and courtship, known to have been played out in connection with death and burial, and at the release of the farm animals in the summer as protection against evil forces (Hagen & Liestøl 1947: 183; Storm Borchgrevink 1956: 44ff.). The context and contents of these 'rites' seem as removed from Stone Age Frøysjøen, or more so, than were Gjessing's faraway analogies.[12] Folklore, superstition and fairy tales are known from western Norway, relating to significant aspects of life such as birth, marriage and death, hunting, farming and fishing, animals and nature (e.g. Loen 1893; Storm Borchgrevink 1956; Bondevik 1980; Bull 1999). Some beliefs connect directly to certain wild animals, such as the belief in the red deer's peculiar longevity or the propensity of bears to seek out pregnant women (Krogh 1813: 119ff.; Storm Borchgrevink 1956: 11), yet there is little to link such stories to the rock art. The dialogue between archaeology and folklore, therefore, is a dialogue between different systems of meaning (Layton 1999: 26).

At Frøysjøen, local lore and tradition are often linked to landscape. A strong relationship to place is evident in the more than 40 place names recorded for features surrounding the small Vingepollen Bay (Vanberg 1988: 26). The historic Norwegian custom of naming a person for the land – by which Thue became Thue Vingen, and his son became Rasmus Vingelven when he married and settled there – is also evidence of the way people identified with, and were identified through, the land. Stories of strange and supernatural experiences connected to life and history at Vingen and Vingelven are still narrated by the people of Vingelven farm (pers. comm. 1998); these are part of the experience of the place, if not the rock art. But in the absence of an ethnography of rock art, a myth of place may take its place at the interface between local lore and archaeology. This myth-making connects to the rugged landscape surrounding Frøysjøen and its rock art sites, and the sites' proximity to and views of the characteristic 860 m high mountain Hornelen, about five kilometres west of Vingen: "overwhelming in its immensity, the highest sea-cliff in Europe, the great Hornelen – an impressive pile of grey, bare rock rising almost vertically from the water's edge ... Above looms the overhanging summit with its face fractured and scarred by past falls of rock, frowning down upon the ship underneath" (Beckett 1935: 86; Figure 13.9).

Shifting from the functional viewpoint of earlier research towards a phenomenological approach to landscape at Vingen, Mandt (1995: 278) argues: "The tiny fjord, surrounded by steep and seemingly impassable mountains, with its large number of rock pictures gives the impression of a very special – even a sacred – place. The view from Vingen to a characteristic mountain formation called Hornelen adds to this impression." This reading is then transported by a foreign scholar who, from second-hand experience of the place,

remarks on its "particularly impressive natural setting" and supposed inaccessibility (Bradley 2000: 81ff.).[13] Myth is thus segmented and given academic credibility, as was previously the case with the much-repeated narrative of the Vingen hunt. Developing this line of thought even further in her engendered approach, Mandt sees the mountain Hornelen as both axis mundi – the centre of the world – as well as a phallus; with the rock carving area being "nature's representation of the female body" (Mandt 1998: 221, 2001: 306).[14] But to what extent do such statements reveal the interpreter rather than throw light on fragments of past realities?[15] And how does the landscape come to be experienced in this manner in the first place?

It is true that Hornelen holds a special significance in folklore and history, figuring in song and poetry and in Snorre Sturlusons's medieval sagas of the Norwegian kings: "No other mountain in Norway has been honoured more than Hornelen" (Daae, quoted in Loen 1893: 23). It is connected to events in the lives of the great Viking kings Olav Trygvason and Olav the Holy (St Olav). Snorre links the mountain to the many manly deeds of Olav Trygvason, who was "stronger and lither than any other man" (Sturluson 1995: 182). This he proved by, among other deeds, "going up onto Smalsarhorn [the horn of Hornelen] and fastening his shield on the summit", and also by climbing the mountain a second time to save one of his men (*Ibid*). The song of St Olav tells of a troll calling out from Hornelen to the Christian king as he made the land part before him so his ship could pass, thus creating the island of Marøyna in the channel between Vingenes and Hornelen (Aaland 1939: 22). T.G. Krogh[16] claimed that in his lifetime an altar made of a great slab resting on

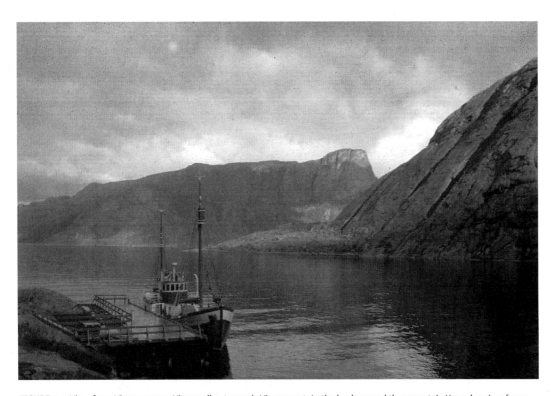

FIGURE 13.9 View from Vingen across Vingepollen towards Vingeneset. In the background the mountain Hornelen rises from Frøysjøen. (*Photograph by E. Walderhaug*)

four large boulders still existed on Hornelen (Loen 1893). According to folklore, witches met with the devil here on midsummer night and Christmas Eve (Aaland 1939), stories which cause Mandt to argue that it "is tempting to ascribe a long-term tradition to this alleged 'use' and see it as a reminiscence of rituals associated with the rock art at Vingen" (Mandt 1998: 221). It is difficult to accept such an enormous transgression of time, and it should be noted that similar traditions relate to many Norwegian mountains. There can be no doubt, however, that tradition influences the way in which we relate to the mountain and its surrounding landscape.

The depiction of the Frøysjøen landscape as inaccessible and forbidding can be traced back to academic descriptions from the early last century. Brøgger quotes archaeologist Jan Petersen from Bergen Museum, who, sailing to Vingen from the coastal settlement of Måløy, found the landscape "foreign and strange! A meaningless desert without oasis". Despite its occupation, he thought Vingen to be "the remotest of the remote" (Brøgger 1925: 76ff.). In Hallström's (1938: 415) terms, life in such a hostile and sterile stone desert seemed "a sheer anachronism". The time around the turn of the last century was a period when townspeople and foreign tourists were discovering and romanticising the joys and drama of unspoilt Norwegian nature, described by one visitor as "Norway mania"; a longing for "the wild freedom of the fjords and fjelds, the quiet valleys and breezy mountain tops, the pure fresh, bracing air" (Stone 1882: 2; see also Wood 1903; Nielsen 1909; Simpson 1912). Hornelen figured poetically in many travellers' tales of the period, rising "sheer out of the dark water, a huge wall of granite tremendous in its proportions ... this wonderful giant ... the famous Hornelen" (Goodman 1892: 240); a place where "heavy surges moan in a most uncanny way, and echo in deep notes up the huge cavernous rents in the mountain-side" (Heaton Cooper 1907: 118); and where the "driving mist which had arisen with the dawn gave it a look of ghostly and threatening aspect" (Wyllie 1907: 168).

The Frøysjøen landscape experienced by the first tourists and academics was in fact a peopled, enculturated environment. Today the inheritance of almost 400 years of habitation and agriculture is deeply stamped into the Vingen landscape, despite the illusion of remote wilderness awakened in many outsiders visiting it. There is no reason to believe that people inhabiting the farms here for centuries thought their home either unusual or inhospitable. Nor is it likely that they thought it inaccessible; the sea has always been the highway of coastal Norway and the mountains and their pathways have been an integrated part of communication, of cattle drives and of mountain summer farming for centuries. There are still farms without road connection in operation at Frøysjøen, including Vingelven .[17] It is hardly likely that Stone Age hunters roaming the mountainous and generally 'dramatic' landscape of western Norway regarded the Frøysjøen area as hostile or even out of the ordinary, nor can we guess at their responses towards Hornelen. At the interface of fact, folklore, local people, academics and tourists, a myth of place is born that replaces geography and fills the gap created by a lack of ethnography with a 'mythography' of rock art, informing our research and interpretations.

IN THE FOOTSTEPS OF GJESSING UNTIL PATHS DIVIDE: A brief return to southern Africa

Like Gjessing before me, I have referred to comparative African ethnography. Megan Biesele writes on the understanding of oral Khoi-San tradition regarding transformation and potency transfer:

> Magical potency is transferred or used for transformative purposes in Khoisan folklore and ritual in contexts which include illness and its treatment, avenging social wrongs, strained kin relationships, the sharing of resources, control of weather, and the passages of life ... Potency may take the form of [among other things] a whirlwind, burning horns or drops of blood ... When a girl becomes a woman she can charm elands so that hunters can bring them down ... Rock paintings have potency partly because blood, a magical substance, is used to bind them. Antelope horns may be blown to flatten the camps of in-laws who have done wrong. Birds may be tied to a person's head to give early warnings ... I present these instances of magical transfer in an undigested heap: I want to call attention to the jumble of references we are called on to deconstruct in our work of description and interpretation. The verbs and nouns of

potency are intricately embedded in the metaphors of narrative and it is only ethnographic context – or, if we are fortunate, narrators' commentary – which can cause them to stand out as figures against ground (Biesele 1996: 142).

The problem of 'translation' is not diminished when attempting to 'read' rock art. How does a conceptually different, but perhaps similar richness of folklore, myth and cosmology translate into the 'language' of Stone Age rock art at Frøysjøen? How tempting is it not – whether formally analysing prehistoric rock art or making use of comparative ethnography – to clutch at surface fragments that seemingly 'fit', rather than penetrate the depths beyond a non-transparent surface? I argued above that ethnography might highlight important aspects missing when dealing with prehistoric rock art; it can also serve to unlock a frozen focus on select elements that obscure the art's inherent and contextual complexity. How fundamentally bleak and unimaginative in fact are the ways in which we often picture the European Mesolithic and Neolithic and its people! Even the most analogically 'well-founded',

speculative or provoking interpretations seem pale and timid in comparison even to the fragmented understanding of, for example, the Khoi-San ethnographies. Yet hunter-gatherers at Frøysjøen are likely to have had more in common with these faraway societies than with the self-regarding romanticism often expressed by many contemporary 'landscape poets'.

The selectivity of analogy is obvious from the research history discussed above. Gjessing's lifeline motif is rare in western Norway and within the circumpolar zone of northern Norway. Red deer have been the pivotal point of interpretations of rock art at Frøysjøen. Local ethnohistory highlights this fact, for while abundant red deer are hunted still in the Frøysjøen area, it is the life of the fisher-farmer that emerges most clearly from history. While we are incurably drawn towards the striking numbers of deer, we know nothing of the real significance once placed upon them.[18] A defining aspect of the Vingen landscape so widely discussed through research history is certainly the presence of water – the sea and its creatures, which amount to a negligible percentage of engraved motifs (Figure 13.10) – yet this is never really focused upon

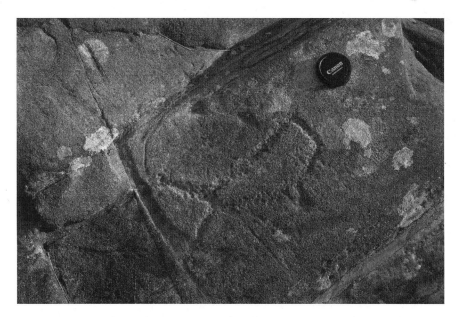

FIGURE 13.10 A rare depiction of what is thought to be a whale at Vingen. (Photograph by E. Walderhaug)

(Walderhaug 2000). The landscape approach suffers from telescopic vision drawn towards what we know is there, obscuring what we are no longer able to see.

Returning to southern Africa, it is notable how, despite many striking and conspicuous features in the Manica landscape, ancestor rites and offerings performed to ensure safe work at a rock art site often take place beneath a carefully selected ancestor tree somewhere in a site's vicinity. Many aspects of rainmaking rituals connected to the sites also take place elsewhere and leave few visible traces. As to the San painters, we no longer know which features of this landscape were the most important to them, those mortal or immortal, conspicuous or otherwise: "The San conceptual landscape 'floats above' the topographical material landscape. It was 'projected down' onto the topography where topography allowed for the making of images. It is not possible to work in reverse and construct the conceptual San landscape from the places where it happens to have been 'projected down' onto the material world" (Smith & Blundell 2004: 256).

THE VALUE OF PRESENT-DAY ETHNO-GRAPHIES AND ETHNOHISTORY

Direct experience of present-day Manica ethnography and ethnohistory led me on a journey in search of fragments of relevant knowledge in the Frøysjøen ethnohistory as well. Local lore, tradition and experience alert us to ways of seeing and understanding founded on an intimate knowledge of life and place we as outsiders lack – at Frøysjøen as at Manica. It is evident, both from the archives at Bergen Museum and from my own experience, that the people of Vingen and later Vingelven remained and remain interested in the rock art, reporting new discoveries and aiding the many academics in their fieldwork. Years of contact also tempered their views; some would recite familiar interpretations of Stone Age Vingen as a natural hunting trap and of engravings being expressions of hunting magic (e.g. Lote 1981; Vingelven 1989). But the present inhabitants of Vingelven claim to have no knowledge of the historic hunting practices described by Brøgger and repeated by others. While viewpoints on hunting and magic originated in an academic belief in 'local ethnography', a study of ethnohistory reveals the inaccuracies of this approach.

The last farmer, Thue's son Peder, was born and bred at Vingen, where he fished and lived a greater part of his later life. He had a particularly keen interest in the rock art and discovered much of it himself. Unrestrained by many of our academic preconceptions, he easily identified octopus, monkey, elephant and domesticated goat in the rock art (Wingen 1972, 1977). Apart from the goat so common to the area, it is interesting that he seeks such exotic explanations, for it seems that even to one who lived with the rock art and its landscape, the past it expresses remains a foreign country. So knowledge of local history also reveals the way in which it displaces the past, in the minds of people as well as in the landscape that at Frøysjøen has subtly changed through processes of enculturation and subsequent repossession by nature. Vingen and Vingelven as we experience them today are products of their own history. The natural history, academic history and ethnohistory of life and people there is therefore a relevant and inseparable part of the long-term 'biography' of the rock art sites, but it importantly does not recreate prehistoric realities. The academic creation of a mythic Frøysjøen landscape served to compensate for lack of 'informed' insight, revealing how academic knowledge is always informed by the constituting contexts of our research (Conkey 1997).

Absence of informed knowledge and true ethnographic insight can, in some cases, lead to fanciful interpretation and unfounded speculation. However, it can also inspire a cautious approach sometimes lacking in cases where 'ethnography' is used to produce wide-ranging explanations, for how often is such ethnography accurate or appropriate? Where 'informed' methods are applied, there is usually debate regarding their validity and acceptable form of application. Ethnography is seldom linked directly to the makers of rock art; rather, in fortunate cases it may be linked to its continued use. More often a detour by way of ethnohistory and historical records is necessary. As with Gjessing's analogies, the circumstances of such ethnography may become blurred, while conclusions built on it continue to be expanded and refined. Even where a certain informed insight exists, a final and exhaustive explanation for the making and meaning of rock art is unlikely ever to be found or accepted. Ethnography, history and folklore can tell us much of value, but we must continue to question what it is they tell us.

Acknowledgements

Research at Frøysjøen was carried out from 1996 to 2000 and was financed by the Norwegian Research Council. I am indebted to farmer Helga Vingelven and her family for so generously receiving me and for sharing with me their knowledge and the late Thorvald Vingelven's original manuscripts. Helga's determination and constant struggle to maintain a fast disappearing way of life no doubt contributed to her sudden death in 2001. Her fearless dedication to the rock art she grew up with and her concern for my well-being during difficult times was much appreciated.

Research in Manica was initially carried out as part of the project led by Tore Sætersdal under research permit 01/07 issued by the Mozambican Ministry of Culture, Youth and Sports, Maputo, and has since continued as part of the project 'Archaeology and Cultural Heritage Management in Mozambique', funded by the Norwegian state and headed by the Mozambican Directorate for Cultural Heritage. We thank official and traditional authorities in Manica District and the local community for their support.

Aspects of this chapter were presented at a research seminar held at the Department of Archaeology, University of Cambridge, in March 2000, and at the seminar held in honour of David Lewis-Williams in the Waterberg, South Africa, in April 2000. I am grateful for comments received on these occasions. An edited and revised version of this chapter was accepted for publication in 2001. A limited revision was carried out in late 2005.

Notes

1 Chippindale and Taçon (1998: 6ff.) distinguish between *formal* and *informed* methods of rock art study: while *informed* methods depend on sources of insight derived through ethnography, ethnohistory, the historical record or contemporary understanding arguably perpetuating ancient knowledge, *formal* methods depend on no inside knowledge and the information being "restricted to that which is immanent in the images themselves, or which we can discern from their relations to each other and to the landscape, or by relation to whatever archaeological context is available".

2 Observations of rock art have also been reported from the larger surrounding area, such as a portable engraved stone, perhaps originating among similar stones at Vingen, found in a field at Hennøya almost six kilometres west of Vingen (Bøe 1932).

3 All translations from Norwegian are by the author.

4 Norwegian *husmann* (lit. 'houseman'); tenant who lived and farmed on rented land. He would provide labour in lieu of rent. Another term used on the coast is *strandsitter* (lit. 'shoresitter'), for a similar tenant living close to the sea and living primarily off fishing.

5 For a more detailed rendering of the history of discovery and documentation of the rock art, see Mandt (1999).

6 Figures are based on the classification of currently accessible material from publications and from Egil Bakka's unpublished records in Bergen Museum's archives.

7 Recorded through the work of individual researchers and students, and as part of the Norwegian Directorate for Cultural Heritage's national rock art management project, 'Bergkunstprosjektet'.

8 This discussion is intentionally selective. I refer those wishing to know more about Scandinavian research history to more and less comprehensive overviews of rock art research presented elsewhere (e.g. Mandt 1976, 1980, 1991; Hesjedal 1990; Helskog 1991; Nordbladh 1995; Sognnes 1996a; Hauptman Wahlgren 2000).

9 One notable exception is Ekholm, who regarded all Scandinavian rock art as part of the same *cult of the dead* and not as distinguished by 'race', chronology or meaning; differences were simply expressions of variance in geographical and economical factors influencing the lives of its makers (Ekholm 1916).

10 Brøgger's interpretation is also notable for the social context within which he placed the art. Arctic rock art belonged in Brøgger's (cultural rather than chronological) "Stone Age that lasts until the common use of Iron". In contrast to the 'true' Stone Age dating of Vingen more commonly accepted today, he found (unspecified) motifs there comparable to the "full-blown Bronze Age" Bohuslän rock art in southern Sweden. He therefore linked the Vingen site to the seasonal activities of hunter-gatherer-farmers on the coast (Brøgger 1925: 74ff.). Bøe and Hallström also believed that some of the rock art at Frøysjøen was of Bronze Age date.

11 Gjessing had studied archaeology in Bergen and Oslo under professors Shetelig and Brøgger (Gjessing 1975).

12 The three largest deer – elk, red deer and reindeer – are the most frequently depicted motifs in Fenno-Scandinavian hunter-gatherer rock art. Regional variations correspond well with present-day preferred habitats (Lindqvist 1994: 29). The red deer motif of coastal western Norway therefore appears to be the regional variant of a larger, recurrent theme in hunter-gatherer symbolism. In contrast, the red deer in southern Scandinavian Bronze Age rock art seems to function in a different cosmological context.

13 But for a critical 'outside' approach to this reading, see Blundell (2004: 79) and Smith and Blundell (2004: 248ff.).

14 For a similar example of rock art interpretation, see Olsrud (2001).

15 Meskell (1995: 83) notes that "sound feminist scholarship needs to be divorced from methodological shortcomings, reverse sexism, conflated data and pure fantasy, since this will only impede the feminist cause and draw attention away from the positive contribution offered by gender and feminist archaeologies".

16 Father of J.A. Krogh mentioned earlier, and also a clergyman.

17 Rural Norway was not as isolated from the rest of the world a century ago as we tend to believe. Like Vingen, even the most isolated and remote Norwegian farms usually have a history of emigration to North America, and generations of coastal people experienced the world by joining the merchant navy – for example Helga Vingelven, who ran Vingelven farm until 2001.

18 Helskog (1999), for example, uses northern ethnography to demonstrate the important ritual and mythological significance of the bear in the Alta rock art, though it is not the animal most frequently portrayed.

References

Aaland, J. 1939. *Nordfjord. Frå Gamle Dagar til no. II. Dei Einskilde Bygder.* 4. *Davik.* Sandane: Utgjeve av ei Nemd.

Anthony, D. 1995. Nazi and eco-feminist prehistories: ideology and empiricism in Indo-European archaeology. In: Kohl, P.L. & Fawcett, C. (eds) *Nationalism, Politics and the Practice of Archaeology.* 82–86. Cambridge: Cambridge University Press.

Bakka, E. 1966. To helleristningar frå steinalderen i Hardanger. *Viking* 30: 77–95.

Bakka, E. 1973a. Om alderen på veideristningane. *Viking* 37: 151–187.

Bakka, E. 1973b. Helleristningar i ytre Fjordane. Lecture, 15 January. Unpublished manuscript.

Bakka, E. 1975a. Geologically dated rock carvings at Hammer near Steinkjer in Nord-Trøndelag. *Arkeologiske Skrifter fra Historisk Museum, Universitetet i Bergen* 2: 7–48.

Bakka, E. 1975b. Bergkunst i barskogsbeltet i Sovjetsamveldet. *Viking* 39: 95–124.

Bakka, E. 1979. On shoreline dating of Arctic rock carvings in Vingen, western Norway. *Norwegian Archaeological Review* 12(2): 115–122.

Bang-Andersen, S. 1992. Rennarsundet – en nyoppdaget bergmaling med veidemotiver i Sandnes kommune, Rogaland. *Viking* 55: 55–75.

Baudou, E. 1993. Hällristningarna vid Nämforsen – datering och kulturmiljö. In: Forsberg, L. & Larson, T.B. (eds)

Ekonomi och Näringsformer i Nordisk Bronsålder. 247–261. Umeå: Studia Archaeologica Universitatis Umensis 3.

Baudou, E. 1998. The problem-orientated scientific biography as a research method. *Norwegian Archaeological Review* 31(2): 79–96.

Bayliss-Smith, T. & Mulk, I-M. 1999. Sailing boats in Padjelanta: Sámi rock engravings from the mountains in Laponia, northern Sweden. *Acta Borealia* 16(1): 3–41.

Beach, D.N. 1980. *The Shona and Zimbabwe 900–1850: An Outline of Shona History.* London: Heinemann.

Beckett, S.J. 1935. *A Wayfarer in Norway.* London: Methuen.

Bergsvik, K.A. 2003. Ethnic boundaries in neolithic Norway. Unpublished Dr Art thesis. Bergen: University of Bergen.

Bhila, H.K.H. 1982. *Trade and Politics in a Shona Kingdom.* Harare: Longman.

Biesele, M. 1996. 'He stealthily lightened at his brother-in-law' (and thunder echoes in Bushman oral tradition a century later). In: Deacon, J. & Dowson, T.A. (eds) *Voices from the Past. /Xam Bushmen and the Bleek and Lloyd Collection*: 142–161. Johannesburg: Witwatersrand University Press.

Bing, K. 1912. Helleristningsfund ved gaarden Vingen i Rugsund, Ytre Nordfjord. *Oldtiden* 2: 25–39.

Bjørn, A. 1933. Ny litteratur om de naturalistiske helleristninger. *Naturen* 2: 54–61.

Blehr, O. 1993. On the need for scientific method in archaeology: Nämforsen reconsidered. *Current Swedish Archaeology* 1: 25–31.

Blindheim, M. 1980. Stavkirkeristninger. In: Hjelvik, D.A. & Mikkelsen, E. (eds) *Ristninger i Forhistorie og Middelalder*: 65–72. Oslo: Varia 1, Universitetets Oldsaksamling.

Blundell, G. 2004. *Nqabayo's Nomansland. San Rock Art and the Somatic Past.* Uppsala: Uppsala University, Studies in Global Archaeology 2.

Bøe, J. 1932. *Felszeichnungen im Westlichen Norwegen. I. Die Zeichnungsgebiete in Vingen und Henøya.* Bergen: Bergen Museums Skrifter 15.

Bondevik, K. 1980. Historiske myter og segner. In: Schei, N. (ed.) *Sogn og Fjordane*: 437–450. Oslo: Gyldendal Norsk Forlag.

Bradley, R. 1997. *Rock Art and the Prehistory of Atlantic Europe: Signing the Land.* London & New York: Routledge.

Bradley, R. 2000. *An Archaeology of Natural Places.* London: Routledge.

Brøgger, A.W. 1906. Elg og ren paa helleristninger i det nordlige Norge. *Naturen*: 356–360.

Brøgger, A.W. 1917a. Unpublished letter to Haakon Shetelig, Kristiana 27 June 1917. Bergen Museum archives.

Brøgger, A.W. 1917b. Unpublished letter to Gustaf Hallström, Kristiania 27 June 1917. Bergen Museum archives.

Brøgger, A.W. 1925. *Det Norske Folk i Oldtiden*. Oslo: H. Aschehoug (W. Nygaard), the Institute for Comparative Research in Human Culture Series A: VIa.

Bull, R. 1999. *Søndfjord – Ufruktbare Klipper og Bjergtroldets Boliger? Utdrag av Hans Arentz Manus 'Beskrivelse over Søndfjord i det Nordre Bergenhusiske Amt' Anno 1785*. Oslo: Det Norske Samlaget.

Chippindale, C. & Nash, G. 2004. *The Figured Landscapes of Rock Art: Looking at Pictures in Place*. Cambridge: Cambridge University Press.

Chippindale, C., Smith, B.W. & Taçon, P.S.C. 2000. Visions of dynamic power: Archaic rock paintings, altered states of consciousness and 'clever men' in western Arnhemland (NT), Australia. *Cambridge Archaeological Journal* 10(1): 63–101.

Chippindale, C. & Taçon, P.S.C. 1998. An archaeology of rock art through informed methods and formal methods. In: Chippindale, C. & Taçon, P.S.C. (eds) *The Archaeology of Rock-Art*: 1–10. Cambridge: Cambridge University Press.

Christensen, A.E. 1980. Ristninger fra nyere tid – noen tanker om motivkrets. In: Hjelvik, D.A. & Mikkelsen, E. (eds) *Ristninger i Forhistorie og Middelalder*: 75–88. Oslo: Varia 1, Universitetets Oldsaksamling.

Clottes, J. & Lewis-Williams, J.D. 1996. *Les Chamanes de la Préhistoire: Transe et Magie dans les Grottes Ornées*. Paris: Éditions Seuil.

Conkey, M.W. 1997. Beyond art and between the caves: thinking about context in the interpretive context. In: Conkey, M.W., Soffer, O., Stratmann, D. & Jablonski, N. (eds) *Beyond Art: Pleistocene Image and Symbol*: 343–367. San Francisco (CA): California Academy of Sciences, Memoir 23.

Conkey, M.W. & Tringham, R. 1996. Cultivating thinking/challenging authority: Some experiments in feminist pedagogy in archaeology. In: Wright, R.P. (ed.) *Gender and Archaeology*: 224–250. Philadelphia: University of Pennsylvania Press.

Conkey, M.W. & Tringham, R. 1998. Rethinking figurines: a critical view from archaeology of Gimbutas, the 'Goddess' and popular culture. In: Goodison, L. & Morris, C. (eds) *Ancient Goddesses: The Myths and the Evidence*: 22–45. London: British Museum Press.

Deacon, J. & Dowson, T.A. (eds) 1996 *Voices from the Past. /Xam Bushmen and the Bleek and Lloyd Collection*. Johannesburg: Witwatersrand University Press.

Dowson, T.A. & Lewis-Williams, J.D. (eds) 1994. *Contested Images: Diversity in Southern African Rock Art Research*. Johannesburg: Witwatersrand University Press.

Ekholm, G. 1916. De skandinaviska hällristningarna och deras betydelse. *Ymer* 4: 21–308.

Engelstad, E. 1932. Den nye 'arktiske' hellerristning i Drammen. *Universitetets Oldsaksamling Årbok* 1930: 36–50.

Engelstad, E. 1934. *Østnorske Ristninger og Malinger av den Arktiske Gruppe*. Oslo: H. Aschehoug & Co. (W. Nygaard), the Institute for Comparative Research in Human Culture, Series B: 26.

Fett, P. 1938. Helleristninger – særlig på Vestlandet. *Naturen* 10: 305–316.

Fett, P. 1941. Nye ristningar i Nordfjord. Vingelva og Fura. *Bergen Museums Årbok 1941, Historisk-antikvarisk Rekke* 6: 1–9.

Forsberg, L. 1993. En kronologisk analys av ristningarna vid Nämforsen. In: Forsberg, L. & Larson, T.B. (eds) *Ekonomi och Näringsformer i Nordisk Bronsålder*: 195–246. Umeå: Studia Archaeologica Universitatis Umensis 3.

Forsberg, L. 2000. The social context of rock art in Middle Scandinavia during the Neolithic. In: Kare, A. (ed.) *Myandash: Rock Art in the Ancient Arctic*: 50–87. Rovaniemi: Arctic Centre Foundation.

Gazin-Schwartz, A. & Holtorf, C. (eds) 1999. *Archaeology and Folklore*. London: Routledge.

Gjessing, D. 1937. Tolkningen av vår steinalders helleristninger. *Naturen* 10: 302–310.

Gjessing, G. 1932. *Arktiske Helleristninger i Nord-Norge*. Oslo: H. Aschehoug & Co. (W. Nygaard), the Institute for Comparative Research in Human Culture, Series B: 21.

Gjessing, G. 1936. *Nordenfjelske Ristninger og Malinger av den Arktiske Gruppe*. Oslo: H. Aschehoug & Co. (W. Nygaard), the Institute for Comparative Research in Human Culture, Series B: 30.

Gjessing, G. 1941. Arktisk og sørskandianviask i Nord-Norges yngre steinalder. *Viking* 5: 75–116.

Gjessing, G. 1944. *Circumpolar Stone Age*. Copenhagen: Ejnar Munksgaard, Acta Arctica.

Gjessing, G. 1945. *Norges Steinalder*. Oslo: Norsk arkeologisk selskap.

Gjessing, G. 1951. Arkeologi og etnografi. *Viking* 15: 215–235.

Gjessing, G. 1975. Nye signal i arkeologien. *Arkeologiske Skrifter fra Historisk Museum, Universitetet i Bergen* 2: 49–71.

Gjessing, G. 1978. Rock pictures in northern Fenno-Scandia and their eastern affinities. In: Marstrander, S. (ed.) *Acts of the International Symposium on Rock Art*: 14–30. Oslo: Norwegian University Press, the Institute for Comparative Research in Human Culture, Series A: 29.

Goldhahn, J. 2002. Roaring rocks: an audio-visual perspective on hunter-gatherer engravings in northern Sweden and Scandinavia. *Norwegian Archaeological Review* 35(1): 29–61.

Goodman, E.J. 1892. *The Best Tour in Norway*. London: Sampson Low, Marston.

Grønnesby, G. 1998. Skandinaviske helleristninger og rituell bruk av transe. *Arkeologiske Skrifter fra Universitetet i Bergen* 9: 59–82.

Haaland, G. & Haaland, R. 1995. Who speaks the goddess's language: imagination and method in archaeological research. *Norwegian Archaeological Review* 28(2): 105–121.

Hætta, O.M. 1995. Rock carvings in a Saami perspective: some comments on politics and ethnicity in archaeology. In: Helskog, K. & Olsen, B. (eds) *Perceiving Rock Art: Social and Political Perspectives:* 348–356. Oslo: Novus Forlag, the Institute for Comparative Research in Human Culture, Series B: 42.

Hagen, A. 1970. *Studier i Vest-norsk Bergkunst. Ausevik i Flora.* Bergen: Norwegian University Press.

Hagen, A. 1976. *Bergkunst. Jegerfolkets Helleristninger og Malinger i Norsk Steinalder.* Oslo: J.W. Cappelens Forlag.

Hagen, A. 1989. Veidekunsten i Vingen – en idéskisse. *ARKEO* 2: 4–11.

Hagen, A. 1990. *Helleristningar i Noreg.* Oslo: Det Norske Samlaget.

Hagen, A. & Liestøl, A. 1947. Storhedder. *Viking* 10: 141–233.

Hallström, G. 1907a. Hällristningar i norra Skandinavien. *Ymer* 3: 211–227.

Hallström, G. 1907b. Nordskandinaviska hällristningar. *Fornvännen* 2: 160–189.

Hallström, G. 1908. Nordskandinaviska hällristningar. II. De norska ristningarna. *Fornvännen* 3: 47–86.

Hallström, G. 1909. Nordskandinaviska hällristningar. II. De norska ristningarna (Forts.). *Fornvännen* 4: 126–159.

Hallström, G. 1938. *Monumental Art of Northern Europe from the Stone Age I: The Norwegian Localities.* Stockholm: Almqvist & Wiksell.

Hallström, G. 1943. En nyupptäckt svensk hällmålning. *Fornvännen* 38: 146–161.

Hallström, G. 1960. *Monumental Art of Northern Sweden from the Stone Age 2: Nämforsen and Other Localities.* Stockholm: Almqvist & Wiksell.

Hansen, A.M. 1904. *Landnåm i Norge. En Udsigt Over Bosætningens Historie.* Kristiania: W.C. Fabritius & Sønner.

Hauptman Wahlgren, K. 2000. The lonesome sailing ship: reflections on the rock carvings of Sweden and their interpreters. *Current Swedish Archaeology* 8: 67–96.

Heaton Cooper, A. 1907. *The Norwegian Fjords.* London: Adam and Charles Black.

Helle, T. 1990. *Kulturlandskap og Kulturmarkstypar i Bremanger Kommune.* Sogndal: Sogn og Fjordane distriktshøgskule skrifter 1990: 2, Kulturlandskap og Kulturmarkstypar i Sogn og Fjordane, Bruk og vern 9.

Helskog, K. 1987. Selective depictions: a study of 3700 years of rock carvings and their relationship to the Sami Drums. In: Hodder, I. (ed.) *Archaeology as Long-term History.* 17–30. Cambridge: Cambridge University Press.

Helskog, K. 1991. Fra tvangstrøyer til 90-åras pluralisme i helleristningsforskning. In: Prescott, C. & Solberg, B.

(eds) *Nordic TAG: Report from the Third Nordic TAG Conference 1990:* 70–75. Bergen: Historisk Museum, University of Bergen.

Helskog, K. 1995. Maleness and femaleness in the sky and the underworld – and in between. In: Helskog, K. & Olsen, B. (eds) *Perceiving Rock Art: Social and Political Perspectives:* 247–262. Oslo: Novus Forlag, the Institute for Comparative Research in Human Culture, Series B: 42.

Helskog, K. 1999. The shore connection: cognitive landscape and communication with rock carvings in northernmost Europe. *Norwegian Archaeological Review* 32(2): 73–94.

Hesjedal, A. 1990. Helleristninger som tegn og tekst. En analyse av veideristningene i Nordland og Troms. Unpublished Mag. Art. thesis. Tromsø: University of Tromsø.

Hesjedal, A. 1994. The hunters' rock art in northern Norway: problems of chronology and interpretation. *Norwegian Archaeological Review* 27(1): 1–14.

Hodder, I. 1999. *The Archaeological Process.* Oxford: Blackwell.

Hoffman, W.J. 1891. The Midé'wiwin or 'Grand medicine society' of the Ojibwa. In: *Seventh Annual Report of the Bureau of Ethnology 1885–1886:* 143–299. Washington (DC): Government Printing Office.

Hood, B.C. 1988. Sacred pictures, sacred rocks: ideological and social space in the North Norwegian Stone Age. *Norwegian Archaeological Review* 21(2): 65–84.

Hultkranz, Å. 1986. Rock drawings as evidence of religion: some principal points of view. In: Steinsland, G. (ed.) *Words and Objects: Towards a Dialogue Between Archaeology and History of Religion:* 43–66. Oslo: Norwegian University Press, the Institute for Comparative Research in Human Culture, Series B: 71.

Hultkrantz, Å. 1989. Hällristningsreligion. In: Janson, S., Lundberg, E.B. & Bertilsson, U. (eds) *Hällristningar och Hällmålningar i Sverige:* 43–58. Sweden: Forum.

Insoll, T. 2004. *Archaeology, Ritual, Religion.* London & New York: Routledge.

Jolly, P. 1998. Modelling change in the contact art of the south-eastern San, southern Africa. In: Chippindale, C. & Taçon, P.S.C. (eds) *The Archaeology of Rock-Art:* 247–267. Cambridge: Cambridge University Press.

Katz, R., Biesele, M. & St. Denis, V. 1997. *Healing Makes our Hearts Happy. Spirituality and Cultural Transformation Among the Kalahari Ju/'hoansi.* Rochester, Vermont: Inner Traditions International.

Klindt-Jensen, O. 1975. *A History of Scandinavian Archaeology.* London: Thames and Hudson.

Krogh, J.A. 1813. Efterretninger om provstiet Nordfjord i Bergens stift i Norge: af en beskrivelse over bemeldte prostie, forfattet i i haandskrift efterladt. In: Krogh, J.A. (ed.) *Topographisk-Statistiske Samlinger Udgivne av det Kongelige Selskab for Norges Vel. Anden dels Første Bind.* Christiania: C. Grøndahl.

Kühn, H. 1956. *The Rock Pictures of Europe*. London: Sidgwick and Jason.

Lahelma, A. 2005. Between the worlds: rock art, landscape and shamanism in Subneolithic Finland. *Norwegian Archaeological Review* 38(1): 29–47.

Layton, R. 1985. The cultural context of hunter-gatherer rock art. *Man* 20: 434–453.

Layton, R. 1999. Folklore and world view. In: Gazin-Schwartz, A. & Holtorf, C. (eds) *Archaeology & Folklore*: 26–34. London: Routledge.

Lefdal, L.P. 1936. Davik, bygd og folk. In: Aardalsbakke, H., Førde R. & Indredavik, H. (eds) *Davik Herad 1837–1937*. Sandane: R. Søreides Prenteverk.

Lewis-Williams, J.D. 1981. *Believing and Seeing: Symbolic Meanings in Southern San Rock Paintings*. London: Academic Press.

Lewis-Williams, J.D. 1991. Wrestling with analogy: a methodological dilemma in Upper Palaeolithic art research. *Proceedings of the Prehistoric Society* 57(1): 149–162.

Lewis-Williams, J.D. 1995. ACRA: a retrospect. In: Helskog, K. & Olsen, B. (eds) *Perceiving Rock Art: Social and Political Perspectives*: 409–415. Oslo: Novus Forlag, the Institute for Comparative Research in Human Culture, Series B: 42.

Lewis-Williams, J.D. 1997. Harnessing the brain: vision and shamanism in Upper Paleolithic western Europe. In: Conkey, M.W., Soffer, O., Stratmann, D. & Jablonski, N. (eds) *Beyond Art: Pleistocene Image and Symbol*: 321–342. San Francisco (CA): California Academy of Sciences, Memoir 23.

Lewis-Williams, J.D. 2002. *A Cosmos in Stone. Interpreting Religion and Society Through Rock Art*. Walnut Creek (CA): AltaMira Press.

Lindqvist, C. 1994. *Fångsfolkets Bilder. En Studie av de Nordfennoskandiska Kustanknutna Jägarhällristningarna*. Stockholm: Akademitryck AB, Theses and Papers in Archaeology N.S. A5.

Lødøen, T.K. 2001. Contextualising rock art in order to investigate Stone Age ideology. Results from an ongoing project. In: Helskog, K. (ed.) *Theoretical Perspectives in Rock Art Research*: 211–223. Oslo: Novus Forlag, the Institute for Comparative Research in Human Culture, Series B: CVI.

Lødøen, T.K. 2003. Late Mesolithic rock art and expressions of ideology. In: Larsson, L., Kindgren, H., Knutsson, K., Loeffler, D. & Åkerlund, A. (eds) *Mesolithic on the Move. Papers Presented at the Sixth International Conference on the Mesolithic in Europe, Stockholm 2000*: 511–520. Oxford: Oxbow Books.

Loen, A.O. 1893. *Fra Nordfjord: Bygdesagn, Folketro, Skrøner etc.* Nordfjordeid: Eget Forlag.

Lote, A. 1981. 40 'hemmelege' helleristninger [interview with Helga Vingelven]. *Sunnmørsposten* 16 June.

Mandt, G. 1976. Helleristninger gjennom 150 år. En funnhistorie i forskningshistorisk sammenheng. *Viking* 39: 61–95.

Mandt, G. 1980. Ristningsstudiet i forskningshistorisk lys. Hvilke veger fører framover? In: Hjelvik, D.A. & Mikkelsen, E. (eds) *Ristninger i Forhistorie og Middelalder*. 1–17. Oslo: Varia 1, Universitetets Oldsaksamling.

Mandt, G. 1991. Vestnorske ristninger i tid og rom. Kronologiske, korologiske og kontekstuelle studier (I & II). Unpublished PhD thesis. Bergen: University of Bergen.

Mandt, G. 1995. Alternative analogies in rock art interpretation: the west Norwegian case. In: Helskog, K. & Olsen, B. (eds) *Perceiving Rock Art: Social and Political Perspectives*: 263–291. Oslo: Novus Forlag, the Institute for Comparative Research in Human Culture, Series B: 42.

Mandt, G. 1996. Material culture and myth: snake symbolism in Nordic prehistory. *KAN* 21: 125–137.

Mandt, G. 1998. Vingen revisited: a gendered perspective on 'hunters' rock art. In: Larsson, L. & Stjärnquist, B. (eds) *The World-view of Prehistoric Man*: 201–224. Stockholm: Kungl, Vitterhets Historie och Antikvitets Akademien, Konferenser 40.

Mandt, G. 1999. Tilbakeblikk på Vingen – forskning – forvaltning – næring. In: Gustafsson, A. & Karlsson, H. (eds) *Glyfer och Arkeologiska Rum – en Vänbok till Jarl Nordbladh*: 53–77. Gothenburg: Gotarc, Series A 3.

Mandt, G. 2001. Women in disguise or male manipulation? Aspects of gender symbolism in rock art. In: Helskog, K. (ed.) *Theoretical Perspectives in Rock Art Research*: 290–311. Oslo: Novus Forlag, the Institute for Comparative Research in Human Culture, Series B: CVI.

Mandt, G. & Lødøen, T.K. 2005. *Bergkunst. Helleristningar i Norge*. Oslo: Det Norske Samlaget.

Marstrander, S. 1986. Ved 100-årsdagen for Anton Wilhelm Brøggers fødsel. 1884 – 11 Oktober. *Universitetets Oldsaksamling Årbok* 1984/1985: 7–16.

Meskell, L. 1995. Goddesses, Gimbutas and 'new age' archaeology. *Antiquity* 69: 74–86.

Mézec, B. 1989. A structural analysis of the Late Stone-Age engravings at Vingen, Norway. Unpublished MA thesis. London: University College London.

Michelet, J. 1980. Fossekraft – storindustri. In: Schei, N. (ed.) *Sogn og Fjordane*: 324–345. Oslo: Gyldendal Norsk Forlag.

Mikkelsen, E. 1977. Østnorske veideristninger – kronologi og øko-kulturelt miljø. *Viking* 40: 147–201.

Mikkelsen, E. 1981. Veideristninger ved Geithus, Modum, Buskerud. *Universitetets Oldsaksamling Årbok* 1980/1981: 35–52.

Mikkelsen, E. 1986. Religion and ecology: motifs and locations of hunters' rock carvings in eastern Norway. In: Steinsland, G. (ed.) *Words and Objects: Towards a Dialogue Between Archaeology and History of Religion*: 127–141.

Oslo: Norwegian University Press, the Institute for Comparative Research in Human Culture, Series B: 71.

Nash, G. & Chippindale, C. 2002. *European Landscapes of Rock Art*. London & New York: Routledge.

Nielsen, Y. 1909. *Erindringer Fra et Halvt Aarhundredes Vandreliv*. Kristiania: Gyldendalske Boghandel Nordisk Forlag.

Nordbladh, J. 1995. The history of Scandinavian rock art research as a corpus of knowledge and practice. In: Helskog, K. & Olsen, B. (eds) *Perceiving Rock Art: Social and Political Perspectives*. 23–34. Oslo: Novus Forlag, the Institute for Comparative Research in Human Culture, Series B: 42.

Nordbotten, O. 1966. Fisket. In: Frøyen, K., Monsen, M. & Hauge, E. (eds) *Bremanger Herad 1866–1966: Et Hundreårsskrift*: 82–111. Bremanger: Bremanger Sogenemnd.

Odner, K. 2000. *Tradition and Transmission. Bantu, Indo-European and Circumpolar Great Traditions*. Bergen: Norse publications, Bergen Studies in Social Anthropology 54.

Ohnstad, A. 1980. Driftehandel. In: Schei, N. (ed.) *Sogn og Fjordane*: 226–241. Oslo: Gyldendal Norsk Forlag.

Olsrud, I-M. 2001. Symbols in earth and stone. Landscape as a source to understanding rock art. In: Helskog, K. (ed.) *Theoretical Perspectives in Rock Art Research*: 251–259. Oslo: Novus Forlag, the Institute for Comparative Research in Human Culture, Series B: CVI.

Ouzman, S. 1999. 'KOEKA KA KIE, HENTS OP BOKKOR OF IK SCHIET!': introducing the rock art of the South African Anglo-Boer War, 1899–1902. *The Digging Stick* 16(3): 1–5.

Prescott, C. & Walderhaug, E.M. 1995. The last frontier? Processes of Indo-Europeanization in northern Europe: the Norwegian case. *The Journal of Indo-European Studies* 23(3/4): 257–278.

Ramqvist, P.H., Forsberg, L. & Backe, M. 1985. ... and here was an elk too ... A preliminary report on new petroglyphs at Stornorrfors, Ume River. *Archaeology and Environment* 4: 313–337.

Rimstad, J. 1936. Jordbruket med nærskylde næringsvegar. In: Aardalsbakke, H., Førde, R. & Indredavik, H. (eds) *Davik Herad 1837–1937*: 57–61. Sandane: R. Søreides Prenteverk.

Sætersdal, T. 2004. Places, people and ancestors. Archaeology and society in Manica, Mozambique. Unpublished PhD thesis. Bergen: Bergen University.

Sande, A. 1981. Tolvåringen som skaut bjørn i Svelgsdalen. In: Endel, H.E. (ed.) *Gamalt frå Bremanger*: 213–223. Bremanger: Bremanger Sogelag.

Shee Twohig, E. 1998. A 'mother goddess' in North-West Europe c. 4200–2500 B.C.? In: Goodison, L. & Morris, C. (ed.) *Ancient Goddesses: The Myths and the Evidence*: 164–179. London: British Museum Press.

Shetelig, H. 1921. Steinalders-kunst i Noreg. *Norsk Aarbok* 1921: 2–20.

Shetelig, H. 1922. *Primitive Tider i Norge: En Oversigt over Stenalderen*. Bergen: John Griegs Forlag.

Shetelig, H. 1925. *Norges Forhistorie. Problemer og Resultater i Norsk Arkeologi*. Oslo: H. Aschehoug (W. Nygaard), the Institute for Comparative Research in Human Culture, Series A.

Shetelig, H. 1930. *Det Norske Folks Liv og Historie Gjennem Tidene. Fra Oldtiden til Omkring 1000 e. Kr.* Oslo: H. Aschehoug.

Simonsen, P. 1958. *Arktiske Helleristninger i Nord-Norge* II. Oslo: H. Aschehoug (W. Nygaard), the Institute for Comparative Research in Human Culture, Series B: 49.

Simonsen, P. 1986. The magic picture: used once or more times? In: Steinsland, G. (ed.) *Words and Objects: Towards a Dialogue Between Archaeology and History of Religion*: 197–211. Oslo: Norwegian University Press, the Institute for Comparative Research in Human Culture, Series B: 71.

Simpson, H. 1912. *Rambles in Norway*. London: Mills & Boon Limited.

Smith, B.W. & Blundell, G. 2004. Dangerous ground: a critique of landscape in rock art studies. In: Chippindale, C. & Nash, G. (eds) *The Figured Landscapes of Rock Art: Looking at Pictures in Place*: 239–262. Cambridge: Cambridge University Press.

Sognnes, K. 1994. Ritual landscapes: toward a reinterpretation of Stone Age rock art in Trøndelag, Norway. *Norwegian Archaeological Review* 27(1): 29–50.

Sognnes, K. 1996a. Recent rock art research in northern Europe. In: Bahn, P. & Fossati, A. (eds) *Rock Art Studies: News of the World* 1: 15–28. Oxford: Oxbow Monograph 72.

Sognnes, K. 1996b. Dyresymbolikk i midt-norsk yngre steinalder. *Viking* 59: 25–44.

Sognnes, K. (ed.) 2004. *Rock Art in Landscapes – Landscapes in Rock Art*. Trondheim: Tapir, Det Kongelige Norske Videnskabers Selskabs Skrifter 2003(4).

Stoffle, R.W., Loendorf, L., Austin, D.E., Halmo, D.B. & Bulletts, A. 2000. Ghost dancing the Grand Canyon. Southern Paiute rock art, ceremony, and cultural landscapes. *Current Anthropology* 41(1): 11–24.

Stone, O.M. 1882. *Norway in June*. London: Marcus Ward.

Storm Borchgrevink, L. 1956. *Frå ei Anna Tid. Folkeminne frå Nordfjord*. Oslo: Norsk Folkeminnelag 78.

Sturluson, S. 1995. *Norges Kongesagaer* I [based on Gustav Storm's translation (1899)]. Norway: Libri Arte.

Tilley, C. 1991. *Material Culture and Text: The Art of Ambiguity*. London & New York: Routledge.

Vanberg, D. 1988. *Vingen. Frå Gardssamfunn til Landskapsvernområde*. Bremanger: Bremanger Kommune.

Vingelven, T. 1989. Frå steinalderfolk til bureisar. *Fjordenes Tidende* (6 October): 8–9.

Vingelven, T. n.d. a. Torskefiske med snøre og garn. Unpublished manuscript.

Vingelven, T. n.d. b. Sildefiske med landnot. Unpublished manuscript.

Vinnicombe, P. 1976. *People of the Eland: Rock Paintings of the Drakensberg Bushmen as a Reflection of Their Life and Thought.* Pietermaritzburg: University of Natal Press.

Viste, S. 2003. Bildene forteller – sjamanistiske element i veideristningene fra Vingen og Ausevik? Unpublished Cand. Philol. thesis. Bergen: Bergen University.

Walderhaug, E.M. 1994. 'Ansiktet er av stein'. Ausevik i Flora – en analyse av bergkunst og kontekst. Unpublished Cand. Philol. thesis. Bergen: Bergen University.

Walderhaug, E.M. 1996. A view from afar: a comparative approach to rock art interpretation. In: Pwiti, G. & Soper, R. (eds) *Aspects of African Archaeology*: 355–360. Harare: University of Zimbabwe Publications.

Walderhaug, E.M. 1998. Changing art in a changing society: the hunter's rock art of western Norway. In: Chippindale, C. & Taçon, P.S.C. (eds) *The Archaeology of Rock-Art*: 285–301. Cambridge: Cambridge University Press.

Walderhaug, E.M. 2000. Some reflections on the implications of form, context and function in rock art studies. In: Olausson, D. & Vankilde, H. (eds) *Form, Function & Context: Material Culture Studies in Scandinavian Archaeology*: 59–69. Stockholm: Almqvist & Wiksell International, Acta Archaeologica Lundensia Series 8, 31.

Walderhaug Sætersdal, E.M. 2000. Ethics, politics and practices in rock art conservation. *Public Archaeology* 1(3): 163–180.

Whitley, D.S., Dorn, R.I., Simon, J.M., Rechtman, R. & Whitley, T.K. 1999. Sally's rockshelter and the archaeology of the vision quest. *Cambridge Archaeological Journal* 9(2): 221–247.

Wingen, P. 1972. Unpublished letter to Historisk Museum, University of Bergen, 16 March. Bergen Museum archives.

Wingen, P. 1977. Unpublished letter to Bremanger county administration, 16 March. Bergen Museum archives.

Wood, C.W. 1903. *Norwegian By-ways*. London: Macmillan and Co. Limited.

Wyllie, M.A. 1907. *Norway and its Fjords*. London: Methuen.

FIGURE 14.1 Visual representation of the 'story in my body' pattern typical of oral tradition. Note the continuous nature and malleability of the pattern. *(Drawing by P. Vinnicombe)*

14.

'Meaning cannot rest or stay the same'

PATRICIA VINNICOMBE[1]

'WHAT IS THE MEANING OF YOUR WORK?'

After the publication of *People of the Eland* in 1976 (Vinnicombe 1976), followed by the presentation of David Lewis-Williams' thesis *Believing and Seeing* the following year, there were still limitations to the hypotheses presented: there were no San people left of whom one could ask directly – "What is the meaning of your work?" Accordingly, I set off for Australia in 1977 where Aboriginal people still paint, and where there is a profound knowledge of that world view that has produced a wide range of rock paintings and engravings. I have been privileged, over the years that have elapsed since that momentous decision, to have periodically worked with Aboriginal groups in Western Australia who have greatly broadened my understanding and stimulated my thinking. I bring

some facets of this Australian experience to how I now perceive San rock art and the theories that have contributed to our understanding of it.

In attempting to document these insights, some of them salutary, all of them mind-expanding, it is difficult to know where to begin and where to end. This is a matter of concern to us westerners whose thinking has been structured by the rigorous patterning of the written word with all its prescribed sequences of letters and words strung together in logical progression. However, to people whose principal forms of communication depend not on writing but on speech, this sequencing would matter not one whit. For example, attempting to write down myths and stories from an oral tradition can often become a frustrating experience. The information is given incrementally – depending on the circumstances, and depending on the teller's mood and

perception of how ready the listener is to understand or to appreciate the information. The 'story', in our terms, may start at any point in the narrative, and may, quite literally, be told in segments over a period of years. "Why didn't you tell me that before?" I cry when, in Aboriginal Australia, I am at last told of a key episode or concept that, to my mind, makes sense of an otherwise seemingly disparate array of factors. "All same story," they reply, looking baffled.

We westerners are always looking for the 'full story', the 'whole answer', the 'complete myth', and the 'correct sequence' in which events happened. What is more, we want the story all at once, not in dribs and drabs over a period of time. And when finally we collect sufficient written information to satisfy our alphabetically oriented minds, we insist on reordering what we have been told according to our categories, *our* logic. It is of note that Orpen, on whose written work we base so much of our interpretation of southern San rock art, reports that he "strung together" his Bushman informant's "fragmentary stories" and made them "consecutive" (Orpen 1874: 3; Lewis-Williams 1998a: 92).

FLUIDITY OF ORAL TRADITION

The pattern of oral tradition is fluid and malleable – it is a continuous pattern with no beginning and no ending (Figure 14.1). As westerners, we pick up the elastic threads in what seems to us an incoherent pattern and then force the spoken sounds into A, B, C and D. Having done that, we chop the new pattern into fixed words, sequential paragraphs and chapter headings, proceeding logically from introduction, through content, and finally to conclusion. Our dependency on the written word and the fixed order into which we place these letters can be a source of bemusement, and indeed amusement, to many preliterate people. One of my Aboriginal collaborators, a Kija philosopher and spiritual leader by the name of Hector, has a family name, Jandany, that is difficult for a westerner to pronounce and has accordingly been written in numerous different ways. Hector has latterly become an artist of some note, but his works, now represented in many Australian and overseas galleries, are listed under widely varying spellings of his name. I brought this to his attention and asked him

under which name he would prefer to be known. "That's white fella business," was his mildly rebuking reply. "I know who I am!"

How liberating to be so impervious to the labels meted out by other people!

When in Hector's company, I often dive for my notebook, scribble down words, and look up back pages for a previous explanation. He pities my lack of memory, my dependency on these marks on pieces of paper. "You got story in book," he smiles wryly, "I got story in body."

This dichotomy between 'book' and 'body' is a crucial and important factor influencing differences in world view. In my opinion, it is a dichotomy over which we 'literates', who try to understand the thought processes of preliterate people, are forever floundering. We try to bridge the gap but we are continually being 'led by the nose' in the direction of our own cultural perceptions, rather than those of the people about whom we are writing. We are often more preoccupied with academic acceptance than with an empathetic understanding of concepts that are not necessarily compatible with our own.

With the written word, those of us who are literate are forever labelling, categorising, drawing lines and making hard and fast divisions. In so doing, we not only sort the knowledge into categories we prefer and structures we are comfortable with, but we also often change the knowledge. To Confucius is attributed the sage idiom: "Black ink on white paper. Full stop." When you carry information in your 'body', on the other hand, it is all one malleable, readily adaptable, ongoing, functional whole.

Working with Aboriginal people in Australia, I am continually reminded of the fundamental differences in world view that may be attributed to lines and full stops.

Take, for instance, the division we Europeans draw between what is cultural and what is natural: a painting is cultural, while pigmentation in the rock resulting from mineralisation is natural. An Aboriginal person, on the other hand, will take you to see a 'painted' site that turns out to be what we would call 'natural' rock staining, or an 'engraved' site which will be no more than a natural indentation or protuberance in the rock face. Or there may be a combination of both 'natural' and 'cultural' features, but to the Aboriginal person, they are all manifestations of the same power – marks left by the ancestral spirits.

Indeed, all rock art originates from the spirit world, according to the belief system of the Aboriginal people. The images were already in the rock before animals were men and men were animals. Humans are simply the custodians of the images – humans look after them and maintain, or manipulate, the power the images contain. So if you ask an Aboriginal person the million-dollar question that I went all the way to Australia to ask – "Why do you make these paintings?" – the eventual answer is that people did not make them! The images were put there by an ancestral power as a template, a source of concentrated power, to show people how to live and to help them control threats to their continued existence.

I may add that in Australia the images, painted or engraved, are considered to be active and alive, and they are talked to as though they were real. Before strangers are taken to a site, permission is sought by shouting from afar and, on entering the precinct, the stranger is introduced with an explanation of where they come from, which language they speak, and the purpose of the visit. The newcomer is often asked to deposit leaves that have been wiped under the armpit, so that the images will recognise the smell of the stranger's perspiration on a future visit.

When on a recent survey in a richly engraved area on the Burrup Peninsula in Western Australia, I had with me an Ngarluma elder, Kennie Jerrold. We came upon what was to me a very ordinary and rather crudely pecked image of a fat human figure in the frontal position, arms upheld and legs bent outwards. Kennie immediately burst into song, clicking the rhythm on the boulder with his fingernails. "That's Yagoli," he announced. "That's Turtle. He used to be Man before. That's his song. We sing it at initiation for boys. Boys not allowed to eat that one, you know, before they made men."

Singing, incidentally, is frequently the first response that is made to a rock painting or engraving, and I am often reminded of Stow's description of the old Bushman couple whose response to seeing rock paintings was to sing and dance (Stow 1905: 103), and to the Bleek's own testimony that dancing, music and singing were their delight, and that the Bushman narratives they recorded were often interspersed with songs which "had a most dramatic effect" when performed with appropriate tones and gestures (Bleek & Bleek 1909: 36, 37; Lewis-Williams 2004: 27). But

to return to the Aboriginal elder on the Burrup Peninsula. When I asked if I could photograph the engraved figure, he agreed; but when I started to attach the coloured scale to the rock, he bent over the engraving in a solicitous fashion, with the assurance: "It's all right, Yagoli. She's just putting something pretty next to you!"

IMAGES ARE REAL

These images on the rocks are real, and one treats them with the same respect that should be accorded to humans. You do not just 'do' things to them without permission and without explanation. I was suddenly and overwhelmingly aware of all the thousands of Bushman paintings I had previously recorded, without permission or introduction, without discussion or explanation. I like to think, however, that there was some exchange of dialogue between them and me, even if it was not spoken out loud.

The lack of differentiation between the real and the non-real, and between what is natural and what is cultural, stems from the even more fundamental lack of differentiation between the material and the spiritual, or the concrete as opposed to the numinous, in the minds of both the Aborigines and the Bushmen (see Lewis-Williams 2004: 7).

In the north of Western Australia, three tribes of Aboriginal people were moved from their traditional homelands in the Kimberley and herded into a community called Mowanjum, meaning, ironically, 'settled at last'. Here lives a remarkable old woman, Patsy Angubirra, calculated to be about 100 years old, who remembers the first white missionaries arriving in the Kimberley in 1911. Her husband, who was already deceased by the time I arrived on the scene in 1980, was the last really powerful Barnman, or spiritual broker, who had lived a traditional lifestyle in the Kimberley. Among his special talents were gifts of healing and reading signs that either foretold the future or described what had already happened in distant places. He could also control weather: he could make rain fall, dispel rain and disperse cyclones, and he could make lightning strike where he wanted it to strike and thus frighten people or even punish them with death. I also established that he had visited painted sites quite often, and that he was the custo-

dian of the songs for the sites in his territory. I ascertained the name of the ancestral Wandjina figure that was painted in the rock shelter from which his spirit and his name derived. Needless to say, my antennae quivered: if I wanted information on how this ritual specialist manipulated power, and what connection he had with the prolific painted sites in the area, who better to work with than his wife? That was mistake number one – followed, I may add, by many more.

Patsy's English is limited, but there were other women in her language group, Worora, who spoke good English and who could translate. So we had session after session sitting on the ground with a tape recorder in our midst, reminiscing about the past and relating anecdotes, always with much laughter and often interspersed with singing. This, I persuaded myself, was establishing good contact and an atmosphere of trust. However, whenever I addressed a question to Patsy about the activities of her husband, she hung her head and looked away. The other women gave a peremptory answer on her behalf, and the conversation shifted in other directions. It was a long time, I am now ashamed to admit, before it dawned on me that Aboriginal widows are not allowed to speak of their husbands after they are dead. Most of the information I was able to obtain about Patsy's husband was therefore gleaned in Patsy's absence.

I was told that her Barnman husband had died during an intense thunder and lightning storm that he had induced through his control of power. "He jumped over the wire and that killed him," I was told. "What a tragedy," I thought, "How ironic that he should be electrocuted by lightning when he was attributed with such power over lightning." Some years later, I was talking to a European doctor who had practised in the area for many years, and who had known Patsy's husband personally. I recounted the irony of his death. "Nonsense," replied the doctor. "He died in hospital of a respiratory disorder."

With great tact, I brought up the subject of the death of Patsy's husband once more among the group of women. Yes, he died in hospital, but it was at a time when a "big lightning" had hit the ground. In their view, he had, during his last moments of life, jumped over the wire that connected him to the lightning. "Must be too strong for him, so it killed him," they commented. My interpretation had been much too literal. For the Aboriginal community, the real

cause of death for this ritual specialist was through a spiritual 'wire' that connected him to his source of power; that he was actually lying safely in a hospital bed at the time of the intense storm was not relevant.

A SEAMLESS UNITY

The dividing line between what is helpful and what is harmful, between the forces that enable and those that constrain, is very, very fine; the hazards of walking the tightrope of this precarious equation are preeminent in much of hunter-gatherer thought and behaviour. In the introduction to his publication of 19th-century records of Bushman folklore, David notes: "For the /Xam, what we may see as a spiritual realm was as real as the affairs of daily life: life was a seamless, mythic unity that was played out in more than one realm of human experience" (Lewis-Williams 2004: 34).

When living, moving and talking with Aboriginal people, I find myself continually brought up short by the ready transition, the easy moving back and forth, between helpful and harmful, between the sacred and the profane, between the real world and the imagined world, or, as Michael Taussig has so aptly expressed, between "the real and the really made up" (Taussig 1993: xv–xvii). Taussig demonstrates that it is impossible for any representational act to be achieved without the intervention of the mimetic faculty, and that the making and existence of an artefact which portrays something in some way gives one power over that which is portrayed. What is faithfully captured is a power. This power can be captured only by means of an image, and better still, by means of entering into that image (Taussig 1993: 62). Taussig quotes from the philosopher Walter Benjamin's essay: "Nature creates similarities. One need only think of mimicry. The highest capacity for producing similarities, however, is man's. His gift of seeing resemblances is nothing other than a rudiment of the powerful compulsion from former times to become and behave like something else. Perhaps there is none of his higher functions in which his mimetic faculty does not play a decisive role" (Taussig 1993: 19). We "get on with living, pretending – thanks to the mimetic faculty – that we live facts, not fiction" (Taussig 1993: xv). The strange thing about this place "between the real and

the really made up is that it appears to be where most of us spend most of our time" (Taussig 1993: xvii). Taussig writes that the wonder of mimesis lies in the ability of the copy to extract or unsheathe the character and power of the original object – to the extent that the representation may assume that character and that power, or even become more powerful than the original. In an older language, this is "sympathetic magic" (Taussig 1993: xiii, 62).

MIMESIS

The title of Michael Taussig's book, *Mimesis and Alterity: A Particular History of the Senses*, brings me to another confession regarding having been 'led by the nose' (Lewis-Williams 1977). This concerns my, and David's, former condemnation of the use of that 'S' word which no one of any consequence (in our eyes) dared allude to for years – 'sympathetic magic'. After reading Taussig, I realised, to my initial horror, that the years I had spent faithfully copying Bushman paintings was nothing short of my own form of mimesis, my own 'sympathetic magic'. I was trying to get into the minds of the Bushmen through copying their art; it became a sort of compulsion to go on and on – copying more and more, trying harder and harder to understand what they were thinking. Now, of course, I am suffering the consequences of all that copying in the work we are now archiving in the Witwatersrand Rock Art Research Institute all these years later – we have just catalogued more than 600 sheets of polythene tracings from my fieldwork of 1958–1961, and the list is not yet complete!

In addition to the realisation that I was copying another person in order to understand that person, there is undoubted and indisputable evidence that the 'S' concept was, and still is, strongly held by Aboriginal people in Australia: there, it was undoubtedly a powerful motivation in the production of rock art. Figures were painted and engraved with gross deformities in order to punish supposed culprits or their kin with illness, women who had been unfaithful or who had broken kinship rules were painted with barbed spears in their vaginas, ridiculous caricatures were made of Europeans who invaded their territory and perpetrated massacres, and ritual activities were performed to direct an outbreak of disease or pesti-

lential insects to the camp of enemy groups. The list could go on and on.

In retrospect, it is now my view that there is ample evidence in the San ethnographic evidence to postulate that a similar though possibly less overt belief operated among the Bushmen. This is neither the time nor the place to give detailed examples, but suffice it to mention, for instance, the detailed behavioural prescriptions and prohibitions that linked hunter to eland during a hunt (Bleek 1932: 233–249; Vinnicombe 1976: 178–180); and both Campbell and Lewis-Williams have quoted an example of a Bushman trancer who, when performing a medicine dance in the Ghanzi district in recent years, called out the registration number of vehicles belonging to unpopular white farmers (Campbell 1987: 117; Lewis-Williams 1995b: 329). Of course, David Lewis-Williams and I would not condescend to describing this behaviour with the dreaded 'S' word, but it would be perfectly acceptable to term it 'mimesis'!

In short, my thinking regarding the 'S' word has come full circle, slowly shifting from dismissive to permissive to full acceptance – but during the circuit, purely to save face and to allow greater acceptance, there is a name change. I look forward to reading more about the application of mimesis to the interpretation of southern African rock art in the years to come. I now accept that mimesis is totally relevant.

ACCESS TO POWER

This euphemism, mimesis, leads on to another 'S' word that causes consternation in the literature – shaman. In some circles, and this includes most of Australia, the word evokes the same shudder and upward-turned eyes as the other 'S' word mentioned earlier. Although David has included meditation, dreaming and even daydreaming as methods through which an altered state of consciousness may be reached (Lewis-Williams 1997: 324, 1998b: 46), overt trance performance and shamanistic behaviour are not a feature of Australian Aboriginal culture. For this reason, the second abominable 'S' word is not generally considered applicable there. In my view, however, the production of art in Australia is governed by principles similar to those relevant to the production of San art – access to power – reached through dream meditation,

and mediated by music, dance and images. I would, therefore, like to see the introduction of a term that allowed for wider application of the second 'S' hypothesis – without the attendant upturned eyes. It all comes down to the written label as opposed to what is really going on in the mind and body.

STRUCTURE

Let us return, then, to the 'story in my body' pattern, or, as it may perhaps be termed in politically correct academic parlance, 'the body politic' (Figures 14.2, 14.3). Lewis-Williams has himself succinctly analysed the various phases through which the study of southern African rock art has moved over the years in a ret-

rospective survey (Lewis-Williams 1995b: 74–81). From the dreaded quantitative analysis, which he and I at one stage felt was necessary but did not ever enjoy, the study mercifully moved on to ideas about rock art as a system of symbols, with some innovative attempts by David to recognise syntax patterns based on linguistic analysis. Structural functionalism was the sign of those times. Functionalism is the box into which I have been put in his critical and self-critical history, with gilt-edged purple-prose quotes from *People of the Eland* (in turn taken almost directly from Radcliffe Brown), to demonstrate an undue emphasis on the requirement for a maintenance of social equilibrium (Lewis-Williams 1995a: 77). This miserable little functionalist tree did not have strong roots and has now been relegated to a dim and distant past, along with

FIGURE 14.2 Grid-like theoretical models with boundaries superimposed on the oral tradition pattern. Each grid hosts the roots of a 'tree' that bears the fruit of the associated theory.

the dinosaurs. I fancy this is the box in which I am still supposed to be located. Not having written on South African rock art for some years, I am seen, by some, as if glued to a spot I moved away from long ago. I must confess at this point to feeling a lot in common with my old Kija informant Hector: "I know who I am," and I am not in a box with a label! Maybe I do not always know where I am, particularly when driving in a city like Johannesburg, but even when I am lost, I am *not in a box*. Anyway, David and his team of researchers, after having embraced Lévi-Straussian structuralism and structural Marxism for a while, "made a decisive break with structural functionalism". They then moved on to neuropsychology and the origin of certain forms of hallucinatory experiences in the human nervous system, leading them to a prioritisa-

tion of belief-context-as-meaning (Lewis-Williams 1995a: 79, 80). I therefore take a certain amount of smug satisfaction in noting that, despite his protestations, David is still being pushed back into the 'functionalist' box by other academics (Solomon 1999: 52–53)! Do not fret David – you're in good company! Using the 'story in the body' pattern, we can trace a succession of trees taking root – each one in its little box, and each bearing progressively more fruit – according to the views of the proponents of the various theories. And so the progression of fashions in thinking continues: structuration theory, practice theory, feminist post-structural theory, postmodernism, the body politic, New Age whatever, constructing this, deconstructing that – a veritable entoptic Elysian field of boxes and conflicting lines.

FIGURE 14.3 As more and more theoretical models are imposed on oral tradition, sight is all but lost of the 'story in my body' pattern.

The really pertinent question, it seems to me, is in which box the people whose art we are studying would choose to be, were they to be consulted. There is little doubt that the general thrust of the answer would be: "That's white fella business. You got story in book. We got story in body."

Now, I'm not knocking theoretical boxes. They are a very necessary structure to focus analytical attention to specific research-oriented questions, and are therefore a means of progression. It is, however, equally important to retain the ability to remove the linear boxes we impose on the basic structure from time to time, in order to regain a view of the overall 'body' pattern. Boxes can be restrictive as well as creative; it may not prove necessary to pluck out all the preceding trees by the root, or to ringbark those that may be trying to establish themselves. Lewis-Williams' own account of his and others' progress in rock art studies stresses the shortcomings of previous approaches that were abandoned as more appropriate views supplanted them. The spirit of each approach nevertheless informs the views of those that follow. All the trees take sustenance from the same source, and will die quite naturally in the course of time if they are not fed with sufficient nutrients. It is equally certain that more and more boxes carrying putative seedlings will evolve through time: "Meaning cannot rest or stay the same."

In closing, I would like to quote the complete verse from the poem by the late Australian poet, Judith Wright, champion of Aboriginal land rights and campaigner for environmental integrity, from which the title of this chapter is taken (Wright 1994: 142):

Meaning cannot rest or stay the same
Meaning seeks its own unthought of meaning,
Murders and is murdered, travels on
into new territory past touch and sight –
is dark entreating light.

FIGURE 14.4 Trees rooted in the 'story in my body' pattern without the restricting grid lines will continue to bear fruit only for as long as nutrients are available. [not referenced in the chapter]

Acknowledgements

I am particularly grateful to Irene Staehelin for having contributed so generously to the project that has enabled me to be in South Africa to continue working on my early rock painting records, and at the same time to participate in the 2000 symposium marking the retirement of David Lewis-Williams. I also thank the editors of this volume for helpful comments and suggestions on the initial paper presented.

Note

1 Patricia Vinnicombe passed away during the preparation of this volume. The editors pay tribute to an archaeologist who made an exceptional contribution to the field of rock art studies.

References

Bleek, D.F. 1932. Game animals. *Bantu Studies* 6: 233–249.

Bleek, E. & Bleek, D. 1909. Notes on the Bushmen. In: Tongue, M.H. *Bushman Paintings*. 36–44. Oxford: Clarendon Press.

Campbell, C. 1987. Art in crisis: contact period rock art in the south-eastern mountains of southern Africa. Unpublished MA thesis. Johannesburg: University of the Witwatersrand.

Lewis-Williams, J.D. 1977. Led by the nose: observations on the supposed use of southern San rock art in rain-making rituals. *African Studies* 36(2): 155–159.

Lewis-Williams, J.D. 1995a. Perspectives and traditions in southern African rock art. In: Helskog, K. & Olsen, B. (eds) *Perceiving Rock Art: Social and Political Perspectives*. 65–86. Oslo: Novus Forlag.

Lewis-Williams, J.D. 1995b. Some aspects of rock art research in the politics of present-day South Africa. In: Helskog, K. & Olsen, B. (eds) *Perceiving Rock Art: Social and Political Perspectives*. 317–337. Oslo: Novus Forlag.

Lewis-Williams, J.D. 1997. Harnessing the brain: vision and shamanism in Upper Palaeolithic Western Europe. In: Conkey, M.W., Soffer, O., Stratmann, D. & Jablonski, N. (eds) *Beyond Art: Pleistocene Image and Symbol*: 321–342. San Francisco (CA): California Academy of Sciences, Memoir 23.

Lewis-Williams, J.D. 1998a. *Quanto?* The issue of 'many meanings' in southern African San rock art research. *South African Archaeological Bulletin* 53: 86–97.

Lewis-Williams, J.D. 1998b. Shamanism and Upper Palaeolithic art: a response to Bahn. *Rock Art Research* 15(1): 46–50.

Lewis-Williams, J.D. 2004. *Stories That Float from Afar: Further Specimens of Nineteenth Century Bushman Folklore*. Cape Town: David Philip.

Orpen, J.M. 1874. A glimpse into the mythology of the Maluti Bushmen. *Cape Monthly Magazine* 9: 1–13.

Solomon, A. 1999. Meanings, models and minds: a reply to Lewis-Williams. *South African Archaeological Bulletin* 54(169): 51–60.

Stow, G.W. 1905. *The Native Races of South Africa*. London: Swan Sonnenschein.

Taussig, M. 1993. *Mimesis and Alterity: A Particular History of the Senses*. London: Routledge.

Vinnicombe, P. 1976. *People of the Eland*. Pietermaritzburg: Natal University Press.

Wright, J. 1994. *Collected Poems of Judith Wright*. Sydney: Angus & Robertson.

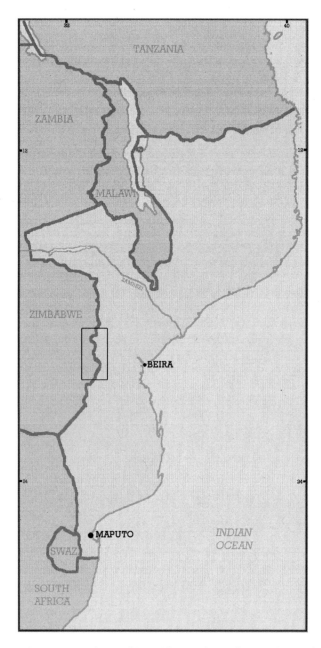

FIGURE 15.1 Map of Mozambique with research area shown enclosed in frame. *(Source: Department of Information, United Nations)*

15.

Manica rock art in contemporary society

TORE SÆTERSDAL

(Institute of Archaeology, University of Bergen, Bergen, Norway)

STUDYING ROCK ART IN MANICA PROVINCE, MOZAMBIQUE

Through archaeological and ethnographic research in the mountainous Mozambican province of Manica, the use of rock shelters as special places through time has been made the focus of study. Many of these shelters are adorned with rock art. Painted images occur on the walls of many shelters formed by the many granite boulders that are characteristic of this rocky terrain (Oliveira 1962: 1; Duarte 1979: 54; Duarte & Duarte 1988: 75). Some of these places play an important role in present rituals and beliefs related to ancestor worship and rainmaking.

Central and southern Mozambique lack any immediate ethnography of the San hunter-gatherers who executed the rock art. However, in Manica there is a 500-year history and ethnography of Shona-speaking people, which also includes relations to some of the painted shelters. Current ethnographic studies are relevant to present-day studies of these people and the management of the cultural heritage there. Can it also shed some light on prehistoric activities in the Manica rock shelters? To what degree can one turn to present Manyika ethnography to learn about the origin of some rituals and beliefs? And can it tell us about the cultural interaction between the early Shona-speaking groups of the region and the hunter-gatherer population who inhabited these lands before they arrived?

THE GEOGRAPHY OF MANICA

The Manica Province stretches along the eastern Zimbabwean escarpment for about 800 km (Figure 15.1).

The border between Mozambique and Zimbabwe generally follows the mountain ranges, cutting through a mountainous and rocky terrain. These peaks may climb as high as 3000 m above sea level; the Manica Valley is situated at 850 m.

Along the eastern foothills of these larger mountains the land slopes steadily downwards towards the lowveld and, finally, the eastern seaboard. The rocky landscape of this part of the Zimbabwean escarpment is strewn with granite 'whaleback' hills and hills with broken 'castle-like' summits. Underneath the large granite boulders, natural caves and dry shelters are abundant.

Of two main research areas, one centres around the hill of Chinhamapere in the Manica Valley. It is located just west of Manica town. Another area where intensive surveys have been carried out is around the hill of Guidingue, south-east of Serra Vumba. Here the Serra Vumba foothills stretch southwards towards Rotanda and the Chimanimani range to the south. They rise some 100 m from the plains, and form a natural border towards the west. The mountains and hills are divided by several deep river valleys. The Mavita plains, with the present-day Chikamba Dam, stretch eastward towards the modern provincial capital of Chimoio. In ancient times these plains were traversed by four major rivers, creating an area with rich pastures where water rarely ran scarce.

THE ROCK ART OF MANICA

The first-known account of southern African rock art was in a Portuguese report from Mozambique to the Royal Academy of History in Lisbon in the 18th century (Willcox 1984: 1). The actual site that this report referred to is not known, but the area would become known as the richest rock art region of the world.

Apart from Chinhamapere (Figure 15.2), very few prehistoric sites in general, and rock art sites in particular, were known in the Manica District and the Vumba area when fieldwork commenced in 1997. The site was first brought to the attention of colonial administrators in the 1930s as one of the first reported archaeological sites in Mozambique (Oliveira 1962: 1, 1971: 4; Felgueiras 1965: 27; Duarte 1979: 54; Willcox 1984: 145; Duarte & Duarte 1988: 75).

On the northern side of Mount Vumba, the rock art of Manica consists of paintings only. During field-work, several hitherto unrecorded rock art sites were registered, with the art of San hunter-gatherers and of later farmers. Although reports exist of a few individual petroglyphs, none have been verified on the Mozambican side of the border. This is probably the result of a lack of research rather than a real absence. Just underneath the top of the Chinhamapere hill is a shelter with numerous San paintings. The rock art at the known panel is easily attributable to the classic San tradition. Apart from this, the art of the region is poorly known and described. Through my survey, three shelters with rock art have been found on the hill itself, as well as two other sites with extensive rock art in the immediate vicinity.

In the area of the village of Guidingue, at the river Zonue on the southern side of Mount Vumba, the sites are situated in rock shelters (save one, on the side of a large granite boulder). Of eight sites containing rock art, six have San paintings, although only one exclusively. The others contain white and red paintings of anthropomorphs and animals; while a few geometric designs can also be found. These seem to a large degree to be finger paintings. In southern Africa these are generally later than the San paintings, which often include fine detail and line work. The numbers of individual images on each site range from one to more than 100.

Across the border in the Manicaland Province of Zimbabwe, a few sites showing a richness in rock art are known, varying from the Inyanga farm rock engravings, resembling the map-like engravings of South Africa, to the wonderful painted panel at Diana's Vow near Rusape (Goodall *et al.* 1959: 230; Cooke 1979: 115; Maggs 1995: 132).

MANICA VALLEY

In the Chinhamapere area, just outside Manica town, all the sites contain classical San art executed in monochrome red. At the Chinhamapere II site a white anthropomorphic figure is also present, and a yellow therianthrope – with a human upper body with long locust-like legs. In general, the sites around Manica town do not contain any finger paintings or paintings that may be attributed to cultures other than the San. The San art here contains images well known to students of South African rock art – humans and antelopes predominate. Although a large proportion

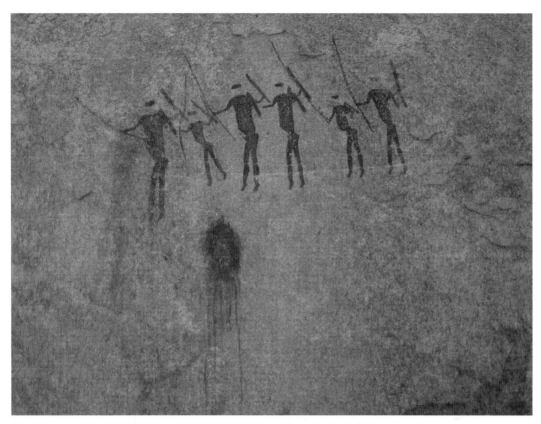

FIGURE 15.2 Detail from the Chinhamapere I main panel. *(Photograph by Tore Sætersdal)*

of the depicted antelope are indeterminate species, some are easily recognisable. The giant kudu is the most prominent species, recognisable by its characteristic ears and hump. Few of the animals depicted have horns; this may suggest that it is the female kudu that has been painted, or very young males. Also depicted are smaller antelope like the tsessebe and the small duiker, one possible reptile, and larger animals such as elephant and rhino. The animals are painted in various styles that have been attributed to hunter-gatherer San-speaking groups across the region. At the Chinhamapere I site there is great variation in shape, size and content, although all the images are recognisable as 'San hunter-gatherer art'. Some animal fig-

ures are large, with only a thick line outlining the shape; they are depicted in profile. Superimposed on these are figures of humans and animals which are smaller and filled in; although some of the smallest are made using only a very fine single-line technique.

Human images, in some cases, are found in very stylised groups, either holding weapons such as a bow and arrows, or carrying quivers in their hand or slung across their shoulder (Figure 15.2). These figures are either depicted in a line in side silhouette, as if moving to one side of the panel, or they are depicted frontally with their arms held out. In Figure 15.2 a group is shown with a possible hunting bag painted underneath them; the depiction is similar to that of bags

painted in the Western Cape (e.g. Parkington *et al.* 1996: 229). Gender is sometimes visible where a silhouetted penis is shown, but most images are not gender-specific, and many carry no material culture. Fine-lined humans are common to several sites in the Manica Valley, often depicted in long lines and in very dynamic postures, possibly representing some kind of scene such as a dance. At Chinhamapere I, such a line is encircling a bird-like figure. These human figures, normally only 4 cm–5 cm tall, are painted with only one thin line and without items of material culture (Figure 15.3). Postures and 'scenes' which in other parts of southern Africa have been interpreted as trance-related, are also present in the Manica art.

The kneeling posture with arms raised behind the body, floating postures and dancing scenes are present at several of the sites with art belonging to the classical San tradition. Superimposition is a common feature at the sites, save at two that only have a few images.

ART IN THE GUIDINGUE AREA

Of the two research areas, the art in the Guidingue area is more varied. At the Moucondihwa rock shelter, classical San art exists side by side with white and red finger paintings depicting mainly humans and animals. The art traditions differ greatly in style, colour and

FIGURE 15.3 Detail from the Chinhamapere I main panel. Fine-lined images of humans filing in procession around a bird-like creature. Colour: dark red. *(Photograph by Tore Sætersdal)*

FIGURE 15.4 Detail from the Moucondihwa main panel. Naturalistic white paintings of large elephants superimposed on each other, and smaller finger paintings in red and white, some in spread-eagled style. Another panel in the same shelter contains classical San images done exclusively in red. *(Photograph by Tore Sætersdal)*

content. The San paintings are all to the right of this main panel. Situated underneath the roof of the shelter is a large number of faded, finely detailed San paintings, all depicting scenes involving humans and indeterminable antelopes. The images are small and all are executed in what today seems like monochrome red ochre; the majority are greatly faded. The humans are done in the thin-line style known from other sites in the area, where the human shape is depicted without attached material culture. The finger-painted images attributed to the agricultural societies are all in a different location within the shelter. Monochrome

images done in various shades of white and bright red depict some large animals – elephants and possibly a buffalo (Figure 15.4) – some schematic smaller animals, maybe lizards or scorpions, and human figures.

In several instances humans and animals are depicted together: a human figure and what may be giraffe; a human possibly riding a horse. Items attributable to agricultural or at least pastoral lifeways also may be depicted – an animal with a body like a humped cow's and antlers like a kudu's. Although this does not determine the authorship of the paintings, it does suggest an earliest possible date for the painting

of around the first part of the first millennium CE. Three large elephants are superimposed on each other in the centre of the main panel. As a lot of unpainted space surrounds them, they could have been painted without superimpositioning. It thus seems that the very act of superimpositioning the elephant images one on top of the other was significant.

Other rock art sites in the vicinity of this large shelter are less varied, the art consisting mostly of monochrome red finger paintings. Again the predominant motifs are humans and animals as well as some geometric designs consisting of crosses and lines. The human figures here are schematic, elongated figures with legs extending for up to a metre, without any material culture.

Although no mention is made in Portuguese records of San-speaking hunter-gatherer groups south of the Zambezi in Mozambique, the rich San ethnography from the southern African interior may be used as an analogy to explore the meaning of the images (Marshall 1957: 232, 1962: 221; Vinnicombe 1976; Lewis-Williams 1981, 1986: 93, 1987, 1992: 56;

FIGURE 15.5 The traditional custodian of Chinhamapere, Mrs Mbeya Gondu, praying to the ancestors during a rainmaking ceremony. (*Photograph by Andrew Salomon*)

Barnard 1992: 91; Biesele 1993; Lewis-Williams & Dowson 1994). Ethnographic accounts of San groups in the vicinity of Mozambique are few, and only Potgieter's (1955) study of the sad state of the few remaining //Xegwi people from the Lake Chrissie area in Mpumalanga describes the possible descendants of groups similar to those that once inhabited the Mozambican area (Potgieter 1955; Barnard 1992: 85). North of the Zambezi the distinct rock art attributed to the Kafula and BaTwa cultural complex may provide us with further analogies. The elusive, so-called 'Twa people' may have existed in the Malawi region until very recently. The very different Twa rock art tradition lies as a massive barrier between the art of Tanzania and East Africa and the art south of the Zambezi, both of which comprise more naturalistic art zones (Masao 1979; Leakey 1983; Schoffeleers 1992: 25; Smith 1997: 47).

Since aspects of southern African rock art are normally linked to particular groups (hunter-gatherers, herders, farmers), one expects comparable links in the new study area. Because these various groups often existed side by side over the last 1500 years, a secure chronology is difficult in southern African rock art research. In some areas there seems little doubt that the San art is considerably older than Bantu-speaker, or farmers', art (Walker 1987: 137, 1995, 1996: 11; Garlake 1995: 17). In other cases this seems open to debate. However, it is reasonable to expect the local chronology and cultural affiliation in Manica broadly to parallel the better-known regional sequence. Looking south and west, the art of Manica strongly resembles the art of northern South Africa and Zimbabwe (Garlake 1987, 1995: 11, 1997: 33; Walker 1995, 1996: 7; Eastwood 1999: 16; Eastwood & Cnoops 1999: 107). The major difference between the Manica art and the Zimbabwe/Limpopo San paintings is the predominance of monochrome images, although this may be a result of colours fading away. The form and content are very similar to those of Zimbabwean art, with a predominance of kudu as the large antelope. In this way it matches the broad pattern in which a particular animal dominates in any one region – the eland in the Drakensberg and the kudu in this region. This may be related to a similar belief in spiritual power, or *n/om*, which is known from the areas where eland is the predominant animal in the art, or it may have to do with the forces that affect the weather through the

FIGURE 15.6 Chief Chirara, with a pangolin. *(Photograph by Tore Sætersdal)*

societies as subjects. The behaviour and rituals of 'the other', in this case the hunter-gatherer population, offered a means to gain quick control of the ritual sites and to secure the willing cooperation of the spirits of the land. Dowson (1998: 75) discusses the significance of mythical rain creatures as part of rainmaking ceremonies. The association of rainmaking, water and serpents occurs in Manica beliefs as it does over large parts of southern Africa, although only one possible reptile has so far been identified in the known rock art. Serpents are believed to be part of San rainmaking beliefs (Vinnicombe 1976: 233). Large black serpents are said to guard the sites, and large water serpents are said to dwell in the sacred pools that are often to be found on the mountaintops. People who are suspected of killing and eating the meat of the rock python are viewed with fear and suspicion as well as some envy. Rumours have it that these people also indulge in cannibalistic activities. The fat from a python is regarded as highly potent medicine to protect against witchcraft, and presenting its owner with great power.

Among the Manica Shona speakers the most potent animal is the scaly anteater, the pangolin, which the chief may claim immediately if it is killed in his territory. It should be brought to his homestead without delay (Figure 15.6). The animal is believed to have great medicinal and magical potency. As it is usually encountered during the wet season, it is affiliated with rain, and some believe it comes from the clouds together with the rain. Interestingly enough, this animal is not represented in the rock art.

ARCHAEOLOGICAL EXCAVATIONS

Archaeology in the modern sense, starting late in Mozambique, has grown thanks to numerous projects supported by Swedish funding programmes. The war of liberation and the consequent civil war made fieldwork difficult and dangerous. In spite of this, work in the south, around the capital Maputo, intensified. In the north, archaeological investigations were undertaken into the archaeology of the Swahili coast and the Nampula Province in the northern interior, while ground-breaking investigations were carried out at Chibuene (Cruz e Silva 1979; Sinclair 1982: 150, 1985a, 1985b; Morais 1984: 113, 1988; Duarte 1988: 57, 1990; Adamowicz 1990: 137; Sinclair *et al.* 1993: 409).

concept of *n!ao*. For the Limpopo-Shashi Confluence Area, Eastwood and Cnoops (1999: 107) have convincingly argued that the kudu is connected to the San concept of *n!ao*, a notion connected to gender, meat animals and weather, and also to fertility (Marshall 1957: 236; Barnard 1992: 59; Biesele 1993: 88). As the interaction of *n!ao* from people and hunted animals affects the weather, the concept is important in connection with weather changes from dry to wet seasons. Indeed, the very notion of *n!ao* is divided into these two categories, wet and dry.

The San people are known historically as fierce medicine men and sorcerers, often employed in these roles by the surrounding non-San population. Controlling the forces of the land and the animals that are part of the land would be of immense importance to any immigrating population. The Nguni are an exception, as Shaka Zulu expelled all the rainmakers; no man other than himself should control the elements. The Shona-speaking societies, on the other hand, have a long tradition of including non-Shona speakers into their

Apart from the Zimbabwe stone monuments at Barue and Songo in the Tete Province, the archaeology of the central mountainous part of Mozambique is poorly known and understood (Macamo 2006). Although the archaeology across the border in Zimbabwe is generally better known with more research having been done, only a few studies have focused on the earlier prehistory of Zimbabwe's Manicaland Province, which borders Manica. The emphasis in recent years has been on the terraced settlements of Inyanga and the more recent iron-using societies rather than on the earlier periods (Soper 1996: 1).

Very few archaeological excavations have been carried out in central Mozambique, contrary to the substantial work being done in other parts of the country (Sinclair *et al.* 1993: 410). The excavations at Chinhamapere are the first in Manica. In Zimbabwe, a few comparable investigations have been done in the eastern highlands (Robinson 1958: 270; Cooke 1978: 1, 1979: 115; Walker & Thorp 1997: 9).

The archaeological material excavated at the Chinhamapere II site in Manica testifies to the extensive use of the painted shelter by Late Stone Age groups from at least 3000 years ago until the relatively recent past. Ochre in various shades of red is present throughout the layers; it may have been used as a rock art paint ingredient as well as for other purposes, such as body painting. There is no evidence for any long-term occupation of the shelter, as household goods are absent from the recovered material. The small shelter seems to have been used for short periods by a limited number of people. The rock art is by far the most striking part of the archaeological remains. The five panels are extensively decorated with classical San images. Almost no traces of iron-using societies were retrieved from the site, save for some recent potsherds in the top 10 cm spit. The small Chinhamapere IV shelter is situated just 50 m directly below and in plain view of Chinhamapere II; it yielded pottery of the Ziwa and Gokomere early iron-using traditions (Bernard 1961: 84; Phillipson 1993: 192). One very large vessel was retrieved, of a size consistent with use in brewing beer. Although there are faint traces of paint on the rocks in the Chinhamapere IV shelter, no Late Stone Age material was found save a few quartz scrapers – and scrapers are not exclusively Stone Age tools.

From the Chinhamapere IV one may enter into a large cave with a low ceiling. Excavations in the cave provided proof of occasional use through the last 800 years. Again, no evidence was discovered for long-term occupation, as only a few artefacts were found that may be characterised as household goods. Grinding stones were present, and it is expected they were used to prepare medicines and paint for ritual use. For both shelters, it is possible to argue that rituals were the main activities taking place. At some point in time these activities included painting. It is too simple to expect the dwelling places to be in the same shelters as the rock art. I expect that temporary dwelling places will be found some distance from the ritual site, possibly in another cave or shelter for the hunter-gatherer groups and as open-air sites for the agriculturalists. During times of unrest these places in the rocks would have provided the inhabitants of the Manica Valley with refuge and safety, as during the Nguni sieges (Liesegang 1970: 330; Bhila 1982: 169; Rita-Ferreira 1982). The two sites may not have been used simultaneously; doubtless the later users would have been aware of the paintings left by their predecessors. An important, and overlooked, aspect of rock art is that it endures on the walls of shelters (Chippindale & Nash 2004): people going into a shelter in this way see material traces of these predecessors, in a way that they would not see the stone tools, potsherds and other debris buried within the sediments of the shelter. So rock art has an unusual, and perhaps a special, role when a population moves into an area previously occupied by others.

Of course, the material retrieved through excavation may not have been left there by the people who painted. However, the activities we find traces of through excavation may have taken place there because of the painted images that were already there.

SHONA HISTORY AND ETHNOHISTORY

The traditional Shona leadership consists of paramount chiefs and headmen whom rural people relate to just as much as they do to the political authorities. Among the Shona-speaking population of Manica, chiefs rule over areas according to tribal and chiefly descent; they allocate areas to local headmen, who also rule by descent. In Manica, Chief Chirara is the latest in a long line of rulers from the Chirara family. It is important for the political authorities to have good

cooperation with the chiefs; without that, it would be difficult to involve people and to muster their enthusiastic following when the need arises. There is no doubt that local people's relationship with the chiefs and their *sabuku*, local headman, is just as strong as that with their political leadership. Traditionally, local villages and rain shrines have been the enduring social institutions. The larger-scale political leadership has often changed over the years. Access to the gold mines of Manica caused fierce competition between the Mutapa state and the Portuguese from the 16th century onwards, and local villages often shifted their allegiance (Beach 1980: 171; Newitt 1995: 55). In general, the Portuguese often tried to install people they could control in the places of the traditional leaders, in that way trying to achieve a semblance of legitimacy (Bowen 2000: 69). In Manica, however, the chiefly dynasties have survived to a great extent, although close cooperation exists between the political and traditional leadership in present-day society. The chief still holds court and rules over subjects and property. He has the last word in disputes over land and animals, heritage or family feuds. When people relate to him, they also relate to a stable authority with hundreds of years of history and tradition. Political systems and authorities in faraway Maputo may change, as they have done in the past, but a member of the local chiefly dynasty will rule over the Vumba for as long as the Manica people exist.

The chiefs are in many ways dependent on a third authority, that of ancestor spirits, who provide the rulers of the present with authority and power. The spirits rule certain areas and sites; they are particularly potent in certain contexts. They may be malicious or benign, depending on our conduct as living people (Bourdillon 1976: 227; Lan 1985: 31). Chiefly territories and rule are traditionally connected to rain shrines and certain local ancestor spirits, who will communicate through the local spirit medium.

The population history of Manica shows a tumultuous and dynamic picture with various groups migrating into, and passing through, what today is an area dominated by Shona speakers. The dialect of ChiManyika is spoken in the present-day Manicaland of Zimbabwe as well as among the Shona-speaking groups in Mozambique's Manica District. It is the easternmost of the six major Shona dialects. To the south the N'Dau-speaking peoples occupy the vast

areas of Chimanimani; to the north the BaTonga-speaking people still occupy the areas of their ancient kingdom of Barue, with the important rain shrine of Kaguru (Newitt 1995: 32). The Shona invariably classify their neighbours as BaTonga; this means simply 'chiefless people' and is used for neighbours from the Zambezi to Delagoa Bay (Abraham 1959; Beach 1980: 157). Some Shona dynasties used the word even to label their own subjects.

Archaeological sources indicate that the area was populated by hunter-gatherer groups prior to the arrival of Bantu-speaking groups. Although most researchers believe them to have taken a more westerly route, it is possible that some Khoi-speaking herder groups may have passed through or stayed in the area, interacting with the existing hunter-gatherer population. It remains difficult to connect them with any specific traits in the rock art.

Oral history of the Manica Shona describes how a party of hunters from Mbire, a mythical place, came into the valleys of Manica while out hunting. The location of the country Mbire is uncertain; it is placed either in the north-west or in the north. Some claim it was part of the Mutapa state and that the people who first entered the territory of Manica were an offshoot from the Mutapa state. Other traditional tales tell of an origin along Lake Tanganyika and point to a possible relationship with the Fipa along its eastern shore (Bhila 1982: 10). Alpers (1968: 8) suggests a steady stream of people trailing in from the north with a north-western origin, most probably from the Congo basin or areas north of Lake Malawi. Bhila (1982: 10), who also reports a north-western or north-eastern origin for the Manica peoples, goes on to say that the identity and the pattern of Manica settlements are highly uncertain.

Beach (1980: 167) suggests that the mythical place of Mbire is related to regions Mbire I or II in the Mutapa state. The first figure in Manyika traditions who may be historically verified is the ruler Nyamubvambire, in some accounts the head of the hunting party mentioned above. He was of the Shumba (Lion) totem and the Mutasa dynasty (also referred to as the Chikanga dynasty); this line has ruled the Manyika kingdom, of which Chirara is one of the paramount chiefs, until the present (Figure 15.6).

According to oral tradition, the newly arrived Nyamubvambire possessed a superior knowledge of fire-making and the cooking of foods. The owners of

the country, the Mponda and the Muchena clans, did not possess these skills and ate their food raw. Nyamubvambire soon acquired the land by trickery and consolidated his land claims by matrimonial alliances with the two clans already present in Manica. As an act of honour, the Mponda clan was charged with the priestly function of performing burial rituals in the new kingdom, something which this clan still holds as its responsibility in Manica (Bhila 1982: 10; Bannerman 1993).

The Chinhamapere hill is conceived of by many living Manica people as a place of 'kings' or a place of the 'spirits'. Many stories are told of the large, black spirit snakes that hide among the large boulders and rocks around the top of the hill. They will attack you if you have not made contact with the ancestors and been authorised by them to approach the place. Consent may be obtained through a simple ceremony that can only be performed by people authorised by a spirit medium to do so. To venture forth without having communicated with the ancestors is foolhardy and invites disaster. As will be shown, these rites or small ceremonies are not only confined to entering Chinhamapere or sites that are recognised as 'special' in any way; they take place whenever people do anything that they feel the ancestors need to know about, or whenever they do anything where protection might be needed. Venturing into unknown territories may be one such situation where it is prudent to call upon one's ancestors for protection and guidance. The present custodian of the site tells of the site's importance in rainmaking rituals of the past and of how young girls used to dance at the Chinhamapere I site at night. None of the girls had menstruated yet; the custodian described it as part of their "growing-up" rites. This custom is similar to the one described by Ranger (1999: 20) from Nswatugi cave and other places in the Matopo Hills.

The Manica ancestor spirits play an important role in social life on all levels, from the individual, through family and clan, to the collective experience of life in a larger Shona-speaking society. It is the Manica belief that life is greatly enhanced by death, as in the spirit world one may better protect family and possessions. When a person dies, he or she becomes a *mudzimu* (pl. *mudzimu*), an ancestor spirit. A whole lifetime of accumulated knowledge and experience will be available to the living in a spirit version that is a resource to be drawn upon and consulted when guidance,

protection or divination are needed (Abraham 1966: 28; Lan 1985: 32). Worldly worries and problems no longer hinder the dead, and so they are able to devote their whole attention to guiding and protecting their families at all times. They see into the future and may give advice on how to avoid impending dangers; they have curing power and may be called upon to cure illnesses. Having no material form, they are not bound by time or dimensions and can be in all places at all times; the form they take is called *mweya*, 'breath' or 'air'. However, the spirits do have sensory experience, eyesight, hearing and emotions (Lan 1985: 32). Spirits may go quiet and never be heard of again, and new spirits may take their place. The spirits exist in a mirror-image world of our own. Hence, they also age and fade away; new spirits are 'born' when younger relations die and end their existence in this world. Ranking above the *midzimu* in importance is the *Mhondoro*, usually the spirit of a dead chief related to a specific region, and the *Mwari*, the Shona high deity.

The physical land of Manica, save the high mountains, is very similar to the land of granite hills and whaleback hills so characteristic of much of the area inhabited by Shona speakers. The Shona myth of 'the creation of water', which stems from the Matopo Hills in the south-west, the Shona Banyubi area, is consequently from an area that physically resembles the Vumba foothills. The water which brings life to the valleys comes from the hills and mountains, where an abundance of small streams and pools empty themselves into the larger river systems in the valleys. Moreover, the rain that brings precipitation comes from the south and south-west in October/November. Viewed from below the Chinhamapere and the location where rainmaking ceremonies are performed today, these clouds appear over the 'shoulder' of the Serra Vumba and then above Chinhamapere. These clouds invariably are accompanied by thunder and lightning, a spectacular sight at Chinhamapere as the large boulders around the top of the hill take their pounding from the lightning.

Some believe that there has been continuity from hunter-gatherer rainmaking rituals to the later rituals; some sites, like the Matopos, may have been used for such rites for thousands of years. This probably means that agricultural peoples, of the first iron-using communities to settle in the area, may have danced and executed rainmaking ceremonies in the painted caves of

the Matopo Hills long before the arrival of the Shona-speaking societies at the beginning of this millennium.

Oral tradition among the Shona Banyubi regards many of the hills in the Matopos as very important rain-dance hills. The following oral tradition is quoted from Tredgold (1956: 85, in Ranger 1999: 20), who collected it from "an old" informant in the early 1950s:

> The dancers were young girls about twelve years old who wore a small apron only when they danced; old women danced, too. They danced to the music of drums and women clapped their hands, whistles were not allowed. All the men had to go away when the dance was on. As they danced they threw water up into the air.

Tredgold argues that this ceremony has roots far into the past; it is much older than the *Mlimo* (*Mwari*) cult in the area. Ranger (1999: 20) relates the story of a guard at Nswatugi cave in the Matopos, one of the most famous rock art sites in the area. The cave, adorned with San paintings, is a major tourist attraction of the Matopos. When Ranger visited the cave in 1985, he was told by the guard on duty that the place was used in the early 1960s for rain dances, when the man was young. Because all the villages were removed in the early 1980s, the cave was no longer used for ceremonies. However, he said, Silozwane cave in the same area was still used for female dancing ceremonies at that time; indeed, his own grandmother was the keeper of the Silozwane rainmaking shrine. Ranger concludes that neither of these caves has ever been a *Mwari* shrine. If the dances were not part of a *Mwari* ritual at the time of his visit, they may – consequently – be of greater antiquity than the cult. Both the caves mentioned are famous for the number of San paintings in them.

The link between fertility and rainmaking is close and, in everyday language in Manica, obvious. Biesele (1993: 114) shows how, among the Kalahari Ju/'hoan, changes in weather relate to fertility. Related to this is also the potential danger of menstruation; only pre-pubertal girls and women past menopause take part in the ceremony and dancing. This connecting element between acts of transformation and women is seen elsewhere in east African Bantu societies, in pottery-making and iron-making, where a natural substance is transformed into cultural objects through the forces of fire.

At initiation rites women past menopause play a very important part as guardians of the rite and fire. Their control of fire even extends to male rites. The rainmaking ritual holds elements of the same transformative action, as dry is transformed into wet through a ceremony of dancing. No mention is made of fire in the Matopo Hills accounts. However, it is assumed that fire plays an active part in the rite, as it certainly does in present Manica rain rituals where the role of the oldest woman is closely related to lighting the fire and brewing beer. The heat is an important factor in any transformation and healing ritual (Jacobson-Widding 1989: 27; Collett 1993: 499; Sætersdal 1995, 1996a: 755, 1996b: 133, 1999: 121). In a powerful metaphor, the lightning from the sky is the fire that transforms the weather. Rain is accompanied by thunder and lightning, which the Ju/'hoansi call "gods' fire" (Biesele 1993: 115).

The Mwari oracular cult, active at the time of European arrival, is closely connected to the standing stones of the Matopos. The main shrine, Njelele, is a column of standing rocks located in the south-western part of the hills. The rocks of the Matopos have become a symbol of the gods' endurance. According to the Njelele followers (Ranger 1999: 21), it "always has to be a stone. A stone can keep something better. A tree rots." A tree is always used in communication with a *mudzimu* among the Manica and, indeed, generally throughout eastern and southern Africa. The fact that a stone is thought to "keep something better" is of significance, and this may reflect the durability of the Mwari deity as opposed to a *mudzimu*, or even the *Mhondoro*, who are both thought to fade away into silence as new ancestors gradually take their places.

The Mwari cult was also present in the Mutapa dynasty, even further afield from Matopos than Manica. Ranger (1999: 22) mentions a cave at Nyachiranga where the voice of the Dzivaguru, the high god of eastern Zimbabwe, may be heard. The cave is seen as the nucleus of a living and active landscape (Zvabva 1988, in Ranger 1999: 22). As Zvabva refers to the cult as a "regional cult", I take it to be a *Mhondoro* regional ancestor cult. Certain rules of behaviour and ways of doing things within the shrine may also suggest a link backwards in time: people adept in the cult sweep the floors of the caves and shrines with their bare hands and not with brooms; stone tools are used to cut the grass; no metal tools are allowed.

There is considerable ritual and religious similarity over parts of the region. The centrality of the rainmaking and fertility cults may partly be explained with reference to the 'ritual ownership of the land', where immigrating and conquering groups concentrated their political efforts against the local chieftainships and the rain cults, as was the case in Barue and QuiTeve, the kingdoms north-east and east of Manica. Here authorities of traditional villages headed by descent and rain cults were the enduring social institutions.

DISCUSSION: Art then and art now

This chapter has not been about the original meaning content of the rock art of Manica. However, I am concerned instead with two aspects of the art: the possibility of saying something about prehistoric practices by looking at the present and historically known ethnography, and the associations that people make with the art and the landscape where the art is found. Although people do not distinguish between traditions in the art in academic terms based on style or chronology, they do clearly connect the art to the ancestors, which may also consist of the people who occupied the area before their own Shona-speaking ancestors arrived. The rock art shelters are not the main ritual arenas for a rainmaking ritual but, at certain stages in the proceedings, the ritual leaders give sacrifice to the ancestors by placing pots of beer in front of the painted panel. The painted sites are referred to many times during the ritual as a meeting place between the spirits because of the art, which is made visible as a sign from the spirits to us.

The sites represent a link backwards through time, even if the actual rock art is not physically a part of current ritual activities. The link is the ritual ownership of the sites, which has been handed over, or taken over, through generations of users. This reuse and the links between these phases of use and groups of people are presented to us through the archaeological material present at the sites:

- San paintings;
- San and Bantu-speaker paintings;
- San paintings and Early Iron Age pottery;
- San painting and Bantu-speaker burials;
- San and Bantu-speaker paintings and rainmaking today.

The continuing use of the same sites and the obvious importance ascribed to some of the sites and painted panels may obscure real disjunctions in the ritual meaning and performance. For much of the information about Shona ritual activities we also have to look beyond the Manica core area. The various Shona-speaking groups have demonstrably similar cultural traits across space today. Although the Manyika have no site that can match the importance of Njelele, the beliefs in ancestral spirits and the importance of the rainmaking ceremonies are very similar. Indeed, they are also very similar to beliefs found among other Bantu-speaking groups in the region.

Have the differences and the distances between people with different economic adaptations, and also between various groups of farmers, really been as undynamic and rigid as they are often portrayed? It is reasonable to believe that the 'otherness' found in other groups was both attractive and frightening. When people venture into a new area there is not only a physical adjustment to a new geographic and ecological zone, but also a social adjustment to the people already living on the land as well as a ritual adaptation to the land and its spirits. Spirits of the land may be represented through rock art, or may be part of a landscape such as vegetation. It may be an inconspicuous part, like a tree or a hole in the ground. These spirits are as important as the people who already inhabit the land, and to appease them is of paramount importance. The spirits of the ancestors and the land are everywhere and are present at all times. In the homestead you know who they are as they are your own; in the open bush, your own must negotiate with the unknown spirits of the 'others' for your safe passage. Also in the bush are these fixed points related to the ancestors and their spirits. Walking through the landscape of Manica, people will know these fixed points between which they are navigating and relate to the meaning attributed to them in various ways, such as going through certain ritualised behaviour.

Not all rock art sites are of significance in the present, as no specific image seems to be of greater importance than others. Some sites may be totally unknown at present, to be rediscovered later and for some reason become important in a new frame of ritual and religious activities, or when ritual leaders change or certain traditions are for some reason reborn. Meanings attached to individual images are long since

gone, but the panels continue to play an ever-important part in present understandings of the cultural landscape. The rainmaking ceremonies of the present Manyika people have many aspects, including the blessing of people or animals and the increase of fertility and harvests. However, all these aspects are tied to the all-important features of rain and water. Without food, health and fertility, people will suffer and diseases will increase.

Barnard sees the relationship between Khoe-speaking herders and non-Khoe-speaking San hunter-gatherer groups as particularly dynamic. It seems that these groups could easily take up each other's economic adaptation and 'become' the other, if circumstances so demanded. The extensive borrowing from Khoe language found in present Nguni dialects bears witness to the degree of interaction between these groups (Barnard 1992: 159; Newitt 1995: 149).

Vinnicombe (1976: 136) and others show how close the interaction was between the San groups of the KwaZulu-Natal Drakensberg and the surrounding Nguni-speaking groups. The San, considered by the Nguni as ritual experts, were employed as rainmakers. Such interaction has been shown in other parts of the region as well (Hall 1994: 61; Jolly 1998: 247).

When discussing cultural similarities over the vast area of southern Africa, we are walking into contested territory. David Lewis-Williams and Thomas Dowson (1994: 207), discussing the validity of a concept such as 'Pan San', decide against the use of this term that they themselves had earlier employed (Lewis-Williams 1981: 37). Even though striking similarities do exist between present !Kung ethnography and what was recorded by Bleek and Lloyd a century earlier in Cape Town, temporal and cultural variation undoubtedly existed and still exists through time and space. The image of the 'Bushmen' or 'San' as a coherent unit is a European or settler concept; the San do not see themselves as members of an integrated unit but rather as !Kung or Ju/'hoansi or /Gwi or Nharo or any of the other Khoi-San speaking groups (Barnard 1992: 152; Gordon & Sholto Douglas 2000: 4).

There seem, however, to be areas where a great deal of cultural similarity exists between various San groups. Lewis-Williams and Dowson (1994: 207) identify concepts like *n/om*, *n!ao*, puberty rituals for both sexes, marriage and shamanistic performances where trance played a prominent role. The existence

of puberty or initiation rites among Shona-speaking peoples has been debated with regard to the interpretations of Great Zimbabwe (Huffman 1996: 200; Beach 1998: 47). Initiation rites in Africa seem to be expected always to follow the same three-stage pattern: a segregation phase and a rather long seclusion or liminal phase of removal from society, followed by a reintroductory phase often coupled with a new identity, as in the classical *rite de passage*, where the emphasis is on the passage. However, the vast cultural variations in Africa mean great variation also in how initiation rites are defined and carried out. Initiation of some sort may be an element or part of a larger rite, such as a rainmaking ritual. Classical studies of ritual such as Turner's (1967) studies of Ndembu initiation, often portray the societies as closed, small-scale, with a shared cultural and symbolic code that takes symbolic consensus for granted. We may have to look for a more dynamic and multicultural model of rituals, which takes into account the plurality of individual cultural and ethnic backgrounds present among the participators. We realise that this is the case in present-day Mozambique. It may, however, also have been the case in previous times, where bearers of various social experiences sought to reform or reinvent their tradition on the basis of their background or individual understanding of the symbols presented in the ritual. The elders in Manica always emphasised "in October we do our rain ritual, which is also for crops, animals, health and family". However, each time the procedures are discussed among the elders, which in recent times has also involved political administrators. This is an obvious potential engine of change.

Schoffeleers (1992: 9) directs attention to the cultural dynamics between the Kafula (or BaTwa), the autochthons of Malawi, and immigrant Bantu speakers in his discussion on the Mbona cult. The 'ritual ownership' of the land is essential to the immigrating power. Through the autochthonous ancestral spirits, natural forces are controlled, in particular the rain. Schoffeleers does not make the full connection between the founding myth of the Mbona cult and a hunter-gatherer origin for the rain cult. However, in his description of the oral tradition around the founding of the cult, Mbona is described as a person who lived in the Shire Valley prior to chiefdoms, and who was a great sorcerer. He left marks of his body, utensils and weapons on the rock faces and was finally killed

by people using iron tools. His followers took his head and built a shrine to him (Schoffeleers 1992: 142). It would seem that a connection to the original hunter-gatherer population and their fame as sorcerers might be made. The similarities between the rain cults of Malawi and the territorial cults of the Shona-speaking region south of Malawi, such as Chaminuka, Karuva and Dzivaguru, show the regional cultural similarities between the rainmaking cults. Beach (1980: 314) sees the spread and rising popularity of these cults in relation to the lack of central powers during the 19th century. He asks if Shona politics was taking new turns to adjust to a 'frontier politics' in the absence of centralised powers such as Mutapa and Changamire.

The ritual performers, the spirit mediums, were also connected to the local headmen, the *sabukus*, and to villages rather than the paramount chiefs and royal lineages. The enduring element of the social structure in historical Manica was the village and its headman, as it has been in recent history and as it still is. The Karanga states of Barue and Quiteve were established as an over-rule grafted onto these pre-existing social institutions. The Karanga rulers tried to build alliances with the rainmakers and the local villages in various ways (Newitt 1995: 43). In times of strife and emergency the local headmen could easily turn their allegiance to other paramount chiefs or to the Portuguese. As discussed above, several authors doubt any great antiquity for the Mwali and other 'cave cults' in the region. However, there is no doubt that caves and shelters have been used as ritual places from far earlier times. The archaeological material, such as the rock art, tells us that much. Shifting politics and cultures have necessitated religious changes and adaptations in ritual and religious practices and beliefs, although the material context has been much the same over the years, as have aspects of the ritual as it is practically conducted, if not in its meaning.

A new religious order very often not only takes over the place of the previous religious order, but also continues various ritual practices. This may be particularly so if religion is supplanted by a recently immigrated power. In order to accommodate and gain control of the 'spirits of the land', the ritual experts of the original population will often be used and a large part of their ritual practices incorporated into the new religious order. The cultural interaction between the white and black populations seems to have been greater in the Portuguese territories than in the other southern African colonies. Many of the white settlers who arrived in Mozambique came from the rural districts of Portugal. From their own country they would have been accustomed to many of the elements of religious practices and beliefs that they met among the indigenous population of Mozambique (Pina-Cabral 1986: 174). In current Manyika society, the Christian sect of the Zion Apostles gathers to pray at places known to be important and sacred ancestral places, such as the Chinhamapere and Monte Guidingue. They normally gather just above the painted shelter. The local spirit medium at Chinhamapere is also a Catholic and an eager churchgoer. It would be naive to believe that almost 500 years of exposure to the Catholic Church and Portuguese customs has had no impact on local beliefs and customs.

It is impossible to tell with any degree of accuracy when the original painters ceased to use the sites. What is plausible is that some of the rituals that took place in these sites involved control of the natural forces and water. The paintings would have been recognised as the makings of ancestors, as they are today, and the site would have provided the liminal space of ritual timelessness that is natural for this type of ritual context. The painted surface represents the past timeless realm of the ancestral powers, and the present beyond the shelter represents the future. Through the elders the messages from the past are interpreted in the eyes of the present and passed on as guidance for times to come. The painted sites thus present a physical continuation and link to the past that endures beyond the shifting cultural traditions in which they may be interpreted at any point in time.

Acknowledgements

I would like to thank Professor David Lewis-Williams for showing the way and for sharing generously and inspiringly his immense knowledge and ideas in the Drakensberg and Waterberg in 2000. A most unforgettable experience! Thanks also to the people of Manica who always received me openly and kindly, with much patience and humour. My wife, Eva Walderhaug Sætersdal, participated in the fieldwork – thanks for endless help and support. Professor Randi Haaland is thanked for enthusiastic supervision during PhD fieldwork. Professor Paul J.J. Sinclair introduced me to Mozambican archaeology at Chibuene and shared his knowledge unreservedly, for which I am forever grateful. My Mozambican colleagues at the Department of Anthropology and Archaeology at Universidade de Eduardo Mondlane are thanked for all their advice and assistance. Special thanks are due to David Frangue of the District Cultural Office in Manica and James Hugh Bannerman for all their help and support. The work was carried out under research permit Number 01/97, issued by Departemento dos Monumentos, Ministerio de Cultura, Juventude e Desportos, Maputo.

References

Abraham, D.P. 1959. The Monomotapa dynasty. *Nada* 36: 58–84.

Abraham, D.P. 1966. The roles of 'Chaminuka' and the Mhondoro-cults in Shona political history. In: Stokes, E. & Brown, R. (eds) *The Zambezian Past*: 28–46. Manchester: Manchester University Press.

Adamowicz, L. 1990. Newly discovered Stone Age and Early Iron Age sites in Nampula Province, northern Mozambique. In: Sinclair, P.J.J. & Pwiti, G. (eds) *Proceedings of the 1990 Workshop, Harare and Great Zimbabwe*: 137–196. Stockholm: Swedish Central Board of National Antiquities.

Alpers, E.A. 1968. The Mutapa and Malawi political systems to the time of Ngoni invasions. In: Ranger, T.O. (ed.) *Aspects of Central African History*: 1–28. London: Heinemann.

Bannerman, J.H. 1993. *Bvumba, Estado Precolonial Shona em Manica na Fronteira entre Moçambique e Zimbabwe*. Arquivo: Boletim do Arquivo Histórico de Moçambique, N1 13, Abril de 1993, Maputo.

Barnard, A. 1992. *Hunters and Herders of Southern Africa*. Cambridge: Cambridge University Press.

Beach, D.N. 1980. *The Shona & Zimbabwe 900–1850: An Outline of Shona History*. London: Heinemann.

Beach, D.N. 1998. Cognitive archaeology and imaginary history at Great Zimbabwe. *Current Anthropology* 39(1): 47–72.

Bernard, F.O. 1961. The Ziwa ware of Inyanga. *Nada* 38: 84–92.

Bhila, H.K.H. 1982. *Trade and Politics in a Shona Kingdom*. Harare: Longman.

Biesele, M. 1993. *Women Like Meat: The Folklore and Foraging Ideology of the Kalahari Ju/'hoan*. Johannesburg: Witwatersrand University Press.

Bourdillon, M. 1976. *The Shona Peoples*. Revised edition. Gweru: Mambo Press.

Bowen, M.L. 2000. *The State Against the Peasantry: Rural Struggles in Colonial and Postcolonial Mozambique*. Charlottesville (VA): University Press of Virginia.

Chippindale, C. & Nash, G. 2004. Pictures in place: approaches to the figured landscapes of rock-art. In: Chippindale, C. & Nash, G. (eds) *The Figured Landscapes of Rock-Art: Looking at Pictures in Place*: 1–36. Cambridge: Cambridge University Press.

Collett, D.P. 1993. Metaphors and representation associated with precolonial iron-smelting in eastern and southern Africa. In: Shaw, T., Sinclair, P., Andah B. & Okpoko, A. (eds) *The Archaeology of Africa: Food, Metals and Towns*: 499–511. London: Routledge, One World Archaeology 20.

Cooke, C.K. 1978. Nyazongo rock shelter: a detailed re-examination of the cultural material. *Arnoldia* (Rhodesia) 20: 1–20.

Cooke, C.K. 1979. Excavations at Diana's Vow Rock Shelter, Makoni District, Zimbabwe, Rhodesia. *Occasional Paper of the National Museum, Southern Rhodesia* A4: 115–148.

Cruz e Silva, T. 1979. A preliminary report on an Early Iron Age site: Matola IV/68. In: Leakey, R.E. & Ogot, B.A. (eds) *Proceedings of the 8th Panafrican Congress of Prehistory and Quaternary Studies*. 349. Nairobi: International Louis Leakey Memorial Institute for African Prehistory.

Dowson, T.A. 1998. Rain in Bushman belief, politics and history: the rock art of rain-making in the south-eastern mountains, southern Africa. In: Chippindale, C. & Taçon, P.S.C. (eds) *The Archaeology of Rock-Art*. 73–89. Cambridge: Cambridge University Press.

Duarte, M. De L. & Duarte, R.T. 1988. Arte Rupestre em Mozambique (Sobre oito dos mais belos paineis). *Arqueologia e Antropologia* (Maputo) 5: 75–77.

Duarte, R.T. 1979. Arte Ruspestre em Mozambique: pintura de oito mil anos. *Revista Tempo* (Maputo) 477: 54–59.

Duarte, R.T. 1988. Arqueologia de idade do ferro em Moçambique. *Trabalhos de Arqueologia e Antropologia* 5: 57–73.

Duarte, R.T. 1990. *Northern Mozambique in the Swahili World: An Archaeological Approach*. Uppsala: University of Uppsala.

Eastwood, E.B. 1999. Red lines and arrows: attributes of supernatural potency in San rock art of the Northern Province, South Africa and south-western Zimbabwe. *South African Archaeological Bulletin* 54: 16–27.

Eastwood, E.B. & Cnoops, C.J.H. 1999. Capturing the spoor: towards explaining kudu in San rock art of the Limpopo-Shashi confluence area. *South African Archaeological Bulletin* 54: 107–119.

Felgueiras, J. 1965. Arqueologia e história – problemas das pinturas rupestres de Serra do Vumba em Manica (Mozambique). *Cartaz* (Lisboa) 1(7): 27–44.

Garlake, P.S. 1987. *The Painted Caves: An Introduction to the Prehistoric Rock Art of Zimbabwe*. Harare: Modus Publications.

Garlake, P.S. 1995. *The Hunter's Vision*. Harare: Zimbabwe Publishing House.

Garlake, P.S. 1997. The first eighty years of rock art studies, 1890–1970. In: Pwiti, G. (ed.) *Caves, Monuments and Texts*: 33–53. Uppsala: Uppsala University, Studies in African Archaeology 14.

Goodall, E., Cooke, C.K. & Clark, J.D. 1959. Rock engravings. In: Summers, R. (ed.) *Prehistoric Rock Art of the Federation of Rhodesia & Nyasaland*: 221–244. Salisbury: National Publications Trust Rhodesia and Nyasaland.

Gordon, R.J. & Sholto Douglas, S. 2000. *The Bushman Myth. The Making of a Namibian Underclass*. Second edition. Boulder: Westview Press.

Hall, S. 1994. Images of interaction: rock art and sequence in the Eastern Cape. In: Dowson, T.A. & Lewis-Williams, J.D. (eds) *Contested Images: Diversity in Southern African Rock Art Research*: 61–82. Johannesburg: Witwatersrand University Press.

Huffman, T. 1996. *Snakes and Crocodiles: Power and Symbolism in Ancient Zimbabwe*. Johannesburg: Witwatersrand University Press.

Jacobson-Widding, A. 1989. Notions of heat and fever among the Manyika of Zimbabwe. In: Jacobson-Widding, A. & Westerlund, D. (eds) *Culture, Experience and Pluralism: Essays on African Ideas of Illness and Healing*: 27–44. Uppsala: University of Uppsala, Department of Cultural Anthropology.

Jolly, P. 1998. Modelling change in the contact art of south-eastern San, southern Africa. In: Chippindale, C. & Taçon, P.S.C. (eds) *The Archaeology of Rock-Art*: 247–267. Cambridge: Cambridge University Press.

Lan, D. 1985. *Guns and Rain. Guerrillas & Spirit Mediums in Zimbabwe*. London: James Currey.

Leakey, M.D. 1983. *Africa's Vanishing Art: The Rock Paintings of Tanzania*. New York (NY): Doubleday.

Lewis-Williams, J.D. 1981. *Believing and Seeing: Symbolic Meanings in Southern San Rock Paintings*. London: Academic Press.

Lewis-Williams, J.D. 1986. Beyond style and portrait: a comparison of Tanzanian and southern African rock art. In: Vossen, R. & Keuthmann, K. (eds) *Contemporary Studies on Khoisan* 2: 93–139. Hamburg: Helmut Buske Verlag.

Lewis-Williams, J.D. 1987. A dream of eland: an unexplored component of San shamanism and rock art. *World Archaeology* 19: 165–177.

Lewis-Williams, J.D. 1992. Ethnographic evidence relating to 'trance' and 'shamans' among Northern and Southern Bushmen. *South African Archaeological Bulletin* 47: 56–60.

Lewis-Williams, J.D. & Dowson, T.A. 1994. Aspects of rock art research: a critical retrospective. In: Dowson, T.A. & Lewis-Williams, J.D. (eds) *Contested Images: Diversity in Southern African Rock Art Research*: 201–222. Johannesburg, Witwatersrand University Press.

Liesegang, G. 1970. Nguni migrations between Delagoa Bay and the Zambezi, 1821–1839. *African Historical Studies* 3(2): 317–337.

Macamo, S. 2006. *Privileged Places in South Central Mozambique*. Uppsala: Uppsala University, Humanistisk-samhällsvetenskapliga vetenskapsområdet, Faculty of Arts, Department of Archaeology and Ancient History, African and Comparative Archaeology, Studies in Global Archaeology 4.

Maggs, T. 1995. Neglected rock art: the rock engravings of agriculturalist communities in South Africa. *South African Archaeological Bulletin* 50: 132–142.

Marshall, L. 1957. N!ow. *Africa* 27: 232–240.

Marshall, L. 1962. !Kung Bushmen religious beliefs. *Africa* 32: 221–251.

Masao, F.T. 1979. *The Later Stone Age and the Rock Paintings of Central Tanzania*. Wiesbaden: Franz Steiner Verlag, Studien zur Kulturkunde 48.

Morais, J. 1984. Mozambiquan archaeology: past and present. *African Archaeological Review* 2: 113–128.

Morais, J. 1988. *The Early Farming Communities of Southern Mozambique*. Stockholm: Eduardo Mondlane University & Swedish Central Board of National Antiquities.

Newitt, M. 1995. *A History of Mozambique*. Bloomington (IN): Indiana University Press.

Oliveira, O.R. 1962. Pinturas rupestres dos Contrafortes da Serra Vumba (Chinhamapere). *Caderno de Divulgação Cultural* (Beira) 1: 1–12.

Oliveira, O.R. 1971. Rock art of Moçambique. In: Schoonraad, M. (ed.) *Rock Paintings of Southern Africa*: 4–6. Pretoria: Supplement to the South African Journal of Science, Special issue 2.

Parkington, J., Manhire, T. & Yates, R. 1996. Reading San images. In: Deacon, J. & Dowson, T.A. (eds) *Voices From the Past. /Xam Bushmen and the Bleek and Lloyd Collection*: 212–233. Johannesburg: Witwatersrand University Press.

Phillipson, D.W. 1993. *African Archaeology*. Cambridge: Cambridge University Press.

Pina-Cabral, J. 1986. *Sons of Adam, Daughters of Eve*. Oxford: Clarendon Press.

Potgieter, E.F. 1955. *The Disappearing Bushmen of Lake Chrissie*. Pretoria: J.L. Van Schaik Ltd., Hidding-Currie Publications of the University of South Africa 1.

Ranger, T. 1999. *Voices From the Rocks*. Bloomington (IN): Indiana University Press.

Rita-Ferreira, A. 1982. *Presença Luso-Asiática e Mutações Culturais no Sul de Moçambique, até c.* 1900. Lisboa: Instituto de Investigação Científica Tropical, Junta de Investigações Científicas do Ultramar, Estudos, ensaios e documentos 139.

Robinson, K.R. 1958. Some Stone Age sites in Inyanga District. In: Summers, R. (ed.) *Inyanga: Prehistoric Settlements in Southern Rhodesia*: 270–314. Cambridge: Cambridge University Press.

Sætersdal, T. 1995. Behind the mask: an ethnoarchaeological study of Maconde material culture. Unpublished Cand. Philol. thesis. Bergen: Bergen University.

Sætersdal, T. 1996a. The Maconde Mapico mask: a ritual symbol in a changing society. In: Pwiti, G. & Soper, R. (eds) *Aspects of African Archaeology: Papers from the 10th Congress of the PanAfrican Association for Prehistory and Related Studies*: 755–761. Harare: University of Zimbabwe Press.

Sætersdal, T. 1996b. Male world – female forms. *KAN* 21: 125–139.

Sætersdal, T. 1999. Symbols of cultural identity: a case study from Tanzania. *African Archaeological Review* 16(2): 121–135.

Schoffeleers, J.M. 1992. *River of Blood*. Madison (WI): University of Wisconsin Press.

Sinclair, P.J.J. 1982. Chibuene: an early trading site in southern Mozambique. *Paideuma* 28: 150–164.

Sinclair, P.J.J. 1985a. *Ethno-archaeological Survey of the Save River Valley, South Central Mozambique*. Uppsala: University of Uppsala, Department of Cultural Anthropology, Working Papers in African Studies 11.

Sinclair, P.J.J. 1985b. *An Archaeological Reconnaissance of Northern Mozambique. Part 1: Nampula Province*. Uppsala: University of Uppsala, Department of Cultural Anthropology, Working Papers in African Studies 12.

Sinclair, P.J.J., Morais, J.M.F., Adamowicz, L. & Duarte, R.T. 1993. A perspective on archaeological research in Mozambique. In: Shaw, T., Sinclair, P., Andah B. & Okpoko, A. (eds) *Archaeology in Africa: Food, Metals and Towns*: 409–431. London: Routledge, One World Archaeology 20.

Smith, B. 1997. *Zambia's Ancient Rock Art: The Paintings of Kasama*. Livingstone: The National Heritage Conservation Commission of Zambia.

Soper, R. 1996. The Nyanga terrace complex of eastern Zimbabwe: new investigations. *Azania* 31: 1–35.

Tredgold, R. 1956. *The Matopos*. Salisbury: Federal Department of Printing.

Turner, V. 1967. *The Forest of Symbols: Aspects of Ndembu Ritual*. Ithaca (NY): Cornell University Press.

Vinnicombe, P. 1976. *People of the Eland: San Rock Paintings of the Drakensberg as a Reflection of Their Life and Thought*. Pietermaritzburg: Natal University Press.

Walker, N.J. 1987. The dating of Zimbabwean rock art. *Rock Art Research* 4(2): 137–149.

Walker, N.J. 1995. *Late Pleistocene and Holocene Hunter-gatherers of the Matopos*. Uppsala: Uppsala University, Studies in African Archaeology 10.

Walker, N.J. 1996. *The Painted Hills: Rock Art of the Matopos*. Gweru: Mambo Press.

Walker, N.J. & Thorp, C. 1997. Stone Age archaeology in Zimbabwe. In: Pwiti, G. (ed.) *Caves, Monuments and Texts*: 9–31. Uppsala: Uppsala University, Studies in African Archaeology 14.

Willcox, A.R. 1984. *The Rock Art of Africa*. London: Croom Helm.

Zvabva, O. 1988. Nyachiranga regional cult. Unpublished BA Honours thesis. Harare: University of Zimbabwe, Department of Religious Studies.

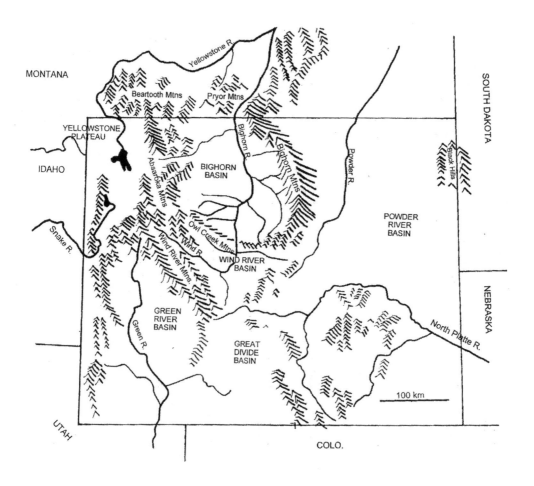

FIGURE 16.1 Map of Wyoming showing the Bighorn and Wind River basins. Pecked Dinwoody tradition rock art occurs on the west side of the Bighorn and Wind rivers; incised and painted imagery occurs east of the river. *(Map courtesy of University of Utah Press)*

16.

Oral tradition, ethnography, and the practice of North American archaeology

JULIE E. FRANCIS AND LAWRENCE L. LOENDORF
(Laramie WY, USA and Albuquerque NM, USA)

THE CHANGING SHAPE OF NORTH AMERICAN ARCHAEOLOGY

Over the course of the last half of the 20th century, North American anthropology and archaeology have witnessed many changes, not the least of which has been the divergence of the sub-disciplines as most dramatically exemplified by the organisational split between the Society for American Archaeology and the American Anthropological Association in the mid-1980s. Many academic departments have moved away from the traditional four-fields approach, with little to no crossover between sub-disciplines at the graduate level and specialisation within sub-disciplines for undergraduates. With increased specialisation, it has been many years since archaeologist and ethnographer have been the same individual, in the fashion of

Frederica de Laguna (1960) in south-east Alaska. As a result, studies which explicitly seek to integrate oral tradition, ethnographic and archaeological data are extremely rare.

Specialisation has also been the dominating trend within North American archaeology. With the rise of the cultural ecological paradigm in the 1960s, many archaeologists began to employ a multidisciplinary approach, particularly with respect to natural sciences such as biology, plant and animal ecology, palynology, geology, chemistry and physics, giving rise to the technical specialist. As a result, many academic departments now offer tracks to train geo-archaeologists, ethnobotanists, faunal analysts, lithic analysts, or specialists in quantitative methods. It is notable that, with our roots in anthropology, the outside discipline that was left out was often cultural anthropology.

With the 'New Archaeology' of the 1960s and the goal to go beyond the reconstruction of culture history to the explanation of culture change (e.g. Fritz & Plog 1970), we archaeologists also desired to be viewed as 'scientists'. We wished to use the scientific method to conduct experiments, to develop multiple working hypotheses and test them in a deductive manner, and to employ logical positivism (Hempel 1966) in a manner analogous to that of the natural sciences in order to discover laws governing human behaviour. We adopted the trappings of science in an effort to distance ourselves from the humanities.

A critical element of logical positivist philosophy is that the understanding and explanation of natural phenomena is extrinsic to the objects of study. In other words, through 'objective' observation and deductive reasoning, laws governing natural phenomena can be discovered. When applied to people, it stands to reason that, if laws are universal, they must be cross-cultural. Therefore, understanding and explaining the archaeological record is extrinsic to the people under study. This philosophy has deeper roots than the 1960s in archaeological method and theory. It reaches back to the debate on the meaning of artefact types in which Spaulding (1953) argued that types were culturally real to the makers of the artefacts, and Ford (1954) countered that types were imposed upon the data by the researcher. The latter perspective was readily incorporated into the 'New Archaeology'. Consequently, many of us trained during this era saw little need to learn much about cultural anthropology or modern Native Americans and, as a result, we removed the archaeological record from the people who left that record behind.

ROCK ART AND THE 'NEW ARCHAEOLOGY'

Rock art generally does not fit well within the cultural ecological paradigms and has, more often that not, been studied as an aside to most archaeological research projects (see Whitley [2001] for an in-depth discussion of these issues). We have often mused that many of our more macho colleagues view rock art as a little too 'artsy' for their scientific tastes. This is clearly based in the epistemology of North American archaeology, as we have long realised that understand- ing rock art was intrinsic to the people and cultures who made it and that we simply have no way of know- ing about it. As pointed out by William Mulloy over 40 years ago: "Their pictographic significance must remain obscure, however, for such symbolism is a highly individualised thing, capable of decipherment only by the original artist and his community ... archaeologically we cannot cope with petroglyphic meanings ..." (1958: 119).

This perspective is based upon the many accounts by military explorers, early settlers, and ethnographers who reported that Native Americans claimed to know nothing about the rock art of many areas (Steward 1968). Therefore, under the presumption that many tribes were 'recent' arrivals where they were first encountered by Euro-Americans (e.g. Heizer & Baumhoff 1962; Bettinger & Baumhoff 1982, 1983), it was inferred that rock art pre-dated the arrival of historically documented tribes, had to have been made by somebody else, and that the ethnographic record was of little use. In addition, conventional wisdom has always held that, because of the profound and destruc- tive changes wrought on Native Americans during the Historic Period, because people were put on reserva- tions and were no longer living traditional lifeways, and because of our goals of 'acculturating' Native Americans, oral tradition would not pre-date the reser- vation era and would be of no use in interpreting pre- historic imagery (see de Laguna 1960: 2). Furthermore, from a 'scientific' perspective, there is no way to verify oral tradition, especially considering the versions of stories told by different individuals.

These premises are clearly the result of an imposi- tion of western thought on non-western cultures: our tendency to take ethnographic information and responses from Native American informants very literally and directly; and our equation of the role of oral tradition in non-literate societies with our own in which the written word has almost completely replaced oral tradition. Coupled with the fact that many early studies viewed rock images from a stylistic or 'art for art's sake' perspective, and with our predilection for interpreting imagery as writing, if only universal patterns of meaning could be discovered within it, it is no wonder that most archaeologists have implicitly held that we simply have no way of knowing about rock art and that it cannot be studied in a scientific manner.

ROCK ART AND THE 'NEWER ARCHAEOLOGY'

Over 30 years ago, South African archaeologist David Lewis-Williams began a journey that has brought rock art studies to entirely new levels of understanding and meaning. Through the discovery of a large body of ethnographic data and accounts collected from the San in southern Africa, Lewis-Williams was able to define many of the social and cultural contexts for the manufacture of San rock art. His research (Lewis-Williams 1981, 1982, 1983; Lewis-Williams & Dowson 1989) focuses upon emic concepts of supernatural power and potency, which creatures hold which types of power and how humans may acquire this power. Many aspects of mundane activities, such as hunting eland, are imbued with religious meaning; and aspects of personal dress, decoration and ritual are rooted in beliefs about the invocation of supernatural power that have origins in visionary experiences subsequently painted upon the rock faces of the landscape.

Lewis-Williams makes strong arguments that, cross-culturally, rock art manufacture and meaning are rooted in religious belief and ideology. Furthermore, in order to understand the images one has to rely upon ethnography, emic perspectives, and ethnographic analogy (Lewis-Williams 1991: 149), and he has repeatedly urged his students to go back to the ethnographic records. In North America, Whitley (1988, 1992, 1994a, 1994b, 1994c) has been the most vocal proponent of this approach, and his re-analysis of the ethnographic record from western North America demonstrates clear relationships between religious ideology, the activities of shamans and rock art, especially for Numic-speaking groups.

EXAMPLES: Ethnography, oral tradition and understanding

With these thoughts in mind, we offer three examples where the use of ethnographic sources and oral tradition has resulted in far greater understanding of several different types of rock images in the Bighorn and Wind River basins of north-western Wyoming (Figure 16.1). We have been engaged in a research programme over the last 15 years to obtain numerical age estimates and to classify and understand the rock images of the area (Francis *et al*. 1993; Francis 1994;

Francis & Loendorf 2002). Briefly, rock art in the area can be grouped into two major classes: pecked and incised/painted. Pecked rock art, which includes the well-known Dinwoody tradition (Wellmann 1979), occurs almost exclusively on the west side of the Bighorn Basin, has a demonstrated antiquity of several thousand years, and is most likely attributable to Numic-speaking groups. Incised/painted images occur almost exclusively on the east side of Bighorn River, with ages ranging from slightly over 2000 years to the Historic Period. This class is attributable to Plains groups. The two classes share little in the way of common figure types or symbols.

As our first example, we shall consider one case within the Dinwoody tradition. Many ethnographic sources indicate that Shoshone shamans created rock art the morning after a vision was received in order to preserve it. Documented vision-questing areas include several locales on the Wind River Reservation as well as near the Thermopolis area (Whitley 1994a), with concentrations of Dinwoody rock art in the area. Rock art sites, or *poha kahni*, were thought of as portals to the supernatural and home to a variety of dangerous, if not deadly, supernatural beings (Liljeblad 1986: 652; Whitley 1994b: 7). Shamans received knowledge and power from these beings for the purposes of curing. The Dinwoody region was known as home to a variety of ghost beings, and Shimkin (1986: 325) reports that many of the rock art figures in this area represent water ghosts or rock ghosts (Figure 16.2). Archaeological evidence directly confirms the use of some of these sites by shamans; Frison and Van Norman (1993) recovered the remains of several carved steatite pipes or sucking tubes from beneath the base of figures that appear to represent water ghosts.

Water ghosts, *pan dzovaits*, and water babies are said to be the cause of the boiling water in hot springs and geysers (Hultkrantz 1986: 633). The ghosts are said to be giants, with enormous hands and feet, who live in the water. These beings cause a variety of illnesses by shooting victims with magical arrows (Shimkin 1986: 325), and if one is successful in meeting and surviving an encounter with them, one is given special powers. *Pa Waip* or 'Water Ghost Woman' (Figure 16.3) is one well-known water ghost (see Francis & Loendorf 2002: 116–118). It is said she lives in the water; Turtle is her assistant, doing chores for her on land. This figure is quite large, almost gigantic, being over 1.4 m

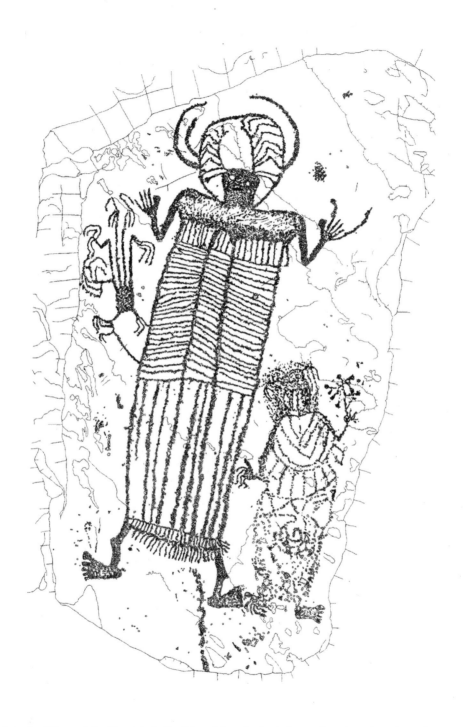

FIGURE 16.2 Example of Dinwoody tradition, interior-lined figure inferred to be the image of a rock or water ghost. This image is about 1 m in height. *(Tracing by Linda Olson, courtesy of University of Utah Press)*

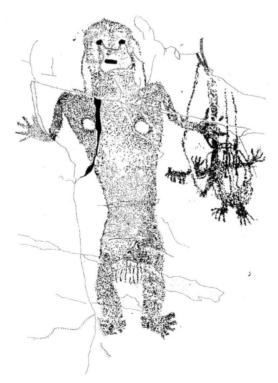

FIGURE 16.3 'Water Ghost Woman' from the Bighorn Basin. This image is over 1.4 m in height. Note that she holds a bow and another creature in her left hand. A pecked turtle occurs to her right. *(Photo by Julie Francis; tracing by Linda Olson, courtesy of University of Utah Press)*

tall, and with exaggerated fingers and toes. *Pa Waip* is said to have long hair (Hultkrantz 1987: 49), as depicted by the braids in the petroglyph. People knew she was about because they heard her crying, as demonstrated by the tear streaks below her eyes.

Pa Waip caused illness by shooting magical arrows, and she might grab people, often children, and drown them. Often she would entice men into sexual encounters before doling out an unpleasant fate. As described by Shoshone elder, John McAdams, to Shimkin (1947: 306), a man was enticed into Bull Lake by a pretty woman. As he was making love "... some Indians come along, spearing fish, and [he] jumped out like a trout, thus saving [his life] but losing the girl". The story suggests the man almost

wished he had not been interrupted, though one wonders what would have happened had he been allowed to continue the tryst.

The incised and painted sites found on the east side of the Bighorn Basin are quite diverse and cannot necessarily be ascribed a single tribal or linguistic affiliation (Francis & Loendorf 2002: 135). Nevertheless, ethnographic evidence suggests that a series of sites containing distinctive red-painted figures may be related to the Crow Tobacco Society. The paintings include images of plants with vertical stems and opposing horizontal branches, and anthropomorphic figures with large eyes and distinctive flat headdresses (Figures 16.4, 16.5). The human figures occasionally hold the plants.

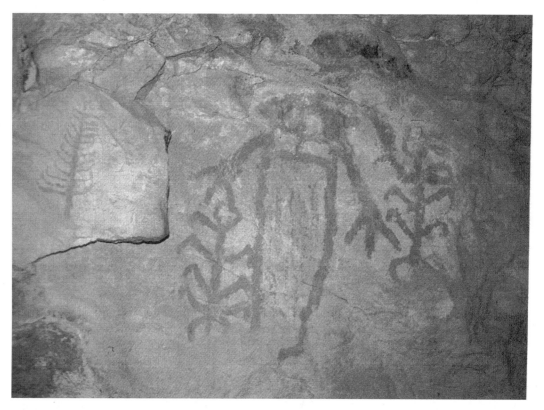

FIGURE 16.4 Flat headdress human figure (holding tobacco plants) from extreme southern Montana. *(Photo by Lawrence Loendorf, courtesy of University of Utah Press)*

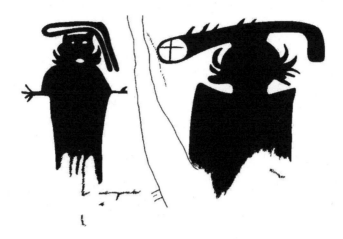

FIGURE 16.5 Solid red-painted human figures from the extreme northern Bighorn Basin in southern Montana. Note the star at one end of the headdress. Comparison with historic photographs (see Francis & Loendorf 2002: 172) suggests that the headdress is made of the leaves of native tobacco draped off a flat platform worn on the head. (*Drawing by Terry Wolfgram, courtesy of University of Utah Press*)

Tobacco (*Nicotiana multivalvis*) plays an essential role in Crow creation and survival lore (Lowie 1919; Nabokov 1988). *Batseesh* is the Rockman, the original being on earth. In his wanderings, *Batseesh* encounters Coyote and tells him he is lonely. Coyote advises *Batseesh* to go to the Tobacco plant, where he will find his mate. *Batseesh* heeds this advice, mating with Tobacco to produce the first generation of Crow people (Wildschut 1975).

In addition, the Crow received their first sacred tobacco seeds through a vision that No Intestines had on a peak in the Bighorn mountains, known to the Crow as *Awaxaawakussawishe* or the 'Extended Mountains' (McCleary 1997: 18). In the vision he was instructed to search for tobacco seeds at the base of the mountain. Looking down for the seeds, he saw "twinkling stars", thus making an association between the stars and the Crow Sacred Tobacco. The origin of Sacred Tobacco is clearly visionary, and the Crow plant and harvest it according to great ritual; this is done by members of various chapters of the Tobacco Society.

The plant images are strikingly similar to icons of the tobacco plant on moccasin and medicine bags of the Crow Tobacco Society (Nabokov 1988) and, at one site in Bighorn Canyon, Loendorf (1994) collected pollen samples from sediments beneath paintings of this plant, along with a series of pollen samples

from caves that did not contain paintings. The samples from the painted cave contained a far richer variety of pollen than the control samples. Furthermore, pollen from a variety of medicinal plants, including *Nicotiana*, was found only in the samples from the painted cave. Local and wind-transportation sources for these plants have been ruled out, strongly indicating that they were introduced into the cave deposits by humans and strengthening the possibility that the image represents tobacco. Images that strongly resemble tobacco seed pods also occur at these sites and the flat headdresses seen on the human figures strongly resemble the ceremonial regalia of Tobacco Society members. Thus, there is a strong likelihood that these sites are indeed related to the Tobacco Society.

Our final example also suggests affiliations with the Crow. Two unusual rectangular-bodied human figures occur in the Red Canyon area of the Wind River Basin (Figure 16.6). These figures exhibit herringbone designs on their chests, and bulbous heads with eyes and mouths. Ears are shown as half-circles attached to the sides of the head. One figure has teeth and a topknot for hair. Other anatomical features are shown in great detail, and the entire figure sits among a set of deeply incised stars. The second figure does not sit among the stars and is slightly more realistic. The ears show earrings, and hair or head decoration is shown as a series of vertical lines. The toes resemble bear claws.

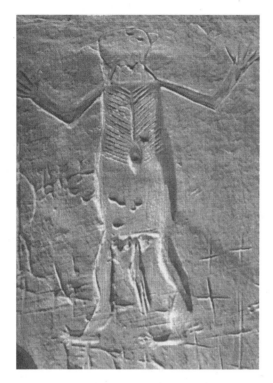

FIGURE 16.6 Human image thought to represent one of the Crow/Hidatsa twin heroes from the Wind River Basin. Note the bulbous ears, herringbone breast plate and stars at the base of the figure. *(Photo by Lawrence Loendorf, courtesy of University of Utah Press)*

Boy, or as he is known among the Crow, 'Thrown Into the Spring'. Additional likenesses of both twin heroes occur on other Crow shields (Cowdrey 1995).

Many of the exploits of Thrown Into the Spring and Thrown Behind the Tipi Lining take place among the stars. McCleary (1997: 49–72) describes the Crow constellation known as the Hand Star and its origin as related to the twin heroes. The Hand Star is part of the Euro-American constellation Orion. The belt of Orion is seen as the wrist, his sword as the thumb, and the stars Cursa, Rigel, and SAO 132067 as the fingertips (McCleary 1997: 49). In one narrative, Thrown Into the Spring saves his brother by cutting off the hand of Long Arm, whereupon it is placed in the sky by the moon (Lowie 1918: 93; McCleary 1997). In another version, Thrown Into the Spring is said to be the Evening Star, and Thrown Behind the Tipi Lining is the last star in the Big Dipper (Lowie 1918: 85). There are several variants of the story, but the twin heroes always travel to the heavens, and the severed hand of the antagonist becomes the Hand Star constellation.

We believe we have identified these images at one other site in the Black Hills. Here two upside down heads occur on one panel. These faces sport many of the same features reported for both Spring Boy and Lodge Boy. There is a horizontal line extending from one head. From the other, a hand-like figure is attached to the horizontal line and appears to be grasping the head by the chin.

INTEGRATION OF ETHNOGRAPHIC INFORMATION AND TRADITIONAL ARCHAEOLOGICAL DATA: Implications for archaeology

Through the integration of ethnographic information and traditional archaeological data, we have gained a much richer understanding of individual figures or images in the rock art of Wyoming, as well as different views of the ideological variability within the northwestern portion of the state, of the ancestral antiquity of historically documented tribes, and of the landscape; that is, rock art sites can be viewed as reflecting the sacred geography of the area and the distribution of supernatural power. We should also note that much of the archaeological data in and of itself is consistent with many Native American's versions of their own history.

These figures bear an uncanny resemblance to the human representation on the shield of *Arapoosh* or Rotten Belly, a well-known Mountain Crow chief in the 1830s. The human figure on Rotten Belly's shield exhibits a similar herringbone design on the chest, along with a ferocious face showing a mouth full of teeth and round ears. Based upon the recent discovery of a Hidatsa ledger book with pictures of the twin heroes Spring Boy and Lodge Boy, specifically identified by the original artists, Cowdrey (1995) identifies the human figure on Rotten Belly's shield as Spring

These lessons have been hard won; they have come only with the realisation that rock art is often metaphorical – for both the aural and the visual sensations of the trance experience, and also for the natural landscape (see Whitley 1994b) – and that the visionary experience forms the fundamental basis for the religious world view for most Native Americans, and perhaps for hunting and gathering people around the world. Irwin (1994) argues that dreaming and the individual visionary experience are the foundation of religious world view in the Great Plains. He examines a large body of ethnographic data to suggest that Plains groups did not distinguish between the 'lived' and the 'dreamed' worlds, between the natural and the supernatural (Irwin 1994: 23–32). Sojourns to different cosmological worlds are an expected part of life from childhood on, and encounters with beings through dreams and visions are the primary source of knowledge and power for all individuals.

We are familiar with the lack of boundaries between the waking and the dreamed worlds among aboriginal cultures of Australia (Spencer & Gillen 1927; Stanner 1956). We are less accustomed to, or even comfortable with, thinking about Native American religious world view in similar terms. As noted by Irwin, this aspect of Native American religions has been downplayed, in part because our culture perceives it as irrational. The late Lakota scholar Vine Deloria Jr. (2000) observed that, without an understanding of the central role played by the visionary experience in Native American world view, oral tradition is easily dismissed as physically impossible flights of fancy reflecting primitive superstitions. It is this perspective that has often characterised many North American archaeologists' views of Native American oral traditions, especially throughout the latter half of the 20th century.

Deloria's observations highlight an important paradox in American archaeology and anthropology that has developed over the last 20 years. During this time,

the bulk of American archaeology has come to be undertaken under the rubric of publically funded cultural resource management studies. New federal laws and guidelines increasingly emphasise the cooperation, involvement, and integration of Native American tribal governments and viewpoints in the day-to-day practice of public archaeology (see Thomas [2000] for a summary of political and legal developments). Yet, at the same time, the sub-disciplines of anthropology have become increasingly separated and esoteric, and many departments no longer teach traditional cultural anthropology in a four-fields curriculum. Postgraduate training of students as specialists in particular analytical techniques has become increasingly common, and many departments have been slow to realise that the vast majority of their students will not find employment in the academy. As a result, many students are poorly equipped with the knowledge and skills necessary for professional positions with government agencies, museums, historic preservation organisations, and consulting firms.

It is probably unrealistic to assume that traditional cultural anthropology will suddenly be included in the curriculum of many anthropology departments. However, several American universities (e.g. the University of Wyoming, Arizona State University and New Mexico State University, to name but a few) now offer rock art classes as part of their regular curriculum and include rock art documentation as part of their field schools. It is rock art research, as pioneered by David Lewis-Williams, that bridges the gap between current academic training and professional employment. Rock art research integrates the humanistic and scientific aspects of archaeology, opens students to different ways of thinking about the archaeological record and indigenous peoples, offers new interpretations and understanding of the people and ancient history of many regions, and will become an increasingly important facet of American archaeology.

Acknowledgements

We offer our deepest appreciation to Geoff Blundell and Ben Smith for inviting our participation in the celebration honouring the retirement of David Lewis-Williams. It was truly an honour to be included with such distinguished researchers and scholars. We also owe hearty thanks to all the students and staff at the Rock Art Research Institute for their gracious hospitality, patience, and knowledge in leading us to so many wonderful places in South Africa. We owe thanks to the Bureau of Land Management in Wyoming for funding assistance for much of the original fieldwork on which this chapter is based, and to Linda Olson for the figures used in this chapter. Illustrations are used courtesy of University of Utah Press. Most important, our deepest gratitude goes to David Lewis-Williams. You have opened our minds to new ways of thinking and shepherded us on an exciting journey of new knowledge and understanding.

References

Bettinger, R.L. & Baumhoff, M.A. 1982. The Numic spread: Great Basin cultures in competition. *American Antiquity* 47: 485–503.

Bettinger, R.L. & Baumhoff, M.A. 1983. Return rates and intensity of resource use in Numic and Prenumic adaptive strategies. *American Antiquity* 48: 830–834.

Cowdrey, M. 1995. Spring Boy rides the Moon: celestial patterns in Crow shield design. Unpublished manuscript in possession of L.L. Loendorf.

De Laguna, F. 1960. *The Story of a Tlingit Community: A Problem in the Relationship between Archaeological, Ethnological, and Historical Methods.* Washington (DC): Smithsonian Institution, Bureau of American Ethnology Bulletin 172.

Deloria, V. Jr. 2000. Comment on Ghost Dancing the Grand Canyon: southern Paiute rock art, ceremony, and cultural landscapes. *Current Anthropology* 41(1): 27.

Ford, J.A. 1954. The type concept revisited. *American Anthropologist* 56: 42–53.

Francis, J.E. 1994. Cation-ratio dating and chronological variation within Dinwoody tradition rock art in northwestern Wyoming. In: Whitley, D.S. & Loendorf, L.L. (eds) *New Light on Old Art: Recent Advances in Hunter-gatherer Rock Art Research*: 37–50. Los Angeles (CA): University of California, Institute of Archaeology Monograph No. 36.

Francis, J.E. & Loendorf, L.L. 2002. *Ancient Visions: Petroglyphs and Pictographs of the Wind River and Bighorn Country, Wyoming and Montana.* Salt Lake City (UT): University of Utah Press.

Francis, J.E., Loendorf, L.L. & Dorn, R.I. 1993. AMS radiocarbon and cation-ratio dating of rock art in the Bighorn Basin of Wyoming and Montana. *American Antiquity* 58: 711–737.

Frison, G.C. & Van Norman, Z. 1993. Carved steatite and sandstone tubes: pipes for smoking or shaman's paraphernalia? *Plains Anthropologist* 38(143): 163–176.

Fritz, J.M. & Plog, F.T. 1970. The nature of archaeological explanation. *American Antiquity* 35: 405–412.

Heizer, R.F. & Baumhoff, M.A. 1962. *Prehistoric Rock Art of Nevada and Eastern California.* Berkeley (CA): University of California Press.

Hempel, C.G. 1966. *Philosophy of Natural History.* Englewood Cliffs (NJ): Prentice-Hall.

Hultkrantz, Å. 1986. Mythology and religious concepts. In: D'Azevedo, W.L. (ed.) *Handbook of North American Indians, Volume 11, Great Basin*: 630–640. Washington (DC): Smithsonian Institution.

Hultkrantz, Å. 1987. *Native Religions of North America: The Power of Visions and Fertility.* San Francisco (CA): Harper and Row.

Irwin, L. 1994. *The Dream Seekers: Native American Visionary Traditions of the Great Plains.* Norman (OK): University of Oklahoma Press.

Lewis-Williams, J.D. 1981. *Believing and Seeing: Symbolic Meaning in Southern San Rock Paintings.* London: Academic Press.

Lewis-Williams, J.D. 1982. The economic and social context of southern San rock art. *Current Anthropology* 23: 429–438.

Lewis-Williams, J.D. 1983. *The Rock Art of Southern Africa.* Cambridge: Cambridge University Press.

Lewis-Williams, J.D. 1991. Wrestling with analogy: a methodological dilemma in Upper Palaeolithic rock art research. *Proceedings of the Prehistoric Society* 57(1): 139–162.

Lewis-Williams, J.D. & Dowson, T.A. 1989. *Images of Power: Understanding Bushman Rock Art.* Johannesburg: Southern Books.

Liljeblad, S. 1986. Oral tradition: content and style of verbal arts. In: D'Azevedo, W.L. (ed.) *Handbook of North American Indians, Volume 11, Great Basin*: 641–659. Washington (DC): Smithsonian Institution.

Loendorf, L.L. 1994 Traditional archaeological methods and their applications at rock art sites. In: Whitley, D.S. & Loendorf, L.L. (eds) *New Light on Old Art: Recent Advances in Hunter-Gatherer Rock Art Research*: 95–103. Los Angeles (CA): University of California, Institute of Archaeology Monograph No. 36.

Lowie, R.H. 1918. Myths and traditions of the Crow Indians. *Anthropological Papers of the American Museum of Natural History* 25: 1–308.

Lowie, R.H. 1919. The Tobacco Society of the Crow Indians. *Anthropological Papers of the American Museum of Natural History* 21(2): 101–200.

McCleary, T.P. 1997. *The Stars We Know: Crow Indian Astronomy and Lifeways*. Prospect Heights (IL): Waveland Press.

Mulloy, W.T. 1958. A preliminary historical outline for the Northwestern Plains. *University of Wyoming Publications* 22(1): 1–235.

Nabokov, P. 1988. Cultivating themselves: the inter-play of Crow Indian religion and history. Unpublished PhD thesis. Berkeley: University of California, Department of Anthropology.

Shimkin, D.B. 1947. Childhood and development among the Wind River Shoshone. *University of California Anthropological Records* 59(5): 289–325.

Shimkin, D.B. 1986. Eastern Shoshone. In: D'Azevedo, W.L. (ed.) *Handbook of North American Indians, Volume 11, Great Basin*: 308–335. Washington (DC): Smithsonian Institution.

Spaulding, A.C. 1953. Statistical techniques for the discovery of artefact types. *American Antiquity* 18: 305–313.

Spencer, B. & Gillen, F.J. 1927. *The Arunta: A Study of Stone Age People*. Macmillan: London.

Stanner, W.E.H. 1956. The dreaming. In: Hungerford, T.A.G. (ed.) *Australian Signpost: An Anthology*: 51–65. Melbourne: F.W. Cheshire.

Steward, J.H. 1968. Foreword. In: Grant, C. *Rock Drawings of the Coso Range, Inyo County, California*: vii–x. China Lake (CA): Maturango Museum.

Thomas, D.H. 2000. *Skull Wars: Kennewick Man, Archaeology, and the Battle for Native American Identity*. New York: Basic Books.

Wellmann, K.F. 1979. *A Survey of North American Rock Art*. Graz: Akademische Druck-u, Verlagsanstalt.

Whitley, D.S. 1988. Reply. *Current Anthropology* 29: 238.

Whitley, D.S. 1992. Shamanism and rock art in Far Western North America. *Cambridge Archaeological Journal* 2: 89–113.

Whitley, D.S. 1994a. Ethnographic and rock art in the Far West: some archaeological implications. In: Whitley, D.S. & Loendorf, L.L. (eds) *New Light on Old Art: Recent Advances in Hunter-gatherer Rock Art Research*: 81–94. Los Angeles (CA): University of California, Institute of Archaeology Monograph No. 36.

Whitley, D.S. 1994b. Shamanism, natural modeling and rock art of Far Western North American hunter-gatherers. In: Turpin, S. (ed.) *Shamanism and Rock Art in North America*: 1–43. San Antonio (TX): Rock Art Foundation, Special Publication 1.

Whitley, D.S. 1994c. By the hunter, for the gatherer: art, social relations, and subsistence change in the prehistoric Great Basin. *World Archaeology* 25(3): 356–373.

Whitley, D.S. 2001. Rock art and rock art research in a worldwide perspective: an introduction. In Whitley, D.S. (ed.) *Handbook of Rock Art Research*: 1–43. Walnut Creek (CA): AltaMira Press.

Wildschut, W. 1975. *Crow Indian Medicine Bundles*. New York: Heye Foundation, Contributions from the Museum of the American Indian 17.

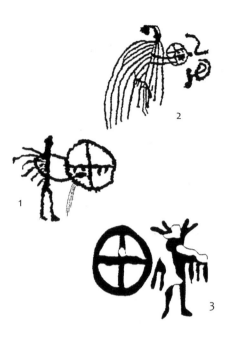

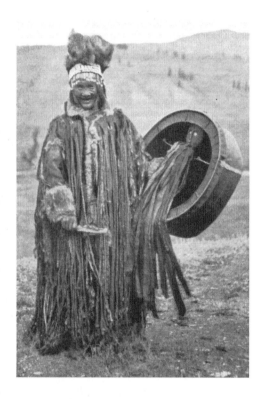

FIGURE 17.1 Prehistoric rock carvings such as these from Siberia show astonishing parallels with shaman costumes photographed by early ethnographers, but does the one 'prove' the antiquity of the other, and how secure are our definitions? The rock engravings at the top are from (1) Oglakhty, Middle Yenisei River, (2) Middle Yenisei River, (3) Mokhsogolokh-Khaja, Middle Lena River (after Devlet 2001: 47). The photograph at the bottom is of an Altai shaman in the early 1920s (after Nioradze 1925: 88).

17.

Beyond rock art:
Archaeological interpretation and the shamanic frame

NEIL PRICE

(Department of Archaeology, University of Aberdeen, Scotland)

There are images carved into or painted on rock – a perspective of a village seen from the height of a nearby hill, a single line depicting a woman's back bent over a child – that have altered Sarath's perceptions of his world (Ondaatje 2000: 156).

INTRODUCTION: Southern African rock art research, in southern Africa and elsewhere

Let us take as our subject the archaeological enquiry into the prehistoric mind, considering all its aspects, including ancient cognition, spirituality, symbolic storage and many others. If we review the work that has been undertaken over the last 20 years or so then it is clear that one particular framework of interpretation has become increasingly prominent: the study of shamanism.

Although this has embraced a variety of fields from portable material culture to monumental archi-tecture, it is primarily through research into rock art that a shamanic focus has become well known in archaeology (see for example the numerous references to shamanism in Whitley [2005]). In particular, this is a development that has arisen from the work under-taken by David Lewis-Williams and his colleagues in southern Africa.

In the context of the present volume it would be superfluous to summarise this research in detail, but for the benefit of readers perhaps coming fresh to this subject it is worth considering the sheer extent to which these perspectives have broken through in archaeological interpretation. Building on the platform

earlier established by scholars such as Patricia Vinnicombe (e.g. 1975, 1976) and not least David himself in his classic *Believing and Seeing* (1981), from the early 1980s onwards it is possible to trace a continuously developing tradition in southern African rock art studies, encompassing several parallel strands of enquiry in a unified study of shamanic belief systems. These include the fundamental research into entoptic phenomena, dreams, transformation and spirit animals (e.g. Lewis-Williams 1987, 1988a, 1988b, 1992, 1995, 2001a; Lewis-Williams & Dowson 1989), and the crucial concept of the rock surface as a membrane between the worlds (Lewis-Williams & Dowson 1990), subsequently developed into a unitary thesis of San spirituality (Lewis-Williams 2001b, 2002a; Lewis-Williams & Pearce 2004). This is only to touch the surface, as it were, and a true assessment of the impact of these ideas, even within southern Africa alone, would have to include their stimulation of a range of wider work on the art (e.g. Blundell 2004, 2005) and even original publications of the underlying ethnography (e.g. Lewis-Williams 2000; Hollmann 2004).

Not least, this period has seen the establishment of the Rock Art Research Unit (later a Centre, and now an Institute) at the University of the Witwatersrand in Johannesburg as a focus for this work, not just in southern Africa, but as a centre of excellence with a global perspective.

The influence of the southern African school has perhaps been felt most directly through the development of these ideas in the context of the American Far West (Whitley 2000 and references therein) and the European Palaeolithic. In the latter case, the process was initiated from within South Africa with the famous paper 'The Signs of all Times' (Lewis-Williams & Dowson 1988), and developed rapidly thereafter (Lewis-Williams 1990, 1991, 1997a, 1997b; Clottes & Lewis-Williams 1996; Lewis-Williams & Clottes 1998). Its ultimate expression is probably *The Mind in the Cave*, Lewis-Williams' (2002b) attempt to place the origins of art in the context of human cognitive evolution. This work has now been extended into the European and Near Eastern Neolithic (Lewis-Williams & Pearce 2005), building on a range of earlier studies that had applied the principles of the southern African school to Atlantic rock art and decorated tombs (Bradley 1989, 1997; Lewis-Williams & Dowson 1993; Dronfield 1994, 1995).

The achievement of altered states of consciousness through shamanic rituals, the use of hallucinogens and mind-altering substances, and the notion of painted or engraved images as a record of vision quests and soul journeys, guides for initiates and future travellers, ancestral maps, even foci of interaction or points of entry between the worlds have now been explored through shamanic readings of rock art over most of Europe and Scandinavia, the Americas, Asia and the Pacific – not least, many of the contributors to this volume and the other participants in the colloquium on which it is based stand as representatives for this new work.

DIVERSITY AND DEFINITION IN A SHAMANIC ARCHAEOLOGY

Lest the above outline give the impression of a uniform approach, one should stress that the current research in this field also lays a crucial emphasis on a shamanic world view as one of many alternative or simultaneous conceptions that may have lain behind the creation of the art. Secondly, rock art scholars working with shamanism see such explanations as being far from universal in scope, and thirdly, an emphasis is placed on the broad diversity of shamanic traditions across the globe (this research orientation is treated at length by Whitley and Keyser [2003]; see also Guenther [1999] and Layton [2000] for comparative, and critical, perspectives with regard to totemism).

To a degree, this situation mirrors developments in wider shamanic research, but it is also true that in some ways this debate still retains a certain sense of distance, as Taçon and Chippindale (1998: 4–6) noted nearly a decade ago. Despite its considerable breadth of study area and methodological advances, the archaeology of rock art still remains somewhat apart from archaeology in a wider sense. This greater arena, the work beyond the field of rock art studies that has nevertheless felt its influence, forms the primary subject of this chapter. In particular, I want to address the much broader discipline of which shamanic interpretations of rock art are an integral part: the archaeology of shamanism itself.

Unlike in the case of most of the contributors to this volume, the majority of them rock art researchers, it is this material culture of shamanic belief systems in

their own right that forms one of my primary fields of study. (I work mainly on the Viking Age, where much of my recent research has focused on the pre-Christian religion of Scandinavia and on the shamanic structures that are found there, at the meeting point of the Germanic and circumpolar cultural spheres.) It is thus from this perspective that this chapter has been prepared, looking at rock art research from the outside.

From this point of view, of key importance is the relationship of parietal imagery to the social arena within which it was produced. This has long been a preoccupation of rock art research, of course, but it should be emphasised that the study of arguably shamanic painting or engraving traditions naturally presupposes a study of shamanic societies, and the full spectrum of their material culture. If this sounds obvious, it is worth remembering just what a vast research field shamanism represents. I have earlier reviewed the long history of research into shamanic belief systems in some detail and will not repeat this here (Price 2001a, 2001b, 2002: chapter 5; for later reviews, see also Harvey [2003], Stutley [2003], and the volumes in the continuing Hungarian *Bibliotheca Shamanistica* series).

If we attempt to draw out the essential traits in the modern study of shamanism, the most important is probably a concern for precise definition that has, for example, always been a hallmark of David Lewis-Williams' work (though regrettably not always of his critics'). Beyond this, we may isolate several other issues which perhaps characterise the current archaeology and anthropology of shamanism as a whole, and which by extension may be of particular interest in the present context:

- the diversity of shamanic practitioners within a given community;
- the diversity of social roles and ritual functions served by these different types of shaman;
- the existence of shamans as one kind of ritual specialist alongside others in the same community;
- the variation in shamanic practice from one community (and culture) to another;
- the complexity of gender identities and sexual constructions associated with shamanism;
- a focus on aggression and violence within shamanic ritual, equal or at times exceeding the focus on healing.

Although shamanic interpretations of parietal art have aroused controversy in themselves, this has primarily been a matter of context and emphasis. Seen against the background outlined above, however, it is clear that rock art scholars have largely managed to avoid one of the most fundamental recurring debates of broader shamanic research – perhaps the most fundamental one possible in this context. Quite simply, is the use of a shamanic framework of interpretation academically defensible at all? An attempt to answer this, especially for a rock art audience, will form the bulk of this chapter.

SHAMANISM: The big question

Although it is now employed as a useful collective term for belief systems found all over the world which share certain common traits that were first observed in Tungus' religious practice, the notion of shamanism as a unifying concept is in fact quite recent, entering into general usage only in the first decades of the 20th century, before which it was almost exclusively applied to Siberian cultures (see Hutton [2001] for a lucid discussion of this process). Of central importance here is the fact that among all these peoples there was no indigenous term for what the *šaman* actually did. It therefore cannot be stated often enough that the concept of shamanism, as used by academics and the public alike, is entirely a construction of western anthropology – or as the Sámi specialist Håkan Rydving has noted, "historians of religion sometimes have a tendency to talk as if 'shamanism' were something concrete, thereby forgetting that it only exists as an abstraction and a concept in the brains of its students" (1987: 186–187). We can argue about the 'reality' of shamanism, and this entire field of study certainly has its critics and sceptics, but we must all accept that *the very idea* of it as a recognisable human spiritual phenomenon is purely a product of anthropological and ethnographic analogy.

When we acknowledge this situation, then it quickly becomes clear that despite the broad range of specialist topics that it addresses, at the centre of most work on ancient shamanism is something that in fact has highly specific resonances with rock art research – namely, the role played by the documentary record of the indigenous voice. This correspondence throws up some interesting theoretical dilemmas, including the recognition that the problems inherent in using indigenous analogy

in the interpretation of rock art are exactly the same as those surrounding the definition of shamanism itself.

On the one hand there is an obvious need for source critique in the making of ethnographic comparisons from early modern anthropology to the remote, even prehistoric, past. But even though our critical apparatus does not yet seem to be up to this task, at least for these particular data-sets, on the other hand it is clearly foolish to simply dismiss indigenous analogies altogether. If we can accept the arguments for shamanism's conceptual existence at all, anywhere, then by extension we must accept what are theoretically the same arguments relating to the principle validity of indigenous knowledge as applied to the interpretation of rock art. However, if we take the opposite path and reject the applicability of indigenous analogy, as many rock art researchers do, then it follows that we must also totally reject the very notion of shamanism.

We see this situation clearly demonstrated in the aspect of recent rock art research that has perhaps provoked the most intense debate. In works such as *Les Chamanes de la Préhistoire* and *The Mind in the Cave*, Jean Clottes and David Lewis-Williams have brought us back to a number of questions that have hovered at the fringes of archaeology for decades, even centuries, and which lead directly to the very origins of human spiritual aspiration. Does shamanism represent a relic of something approaching a primal human religion? In its essentials, does it go back to the very beginnings of our species? Might it even, in some way, have been one of the milestones that marked the route of that long and shadowy path towards the evolution of our modern cognitive structures?

These are desperately difficult questions, and the problem is muddied further by the 'fringes of archaeology' referred to above – an exact description as this debate lives a parallel existence beyond the academic world in the grey zone where material culture studies meet the more esoteric flourishes of modern New Age beliefs, Goddess worship and so on (see Meskell [1995] for a perceptive analysis of this battleground). The battiness of some of the theories emerging from that field should in no way be allowed to invalidate the central issue, and the serious work of Lewis-Williams and others has been unfairly criticised in some quarters for exactly the reliance on later indigenous analogies that, as we have seen, is central to the 'shamanic frame' of my title. The question as to the

origins of shamanism may be more or less unanswerable, but it is not a stupid one to ask.

I want to look briefly now at this question of shamanism's antiquity from a different perspective that can also, I believe, help us in our difficulties with analogy. In my specific choice of examples I also want to spotlight perhaps the most surprising gap in terms of links from rock art studies to broader research, the comparative lack of attention paid to the archaeology of shamanic practice in the circumpolar region, the proverbial 'cradle of shamanism' itself.

THE ANTIQUITY OF SHAMANISM

The essence of the problem (and its potential reward) is encapsulated in a single research topic – the question of the 'world support' in circumpolar belief systems. This will be familiar to many readers, the notion of a number of layered realms of existence linked by a single axle on which the entire cosmos rests. The idea is found in many northern religions, and is usually expressed in the form of a tree or a pillar, or sometimes a nail. The tree has many, many aspects and characteristics – in some traditions, for example, its leaves hold the souls of the unborn – but in Eurasian belief the tree is principally the medium by which the shaman travels from one world to another, climbing its trunk to another plane of existence.

The first major study of the world support, in the specific form of the tree, was undertaken by Holmberg in 1923 and radically updated by Åke Hultkrantz in 1996, whose definition may be useful to repeat here:

> [T]he world tree, a symbolic representation of the sacred centre of the world … an axis that measures the three main rooms of the world (and their subdivisions into a great plurality of rooms): heaven, earth and underworld. The tree runs through all these worlds, and is a means of communications between them, used by spirits and shamans. In Siberia shamans may have their own trees which are representatives of the world tree, and which they may climb. Sometimes the tree is marked to indicate seven, nine, or up to thirty levels in the sky. … The tree is often crowned by a bird, usually an eagle (like the Russian imperial double eagle in

Siberia, the thunderbird in North America) ... The tree of life and tree of knowledge are variations of the world tree idea (Hultkrantz 1996: 42).

In this work Hultkrantz made a complete survey of this phenomenon in the circumpolar and Eurasian area, comparing the pillar with the tree, and isolated every culture in the northern hemisphere in which these beliefs were found. In summary, the result produced the following cultural distribution for each category (Hultkrantz 1996: 35):

Europe
- World Tree: Cheremisses, Karelians, Mordvin, Viking Age Scandinavians, Votes
- World Pillar: Finns
- Both tree and pillar: Estonians, Sámi, Samoyeds

Asia
- World Tree: Tungus
- World Pillar: Ainu, Altai, Buryats, Dolgans, Mansi, Mongols, Orotchi, Teleuts, Yakuts
- Both tree and pillar: Khanty

North America
- World Tree: Timucua
- World Pillar: Creek, Great Basin Numic, Haida, Hare, Inuit, Kalispel, Kaska, Nuxalk, Okanagon, Omaha, Sanpoil, Tahltan, Thompson Indians, Tlingit, Tshimshian
- Both tree and pillar: Delaware, Kwakwaka'wakw, Plains tribes

These comparisons are naturally at a relatively coarse level, obscuring the regional differences in the mythologies. However, closer inspection reveals an astonishing correspondence between the cosmological beliefs of geographically widely separated areas. Although the pillar and tree are found in some Middle Eastern cultures, it is almost universal in the far north. Hultkrantz's conclusions are startling, but inevitable given the implications of how far back one has to go to find a point at which the ancestors of these disparate peoples could have had direct contact:

The world pillar, we may insist, genuinely represents an archaic, circumpolar world-view. Since circumpolar culture, besides being an adaptation to the Arctic and sub-Arctic environment, typifies a culture of Mesolithic-Palaeolithic origins it seems probable that the world pillar and its associated mythic-ritual complex may be traced back to this time and age (Hultkrantz 1996: 43).

The broader implications of this will be taken up below, but we can observe the same process at a deeper, more specific level through a second example, taken from the 1987 work of Karl Schlesier on Tsistsista (Cheyenne) religion on the northern American Plains.

Produced in collaboration with Tsistsista *maheon-hetaneo*, 'persons working for the sacred', this is a very careful piece of research in which Schlesier deliberately highlights the range of ritual specialists and uses the indigenous terms for them. He published a nuanced, carefully considered study of a people's conceptions of the holy, using 'shamanism' when appropriate to describe elements common in circumpolar belief, and discarding it when not. As part of this study he compared Tsistsista spiritual practices with those of the northern Siberian peoples, and noted some 108 directly identical features (Schlesier 1987: 45–499). It must be stressed that these were not vague concepts, such as worshipping the sun, but specifics: the centre of the spirit lodge in which ceremonies are performed has a pole symbolising the World Tree, on which seven divisions are marked; the vault of heaven is conceptualised as a kettle; the crane is a sacred bird of the world above, and so on.

There seems no doubt that the correspondences identified by Schlesier must be meaningful, and they are suggestive in their implications. Just how far back in time do we have to go before such a connection between the North American plains and northern Siberia begins to make sense? The same is true for the extraordinary distribution of beliefs in the world support. This cannot possibly be coincidence, nor does it represent a common feature of religion found outside the extended circumpolar region. And yet to find the last feasible point of contact between some of these cultures we must go back at least to the Mesolithic and in some cases even earlier. In all this work I would emphasise that the basic data are uncontroversial. No one claims that Schlesier has made a mistake with his comparisons, or that Hultkrantz's collection of circumpolar peoples did not conceive of the axis of the worlds in this way.

However uncomfortable the idea, it is actually difficult to make a case that this cosmological notion of the world support (amazingly, still an active belief in some parts of the Arctic), and the spiritual links between Siberia and the Great Plains, do *not* originate with the very early Stone Age populations of the far north. I would ask the reader to pause a moment to let this sink in.

There is no doubt that we cannot trace the wider pattern of explicit shamanic practices (in the generally accepted anthropological sense) back this far, but at the same time features such as the World Tree form a fundamental component of shamanic belief systems in later times. Indeed, it is only from this context that we have records of them, and it is merely their widespread distribution that gives away their immense antiquity. The suggestion then is clear: that the probable dating of these beliefs to the Palaeolithic implies that shamanism itself also originates at this time.

Given the controversy that greeted Lewis-Williams and Clottes on the publication of *Les Chamanes de la Préhistoire* or *The Mind in the Cave*, I would note that the above argument is utterly independent of these authors' claims made on the basis of neuropsychology, and yet arrives at exactly the same conclusion. The archaeology of shamanism and the shamanic reading of rock art are thus in useful agreement, complementing each other by taking different analytical paths to the same interpretive destination.

SHAMANISM AND THE INDIGENOUS VOICE

This discussion is also valuable for our earlier question relating to the relationship between indigenous knowledge and rock art interpretation. Consider the process by which our argument above is built up. The most simplistic analogies rely on a basic scale of similarity and difference, usually within one region over time – for example, as in Siberia on the Middle Yenisei, through perceived similarities between the costume of figures in rock engravings and later ethnographic photographs of shamans (Price [2002: 281–283], building on material presented by Devlet [2001], and references therein), though we cannot be sure that the later shamans are not copying the rock carvings, reinterpreting them in a different social context.

From this we can move to similar phenomena found not just within cultures over time, but across cultures – such as the drums that appear to be carried by these same Siberian rock art figures, matching not only actual objects from the same area but also similar artefacts from Sámi contexts in northern Scandinavia.

However, if we take an example such as Hultkrantz's work on the world support, with its implications affecting the entire northern hemisphere, then we can expand on this more localised argument. By building up patterns of repeated connections of the same type, or extended chains of directly comparable data, from different sources, over time and/or space, then the intellectual coherence of the analogy dramatically improves. And it is into these globalising theories that the detail – equally compelling, in my opinion – can then be placed.

In practice, interpretive chains such as this are common in the archaeological application of the 'shamanic frame' of spiritual belief and practice. Numerous examples may be found in the rock art research undertaken in southern Africa and cited above, with detailed interplay between archaeological data and written ethnography. However, similar demonstrations of the process could equally be found in quite different contexts (for example, an extended case study for the cultures of Viking Age Scandinavia, involving particularly complex successive levels of inference, can be found in my own work; Price [2002] and references therein).

ARCHAEOLOGICAL INTERPRETATION AND THE SHAMANIC FRAME

We began with the link between shamanic interpretations in rock art research and the broader archaeology of shamanism, with specific reference to the question of whether or not such lines of enquiry can be defended at all. In what direction, then, are we now heading?

No one familiar with the belief systems of the circumpolar region, and the practices associated with them, can be in any doubt that there are very, very close similarities between them. There are also, of course, a great many differences, and each ethnic group has its own specific forms of spiritual expression. However, the points of contact and their implications cannot be ignored. The very fact of this repetition, albeit with

regional variation and change over time, surely demands a vocabulary for its articulation. (A rejection of this idea is certainly possible, but this would be a very difficult position to maintain in the face of the evidence.)

One solution to this would be to speak of something suitably vague along the lines of a 'consistent spiritual pattern of behaviour and belief' (or some similar phrase), with traits within it that can also be very closely paralleled elsewhere. But why not embrace the term that is not only already on offer but in fact also in widespread use?

An acceptance of a shamanic label, in full awareness of its artificial, anthropological character, is not to ignore the differences between the various 'shamanic' cultures of the north, or to imply that shamanism exists in isolation. On the contrary, the shamanic complex is found alongside many other forms of spiritual expression, and its practitioners operate together with numerous other types of ritual specialists. Nor is shamanism monolithic in its manifestation across the region – in fact, it is highly dynamic in its variation over time and space. Of course, we need to exercise caution in deciding whether it is appropriate to use its descriptive terminology in our interpretations of specific ancient thought-worlds. Nevertheless, if 'shamanism' is a collective term with an infinity of specific manifestations – and interpretations – the essential pattern of close similarities that underpins it remains entirely consistent, and it must be explained.

It will be clear by now that I believe the shamanic interpretation of rock art and the wider field of archaeological research on shamanism could gain much from more developed contact, but this is not to say that we have not already come a long way towards this end. Today, the archaeology of the mind is a specific research specialism in its own right, and shamanism's prominent place here is in large part due to the work of David Lewis-Williams (not neglecting, of course, the contributions made by his colleagues and co-authors). David has indeed given us new and different ways of knowing and seeing, and we have already seen how retirement means no end of any kind to that. His work on the archaeology of rock art has been and continues to be of immense importance, but so too has his contribution to the archaeology of shamanism, beyond rock art. I for one look forward to many more years of collaborative work and discussion on a subject that can only continue to astonish us.

Acknowledgements

The original version of this chapter, substantially different from that published here, was prepared in 2000 for the colloquium held in the Waterberg, South Africa, in honour of David Lewis-Williams. Then entitled 'The Archaeology of Shamanism: Beyond Rock Art', it has been cited under that name as 'forthcoming' in several of my publications that have appeared since that time. Following the delay in publishing the colloquium proceedings, the present text was extensively revised in 2006, incorporating large portions of the paper delivered to a second southern African rock art conference held in Kimberley earlier that year. I am very pleased to have been invited to speak at these gatherings of friends and scholars, and I would like to thank the organisers and participants of both conferences.

My chief thanks must go to David himself, of course, for advice and inspiration on many occasions, and not least as a guide on the first of many memorable treks through the rock shelters of the Drakensberg. I would also like to warmly thank my friend, Geoff Blundell, and his wife, Carol Wallace, for their hospitality and good company over several years of travelling in South Africa. Ben Smith and all at the Rock Art Research Institute have made me more than welcome during my numerous return visits to their institution, and I look forward to continued links in the years to come. Finally, thanks to five colleagues who have shared some of these journeys and become my friends in the process – Ericka Engelstad, Knut Helskog, Tore Sætersdal, Eva Walderhaug Sætersdal and Dave Whitley – and a weary wave to all my fellow travellers on the now-infamous Namibian 'road movie' that followed the rock art conference in 2006.

References

Blundell, G. 2004. *Nqabayo's Nomansland: San Rock Art and the Somatic Past*. Uppsala: Uppsala University, Studies in Global Archaeology 2.

Blundell, G. (ed.) 2005. *Further Approaches to Southern African Rock Art*. Cape Town: South African Archaeo - logical Society Goodwin Series 9.

Bradley, R. 1989. Deaths and entrances: a contextual study of megalithic art. *Current Anthropology* 30: 68–75.

Bradley, R. 1997. *Rock Art and the Prehistory of Atlantic Europe: Signing the Land*. London: Routledge.

Clottes, J. & Lewis-Williams, J.D. 1996. *Les Chamanes de la Préhistoire: Transe et Magie dans les Grottes Ornées*. Paris: Le Seuil.

Devlet, E. 2001. Rock art and the material culture of Siberian and Central Asian shamanism. In: Price, N.S. (ed.) *The Archaeology of Shamanism*: 43–55. London & New York: Routledge.

Dronfield, J. 1994. Subjective visual phenomena in Irish passage-tomb art: vision, cosmology and shamanism. Unpublished PhD thesis. Cambridge: University of Cambridge.

Dronfield, J. 1995. Subjective vision and the source of Irish megalithic art. *Antiquity* 69: 539–549.

Guenther, M. 1999. From totemism to shamanism: hunter-gatherer contributions to world mythology and spirituality. In: Lee, R.B. & Daly, R. (eds) *The Cambridge Encyclopedia of Hunters and Gatherers*: 426–433. Cambridge: Cambridge University Press.

Harvey, G. (ed.) 2003. *Shamanism: A Reader*. London & New York: Routledge.

Hollmann, J.C. (ed.) 2004. *Customs and Beliefs of the /Xam Bushmen*. Johannesburg: Wits University Press.

Holmberg [Harva], U. 1923. Der Baum des Lebens: Göttinen und Baumkult. *Toimituksia* B: XVI 3. Helsinki: Suomalaisen Tiedakatemian.

Hultkrantz, Å. 1996. A new look at the world pillar in Arctic and sub-Arctic religions. In: Pentikäinen, J. (ed.) *Shamanism and Northern Ecology*: 31–49. Berlin: Mouton de Gruyer.

Hutton, R. 2001. *Shamans: Siberian Spirituality and the Western Imagination*. London & New York: Hambledon.

Layton, R.H. 2000. Shamanism, totemism and rock art: "Les chamanes de la préhistoire" in the context of rock art research. *Cambridge Archaeological Journal* 10(1): 169–186.

Lewis-Williams, J.D. 1981. *Believing and Seeing: Symbolic Meanings in Southern San Rock Paintings*. London: Academic Press.

Lewis-Williams, J.D. 1987. A dream of eland: an unexplored component of San shamanism and rock art. *World Archaeology* 19: 165–177.

Lewis-Williams, J.D. 1988a. *Reality and Non-reality in San Rock Art*. Johannesburg: Institute for the Study of Man in Africa.

Lewis-Williams, J.D. 1988b. Preparation for transformation: some remarks on the role of metaphors in San shamanism. In: Sienaert, E.R. & Bell, A.N. (eds) *Catching Winged Words: Oral Tradition and Education*: 134–145. Durban: Natal University Press.

Lewis-Williams, J.D. 1990. On Palaeolithic art and the neuropsychological model. *Current Anthropology* 31: 407–408.

Lewis-Williams, J.D. 1991. Upper Palaeolithic art in the 1990s: a southern African perspective. *South African Journal of Science* 87: 422–429.

Lewis-Williams, J.D. 1992. Ethnographic evidence relating to 'trancing' and 'shamans' among Northern and

Southern Bushmen. *South African Archaeological Bulletin* 47: 56–60.

Lewis-Williams, J.D. 1995. Seeing and construing: the making and 'meaning' of a southern African rock art motif. *Cambridge Archaeological Journal* 5: 3–23.

Lewis-Williams, J.D. 1997a. Agency, art and altered states of consciousness: a motif in French (Quercy) Upper Palaeolithic parietal art. *Antiquity* 71: 810–830.

Lewis-Williams, J.D. 1997b. Harnessing the brain: vision and shamanism in Upper Palaeolithic Western Europe. In: Conkey, M.W., Soffer, O., Stratmann, D. & Jablonski, N. (eds) *Beyond Art: Pleistocene Image and Symbol*: 321–342. San Francisco: California Academy of Sciences.

Lewis-Williams, J.D. 2000. *Stories that Float from Afar: Ancestral Folklore of the San of Southern Africa*. Cape Town: David Philip.

Lewis-Williams, J.D. 2001a. Brainstorming images: neuropsychology and rock art research. In: Whitley, D.S. (ed.) *Handbook of Rock Art Research*: 332–357. Walnut Creek: AltaMira Press.

Lewis-Williams, J.D. 2001b. Southern African shamanistic rock art in its social and cognitive contexts. In: Price, N.S. (ed.) *The Archaeology of Shamanism*: 16–39. London: Routledge.

Lewis-Williams, J.D. 2002a. *A Cosmos in Stone: Interpreting Religion and Society Through Rock Art*. Walnut Creek: AltaMira Press.

Lewis-Williams, J.D. 2002b. *The Mind in the Cave: Consciousness and the Origins of Art*. London & New York: Thames & Hudson.

Lewis-Williams, J.D. & Clottes, J. 1998. The mind in the cave – the cave in the mind: altered consciousness in the Upper Palaeolithic. *Anthropology of Consciousness* 9(1): 13–21.

Lewis-Williams, J.D. & Dowson, T.A. 1988. The signs of all times: entoptic phenomena in Upper Palaeolithic art. *Current Anthropology* 29: 201–245.

Lewis-Williams, J.D. & Dowson, T.A. 1989. *Images of Power: Understanding Bushman Rock Art*. Johannesburg: Southern Book Publishers.

Lewis-Williams, J.D. & Dowson, T.A. 1990. Through the veil: San rock paintings and the rock face. *South African Archaeological Bulletin* 45: 5–16.

Lewis-Williams, J.D. & Dowson, T.A. 1993. On vision and power in the Neolithic: evidence from the decorated monuments. *Current Anthropology* 34: 55–65.

Lewis-Williams, J.D. & Pearce, D.G. 2004. *San Spirituality: Roots, Expressions and Social Consequences*. Walnut Creek: AltaMira Press.

Lewis-Williams, J.D. & Pearce, D.G. 2005. *Inside the Neolithic Mind*. London & New York: Thames & Hudson.

Meskell, L. 1995. Goddesses, Gimbutas, and 'new age' archaeology. *Antiquity* 69: 74–86.

Nioradze, G. 1925. Der Schamanismus bei den siberischen Völkern. Stuttgart.

Ondaatje, M. 2000. *Anil's Ghost*. New York: Alfred A. Knopf.

Price, N.S. (ed.) 2001a. *The Archaeology of Shamanism*. London & New York: Routledge.

Price, N.S. 2001b. An archaeology of altered states: shamanism and material culture studies. In: Price, N.S. (ed.) *The Archaeology of Shamanism*: 3–16. London & New York: Routledge.

Price, N.S. 2002. *The Viking Way: Religion and War in Late Iron Age Scandinavia*. Uppsala: Uppsala University Press.

Rydving, H. 1987. Shamanistic and postshamanistic terminologies in Saami (Lappish). In: Ahlbäck, T. (ed.) *Saami Religion*: 185–207. Åbo: Donner Institute.

Schlesier, K.H. 1987. *The Wolves of Heaven: Cheyenne Shamanism, Ceremonies and Prehistoric Origins*. Norman & London: University of Oklahoma Press.

Stutley, M. 2003. *Shamanism: An Introduction*. London & New York: Routledge.

Taçon, P.S.C. & Chippindale, C. 1998. An archaeology of rock art through informed methods and formal methods. In: Chippindale, C. & Taçon, P.S.C. (eds) *The Archaeology of Rock Art*: 1–10. Cambridge: Cambridge University Press.

Vinnicombe, P. 1975. The ritual significance of eland (Taurotragus oryx) in the rock art of southern Africa. In: Anati, E. (ed.) *Les Religions de la Préhistoire*: 379–400. Capo di Ponte: Centro Camuno di Studi Preistorici.

Vinnicombe, P. 1976. *People of the Eland: Rock Paintings of the Drakensberg Bushmen as a Reflection of Their Life and Thought*. Pietermaritzburg: Natal University Press.

Whitley, D.S. 2000. *The Art of the Shaman: Rock Art of California*. Salt Lake City: University of Utah Press.

Whitley, D.S. 2005. *Introduction to Rock Art Research*. Walnut Creek: Left Coast Press.

Whitley, D.S. & Keyser, J.D. 2003. Faith in the past: debating an archaeology of religion. *Antiquity* 77: 385–393.

List of figures

Figure 6.6 A pair of twin boards from identical male twins. Front and back of boards are shown.

Figure 6.7 Two sets of twin boards from one family. To the left are boards for identical female twins, born in 1987, and to the right are those for fraternal twins, born in 1979.

Figure 6.8 The *iyari* ceremony is held in the twins' home. Note the painted boards held by female elders and the thorny brush placed at the doorway.

Figure 6.9 Bambara nuts are placed around the *leba* tree.

Figure 6.10 A sheep is sacrificed and its chyme is smeared on the *leba* tree.

Figure 6.11 This baobab tree is associated with the clan rain hill, Malagwe.

Figure 6.12 Beseto 1, a rain sacrifice site with primarily red-coloured figures.

Figure 6.13 Bonk'olo 1, a rain sacrifice site with red- and white-coloured figures.

Figure 6.14 A *simbò* dancer with charcoal around his eyes. The charcoal protects the dancer from spirit possession. (Photo by B.W. Smith)

Figure 7.1 Continuity in Native American beliefs about rock art sites, extending from the first recorded accounts into contemporary times, is evident in many regions. For example, the connection between Numic shamans and Great Basin rock art sites was first documented by westerners in 1874. In 1999 Numic consultants continued to refer to this engraving panel at the Red Canyon site in eastern California as a 'doctor's rock', meaning a panel created by a shaman. (Photo by D.S. Whitley)

Figure 7.2 The hallmark representational motif in the Great Basin is the bighorn sheep. These are particularly common in the Coso Range of eastern California, which contains roughly 51 000 bighorn engravings, representing shamans' spirit helpers. These examples are from Big Petroglyph Canyon. (Photo by D.S. Whitley)

Figure 7.3 Geometric engravings are also very common in Great Basin rock art where, in most regions, they are the most common class of motif. In the Coso Range they are the second most common motif class, after bighorns. This example is from Little Petroglyph Canyon in the Cosos and, like many of the geometrics, is a variation on an entoptic pattern, in this case a meander. (Photo by D.S. Whitley)

Figure 7.4 The combination of bighorns and geometric motifs is present throughout the 10 000 years+ engraving tradition in eastern California. This continuity in the nature of the motif assemblage is paralleled by a series of specific continuities in the iconographic attributes of the majority of the bighorns. These include large

side-facing horns, indicating the depiction of adult male rams; an anatomically impossible twisted head and horn combination; navicular bodies; and exaggerated tails in an upraised posture (associated with death and *rigor mortis*). Example from Little Petroglyph Canyon in the Cosos. (Photo by D.S. Whitley)

Figure 7.5 'Patterned-body anthropomorphs' become a common component of the rock art assemblage during the last 2000 years. The internal body patterns represent the designs that shamans painted on their ritual shirts and appear to reflect the integration of iconic and entoptic imagery. Note that there is effectively no duplication in the internal designs, with each pattern serving as a unique 'signature' piece. This suggests the development of a concern with the expression of personal identities, and the emergence of band headmen-shamans. The central figure on this panel, from Little Petroglyph Canyon in the Cosos, wears a quail topknot feather headdress. This was the special headgear of the rain shaman. The bighorn sheep was said to be the special spirit helper for the rain shaman; and the Cosos region, where bighorn motifs are heavily concentrated, was renowned for its rain shamans. (Photo by D.S. Whitley)

Figure 8.1 A bull elk with two cows. Bulls have massive antlers whereas cows have none. Yellowstone National Park digital slide file. (Photo by John Good 1966)

Figure 8.2 Castle Gardens, Wyoming. Petroglyphs depict an elk love-magic scene. The female figure, whose dress is lifted to expose her vulva, appears to be lying on her back. Note that elk teeth decorate her dress. A male figure at the far left, only partly visible in this photograph, has an erect phallus. An elk appears to be stumbling or falling as though in death. Vulva forms are present throughout the scene. (Photo by J. David Love *c.* 1930)

Figure 8.3 The Castle Butte bull and cow elk. The female figure in the scene, recognisable by her long hair, appears to be playing a flute. This scene may represent elk love-power as used by women to control errant husbands. (Drawing by Linda Olson)

Figure 8.4 The Davidson Microcave elk and associated vulva forms. A faint arrow in the back of the elk symbolises its death. Vulva forms are present throughout the scene. (Photo by Lawrence Loendorf)

Figure 8.5 An elk in the process of changing into a human. The human figure is emerging from the elk's antlers. (Drawing by Linda Olson)

Figure 9.1 Map of Baja California showing the location of the Sierra de San Francisco.

Figure 9.2 Direct stratigraphic relationships between motifs in Area B3. Internal stratigraphy of individual

motifs not shown unless separated by other motifs. Calcium oxalate layer shown by wavy line. Not to scale.

Figure 9.3 Direct stratigraphic relationships between motifs in areas D1, D2a, D2b, D2c and D3b. Internal stratigraphy of individual motifs not shown unless separated by other motifs. Calcium oxalate layer shown by wavy line. Not to scale.

Figure 9.4 Direct stratigraphic relationship between motifs in areas D3b, D3c, E1a, E2a/b and F. Internal stratigraphy of individual motifs not shown. Not to scale.

Figure 9.5 Typical internal stratigraphy of a checkerboard-like motif in Area B3. Not to scale.

Figure 9.6 Typical internal stratigraphy of rabbit-like and deer-like animals. Not to scale.

Figure 9.7 Stratigraphic relationship between the 'mountain lion' and 'deer' in Area B3. Not to scale.

Figure 9.8 Typical internal stratigraphy of human paintings (left) and human paintings with black faces (right). Not to scale.

Figure 9.9 Internal stratigraphy of two mountain sheep in Area B3. Note that two human figures are sandwiched within the lower sheep. Not to scale.

Figure 9.10 Internal stratigraphy of two deer-like animals in Area D1. Note that the one animal is sandwiched within the other. Not to scale.

Figure 9.11 Internal stratigraphy of a deer-like animal incorporating two other animal paintings in Area D2b. Not to scale.

Figure 9.12 Summary of painting sequence within Cueva de El Ratón. Not to scale.

Figure 10.1 Map of northernmost Europe showing the location of Alta and Zalavruga (at the river Vyg).

Figure 10.2 Bergbukten I. Photograph of part of the panel, taken from a high ladder; a perspective that was probably never seen in prehistoric times. Water has collected in small pools after a rainstorm. Tracks lead up to but do not descend into the largest of these pools (bottom right corner). Clearly, this pool of water formed a part of the story of the panel. The figures are now painted red so as to be more visible to visitors.

Figure 10.3 The main part of Bergbukten I. This redrawing shows a common type of rock art documentation in which only the engraved figures are represented. It is devoid of 'disturbing' topographic features and has flattened out an otherwise undulating surface. Not much can be gained from it concerning any meanings that may be derived from the relationships between the figures and the rock surface.

Figure 10.4 Bergbukten I. A perspective drawing which emphasises the relationships between the figures and the rock surface. The view is from the direction of the shoreline. This is a more 'correct' representation

than the redrawing in Figure 10.3. (Drawing by Ernst Høgtun, Tromsø Museum)

Figure 10.5 Bergheim I. This redrawing emphasises a number of figures and cracks that have been added to a standard redrawing such as that seen in Figure 10.3. As a result, the perspective is faulty. Note the concentration of elk in the lower section.

Figure 10.6 Bergheim I. Photograph showing the northern section of the surface, looking north-north-west.

Figure 10.7 Bergbukten IV B. A redrawing emphasising engraved figures and cracks. In this case most of the surface is relatively flat, with a gradient of approximately 45°. The northern and southern sections are oriented in slightly different directions. Note the concentration of elk in the lower section.

Figure 10.8 Bergbukten IV B. The northern part of the panel, looking south.

Figure 10.9 Old Zalavruga, at the river Vyg, Karelia, Russia (Savvatejev 1970: figure 14). The 'plowshaped' concentration of elk and reindeer acts as a 'boundary' between the panel and the rock surface to the south. In other directions, the panel is bounded by a river.

Figure 11.1 The figure with the head of a lion and the body of a human, in ivory, from Hohlenstein-Stadel (Germany). Height 28 cm. (Drawing by J. Hahn 1986)

Figure 11.2 The 'killed man' in the Grotte Cosquer (Marseilles, France). Length 28 cm. (Drawing by J. Clottes)

Figure 11.3 Female human with feline head. Isturitz (Pyrénées-Atlantiques, France). Height 12 cm. (Drawing by L. Pales)

Figure 11.4 The little hybrid being ('*petit être mixte*') from Les Trois-Frères (Ariège, France). Length 30 cm. (Drawing by H. Breuil)

Figure 11.5 The 'Sorcerer' in the Grotte Chauvet (Ardèche, France). Length about 100 cm. Notice the arm ending with tapering fingers on the thigh of the female figure to the left. (Discovery and photograph by Y. Le Guillou)

Figure 11.6 Bison 52 in Niaux (Ariège, France), with sheath in the groin. Length about 108 cm. (Photograph by J. Clottes)

Figure 11.7 Bison Bi1 at Cosquer, radiocarbon-dated to 18 530±180 BP (Gif A 92.492). Length about 120 cm. (Photograph by A. Chêné)

Figure 11.8 Bison Bi2 at Cosquer, which has two radiocarbon dates: 26 250±350 BP (Gif A 96.069) and 27 350±430 BP (Gif A 95.195). (Photograph by A. Chêné)

Figure 11.9 Engraved bison at Ebbou (Ardèche), also with sheath in the groin. (Photograph by B. Gély)

Figure 12.1 Entrance to Niaux Cave

Figure 13.1 Human and one of many puzzling hook-like engravings from Vingen, western Norway. Extent of image is 40 cm by 40 cm. (Tracing by E. Bakka)

Figure 13.2 Frøysjøen area showing places mentioned in the text.

Figure 13.3 Remnants of human occupation at Fura. Vingenes can be seen on the left at the foot of Tussurfjell Mountain. The enclosed Vingepollen Bay with the Vingen rock art site and farmstead is at the far centre. Vingelven with the present-day farm, lies to the right, between Fura and Vingen. (Photograph by E. Walderhaug)

Figure 13.4 Mbeya Gondo, spirit medium and traditional custodian of the San rock paintings at Chinhamapere rock shelter in Manica District, Mozambique. The site is used in annual rainmaking ceremonies and proper ancestor rituals must be observed whenever visiting it. (Photograph by E. Walderhaug)

Figure 13.5 Innermost Vingepollen and the site of the old Vingen farms. Ruined walls bear witness to the many buildings once found here; later boathouses and a cottage for use as a holiday home have been built on the foundations of the older buildings. Rock art is found here on boulders and outcrops. (Photograph by E. Walderhaug)

Figure 13.6 Vingen's last resident farmer, Thue Vingen, with his wife, photographed at their home around 1920. Father of 15 children by two marriages, Thue lived here from 1890 to 1933 and died in 1934.

Figure 13.7 Red deer and other motifs from Vingen. The animals are depicted running westwards towards the sea, a fact emphasised by proponents of the hunting magic viewpoint. (Tracing by E. Bakka)

Figure 13.8 Tracings of engravings from Møllerstufossen rapids in eastern Norway, showing the alleged lifeline motif. (Tracing by E. Walderhaug)

Figure 13.9 View from Vingen across Vingepollen towards Vingeneset. In the background the mountain Hornelen rises from Frøysjøen. (Photograph by E. Walderhaug)

Figure 13.10 A rare depiction of what is thought to be a whale at Vingen. (Photograph by E. Walderhaug)

Figure 14.1 Visual representation of the 'story in my body' pattern typical of oral tradition. Note the continuous nature and malleability of the pattern. (Drawing by P. Vinnicombe)

Figure 14.2 Grid-like theoretical models with boundaries superimposed on the oral tradition pattern. Each grid hosts the roots of a 'tree' that bears the fruit of the associated theory.

Figure 14.3 As more and more theoretical models are imposed on oral tradition, sight is all but lost of the 'story in my body' pattern.

Figure 14.4 Trees rooted in the 'story in my body' pattern without the restricting grid lines will continue to bear fruit only for as long as nutrients are available.

Figure 15.1 Map of Mozambique, with research area shown enclosed in frame. (Source: Department of Information, United Nations)

Figure 15.2 Detail from the Chinhamapere I main panel. (Photograph by Tore Sætersdal)

Figure 15.3 Detail from the Chinhamapere I main panel. Fine-lined images of humans filing in procession around a bird-like creature. Colour: dark red. (Photograph by Tore Sætersdal)

Figure 15.4 Detail from the Moucondihwa main panel. Naturalistic white paintings of large elephants superimposed on each other, and smaller finger paintings in red and white, some in spread-eagled style. Another panel in the same shelter contains classical San images done exclusively in red. (Photograph by Tore Sætersdal)

Figure 15.5 The traditional custodian of Chinhamapere, Mrs Mbeya Gondu, praying to the ancestors during a rainmaking ceremony. (Photograph by Andrew Salomon)

Figure 15.6 Chief Chirara, with a pangolin. (Photograph by Tore Sætersdal)

Figure 16.1 Map of Wyoming showing the Bighorn and Wind River basins. Pecked Dinwoody tradition rock art occurs on the west side of the Bighorn and Wind rivers; incised and painted imagery occurs east of the river. (Map courtesy of University of Utah Press)

Figure 16.2 Example of Dinwoody tradition, interior-lined figure inferred to be the image of a rock or water ghost. This image is about 1 m in height. (Tracing by Linda Olson, courtesy of University of Utah Press)

Figure 16.3 'Water Ghost Woman' from the Bighorn Basin. This image is over 1.4 m in height. Note that she holds a bow and another creature in her left hand. A pecked turtle occurs to her right. (Photo by Julie Francis; tracing by Linda Olson, courtesy of University of Utah Press)

Figure 16.4 Flat headdress human figure holding tobacco plants from extreme southern Montana. (Photo by Lawrence Loendorf, courtesy of University of Utah Press)

Figure 16.5 Solid red-painted human figures from the extreme northern Bighorn Basin in southern Montana. Note the star at one end of the headdress. Comparison with historic photographs (see Francis & Loendorf 2002: 172) suggests that the headdress

is made of the leaves of native tobacco draped off a flat platform worn on the head. (Drawing by Terry Wolfgram, courtesy of University of Utah Press)

Figure 16.6 Human image thought to represent one of the Crow/Hidatsa twin heroes from the Wind River Basin. Note the bulbous ears, herringbone breast plate and stars at the base of the figure. (Photo by Lawrence Loendorf, courtesy of University of Utah Press)

Figure 17.1 Prehistoric rock carvings such as these from Siberia show astonishing parallels with shaman costumes photographed by early ethnographers, but does the one 'prove' the antiquity of the other, and how secure are our definitions? The rock engravings at the top are from (1) Oglakhty, Middle Yenisei River, (2) Middle Yenisei River, (3) Mokhsogolokh-Khaja, Middle Lena River (after Devlet 2001: 47). The photograph at the bottom is of an Altai shaman in the early 1920s (after Nioradze 1925: 88).

List of tables

List of publications by David Lewis-Williams

1958 J.D. Lewis-Williams. The development of Constantia. *Journal for Geography* 1(2): 30-40.

1960 J.D. Lewis-Williams. The development of East London harbour. *Journal for Geography* l(6): 67-73.

1962 J.D. Lewis-Williams. The Tarkastad rock engravings, *South African Archaeological Bulletin* 17: 24-26.

1972 J.D. Lewis-Williams. The syntax and function of the Giant's Castle rock paintings. *South African Archaeological Bulletin* 27: 49-65.

1974 J.D. Lewis-Williams. The First International Symposium on Prehistoric Religions. *Humanitas* 2: 319-321.

1974 J.D. Lewis-Williams. Superpositioning in a sample of rock paintings from the Barkly East district. *South African Archaeological Bulletin* 29: 93-103.

1974 J.D. Lewis-Williams. Re-thinking the South African rock art. *Origini* 8: 229-257.

1975 J.D. Lewis-Williams. The Drakensberg rock paintings as an expression of religious thought. In E. Anati (ed.) *Les Religions de la Préhistoire*. Capo di Ponte: Centro Camuno di Studi Preistorici.

1975 J.D. Lewis-Williams. Bushman paintings – a signifying system. In: E. Voigt (ed.) *Rock art studies in South Africa*. South African Archaeological Society, Occasional Paper.

1976 J.D. Lewis-Williams. Myth and message in Bushman art. *Lantern* 25(4): 32-41.

1976 J.D. Lewis-Williams. Review of People of the Eland by P. Vinnicombe. *Natalia* I (6): 53-54

1977 J.D. Lewis-Williams. Ezeljagdspoort revisited. *South African Archaeological Bulletin* 32: 165-169.

1977 J.D. Lewis-Williams. Led by the nose: observations on the supposed use of southern San rock art in rain-making rituals. *African Studies* 36(2): 155-159.

1978 J.D. Lewis-Williams & M. Biesele. Eland hunting rituals among northern and southern San groups: striking similarities. *Africa* 48(2): 117-134.

1979 J.D. Lewis-Williams. Review of Image and Pilgrimage in Christian Culture by V. Turner & E. Turner. *African Studies* 38: 95-96.

1979 J.D. Lewis-Williams. Review of Pastoral Partners by V. Almagor. *African Studies* 38: 89-90.

1979 J.D. Lewis-Williams. Review of The peopling of Southern Africa by R. Inskeep. *South African Archaeological Bulletin* 34: 142-144.

1979 J.D. Lewis-Williams, J. Butler-Adam & M. Sutcliffe. Some conceptual and statistical difficulties in the interpretation of southern San rock art. *South African Journal of Science* 75: 211-214.

1980 J.D. Lewis-Williams. Remarks on southern San religion and art. *Religion in Africa* 1(2): 19-32.

1980 J.D. Lewis-Williams. Ethnography and iconography: aspects of southern San thought and art. *Man* 15: 467-82.

1980 J.D. Lewis-Williams. The economic and social determinants of southern San rock art. In: *Transactions of 2nd International Conference on hunting and gathering societies*. Quebec: Universite Leval.

1980 J.D. Lewis-Williams. Review of Felsbilder in Sudafrika, Teil 1 by G.J. Fock. *African Studies* 39: 225-226.

1980 J.D. Lewis-Williams. Review of Major Rock Paintings of Southern Africa by T. Johnson & T.M.O'C. Maggs. *South African Archaeological Bulletin* 35: 123-124.

1981 J.D. Lewis-Williams. *Believing and seeing: symbolic meanings in southern San rock paintings*. London: Academic Press.

1981 J.D. Lewis-Williams. The thin red line: southern San notions and rock paintings of supernatural potency. *South African Archaeological Bulletin* 36:5-13.

1981 J.D. Lewis-Williams. The art of music. *South African Archaeological Society Newsletter* 4(1): 8-9.

1981 J.D. Lewis-Williams. Review of Social and Ecological Systems by C.P. Burnham & F.R. Ellen (eds). *African Studies* 40: 45.

1981 J.D. Lewis-Williams. Review of Anthropological Literature: An index to periodical articles and essays. *African Studies* 40: 49.

1981 J.D. Lewis-Williams. Review of Marchen aus Namibia by S. Schmidt. *Africana notes and news* 24(7): 254-245.

1982 J.D. Lewis-Williams. The economic and social context of southern San rock art. *Current Anthropology* 23: 429-449.

1982 J.D. Lewis-Williams. The Bleek collection. *Jagger Journal* 3: 6-11.

1983 J.D. Lewis-Williams. *New approaches to southern African rock art*. South African Archaeological Society Goodwin Series 4. Cape Town: South African Archaeological Society.

1983 J.D. Lewis-Williams. *The rock art of southern Africa*. Cambridge: Cambridge University Press (*Arte della Savana le pitture rupestri dell Africa australe*. Milan: Jaca Book).

1983 J.D. Lewis-Williams. An ethnographic interpretation of a rock painting from Barkly East. *Humanitas* 9: 245-9.

1983 J.D. Lewis-Williams. Reply to A.R. Willcox and C.K. Cooke. *Current Anthropology* 24: 540-5.

1983 J.D. Lewis-Williams. Introductory essay: science and rock art. *South African Archaeological Society Goodwin Series* 4: 3-13.

1983 J.D. Lewis-Williams. Review of The dawn of European art: rock art of the Spanish Levant-A. Beltran by A. Leroi-Gourhan. *South African Archaeological Bulletin* 38: 100-101.

1984 J.D. Lewis-Williams. Ideological continuities in prehistoric southern Africa: the evidence of rock art. In: C. Schrire (ed.) *Interfaces: the relationship of past and present in hunter-gatherer studies*. 225-252. New York: Academic Press.

1984 J.D. Lewis-Williams. Reply to H.C. Woodhouse. *Current Anthropology* 25: 246-248.

1984 J.D. Lewis-Williams. The empiricist impasse in southern African rock art studies. *South African Archaeological Bulletin* 39: 58-66.

1984 J.D. Lewis-Williams. The rock art workshop: Narrative or metaphor? In: M. Hall, A. Avery, D.M. Avery, M.L. Wilson & A.J.B. Humphreys (eds) *Frontiers: southern African archaeology today*. 323-327. Cambridge: B.A.R International Series 207.

1985 J.D. Lewis-Williams. Testing the trance explanation of southern African rock art: depictions of felines. *Bollettino del Centro Camuno di Studi Preistorici* 22: 47-62.

1985 J.D. Lewis-Williams. The San artistic achievement. *African Arts* 18: 54-59.

1985 J.D. Lewis-Williams. Review of Felsbilder in Sudafrika by G.J. Fock & D. Fock. *African Studies* 44: 207-208.

1986 J.D. Lewis-Williams. The last testament of the southern San. *South African Archaeological Bulletin* 41: 10-11.

1986 J.D. Lewis-Williams. Cognitive and optical illusions in San rock art research. *Current Anthropology* 27: 171-178.

1986 J.D. Lewis-Williams. The San: life, belief and art. In: T. Cameron and S.B. Spies (eds) *An illustrated history of South Africa*: 31-36. Johannesburg: Jonathan Ball.

1986 J.D. Lewis-Williams. Beyond style and portrait: a comparison of Tanzanian and southern African rock art. In: R. Vossen and K. Keuthmann (eds) *Contemporary studies on Khoisan*: 93-139. Hamburg: Buske Verlag.

1986 J.D. Lewis-Williams, P. den Hoed, T.A. Dowson & G.A. Whitelaw. Two crabs in a box. *The Digging Stick* 3:1.

1986 J.D. Lewis-Williams & J.H.N. Loubser. Deceptive appearances: a critique of southern African rock art studies. *Advances in World Archaeology* 5: 253-289.

1986 J.D. Lewis-Williams, C. Schrire, J. Deacon & M. Hall. Burkitt's milestone. *Antiquity* 60: 123-132.

1987 J.D. Lewis-Williams. The cultural context of hunter-gatherer rock art. *Man* 22: 171-175.

1987 J.D. Lewis-Williams. A dream of eland: an unexplored component of San shamanism and rock art. *World Archaeology* 19: 165-177.

1987 J.D. Lewis-Williams. Art as a window to other worlds. *South African Journal of Science* 83: 245.

1987 J.D. Lewis-Williams. Comment on J. Halverson 'Art for art's sake in the Palaeolithic'. *Current Anthropology* 28: 79-80.

1987 J.D. Lewis-Williams. Paintings of power: ethnography and rock art in southern Africa. In M. Biesele and R. Gordon (eds) *Past and future of !Kung ethnography*: 231-273. Hamburg: Buske Verlag.

1988 T.A. Dowson & J.D. Lewis-Williams. Reservoirs of power. *Sanctuary* 9: 14-15.

1988 J.D. Lewis-Williams. *Reality and non-reality in San rock art*. Twenty-fifth Raymond Dart Lecture. Johannesburg: Institute for the Study of Man in Africa.

1988 J.D. Lewis-Williams. *The world of man and the world of spirit: an interpretation of the Linton rock paintings*. Second Margaret Shaw Lecture. Cape Town: South African Museum.

1988 J.D. Lewis-Williams. Southern African clues to the art of Western Europe. *The Wits Review* 1: 19-21.

1988 J.D. Lewis-Williams. People of the eland: an archaeolinguistic crux. In T. Ingold, D. Riches and I. Woodburn (eds) *Hunters and gatherers: property, power and ideology*. 203-211. London: Berg.

1988 J.D. Lewis-Williams. Preparation for transformation: some remarks on the role of metaphors in San shamanism. In E.R. Sienaert and A.N. Bell (eds) *Catching winged words: oral tradition and education*: 134-145. Durban: Natal University Press.

1988 J.D. Lewis-Williams. Review of Searching for the Past: the methods and techniques of Archaeology by B.J.A. Humphreys. *African Studies* 47: 75-76.

1988 J.D. Lewis-Williams. Review of The petroglyphs in the Guianas and adjacent areas of Brazil and Venezuela: an inventory by N.C. Dubelaar. *African Studies* 47: 88.

1988 J.D. Lewis-Williams & T.A. Dowson. The signs of all times: entoptic phenomena in Upper Palaeolithic art. *Current Anthropology* 29: 201-245.

1989 J.D. Lewis-Williams. Southern Africa's place in the archaeology of human understanding. *South African Journal of Science* 85: 47-52.

1989 J.D. Lewis-Williams. San rock art. In: A. Nettleton and W.D. Hammond-Tooke (eds) *African Arts*. 30-48. Johannesburg: Balkema.

1989 J.D. Lewis-Williams & T.A. Dowson. *Images of power: understanding Bushman rock art*. Johannesburg: Southern Book Publishers.

1989 J.D. Lewis-Williams & T.A. Dowson. Theory and data: a brief critique of A. Marshack's method and position on Upper Palaeolithic shamanism. *Rock Art Research* 6: 38-53.

1990 J.D. Lewis-Williams. *Discovering southern African rock art*. Cape Town: David Philip (Reprinted in: 1996, 2000).

1990 J.D. Lewis-Williams. On Palaeolithic art and the neuropsychological model. *Current Anthropology* 31: 407-8.

1990 J.D. Lewis-Williams. Documentation, analysis and interpretation: problems in rock art research. *South African Archaeological Bulletin* 45: 126-136.

1990 J.D. Lewis-Williams. A reply to A.R. Willcox. *Rock Art Research* 7: 64-66.

1990 J.D. Lewis-Williams. Review of Stylistic boundaries among mobile hunter-foragers by G.C. Sampson. *African Studies* 48: 209-211.

1990 J.D. Lewis-Williams. Review of Animals into Art by H. Morphy (ed.). *Antiquity* 64: 426-428.

1990 J.D. Lewis-Williams & T.A. Dowson. Neuropsychology and shamanism in rock art. A reply to R.G. Bednarik. *Current Anthropology* 31: 80-84.

1990 J.D. Lewis-Williams & T.A. Dowson. Through the veil: San rock paintings and the rock face. *South African Archaeological Bulletin* 45: 5-16.

1990 J.D. Lewis-Williams & T.A. Dowson. Reply to J.B. Deregowski. *Rock Art Research* 7: 62-63.

1990 J.D. Lewis-Williams & T.A. Dowson. Reply to M. Lanteigne. *Rock Art Research* 7: 63-64.

1991 J.D. Lewis-Williams with photographs by A. Bannister. *Bushmen: a changing way of life*. Cape Town: Struik. (Reprinted in: 1996, 3rd and 4th printing).

1991 J.D. Lewis-Williams. Reply to C.A. Hromnik. *Rock Art Research* 8: 102-104.

1991 J.D. Lewis-Williams. Wrestling with analogy: a problem in Upper Palaeolithic art research. *Proceedings of the Prehistoric Society* 57 (1): 149-162.

1991 J.D. Lewis-Williams. Debating rock art research: a reply to Butzer. *South African Archaeological Bulletin* 46: 48-50.

1991 J.D. Lewis-Williams. Upper Palaeolithic art in the 1990s: a southern African perspective. *South African Journal of Science* 87: 422-429.

1991 J.D. Lewis-Williams. Review of Felsbilder in Sudafrika by G.J. Fock & D. Fock. *African Studies* 49: 122-123.

1992 J.D. Lewis-Williams. *Vision, power and dance: the genesis of a southern African rock art panel*. Fourteenth Kroon Lecture. Amsterdam: Stichting Nederlands Museum voor Anthropologie en Praehistorie.

1992 J.D. Lewis-Williams. Foreword. In: T.A. Dowson, *Rock engravings of southern Africa*: ix-x. Johannesburg: Witwatersrand University Press.

1992 J.D. Lewis-Williams. Ethnographic evidence relating to 'trance' and 'shamans' among northern and southern Bushmen. *South African Archaeological Bulletin* 47: 56-60.

1992 J.D. Lewis-Williams & T.A. Dowson. *Rock paintings of the Natal Drakensberg*. Pietermaritzburg: Natal University Press.

1992 J.D. Lewis-Williams & T.A. Dowson. Art rupestre San et Paleolithique superieur: le lien analogique. *L'Anthropologie* 96 (4): 769-790.

1992 P.V. Tobias, T.A. Dowson & J.D. Lewis-Williams. 'Blue ostriches' captured. *Nature* 358: 185.

1993 J.D. Lewis-Williams. South African archaeology in the 1990s. *South African Archaeological Bulletin* 48: 45-50.

1993 J.D. Lewis-Williams & T.A. Dowson. L'art des Boschimans: peintures et gravures d'Afrique australe. In: *Le Grand Atlas de l'art*: 24-25. Paris: Encyclopaedia Universalis.

1993 J.D. Lewis-Williams & T.A. Dowson. On vision and power in the Neolithic: evidence from the decorated monuments. *Current Anthropology* 34: 55-65.

1993 J.D. Lewis-Williams & T.A. Dowson. Myths, museums and southern African rock art. *South African Historical Journal* 29: 44-60.

1993 J.D. Lewis-Williams, T.A. Dowson & J. Deacon. Rock art and changing perceptions of Southern Africa's past: Ezeljagdspoort reviewed. *Antiquity* 67: 273-91.

1994 T.A. Dowson & J.D. Lewis-Williams. Diversity in southern African rock art research. In: T.A. Dowson and J.D. Lewis-Williams (eds) *Contested images: diversity in southern African rock art research*: 177-188. Johannesburg: Witwatersrand University Press.

1994 T.A Dowson & J.D. Lewis-Williams. Myths, museums and southern African rock art. In: T.A. Dowson and J.D. Lewis-Williams (eds) *Contested images: diversity in southern African rock art research*: 385-402. Johannesburg: Witwatersrand University Press.

1994 T.A. Dowson & J.D. Lewis-Williams. *Contested images: diversity in southern African rock art research*. Johannesburg: University of the Witwatersrand Press.

1994 T.A. Dowson, P.V. Tobias & J.D. Lewis-Williams. The mystery of the blue ostriches: clues to the origin and authorship of a supposed rock painting. *African Studies* 53: 3-38.

1994 J.D. Lewis-Williams. Rock art and ritual: southern Africa and beyond. *Complutum* 5: 277-289.

1994 J.D. Lewis-Williams. Obituary: A.R. Willcox. *Transactions of the Royal Society of South Africa* 49(2): 270-271.

1994 J.D. Lewis-Williams. Searching for symbols. *Pictograph* 6(2): 16-17.

1994 J.D. Lewis-Williams. The feral mind. In: D. Bloom (ed.) *Morild: Bioluminescence* (exhibition catalogue): G l. Holtegaard, Copenhagen, Denmark.

1994 J.D. Lewis-Williams. Review of The Bushman myth: the making of a Namibian underclass by R. Gordon. *African Studies* 53: 160-162.

1994 J.D. Lewis-Williams & T.A. Dowson. Aspects of rock art research. In: T.A. Dowson and J.D. Lewis-Williams (eds) *Contested images: diversity in southern African rock art research*: 201-221. Johannesburg: Witwatersrand University Press.

1995 J.D. Lewis-Williams. Seeing and construing: the making and 'meaning' of a southern African rock art motif. *Cambridge Archaeological Journal* 5(1): 3-23.

1995 J.D. Lewis-Williams. Modelling the production and consumption of rock art. *South African Archaeological Bulletin* 50: 143-154.

1995 J.D. Lewis-Williams. Image des San et art San. *Les Temps Moderne* 585: 664-679.

1995 J.D. Lewis-Williams. Perspectives and traditions in southern African rock art research. In: K. Helskog and B. Olsen (eds) *Perceiving rock art: social and political perspectives*: 65-87. Oslo: Novus Forlag.

1995 J.D. Lewis-Williams. Some aspects of rock art research in the politics of present-day South Africa. In: K. Helskog and B. Olsen (eds) *Perceiving rock art: social and political perspectives*: 317-337. Oslo: Novus Forlag.

1995 J.D. Lewis-Williams. ACRA: a retrospect. In K. Helskog and B. Olsen (eds) *Perceiving rock art: social and political perspectives*: 409-415. Oslo: Novus Forlag.

1995 J.D. Lewis-Williams. Linton Panel. In: J. Phillips (ed.) *Africa: the art of a continent*: 188. London: Royal Academy of Arts.

1995 J.D. Lewis-Williams. Rock painting. In: J. Phillips (ed.) *Africa: the art of a continent*: 189. London: Royal Academy of Arts.

1995 J.D. Lewis-Williams. Coldstream Stone. In: J. Phillips (ed.) *Africa: the art of a continent*: 189. London: Royal Academy of Arts.

1996 J.D. Lewis-Williams. Comment on J. Dronfield. *Cambridge Archaeological Journal* 6: 60-63.

1996 J.D. Lewis-Williams. Image and counter-image: the work of the Rock Art Research Unit, University of the Witwatersrand. *African Arts* 19: 34-43.

1996 J.D. Lewis-Williams. Light and darkness: earliest rock art evidence for an archetypal metaphor. *World Journal of Prehistoric and Primitive art*: 125-132.

1996 J.D. Lewis-Williams. A visit to the Lion's House: the structure and metaphors of a nineteenth century Bushman myth. In: J. Deacon & T.A. Dowson (eds) *Voices from the past:*

Bleek and Lloyd collection: 122-141. Johannesburg: Witwatersand University Press.

1996 J.D. Lewis-Williams. Southern African rock art. In: *Oxford Companion to Archaeology*: 594. Oxford: Oxford University Press.

1996 J.D. Lewis-Williams. San rock art. In: *Dictionary of Art*: 695-698. London: Macmillan.

1996 J.D. Lewis-Williams & J. Clottes. Upper Palaeolithic cave art: French and South African collaboration. *Cambridge Archaeological Journal* 6: 137-139.

1996 J.D. Lewis-Williams, T.A. Dowson, A. Lock & C.R. Peters. Southern African Bushman Art. In: A. Lock & C.R. Peters (eds) *A handbook of human symbolic evolution*. Oxford: Oxford University Press.

1997 J.D. Lewis-Williams. Prise en compte du relief naturel des surfaces rocheuses dans l'art pariétal Sud Africain et Paléolithique Ouest Européen: étude culturelle et temporelle croisée de la croyance religieuse. (The incorporation of natural features of rock surfaces into Southern African and West European Upper Palaeolithic parietal art: a cross-cultural, cross-temporal study of religious belief.) *L'Anthropologie* 101: 220-237.

1997 J.D. Lewis-Williams. Art, agency and altered consciousness: a motif in French (Quercy) Upper Palaeolithic parietal art. *Antiquity* 71(274): 810-830.

1997 J.D. Lewis-Williams. Exhibiting and studying San rock art: response to Nettleton. *African Arts* 30(3): 90.

1997 J.D. Lewis-Williams. The Mantis, the Eland and the Meerkats: conflict and mediation in a nineteenth century San myth. In P. McAllister (ed.) Culture and the commonplace: anthropological essays in honour of David Hammond-Tooke. *African Studies* 56(2): 195-216.

1997 J.D. Lewis-Williams. The San shamanic dance and its relation to rock art. In: E.A Dagan (ed.) *The Spirit's dance in Africa: evolution, transformation and continuity in sub-Sahara*: 36-41. Montreal, Galerie Amrad African Art Publications.

1997 J.D. Lewis-Williams. Rock art: southern Africa. In: J. Middleton (ed.) *Encyclopedia of Africa south of the Sahara Volume 4*: 7-9. New York: Scribners.

1997 J.D. Lewis-Williams. Harnessing the brain: vision and shamanism in Upper Palaeolithic Western Europe. In: M.W. Conkey, O. Sopher, D. Stratmann & N.G. Jablonski (eds)

Beyond art: Pleistocene image and symbol: 321-342. Berkeley: University of California Press.

1997 J.D. Lewis-Williams. Review of The hunter's vision: the prehistoric art of Zimbabwe by P.S. Garlake. *Journal of African History* 38(1): 128-130.

1997 J.D. Lewis-Williams & G. Blundell. New light on finger-dots in southern African rock art: synesthesia, transformation and technique. *South African Journal of Science* 93: 51-54.

1997 J.D. Lewis-Williams & J. Clottes. *Les Chamanes de la Préhistoire: transe et magie les grottes ornées*. Paris: Éditions du Seuil.

1997 J.D. Lewis-Williams & J. Clottes. *Shamanen: trance und magie in der Höhlenkunst der Steinzeit*. Sigmaringen: Jan Thorbecke Verlag.

1997 J.D. Lewis-Williams & J. Clottes. Tense on pas transe: response a Roberte Hamayon. *Les nouvelles de l' Archaelogie*: 45-47.

1998 J.D. Lewis-Williams. Quanto? The issue of 'many' meanings in southern African San rock art research. *South African Archaeological Bulletin* 53: 86-97.

1998 J.D. Lewis-Williams. Wrestling with analogy: a methodological dilemma in Upper Palaeolithic art research. In: D.S. Whitley (ed.) *Reader in Archaeological theory, post-processual and cognitive approaches*: 157-175. London: Routledge.

1998 J.D. Lewis-Williams. Current South African rock art research: a brief history and review. *International Newsletter on Rock Art* 20: 12-22.

1998 J.D. Lewis-Williams & G. Blundell. *Fragile heritage: a rock art fieldguide*. Johannesburg: University of the Witwatersrand Press.

1998 J.D. Lewis-Williams & J. Clottes. *The Shamans of prehistory: trance magic and the painted caves*. New York: Abrams.

1998 J.D. Lewis-Williams & J. Clottes. The mind in the cave - the cave in the mind: altered consciousness in the Upper Palaeolithic. *Anthropology of Consciousness* 9(1): 13-21.

1998 J.D. Lewis-Williams & J. Clottes. Shamanism and Upper Palaeolithic art: a response to Bahn. *Rock Art Research* 15(1): 46-50.

1998 J.D. Lewis-Williams & B.W. Smith. Ancient art in South Africa: history and national resolve in a period of change. *CSD Bulletin* 5(1): 13-16.

1999 J.D. Lewis-Williams. Images of the spirit world: rock art of the San people. *Archaeology* 52(3): 61-63

1999 J.D. Lewis-Williams. Dance and representation (Shorter Notes). *Cambridge Archaeological Journal* 9(2): 281-283.

1999 J.D. Lewis-Williams. 'Meaning' in southern African San rock art: another impasse? *South African Archaeological Bulletin* 54(170): 141-145.

1999 J.D. Lewis-Williams. Foreword. In: L.J. Marshall, *Nyae Nyae !Kung beliefs and rites.* Massachusetts: Harvard University.

1999 J.D. Lewis-Williams. Rock Art Research Unit. *CSD News.* March: 16-17.

1999 J.D. Lewis-Williams & T.A. Dowson. *Images of power: understanding San rock art.* Johannesburg: Southern Book Publishers (Second Edition).

1999 J.D. Lewis-Williams & T.A. Dowson. Afrique Autrale, art. In: A. Michel & B. Van Der Meersch (eds) *Dictionaire de la Préhistoire*: 40-43. Paris: Encyclopedia Universalis.

2000 J.D. Lewis-Williams. *Stories that float from afar: further specimens of 19th Century Bushman folklore.* Cape Town: David Philip Publishers.

2000 J.D. Lewis-Williams. (Foreword) In P. Charteris (ed.) *Selected southern African rock art.* Johannesburg: South African Archaeological Society.

2000 J.D. Lewis-Williams, G. Blundell, W. Challis. & J. Hampson. Threads of light: re-examining a motif in southern African San rock art. *South African Archaeological Bulletin* 55(172): 123-136.

2000 B.W. Smith, J.D. Lewis-Williams, G. Blundell & C. Chippindale. Archaeology and symbolism in the new South Africa coat of arms. *Antiquity* 74(284): 467-468.

2001 G. Blundell & J.D. Lewis-Williams. Storm Shelter: an important new rock art site in South Africa. *South African Journal of Science* 97: 43-46.

2001 J.D. Lewis-Williams. Paintings of the spirit: rock art opens a new window into the Bushmen world. *Journal of the National Geographic Society* 199(2): 117-125.

2001 J.D. Lewis-Williams. New rock art site: how a lost past was found. *Archimedes* 43(1): 4-7.

2001 J.D. Lewis-Williams. Brainstorming images: neuropsychology and rock art research. In: D.S. Whitley (ed.) *Handbook of rock art research*: 332-357. Oxford: Altamira Press.

2001 J.D. Lewis-Williams. Southern African shamanistic rock art in its social and cognitive contexts. In: N.S. Price (ed.) *The archaeology of shamanism*: 16-39. London: Routledge.

2001 J.D. Lewis-Williams. The enigma of Palaeolithic cave art. In: B.M. Fagan (ed.) *The seventy great mysteries of the ancient world: unlocking the secrets of past civilisations*: 96-100. London: Thames and Hudson.

2001 J.D. Lewis-Williams. Threads of light. In: S.T. Basset, *Rock paintings of South Africa: revealing a legacy*: 78-83. David Philip: Cape Town.

2001 J.D. Lewis-Williams. Monolithism and polysemy: Scylla and Charybdis in rock art research. In: K. Helskog (ed.) *Theoretical perspectives in rock art research*: 23-39. Oslo: Novus verlug, The Institute for Comparative Research in Human Culture.

2001 J. Clottes & J.D. Lewis-Williams. *Les chamanes de la préhistoire: texte integral, polémique et résponses.* Paris: Éditions du Seuil (La maison des roches).

2001 J. Clottes & J.D. Lewis-Williams. *Los chamanes de la prehistoria.* Barcelona: Ariel Prehistorica (Spanish edition).

2002 G. Blundell & J.D Lewis-Williams. A new discovery in Nomansland, South Africa. *International Newsletter on Rock Art.* No. 33:1-7

2002 J.D. Lewis-Williams. Three-dimensional puzzles: southern African and Upper Palaeolithic rock art. *Ethnos* 66(2):245-264.

2002 J.D. Lewis-Williams. Image des San et art san. Une dialectique potentiellement créatrice en Afrique australe. In: *Ubuntu Arts et cultures d'Afrique du Sud*: 34-41. Paris, musée national des Arts d'Afrique et d'Océanie (20 février-17 juin 2002)

2002 J.D. Lewis-Williams. *A cosmos in stone: interpreting religion and society through rock art.* Walnut Creek, California: Altamira Press.

2002 J.D. Lewis-Williams. *The Mind in the Cave: Consciousness and the Origins Of Art.* London: Thames & Hudson.

2003 J.D. Lewis-Williams. *Images of Mystery: Rock Art of the Drakensberg.* Cape : Double Storey.

2003 J.D. Lewis-Williams. *L'art Rupestre en Afrique du Sud: Mystérieuses Images du Drakensberg.* Paris: Seuil.

2003 J.D. Lewis-Williams. Chauvet: The Cave that Changed Expectations. *South African Journal of Science* 99: 191-194.

2003 J.D. Lewis-Williams. Putting the Record Straight: Rock Art and Shamanism. *Antiquity* 77(295): 165-169.

2003 J.D. Lewis-Williams. Review Feature. The mind in the cave: consciousness and the origins of art. *Cambridge Archaeological Journal* 13: 263-279.

2003 J.D. Lewis-Williams. Comment. In: Bradford Keeney *Ropes to God: Experiencing the Bushman*

Spiritual Universe: 159-165. Philadelphia: Ringing Rocks Press.

2003 J.D. Lewis-Williams. Obituary: Dr Patricia Vinnicombe. *South African Archaeological Bulletin* 58: 44-47.

2003 J.D. Lewis-Williams. Obituary: Patricia Vinnicombe. *Before Farming* 12(2): 1-2.

2003 J.D. Lewis-Williams. Shamanism and the Ancient Mind: A Cognitive Approach to Archaeology by James L. Pearson. *Journal of Anthropological Research* 59: 93.

2003 J.D. Lewis-Williams. World Rock Art by Jean Clottes. *South African Archaeological Bulletin* 58: 38-43.

2004 J.D. Lewis-Williams. *Building an Essay: A Practical Guide for Students*. Cape Town: New Africa Books.

2004 J.D. Lewis-Williams. On Sharpness and Scholarship in the Debate on 'Shamanism'. *Cambridge Archaeological Journal* 45(3): 404-406.

2004 J.D. Lewis-Williams. Constructing a cosmos: architecture, power and domestication at Catalhöyük. *Journal of Social Archaeology* 4(1): 28–59.

2004 J.D. Lewis-Williams. Neuropsychology and Upper Palaeolithic Art: Observations on the Progress of Altered States of Consciousness. *Cambridge Archaeological Journal* 14(1): 107-111.

2004 J.D. Lewis-Williams. Consciousness, Intelligence and Art: A view of the West European Upper Palaeolithic Transition. In: G. Berghaus (ed.) *New Perspectives on Prehistoric Art: A View of the West European Middle to Upper Palaeolithic Transition*: 11-29. Westport: Praeger Publishers.

2004 J.D. Lewis-Williams & D.G. Pearce. Southern African San rock painting as social intervention: A study of rain-control images. *African Archaeological Review* 21(4): 199-228.

2004 J.D. Lewis-Williams & D.G. Pearce. *San Spirituality: Roots, Expressions and Social Consequences*. Cape Town: Double Storey.

2005 J.D. Lewis-Williams. *La Mente en la caverna* (Spanish translation of "The mind in the cave"). Madrid: Ediciones Akal.

2005 J.D. Lewis-Williams. The southern African San and their rock art. *Transactions of the Royal Society of South Africa* 60(2): 139-146.

2005 J.D. Lewis-Williams. Les Bushmen et l'art rupestre. Les Bushmen dans l'histoire. In: E. V. Olivier & M. Valentin (ed.) *Les Bushmen dans l'Histoire*: 113-130. Paris: CNRS Éditions.

2005 J.D. Lewis-Williams. New neighbours: interaction and image-making during the West European Middle to Upper Palaeolithic transition. In: F. B. D'Errico and L. Backwell (eds) *From Tools to Symbols: From early hominids to modern humans*: 372-388. Johannesburg, Witwatersrand University Press.

2005 J.D. Lewis-Williams. Entoptic images. : M. N. Walter & Neumann Fridmann E. J. (eds) *Shamanism: an encyclopedia of world beliefs, practices and culture*: 117-119. Santa Barbara, ABC Clio. Volume I.

2005 J.D. Lewis-Williams. Bushman Art. *Times Literary Supplement*: 15.

2005 J.D. Lewis-Williams. The Origins Centre at the University of the Witwatersrand, Johannesburg. *International Newsletter on Rock Art* (INORA) 43: 21-24.

2005 J.D. Lewis-Williams & D.G. Pearce. *Inside the Neolithic Mind*. London: Thames & Hudson.

2006 J. Clottes & J.D. Lewis-Williams. After the *Shamans of Prehistory*: polemics and responses. In: J.D. Keyser, G. Poetschat and M.W. Taylor (eds) *Talking with the past: the ethnography of rock art*: 100-142. Portland: Oregon Archaeological Society.

2006 J.C. Hollmann & J.D. Lewis-Williams. Species and supernatural potency: an unusual rock painting from the Motheo District, Free State Province, South Africa. *South African Journal of Science* 102: 509-512.

2006 J.D. Lewis-Williams. Debating rock art: myth and ritual, theories and facts. *South African Archaeological Bulletin* 61: 105-114.

2006 J.D. Lewis-Williams. The evolution of theory, method and technique in southern African rock art research. *Journal of Archaeological Method and Theory* 13(4): 343-377.

2006 J.D. Lewis-Williams. Early San spirituality: evidence from the Howieson's Poort industry: a note on J. Parkington's Review of San Spirituality. *Journal of African Archaeology* 4(2): 349-350.

2006 J.D. Lewis-Williams. Shamanism: a contested concept in archaeology. *Before Farming* 2006/4 article 1

2006 J.D. Lewis-Williams. Response. *Before Farming* 2006/4 article 12.

2006 J.D. Lewis-Williams. Saving a tradition. In: G. Blundell (ed.) *Origins: the story of the emergence of humans and humanity in Africa*: 160-165. Cape Town: Double Storey.

2006 J.D. Lewis-Williams. Building bridges to the

deep human past: consciousness, religion and art. In: LeRon Shults, F. (ed.) *The Evolution of Rationality*: 149-166. Cambridge: William B. Eerdmans.

2006 J.D. Lewis-Williams. Rock art and ethnography: a case in point from southern Africa. In: J.D. Keyser, G. Poetschat and M.W. Taylor (eds) *Talking with the past: the ethnography of rock art*: 30-48. Portland: Oregon Archaeological Society.

2006 J.D. Lewis-Williams. Explaining the inexplicable: Upper Palaeolithic cave art. *Minerva* 17(3): 28-30.

2006 J.D. Lewis-Williams. Setting the record straight. *The Digging Stick* 23(2): 6-8.

2006 J.D. Lewis-Williams & D.G. Pearce. An accidental revolution? Early Neolithic religion and economic change. *Minerva* 17(4): 29-31.

2006 J.D. Lewis-Williams & D.G. Pearce. Data and types of explanation in Lombard's review of the Howieson's Poort debate. *Southern African Humanities* 18(2): 182-188.

2007 J. Clottes & J.D. Lewis-Williams. *Los Chamanes de la Prehistoria*. Barcelona: Ariel Prehistorica (Spanish paperback edition of *Shamans of Prehistory*).

2007 J. Clottes & J.D. Lewis-Williams. Palaeolithic art and religion. In: Hinnells, J.R. (ed.) *Penguin Handbook of Ancient Religions*: 7-45. London: Penguin Books.

2007 J.D. Lewis-Williams. The current rock art controversy: a coda. *South African Archaeological Bulletin* 62: 79-81.

2007 J.D. Lewis-Williams. Rock Art, southern Africa. In: Middleton, J. & Miller, J.C. (eds) *New Encyclopedia of Africa, Volume 1*: 148-150. New York: Thomson Gale.

2007 J.D. Lewis-Williams. Wilhelm Bleek, Lucy Lloyd and Dorothea Bleek: A personal tribute. In: Skotnes, P. (ed.) *Claim to the country: the Archive of Wilhelm Bleek and Lucy Lloyd*: 177-181. Johannesburg: Jacana.

2008 J.D. Lewis-Williams. A nexus of lives: How a heretical bishop contributed to our knowledge of South Africa's past. *Southern African Humanities* 20: 463-475.

2008 J.D. Lewis-Williams. Mobiliser le cerveau: vision et chamanisme au Paléolithique supérieur en Europe de l'Ouest. *Cahiers Jungiens de Psychanalyse* 127: 11-35.

2008 J.D. Lewis-Williams. Religion and archaeology: an analytical, materialist account. In: Whitley, D.S. & Hays-Gilpin (eds) *Belief in the Past: Theoretical Approaches to the Archaeology of Religion*: 23-42. Walnut Creek (CA): Left Coast Press.

2008 J.D. Lewis-Williams. Our ancient forebears got there first. Review of *Cave Art* by Clottes, J. *South African Journal of Science* 104: 415-416.

2008 J.D. Lewis-Williams & T.A. Dowson. The case of the 'blue ostriches'. *The Digging Stick* 25(3) 1-5.

2008 J.D. Lewis-Williams & D.G. Pearce. From generalities to specifics in San rock art. *South African Journal of Science* 104: 428-430.

2008 J.D. Lewis-Williams & D.G. Pearce. *Uvnit Neolitické Mysli* (Czeck translation of *Inside the Neolithic Mind*). Prague: Galileo.

2008 J.D. Lewis-Williams & B.W. Smith. *Reservoirs of potency: the documentary paintings of Stephen Townley Bassett*. Johannesburg: Rock Art Research Institute.

2009 J. Clottes & J.D. Lewis-Williams. *Prehistoryczni Szamani: trans i magia w zdobionych grotach*. Warsaw: Warsaw University Press. (Polish paperback edition of *Shamans of Prehistory*).

2009 J. Clottes & J.D. Lewis-Williams. *Historiaurreko Xamanak*. San Bartolome: Gaiak Argitaldaria. (Basque paperback edition of *Shamans of Prehistory*).

2009 J.D. Lewis-Williams. Of people and pictures: the nexus of Upper Palaeolithic religion, social discrimination, and art. In: Renfrew, C. & Morley, I. (eds) *Becoming human: innovation in prehistoric material and spiritual culture*: 135-158. Cambridge: Cambridge University Press.

2009 J.D. Lewis-Williams. Patricia Vinnicombe: a Memoir. In: Mitchell, P. & Smith, B.W. (eds) 2009. *The Eland's People: New Perspectives in the Rock art of the Maloti-Drakensberg Bushmen*: 13-28. Johannesburg: Wits University Press.

2009 J.D. Lewis-Williams & D.G. Pearce. Constructing spiritual panoramas: order and chaos in southern African San rock art panels. *Southern African Humanities* 21: 41-61.

2010 J.D. Lewis-Williams. *Conceiving God: The Cognitive Origin and Evolution of Religion*. London: Thames and Hudson.

2010 J.D. Lewis-Williams & D.G. Pearce. *Dentro de la Mente Neolítica: Conciencia, Cosmos y el Mundo de los Dioses* (Catalan edition of Inside the Neolithic Mind). Madrid: Ediciones Akal.

2010 J.D. Lewis-Williams. Science, religion, and pictures: an origin of image making. In: Milbrath, C. & Lightfoot, C. (eds) 2010. *Art and Human Development*: 11-40. New York: Psychology Press.

Index